ASMP
BOOK
2

Distributors to the trade in the United States:
Contemporary Books, Inc., 180 North Michigan Avenue, Chicago, IL 60601

Distributed in Continental Europe by:
Feffer and Simons, B.V., 170 Rijnkade, Weesp, Netherlands

Distributed throughout the rest of the world by:
Fleetbooks, S.A. % Feffer and Simons, Inc., 100 Park Avenue, New York, NY 10017

ISBN 0-912417-00-5

ISSN 0737-2841

Annuals Publishing Company, Inc., 10 East 23rd Street, New York, NY 10010
(212) 744-2740

Distributor to the art supply trade:
Robert Silver Associates, 95 Madison Avenue, New York, New York 10016

ANNUALS PUBLISHING COMPANY, INC.

Publishers–Arie Kopelman, Gerald McConnell

Editor and Sales Director–Pauline Augustine

Production Manager–Cathy Citarella

Controller–Eileen Farley

Distribution Director–Kristin Crawford

Traffic Manager–Katherine Brown

Administrative Assistant–Zulema Rodriguez

Design–Robert Anthony, Inc.

Typography–Advani Typographic Associates

Printing–Dai Nippon Tokyo

We wish to express our thanks to the following for their help in the production of this volume:

Yoh Jinno	DNP (America), Inc.
David Milne	AIRE Graphics
Andy Carnase	Adesign
Ken Lieberman	Stuart Color Labs

Special thanks to ASMP Book Committee

Dick Frank Harvey Lloyd Marvin Newman

ASMP Executive Director, Stuart Kahan, and his staff

ASMP Chapter Presidents and Board Members whose support was invaluable

PRINTED IN JAPAN

TABLE OF CONTENTS

OFFICERS OF ASMP

ASMP National Headquarters

Executive Director, Stuart Kahan
205 Lexington Avenue, New York, NY 10016
(212) 889-9144

Staff:
Roberta Wexler, Administrative Director
Beverly Adler, Advertising, Membership
Lorraine Pastore, Business Practices Book, Membership
Gloria Rivera, Bookkeeping

Legal Counsel:
Michael D. Remer
Shanks, Davis & Remer
888 Seventh Avenue
New York, N.Y. 10106
(212) 586-5960

Presidents Council

Barbara Bordnick
Jerry Cooke
Lawrence Fried
Barrett Gallagher
Burt Glinn
Tom Hollyman

Myron Miller
Charles Rotkin
Henry Sandbank
Ezra Stoller
Ike Vern

We are proud to present this book of photographs by members of ASMP, the world's leading organization of professional photographers.

There were many reasons to do this book. Foremost was the service to our members and the photographic community. Members who might not otherwise have this kind of advertising opportunity were able to utilize these pages. Because of this book the photographic industry's resources have been enriched.

I hope this will be an ongoing presentation of the creativity and talent of our membership with benefits to all.

Sincerely,

Marvin E. Newman
ASMP President 1982

ABOUT THE ASMP

ASMP—The American Society of Magazine Photographers—was organized in 1944 to further the interests of professional photographers. It remains the world's foremost organization of professional photographers comprising a membership of over 3,500 of the finest in many categories from documentary and photojournalism to industrial/corporate and advertising, in print, film, tape, and related visual media.

WHAT ASMP DOES

ASMP acts as the clearinghouse of photographic information for the industry, collecting information about photographers' rates and rights, and disseminating data on economic and ethical practices for the benefit of members and their clients. The Society's regularly updated book *Professional Business Practices in Photography*, has become the primary sourcebook for both buyers and sellers of photography.

Throughout the past 39 years, ASMP has been at the crossroads of the profession. The Society's list of members (past and present) reads like a Who's Who in photography including: Ansel Adams, Margaret Bourke-White, Ernst Haas, Henri Cartier-Bresson, Edward Steichen, Paul Strand, Philippe Halsman (ASMP's first President), W. Eugene Smith, Richard Avedon, Gordon Parks and Gjon Mili.

Through its twenty chapters nationwide, ASMP helps photographers communicate with each other and with clients. At its New York City headquarters and regionally, programs are offered, together with a monthly Bulletin, to keep members informed about technical developments, business practices and their own activities and growth. Regular national meetings of chapter presidents with ASMP Officers and trustees, provide an exchange of information about business conditions and related matters throughout the country.

ASMP has an established voice in the communications industry based on a continuing and successful monitoring of photographer-client relationships. Over the years, the Society has negotiated with the world's major publishers, advertising agencies, industrial firms and other buyers of photography. It has also presented its views before the Congress of the United States, as well as State legislatures, in a number of matters ranging from copyright to compulsory licensing. A major contribution to photographers and to clients was ASMP's involvement in revising the copyright law.

The Society's active role in a changing communications field enjoys the full support of its growing international membership.

WHAT ASMP HAS ACCOMPLISHED

ASMP was originally established by a handful of aware photographers to support and further the interests of professionals in the magazine field. Over the succeeding years, the field of advertising grew enormously as a marketplace for photography, and television too, became a major user of still photographs. The province of the photographer has been greatly expanded and its future will continue to be tightly interwoven with that of the communications industry.

As the leading organization of professional photographers today, these are ASMP's functions:

We help coordinate relations between members and publishers, advertising agencies, industrial firms and other users of quality photography

We help to establish proper standards for photographers to retain ownership and resale rights to their work

We are instrumental in helping to set legal precedents in areas such as copyright and credit lines

We work to protect photographers' rights

We provide surveys of rates and standards for all phases of the photographer's business with editors, advertising personnel and picture agencies

We offer suggested sample forms for model and property releases, assignment confirmation, book contracts and stock picture submissions

One of the principal publications of the Society is the *Professional Business Practices in Photography* book which is considered the "Bible" of the industry. The following information is adapted from the 1982 edition dealing with some aspects of usages, agreements, professional practices and standards.

ASSIGNMENT PHOTOGRAPHY

Advertising

Advertising photography consists primarily of creating images included in advertisements used in magazines (whether national, regional or trade), billboards, newspapers, brochures, packaging, catalogues, general sales literature, other print media and television commercials, to name the most important categories.

Given the relatively large budgets involved in this field, many cost factors are carefully planned well in advance. Written estimates, provided before the assignment is begun, protect both the photographer and the client and are considered the best practice. As a rule, all expenses agreed upon as necessary by both photographer and client, are customarily billed by the photographer and paid by the client. Also in advance, usage of the photographs is discussed and agreed upon. Usage beyond that for which the assignment was initially undertaken requires additional compensation to the photographer, and such additional use is a subject of negotiation between the photographer and the client. It is usual for such usage to be detailed in writing before the assignment is begun. Reuse of the photographs by the photographer in his or her own promotion or portfolio pieces is generally accepted without question. This has been the practice for many years.

Photographs which are not used in an ad and are similar to those in the original layout belong, also by custom, to the photographer, unless it is agreed to be otherwise at the outset. In any event, if such similar pictures are used by the client, additional compensation is paid to the photographer.

The fee structure in advertising photography reflects several important variables including:

(1) Fees to cover one or more day's shooting usually involve days of preparation and, therefore, will be high enough to reflect that preparation.

(2) When major national print campaigns involve hundreds of thousands of dollars, photographers' top fees set to reflect the most exacting of a client's requirements, will seem easily justified.

It should be noted that advertising photographers, as a result of client needs, have typically sustained larger overheads than many other photographic professionals. Increased staffing, larger studio space and special equipment to satisfy job requirements all contribute to the photographic fee structure.

Editorial

Most editorial assignments can be placed into one or two basic categories:

(1) Reportage, where the photographer makes a series of photographs over an assigned period of time, the object of which is a layout assembled by the assigning publication. This is the traditional photojournalistic approach.

(2) Illustration, where the photographer exercises the discipline of producing one or more photographs to a preconceived concept or layout. At times, a combination of both categories may apply.

Customarily, in editorial photography, all expenses necessary to execute the assignment are billable to the client. Accordingly, it is always advisable for photographer and client to have at least a preliminary estimate of expenses in advance to avoid surprises or misunderstandings. Because of the increased costs of supplies and services today, many photographers obtain an advance payment before beginning the assignment.

The long-established tradition in all editorial photography is that the photographer's basic fee covers one time use, one language, in the designated publication. All other rights, including copyright, belong to the photographer. This limitation on usage has become an accepted principle among professional freelance editorial photographers for these reasons:

Reuse income is critical to the photographer's economic position given the relation between professional overheads and current editorial day and page rates.

There is the underlying residual principle that the photographer is entitled to own the results of his or her creative efforts, a position now solidly entrenched in the new United States Copyright Act.

An absolutely essential element of editorial photography is the need for a proper credit line, and it is customary for both reportage photographers and illustrators to secure legible credits next to each photograph or group of photographs. Credit adjacent to the photograph is the most widely-accepted practice and essential if the photographer is to secure resale income and name recognition. The form of the credit line is also important. It is becoming common for photographers to request and obtain credit line in proper copyright form: "(Copyright (or ©) 1983 P. Photographer)"

Corporate/Industrial & Annual Reports

The fields of corporate/industrial and annual report photography embrace material published primarily in brochures, promotional literature, audiovisual programs and annual reports of industrial and nonprofit corporations, as well as governmental, educational and similar institutions. Photography for so-called "house organs" (a corporation's own promotional magazine) also has characteristics associated with corporate, industrial and editorial assignments. Corporate/industrial assignments are normally executed on a "day rate" basis plus all expenses.

Use of the photographs beyond that for which the assignment was initially undertaken requires additional compensation to the photographer. This is a clear, general practice, agreed upon before work begins.

For example, additional compensation is invariably negotiated with a photographer when photographs taken for and used in a recruiting brochure or album cover are later chosen by the client for inclusion in a paid advertisement or annual report. In a similar vein, photographs taken for a particular year's annual report may not be used in another year's report (or in a paid advertisement) without further compensation to be negotiated with the photographer.

It is precisely because of these conditions that the photographer and client should have a clear understanding in writing of the contemplated usage at the outset of an assignment.

Publicity/Promotional

This field involves the creation of materials used by business organizations, press agents, public relations firms, corporate directors of communications, and individual talents who may handle their own public relations. The clients in this area are often associated with theatre, television, sports, dance, film, tape, book publishing, music, and to some degree, general corporate activities. Financially, the field incorporates elements of both photojournalism and commercial illustrations.

Under current practice, a photographer's basic fee may only cover limited client usage such as press kits, brochures, local poster display or certain editorial usage in newspapers, trade publications and television. Other reproduction rights granted usually result in additional income to the photographer for extended use by the client.

In addition, photographers request adjacent credit lines, preferably in proper copyright form to accompany every usage. For example, it should be noted that protecting the copyright on a book jacket requires the placement of the copyright notice on the jacket itself. Book jackets are considered advertising and not part of the book proper. It is also common practice, as in other fields of photography that all negatives and transparencies should be returned to the photographer immediately after usage.

STOCK PHOTOGRAPHY

A stock picture is one that is already taken, available on file, and which may be licensed for use or reuse. The photographer may either license its use directly to a client or give permission to a designated representative, such as a stock photo agency, to license the use of the picture to clients in return for a percentage of the license fee. To "license" means to offer permission for limited use of the photograph which is subsequently returned to the owner or agent after reproduction or projection. While photographers may casually say they "sell" stock photographs, they mean they are selling the license to use such pictures, ownership of which remains in their possession.

Today, the selling of stock photography plays an important role in the business life of the professional freelance photographer. Since it can provide a significant and relatively dependable amount of income, it is important that the photographer and the client understand the mechanisms of stock picture licensing, as well as the principles of pricing. ASMP's *Professional Business Practices in Photography* book has become the industry source for such information. Included are more than eleven pages of stock rates in more than twenty fields. Each market has its own requirements, vocabulary and trade practices, and each applies its own scale of prices to photographs. It should be specifically noted that reproduction by any means, including print, audio-visual, TV, or other electronic process devised now or in the future is covered by copyright, and stock pictures may not be licensed or used without the permission of the copyright owner.

The New Copyright Law

The Copyright Law provides protection against reproducing a copyrighted work "in whole or any substantial part . . . by duplicating it . . . exactly or by imitation or simulation," without permission. Under the new law, a photographer owns the copyright to work that he or she has created on or after January 1, 1978. The major exception is that work done by an employee is owned by the employer, if it is part of the staff member's regular duties. This latter situation is one instance of "work made for hire."

Thus, freelance photographers commissioned for an assignment are not on a regular employment basis and are deemed the copyright owners of their work unless they specifically agree, in writing, to surrender that right.

Protecting Copyright

There are two essential methods of protecting copyright. The first is to include the proper copyright notice on all photographs and their reproduction, and the second is registration in Washington, D.C. It is good practice to include a copyright notice on all work, unpublished as well as published, whether registered or not. Improper notice or failure to provide a notice can result in a loss of protection. The new law, however, prevents the copyright owner from losing the copyright if copyright does not accompany a published photograph, when notice is a condition of license. This emphasizes the importance of also stipulating in writing that the publisher of a photograph is authorized to publish solely on the condition that proper copyright notice is provided.

Admittedly, the area of copyright is a vast one, but ASMP has set up a "hot line" arrangement whereby members and their clients may call ASMP's national headquarters in New York City for answers to questions concerning various aspects of the copyright law. The Society has taken an active and important interest in this area, and its knowledge of copyright ranges from registration procedures and unauthorized uses to fair use and assignments. (The Society's *Business Practices* book devotes eight pages to the workings of the new copyright law; ASMP also publishes periodically updated White Papers on the subject.)

ASMP member photographers are in the business of selling or licensing reproduction rights. The nature of such rights to a specific work which may be transferred to a specific client is primarily an economic decision. The photographer must decide whether the payment offered is adequate compensation for the rights being purchased. The client must decide if the rights acquired are worth the payment asked. The balance between these two factors is settled by negotiation.

GENERAL MEMBERS NEW YORK CITY

A

AARON, PETER 677 Madison Ave, NYC (212) 486-0019

ABBE, KATHRYN Brookville Rd, Jericho, NY (212) 369-4460

ABBOTT, WARING 78 Franklin St, NYC (212) 925-6082

ABRAMSON, MICHAEL 84 University Pl, NYC (212) 691-2601, 989-2004

ACS, SANDOR 39 W 67 St, NYC (212) 787-0868

ADAMS, EDDIE 435 W 57 St, NYC (212) 664-0999

ADAMS, GEORGE J. 15 W 38 St, NYC (212) 391-1345

ADAMS, MOLLY Kennedy Rd, Mendham, NJ (201) 543-4521

ADELMAN, BOB 119 Fifth Ave - Rm 606, NYC (212) 982-0238

AGOR, ALEXANDER 238 E 14 St, NYC (212) 477-6563

AGUIAR, WALTER Box 328, NYC 10011 (212) 929-9045

AICH, CLARA 218 E 25 St, NYC (212) 686-4220

AKIS, MANNY 6 W 18 St, NYC (212) 620-0299

ALBERT, JADE 9 E 68 St - Apt 3C, NYC (212) 283-9653

ALCORN, RICHARD 160 W 95 St - Apt 7A, NYC (212) 866-1161

ALEXANDER, JULES 333 Park Ave S, NYC (212) 533-3150

ALEXANDER, ROBERT 50 W 29 St, NYC (212) 684-0180

ALEXANDERS, JOHN 308 E 73 St, NYC (212) 734-9166

ALLEN, CASEY 451 West End Ave, NYC (212) 787-5400

ALMY, DAVID Hangar C1, Bus & Commercial Aviation, Westchester Co Airport,
 White Plains, NY (212) 725-7539/7960, (914) 948-1912

ALPER, BARBARA 335 E 13 St - 12, NYC (212) 228-8187

AMBROSE, KEN 44 E 23 St, NYC (212) 260-4848;
 Rep—Don Stogo (212) 490-1034 **P 85**

AMES JR., THOMAS W. 404 Third St - Loft 4A, Hoboken, NJ (201) 674-7160

AMPLO, NICHOLAS 1809 Ave X, Brooklyn, NY (212) 741-2799 **P 205**

AMRINE, JAMIE 900 Broadway, NYC (212) 243-2178 **P 81**

ANCONA, GEORGE Crickettown Rd, Stony Point, NY (914) 786-3043

ANDERSON, DICK Mooreland Rd, Greenwich, CT (212) 582-1424

ANDERSON, JIM 188-90 Grand St, Brooklyn, NY (212) 388-1083

ANDERTON, DAVID 30 S Murray Ave, Ridgewood, NJ (201) 652-0632

ANZALONE, JOSEPH PO Box 1802, S Hackensack, NJ 07606 (201) 440-6845

ARANITA, JEFFREY 60 Pineapple St - Apt 3A, Brooklyn, NY (212) 625-7672

ARKY, DAVID 3 W 18 St - 7 Flr, NYC (212) 242-4760

ARMA, TOM 38 W 26 St, NYC (212) 243-7904 **P 76**

ARNDT, DIANNE 400 Central Park W - Apt 14R, NYC (212) 866-1902

ARNOLD, EVE, Magnum Photos, 251 Park Ave S - 11 Flr, NYC (212) 475-7600

ATKIN, JONATHAN 23 E 17 St, NYC (212) 242-5218

AVEDON, RICHARD 407 E 75 St, NYC (212) 879-6325

AZZI, ROBERT % Woodfin Camp, 415 Madison Ave, NYC (212) 750-1020

B

BADER, MITCH 130 W 29 St, NYC (212) 947-7638

BAEHR, SARAH 114 W 29 St, NYC (212) 244-4573

BALIOTTI, DAN 101 Fifth Ave, NYC (212) 989-4600 **P 224**

BANKS, DON 10 Waterside Plaza, NYC (212) 684-4139

BARBERIS, TITO 333 Park Ave S, NYC (212) 473-1693

BARDES, HAROLD 1812 Kennedy Blvd, Union City, NJ (201) 867-7808

BARNELL, JOE, Shostal Assoc, 60 E 42 St, NYC (212) 687-0696

BARNETT, PEGGY 26 E 22 St, NYC (212) 763-0500

BARNS, LARRY 200 E 53 St, NYC (212) 355-1371 **P 58**

BARONIO, JOYCE 33 W 17 St - 11 Flr, NYC (212) 242-5224

BARRETT, JOHN 40 E 20 St, NYC (212) 777-7309

BARROWS, WENDY 172 Lexington Ave, NYC (212) 685-0799 **P 188**

BARTON, PAUL 101 W 18 St, NYC (212) 533-1422;
 Rep—Gary Lerman (212) 683-5777 **P 140-141**

BAUM, CHARLES 320 West End Ave, NYC (212) 724-8013

BAUMEL, KEN 233 Bergen St, Brooklyn, NY (212) 855-8051

BEAUDIN, TED 6 W 37 St, NYC (212) 683-5480 **P 106-107**

BECK, JIM 615 Fullerton Ave, Montclair, NJ (201) 746-8025

BECKHARD, ROBERT 130 E 24 St, NYC (212) 777-1411

BECHTOLD, JOHN 117 E 31 St, NYC (212) 679-7630;
 Rep—Gary Lerman (212) 683-5777 **P 38**

BELLER, JANET 228 W 72 St, NYC (212) 799-1126 **P 126**

BELOTT, ROBERT 156 Fifth Ave - Apt 327, NYC (212) 924-1510

BENDER, BOB, 1 Rockefeller Bldg., Cleveland, OH (216) 861-4338;
 NY—Julia Della Croce (212) 355-7670; CHIC—Clay Timon (312) 527-1114;
 Tokyo—Dane Janpel 585-2721; London—01-250-1421 **P 154-155**

BENDER, RHODA 29 Artista Dr, Dix Hills, NY (516) 549-9158

BENEDICT, WILLIAM 5 Tudor City, NYC (212) 697-4460

BENVENUTI, JUDI 12 N Oak Crt, Madison, NJ (201) 377-5075

BERG, HAL 67 Hillary Cir, New Rochelle, NY (914) 235-9356

BERGMAN, BETH 150 West End Ave, NYC (212) 724-1867

BERINSKY, BURTON 789 West End Ave, NYC (212) 865-3100

BERKWIT, LANE 111 W 11 St, NYC (212) 255-3909

BERNHEIM, MARC 15 Park Ave, Larchmont, NY (212) 355-1855

BERNSON, CAROL 277 Ave C - Apt 9H, NYC (212) 777-1627

BERMAN, BRAD 365 Washington Ave, Brooklyn, NY (212) 638-7942 **P 48**

BERMAN, HOWARD 5 E 19 St, NYC (212) 982-9480; CHIC—Vince Kamin
 (312) 787-8834 **P 185**

BERNSTEIN, ALAN 365 First Ave, NYC (212) 254-1355; Rep—Harold Goodman
 (212) 242-9042 **P 172**

BERNSTEIN, BILL 59 Thompson, NYC (212) 925-6853 **P 192**

BESTER, ROGER 119 Fifth Ave, NYC (212) 254-0108 **P 209**

BETTS, GLYNNE 116 E 63 St, NYC (212) 688-4951

BEVILACQUA, JOE 202 E 42 St, NYC (212) 490-0355

BICKING, JOHN F. 317 Demarest Ave, Oradell, NJ (212) 759-7900

BIDDLE, GEOFFREY 5 E 30 St, NYC (212) 228-6165

BIJUR, HILDA 190 E 72 St, NYC (212) 737-4458

BINZEN, BILL Indian Mountain Rd, Lakeville, CT (203) 435-2485

BISBEE, TERRY 290 W 12 St, NYC (212) 242-4762

BISHOP, RANDA 59 W 12 St, NYC (212) 924-0949

BLACK, STAR 111 E 36 St - 3B, NYC (212) 686-6127

BLACKMAN, BARRY 115 E 23 St - 10 Flr, NYC (212) 473-3100

BLACKMAN, JEFFREY 23-23 E 12 St, Brooklyn, NY (212) 769-0986

BLAKE, REBECCA 35 W 36 St, NYC (212) 695-6438

BLEIWEISS, HERB 959 Eighth Ave, NYC (212) 262-3603,4

BLINKOFF, RICHARD 147 W 15 St, NYC (212) 620-7883

BLOCK, IRA 512 E 82 St, NYC (212) 879-4697

BLOOM, MARY 178 Fifth Ave, NYC (212) 255-1896

BLOOMBERG, ROBERT 172 Kohanza St, Danbury, CT (203) 794-1764

BODI 340 W 39 St, NYC (212) 947-7883

BOEHM, J. KENNETH 3 Sandalwood Ln, Ridgefield, CT (203) 438-5191

BOHM, LINDA 7 Park St, Montclair, NJ (201) 746-3434, 672-6869

BOLESTA, ALAN 11 Riverside Dr, NYC (212) 873-1932 **P 194-195**

BOOKBINDER, SIGMUND Jeremy Swamp Rd - Box 833, Southbury, CT 06488
 (203) 264-5137

BORDNICK, BARBARA 39 E 19 St, NYC (212) 533-1180 **P 1**

BORETZ, CARRIE 31 Bank St, NYC (212) 243-6149

BORNS, STEVEN PO Box 311, Old Chelsea Sta, NYC 10113-0311 (212) 722-8803

BOWER, HOLLY 61 E 11 St, NYC (212) 228-3198

BRANDT, PETER 73 Fifth Ave, NYC (212) 242-4289 **P 101**

BREDEL, WALTER 21 E 10 St, NYC (212) 228-8565

BREIL, RUTH 30 E 9 St - Apt 2N, NYC (212) 982-5611

BRESSON, HENRI CARTIER, Magnum Photos, 251 Park Ave S, NYC (212) 475-7600

BREUER, HERB 167 S Mountain Rd, NYC (914) 634-1234

BREWSTER, DONALD 235 West End Ave - Apt 14D, NYC (212) 874-0548

BRIGNOLO, JOSEPH Rd No 1 Box 121, Oxford Springs Rd, Chester, NY 10918
(914) 496-4453

BRIGNOLO JR., JOSEPH 11 Fox Run Rd, Redding, CT (203) 327-0949, 938-9515

BRITTON, PETER 315 E 68 St, NYC (212) 737-1664

BRIZZI, ANDREA 126 Madison Ave, NYC (212) 522-0836 **P 91**

BRODY, ROBERT 5 W 19 St, NYC (212) 239-8082

BRONFMAN, CORINNE 182 Grand St, NYC (212) 966-5194

BRONSON, EMERICK Rt 1 - Box 454 BC, Sag Harbor, NY 11963 (516) 725-2266

BRONSTEIN, STEVE 5 E 19 St, NYC (212) 982-9480

BROOKS, ALAN 186 E 64 St, NYC (212) 751-6811,2

BROOKS, CHARLOTTE Milltown Rd, Holmes, NY (914) 878-9376

BROWN, NANCY & DAVID 6 W 20 St, NYC (212) 675-8067;
Japan (03) 585-2562 **P 72-73**

BROWNING, TONI 450 West End Ave - 2C, NYC (212) 799-5267

BRUMMETT, RICHARD 117 W 13 St - 62, NYC (212) 989-2313

BRYSON, JOHN 12 E 62 St, NYC (212) 755-1321, (213) 456-6170

BUCHENHOLZ, BRUCE 410 E 89 St, NYC (212) 861-1730

BUCK, BRUCE 171 First Ave, NYC (212) 777-8309 **P 144**

BUCKLER, SUSANNE 344-348 W 38 St, NYC (212) 279-0043 **P 173**

BUCKLEY, PETER 140 E 83 St - Apt 10, NYC (212) 744-0658

BUDIN, ELBERT 424 W 33 St, NYC (212) 564-9050

BUDNIK, DAN % Woodfin Camp & Assoc, 415 Madison Ave, NYC (212) 750-1020

BURGMAN, GER 57 Second Ave - 33, NYC (212) 475-3790

BURNES, BARBARA 9 Harbor Rd, Westport, CT (203) 226-0452

BURNETT, DAVID 328 W 19 St - Apt 3A, NYC (212) 243-1677

BURRI, RENE, Magnum Photos, 251 Park Ave S - 11 Fl, NYC (212) 475-7600

C

CADGE, JEFF 15 W 28 St - 8 Fl, NYC (212) 685-2435

CADGE, WILLIAM F. 15 W 28 St - 8 Fl, NYC (212) 685-2435

CAMEOLA, JOHN J. 156 Fifth Ave, NYC (212) 275-0096

CANNARELLA, BUD 156 Fifth Ave - 308, NYC (212) 961-1750

CAPA, CORNELL 275 Fifth Ave, NYC (212) 685-1013, 475-7600

CARDACINO, MICHAEL 310 E 49 St, NYC (212) 308-3287 **P 215**

CARROLL, DON 315 E 206 St, Bronx, NY (212) 231-0420

CARTER, BILL 39 E 12 St, NYC (212) 755-4475

CATALDO JR., JOE 49 Riggs Pl, W Orange, NJ (201) 731-7675

CAULFIELD, PATRICIA 115 W 86 St - Apt 2E, NYC (212) 799-8068

CEARLEY, GUY 156 Fifth Ave - Apt 600, NYC (212) 243-6629

CHALKIN, DENNIS 91 Fifth Ave, NYC (212) 929-1036 **P 216**

CHANDOHA, WALTER RFD 1, Annandale, NJ (201) 782-3666 **P 92, 434**

CHAO, JOHN 275 Fifth Ave, NYC (212) 685-1013

CHARLES, BILL 265 W 37 St, NYC (212) 719-9156 **P 44**

CHARLES, JANET 255 W 14 St - 2F, NYC (212) 243-4251

CHAZ 61 Crosby St, NYC (212) 925-7693

CHECANI, RICHARD 31 E 32 St - 12 Fl, NYC (212) 889-2049

CHIAPEL, THOMAS 11 Main St, Mt Kisco, NY (914) 241-1156

CHOROSZEWSKI, WALTER J. 4515 Auburndale Ln, Flushing, NY (212) 463-5439 **P 39**

CHRISTENSEN, PAUL 286 Fifth Ave, NYC (212) 279-2838 **P 127**

CHURCH, DIANA 31 W 31 St, NYC (212) 736-4116

CHWATSKY, ANN 85 Andover Rd, Rockville Ctr, NY (516) 766-2439

CIRONE, BETTINA 57 W 58 St, NYC (212) 888-7649

CLAYMAN, ANDREW 334 The Bowery, NYC (212) 674-4906

CLAYTON, TOM 1591 Second Ave, NYC (212) 744-1415

CLYMER, JONATHAN, Photron Inc, 244 Midland Ave, Saddle Brook, NJ (201) 546-2204

COBB, JAN 381 Park Ave S, NYC (212) 889-2257

COBIN, MARTIN 145 E 49 St, NYC (212) 758-5742

COGGIN, ROY 64 W 21 St, NYC (212) 929-6262

COHEN, MARC 5 W 19 St, NYC (212) 391-8232

COHEN, RIC 156 Fifth Ave, NYC (212) 924-6749

COHEN, ROBERT 256 Fifth Ave, NYC (212) 683-6354

COLBY, RON 140 E 28 St, NYC (212) 684-3084

COLLINS, SHELDAN 290 Potter Pl - Apt 504, Weehawken, NJ (212) 242-0076

COLTON, ROBERT 1700 York Ave, NYC (212) 831-3953; Serv—581-6470

CONNORS, BILL 310 E 46 St, NYC (212) 490-3801; Rep—Sue Mosel
(212) 599-1806

CONTE, MARGOT 165 Old Mamaroneck Rd, White Plains, NY (914) 997-1322

COOK, ROD 108 W 25 St, NYC (212) 242-4463

COOKE, COLIN 380 Lafayette St, NYC (212) 254-5090; Rep—Joan Jedell
(212) 861-7861

COOKE, JERRY 161 E 82 St, NYC (212) 288-2045

COOPER, MARTHA 310 Riverside Dr - 805, NYC (212) 222-5146

COOPER, STEVE 5 W 31 St, NYC (212) 279-4543

CORMAN, BERT 5 Union Square W, NYC (212) 564-5052

COTTER, MIMI 33 E 38 St, NYC (212) 972-0175, 972-0176

CRAIG, MICHEL 25 Fifth Ave, NYC (212) 477-2956

CRAMPTON, NANCY 35 W 9 St, NYC (212) 254-1135

CSERNA, GEORGE 80 Second Ave - 2, NYC (212) 247-5738

CUCINOTTA, AMBROSE 1525 W 4 St - 2, Brooklyn, NY (212) 645-0856

CUESTA, MIKE 5 Randolph Dr, Dix Hills, LI, NY (516) 864-8373

CULVER, GENE 160 Anstice St, Oyster Bay, NY (516) 922-1708

CUNNINGHAM, PETER 214 Sullivan St, NYC (212) 475-4866

CURRAN, PETER 12 E 22 St, NYC (212) 533-3289

CURTIS, JACKIE Alewives Rd, Norwalk, CT (203) 866-9198, (212) 924-5678

D

DAHLIN, ED Box 221, Pt. Washington, NY 11050 (516) 883-5201

DANTZIC, JERRY 910 President St, Brooklyn, NY (212) 789-7478

DAUMAN, HENRI 136 E 76 St, NYC (212) 737-1434

DAVIDSON, BRUCE, Magnum Photos, 251 Park Ave S - 11 Fl, NYC (212) 475-7600

DAVIDSON, DARWIN K. 32 Bank St, NYC (212) 242-0095

DAVIDSON, ERIKA 30 W 60 St, NYC (212) 246-5066

DAVIS, DICK 400 E 59 St, NYC (212) 751-3276

DAVIS III, FRANK Strathaven - 3A, Glen Cove, NY (516) 676-0543

DAVIS, HAL 220 E 23 St, NYC (212) 689-7787; Rep—Ken Mann
(212) 245-3192

DAY, BOB 29 E 19 St, NYC (212) 475-7387

DAY, OLITA 29 E 19 St, NYC (212) 673-9354

DEGGINGER, DR. EDWARD PO Box 186, Convent Station, NJ 07961 (201) 455-2737, 267-4165

DE GRADO, DREW PO Box 445, 37 Midland Ave, Elmwood, NJ 07407
(212) 860-0062, (201) 797-2890

DEKKER, JOHN DEN USREP-JECOR, APO, NY 09038

DELESSIO, LEN 49 W 27 St - 806, NYC (212) 254-4620

DE LUCIA, RALPH 120 E Hartsdale Ave, Hartsdale, NY (914) 472-2253

DE MENIL, ADELAIDE 222 Central Park S, NYC (212) 247-5945

DEMILT, RONALD 873 Broadway, NYC (212) 228-5321

DENNIS, LISL, Photo Features Int'l, 135 E 39 St, NYC (212) 532-8226

DEPRA, NANCY 15 W 24 St - 11 Fl, NYC (212) 242-0252

DERR, STEVE 456 W 57 St - 4B, NYC (212) 246-5920

DE SANTO, THOMAS 134 Fifth Ave, NYC (212) 989-5622

DE TOY, TED 205 W 19 St, NYC (212) 675-6744

DE VAN, FRED 853 Seventh Ave, NYC (212) 666-1633

DE VINE, WILLIAM, Corporate Photographers, 45 John St - Rm 1109, NYC (212) 964-6515,16
DEVITO, BART J. 43 E 30 St, NYC (212) 889-9670 **P 34-35**

DE VOE, MARCUS E. 34 E 81 St, NYC (212) 737-9073, 868-3330
DIAMOND, JOE 915 West End Ave, NYC (212) 316-5295 **P 164-165**

DICRAN STUDIO 100 Fifth Ave - 15 Fl, NYC (212) 242-0055 **P 221**

DICKSTEIN, BOB 101 Hillturn Ln, Roslyn Hgts, NY (516) 621-2413
DI GIACOMO, MELCHIOR 32 Norma Rd, Harrington Pk, NJ (201) 348-3510
DI MAGGIO, JOE 512 Adams St, Centerport, NY (516) 271-6133
DI MARTINI, SALLY % Stockhold, 137 Riverside Dr - 10D, NYC (212) 799-0605
DINIZ, PEPE 177 Hudson St - 3 Fl, NYC (212) 966-6388
DOLCE, BILL 135 Fifth Ave, NYC (212) 777-3350
DOLCE, STEVE 135 Fifth Ave, NYC (212) 777-3350
DOLIN, PENNY ANN 107 Briar Brae Rd, Stamford, CT (203) 322-7499
DOMINIS, JOHN Time-Life Bldg, Rockefeller Ctr - Rm 2020, NYC (212) 841-3131
DORF, MYRON JAY 205 W 19 St, NYC (212) 255-2020 **P 187**

DORIN, JAY 220 Cabrini Blvd, NYC (212) 781-7378
DOROT, DIDIER 552 Milton Rd, Rye, NY
DOUBILET, DAVID 1040 Park Ave - Apt 6J, NYC (212) 348-5011, 289-4719
DRESSLER, MARJORY 300 Elizabeth St, NYC (212) 254-9758
DREW, RUE FARIS 177 E 77 St, NYC (212) 794-8994
DUBIN, NANCY 347 E 58 St - 5F, NYC (212) 355-5887
DUDEK, KATHRYN PO Box 478, Floral Park, NY (212) 343-4140
DUKE, DANA 620 Broadway, NYC (212) 260-3334
DUNCAN, KENN 853 Seventh Ave, NYC (212) 582-7080

E

EAGAN, TIMOTHY 10 W 74 St - 7G, NYC (212) 777-9210
EAGLE, ARNOLD, A Eagle Productions, 236 W 27 St - 6 Fl, NYC (212) 675-1339
EBERSTADT, FRED 791 Park Ave - Apt 2B, NYC (212) 794-9471
EDAHL, EDWARD 100 Fifth Ave, NYC (212) 929-2002
EDGEWORTH, ANTHONY 333 Fifth Ave, NYC (212) 679-6031 **P 178-179**

EDWARDS, GREGORY 30 East End Ave, NYC (212) 879-4339
ECKSTEIN, ED 234 Fifth Ave - 5 Fl, NYC (212) 685-9342
EHRENPREIS, DAVID 156 Fifth Ave, NYC (212) 242-1976
EHRLICH, GEORGE PO Box 186, New Hampton, NY 10958 (914) 355-1757
EISENBERG, STEVE 25 E 21 St, NYC (212) 228-8616
ELBERS, JOHAN 18 E 18 St, NYC (212) 929-5783 **P 118**

ELGORT, ARTHUR 300 Central Park W, NYC (212) 724-6557
ELKIN, IRVING 12 E 37 St, NYC (212) 686-2980
ELKINS, JOEL 5 E 16 St, NYC (212) 989-4500
ELLIOTT, JON 329 W 85 St - Apt 3B, NYC (212) 799-8828
ELLIS, RAY 176 Westminster Rd, Brooklyn, NY (212) 282-6449 **P 186**

ELSON, PAUL 8200 Blvd East, North Bergen, NJ (212) 879-2681
EMMET, HERMAN 41 Central Park W, NYC (212) 307-1450
**ENDRESS, JOHN PAUL 254 W 31 St, NYC (212) 736-7800; Rep—Elaine Rubin
 (212) 725-8318** **P 88-89**

EPSTEIN, DANIEL 55 W 21 St, NYC (212) 989-9476
EPSTEIN, KARIN 233 E 70 St - Apt 6P, NYC (212) 472-0771
ERWITT, ELLIOTT, Magnum Photos, 251 Park Ave S - 11 Fl, NYC (212) 475-7600
ESTENSSORO, HUGO 117 MacDougal St - Apt 4, NYC (212) 777-2912, 673-5772
ESTRADA, SIGRID 902 Broadway, NYC (212) 673-4300

F

FAULKNER, DOUGLAS 5 W 8 St, NYC (212) 260-4758
FAURE, NICHOLAS 350 W 21 St, NYC (212) 691-0282
FAY, JOHN SPENCER 54 Riverside Dr - Apt 3C, NYC (212) 787-7918
FERNANDEZ, BENEDICT J. 1432 37 St, No Bergen, NJ (201) 265-6997
FERORELLI, ENRICO 50 W 29 St, NYC (212) 685-8181
FERRANTE, TERRY 555 Third Ave, NYC (212) 679-6427
FERRER, LINDA 60 W 15 St, NYC (212) 691-6615
FICALORA, TONI 28 E 29 St, NYC (212) 679-7700
FIELDS, BRUCE 71 Greene St, NYC (212) 431-8852; Rep—Jean Jacques
 Dubane (212) 807-7457 **P 42-43**

FINE, PETER M. 115 Crosby St, NYC (212) 431-9776
FINLAY, ALASTAIR 38 E 21 St, NYC (212) 260-4297
FIRMAN, JOHN 434 E 75 St, NYC (212) 794-2794 **P 176**

FISH, VINNIE PO Box 794, Main St, Stony Brook, NY 11790 (516) 689-9672
FISHBEIN, CHUCK 49 W 27 St, NYC (212) 532-4452
FIUR, LOLA 360 E 65 St, NYC (212) 861-1911
FLATOW, CARL 20 E 30 St, NYC (212) 683-8688
FLORET, EVELYN 3 E 80 St, NYC (212) 472-3179
FLOTTE, LUCIEN 5 W 31 St - 8 Fl, NYC (212) 564-9670
FOGLIANI, TOM 325 W 37 St - 6 Fl, NYC (212) 279-0043
FOOTE, JAMES A. 22 Tomac Ave, Old Greenwich, CT (203) 637-3228
FORBERT, DAVID J., Shostal Assoc, 60 E 42 St - Rm 2130, NYC (212) 687-0696
FORREST, BOB 273 Fifth Ave, NYC (212) 288-4458 **P 184**

FORTE, JOHN 162 W 21 St, NYC (212) 620-0584 **P 37**

FOSTER, NICHOLAS 143 Claremont Rd, Bernardsville, NJ (201) 766-7526
FRANCAVILLO, JOHN 710 Union St, Brooklyn, NY (212) 834-8318
FRANCEKEVICH, AL 73 Fifth Ave, NYC (212) 691-7456 **P 196-197**

FRANK, DICK 11 W 25 St, NYC (212) 242-4648; Rep—Ted Wasserman
 (212) 867-5360 **P 8-9**

FRANK, RICHARD 162 Eighth Ave, Brooklyn, NY (212) 857-5525
FREEDMAN, JILL 181 Sullivan St, NYC (212) 982-9451
FREEMAN, BILL 21 Ladder Hill Rd So, Weston, CT (212) 686-3195
FREER, BONNIE 265 S Mountain Rd, NYC (914) 634-4170, (212) 866-6307
FRIED, LAWRENCE ℅ Image Bank, 633 Third Ave, NYC (212) 751-6677, 953-0303
FRIEDMAN, STEVE 545 W 111 St, NYC (212) 864-2662
FUNK, MITCHELL 500 E 77 St, NYC (212) 988-2886 **P 64**

FUNT, DAVID W. 220 E 23 St, NYC (212) 686-4111
FURMAN, MICHAEL 115 Arch St, Philadelphia, PA (215) 925-4233 **P 124-125**

G

GAFFGA, DAVIS A. Koral Dr, PO Box 750, Southampton, NY 11968 (516) 283-9010
GAHR, DAVID 49 Eighth Ave, Brooklyn, NY (212) 789-3365
GALELLA, RON 17 Glover Ave, Yonkers, NY (914) 237-2988, 237-3366
GALLUCCI, ED 381 Park Ave S, NYC (212) 532-2720
GAMBEE, ROBERT 1230 Park Ave, NYC (212) 289-9393
GANS, HANK 40 Waterside Plaza, NYC (212) 683-0622
GANS, HARRIET 50 Church Ln, Scarsdale, NY (914) 723-7017
GANTON, BRIAN 13 Marion Rd, Verona, NJ (201) 239-8824
GARBIN PHOTOGRAPHY 208 Fifth Ave - Ste 3E, NYC (212) 683-9188;
 Rep—Elaine Korn (212) 679-6739 **P 21**

GARCIA, FELICIANO 29 W 38 St, NYC (212) 354-7683
GARIK, ALICE 275 Clinton Ave, Brooklyn, NY (212) 783-1065
GARRETT JR., WILLIAM 874 Broadway, NYC (212) 473-6934
GATES, RALPH 364 Hartshorn Dr, Short Hills, NJ (201) 379-4456
GAZDAR, JEHANGIR, Woodfin Camp & Assoc, 415 Madison Ave, NYC (212) 750-1020
GELLER, BONNIE 57 W 93 St, NYC (212) 864-5922
GEORGE, MICHAEL 525 Hudson St - 2FN, NYC (212) 924-5273
GEORGES, SAMMY 256 Fifth Ave, NYC (212) 683-6353
GERACI, STEVE ℅ Reflex Photo, 125 Wilbur Pl, Bohemia, NY (516) 567-8777

GESCHEIDT, ALFRED 175 Lexington Ave, NYC (212) 889-4023
GIDLEY, E. FENTON 43 Tokeneke Rd, Darien, CT (203) 655-1321
GIESE, AL 156 Fifth Ave - Rm 900, NYC (212) 675-2727
GIGLI, ORMOND 327 E 58 St, NYC (212) 758-2860
GILLARDIN, ANDRE 6 W 20 St, NYC (212) 675-2950
GILLETTE, GUY 133 Mountaindale Rd, Yonkers, NY (212) 986-3712, (914) 779-4684
GILMOUR, JAMES 377 Park Ave S, NYC (212) 532-8288
GIOVANNI, RAEANNE 32 Union Sq E, NYC (212) 254-6406
GLADSTONE, GARY 237 E 20 St, NYC (212) 982-3333
GLANCZ, JEFF 38 W 21 St - 12 Fl, NYC (212) 741-2504 **P 210-211**

GLASER, HAROLD 143-30 Roosevelt Ave, Flushing, NY (212) 939-1829
GLASSMAN, CARL 80 N Moore St - Apt 37G, NYC (212) 732-2458
GLINN, BURT 41 Central Park W, NYC (212) 877-2210 **P 226-227**

GLOBUS BROTHERS, Richard Globus, 44 W 24 St, NYC (212) 243-1000 **P 116-117**

GOFF, LEE 32 E 64 St, NYC (212) 223-0716
GOLD, BERNIE 873 Broadway, NYC (212) 677-0311 **P 109**

GOLDBERG, KEN 141 Fifth Ave, NYC (212) 674-1583, (215) 925-3825
GOLDFARB, ED 428 E 84 St, NYC (212) 543-6183
GOLDMAN, A. BRUCE 440 Riverside Dr, NYC (212) 666-9143, (802) 276-3338
GOLDSMITH, ALAN Plumb Brook Rd, Woodbury, CT (212) 247-5997 X304
GOLDSMITH, LYNN 241 W 36 St, NYC (212) 736-4602
GOLDSTEIN, ROBERT Box 310, New Milford, NJ 07646 (201) 262-5959
GOLOB, STANFORD 40 Waterside Plaza, NYC (212) 532-7166
GOODSTEIN, GERRY 327 W 30 St, NYC (212) 695-1586
GOODWIN, JOHN C. 28 Meadow St, Demarest, NJ (201) 768-0777
GORDON, JOEL 5 E 16 St - 5 Fl, NYC (212) 989-9207
GORDON, LARRY DALE 2047 Castilian Dr, Los Angeles, CA (213) 874-6318, (212) 753-0462
GORODNITZKI, DIANE 160 W 71 St, NYC (212) 724-6259
GOTFRYD, BERNARD 46 Wendover Rd, Forest Hills, NY (212) 350-2505, 261-8039
GOUDVIS, PATRICIA 61 Lexington Ave - Apt 43, NYC (212) 228-6396
GOULD, PETER L. Box 838, Newark NJ 07101 (212) 675-3707
GOVE, GEOFFREY 117 Waverly Pl, NYC (212) 260-6051, NJ—Schooley & Assocs.
(201) 530-1480 **P 14-15**

GRANITSAS, MARGOT 520 E 90 St, NYC (212) 722-6691
GREENE-ARMYTAGE, STEPHEN 171 W 57 St - Apt 7A, NYC (212) 247-6314
GREENBERG, DAVID 54 King St, NYC (212) 807-0431
GREENE, JOSHUA 156 Fifth Ave - 1130, NYC (212) 741-2232
GREENE, SUE 44 Gramercy Park, NYC (212) 777-8891
GREGORY, JOHN 105 Fifth Ave - Ste 903, NYC (212) 691-1797
GREHAN, FARRELL 112 Paradise Ave, Piermont, NY (914) 359-0404
GROSKINSKY, HENRY 5 Woodcleft Ave, Port Washington, NY (516) 883-3294
GROSS, CY 59 W 19 St, NYC (212) 243-2556 **P 180-181**

GROSS, GARRY 907 Broadway, NYC (212) 533-8640
GROSSMAN, EUGENE 80 N Moore St, NYC (212) 962-6795
GROSSMAN, HENRY 37 Riverside Dr, NYC (212) 580-7751
GROSSMAN, MILDRED 35-24 78 St, Jackson Hts, NY (212) 426-0704
GRUBER, TERRY 885 West End Ave, NYC (212) 749-2840
GSCHEIDLE, GERHARD 792 Columbus Ave - 12M, NYC (212) 873-8800
GUROVITZ, JUDY 207 E 74 St, NYC (212) 988-8685

H

HAAS, DAVID 330 W 86 St, NYC (212) 877-5003
HAAS, KEN FLAT 15 Sheridan Sq - 3E, NYC (212) 255-0707
HALMI, ROBERT 6 E 45 St, NYC (212) 867-1460
HAMBOURG, SERGE 318 W 108 St - 8, NYC (212) 866-0085
HAMILTON JR., ALEXANDER 946 Atlantic Ave, Brooklyn, NY (212) 857-1583, 857-1888
HAMILTON, DAVID 47 Walker St, Loft 2, NYC (212) 226-1271 **P 29**

HAMMOND, JEANNE 49 E 86 St, NYC (212) 348-8623
HAMMOND, MAURY 19 W 36 St, NYC (212) 564-5508
HANSEN, JAMES Box 721 North Country Rd, Setauket, NY (516) 941-4179
HARBUTT, CHARLES, Archive Pictures Inc, 111 Wooster St, NYC (212) 431-1610
HARDIN, EDWARD 156 Fifth Ave, NYC (212) 685-2188
HARRINGTON, GRACE 300 W 49 St, NYC (212) 246-1749
HARRIS, BROWNIE 459 W 21 St, NYC (212) 929-1796, 540-5992 (Paris)
HARRIS STUDIO, MICHAEL 18 W 21 St, NYC (212) 255-3377
HARRIS, RONALD 119 W 22 St, NYC (212) 255-2330
HARRISON, HOWARD 20 W 20 St, NYC (212) 989-9233
HARTMANN, ERICH, Magnum Photos Inc, 251 Park Avenue S - 11 Fl, NYC (212) 475-7600
HARVEY, NED 300 E 70 St, NYC (212) 807-7043
HASHI 49 W 23 St, NYC (212) 675-6902; Rep—Ken Mann (212) 245-3192 **P 62-63**

HAUSMAN, GEORGE 1181 Broadway, NYC (212) 686-4810
HAYES, KERRY 156 Fifth Ave, NYC (212) 242-2012
HEDRICH, DAVID 7 E 17 St, NYC (212) 924-3324
HEISLER, GREGORY 611 Broadway - Rm 900, NYC (212) 777-8100
HELMS, BILL 1175 York Ave, NYC (212) 759-2079
**HENDERSON, GORDON 10612 172 St, Edmonton Alta T5S 1H8, Canada
 (403) 483-8049** **P 17**

HENIS, MARSHALL C. PO Box 1088, Great Neck, NY 11623 (516) 466-9098
HENKE, ROBERT 75 Park Ter E, NYC (212) 567-4564
HENRY, DIANA MARA 1160 Fifth Ave, NYC (212) 722-8803
HERON, MICHAL 28 W 71 St, NYC (212) 787-1272
HESS, BRAD 485 Fifth Ave, NYC (212) 599-1500
HEYMAN, ABIGAIL 40 W 12 St, NYC (212) 989-2010
HEYMAN, KEN 64 E 55 St, NYC (212) 421-4512
**HILL, PAT 118 E 28 St, NYC (212) 679-0884; 532-3479; Japan (813) 585-2721,
 585-2562** **P 61**

HINE, SKIP 34 W 17 St, NYC (212) 691-5903
HIRO 50 Central Park W, NYC (212) 580-8000
HIRST, MICHAEL 300 E 33 St, NYC (212) 982-4062
HOBAN, TANA 105 E 16 St - Apt 6N, NYC (212) 477-6071
HOEBERMANN, ROBERT 49 W 44 St, NYC (212) 840-2678
HOFER, EVELYN 55 Bethune St, NYC (212) 691-0084
HOLBROOKE, ANDREW 50 W 29 St, NYC (212) 679-2477
HOLLANDER, DAVE Box 443, Springfield, NJ 07081 (201) 467-0870
HOLLYMAN, TOM 300 E 40 St, NYC (212) 867-2383
HOOPER, THOMAS 126 Fifth Ave, NYC (212) 691-0122
HOOPS, JAY Peconic Rd, Southampton, NY (516) 728-4017
HOPKINS, DOUGLAS 636 Sixth Ave, NYC (212) 243-1774 **P 222**

HOPKINS, STEPHEN 475 Carlton Ave, Brooklyn, NY (212) 638-3188
HOROWITZ, RYSZARD 103 Fifth Ave, NYC (212) 243-6440
HOROWITZ, TED 465 West End Ave - 28, NYC (212) 595-0040
HORN INC, STEVE 435 E 83 St, NYC (212) 752-3500
HORNE, RODERICK 308 W Putnam Ave, Greenwich, CT (203) 869-2180
HOUSER, ROBERT 75-19 184 St, Flushing, NY (212) 454-0757
HOWARD, KEN 130 W 17 St - 9 Fl, NYC (212) 691-3445
**HUBBELL, WILLIAM 99 E Elm St, Greenwich, CT (203) 629-9629;
 Stock—(212) 750-1020** **P 198-199**

HUBER, JOHN 629 Edgewater Ave, Ridgefield, NJ (201) 327-6763
HUNGASKI, ANDREW Merribrook Ln, Stamford, CT (203) 327-6763
HUNTZINGER, ROBERT 832 Broadway, NYC (212) 675-1710
HUSZAR, STEVEN 156 Fifth Ave, NYC (212) 929-2593 P 65

HUTCHINGS, RICHARD 174 Rochelle St, City Island, NY (212) 885-0846
HYATT, MORTON 352 Park Ave S - 2 Fl, NYC (212) 889-2955
HYDE, DANA Box 1302, Southampton, NY 11968 (516) 283-1001, (212) 369-4040

I

IGER, MARTIN 349 E 49 St, NYC (212) 755-7226
IHARA 5 Union Sq W, NYC (212) 243-4862 P 220

IMGRUND, PAUL 75 Stockton Lake Blvd, Manasquan, NJ (201) 449-6647

J

JACOBSON, ALAN J. 1466 Broadway - Rm 422, NYC (212) 221-0464
JEFFERY, RICHARD 119 W 22 St, NYC (212) 255-2330
JEFFREY, LANCE 30 E 21 St, NYC (212) 674-0595
JEFFRY, ALIX 71 W 10 St, NYC (212) 982-1835
JOEL, SETH 440 Park Ave S, NYC (212) 685-3179
JOEL, YALE Woodybrook La, Croton-on-Hudson, NY (212) 757-5976, (914) 271-8127
JOERN, JAMES 125 Fifth Ave, NYC (212) 260-8025 P 204

JOHANSKY, PETER 108 E 16 St, NYC (212) 260-4301, 361-7400 P 193

JONES, CHRIS 220 Park Ave S - 6B, NYC (212) 777-5361 P 22

JONGEN, ANTOINETTE 27 Alewive Brook Rd, East Hampton, NY (516) 324-2786
JOSEPH, GEORGE E. 19 Barnum Rd, Larchmont, NY (914) 834-5687, 1425
JULIANO, VINCENT T. PO Box 404, Little Neck, NY 11363 (212) 777-2980
JUSCHKUS, RAYMOND, Corporate Photographers, 45 John St - Rm 1109, NYC
 (212) 964-6515, 16

K

KACHATURIAN, ARMEN 10 E 23 St, NYC (212) 533-3550, 3551
KAHN, R. T. 156 E 79 St, NYC (212) 988-1423
KALISH, JOANNE 512 Adams St, Centerport, NY (516) 271-6133
KALISKI, ARTHUR Box 54, Northport, NY 11768 (516) 757-0745
KALINSKY, GEORGE 4 Pennsylvania Plaza, NYC (212) 594-6600
KALISHER, SIMPSON Roxbury, CT (212) 288-5542
KAMP, ERIC 98-120 Queens Blvd, Forest Hills, NY (212) 896-7780
KAMSLER, LEONARD 140 Seventh Ave, NYC (212) 242-4678
KANE, PETER 342 Madison Ave, NYC (212) 687-5848
KAPLAN, ALAN 7 E 20 St, NYC (212) 982-9500 P 6-7

KAPLAN, PETER B. 126 W 23 St, NYC (212) 989-5215 P 230-231

KAPLAN, PETER J. 924 West End Ave, NYC (212) 222-1193;
 Stock—(212) 679-8480 P 142

KARALES, JAMES H. 147 W 79 St, NYC (212) 779-2483
KARIA, BHUPENDRA 9 E 96 St - Apt 15B, NYC (212) 595-1047
KARLIN, DENIS 178 Roseville Rd, Westport, CT (212) 580-9589
KARLIN, LYNN 598 3 St, Brooklyn, NY (212) 788-0461; 868-3330
KASPIEV, KALMAN 266 Bedford Park Blvd, Bronx, NY (212) 365-0835
KASSABIAN, ASHOD 127 E 59 St, NYC (212) 421-1950
KATCHIAN, SONIA 47 Greene St, NYC (212) 966-9641
KATZ, BARUCH 252 W 37 St - 15 Fl, NYC (212) 947-8074
KAUFMAN, MICKEY 144 W 27 St, NYC (212) 255-1976 P 119

KAUFMAN, TED 121 Madison Ave, NYC (212) 685-0349 P 26-27

KAWALERSKI, TED 52 San Gabriel Dr, Rochester, NY (716) 244-4656 P 50-51

KEAVENY, FRANCIS 260 Fifth Ave, NYC (212) 679-1229
KEEGAN, MARCIA 140 E 46 St, NYC (212) 953-9023
KELLER, TOM 440 E 78 St, NYC (212) 472-3667
KELLNER, JEFF 16 Waverly Pl, NYC (212) 475-3719 P 96

KELLY, BILL 140 Seventh Ave, NYC (212) 989-2794
KELLY/MOONEY PRODUCTIONS 87 Willow Ave, N Plainfield, NJ (212) 360-2576

P 189

KENDER, JOHN 233 E 21 St, NYC (212) 228-1964
KERNAN, SEAN 5 White St, NYC (212) 966-0259
KERR, JUSTIN & BARBARA 14 W 17 St - 2 Fl, NYC (212) 391-4955, 741-1731
KHORNAK, LUCILLE 425 E 58 St, NYC (212) 593-0933

P 190-191

KIEHL, STUART LEE 365 First Ave, NYC (212) 260-5466
KING, WILLIAM 100 Fifth Ave, NYC (212) 675-7575
KIRK, BARBARA E. 447 E 65 St, NYC (212) 734-3233
KIRK, CHARLES 333 Park Ave S, NYC (212) 677-3770

P 56-57

KIRK, RUSSELL 13 E 16 St, NYC (212) 691-0014; Rep—Barbara Lee (212) 724-6176

P 4

KIRSH, ELAINE 243 West End Ave, NYC (212) 580-8023
KISS, BOB, Kiss Photography Inc 29 E 19 St, NYC (212) 505-6650

P 40-41

KITMAN, CAROL 147 Crescent Ave, Leonia, NJ (201) 947-8649
KLAUSS, CHERYL 299 De Kalb Ave - 3, Brooklyn, NY (212) 783-3987
KOENIG, GEA, Westbeth 463 West St - D 948, NYC (212) 243-3248
KOLANSKY, PALMA 155 W 13 St, NYC (212) 243-4077
KOMAR, GRED 30 Waterside Plaza - Apt 18A, NYC (212) 685-0275
KONER, MARVIN 345 E 56 St, NYC (212) 751-7734
KOPELOW, PAUL 135 Madison Ave, NYC (212) 689-0685
KOYCE, PAUL 108 Ridgedale Ave, Morristown, NJ (201) 539-0072
KOYCE SR., TERRENCE 108 Ridgedale Ave, Morristown, NJ (201) 539-0072
KOZAN, DAN 32 W 22 St, NYC (212) 691-2288
KOZLOWSKI, MARK 39 W 28 St, NYC (212) 684-7487; Rep—Jane Mautner (212) 777-9024

P 132-133

KRAMER, DANIEL 110 W 86 St, NYC (212) 873-7777
KRAMER, ERWIN 5 N Clover Dr, Great Neck, NY (516) 466-5582
KREMENTZ, JILL 228 E 48 St, NYC (212) 688-0480
KRIST, BOB, 538 Undercliff Ave, Edgewater, NJ (201) 943-8874

P 71

KROLL, ERIC 118 E 28 St - Ste 1005, NYC (212) 684-2465
KRONGARD, STEVE 212-A E 26 St, NYC (212) 689-5634

P 74-75

KRUBNER, RALPH 4 Juniper Ct, Jackson, NJ (201) 364-3640
KRUPENYE, PETER 41 Teno St, New Rochelle, NY (914) 632-0995
KUHN, ANN 1155 Broadway, NYC (212) 685-1774
KURTZ, MARA 322 Central Park W, NYC (212) 666-1453

L

LADNER, STEVE 206 E 63 St, NYC (212) 753-6095
LAFFONT, JEANE PIERRE 322 W 72 St, NYC (212) 787-7831
LAMBRAY, MAUREEN (212) 879-3960

P 168-169

LA MONICA, CHUCK 16 W 22 St, NYC (212) 243-4400
LANE, WHITNEY 109 Somerstown Rd, Ossining, NY (212) 762-5335
LAPIDUS, LARRY 340 W 57 St, NYC (212) 245-1986
LAREDO, VICTOR 205 W 88 St, NYC (212) 874-1975
LARRAIN, GILLES 95 Grand St, NYC (212) 925-8494
LATHAM, SID 3635 Johnson Ave, Riverdale, NY (212) 543-0335
LAURE, JASON 8 W 13 St, NYC (212) 691-7466, 355-1855
LAURENCE, MARY PO Box 1763, NYC (212) 940-0025
LAVINE, ARTHUR, Chase Manhattan Bank, 1 Chase Manhattan Plaza, NYC (212) 552-3716
LEE, VINCENT 5 Union Sq W - Rm 301, NYC (212) 857-4319
LEEDS, KAREN 8 W 13 St, NYC (212) 243-4546, 5154
LEIGHTON, THOMAS % PH 12 - 321 E 43 St, NYC (212) 370-1835; Serv—532-2925

P 104-105

LEIPZIG, ARTHUR 378 Glen Ave, Sea Cliff, NY (516) 676-6016
LEO, DONATO 170 Fifth Ave, NYC (212) 989-4200

P 157

LEONARDI, CARL, CLM Photo Co Inc, 2036 New York Ave, Huntington Sta, NY (516) 549-3582
LEONIAN, PHIL 220 E 23 St, NYC (212) 989-7670
LERMAN, PETER M. 37 E 28 St - Rm 506, NYC (212) 685-0053 **P 12**

LEUNG, JOOK 110 E 23 St, NYC (212) 254-8334
LEUTHOLD, CATHERINE 300 E 70 St, NYC (212) 988-1270
LEVINE, GERALD 6 Powell St, Farmingdale, NY (212) 293-4750
LEVINE, NANCY 60 E 9 St, NYC (212) 473-0015
LEVY, PETER 119 W 22 St, NYC (212) 691-6600
LEVY, RICHARD 5 W 19 St, NYC (212) 243-4220 **P 171**

LEWIS, ROSS 460 W 24 St, NYC (212) 691-6878 **P 177**

LICHTMAN, BOB 381 Park Ave S - Studio 621, NYC (212) 679-9002
LIEBERMAN, ALLEN 5 Union Sq W, NYC (212) 255-4646 **P 234-235**

LIFTIN, JOAN 1 Fifth Ave, NYC (212) 475-1489
LILLIBRIDGE, DAVID PO Box 1172 - Rte 4, Burlington, CT (203) 673-9786
LINCK, ANTHONY 2100 Linwood Ave, Fort Lee, NJ (201) 944-5454
LINDLEY, THOMAS 133 Fifth Ave, NYC (212) 533-6813
LINDNER, STEVEN 25 E 21 St, NYC (212) 473-4533
LINDSAY, GUY 392 Central Park W - Apt 17X, NYC (212) 666-9226
LIPTON, E. TRINA 60 E 8 St, NYC (212) 533-3148, 674-3523, 255-6620, 930-4200
LISANTI, VINCENT 330 Clinton Ave, Dobbs Ferry, NY (212) 695-5218, (914) 693-5373
LITTLE, CHRISTOPHER 4 W 22 St, NYC (212) 691-1024
LITWIN, RICHARD 23 E 11 St, NYC (212) 757-2124
LLOYD, HARVEY, Image Makers, 310 E 23 St, NYC (212) 533-4498 **P 131**

LOBELL, RICHARD 25-12 Union St, Flushing, NY (212) 461-3817
LOMBARDI, FRED 180 Pinehurst Ave, NYC (212) 568-0704
LOMEO, ANGELO & SONJA BULLATY 336 Central Park W, NYC (212) 663-2122
LONG, LEW 3 Ruston Mews, London W11, England 01-229-9415 **P 66-67**

LONGCOR, WILLIAM Rd-2 Box 381, Andover, NJ 07821 (201) 398-2225
LONSDALE, WILLIAM 35 Orange St, Brooklyn, NY (212) 834-8281
LORENZ, ROBERT 873 Broadway, NYC (212) 505-8483 **P 214**

LOVE, ROBIN 333 W 19 St, NYC (212) 243-7339 **P 151**

LUCKA, KLAUS 35 W 31 St, NYC (212) 594-5910
LURIA, DICK 5 E 16 St, NYC (212) 929-7575 **P 110-111**

M

MACEDONIA, CARMINE 6 W 20 St, NYC (212) 255-7910
MACGREGOR, HELEN, Fresh Air Photography 60 E 11 St, NYC (212) 505-7561;
 Rep—Jane Lander (212) 861-7225; London—Julian Seddon 01-935-0702 **P 16**

MACWEENEY, ALLEN 171 First Ave, NYC (212) 473-2500
MADERE, JOHN 306 W 80 St, NYC (312) 724-3432
MAISEL, JAY 190 The Bowery, NYC (212) 431-5013 **P 122-123**

MALONE, LYN 200 East End Ave, NYC (212) 534-5827
MANALIS, KAREN Goodsell Pl, Highland Falls, NY (914) 446-2938
MANNA, LOU 20 E 30 St, NYC (212) 683-8689 **P 46**

MANNO, JOHN 20 W 22 St - Apt 802, NYC (212) 243-7353
MANOS, CONSTANTINE, Magnum Photos Inc, 251 Park Avenue S - 11 Fl, NYC (212) 475-7600
MARCHAND, NICOLE 306 W 90 St, NYC (212) 362-8943
MARCHESE, JIM 200 W 20 St, NYC (212) 242-1087
MARCUS, HELEN 120 E 75 St, NYC (212) 879-6903 **P 152**

MARCUS, STEPHANIE 103 Joralemon St, Brooklyn, NY (212) 852-0033
MARGERIN, WILLIAM D. 251 Park Ave S, NYC (212) 473-7945
MARK, MARY ELLEN 143 Prince St, NYC (212) 982-8775
MARSHALL, ELIZABETH 24 S Woodland St, Englewood, NJ (201) 568-2671
MARSHALL, EDITH PAUL 40 W 77 St, NYC (212) 877-3921
MARTEL, MARIA 184 E 64 St, NYC (212) 246-1910
MARTIN, BILL 110 W 17 St - 7 Fl, NYC (212) 929-2071
MARTIN, DENNIS 11 W 25 St, NYC (212) 929-2221
MARTIN, MIGUEL 5 W 31 St, NYC (212) 564-3677

MARINELLI, JACK, Jack Marinelli Studio, 673 Willow St, Waterbury, CT (203) 766-3273

MARVULLO STUDIO, JOSEPH F. 404 Park Ave S - Ste 1303, NYC (212) 532-2773

MARX, RICHARD 8 W 19 St, NYC (212) 929-8880

MASON, DON 101 W 18 St, NYC (212) 675-3809; Rep—Kathy Mason (212) 855-9074 **P 150**

MASSER, RANDY 136 E 31 St, NYC (212) 684-0558

MASSIE, KIM Old Mill Rd, Accord, NY (914) 687-7744

Masunaga, Ryuzo 873 Broadway, NYC (212) 254-1402

MATTHEWS, CYNTHIA 200 E 78 St, NYC (212) 288-7349 **P 102**

McCABE, DAVID 39 W 67 St, NYC (212) 874-7480

McCABE, INGER % Ocborne Elliott, 10 Gracie Sq, NYC (212) 535-3030, 9696

McCABE, ROBERT 117 E 24 St, NYC (212) 677-1910

McCANN, RUSSELL 404 Park Ave S, NYC (212) 683-1686

McCARTHY, MARGARET 31 East St - 11A, NYC (212) 696-5971

McCARTNEY'S, SUSAN 902 Broadway - Rm 1608, NYC (212) 533-0600

McCURDY, JOHN CHANG 156 Fifth Ave, NYC (212) 243-6949

McDARRAH, FRED W. 505 La Guardia Pl, NYC (212) 777-1236

McELROY, ROBERT R. 245 W 107 St, NYC (212) 866-1877

McFARLAND, LOWELL & NANCY 115 W 27 St, NYC (212) 691-2600 **P 158-159**

McGINTY, KATHIE 377 W 11 St, NYC (212) 620-0596

McGRATH, NORMAN 164 W 79 St, NYC (212) 799-6422

McKAVISH, DELIAH 84 Charles St, NYC (212) 675-1235

McLAUGHLIN-GILL, FRANCES 49 E 86 St, NYC (212) 534-5596

McLOUGHLIN, JAMES 12 W 32 St, NYC (212) 244-1595 **P 54-55**

MEAD, CHRIS 215 Park Ave S, NYC (212) 475-0448 **P 82-83**

MECCA, PETER 544 Broad Ave, Leonia, NJ (201) 944-3241

MEEK, RICHARD 8 Skyline Dr, Huntington, NY (516) 271-0072

MELFORD, MICHAEL 32 E 22 St, NYC (212) 473-3095

MELILLO, NICK 118 W 27 St, NYC (212) 691-7612; Rep—Anita Green (212) 532-5083 **P 10**

MELLON 69 Perry St, NYC (212) 243-3472

MENASHE, ABRAHAM 900 West End Ave, NYC (212) 254-2754 **P 145**

MENKEN STUDIOS, INC 119 W 22 St, NYC (212) 924-4240; NY—Phyllis Goodwin (212) 570-6021; CHIC—Vicki Peterson (312) 467-0780 **P 232-233**

MENSCHENFREUND, JOAN 168 W 86 St - Apt 14A, NYC (212) 362-8234

MEOLA, ERIC 134 Fifth Ave, NYC (212) 255-8653

MERRIM, LEWIS 31 E 28 St, NYC (212) 889-3124

MERVAR, LOUIS 29 W 38 St, NYC (212) 354-8024 **P 60**

MEYEROWITZ, JOEL 817 West End Ave, NYC (212) 666-6505

MICHAEL, LEE 254 Fifth Ave, NYC (212) 683-0651

MILI, GJON Life Mag, Time-Life Bldg - Rm 2850, Rockefeller Center, NYC (212) 586-1212

MILJAKOVICH, HELEN 114 Seventh Ave - Apt 3C, NYC (212) 242-0646

MILLER, BERT 30 Dongan Pl, NYC (212) 567-7947

MILLER, BILL 36 E 20 St, NYC (212) 674-8026 **P 212**

MILLER, EILEEN 28 W 38 St - Apt 9E, NYC (212) 944-1507

MILLER, MYRON 23 E 17 St, NYC (212) 242-3780

MILLER, PETER M. 105 E 38 St, NYC (212) 683-1576

MILLER, WAYNE, Magnum Photos Inc, 251 Park Ave S, NYC (212) 475-7600, (415) 254-3984

MILLMAN, LESTER J. 304 Fenimore Rd - Apt 7B, Mamaroneck, NY (914) 381-4227

MITCHELL, BENN 103 Fifth Ave, NYC (212) 255-8686 **P 32**

MITCHELL, JACK B. 435 E 77 St, NYC (212) 737-8940

MONROE, ROBERT 255 W 90 St, NYC (212) 879-2550

MOONEY, GAIL 25 Yahana Ave, Rutherford, NJ (212) 360-2576

MOORE, PETER I. 351 W 30 St, NYC (212) 826-6972, 564-5989

MORATH, INGE, Magnum Photos, 251 Park Ave S, NYC (212) 475-7600

MORETZ, CHARLES 141 Wooster St, NYC (212) 254-3766

MORGAN, BRUCE 55 S Grand Ave, Baldwin, NY (516) 546-3554 **P 52**

MORRIS, BILL 34 E 29 St, NYC (212) 685-7354

MORRISON, TED 286 Fifth Ave, NYC (212) 279-2838 **P 100**

MORSCH, ROY J. 1200 Broadway, NYC (212) 679-5537
MOSCATI, FRANK 139 Fifth Ave, NYC (212) 228-4000
MOTISI, GINA V. 1 Ormont Lane, Stony Brook, NY (516) 751-4409
MUCCI, TINA 59 W 73 St - 9, NYC (212) 877-4017
MUFSON, CHRISTINA 7 W 14 St, NYC (212) 243-8548
MULLEN, DAN 110 Madison Ave, NYC (212) 725-8753
MULVEHILL, LARRY Box 98, Cold Springs, NY 10516-0098 (914) 265-9078
MUNRO, GORDON 381 Park Ave S, NYC (212) 889-1610
MUNSON, RUSSELL 6 E 39 St, NYC (212) 689-7672 **P 80**

MURESAN, JON 42 W 96 St, NYC (212) 222-6643 **P 134**

MURPHY, ART 675 West End Ave, NYC (212) 222-5751
MURRAY, ROBERT 149 Franklin St, NYC (212) 226-6860
MYDANS, CARL 212 Hommocks Rd, Larchmont, NY (914) 834-9206, (212) 841-2345
MYLONAS, ELENI 148 Greene St, NYC (212) 925-2789

N

NAAR, JON 230 E 50 St, NYC (212) 752-4625
NAKAMURA, TOHRU 112 Greene St, NYC (212) 334-8011;
 Rep—Sacramone/Valentine (212) 929-0487 **P 160**

NALEWAJK, JEROME 315 Oakridge Rd, Stratford, CT (203) 375-0207
NAMUTH, HANS 157 W 54 St, NYC (212) 245-2811, (516) 537-0719
NANFRA, VINCENT 62 Preston Ave, Staten Island, NY (212) 948-0238
NEDLIN, RADIE 14 Melbourne Rd, Great Neck, NY (516) 482-6073
NEEDHAM, STEVEN 159 Madison Ave - Apt 4A, NYC (212) 696-4973
NEIL, JOSEPH 20 E 22 St, NYC (212) 982-6655
NELKEN, DAN 43 W 27 St, NYC (212) 532-7471, (215)493-3720
NELSON, JANET Finney Farm, Croton-on-Hudson, NY (212) 687-3000, (914) 271-5453,
 (212) 752-3930
NERNEY, DAN 137 Rowayton Ave, Rowayton, CT (203) 853-2782 **P 36**

NEWMAN, ARNOLD 39 W 67 St, NYC (212) TR7-4510
NEWMAN, MARVIN E. 227 Central Park W, NYC (212) 362-2044 **P 225**

NEY, NANCY 108 E 16 St, NYC (212) 260-4300
NICCOLINI, DIANORA 356 E 78 St, NYC (212) BU8-1698
NICHOLSON, NICK 121 W 72 St - Apt 2E, NYC (212) 362-8418, (919) 787-6076
NIEFIELD, TERRY 210 Fifth Ave, NYC (212) 686-8722
NIGHSWANDER, TIM, Nighswander-Sudick, 7 Carrington Rd, Bethany, CT (203) 789-8529
NIKAS, BASIL 710 Park Ave, NYC (212) 472-1570
NONES, LEONARD 5 Union Sq W, NYC (212) 741-3990
NOREN, CATHERINE 143 E 13 St, NYC (212) 473-3979
NOVICK, ELIZABETH 330 Lafayette St, NYC (212) 226-3013
NOYES, WILLIAM 371 Greens Farms Rd, Westport, CT (203) 259-8871

O

OBREMSKI, GEORGE 1200 Broadway, NYC (212) 684-2933; Rep—Susan Steiner
 (212) 673-4704 **P 114-115**

O'BRIEN, MICHAEL 22 W 85 St, NYC (212) 787-2697
OCHI, TORU 100 Fifth Ave, NYC (212) 675-2982
OGRUDEK, ROBERT 36-19 167 St, Flushing, NY (212) 939-5193
OLBRYS, ANTHONY 41 Pepper Ridge Rd, Stamford, CT (203) 322-9422, 322-9494
OLIVO, JOHN 545 W 45 St, NYC (212) 765-8812
O'NEILL, MICHAEL 19 Bethune St, NYC (212) 807-8777
OPPERSDORFF, MATHIAS 1220 Park Ave, NYC (212) 860-4778
O'REILLY, ROBERT J., R J O Associates, 127 E 59 St, NYC (212) 935-2676
OREL, MANO Box E, Croton-on-Hudson, NY 10520 (914) 271-5542
ORINGER, HAL Photographer Inc, 32 W 31 St, NYC (212) 564-7544
ORISTAGLIO, SUSAN 155 W 81 St, NYC (212) 877-8495
ORKIN, RUTH 65 Central Park W, NYC (212) 362-1658 **P 228**

ORLING, ALAN S. 53 E 10 St, NYC (212) 473-8363

**O'ROURKE, J. BARRY 1181 Broadway, NYC (212) 686-4224; CHIC—Clay Timon
(312) 527-1114** **P 98-99**

ORRICO, CHARLES J. 72 Barry Ln, Syosset, NY (516) 364-2257, (212) 490-0980 **P 53**

ORTIZ, GILBERT 249 W 29 St, NYC (212) 736-8770 **P 90**

OTSUKI, TOSHI 241 W 36 St, NYC (212) 594-1939 **P 13**

OUDI 325 Bowery, NYC (212) 777-0847 **P 153**

OWEN, SIGRID 221 E 31 St, NYC (212) 686-5190
OZGEN, NEBIL 6 W 20 St, NYC(212) 924-1719

P

PACCHIANA, RONALD 14 Sycamore St, Central Islip, NY (516) 234-6675
PAGLIUSO, JEAN 12 E 20 St, NYC (212) 674-0370
PAGNANO, PATRICK 217 Thompson St, NYC (212) 475-2566
PAIGE, PETER 37 W Homestead Ave, Palisades Park, NJ (212) 675-2367
PALMER, GABE 269 Lyons Plain, Weston, CT (203) 227-1477
PALMERI, MICHAEL J. 61 Derby Court, Staten Island, NY (212) 273-7945
PANETTA, ANIELLO 17 Agatha Dr, Plainview, NY (516) 935-9376

PAPADOPOLOUS, PETER 78 Fifth Ave, NYC (212) 675-8830 **P 79**

PAPICH, STANLEY 108 E 91 St, NYC (212) 369-8877, 868-3330
PAPPAS, TONY 110 W 31 St, NYC (212) 243-0436

PARKS, CLAUDIA 310 E 23 St, NYC (212) 533-4498 **P 130**

PARRAGA, ALFREDO ℅ John Olivo Inc, 545 W 45 St, NYC (212) 765-8812
PATTON, JESSICA 5 E 16 St, NYC (212) 924-9210
PAZ, PETER 219 E 70 St, PO Box 596, NYC 10021 (212) 672-7790
PECK, JOSEPH 878 Lexington Ave, NYC (212) 472-1929
PEDEN, JOHN 168 Fifth Ave, NYC (212) 255-2674, (415) 495-4435
PELLEGRINI, BRUNO & FRANCES 113 E 22 St, NYC (212) 288-1010
PELTZ, STUART 6 W 18 St, NYC (212) 929-4600
PENDLETON, BRUCE 485 Fifth Ave, NYC (212) 986-7381
PERAZIO, PETER 509 3 St, Brooklyn, NY (212) 788-3654
PERKELL, JEFF 141 Fifth Ave, NYC (212) 473-1382
PERRON, ROBERT 104 E 40 St, NYC (212) 661-8796
PETERSON, BRENT, Parade Magazine, 750 Third Ave, NYC (212) 573-7195
PETERSON, GOSTA 200 E 87 St, NYC (212) 876-0560
PETT, LAURENCE J. 509 Madison Ave, NYC (212) 344-9453
PFEFFER, BARBARA 40 W 86 St, NYC (212) 877-9913

PHILIBA, ALLAN 3408 Bertha Dr, Baldwin, NY (212) 286-0948, (516) 623-7841 **P 47**

PHILLIPS, JOHN 100 W 57 St - Apt 91, NYC (212) 246-1579
PHILLIPS, ROBERT 101 W 57 St, NYC (212) 757-5190
PICKENS, MARJORIE 5 Old Mill Rd, West Nyack, NY (914) 358-1857
PIEL, DENIS 458 Broadway, NYC (212) 925-8929

**PILGREEN, JOHN 91 Fifth Ave, NYC (212) 243-7516;
Rep—Sacramone/Valentine (212) 929-0487** **P 161**

PILING, RICHARD 13-25 Burbank St, Fair Lawn, NJ (201) 791-2282
PINCKNEY, JIM 50 W 17 St, NYC (212) 929-2533; CA—Studio (408) 375-3534 **P 59**

PINNEY, DORIS 555 Third Ave, NYC (212) 683-0637 **P 137**

PLOTKIN, BRUCE 3 W 18 St, NYC (212) 691-6185
POPPER, ANDREW 330 First Ave, NYC (212) 982-9713, 228-0900
PORTER, ALAN 213 E 25 St, NYC (212) 689-5894
POWERS, BILL 72 Barrow St - 5N, NYC (212) 989-7822
POZARIK, JAMES 43-19 168 St, Flushing, NY (212) 539-7836
PRICE, CLAYTON 50 W 17 St, NYC (212) 929-7721 **P 166-167**

PRICE, DAVID 4 E 78 St, NYC (212) 794-9040
PROBST, KEN 251 W 19 St, NYC (212) 929-2031
PRUITT, DAVID 156 Fifth Ave, NYC (212) 809-0767
PRUZAN, MICHAEL 1181 Broadway, NYC (212) 686-5505

QR

QUAT, DANIEL 156 Fifth Ave, NYC (212) 807-0588
RAAB, MICHAEL 831 Broadway, NYC (212) 533-0030
RAINBOLDT, JOYCE 2211 Broadway, NYC (212) 874-4311
RAJS, JAKE 36 W 20, NYC (212) 675-3666 **P 138-139**

RATKAI, GEORGE 404 Park Ave S, NYC (212) 725-2505
RATZKIN, LAWRENCE 392 Fifth Ave, NYC (212) 279-1314
REICHENTHAL, MARTIN 290 Potter Pl, Weehawken, NJ
RENTMEESTER, CO 4479 Douglas Ave, Riverdale, NY (212) 884-0239, 757-4796
RIBOUD, MARC % Magnum Photos, 251 Park Ave S - 11 Fl, NYC (212) 475-7600
RIES, HENRY 204 E 35 St, NYC (212) 689-3794
RIES, STAN 48 Great Jones St, NYC (212) 533-1852
RILEY, JON 12 E 37 St, NYC (212) 532-8326
RILEY, LAURA, PO Box 186, Mt Salem Rd, Pittstown, NJ 08867 (201) 735-7707
RITTER, FRANK 127 E 90 St, NYC (212) 427-0965
RIVELLI, WILLIAM 303 Park Ave S, NYC (212) 254-0990 **P 2-3**

ROBINS, LAWRENCE 5 E 19 St, NYC (212) 677-6310
ROBINS, SUSAN 2005 Old Cuthbert Rd, Cherry Hill, NJ (609) 795-8386, (215) 564-5666
ROBINSON, CERVIN 251 W 92 St, NYC (212) 873-0464
ROCK, MICK 162 Madison Ave - 3 Fl, NYC (212) 686-1288
ROHDES, ARTHUR 325 E 64 St, NYC (212) 249-3974
ROSENBERG, ARNOLD Box 1034, E Hampton, NY 11937 (516) 324-1227
ROSENTHAL, BARRY 1155 Broadway, NYC (212) 889-5840 **P 24-25**

ROSSUM, CHERYL 310 E 75 St, NYC (212) 628-3173
ROTH, PETER 270 Riverside Dr, NYC (212) 594-3190, 866-6625
ROTKER, MARTIN 63 William St, New City, NY (212) 561-3408, (914) 634-8126
RUBENSTEIN, RAEANNE 8 Thomas St, NYC (212) 964-8426 **P 97**

RUBIN, AL 250 Mercer St - 1501, NYC (212) 674-4535
RUBIN, DARLEEN 159 Christopher St, NYC (212) 243-6973
RUBINSTEIN, EVA 145 W 27 St, NYC (212) 243-4115
RUDOLPH, NANCY 35 W 11 St, NYC (212) 989-0392
RUIZ, HECTOR 15 W 38 St, NYC (212) 391-1346
RUIZ, MARIO 241 W 36 St - 12R, NYC (212) 594-4109
RUMMLER, TOM 213 E 38 St, NYC (212) 683-8250
RUSSEL, RAE 75 Byram Lake Rd, Mt. Kisco, NY (914) 241-0057
RYAN, SUSAN 711 West End Ave - Apt 2CN, NYC (212) 866-1434
RYAN, WILL 16 E 17 St, NYC (212) 242-6270 **P 208**

RYSINSKI, EDWARD 636 Ave of the Americas - Studio 5D, NYC (212) 807-7301 **P 19**

S

SACHA, BOB 58 W 72 St, NYC (212) 595-5447
SAGARIN, DAVE % Wm Esty 100 E 42 St, NYC (212) 697-1600
ST. JOHN, LYNN 308 E 59 St, NYC (212) 308-7744
SAMARDGE, NICK 220 E 23 St, NYC (212) 679-2526
SAND 102 Greene St, NYC (212) 421-6249
SANDBANK, HENRY 105 E 16 St, NYC (212) 674-1151
SANDERS, T. W. 319 E 50 St, NYC (212) 980-1893
SANFORD, L. TOBEY 888 Eighth Ave, NYC (212) 245-2736
SANTORO, CARL J. 210 Fairfield Ave, Carle Place, NY (516) 746-4468
SARNER, SYLVIA 10 E 78 St, NYC (212) 744-5449
SATTERWHITE, AL 10 E 13 St, NYC (212) 691-4988;
CHIC—Clay Timon (312) 527-1114 **P 148-149**

SAUBER, MARTIN 30 Werman Ct, Plainview, NY (516) 694-8980
SCARLETT, NORA 37 W 20 St, NYC (212) 741-2620; Rep—Barbara Umlas
(212) 534-4008 **P 218-219**

SCHAAF, PETER 697 West End Ave, NYC (212) 222-2935
SCHENK, FRED 112 Fourth Ave, NYC (212) 677-1250 **P 30**

SCHIFF, NANCY RICA 24 W 30 St, NYC (212) 679-9444
SCHILD, IRVING 34 E 23 St, NYC (212) 475-0090
SCHINZ, MARINA 222 Central Park S, NYC (212) 246-0457
SCHLACHTER, TRUDY 160 Fifth Ave, NYC (212) 741-3128
SCHLIVEK, LOUIS 229 Heights Rd, Ridgewood, NJ (201) 444-6544
SCHMID, BERT 105 Garth Rd - 4G, Scarsdale, NY (914) 723-8033
SCHNEIDER, ROY 116 Lexington Ave, NYC (212) 686-5814 **P 78**

SCHWARTZ, ROBIN 219 W 81 St - 12A, NYC (212) 877-7874
SCHWEIKARDT, ERIC PO Box 56, Southport, CT 06490 (203) 375-8181 **P 156**

SCIANNA, COSIMO 35 W 36 St, NYC (212) 563-2730
SCLIGHT, GRED 146 W 29 St - 11 Fl S, NYC (212) 594-6718
SCOCOZZA, VICTOR 117 E 30 St, NYC (212) 686-9440
SEEMAN, ED 30 Waterside Plaza, NYC (212) 684-2054
SEGAL, MARK 2141 Newport Pl NW, Washington, DC (202) 223-2618;
NY—E.F. Gidley (212) 772-0846 or (203) 655-1321 **P 120**

SEGHERS II, CARROLL 441 Park Ave S, NYC (212) 679-4582
SEIDMAN, BARRY 119 Fifth Ave, NYC (212) 838-3214 **P 201**

SEITZ, SEPP 381 Park Ave S, NYC (305) 764-5635
SELIGMAN, PAUL 163 W 17 St, NYC (212) 242-5688
SELIGSON, STANLEY 468 Park Ave S, NYC (212) 679-9616
SELTZER STUDIO INC, ABE 524 W 23 St, NYC (212) 807-0660
SENZER, JOHN 111 E 26 St, NYC (212) 679-9483
SHAEFER, RICHARD 20 E 35 St, NYC (212) 684-7252, 243-7885
SHAFFER, STAN 2211 Broadway, NYC (212) 807-7700; Rep—Don Stogo
(212) 490-1034 **P 229**

SHAMAN, HARVEY 109 81 Ave, Kew Gardens, NY (212) 793-0434
SHAMES, STEPHEN 277 Ave C 9H, NYC (212) 777-1627
SHARE, JED 61 Chestnut St, Englewood, NJ
SHELDON, JIM 373 Fifth Ave - 1161, NYC (212) 289-7066
SHELLEY, GEORGE 873 Broadway, NYC (212) 598-1521
SHELTON, SYBIL 416 Valley View Rd, Englewood, NJ (201) 568-8684
SHERMAN, GUY 277 W 10 St - 6E, NYC (212) 675-4983
SILBERT, LAYLE 505 La Guardia Pl, NYC (212) OR7-0947
SILK, GEORGIANA Time & Life Bldg - Rm 2850, Rockefeller Center, NYC (212) 245-0477
SILVER, LARRY 404 Park Ave S, NYC (212) MU4-5242
SILVERSTONE, M. Magnum Photos, 251 Park Ave S, NYC (212) 475-7600
SIMON, PETER ANGELO 504 La Guardia Pl, NYC (212) 473-8340 **P 112**

SINGER, ARTHUR Sedgewood Club, Road 12, Carmel, NY (914) 225-6801
SINT, STEVE 6 Second Rd, Great Neck, NY (516) 487-4918 **P 146-147**

SIRDOFSKY, ARTHUR 115 Henry St, Palisades Pk, NJ (201) 592-8661
SKOGSBERGH, ULF 100 Fifth Ave, NYC (212) 255-7536;
Rep—Michael Groves (212) 532-2074 **P 162-163**

SKOLNIK, LEWIS 135 W 29 St - 4 Fl Rear, NYC (212) 758-5662
SLADE, CHUCK 70 Irving Pl, NYC (212) 673-3516; Stock—(212) 750-1386 **P 20**

SLOAN-WHITE, BARBARA 234 Fifth Ave, NYC (212) 679-6739;
Serv—(212) 730-1188; Rep—Elaine Korn (212) 679-6739 **P 31**

SLOVAK, KENNETH 144-22 22 Ave, Whitestone, NY (212) 762-4369
SMITH, GORDON E. Tower Dr, Darien, CT (212) 684-2840
SMITH, JEFF 30 E 21 St, NYC (212) 674-8383
SMOLAN, RICK 237 Lafayette St - 6N, NYC (212) 431-4279, 750-1030
SNIDER, ED 153-22 82 St, Howard Beach, NY (212) 673-3652
SNYDER, CLARENCE 717 Porter St, Easton, PA (212) 252-2109
SNYDER, NORMAN 7 E 19 St, NYC (212) 254-2770
SOBEL, J. & A. Klonsky, Janeart Ltd - Studio 810, 154 W 57 St, NYC (212) 765-1121
SOCHUREK, HOWARD 680 Fifth Ave, NYC (212) 582-1860

SOLOMON, PAUL 714 Ninth Ave, NYC (212) 957-9461
SOLOMON, ROSALIND 30 W 63 St - 260, NYC (212) 247-2182
SORCE, WAYNE A. 20 Henry St - Apt 5G, Brooklyn, NY (212) 237-0497
SORINE, DANIEL S. 40 W 72 St, NYC (212) 362-6100
SPATZ, EUGENE 264 Sixth Ave, NYC (212) 777-6793
SPEIER, LEN 190 Riverside Dr, NYC (212) 595-5480 **P 135**

SPIEGEL Rd 2 - Box 353A, South Salem, NY 10590 (914) 763-3668
STANDART III, JOSEPH G. 5 W 19 St, NYC (212) 532-8268
STAGE, JOHN LEWIS Iron Mountain Rd, New Milford, NY (914) 986-1620
STAHL, BILL 87 Mulberry Ave, Garden City, NY (516) 741-5709
STAHMAN, ROBERT 1200 Broadway, NYC (212) 679-1484
STANTON, WILLIAM 160 W 95 St, NYC (212) 662-3571
STEARNS, PHILLIP O. 21 W 58 St - Apt 6C, NYC (212) 751-5406
STECKER, ELINOR H. 16 Kilmer Rd, Larchmont, NY (914) 937-3800, 834-8514
STEEDMAN, RICHARD 214 E 26 St, NYC (212) 679-6684
STEELE, KIM 640 Broadway, NYC (212) 777-7753
STEIN, LARRY 5 W 30 St, NYC (212) 239-7264; Rep—June Greenman
(212) 947-8150 **P 128**

STEINER, CHARLES 61 Second Ave, NYC (212) 777-0813
STEINER, CHRISTIAN 300 Central Park W, NYC (212) 799-4522
STEINER, LISL Trinity Pass, Pound Ridge, NY (914) 764-5538
STEINHARD, WALTER 155 Fremont, Peekskill, NY (914) 737-3347
STELLATO, TONY 163 Ridge Ave, Yonkers, NY (914) 965-4773
STERBA, JAMES 235 E 49 St - 1A, NYC (212) 688-2347
STERN, BOB 12 W 27 St, NYC (212) 354-4619
STERN, IRENE 117 E 24 St, NYC (212) 475-7464
STERN, LASZLO 157 W 54 St, NYC (212) 757-5098 **P 45**

STETTNER, BILL 118 E 25 St, NYC (212) 460-8180 **P 174-175**

STEVENS, D. 11 W 18 St, NYC (212) 242-4409, (213) 466-7120
STEVENS, ROY 1349 Lexington Ave, NYC (212) 831-3495
STOCK, DENNIS % Magnum Photos, 251 Park Ave S - 11 Fl, NYC (212) 475-7600
STOKES, STEPHANIE 40 E 68 St, NYC (212) 744-0655
STOLLER, EZRA 222 Valley Pl, Mamaroneck, NY (914) 698-4060
STONE, ERIKA 327 E 82 St, NYC (212) 737-6435 **P 70**

STRONGIN, JAMES W. 11 Henhawk La, Huntington, NY (516) 421-4307
STUPAKOFF, OTTO 80 Varick St, NYC (212) 334-8032; Rep—Don Stago
(212) 490-1034 **P 84**

SUTOR, RICHARD 250 W 94 St, NYC (212) 662-8977
SUTPHEN JR., JOHN 148 Palmer Ave, Mamaroneck, NY (914) 698-0812, 698-4898
SUTTON, HUMPHREY 18 E 18 St, NYC (212) 989-9128
SWEDOWSKY, BEN 381 Park Ave S, NYC (212) 684-1454
SZASZ, SUZANNE 15 W 46 St, NYC (212) 832-9387
SZKODZINSKY, WASYL 350 Manhattan Ave, Brooklyn, NY (212) 383-2407

T

TANAKA, VICTOR 156 Fifth Ave, NYC (212) 675-3445
TANNENBAUM, ALLAN 182 Duane St, NYC (212) 431-9797
TANNENBAUM, KEN 16 W 21 St, NYC (212) 675-2345; Rep—Linda Perretti
(212) 687-7392 **P 108**

TAYLOR, ADRIAN 1050 Sixth Ave, NYC (212) 399-2521
TAYLOR, CURTICE 29 E 22 St, NYC (212) 473-6886
TAYLOR, JONATHAN 5 W 20 St, NYC (212) 741-2805 **P 77**

TENIN, BARRY PO Box 2660, Westport, CT 06880 (203) 226-9396 **P 28**

TENZER, PETER 4 W 37 St, NYC (212) 736-1252
TEPPER, PETER 195 Tunxis Hill Rd, Fairfield, CT (203) 367-6172
THOREN, VIRGINIA 37 Perry St, NYC (212) 989-7666
TILLMAN, DENNY 39 E 20 St, NYC (212) 674-7160
TOGASHI 100 Fifth Ave, NYC (212) 929-2290 **P 136**

TOMKINS, JUDY Snedens Landing, Palisades, NY (914) 359-0469
TOTO, JOE 23 E 21 St, NYC (212) 260-3377
TOWNSEND, WENDY 301 E 78 St, NYC (212) 744-5753
TREMMEL, JOHN 1618 W 13 St, Brooklyn, NY (212) 736-1985
TRITSCH, JOSEPH 507 Longstone Dr, Cherry Hill, NJ (609) 795-7518
TULLY, ROGER 215 E 24 St - 506, NYC (212) 683-0789
TURBEVILLE, DEBORAH 2109 Broadway - 1370, NYC (212) 744-2736
TURPAN, DENNIS 25 Amsterdam Ave, Teaneck, NJ (201) 837-4242
TURNER, PETE 154 W 57 St, NYC (212) 765-1733 **P 18-19**

U

UMANS, MARTY 110 W 25 St, NYC (212) 242-4463
UNANGST, ANDREW 381 Park Ave S, NYC (212) 533-1040
URSILLO, CATHERINE 1040 Park Ave, NYC (212) 722-9297 **P 170**

V

VALENTIN, AUGUSTO 137 E 36 St, NYC (212) 532-7480
VAN ARSDALE, NANCY 300 Franklin Tpke, Ridgewood, NJ (201) 652-1202
VAN CAMP LOUIS 535 Broadhollow Rd, Melville, NY (516) 752-1511
VAN GLINTENKAMP, RIK 5 E 16 St,NYC (212) 924-9210
VARNEDOE, SAM 12 W 27 St, NYC (212) 354-4916
VARON, MALCOLM 125 Fifth Ave, NYC (212) 473-5957
VARTOOGIAN, JACK 262 W 107 St - 6A, NYC (212) 663-1341
VATZ, BETTY 411 West End Ave, NYC (212) 724-5089
VELTRI, JOHN % Photo Researchers, 60 E 56 St - 8 Fl, NYC (212) 982-5672
VICKERS, CAMILLE 200 W 79 St, NYC (212) 580-8649
VICTOR, THOMAS 131 Fifth Ave - Apt 402, NYC (212) 777-6004, 582-2218
VIDAL, BERNARD 853 Seventh Ave, NYC (212) 582-3284; Rep—Rita Holt
 (212) 683-2002 **P 202-203**

VILLEGAS, RONALD 220 E 23 St, NYC (212) 683-7897
VOGEL, ALLEN 126 Fifth Ave, NYC (212) 673-2225
VON HASSELL, AGOSTINO 277 W 10 St - Apt 12 D, NYC (212) 242-7290
VON KOSCHEMBAHR, ALEX 9 Harbor Rd, Westport, CT (203) 226-0452
VON MATTHIESSEN, MARIA Bog Hill - Doansburg Rd, Brewster, NY (914) 279-2663
VOS, GENE 440 Park Ave S - Rm 904, NYC (212) 685-8384

W

WAGNER, DAVID A. 156 Fifth Ave, NYC (212) 741-1171 **P 23**

WAHL, PAUL PO Box 6, Bogota, NJ 07603 (201) 487-8460
WAINE, MICHAEL 873 Broadway, NYC (212) 533-4200
WALTHER, MICHAEL 2185 Brookside Ave, Wantagh, NY (516) 799-2580
WALLEN, JONATHAN 149 Franklin St, NYC (212) 966-7531 **P 129**

WALZ, BARBARA 143 W 20 St, NYC (212) 242-7175
WALTZER, CARL 873 Broadway, NYC (212) 475-8748
WANSTALL, THOMAS 61 Frederic St, Yonkers, NY (914) 969-5905
WARNECKE, GRACE 40 W 67 St, NYC (212) 580-4973
WATANABE, NANA 31 Union Sq W, NYC (212) 741-3248 **P 113**

WATSON, ALBERT W. 237 E 77 St, NYC (212) 628-7886
WATTS, C. MONCRIEF 304 E 20 St, Ph E, NYC (212) 674-1270
WEAKS, DANIEL 256 W 81 St, NYC (212) 362-9392
WECKLER, CHAD 825 Washington St, Hoboken, NJ (201) 656-6006
WEIDLEIN, PETER 122 W 26 St, NYC (212) 989-5498 **P 200, 439**

WEINBERG, MICHAEL 5 E 16 St, NYC (212) 691-0713
WEINIK, SUSAN 405 E 63 St, NYC (212) 838-0111
WEINSTEIN, TODD 47 Irving Pl, NYC (212) 254-7526
WELLINGTON 141 Fifth Ave, NYC (212) 777-7901
WEST, BONNIE 156 Fifth Ave, NYC (212) 929-3338 **P 69**

WEST, CHARLES 304 Henry St - Apt 4A, Brooklyn, NY (212) 624-5920
WESTENBERGER, THEO 366 Broadway, NYC (212) 732-5900
WEXLER, MARK 137 W 80 St - Apt 5B, NYC (212) 595-2153 P 33

WHITE III, FRANK 18 Milton Pl, Rowayton, CT (212) 581-8338, (203) 866-4211
WHITE, SAUL 270 Hamilton Rd, Chappaqua, NY (914) 747-1680
WHITELY, HOWARD 60 E 42 St, NYC (212) 490-3111
WHITTINGTON, ROBERT 347 W 39 St - 11E, NYC (212) 947-5689
WIESEHAHN, CHARLES 200 E 37 St, NYC (212) 679-8342
WILCOX, FRANK % Photophile, 381 Fifth Ave - 3 Fl, NYC (212) 246-6367
WILKES, STEPHEN JOEL 190 The Bowery, NYC (212) 925-1939
WILKS, HARRY 234 W 21 St, NYC (212) 929-4772
WILSON, MIKE 441 Park Ave S, NYC (212) 683-3557
WITLIN, RAY 245 W 107 St, NYC (212) 866-7625
WOLF, HENRY 167 E 73 St, NYC (212) 472-2500
WOLFF, BRIAN R. 131 E 23 St - 713, NYC (212) 598-4619
WOLFF, WERNER 397 Bleecker St, NYC (212) 679-3288
WOLTERS, RICHARD A. 12 Sesquehana Rd, Ossining, NY (212) 421-2307, (914) 941-0581
WOOD, SUSAN Olympic Tower, 641 Fifth Ave, NYC (212) 371-0679
WOODSON JR., LEROY 347 W 39 St - 14N, NYC (212) 868-0266
WOODWARD, HERBERT 555 Third Ave, NYC (212) 685-4385
WORMSER, RICHARD L. 800 Riverside Dr, NYC (212) 928-0056
WUNDERLICH, GABRIELE 138 E 36 St, NYC (212) 689-6985
WYMAN, IDA PO Box 327, Bronx, NY 10471 (212) 694-3430, 543-0748
WYNN, DAN 170 E 73 St, NYC (212) 535-1551

Y

YAFFA, CLAIRE Pleasant Ridge Rd, Harrison, NY (914) 698-8150
YAMASHITA, MICHAEL Heron Hollows, Roxiticus Rd, Mendham, NJ (201) 744-7026
YEE, TOM 30 W 26 St - 8 Fl, NYC (212) 242-0301
YENACHEM 35 W 31 St, NYC (212) 736-2254 P 213

YOUNG, ELLAN W. 86 Prospect Dr, Chappaqua, NY (914) 238-4837
YOUNG, JAMES 110 W 25 St, NYC (212) 924-5444 P 143

Z

ZANE, STEVEN 227 Grand St, Hoboken, NJ (201) 420-8868
ZAPPA, TONY 28 E 29 St, NYC (212) 532-3476
ZEHNDER, BRUNO J. PO Box 5996, Grand Central Sta, NYC 10163 (212) 840-1234
ZLOTNIK, CHARLENE 17 Sixth Ave, NYC (212) 226-4149
ZOINER, JOHN 12 W 44 St, NYC (212) 972-0357 P 121

ASSOCIATE MEMBERS NEW YORK

A

ACH, MICHAEL 120 Prospect Ave, Sea Cliff, NY (516) 671-9367
ADDEO, EDWARD 31-47 33 St, Long Island City, NY (212) 721-4375
ALLEN, JANICE K. Box 827, Amagansett, NY 11930 (516) 267-8383, (212) 832-9066
ALLEN, MARIETTE P. 211 Central Park W, NYC (212) 873-3459
AUBRY, DANIEL 365 First Ave, NYC (212) 673-9202
AUGUSTINE, PAULINE 825 West End Ave, NYC (212) 749-8285

B

BAASCH, DIANE 41 W 72 St - 11F, NYC (212) 724-2123
BADER, KATE 41-41 46 St - 3J, Sunnyside, NY (212) 786-1440
BAKER, GLORIA 22 W 75 St, NYC (212) 877-1416
BAKER, SANDRA 1 East End Ave, NYC (212) 288-5938
BARLOWE, JEFF 3125 Dragon Lane, Wantagh, NY (516) 826-9864
BARONIO, JOYCE 33 W 17 St, NYC (212) 242-5224
BEAUCHAMP, JACQUES 42 E 23 St - 6 Fl, NYC (212) 475-7787
BENEDICT, CAMILLE LOWNDS 33 E 70 St, NYC (212) 988-6897-99
BERK, OTTO 303 Park Ave S, NYC (212) 477-3449
BERKUN, PHIL 179 Columbia Heights, Brooklyn, NY (212) 596-0294
BERNAL, RUTH 153 Prince St, NYC (212) 254-3884
BEVAN, DAVID 319 W 13 St, NYC (212) 924-1528
BISHOP, DAVID 251 W 19 St - Rm 2C, NYC (212) 929-4355
BLUM, ROSS ESTES, % Jeff Bailey 408 E 13 St, NYC (212) 533-1535
BOLSTER, MARK 1736 Second Ave, NYC (212) 348-0965
BONIFIELD, ROBERT 141 Fifth Ave, NYC (212) 982-5226
BRAISE, THOMAS 58 W 36 St - 38, NYC (212) 947-8221
BRANCO, TONY 32 Bella Vista St, Locust Valley, NY (516)759-1217
BRANDEIS, ANN 43-12 Parsons Blvd, Flushing, NY (212) 793-7617

C

CLARKE, KEVIN 900 Broadway - 9 Fl, NYC (212) 460-9360
COCHRANE, DOUGLAS 458 W 20 St, NYC (212) 255-1244
COCKRELL, JERE 140 Fifth Ave, NYC (212) 242-1356
CONZO, JAMES 321 W 90 St - Apt 9D, NYC (212) 249-0300
CORNICELLO, JOHN 245 W 29 St, NYC (212) 564-0874
CRAIG, THOMAS 208-10 E 6 St, NYC (212) 254-3941
CZAPLINSKI, CZESLAW 90 Dupont St, Brooklyn, NY (212) 389-9606

D

DADDIO, JAMES 100 W 74 St, NYC (212) 496-7668
D'AGUANNO, SILVIO 3 Hyacinth Ln, Holbrook, NY (516) 981-6128
DALEY, JAMES 105 Fifth Ave, NYC (212) 732-9236
DAVIDIAN, PETER 300 E 71 St, NYC (212) 772-8985
DENSON, WALTER 70 W 83 St - Apt B, NYC (212) 496-7305
DERWIN, JORDAN 305 E 86 St, NYC (212) 228-0900
DIAZ, FERDERICO 312 W 76 St, NYC (212) 877-8582
DOUGHERTY, MARY, CLM Photography Co Inc, 2036 New York Ave, Huntington Sta,
 NY (516) 549-3582
DUBE-VELUTINI, JOHN 20 E 74 St - Apt 5E, NYC (212) 744-9247

E

EASTEP, WAYNE 443 Park Ave S - Ste 1006, NYC (212) 686-8404
ELLMAN, FAYE 270 W 25 St, NYC (212) 243-3759
ESSEL, ROBERT 410 E 64 St - 44, NYC (212) 838-7567

F

FASANO, ELLEN 11 E 32 St, NYC (212) 684-3777
FAVERO, GIAMPIETRO 109 W 26 St, NYC (212) 929-0604
FORSCHMIDT, DON 160 St John's Place, Brooklyn, NY (212) 789-8641; 878-7454
FRANKEL, TRACY 41 Union Sq - Apt 425, NYC (212) 243-5687
FURONES, CLAUDE EMILE 40 Waterside Plaza, NYC (212) 683-0622

G

GAGE, TOM 189 Siscowit, Pound Ridge, NY (914) 764-8371
GALTON, BETH 91 Fifth Ave - 4 Fl, NYC (212) 242-2266
GERARD, LOIS 200 W 58 St, NYC (212) 246-9279
GERMANA, MICHAEL 64 Hett Ave, Staten Island, NY (212) 667-1275
GETLEN, DAVID 60 Gramercy Park, NYC (212) 475-6940
GIANMATTEO, JOHN 139 Church St, Middletown, CT (203) 347-1825
GLASGOW, ELIZABETH 157 E 81 St, NYC (212) 288-2788
GNEITING, ROBIN 448 W 37 St - 9A, NYC (212) 239-1423
GOEBERT, CHIP 136 E 21 St, NYC (212) 684-0559
GORIN, BART 1160 Broadway, NYC (212) 683-3743
GOTTLIEB, DENNIS 5 Union Sq - Rm 301, NYC (212) 620-7050
GOTTFRIED, ARLENE 240 E 23 St, NYC (212) 685-4212
GRANATA, ROBERT 67 Cooper Dr - Ste 1B, New Rochelle, NY (914) 576-2007
GRANEL, RENAUD 1641 Third Ave - 13G, NYC (212) 722-1942
GREEN, BETH 60 Riverside Dr, NYC (212) 580-1928
GRIFFITHS, ED 62 Fairview Ave, Tarrytown, NY (914) 631-2911

H

HAMMELL, CRAIG 6 Skyline Dr, N Caldwell, NJ (201) 228-4994
HAND, GUY 91 Joralemon, Brooklyn, NY (212) 858-2781
HANSEN, CONSTANCE 200 Park Ave S - Apt 514, NYC (212) 460-9416
HAVERN, RONALD, The Seabury Press, 815 Second Ave, NYC (212) 557-0500; Eve/473-7233
HEINY, DONALD River Rd, West Cornwall, CT (203) 672-0092
HERBERT, MARILYNNE 88 Walworth Ave, Scarsdale, NY (914) 725-5025
HERR, H. BUFF 56 W 82 St, NYC (212) 595-4783
HOFFMAN, KENNETH % Optimo, 22 Trumbull St, New Haven, CT (203) 777-9013

JK

JANN, GAYLE 352 E 8 St, NYC (212) 861-4335
JENSEN, PETER M. 22 E 31 St, NYC (212) 689-5026
KATSIN, DANIEL 7 S Rohallion Dr, Rumson, NJ (201) 741-5320
KATVAN, RIVKA 221 E 23 St, NYC (212) 684-0786
KEMP, NEAL 106 E 19 St, NYC (212) 673-3652
KENNRY, KIMBLE 1740 Farmington Ave, Unionville, CT (203) 673-3533
KERN, KAREN 17 Park Ave - 6A, NYC (212) 683-9216
KIERNAN, JIM 34 W 17 St, NYC (212) 243-3547
KLESENSKI, DEBORAH 729 54 St, Brooklyn, NY (212) 288-1010, 748-4881

L

LANGERMAN, STEVEN 16 W 22 St, NYC (212) 691-9322
LATANA 114-116 W 27 St - 21, NYC (212) 255-1127
LAWNE, JUDY 315 E 58 St, NYC (212) 799-0699
LEE, SCHECTER 440 Park Ave S - Rm 807, NYC
LEGRAND, MICHEL 412 Sixth Ave - 7 Fl, NYC (212) 473-2720
LEIFESTE, DALE 46 Clinton Pl - Apt 5, Mt Vernon, NY (914) 699-4735
LEMIEUX III, CHARLES PO Box 171, Fairfield, CT 06430 (203) 259-4987
LESNICK, JOHN 149 W 24 St - 2A, NYC (212) 675-3168
LETTAU, JOANNE 555 Third Ave, NYC (212) 684-0996
LUPIS, ODETTE 25-03 24 Ave, Astoria, NY (212) 932-6963, 721-0308

M

MAASS, ROBERT 166 E 7 St, NYC (212) 473-5612
MARCHAEL, JOHN 100 W 38 St, NYC (212) 729-5614
MARCHESANO, FRANK 35 W 36 St, NYC (212) 563-2732
MARCUS, STEPHANIE 103 Joralemon St, Brooklyn, NY (212) 852-0033
MARSHALL, ALEC 308 E 73 St, NYC (212) 535-6362
MAYERNIK, GEORGE 41 Wolfpid Ave - Apt 2N, Norwalk, CT (203) 846-1406
McGLYNN, DAVID 18-23 Astoria Blvd, Long Island City, NY (212) 726-4890
McGRAIL, JOHN 522 E 20 St - Apt 6A, NYC (212) 475-4927
McKICHEN, KAREN 132 E 17 St - Apt 41, NYC (212) 420-9860
MERCHANT, MARTIN, Everet Studios, 22 Barker Ave, White Plains, NY (914) 997-2200
MESSER, MELAINE 535 W 113 St, NYC (212) 864-0765
MORRIS, BILL 34 E 29 St, NYC (212) 685-7354

NO

NADELSON, JAY 116 Mercer St, NYC (212) 226-4266
NAIDEAU, HAROLD 233 W 26 St, NYC (212) 691-2942
NAVARRE, LOUIS 135-30 82 Dr, Kew Gardens, NY (212) 846-3026
NEUMAN, PETER 85-28 118 St, Kew Gardens, NY (212) 441-5572
O'BRYAN, MAGGIE 344 E 9 St - Apt 17, NYC (212) 777-8574
OMLIN, RUTH 271 Ave C - 7B, NYC (212) 254-6593

P

PENNEBAKER, STACY 445 E 65 St, NYC (212) 472-3293
POLK, MILBRY 463 West St - D705, NYC (212) 243-3291
POLLIO, MICHAEL 860 Broad St, Bloomfield, NJ (201) 748-1495
PRIBULA, BARRY 62 Second Ave, NYC (212) 777-7612
PRICE, GREG 14 Cayuga Rd, Cranford, NJ (201) 276-2379
PROCTOR, KEITH 136 E 31 St, NYC (212) 696-0170
PSZENICA, JUDITH 60 Lawn Ave - Apt 28, Stamford, CT (203) 325-1862

R

RAFFERTY, JOAN 26 Bond St, NYC (212) 777-9500
RANKIN-SMITH, PAMELA 150 E 69 St, NYC (212) 861-6836
RAUCH, BONNIE Crane Road, Somers, NY (914) 277-3986
REZNICKI, JACK 119 Fifth Ave, NYC (212) 473-0943
RICE, JIM 2104 Boston Post Rd, Larchmont, NY (914) 834-7724
ROBERTS, EBET 419 W 119 St - Apt 7E, NYC (212) 663-7724
RODY, JOHN 254 E 202 St, Bronx, NY (212) 584-3887
RUSSEL, ERNIE % E R Studio, 951 Ansonia St, NYC (212) 674-7249

S

SAIA, STEPHANIE 245 W 107 St, NYC (212) 866-8873
SANCHEZ, ALFREDO 14-23 30 Dr, Long Island City, NY (212) 726-0182
SANDS, MARK PO Box 72, Hewlett, NY 11557 (516) 374-5418
SANGIRARDI, JOYCE 332 E 18 St - 4, NYC (212) 533-8009
SCHEER, STEPHEN 9 Murray St - 12NW, NYC (212) 233-7195
SCHILLING, ROBERT 422 W Broadway, NYC (212) 431-5870
SCHMIDT, KATHLEEN 936 West End Ave - C6, NYC (212) 663-1250
SEIGEL, DEBRA 299 Riverside Dr, NYC (212) 864-4489
SHARANEVYCH, OLEH 519 Bellevilli Ave, Glen Ridge, NJ (201) 429-0247
SILVERMAN, PAUL 49 Ronald Dr, Clifton, NJ (201) 472-4339
SILVIA JR., PETER 200 E 30 St, NYC (212) 685-0407
SKELLEY, ARIEL 249 W 29 St, NYC (212) 868-1179
SMITH, CAMILLA 96 Grand St, NYC (212) 226-2088
SORENSEN, CHRIS PO Box 56, Murray Hill Station, NYC 10156 (212) 684-0551
SPAHN, DAVID B. 381 Park Ave S - Ste 915, NYC (212) 689-6120
SPECTOR, JANET 25 Steven Lane, Great Neck, NY (516) 482-1118
STALLER, JAN 37 Walker St, NYC (212) 966-7043
STALLONE, JOSEPH 30 Bay Beach Ave, Bayville, NY (516) 628-8009
STAR, SCOTT 60-33 61 St, Maspeth, NY (212) 497-3449
STATES, RANDALL 331 Sackett St, Brooklyn, NY (212) 852-8674
STUART, JOHN 80 Varick St, NYC (212) 966-6783

T

TAKAHASKI, KOJI 155 Amity St, Brooklyn, NY (212) 834-1853
TAUFIC, WILLIAM 166 W 22 St, NYC (212) 691-8010
TEMPLESMAN, MARCY 140 Riverside Dr, NYC (212) 799-1331
THELLMANN, MARK 19 W Park Ave, Merchantville, NJ (609) 488-9093
THOMAS, CHRISTOPHER 44 Grand St, New City, NY (914) 638-0352
TOGASHI, KIYOSHI 100 Fifth Ave, NYC (212) 929-2290
TOOMEY, MICHAEL 354 W 88 St, NYC (212) 787-6939
TSIARAS, ALEXANDER 225 W 80 St - 3D, NYC (212) 245-3946

V

VANNOY, CYNTHIA, CBS Publications, 1515 Broadway, NYC (212) 719-6000
VASSILIEV, NINA 145 E 17 St, NYC (212) 473-0190
VESEL, DAVE PO Box 224, Nesconset, NY 11767 (516) 487-4448
VIDOR, PETER 70 Chestnut St, Morristown, NJ (201) 267-1104
VOGEL, RICHARD 348 E 9 St, NYC (212) 460-8317
VOGEL, VALERIE 45-A Hicks St, Brooklyn, NY (212) 624-2782

W

WAGONER, ROBERT 150 Fifth Ave - Apt 220, NYC (212) 867-6050
WALLITT, CAROL 222 W 23 St, NYC (212) 243-4269
WANAMAKER, ROGER PO Box 2800, Darin, CT 06820 (203) 655-8383
WEINBERG, CAROL 325 W 37 St, NYC (212) 560-2178
WEINSTEIN, MARCIA 233 E 69 St - 81, NYC (212) 249-2777
WIDES, SUSAN 866 Broadway, NYC (212) 533-6882
WILSER, LAINE 420 Dean St, Brooklyn, NY (212) 857-1843
WINARD, ROSALIE 300 W 17 St - 2C, NYC (212) 924-2235
WISSER, WILLIAM 60 Crane Rd, Scarsdale, NY (914) 723-9016
WOHL, MARTY 404 E 79 St, NYC (212) 288-7821
WRENN, WILLIAM 661 W 187 St, NYC (212) 923-6619

YZ

YARDIS, JEFFREY 41 S Stoney Brook Dr, Marlborough, CT (203) 295-8187
ZAHNER, DAVID 145 W 78 St, NYC (212) 362-9829
ZAPF, TERRY 114 Cory Ave, Blue Point, NY (516) 363-2463

FOREIGN MEMBERS

AB

ANGELO-CASTRILLON, HENRY Pk N 77, Levent PTT, Istanbul, Turkey 63-48-63
AUSTEN, DAVID GPO 2480, Sydney, Australia 2001
AYER, FREDERICK 4 Rue De Stael, 75015 Paris, France (1) 734-6223
BACH, ERIC 2 Bussardstrasse, 8028 Taufkirchem, Munich, Germany 089-6121213
BAKO, ANDREW 3047-4 St SW, Calgary, Alta T2S 1X9, Canada
BAR-AM, MICHA PO Box 923, Ramat Gan, Israel 52109 03-766293
BARTHOLOMEW, PABLO PO Box 11033, Bombay 40020, India
BECQ, JEAN 3047 4 St NW, Calgary T2S 1X9, Alta, Canada (403) 243-9789, NYC (212) 953-0303
BEHAL, STEVE 123 Alton Ave, Toronto Ont M4L 2M3, Canada (416) 463-7022
BENTLEY, LOGAN Via Vincenzo Tiberio 35, Rome, Italy 493641, 390620
BETSCH, WILLIAM % Naggar BP 93, 75675 Paris Cedex 14, France
 Beyda 2 Rue Camille-Tahan, Paris 18, France (1) 522-2854
BLACK, ALASTAIR 20 Chester Crescent, Lee-on-Solent, Hampshire, PO1398H, England
BLAU, TOM Camera Press Ltd, 400 Russell Ct-Coram St, London WC1, England 837-4488
BRADFORD, ROBERT 41 Fleming Rd, 1-F Wanachai, Hong Kong 734939
BRAKE, BRIAN PO Box 60-049, Titirangi-Auckland 7, New Zealand 5477, Cable: Brake Foto
BROOKS, BOB 22 Covington Way, Halifax NS B3M 3K2, Canada
BROWN, RICHARD 6 High Park Blvd - Ste 2, Toronto, Ont M6R 1M4, Canada (416) 534-8717

C

CAMPBELL, WILLIAM % Time-Life PO Box 52630, Saxonwold 2132 Tv1 S-F, Africa
CERVERA, MANEL Provenca 261 I D, Barcelona 8 Spain (93) 215-74-94
CHEN, RAY 8 Place De Boheme, Candiac Que J5R 3N1 Canada (514) 931-2203, 931-2204
CHEN, WILLIE % Newman Co 19-A Jalan Sulam TS-JB, Johore, Malaysia (073) 336211,
 Telex: MA60536 Newman
CHRISTOPH, HENNING Kortumstrasse 61, 4300 Essen, West Germany (0201) 798-089
CLARIDGE, JOHN 47 Frith St Soho, London W1V 5TE, England 01-439-6826
CLARK, HAROLD 55 Harlow Crescent, Rexdale Ont M9V 2Y8, Canada (416) 743-6008
CLARKE, BOB 3171 Beacon Dr Coquitlam BC V3C 3W7, Canada (604) 525-4838
COMESANA, EDUARDO Casilla De Correo 141, 1426 Buenos Aires, Argentina
 941-6113, 773-5943
CONNELL, MARTIN Connell Homestead, Spencerville Ont KOE 1XO, Canada
CONTINO, VICTOR Via Trionfale 5675, 00136 Rome, Italy 3496061
COOKE, DR. JOHN Oxford Scientific Film, Long Hanborough, Oxford OX72LD,
 England (0993) 881-881
COOPER, KEN Box142 Stn A, Vancouver BC V6C 2M3, Canada (604) 681-2522
COURTNEY-CLARKE, Margaret 23A Via S Onofrio, Rome 00165 Italy 6560618
CRALLE, GARY 83 Elm Ave - Apt 205, Toronto, Ont M4W 1P1, Canada (416) 535-1620
CRAMPTON-BAPLA ADM, ELLEN 27 Orchard Way, The Farthings, Bubbenhall Warks, England
CRANE, RALPH 9C Plateau De Frontenex, 1208 Geneva, Switzerland (22) 353853

D

DAVIDSON, JERRY 5271 Blundell Rd, Richmond BC V7C 1H3, Canada
DAVIS, BOB Rm 101 Yue Yuet Lai Bldg, 43-55 Wyndham St, Hong Kong 5-220486, 5-224073,
 Telex 83499 Ppahx
DAVIS, GREGORY B. 313 Nikaido, Kamakura-Shi, Kanagawa-Ken, Japan
DELBUGUET, RENE Delbuguet Photomedia Ltd, 1209 Guy St, Montreal
 Que, Canada (514) 932-1630
DEV, BRAHM 10 Astley Hall PO Box 66, Dehra Dun, UP 248001, India
DIAMOND, RONALD 4843 Westmount Ave, Montreal Que H3Y 1X7, Canada (514) 487-3809
DIAZ-GIRALDO, HERNAN Apartado Aereo 111-15, Dogota, Colombia 432366
DRUSS, CHUCK BJORNS Tradgards Grand 3, Stockholm, Sweden 11621 (08) 202665
DUCATEZ, JEAN PIERRE 56 Rue Caulcaincourt, Paris 18E, France 606-8332, 255-7757
DURAN, GERRY 1452 Ashford Ave, San Juan, PR (809) 722-1526

EFG

ENGLEBERT, VICTOR Apartado Aereo 8221, Cali, Colombia 39-34-33
ENSTROM, BJORN Box 3099, S-10361 Stockholm, Sweden 08-105010
ERICSON, ROLF Spadvaegen 11, S-961 00 Boden, Sweden 0921-14195
FABRY, JOSEPH Apartado 80521, Caracas, Venezuela
FAHN, TED 51 Nyhavn, K-1051 Copenhagen K, Denmark 45-01-158809, Telex 16309
FAUL, JAN Rainbow Studio Vesterbrogade 17A, 1620 Copenhagen Denmark
 (01) 21-22-77, 21-19-99
FRIEDMAN, TOMAS D. W. 1-18015 Terzorio - 1M, Italy 011-48-40-48, NYC (212) 924-5151
FU, SABINA 41 Fleming Rd, 1-F Wanchai, Hong Kong 734-939

G

GATHA, ASHVIN 69 Grafton Rd, London W-3, England 01-993-3728, NYC (212) 924-5151
GRAHAM, WILLIAM A. 132 Rue De Rennes, 75006 Paris, France (1) 548-39-61
GRIGGS, SUSAN BAPLA, 17 Victoria Grove, London W8 England

H

HALBER, JACQUES J. 24 Schaapsdrift, 6871XB Renkum, The Netherlands (0) 8373-3879
HALL, CHADWICK 22 Holland Park Rd, London W14, England 01-602-3559
HARQUAIL, JOHN 10 Shalom Crescent, Toronto, Ont M9V 4J4, Canada (416) 535-1620, 745-6929
HATAKEYAMA, YO 3-17-32 Nishi-Azabu, Minatoku, Tokyo, Japan
HENDERSON, GORDON 10612 172 St, Edmonton Alta T5S 1H8, Canada
 (403) 483-8049 **P 17**

HENLE, FRITZ PO Box 723, Christiansted, St Croix, VI 00820 (809) 773-1067
HENRICHS, WOLF 28 Alexander, 4000 Duesseldorf 1, FR6 West Germany 211-325-252,
 Telex 8588076
HERSEE, PHILIP 155 Water St, Vancouver BC V6B 1A7, Canada
HEYMAN, TOM Flat 5 22 Arnon St, Tel Aviv, Israel 03-224170, 06-730898, Cable: Tomheypix Ta
HIRES-IV, CHARLES E. % Agence Gamma 35 Av Denfert-Rochereau, 75014 France
 33-1-663-3190
HOEFER, HANS North 5 Leng Kong Satu, Singapore 1441 4450751, Cable: Apaproduct,
 Telex: RS36201 Apasin
HOLMES, MALCOLM Box 5157 GPO, Sydney, NSW 2001, Australia
HUF, PAUL Hazenstraat 4-10, Amsterdam-C, Holland 020-267585
HUNTER, GEORGE Box 272 Sta A, Mississauga, Ont L5A 3A1, Canada (416) 828-2486

IJK

ITZIKOWITZ, MARK Langenbrahm 12, 43 Essen, West Germany
JOACOBY, MAX Spessart Str 15, 1000 Berlin 33, West Germany 8-21-18-15
JAMPEL, DAVE Roppongi Plaza, 1-1-26 Azabudai, Minato-Ku, Tokyo, Japan-106
JAQUES, RONNY PO Box 13, Gstaad, Switzerland
JEN, CHUANG LEE 353-B Y10 Chu Kang Rd, Singapore 2880; 92895, 912390
KARSH, MALAK 292 Laurier Ave East, Ottawa Ont K1N 6P5, Canada (613) 235-1884
KARSH, YOUSUF Chateau Laurier Hotel - Ste 660, Ottawa, Ont K1N 857
 Canada (613) 236-7181
KAWAKAMI, ROKUO 3-8-21 Abenosuji, Abeno-Ku, Osaka 545, Japan (06) 622-0783
KIRSCHENBAUM, ROBERT Pacific Press CPO Box 2051, Tokyo, Japan
KJELDSEN, NIKLAS SF-22320 Odkarby, Aland Islands, Finland 928-48413, 928-48013
KOSSOY, BORIS Caixa Postal 21387, Sao Paulo SP Brasil 241-0546

L

LA BANCA, PATRICK Munz Str 7 8 Munchen Z Brd, West Germany 089-226020
LE GOUBIN, TERENCE 17 Palace Ct, London W2, England 01-723-5031, 01-227-5222,
 Cable: Legoubin London WZ
LINDSAY, JACK 5767 Telegraph Trail W Vancouver BC V7W 1R5, Canada
 (604) 921-8212, 921-7111
LLOYD, R. IAN 5 Lengkong Satu, Singapore 1441 445-0751, Cable Apaproduct
LOCKHART, SAUL 72D Repulse Bay Rd, Hong Kong 5-920284, Cable Scrib/Hong Kong
LONG, LEW 3 Ruston Mews, London W11, England 01-229-9415 **P 66-67**

LYONS, BILL PO Box 2089 Amman, Jordan 813-500

M

MADISON, ROBERT % World Vision Intl, PO Box 5184 Mcc Makati, Manila, Phillipines
MAGALHAES BERNARDO, T. S., Rua Rutila 75, 01432 Sao Paulo SP, Brazil
MAGUBANE, PETER % Rand Daily Mail, 171 Main St, Johannesburg, So. Africa,
 NYC (212) 874-7187, So. Africa 944-2931
MAINARDI, CARLOS 549 Chocabuco, 12 Mejia, Buenos Aires, Argentina 971291
MAYER, FRED 47 Dreikonigstrasse, 8002 Zurich, Switzerland 201-1217
MELCHER, RUSSELL Domaine De Tuilerie, 78590 Noisy Le Roi, Paris, France 460-82-98
MOLENAAR, TOBY 126 Blvd Montparnasse, Paris 75014, France 320-37-36
MONTGOMERY, JAMES Hong Kong Publ Co, 43-55 Wyndham St - Rm 307, Hong Kong
MOODY, BURNETT % Aramco Box 2796, Dhahran, Saudi Arabia

NOP

NAMUTH, PETER 13 Leamington Rd, Villas - 1, London W11, England
NERI, GRAZIA Via Senatto 18, Milano 20121, Italy
NOWITZ, RICHARD PO Box 1258, Jerusalem 91012, Israel (02) 281-951
OLANDT, BEVERLEY 592 St Andrews Rd, West Vancouver BC Canada V7S 1V4
OSTROWSKI, ROBERT Ave Anchieta 523, 12 200 Sao Jose Dos - Campos Sao Paulo, Brazil
PANJABI, RAM 49 Nashville Rd, Dedradun 248 001, India 4462
PIZER, THOMAS 49 Ch Machery, Geneva, Switzerland 1292
PORTER, JUDY Correos General, Boca Chica, Dominican Republic

RS

ROLFES, F KURT Cuppage Ctr - Ste 535, 55 Cuppage Rd, Singapore 0922 7370573, 7343854
ROSS, JOHN G Via di Villa Giulia 34, Rome 00196, Italy 360-1824
ROSSI, GUIDO ALBERTO 5 Via Merradi, Milano 20123 Italy 803969, 879270
RUBINGER, DAVID Time-Life Jerusalem, Beth Agron, Jerusalem 02-32074
SACCO, VITTORIO Via Donizetti - 38, Milano 20122, Italy
SALOMON, JUAN CARLOS 1572 Paraquay, Buenos Aires 1061, Argentina 41-0802, 42-6540
SCHULTHESS, EMIL 1127 Forch, Zurich, Switzerland 01-980-01-21
SCHWARTZ, STUART Am Wasser 55, 8049 Zurich, Switzerland
SEMENIUK, ROBERT 3430 W 3 Ave, Vancouver BC V6R 1L5, Canada
SESSA, ALDO Pasaje El Lazo 3136, Buenos Aires 1425, Argentina 71-7544, 802-6746
SHARP, IVOR 1014 55 Harbour Sq, Toronto, Ont M5J, 2L1, Canada (416) 863-9693
SHEPHERD, FRANCIS Kolibriweg, 5000 Koln 30, Germany 0221-58-4823, Telex: 8881028
SIEFF, JEANLOUP 87 Rue Ampere, Paris, France 75017, 267-1348
SINGH, RAGHUBIR 11 Rue de Siam, 75016 Paris, France
STAIGER, WOLFGANG Langenbrahm 12, 43 Essen, West Germany
STALEY, BILL 1401 Crown St, N Vancouver BC V7J 1G4, Canada (604) 683-0441
STAPLEY, TINA FAEP 0 10A Dryden St, London, England 01-240-1171, 01-240-1172, 01-240-1173
STONE, TONY 98 Ossulton Way, London NW Old England
STOPPELMAN, FRANS T Adalid 511-501, 03100 Mexico DF Mexico (905) 536-3456

TV

TABAK, SIDNEY 101 Glen Manor Dr, Toronto, Ont M4E 3Y3, Canada (416) 363-3428, 691-1944
TAPPE, HORST PO Box 22, Montreux-2CH 1820, Switzerland 021-61-65-24, Telex: 451-030 Txcb
TOMPKINS, RICHARD % J Scharkie-UPI-Unicom GPO Box 5692 - Central, Hong-Kong
 234-8082, 391-8681, Telex 84614
TONNAIRE, LILLIAN Van Leijenberghlaan 167, Amsterdam-Buitenveldert, Holland 020-44-2473
TORTOLI, GIANNI 50029 Tavarnuzze, Firenze, Italy (055) 2020506
VAN ES, HUBERT 95A Robinson Rd GF Hong Kong 5-253-504, (212) 245-1890, Cable: Vanesfoto
VAN MAASDIJK, HEIN Prins Hendrikkade 20, 1012 TL Amsterdam, Holland (020) 22-50-31,
 Telex: 16162 DGLONL
VAUGHAN, VINCENT D PO Box 9259, Nassau, NP Bahamas (809) 32-24455

WZ

WHETSTONE, WAYNE 117 E 2 Ave, Vancouver BC V5T 1B4, Canada (604) 873-4914
WICKEN, DOUG PO Box 956, Waterloo, Ont N2J 4C3, Canada (519) 886-5601
WIEDEL, JANINE 6 Stirling Rd, London SW9 England
WILLIAMSON, JOHN 224 Palmerston Ave, Toronto, Ont M6J, 2J4, Canada
WOLF, MICHAEL Langenbrahm 12, 43 Essen, West Germany
WOLFE, MAYNARD % Prodev Ltd GPO Box 36, Hong Kong 5-765361, Telex 65029
ZIMBEL, GEORGE S 1538 Sherbrooke, West Ste 813, Montreal, Quebec H3G 1LS
 (514) 931-6387, 866-0279

Since 1945, The **Joint Ethics Committee** has served the Graphics Industry by providing an alternative to litigation in the settlement of ethic disputes through peer review, mediation and arbitration.

Our five sponsors are the most respected professional organizations in the field: Society of Illustrators, Inc.; The Art Directors Club, Inc.; American Society of Magazine Photographers, Inc.; Society of Photographer and Artist Representatives, Inc.; The Graphic Artists Guild, Inc.

Selected representatives from these organizations serve as volunteers on the Committee. The services of the **JEC** are offered free of charge.

The **Joint Ethics Committee** has formulated a Code of Fair Practice which outlines the accepted ethical standards for the Graphics Industry.

To purchase the Code booklet for $2.50 or for further information please write to:

JOINT ETHICS COMMITTEE
P.O. Box 179, Grand Central Station
New York, NY 10163.

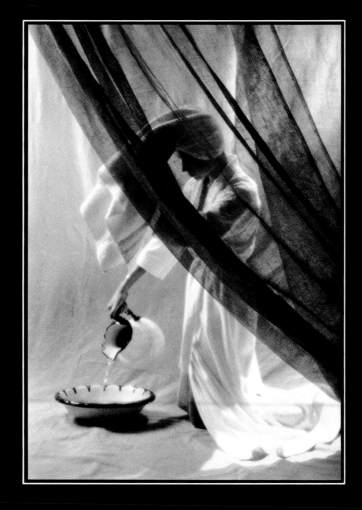

Barbara Bordnick 9 East 12th Street New York City 3-118

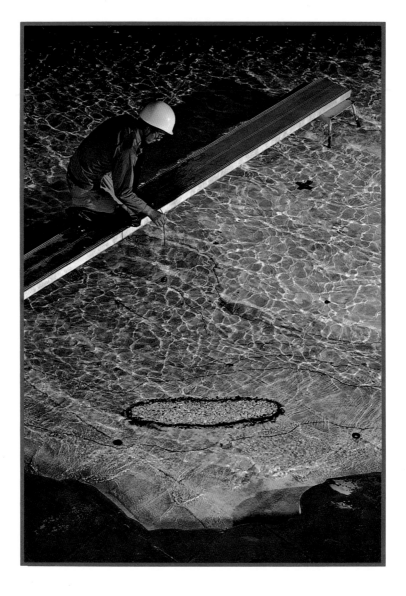

William Rivelli
The specialist in corporate
and industrial photography.

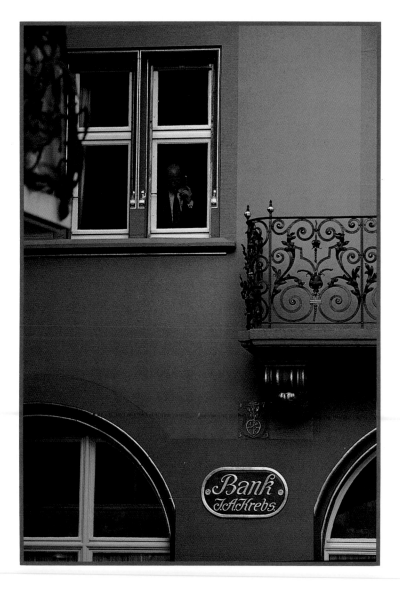

**303 Park Avenue South
New York, New York 10010
212 254-0990**

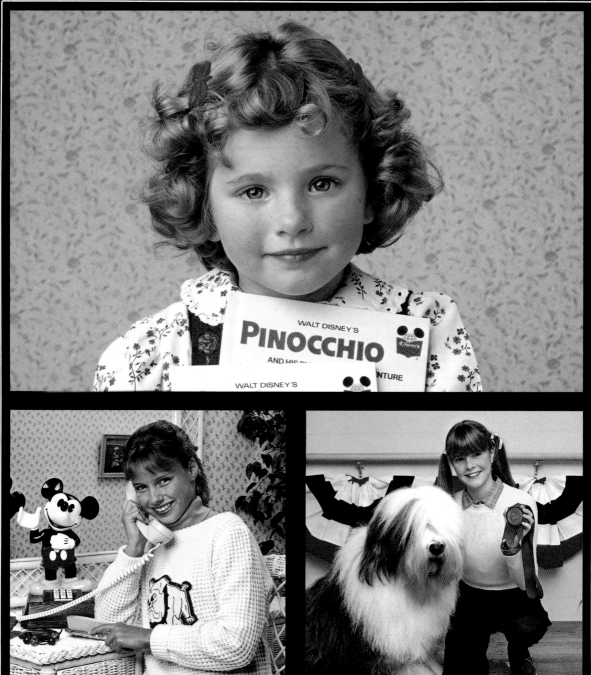

©RUSSELL KIRK 1983

RUSSELL KIRK
13 EAST 16TH STREET, NEW YORK, NY 10003 (212) 691-0014
REPRESENTATIVE: BARBARA LEE (212) 724-6176

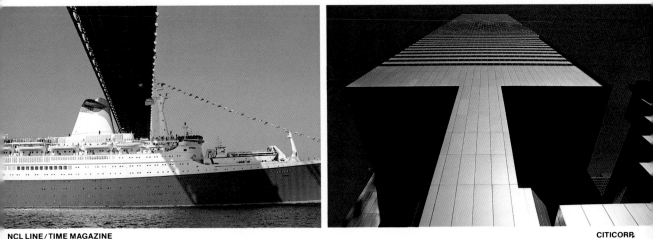

NCL LINE / TIME MAGAZINE

CITICORP.

Dick Davis, 400 East 59th Street, New York, NY 10022 (212) 751-3276

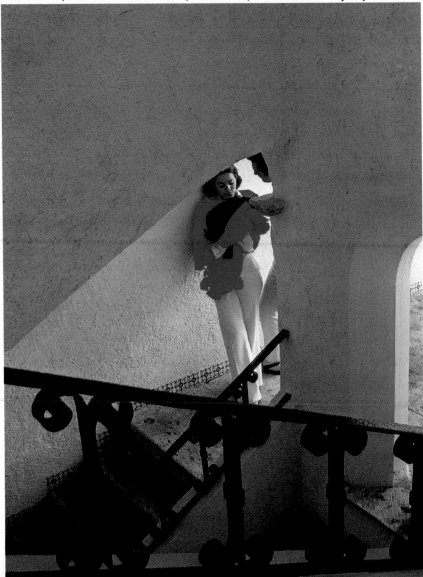

Clients include:
Time, Life, Fortune,
Manufacturers Hanover
Leasing, Lufthansa Air,
TAP Air Portugal, Hilton
International, International
Nickel, Norwegian
Caribbean Lines, German
National Tourist
Association.

WESTIN HOTELS

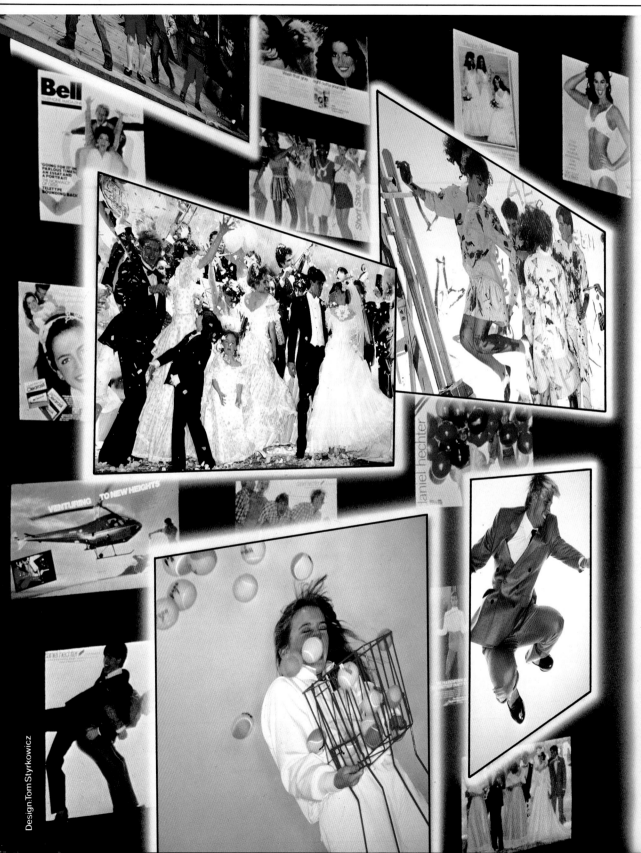

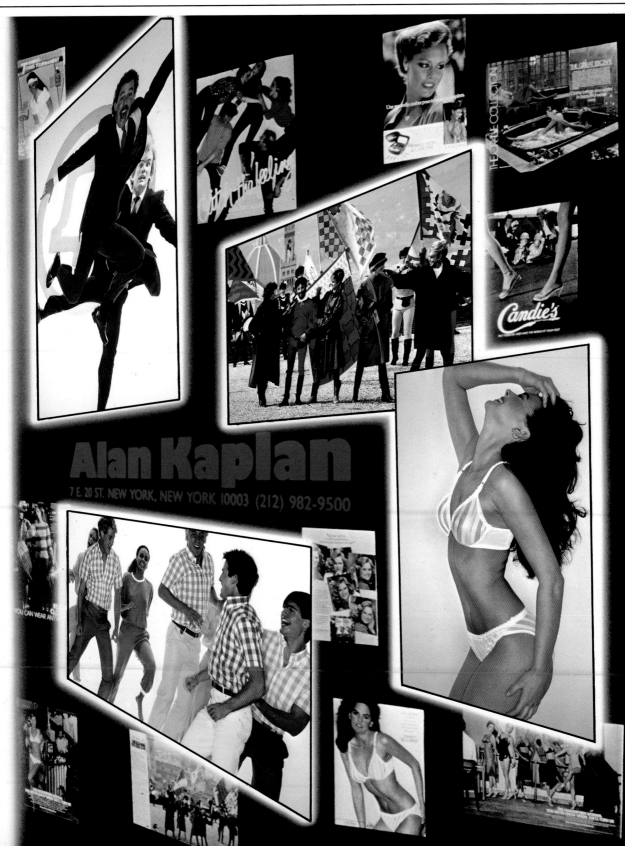

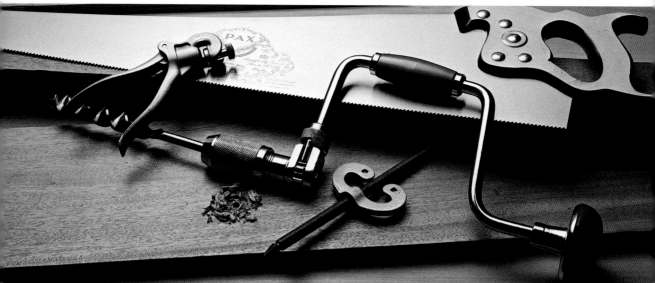

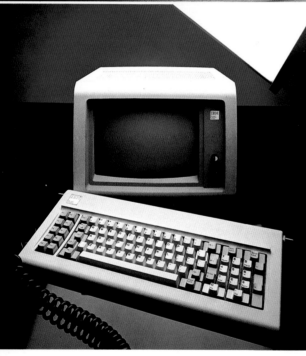

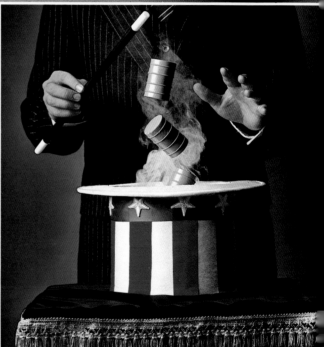

DICK FRANK

11 W 25TH STREET
NYC 10010
(212) 242-4648

REPRESENTED
BY
TED WASSERMAN
(212) 867-5360

Last year we worked for:

ABC Radio	English Leather	Ocean Spray
American Can	GAF	Paco Rabanne
American Home Products	Garrett Wade	Perrier
American Tourister Luggage	General Mills	Poland Springs
Anco Cheese	Grove Press	Prince Tennis Rackets
Ballantine's Scotch	Hathaway Shirts	Quaker Oats
Book Of The Month Club	Health Magazine	Random House
Bristol Myers	Heublein	Rowell Labs
Bulova Watch Co.	Holland American Lines	SCM
Celanese Corp.	IBM	Sheraton Hotels
Chesebrough Ponds	Johnson & Johnson	Smithkline
Citizen Watch	Kanon Cologne	Sony
Clairol	Lederle Labs	Steifel Labs
Commodore Computers	McNeil Labs	Tandberg
Congoleum	Merck & Co.	Weaver Chicken
Cosmopolitan Magazine	Nikon	Westinghouse
De Kuyper Cordials	Norelco	Womans Day Magazine
Durkee Foods		

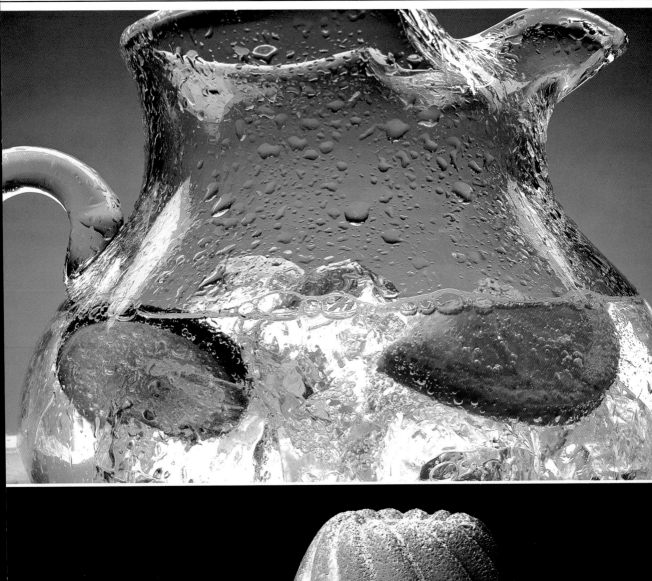

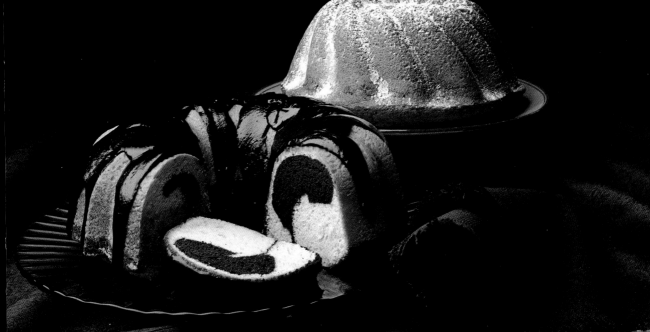

Winston, Diet 7 up, Smirnoff, Hot Sox, Zoom Magazine, Air France, Eastern Airlines, Sportschannel, Fruit of the Loom, Popov Vodka, African Tourism Bureau, R.J. Reynolds, Philip Morris, Australia, Chesebrough-Pond's

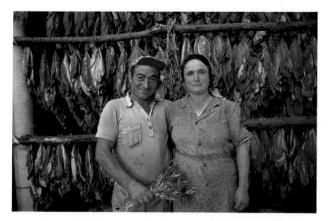

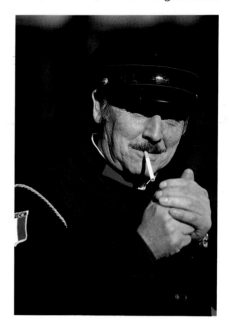

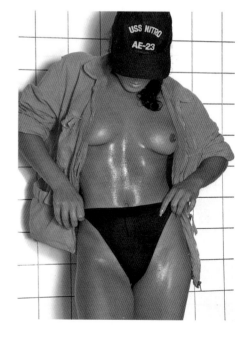

N I C K M E L I L L O

REPRESENTED BY:
ANITA GREEN 212 • 532 • 5083

STUDIO 118 W. 27th ST.
NY NY 212 • 691 • 7612

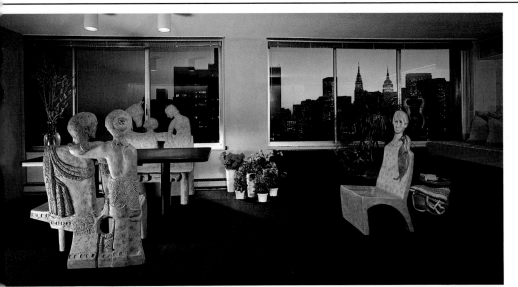

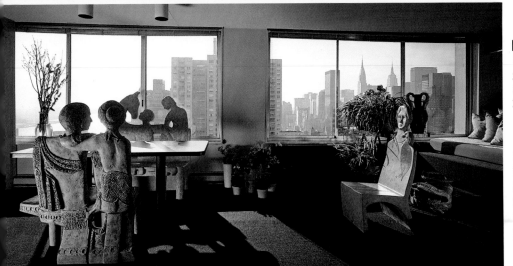

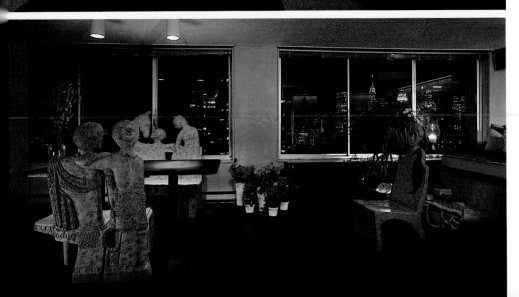

Darwin K. Davidson
32 Bank Street
New York, N.Y. 10014
212/242-0095

Location Photography for:
Advertising
Editorial
Publicity
Catalog

PETER M. LERMAN
37 E 28 ST NYC 10016 (212)685-0053

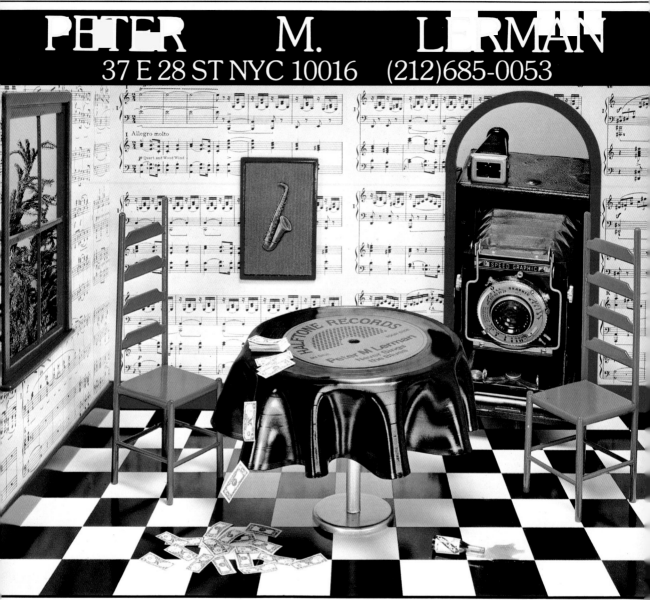

SET CONCEPT AND DESIGN: PETER M. LERMAN SET CONSTRUCTION: RICHARD EGAN, BKLYN., N.Y

©1983 P.M. LERMAN

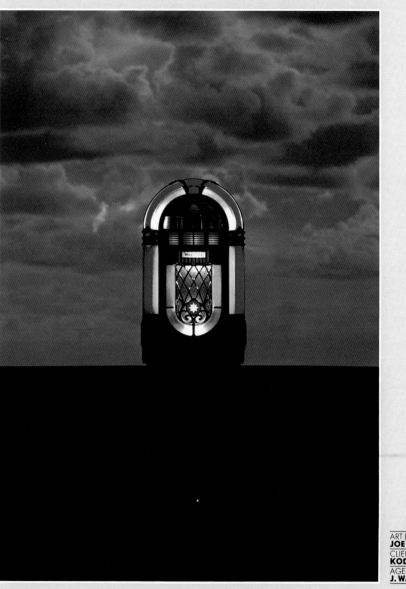

ART DIRECTOR,
JOE SCHICK
CLIENT,
KODAK
AGENCY,
J. WALTER THOMPSON

PETE TURNER
154 WEST 57TH STREET
NEW YORK 10019
(212) 765-1733

Corporate & Industrial
Assignments throughout
North America

Gordon Henderson

10612·172 Street
Edmonton, Alberta
Canada T5S 1H8
403 483·8049

See also 'Black Book' 1983

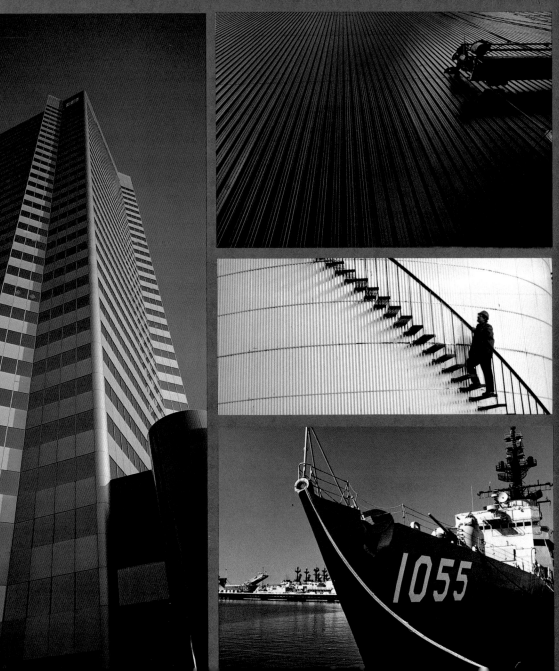

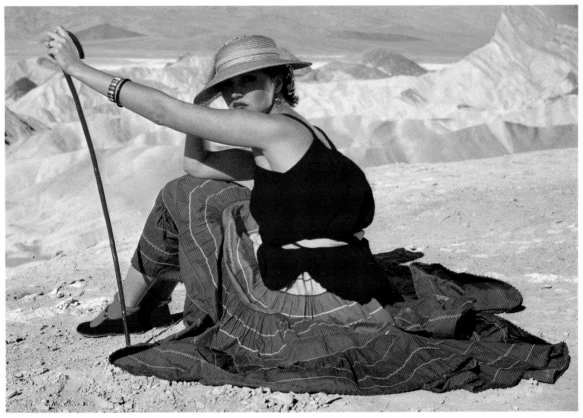

©Helen Macgregor 1983

Helen Macgregor
Fresh Air Photography
60 E 11 St New York NY 10003
212/505 7561
Represented by
Judy Lane/New York
212/861 7225
Represented in Europe by
Julian Seddon/London
01/935 0702

GEOFFREY GOVE

117 WAVERLY PLACE
NEW YORK, N. Y. 10017

(212) 260 - 6051

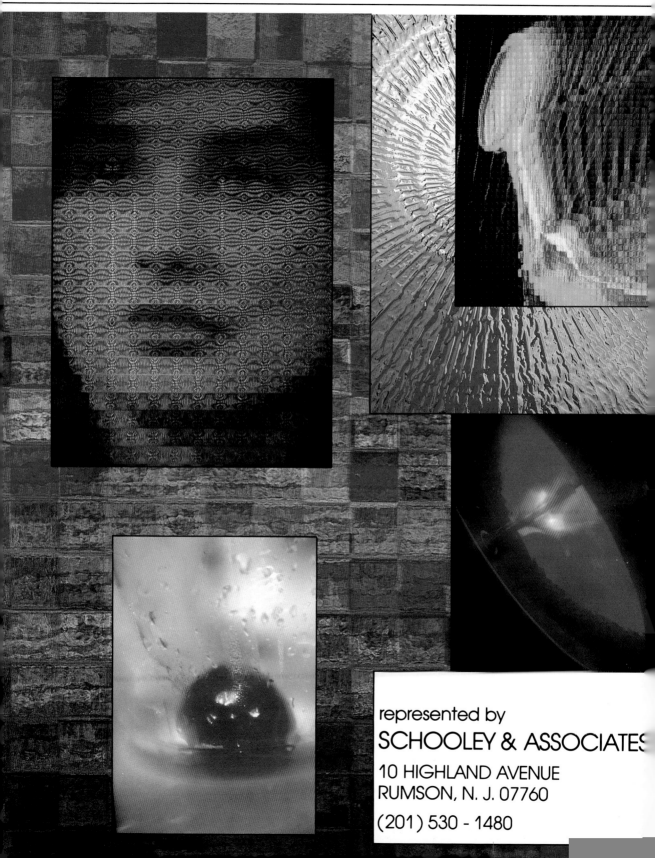

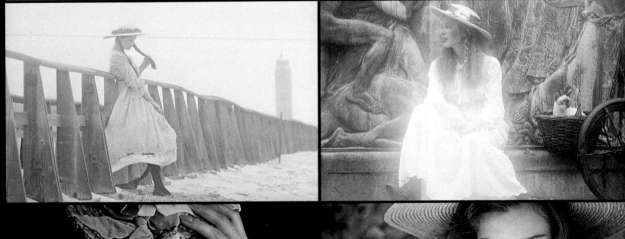

TOSHI OTSUKI
PHOTOGRAPHER
241 West 36 Street New York 10018 (212) 594-1939

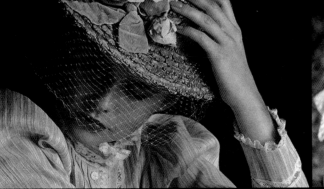

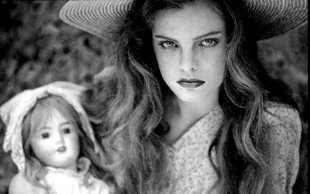

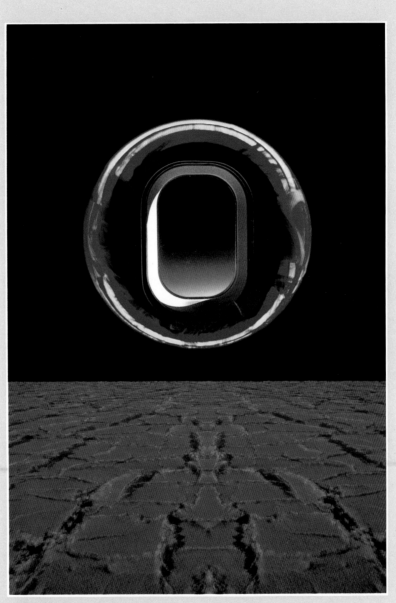

ART DIRECTOR,
BILL FOSTER
CLIENT,
CITIBANK
AGENCY,
FOOTE, CONE & BELDING

PETE TURNER
154 WEST 57TH STREET
NEW YORK 10019
(212) 765-1733

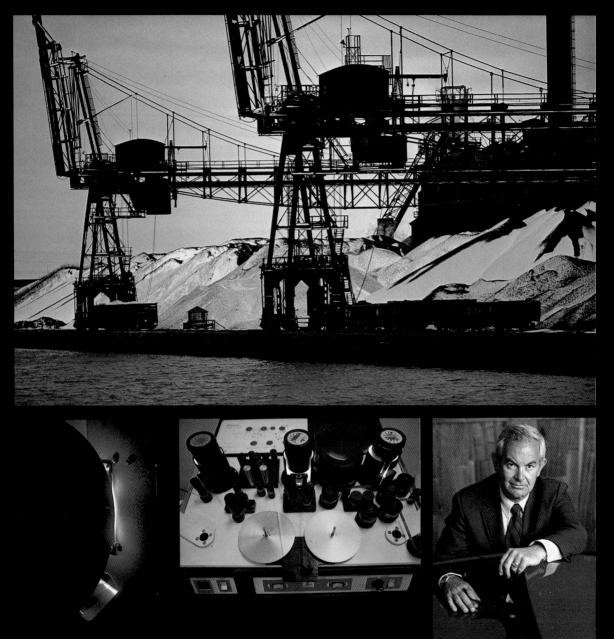

Chuck Slade
70 Irving Place
New York, NY 10003
(212) 673-3516

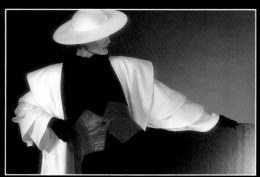

VOGUE

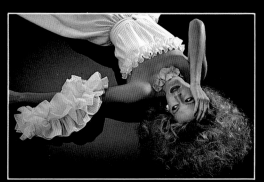

BAZAAR

REPRESENTED BY **ELAINE KORN ASSOCIATES LTD.**
234 FIFTH AVENUE, NEW YORK, NEW YORK 10001 (212) 679-6739 (212) 683-9188

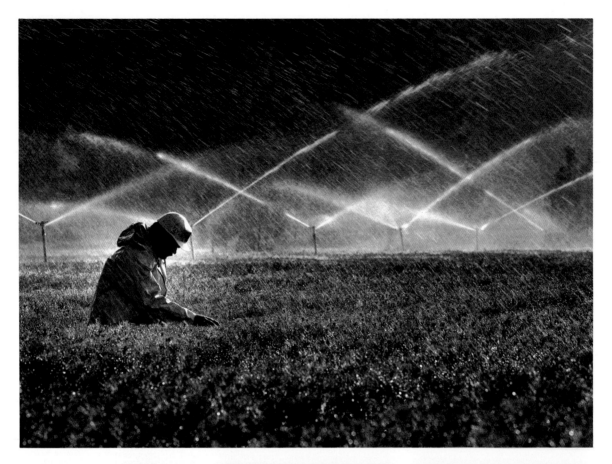

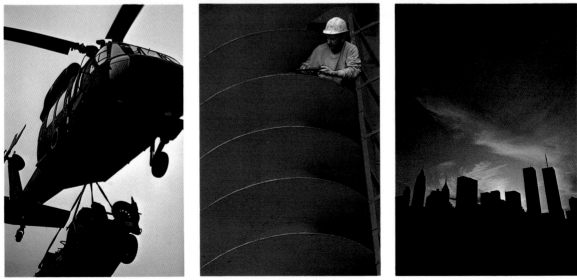

Chris Jones 220 Park Avenue South, 6B New York, NY 10003 Telephone 212 777 5361

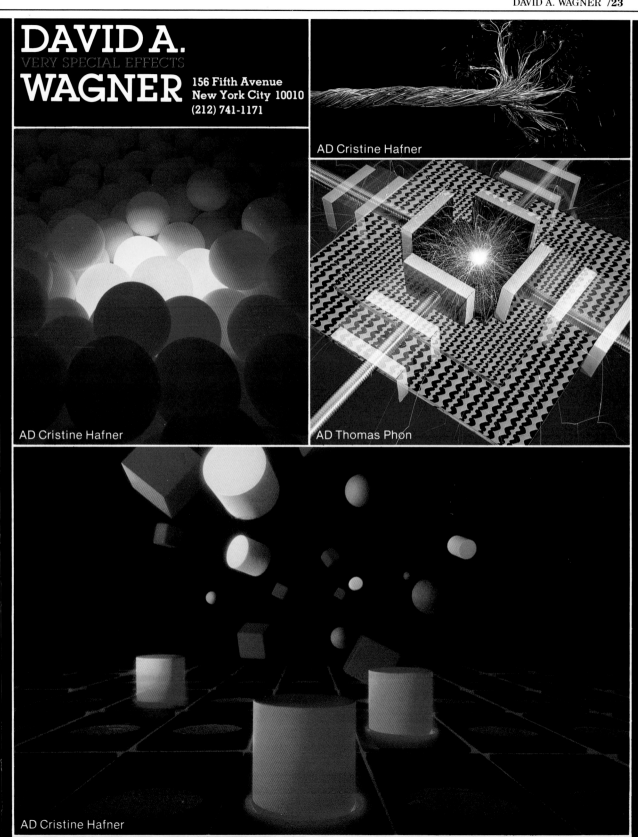

DAVID A.
VERY SPECIAL EFFECTS
WAGNER
156 Fifth Avenue
New York City 10010
(212) 741-1171

AD Cristine Hafner

AD Cristine Hafner

AD Thomas Phon

AD Cristine Hafner

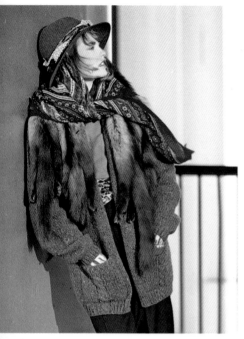

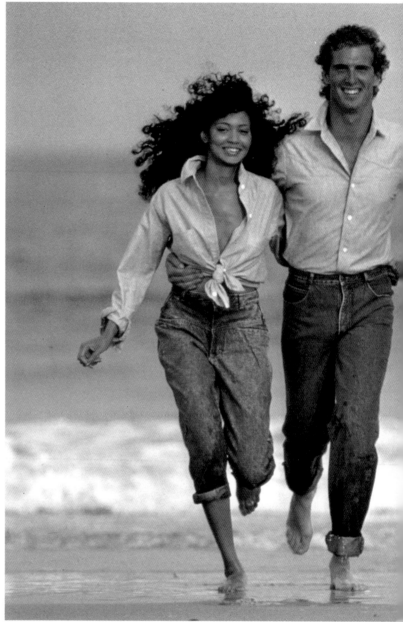

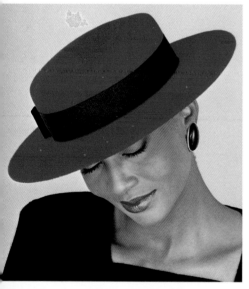

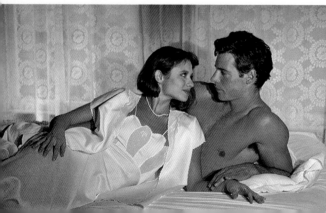

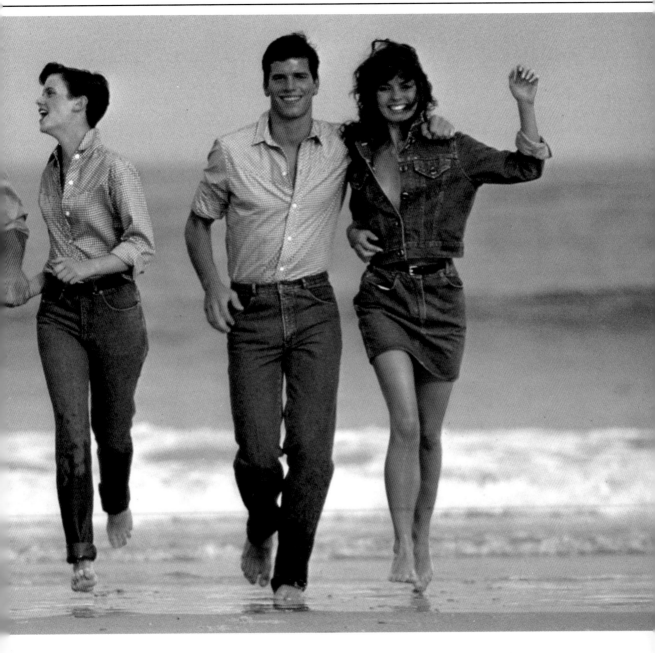

Barry Rosenthal Studio

1155 BROADWAY, NEW YORK, N.Y. 10001

(212) 889-5840

TED KAUFMAN
121 MADISON AVE, NEW YORK, N.Y. 10016 (212) 685-0349

CLIENTS: AUSTIN NICHOLS, BARBER SHIPPING, COLT INDUSTRIES, CONDE NAST, COTY,
DUPONT, E.F. HUTTON, FABERGE, FIELD & STREAM, GABRIEL, GENERAL FOODS,
GOOD HOUSEKEEPING, I.B.M., IN FISHERMAN, JAGUAR, MERRILL LYNCH,

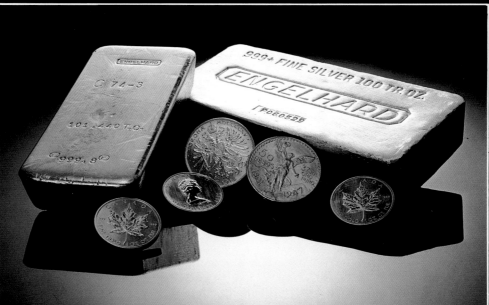

TED KAUFMAN
121 MADISON AVE, NEW YORK, N.Y. 10016 (212) 685-0349

MODERN PHOTOGRAPHY, MOGEN DAVID, MUZAK, NORTH AMERICAN
CRUISE LINES, PENTHOUSE, PRATT & WHITNEY, SEAGRAMS, SELF, SONY, SPORTS
ILLUSTRATED, STP, UNITED ARTISTS, UNITED TECHNOLOGIES.

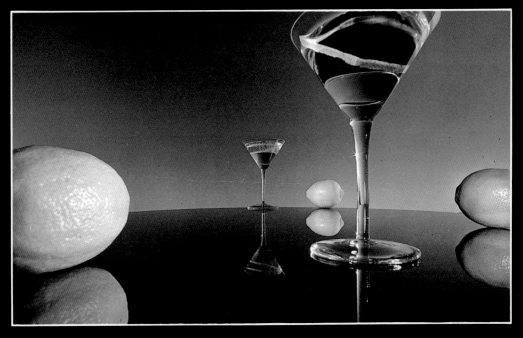

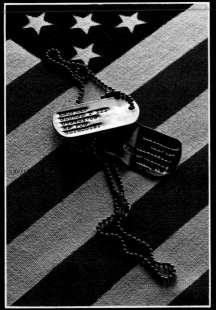

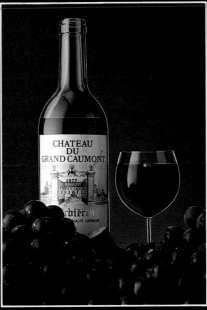

Barry Tenin

P.O. Box 2660
Westport, Ct. 06880
203▪226▪9396

"*Dave, you've done it again.*"

DAVE HAMILTON SHOOTS IN HIS STUDIO OR AROUND THE WORLD. CLIENTS INCLUDE: U.S. ARMY, CBS, DU PONT, HONDA MOTOR COMPANY, HYATT HOTELS, KENTUCKY FRIED CHICKEN, KODAK, WESTINGHOUSE, CUMMINS ENGINES, RAND MC NALLY... STOCK AVAILABLE THROUGH IMAGE BANK.

HAMILTON

47 WALKER STREET/LOFT 2, NEW YORK, NY 10013 212/226-1271

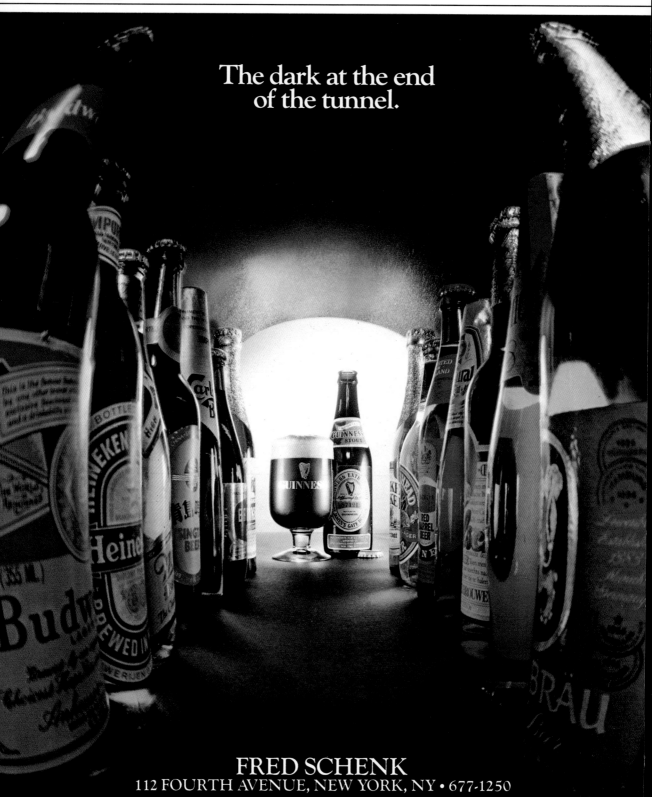

The dark at the end
of the tunnel.

FRED SCHENK
112 FOURTH AVENUE, NEW YORK, NY • 677-1250

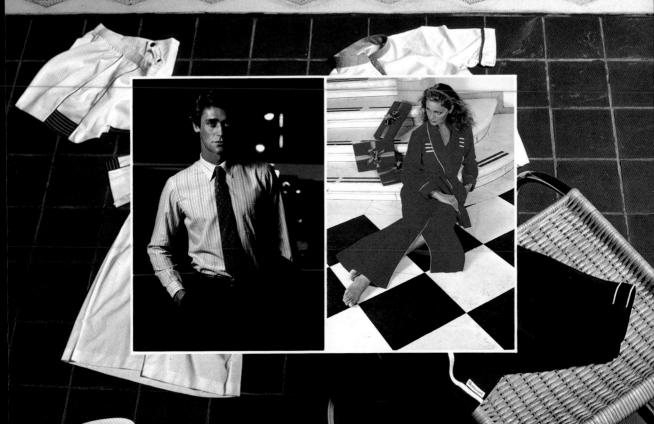

Barbara Sloan-White/Elaine Korn

REPRESENTED BY:

234 Fifth Avenue, New York, N.Y. 10001 • 212-679-6739 212-730-1188 (Service)

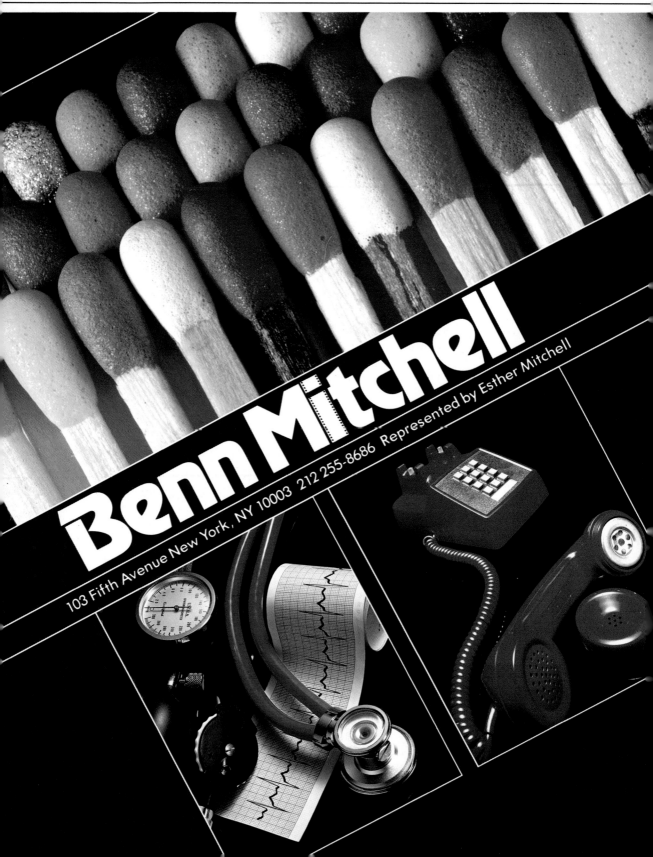

Benn Mitchell

103 Fifth Avenue New York, NY 10003 212 255-8686 Represented by Esther Mitchell

MARK S. WEXLER
CORPORATE/INDUSTRIAL

PHOTOGRAPHY
(212) 595-2153

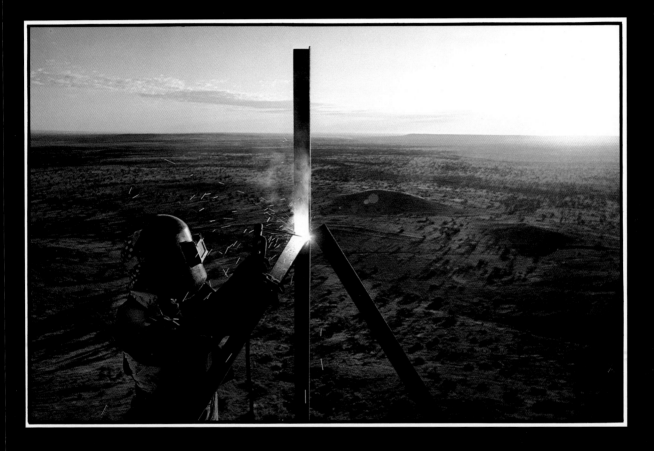

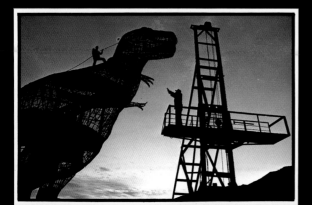

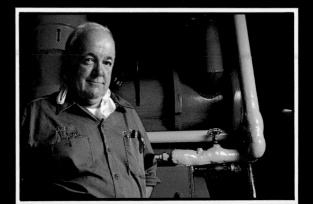

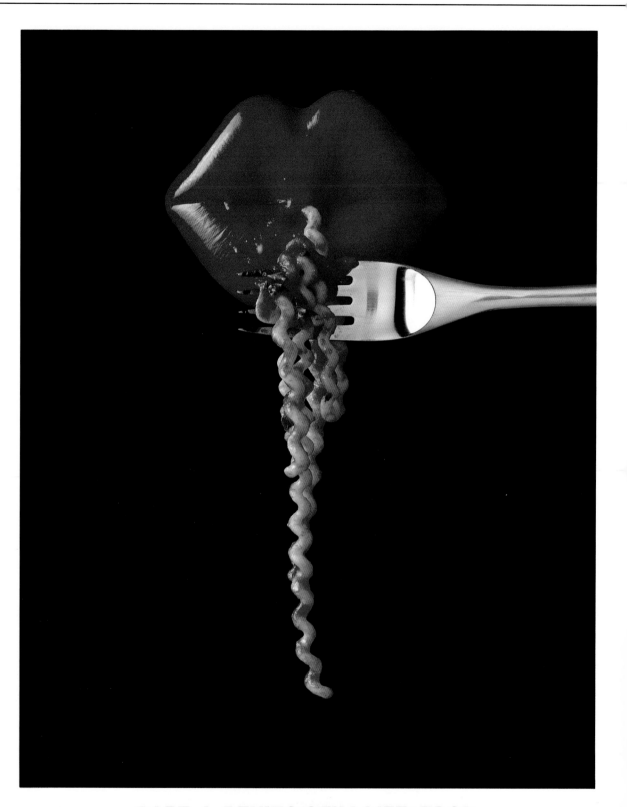

BART J. DEVITO/STILL LIFE•FOOD
43 EAST THIRTIETH STREET, NEW YORK, N.Y. 10016 (212) 889-9670

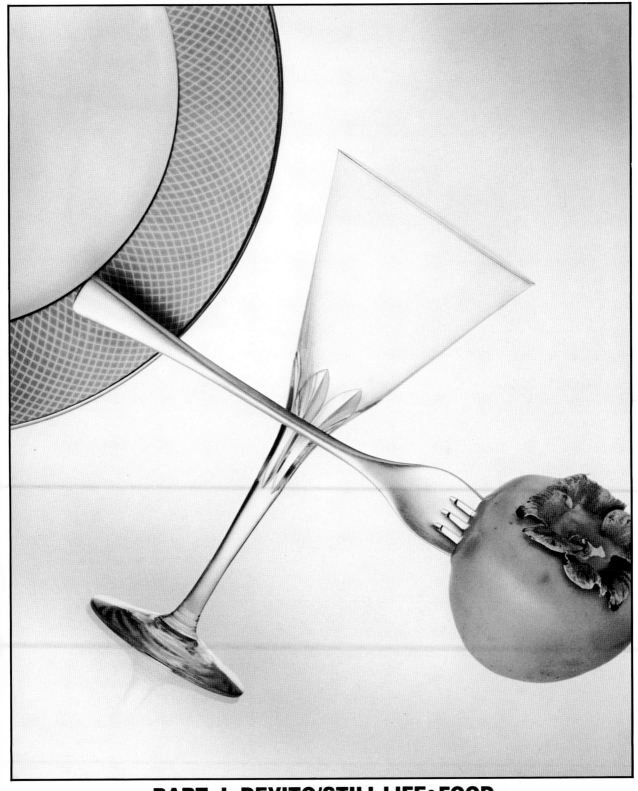

BART J. DEVITO/STILL LIFE•FOOD
43 EAST THIRTIETH STREET, NEW YORK, N.Y. 10016 (212) 889-9670

Dan Nerney

**137 ROWAYTON AVE.
ROWAYTON, CT 06853
203 853 2782**

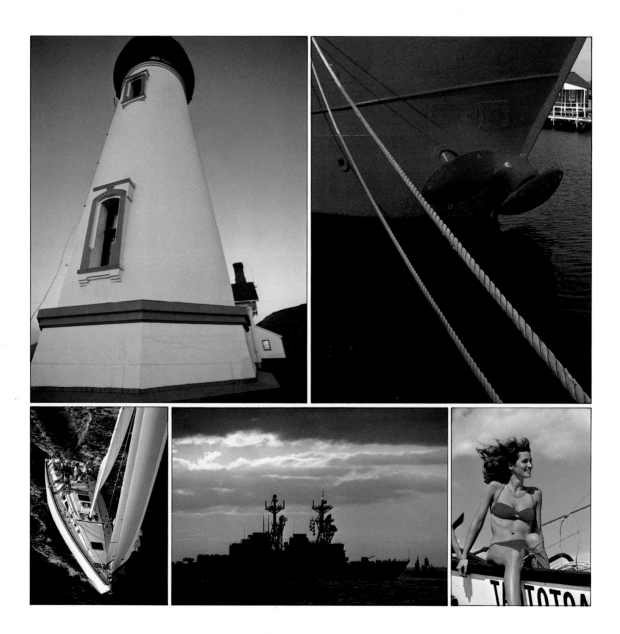

DESIGN : JONSON PEDERSEN HINRICHS & SHAKERY

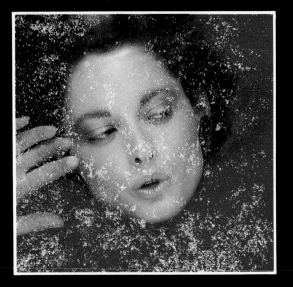

JOHN
FORTE

162 W. 21ST. ST., N.Y.C., N.Y. 10011
212/620-0584

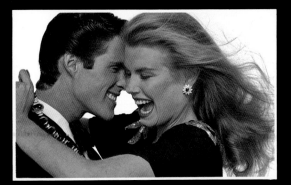

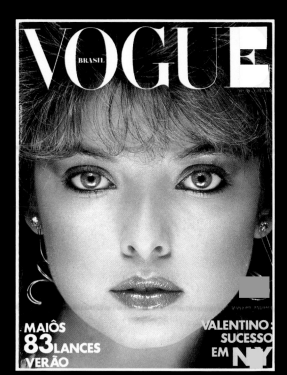

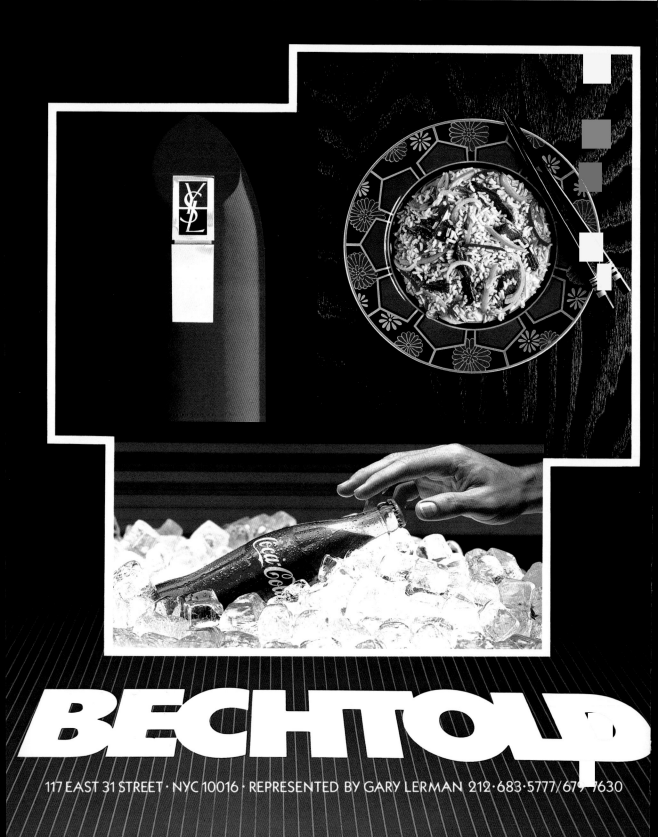

WALTER J. CHOROSZEWSKI

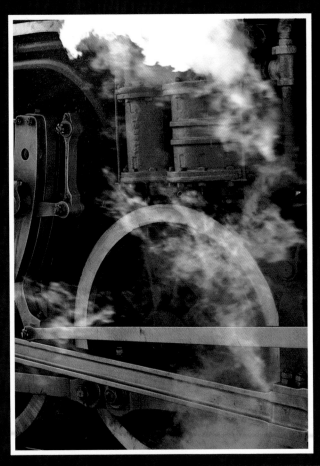

NEW YORK
212 463 5439

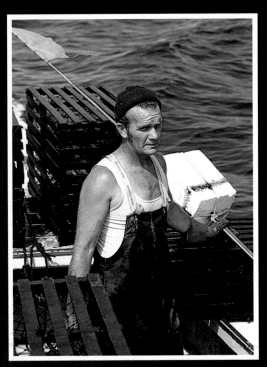

CORPORATE
INDUSTRIAL
& LOCATION
PHOTOGRAPHY

- Annual Reports

- Executive Portraits

- Brochures

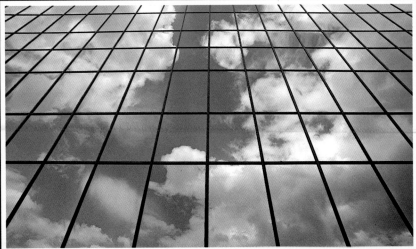

All Photos © 1983 Walter J. Choroszewski (hor•o • shes′ • key)

BOB KISS

**KISS PHOTOGRAPHY INC.
29 EAST 19 STREET,
NEW YORK, N.Y. 10003
(212) 505-6650**

<u>Editorial Clients include</u>:
Interview, Forbes, Essence,
Town & Country

<u>Advertising Clients include</u>:
Seventeen, Babylon, Avon,
Cutex, Gillette, Monet,
Sarah Coventry, Mendocino,
Martin Copeland, J.C. Penney,
Butterick, Playtex, Danskin

© BOB KISS, 1982

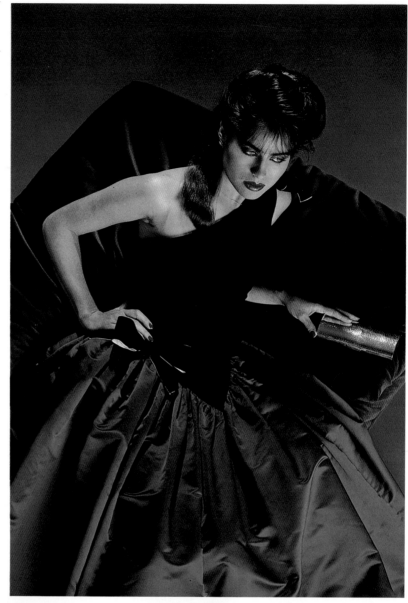

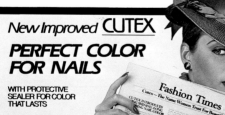

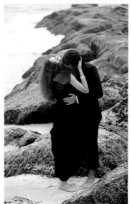

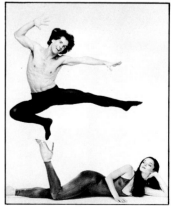

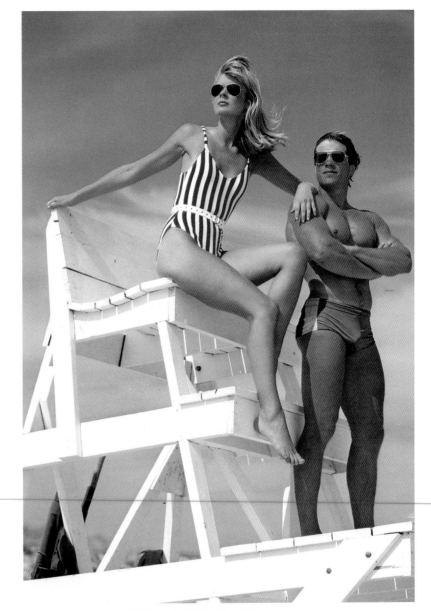

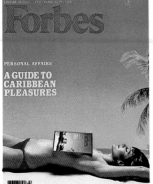

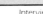

Interview

BRUCE FIELDS
71 Greene St.
New York, 10012
[212]-431-8852
represented by

**JEAN JACQUES
DUBANE**
[212] 807-7457

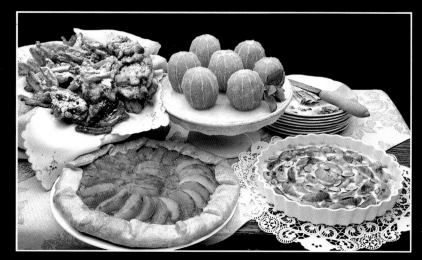

LADIES' HOME JOURNAL

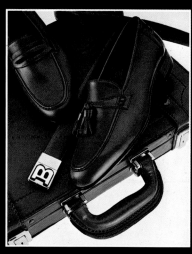

BALLY

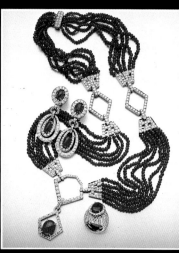

SELF PROMOTION

DAVID WEBB

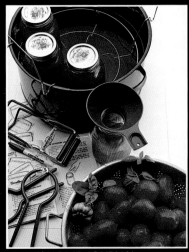

LADIES' HOME JOURNAL

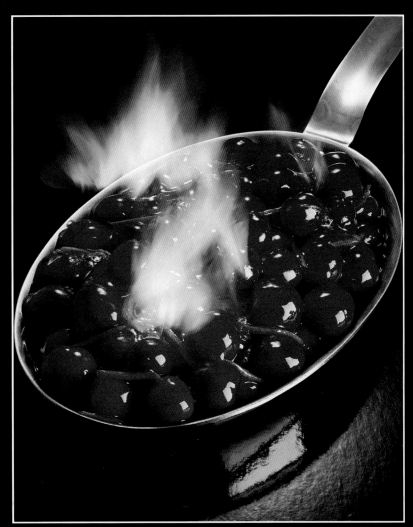

INTERCONTINENTAL HOTELS

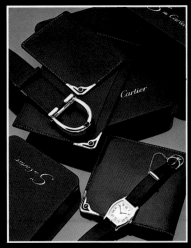

CARTIER

DE MARKOFF

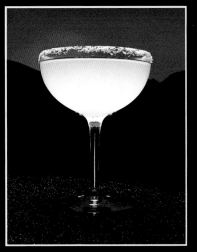

SELF PROMOTION

BRUCE FIELDS
71 Greene St.
New York, 10012
(212) 431 8852
represented by

JEAN JACQUES
DUBANE
(212) 807-7457

BILL CHARLES

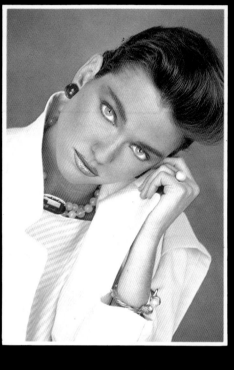
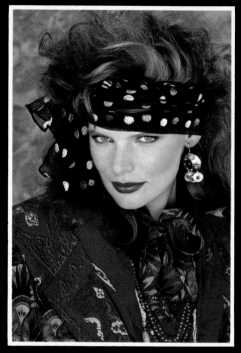
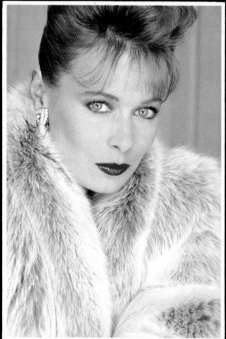
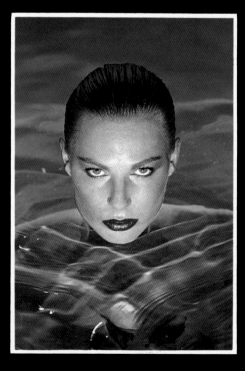

265 West 37 Street, New York, N.Y. 10018 212/719-9156

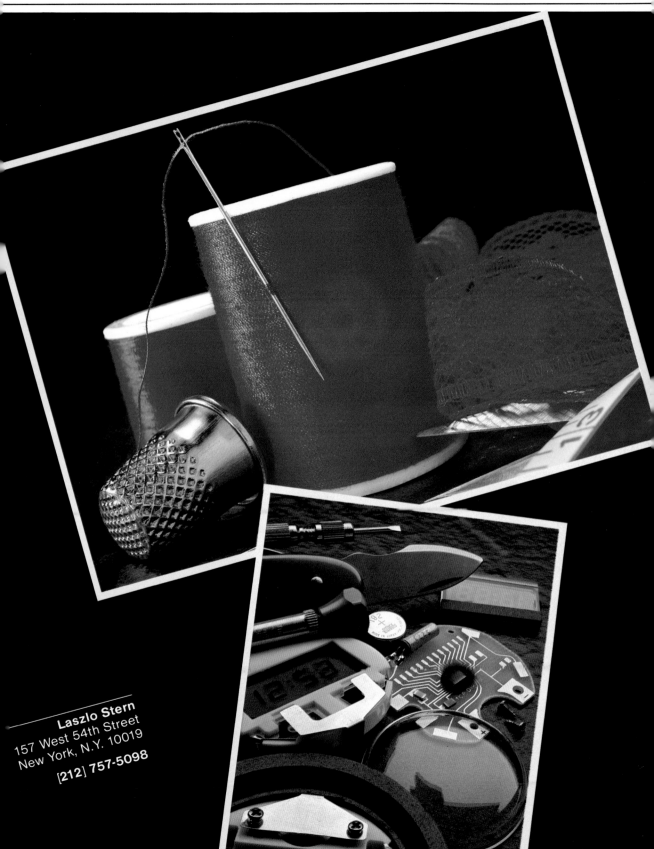

Laszlo Stern
157 West 54th Street
New York, N.Y. 10019
[212] 757-5098

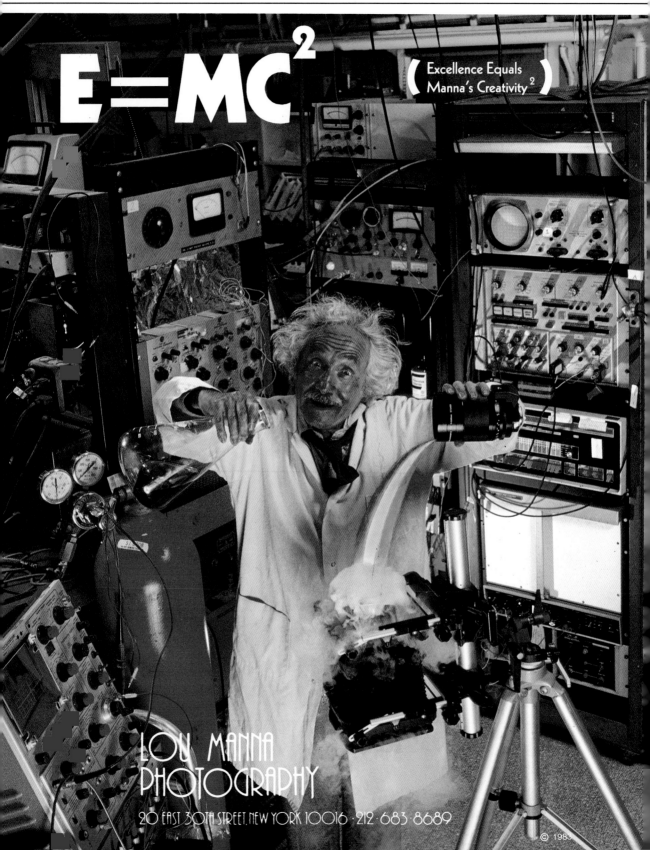

E=MC²

(Excellence Equals
Manna's Creativity²)

LOU MANNA
PHOTOGRAPHY
20 EAST 30TH STREET, NEW YORK 10016 · 212·683·8689

© 1983

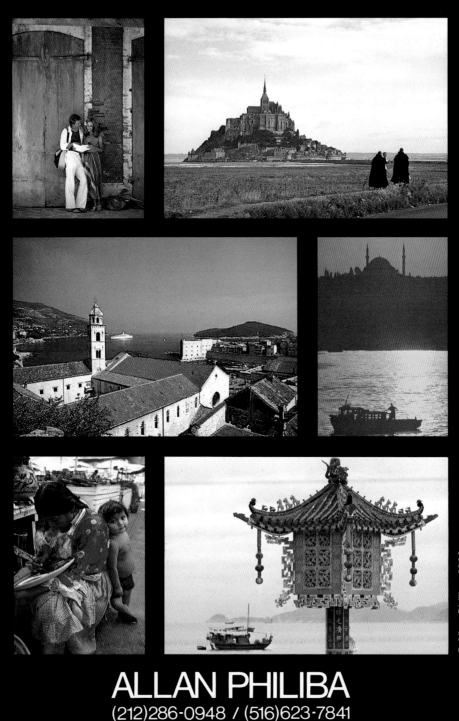

© Allan Philiba–1982

ALLAN PHILIBA
(212)286-0948 / (516)623-7841

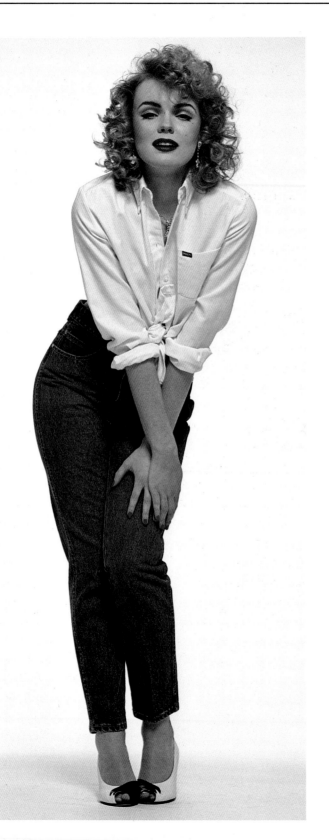

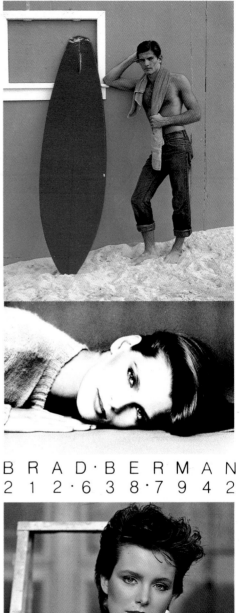

B R A D · B E R M A N
2 1 2 · 6 3 8 · 7 9 4 2

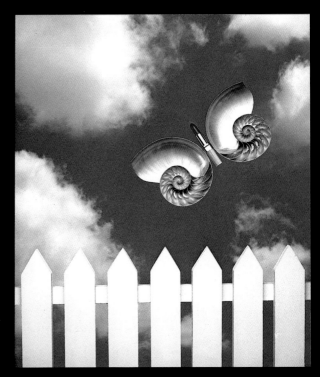

EDWARD RYSINSKI
Tel. (212) 807-7301

636 Avenue of the Americas, N.Y.C. 10011

© E. RYSINSKI, 1982

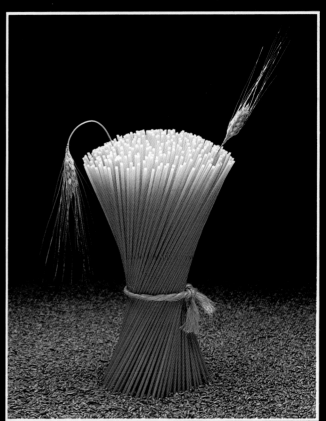

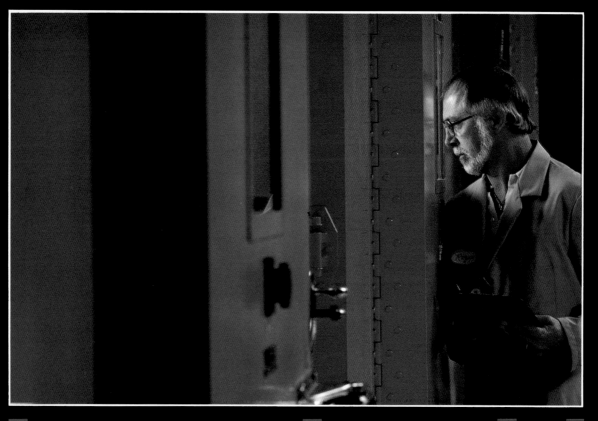

TED KAWALERSKI • 52 SAN GABRIEL DRIVE • ROCHESTER, NEW YORK 14610 • (716) 244-4656

TED KAWALERSKI
52 San Gabriel Drive
Rochester, NY 14610
(716) 244-4656

Location photography
for annual reports
and corporate
advertising.

A partial list of
clients: Bausch &
Lomb, Corning
Glass, Eastman
Kodak, Fortune,
Gannett Co., Inc.,
Louis Harris &
Associates Inc.,
Holiday Inn, Lincoln
First Banks Inc.,
Security New York
State Corporation,
Washington Post
Company, Xerox.

Stock photography:
The Image Bank.

BRUCE MORGAN

photography, inc.

President, L.I. Chapter A.S.M.P.

- Advertising
- Editorial
- Fashion
- Corporate
- Industrial

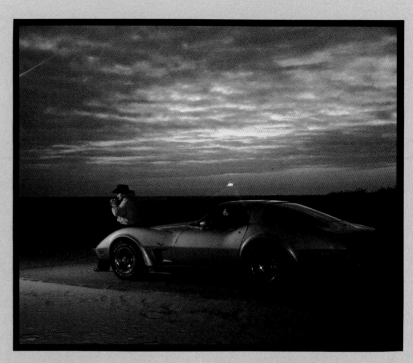

From the Gold Coast to Montauk Point L.I. is rich in its locations:

Take Advantage Of Ours

55 South Grand Ave
Baldwin, N.Y. 11510
(516) 546-3554

©Bruce Morgan, 1983

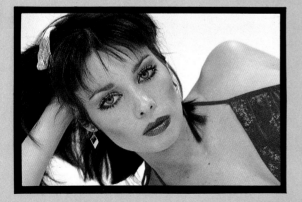

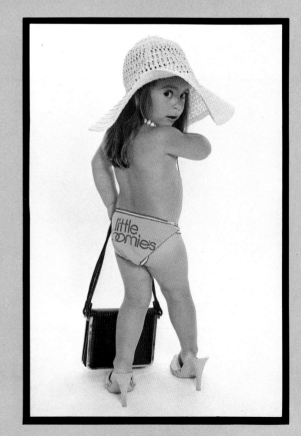

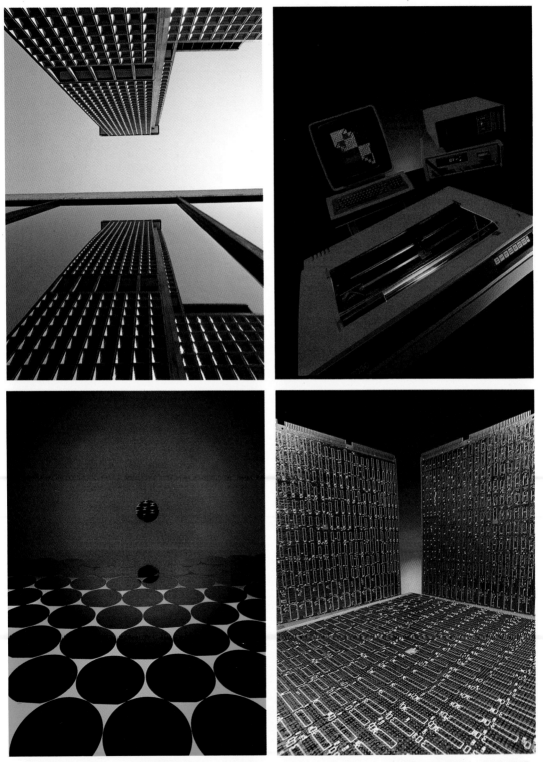

CHARLES J. ORRICO·516/364-2257·212/490-0980

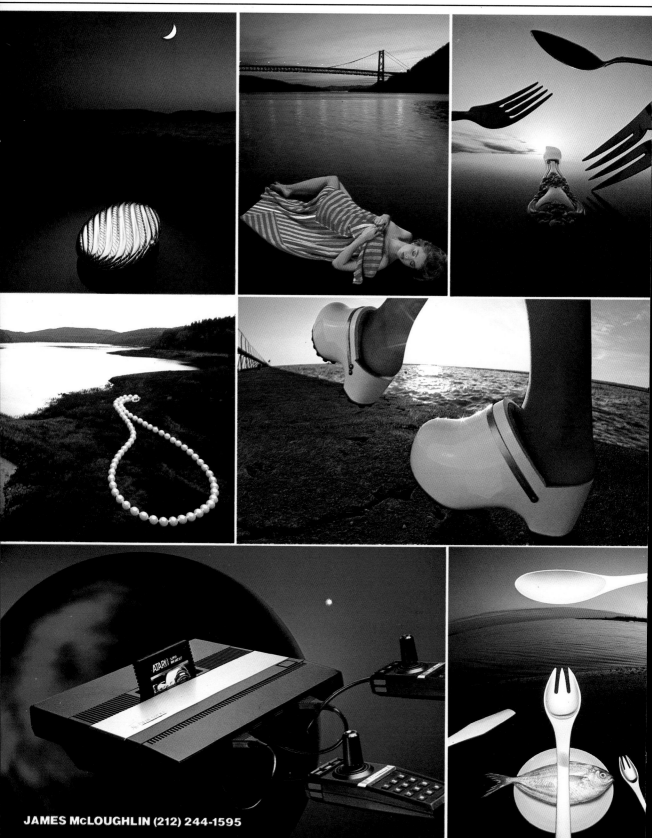

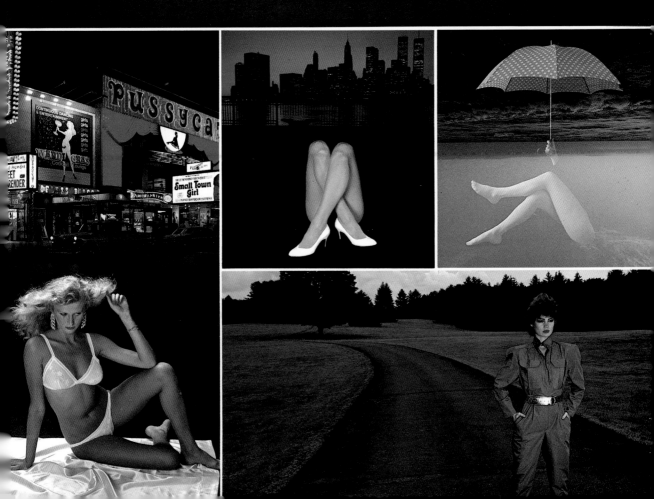

JAMES McLOUGHLIN

REPRESENTED BY JOHN KENNEY
12 WEST 32ND STREET
NEW YORK, N.Y. 10001

(212) 244-1595

© CHARLES KIRK 1983

Charles Kirk Studios, Inc. / 333 Park Ave. So., N.Y., 10010 - 677-3770

SINCE 1897
Dickinson's®

SINCE 1897
Dickinson's

PURE
WILLAMETTE RED RASPBERRY
PRESERVES
INGREDIENTS: WILLAMETTE RED RASPBERRIES, SUGAR,
CORN SYRUP, PECTIN, CITRIC ACID.
K NET WT. 12 OZ. (340)

Purely the finest.

The more
the berrier.

Smucker's introduces new one ounce servings.

We're serving up more Smucker's
goodness...and more happy cus-
tomers.

Because we've doubled our por-
tions. Now we offer a big new one
ounce size of jams and jellies.

And there are five fruit fresh
flavors all U.S.D.A. inspected, la-
beled "U.S. Grade A" and pack-
aged for long life.

Look for strawberry, grape,
boysenberry, seedless blackberry
and orange marmalade with that
good natural Smucker's taste. It's
the taste that says you have good
taste for serving it.

A Smucker's Representative

has a special sample pack for you.
For details fill in the coupon.

Send completed coupon to:
Foodservice Sales, Dept. RI,
The J.M. Smucker Company,
Strawberry Lane, Orrville,
Ohio 44667.

Name _____
Title _____
Company _____
Phone _____
Address _____
City _____ State _____ Zip _____

With a name like Smucker's, it has to be good.

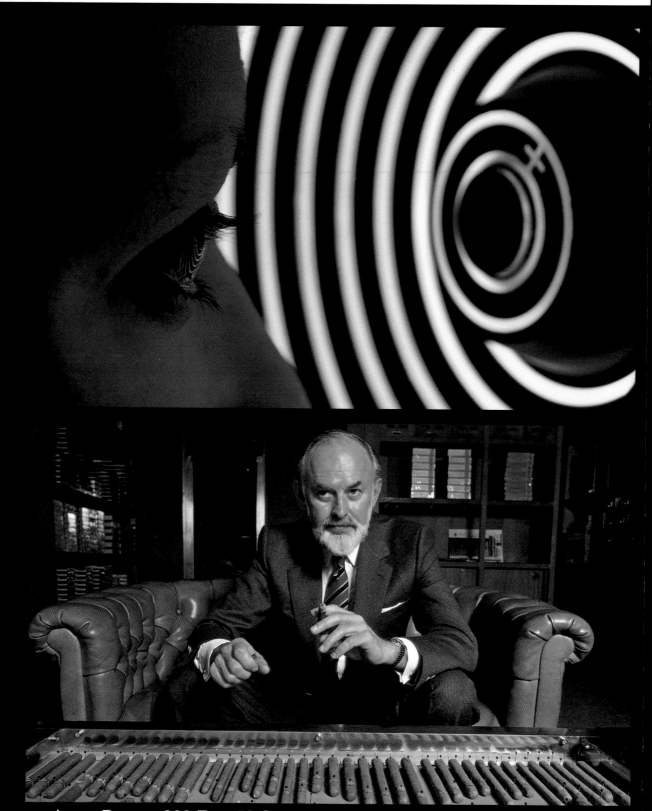

Larry Barns • 200 East 53 Street, New York, N.Y. 10022 • (212)355-1371

Pinckney

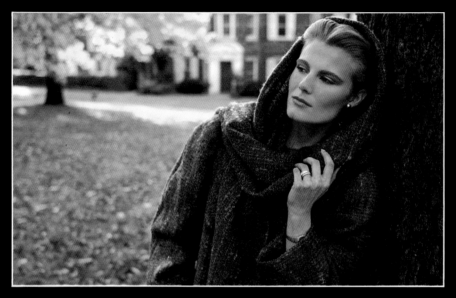

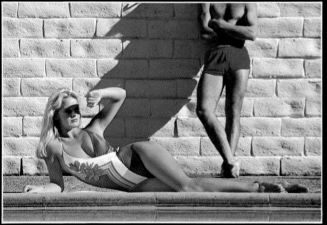

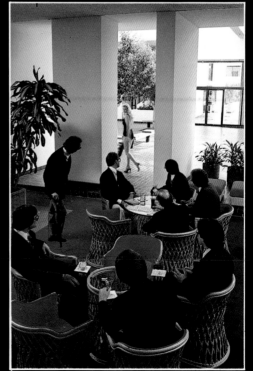

PHOTOGRAPHY / 50 WEST 17TH STREET
NEW YORK, NEW YORK 10011 / (212) 929-2533
CALIFORNIA STUDIO (408) 375-3534

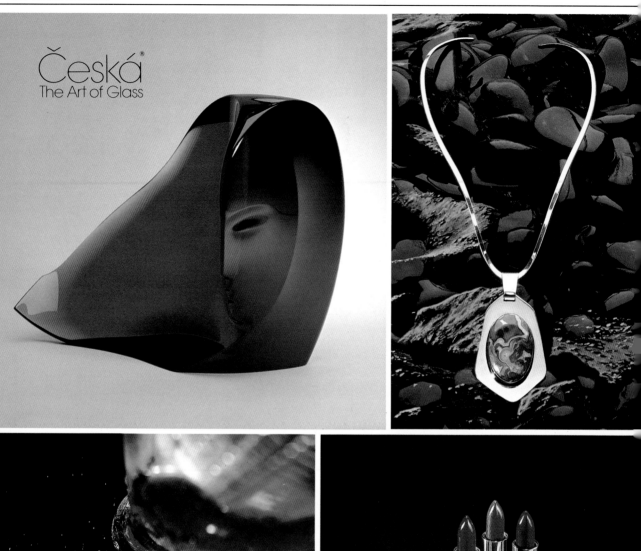

Česká®
The Art of Glass

Louis Mervar
Photography
29 West 38th. Street
New York, N.Y. 10018
(212) 354-8024
Representative:
Susan Moss

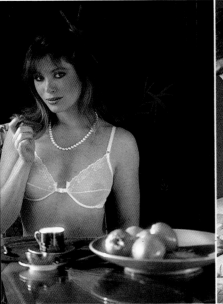

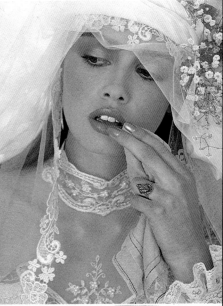

What's under
is as important as
what's over.

The days and nights of being un-
fashionably undressed are no more.
The complete man of fashion just
doesn't overlook his underwear any-
more. Certainly some of his closest
friends don't.

Hom's innovative French designs
and consummately crafted, highest
quality fabrics mean luxurious com-
fort, exciting fit.

Hom is men's fashion underwear,
swimwear, knit shirts and sweaters,
active/leisure Homwear.® Available
at finer stores. Hom Men's Fashions,
350 Fifth Avenue, Suite 6906, New
York, N.Y. 10118.

HOM
For the man.

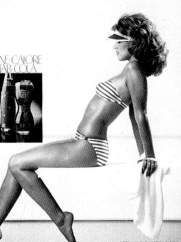

GET IN TAB SHAPE.

ONE CALORIE
TAB COLA

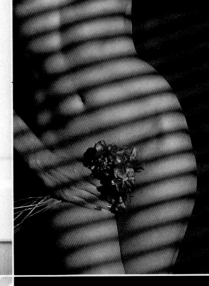

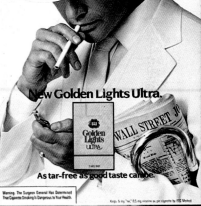

The Ultimate Ultra.

New Golden Lights Ultra.

Golden
Lights
ULTRA

WALL STREET JO

As tar-free as good taste can be.

Warning: The Surgeon General Has Determined
That Cigarette Smoking Is Dangerous to Your Health.

PAT
HILL

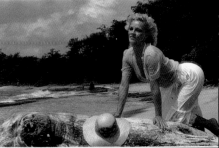

© 1982 PAT HILL

118 E. 28TH STREET • NEW YORK CITY 10016 • (212) 679-0884 532-3479
JAPAN: IMPERIAL PRESS (813) 585-2721 585-2562
CABLE: IMPERIAL PRESS TOKYO

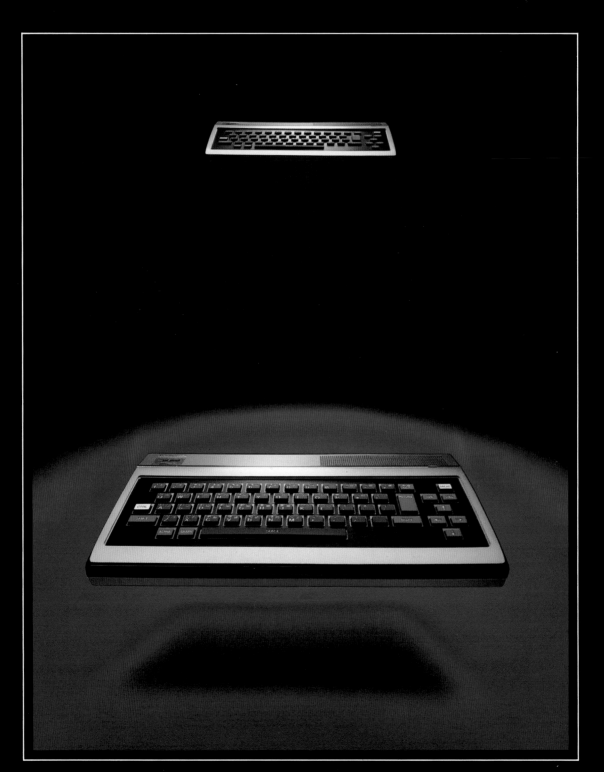

HASHI STUDIO INC · 49 WEST 23 ST · N.Y.C. 1OO1O · (212) 675-69O2 · REPRESENTED BY KEN MANN (212) 245-3192

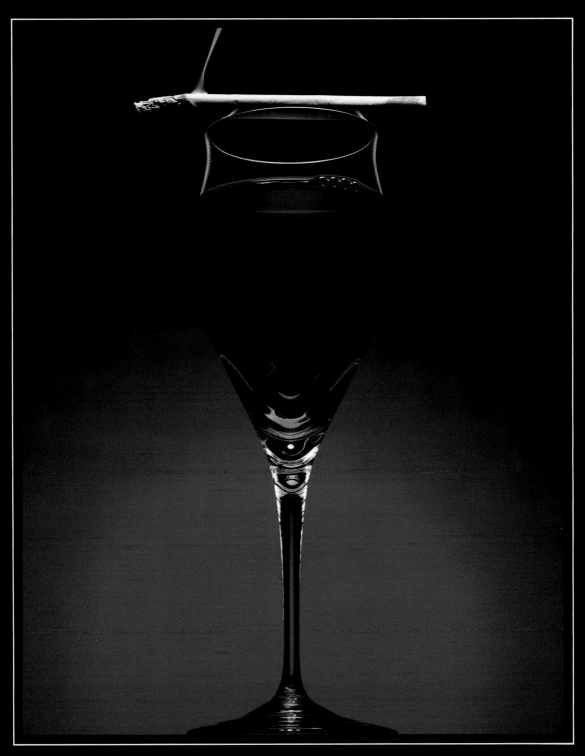

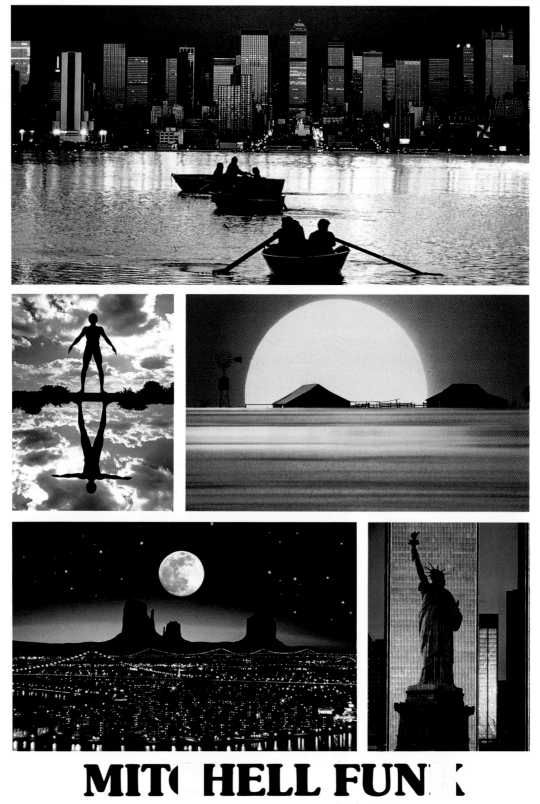

MITCHELL FUNK

500 East 77th Street· New York, N.Y. 10162· (212) 988-2886

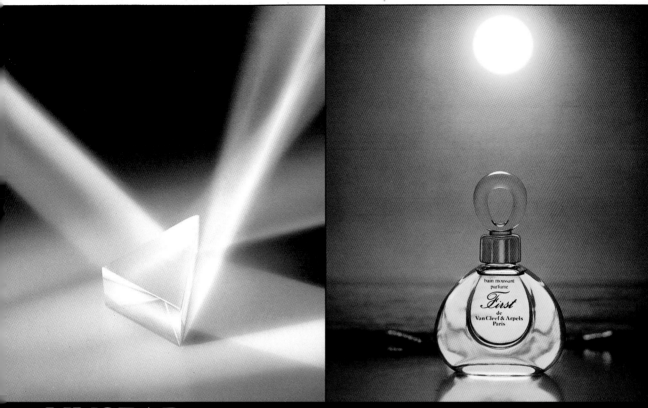

HUSZAR

156 Fifth Avenue, New York, N.Y. 10010 · (212) 929-2593

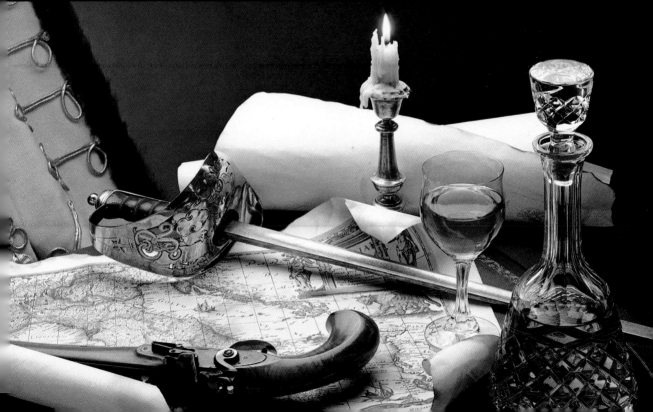

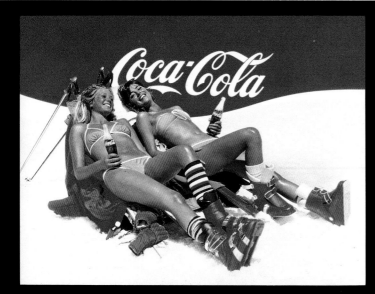

LEW LONG
3 RUSTON MEWS LONDON W11
LONDON 229 9415

American-based in London. Extensive experience shooting throughout Europe, South America and Africa. Collection of stock photo's available from Image Bank.

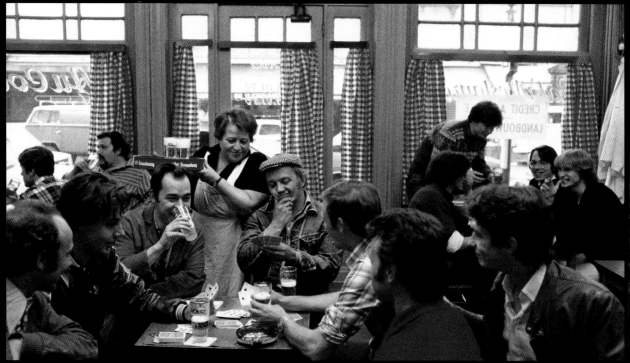

Kronenbourg

Young & Rubicam

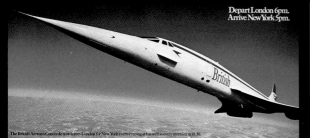

Depart London 6pm.
Arrive New York 5pm.

**BARCLAYS BANK HELPS
DE HAVILLAND OF CANADA
DELIVER IN THE MIDDLE EAST**

LEVI'S

"TALK AS YOU WALK"

"They are more into details than other airlines"

Lufthansa

The British Airways Concorde now leaves London for New York every evening at 6 as well as every morning at 10.30.

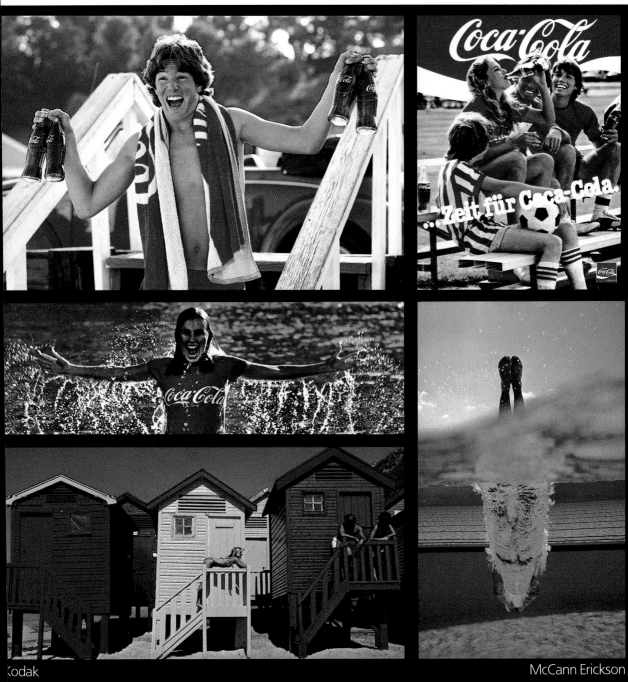

Kodak

McCann Erickson

Have a Coke and a smile.

**Margot Conte
165 Old Mamaroneck Road
White Plains, N.Y. 10605
(914) 997-1322**

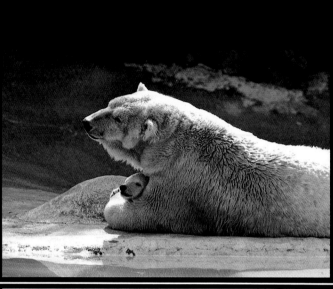

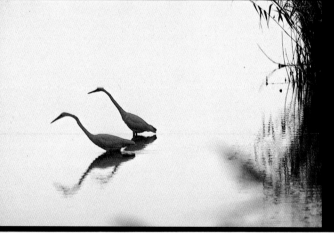

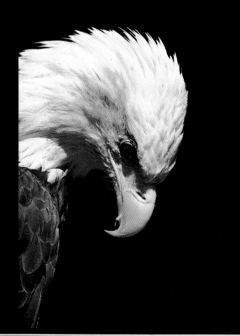

**Wildlife, Birds, Nature
& Special Assignments.**

Stock: Animals Animals

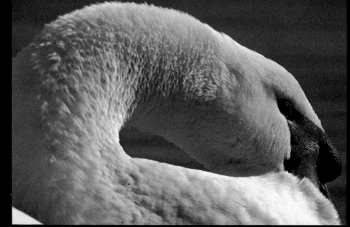

Bonnie**West**

156 Fifth Avenue
New York NY 10010
(212) 929-3338

Fashion Still Life Portraiture

Erika Stone

Specializing in babies, children, families. Other subjects:
New York, documentary, travel. Large stock file in color, black and white.

Erika Stone, 327 East 82 Street, New York, N.Y. 10028
(212) 737-6435

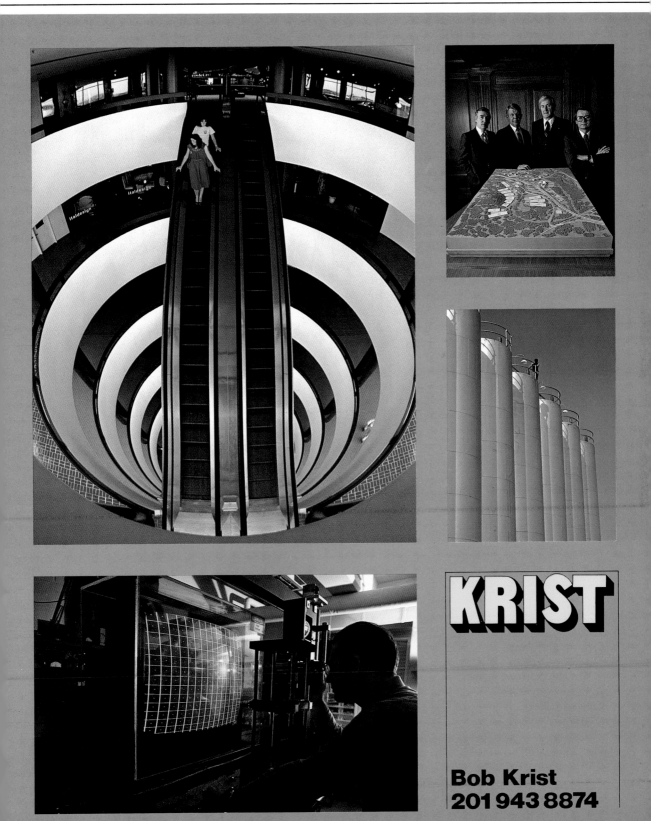

KRIST

Bob Krist
201 943 8874

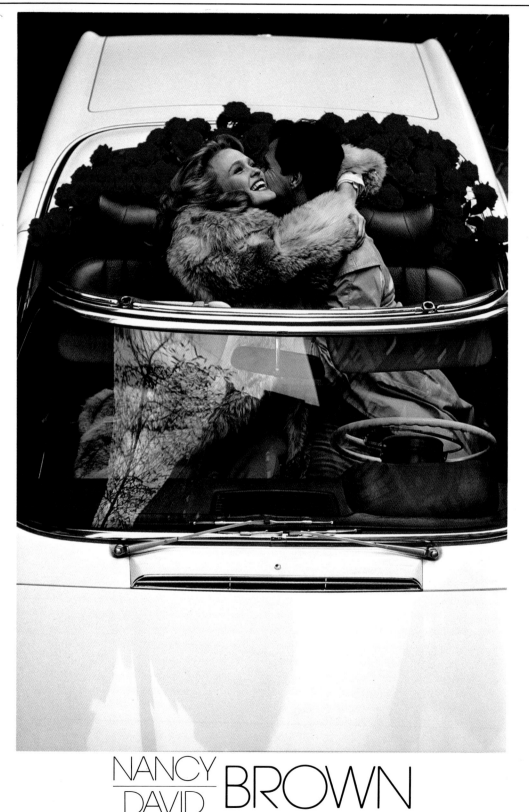

NANCY
─────── BROWN
DAVID

6 W. 20 St., New York, NY 10011, (212) 675-8067

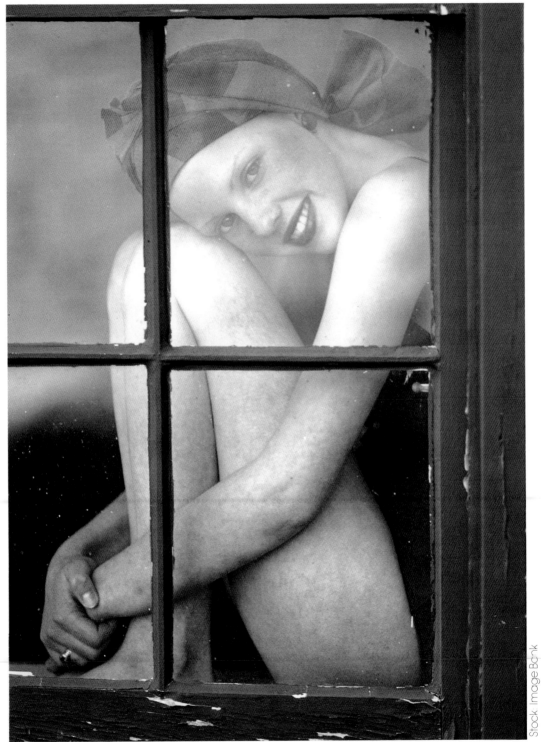

Stock Image Bank

More of our work can be seen in '83 Black Book,
American Showcase, ADIP, Japan Commercial Photo.

Representative: Brinker Benedict (212) 675-8067
Representative for assignment only in Japan:
Dave Jampel (03) 585-2562

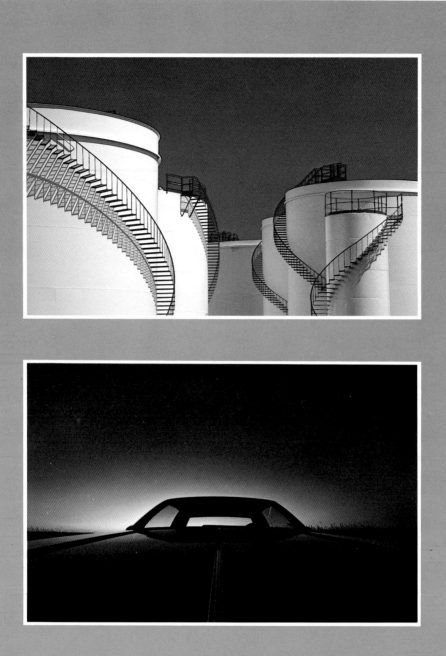

STEVE KRONGARD

212A EAST 26TH STREET NEW YORK CITY 10010 212-689-5634

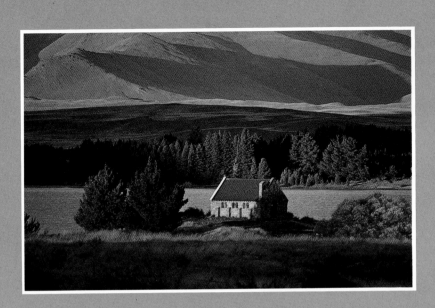

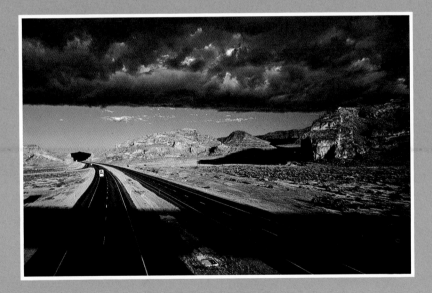

STEVE KRONGARD

212A EAST 26TH STREET NEW YORK CITY 10010 212-689-5634

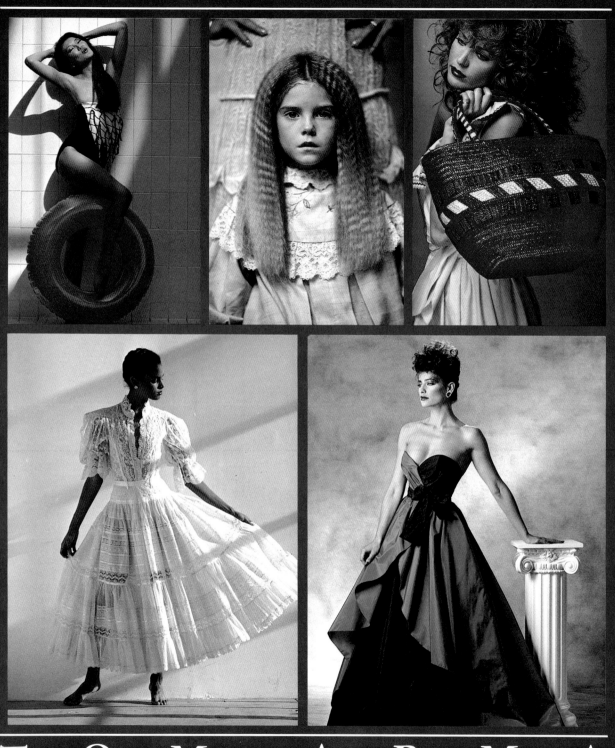

T O M A R M A

Design: Karen Copeland

JONATHAN
TAYLOR photography
incorporated
741-2805

5 WEST 20 STREET
NEW YORK 10011

ROY SCHNEIDER

116 LEXINGTON AVENUE

NEW YORK, N.Y. 10016

212/686-5814

Represented by LYN SCHNEIDER

ALICIA LANDON—CELANESE WORLD

DON SERSEN—T. FERGUSON

JIM HANDLOSER—DELLA FEMINA, TRAVISANO

REO KANOGAWA—N.W. AYER

JIM BURTON—YOUNG & RUBICAM

PAPADOPOLOUS

PETER PAPADOPOLOUS 78 FIFTH AVENUE NEW YORK 10011· (212) 675-8830

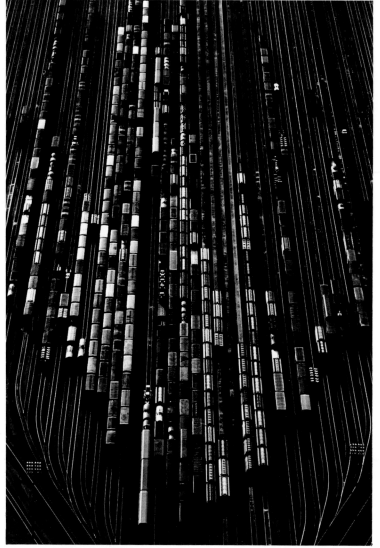

Union Pacific Switch Yard
North Platte, Nebraska

Raytheon Corporation

Flying Magazine

"Nothing By Chance"
Hugh Downs Productions

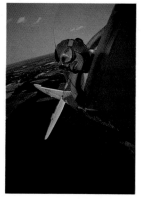

Air & Space Museum
Smithsonian Institution

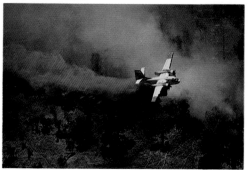

Russell Munson

6 East 39th Street
New York
New York 10016
Telephone:
(212) 689-7672

**Photography
From the Air**

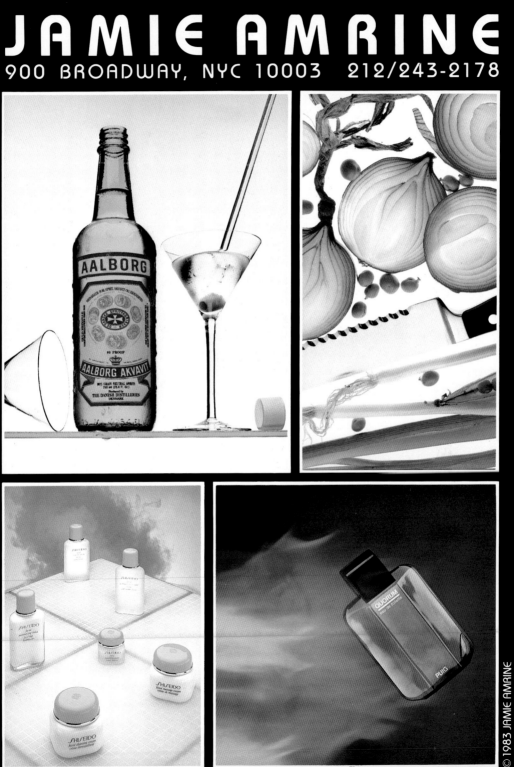

JAMIE AMRINE
900 BROADWAY, NYC 10003 212/243-2178

Finely-spun
strands of Shetland
wool form a warm and
lightweight sweater
when combined
together for color-
patterned knitting.

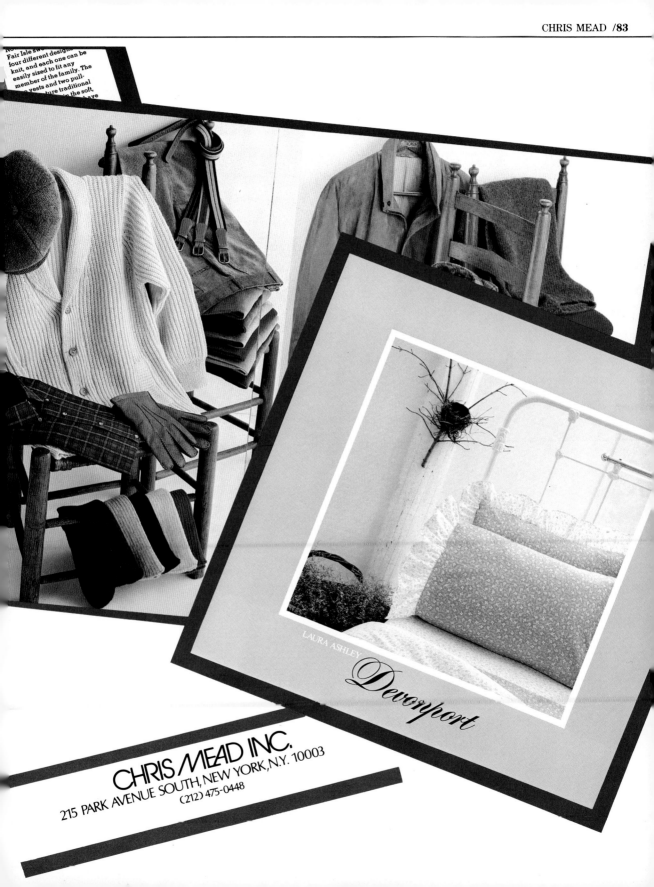

S T U P A K O F F

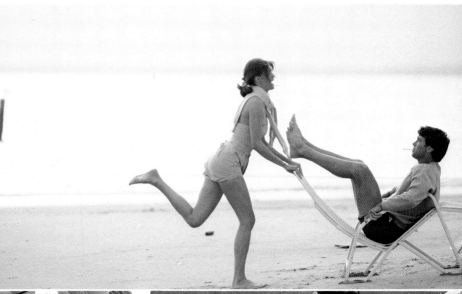

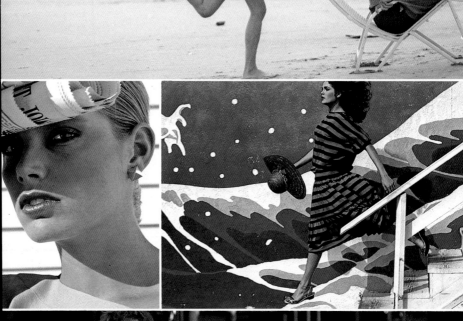

Otto Stupakoff
is represented by
Don Stogo
(212) 490-1034

©1982 Otto Stupakoff

AMBROSE

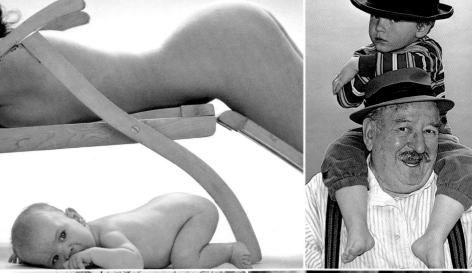
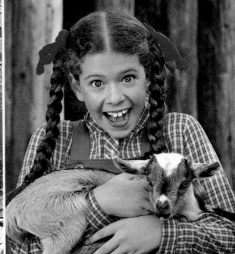
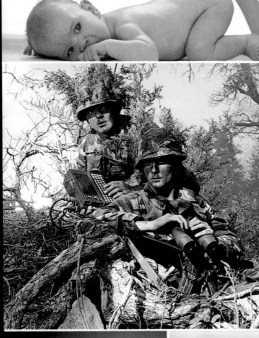
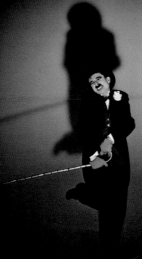
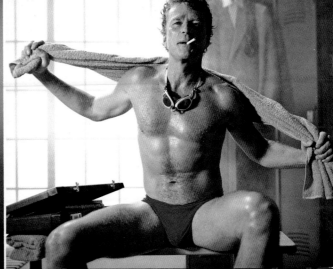

Ken Ambrose
represented by
Don Stogo
(212) 490-1034

©1982 Ken Ambrose

ROBERT COLTON

Robert Colton Studio, Inc.
1700 York Avenue
New York, NY 10028
212 831-3953
Service: 212 581-6470

Award-winning photography for
major clients including
Alcoa, Champion International,
IBM, The New York Times
Company, Beau Gardner Associates,
and Danne & Blackburn.

© 1983 Robert Colton

Award-winning photography for major clients including Louisiana Land and Exploration Company, Ciba-Geigy, RCA, Singer, Gips + Balkind, and Arnold Saks.

ROBERT COLTON

Robert Colton Studio, Inc.
1700 York Avenue
New York, NY 10028
212 831-3953
Service: 212 581-6470

The great put-on

What's the secret of a better burger? Some say it's
what you put *in* it. Others say it's what you put
on it. We say it's both: Ground beef done
to juicy just-rightness, heaped high
with a choice of fixings that really lets
you have it your way. Results: Super,
burgers-to-stay, better than you ever
tasted you-know-where, at a fraction of
those fast-food prices. And that's no put-on.
For foolproof cooking tips—broil, pan-fry and grill
—plus recipes and menu suggestions, see page 125.
By Sue B. Huffman, Food and Equipment Editor.

or how to build a better burger

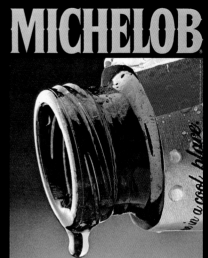

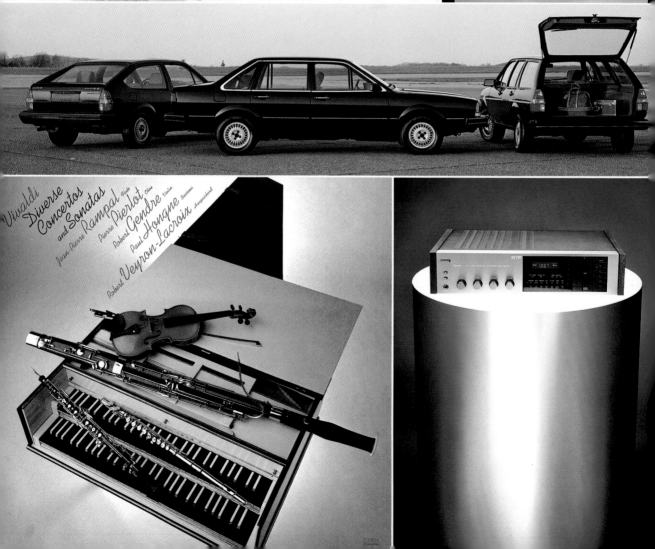

Vivaldi
Diverse
Concertos
and Sonatas
Jean-Pierre Rampal *Flute*
Pierre Pierlot *Oboe*
Robert Gendre *Violin*
Paul Hongne *Bassoon*
Robert Veyron-Lacroix *Harpsichord*

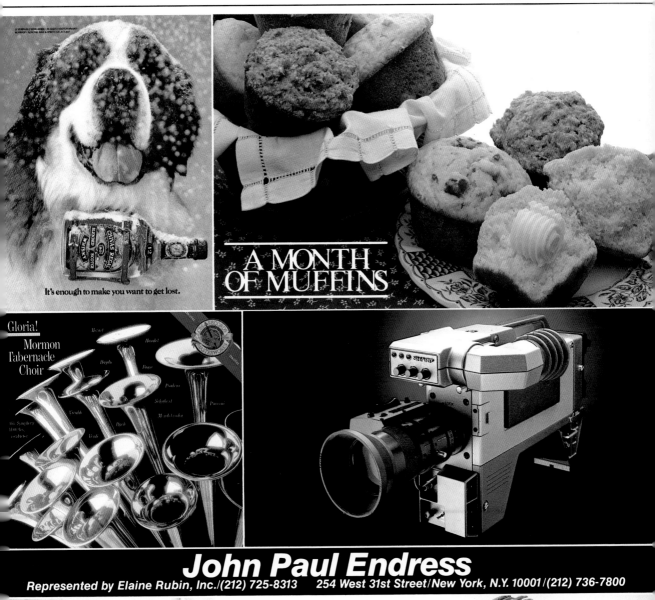

It's enough to make you want to get lost.

A MONTH
OF MUFFINS

Gloria!
Mormon
Tabernacle
Choir

John Paul Endress

Represented by Elaine Rubin, Inc./(212) 725-8313 254 West 31st Street/New York, N.Y. 10001/(212) 736-7800

If you forgot what you ate
on your last flight to Europe,
you're ready for
the Finnish experience.

The
Elegant
Artichoke

BY JAN WEIMER
Photographed by John Paul Endress

Excerpts from ABC's Emmy award winning daytime program `FYI´

GILBERT ORTIZ

Photography 249 West 29th St. New York, N.Y. 10001 212 736·8770

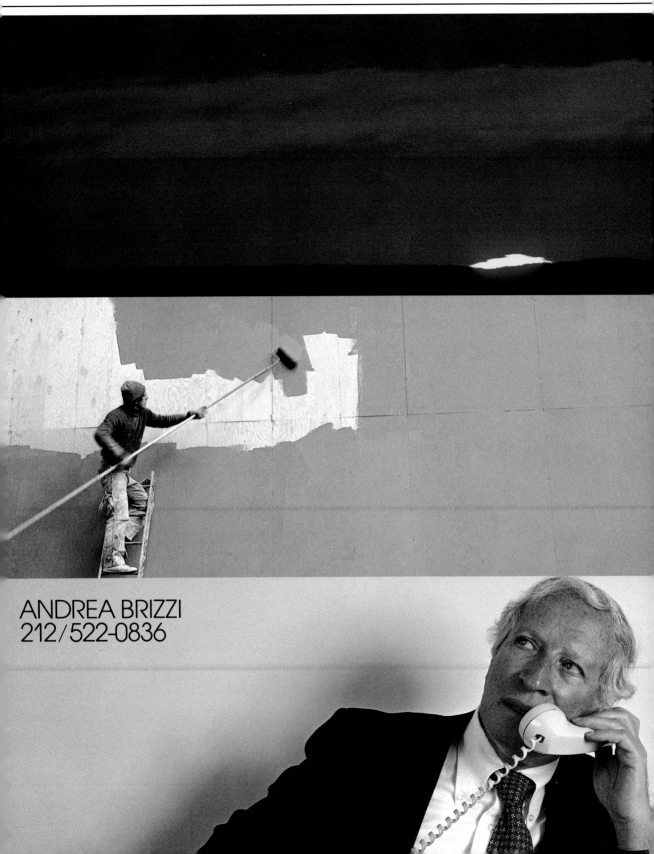

ANDREA BRIZZI
212 / 522-0836

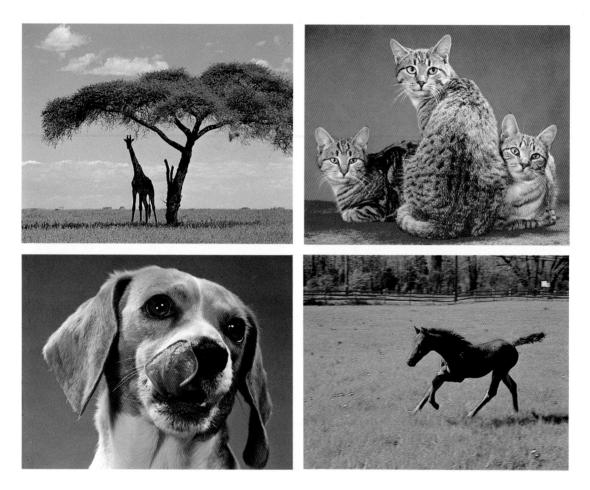

WALTER CHANDOHA

©Walter Chandoha 1983

CATS • DOGS • HORSES • FARM & AFRICAN ANIMALS
GARDENS & GARDENING • VEGETABLES & FRUITS • HERBS • BERRIES • GRAINS
WILD & DOMESTIC FLOWERS • ECONOMIC & DECORATIVE PLANTS
SHRUBS • TREES • LEAVES • THE FOUR SEASONS • SUNS • SCENICS • SKIES
WEATHER & ENVIRONMENT • POLLUTION • CONSERVATION

Over One Hundred Thousand
ANIMAL • HORTICULTURE • NATURE
STOCK PHOTOGRAPHS

WALTER CHANDOHA • ANNANDALE, NJ 08801 • 201-782-3666

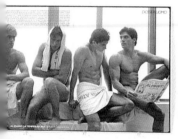

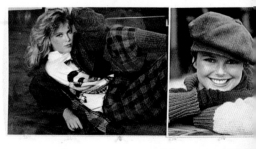

BILL CONNORS
310 EAST 46TH STREET
NEW YORK, NEW YORK
10017

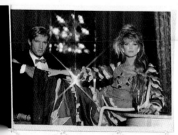

Represented by Sue Mosel (212) 599-1806

COGGIN

64 West 21 Street, New York, New York
212-929 6262

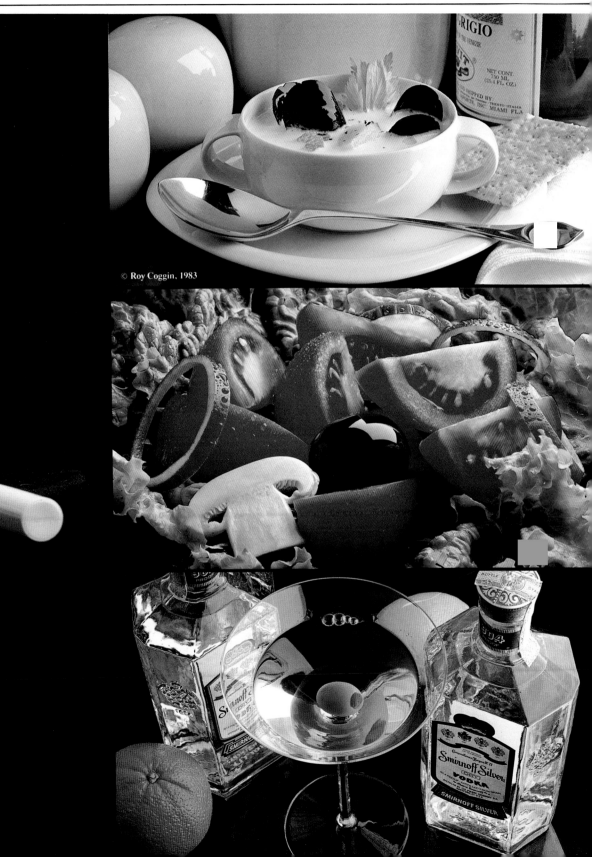

© Roy Coggin, 1983

KELLNER

JEFF KELLNER · PHOTOGRAPHY · 16 WAVERLY PLACE, NEW YORK, NY 10003 212-475-3719

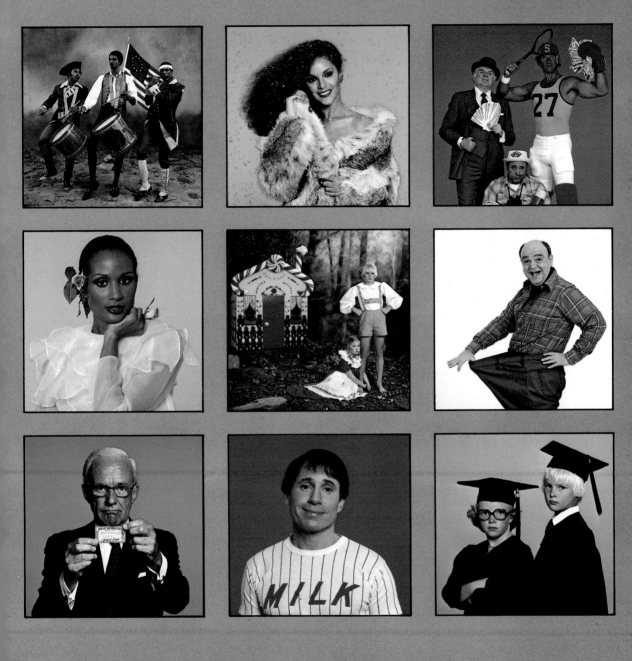

RAEANNE RUBENSTEIN
P O R T R A I T / I L L U S T R A T I O N
8 Thomas Street, New York, N.Y. 10007 Tel: 212·964·8426

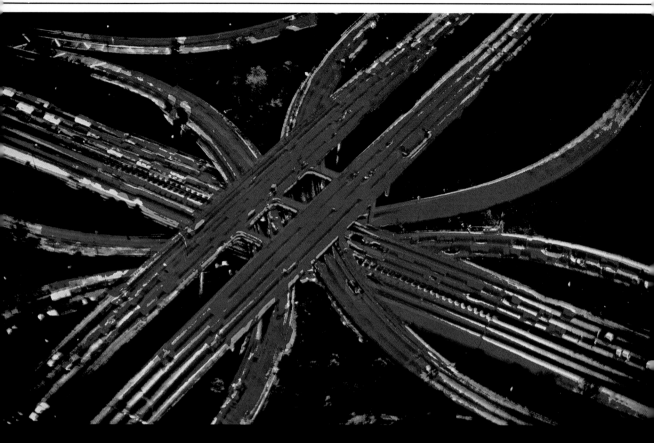

J. Barry O'Rourke
**1181 BROADWAY
NEW YORK, N.Y. 10001
NY REP. LYN SCHNEIDER
(212) 686-4224
CHI REP. CLAY TIMON
(312) 527 1114
STOCK THROUGH THE STOCK MARKET**

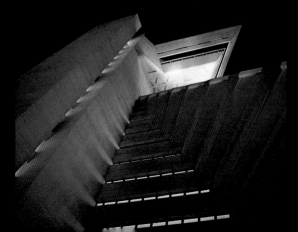

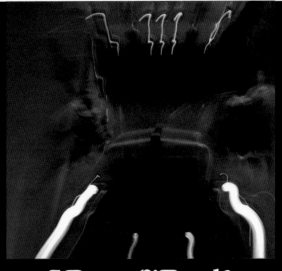

J. Barry O'Rourke

1181 BROADWAY
NEW YORK, N.Y. 10001
NY REP. LYN SCHNEIDER
(212) 686-4224
CHI REP. CLAY TIMON
(312) 527 1114
STOCK THROUGH THE STOCK MARKET

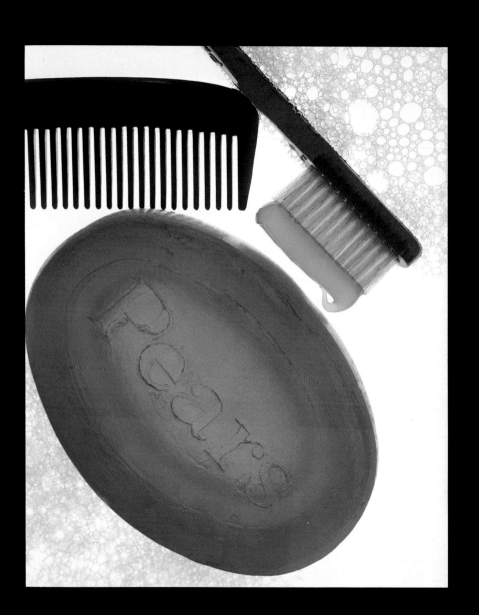

TED MORRISON

286 FIFTH AVENUE
NEW YORK, N.Y. 10001
(212) 279-2838

REPRESENTED BY DENNIS TANNENBAUM

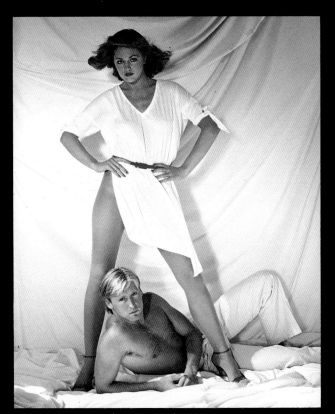

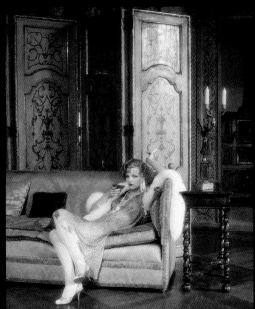

Peter
Brandt

73 Fifth *Ave.*, New York N.Y. 10003

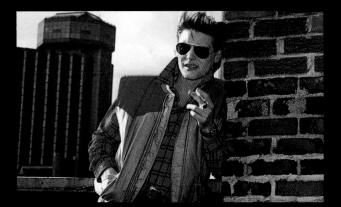

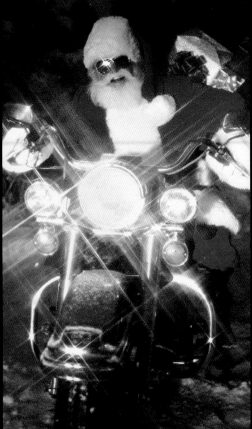

(212) 242-4289

© BRANDT '82

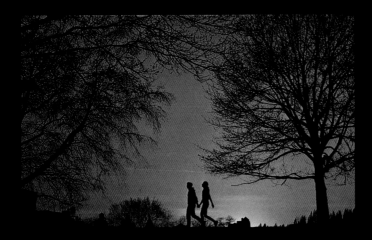

Clients:
PSE&G
The New York Times
Sports Illustrated
Newsweek
New York Magazine
GEO

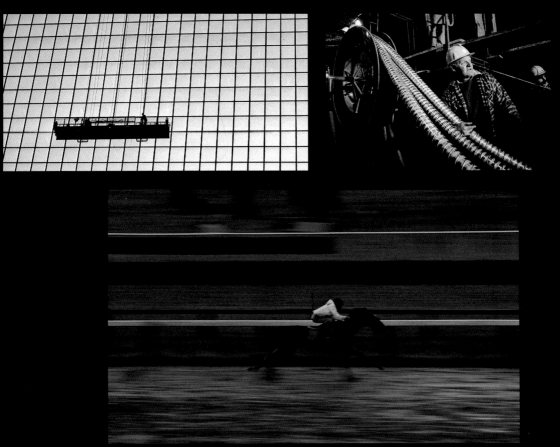

Cynthia Matthews 200 East 78th Street New York NY 10021 (212) 288-7349

COLIN COOKE

PHOTOGRAPHER

380 LAFAYETTE ST.,
NEW YORK, N.Y. 10003
(212) 254-5090

Representative:
JOAN JEDELL
(212) 861-7861

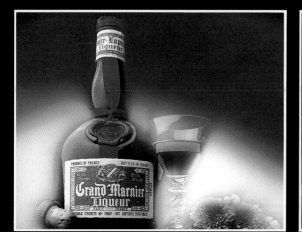

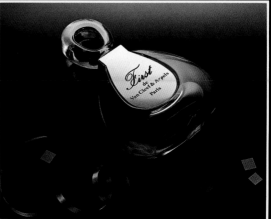

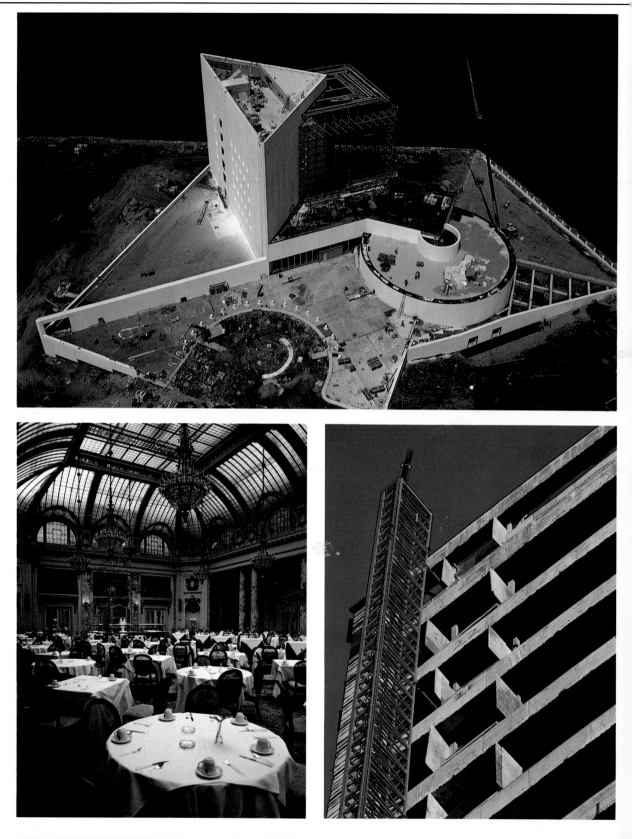

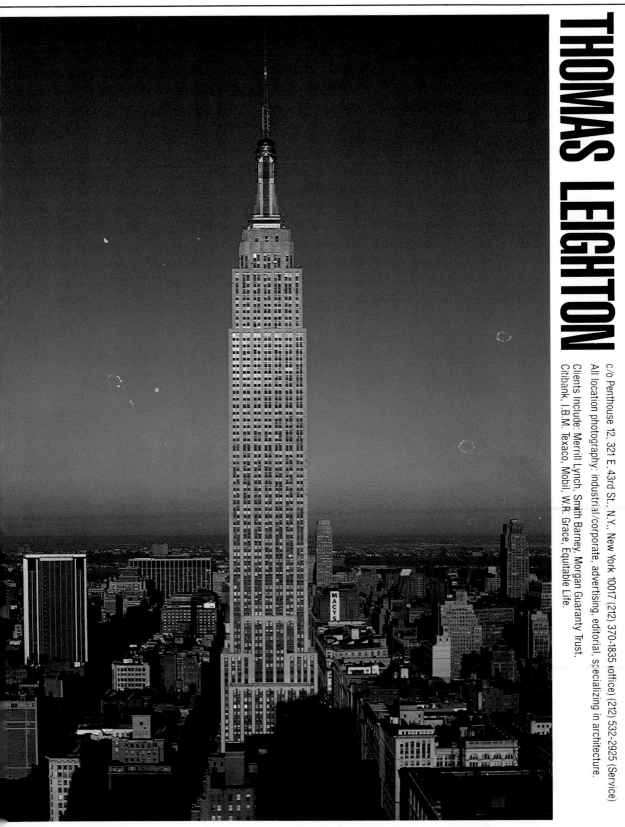

THOMAS LEIGHTON

c/o Penthouse 12, 321 E. 43rd St., N.Y., New York 10017 (212) 370-1835 (office) (212) 532-2925 (Service)

All location photography: industrial/corporate, advertising, editorial, specializing in architecture.

Clients Include: Merrill Lynch, Smith Barney, Morgan Guaranty Trust, Citibank, I.B.M. Texaco, Mobil, W.R. Grace, Equitable Life.

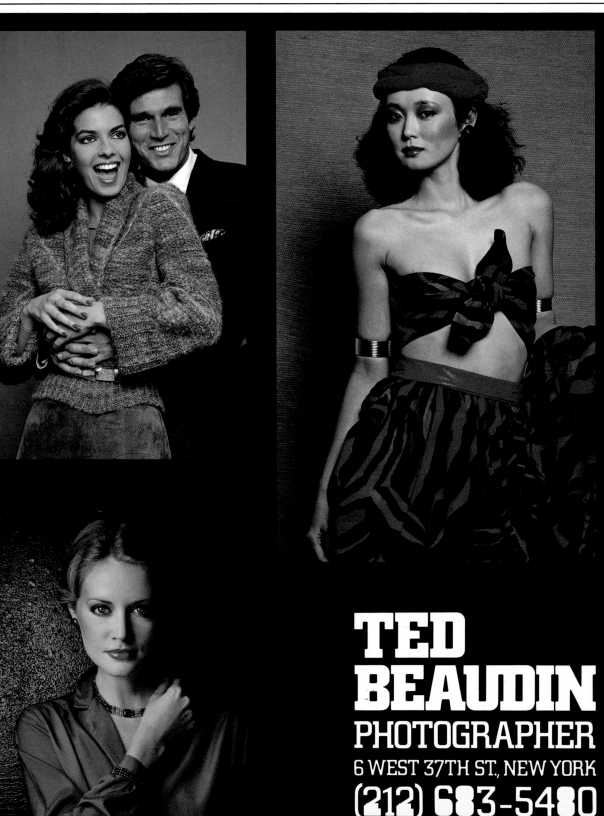

TED
BEAUDIN
PHOTOGRAPHER
6 WEST 37TH ST., NEW YORK
(212) 683-5480

TED BEAUDIN

PHOTOGRAPHER

6 WEST 37TH ST., NEW YORK

(212) 683-5480

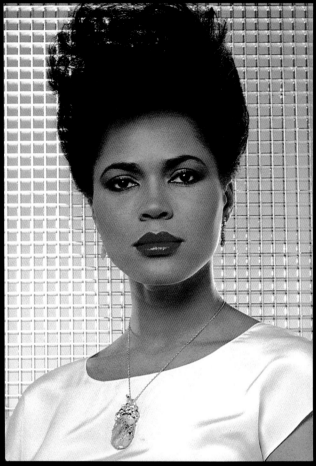

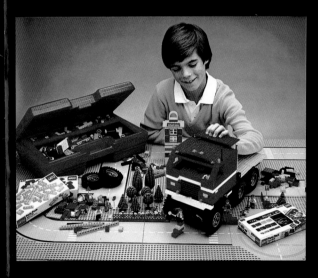

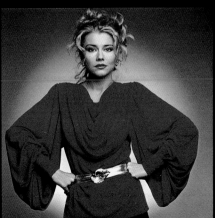

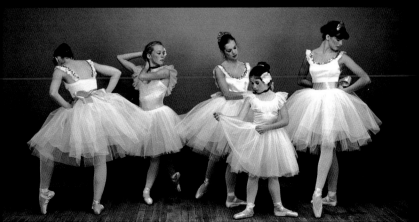

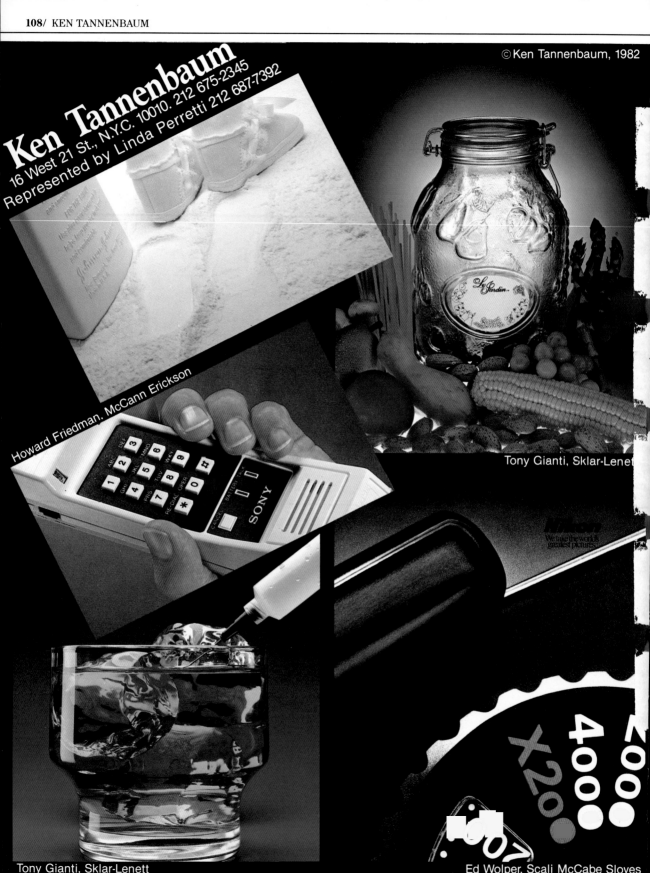

© Ken Tannenbaum, 1982

Ken Tannenbaum
16 West 21 St., N.Y.C. 10010. 212 675-2345
Represented by Linda Perretti 212 687-7392

Howard Friedman, McCann Erickson

Tony Gianti, Sklar-Lenett

Tony Gianti, Sklar-Lenett

Ed Wolper, Scali McCabe Sloves

Specializing in projecting slides of any location, any season, in our New York studio with

STROBE PROJECTION

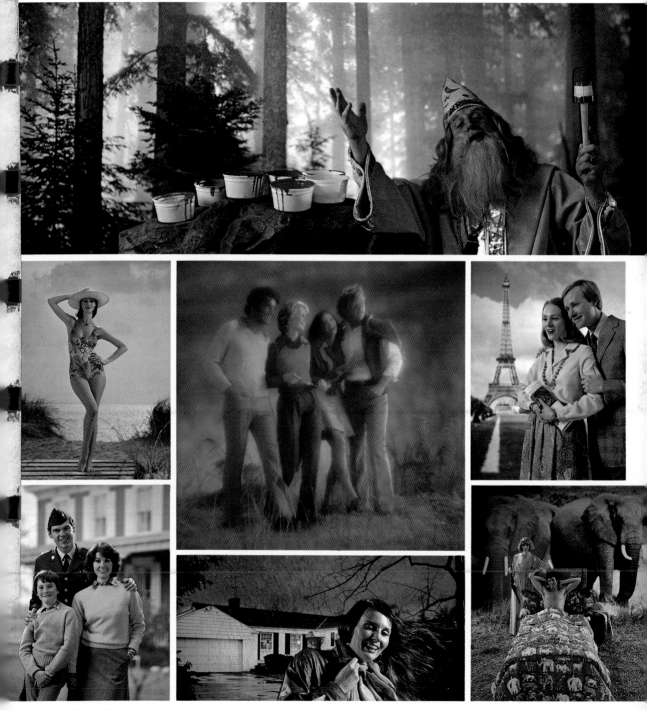

BERNIE GOLD 873 Broadway New York City 212/667-0311

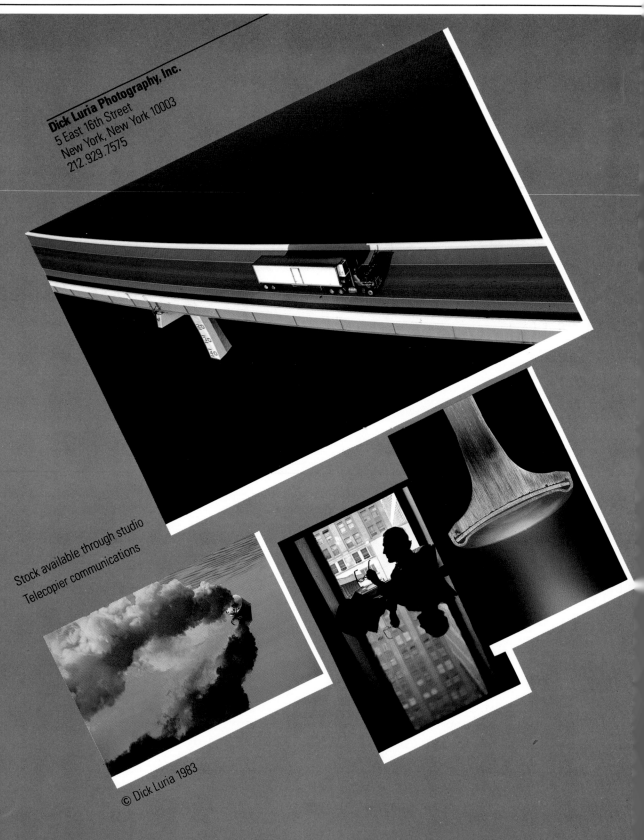

Dick Luria Photography, Inc.
5 East 16th Street
New York, New York 10003
212.929.7575

Stock available through studio
Telecopier communications

© Dick Luria 1983

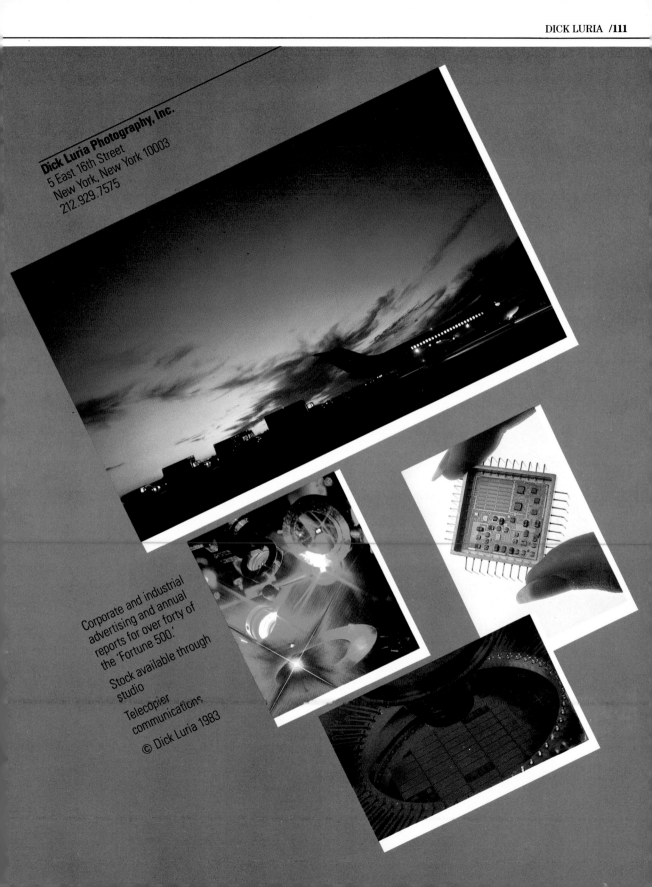

Dick Luria Photography, Inc.
5 East 16th Street
New York, New York 10003
212.929.7575

Corporate and industrial
advertising and annual
reports for over forty of
the 'Fortune 500.'

Stock available through
studio

Telecopier
communications

© Dick Luria 1983

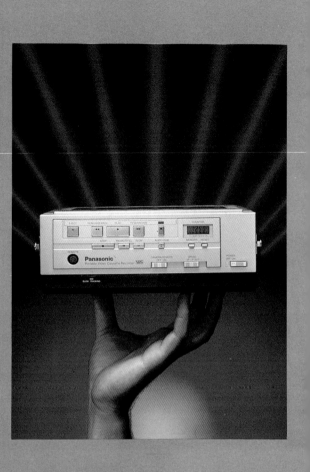

PETER ANGELO SIMON

Studio: 504 La Guardia Place
New York New York 10012
Telephone: 212 473-8340

Clients include: AT&T, Bell Labs, CBS, General Motors Corp, Maryland National Bank, Matsuhita Electric, Mitsubishi Electric, Mobil Corp, The New York Times Corp, Omni Publications, Orion Films, Panasonic, Smithsonian Institution, St Regis Paper Co, Time Inc, Warner Communications.

All images © 1982 Peter Angelo Simon.

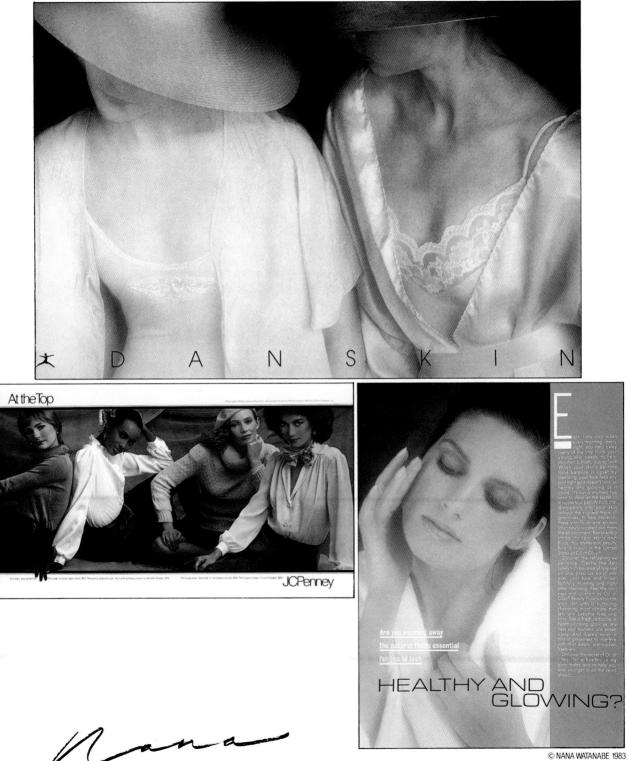

ANA WATANABE 31 UNION SQUARE WEST, NEW YORK, NY 10003 (212) 741-3248

OBREMSKI

GEORGE OBREMSKI
1200 BROADWAY NYC 10001 TEL. 212-684-2933
REPRESENTED BY SUSAN STEINER TEL. 212 673 4704

OBREMSKI

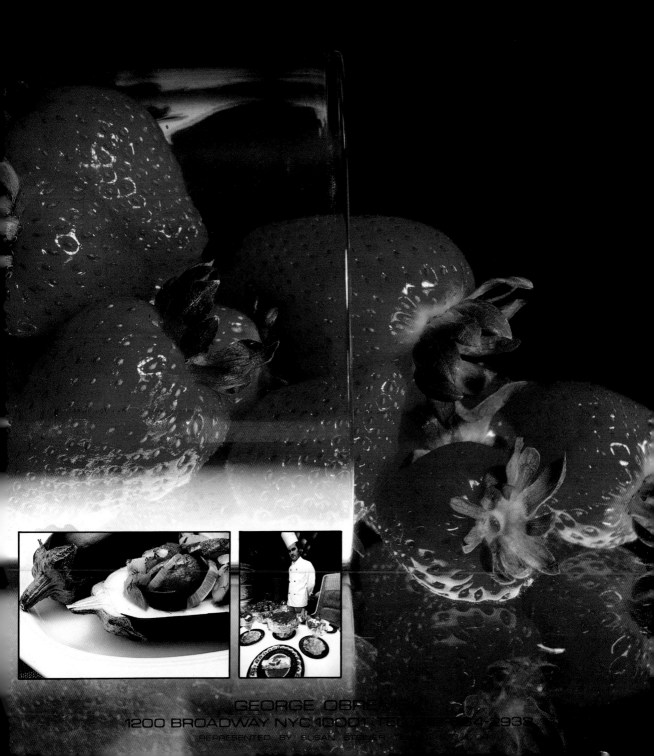

GEORGE OBREMSKI
1200 BROADWAY NYC 10001 TEL 212 684-2938
REPRESENTED BY SUSAN STOLLER

GLOBUS BROTHERS

• PHOTOGRAPHY • FILM • VIDEO •

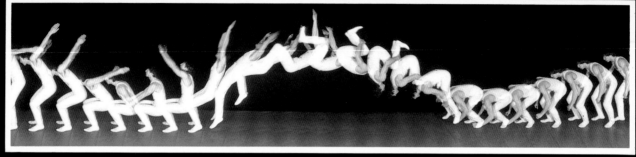

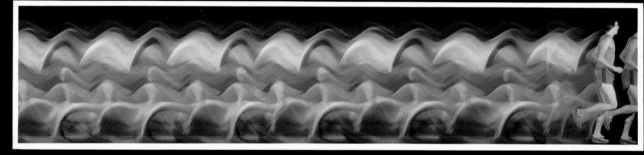

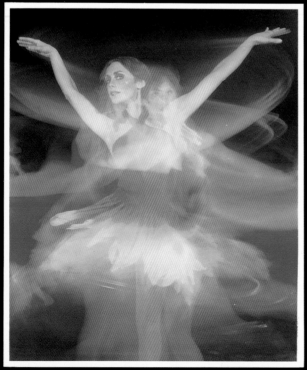

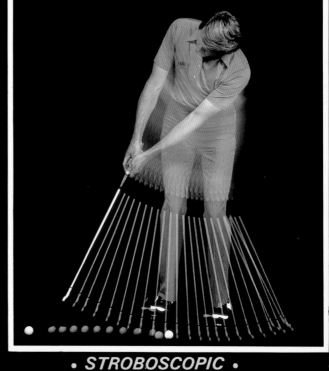

• HIGH SPEED •

• STROBOSCOPIC •

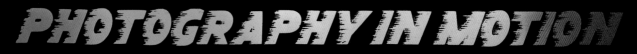

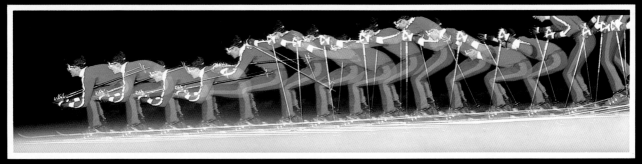

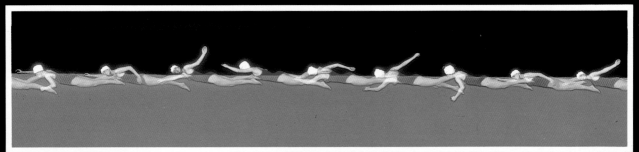

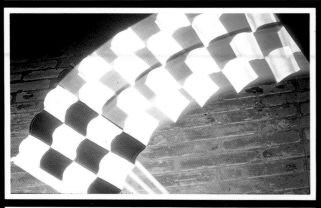

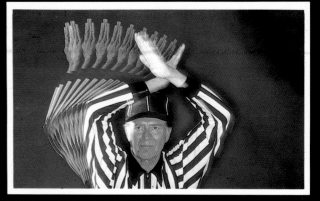

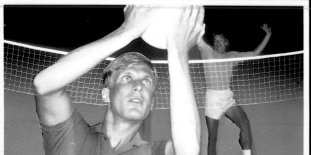

• SLIT-SCAN •

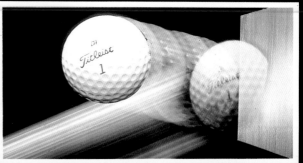

• PIN REGISTER •

JOHAN ELBERS

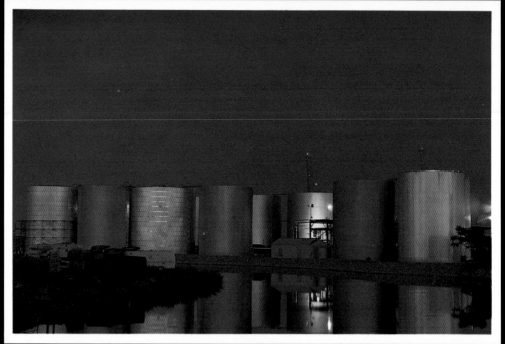

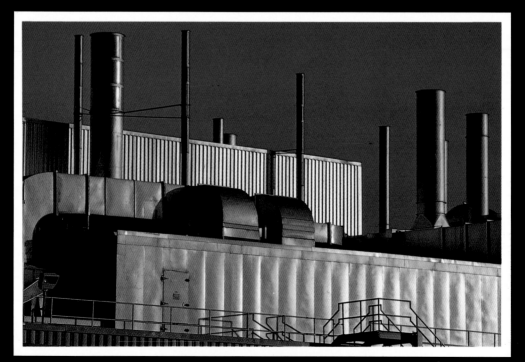

© JOHAN ELBERS 1983

(212) 929-5783

18 East 18th Street New York 10003

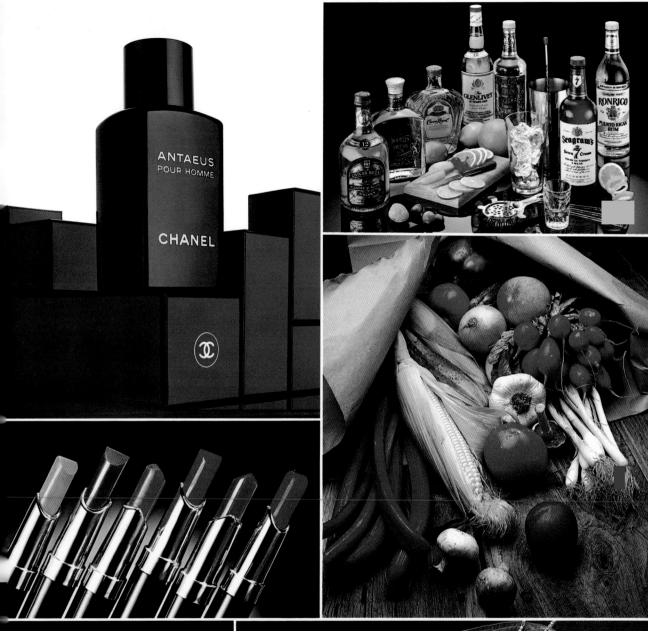

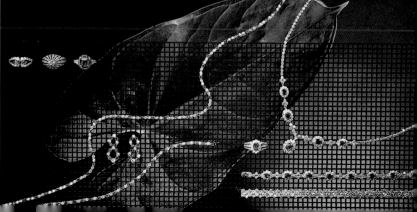

Mickey Kaufman

144 West 27th Street
New York NY 10001
212 255-1976

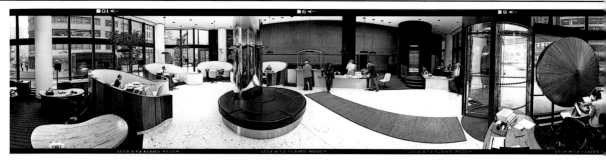

Panoramic and wide-angle photography for advertising, corporate and architecture.

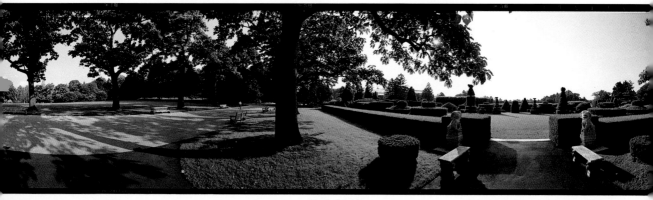

Mark Segal

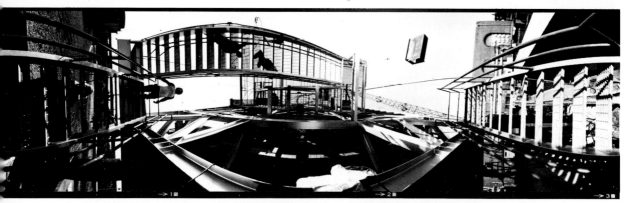

2141 Newport Place, NW, Washington, DC 20037 (202) 223-2618

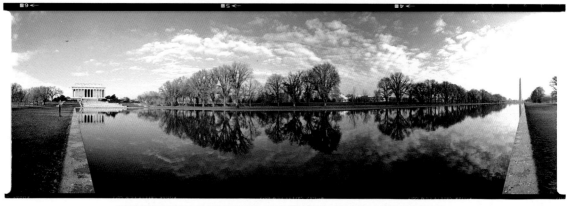

REPRESENTED BY E.F. GIDLEY/ALLIANCE (212) 772-0846 (203) 655-1321 STOCK AVAILABLE.

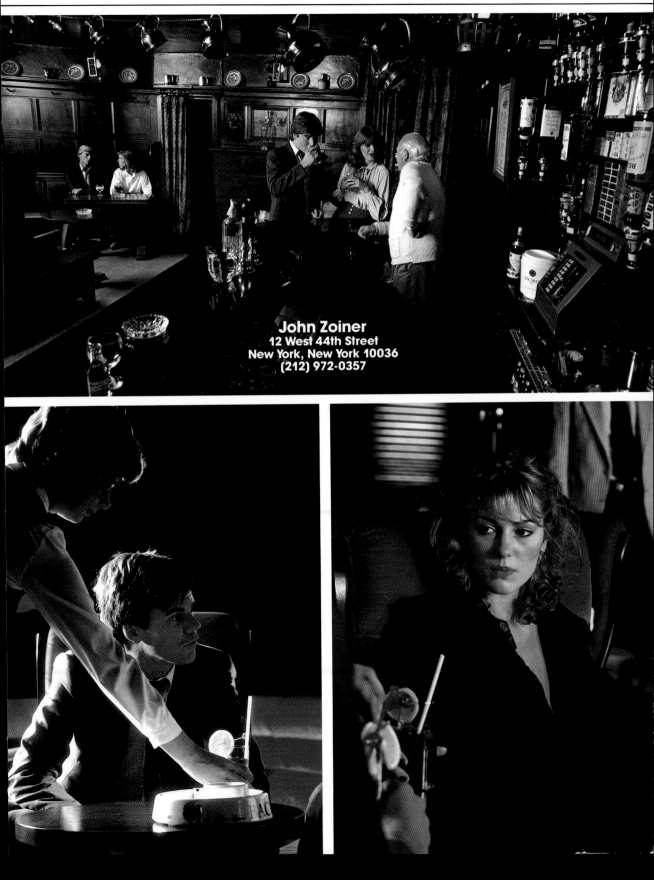

John Zoiner
12 West 44th Street
New York, New York 10036
(212) 972-0357

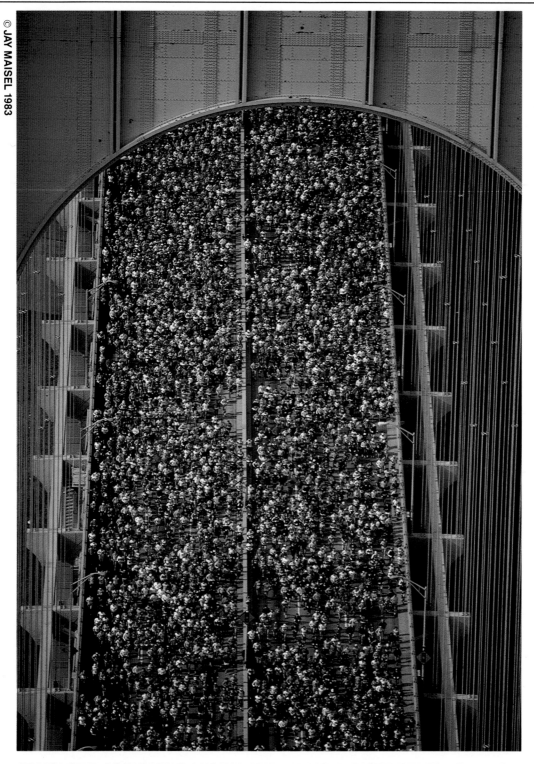

IF YOU'RE ASSIGNING WORK AND WANT A DIFFERENT POINT OF·
VIEW, WE'VE BEEN SHOOTING ON ASSIGNMENT FOR 30 YEARS.
CALL US AT (212) 431-5013 AND ASK FOR OYV, TOM OR EMILY.

JAY MAISEL, 190 BOWERY, NEW YORK, NEW YORK 10012

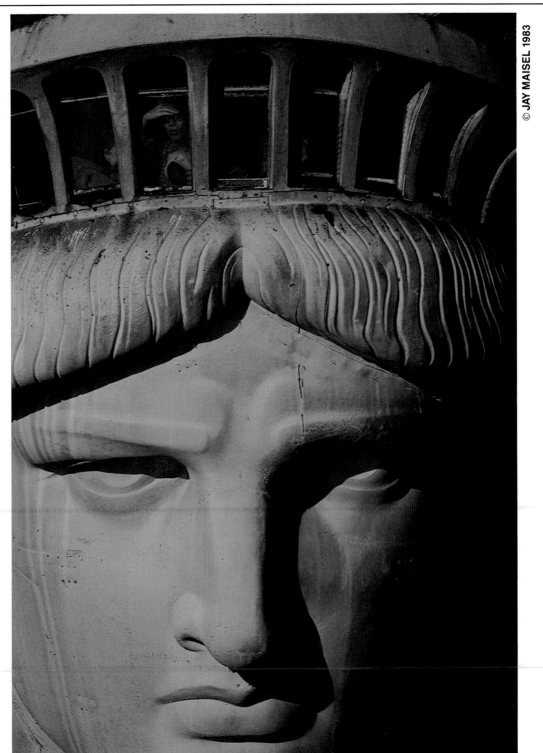

© JAY MAISEL 1983

IF YOU'RE LOOKING FOR STOCK PICTURES AND WANT A DIFFERENT
POINT OF VIEW, WE'VE BEEN ANSWERING STOCK CALLS FOR 30 YEARS.
CALL US AT (212) 431-5013 AND ASK FOR OYV, TOM OR EMILY.
JAY MAISEL, 190 BOWERY, NEW YORK, NEW YORK 10012

MICHAEL FURMAN PHILADELPHIA 215-925-4233

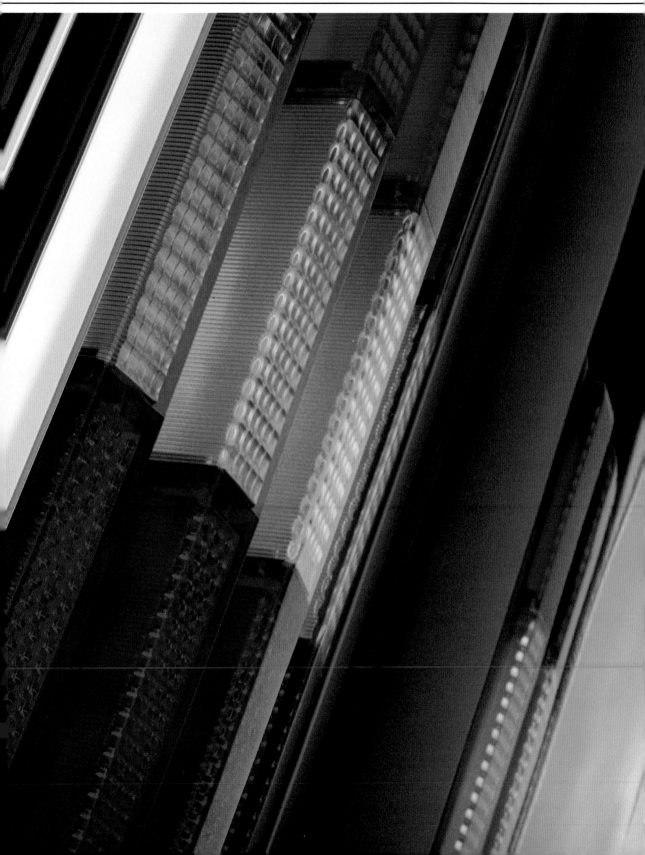

B E L L E R

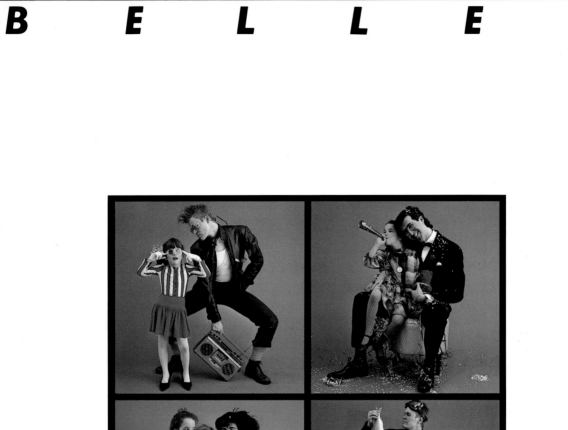

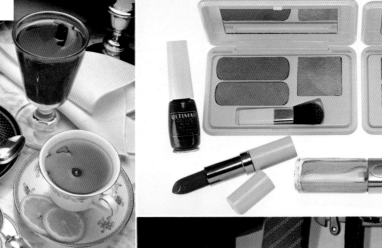

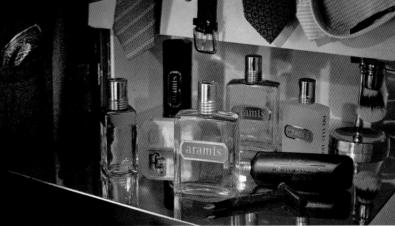

CHRISTENSEN

LOCATION AND STUDIO PHOTOGRAPHY. (212) 279-2838
REPRESENTED BY DENNIS TANNENBAUM

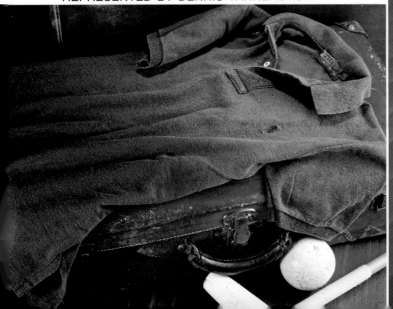

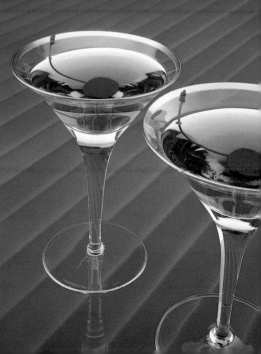

**LARRY STEIN
PHOTOGRAPHY**

5 W 30th St.
NEW YORK, N.Y. 10001
(212) 239-7264

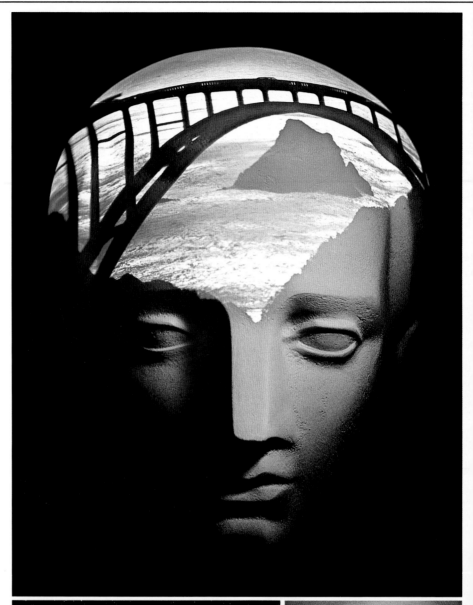

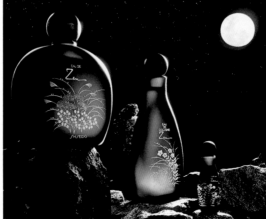

REPRESENTED BY
JUNE GREENMAN
(212) 947-8150

© 1983 LARRY STEIN

JONATHAN WALLEN

CORPORATE / INDUSTRIAL / AUDIO VISUAL / EDITORIAL
149 FRANKLIN STREET
NEW YORK NEW YORK 10013
212 / 966 / 7531

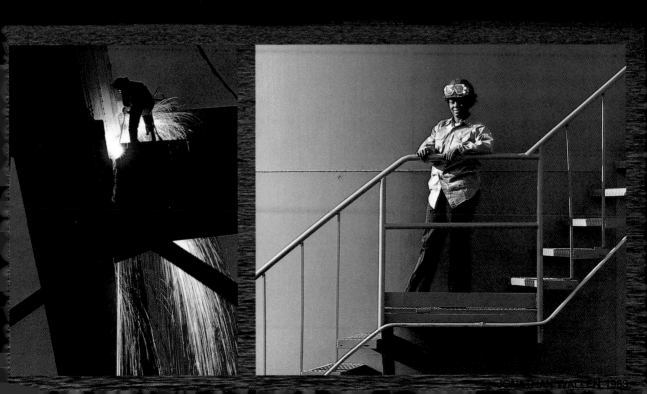

JONATHAN WALLEN 1988

CLAUDIA PARKS

NEW YORK CITY
(212) 533·4498

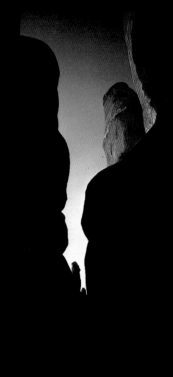

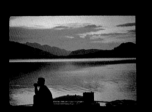
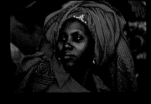

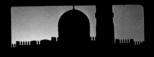

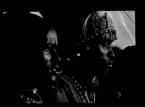
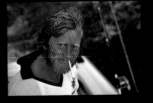

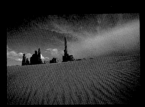
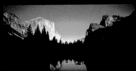

LOCATION PHOTOGRAPHY

Harvey Lloyd

Image Makers
310 E. 23rd Street
New York City 10010
Tel: (212) 533 4498

Royal Viking Line:
Around-the-world aerial shoot for
advertising and promotion.

A.D. Cal Anderson

Dailey & Assoc.

Still photography for advertising,
corporate and industrial communi-
cations. Production of films multi-
screen and multi-media shows.
Specialist in aerial and location
shooting, planning and arrange-
ments world-wide.

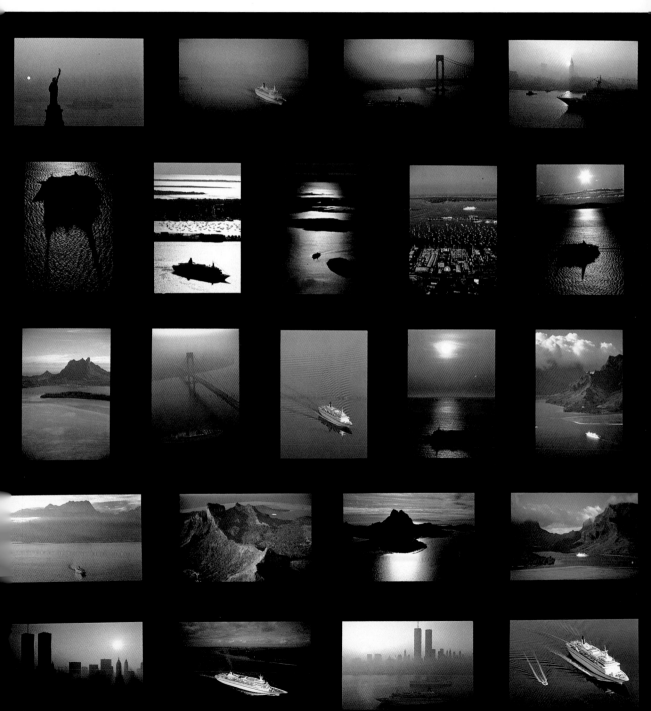

Kozlowski

PHOTOGRAPHER

REPRESENTED BY JANE MAUTNER (212) 777-9024

MARK KOZLOWSKI PHOTOGRAPHY, INC.
39 WEST 28TH STREET • NEW YORK, NY 10001
(212) 684-7487

Client: Congoleum Art Director: Ed Brown

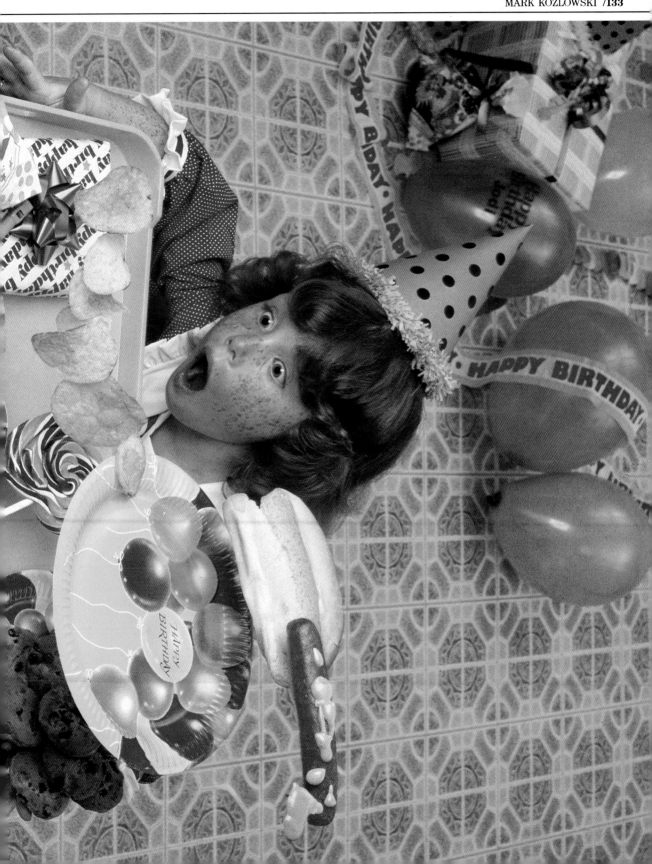

JON MURESAN PHOTOGRAPHY • CONTACT ELLEN MARCUS 212/222-6643

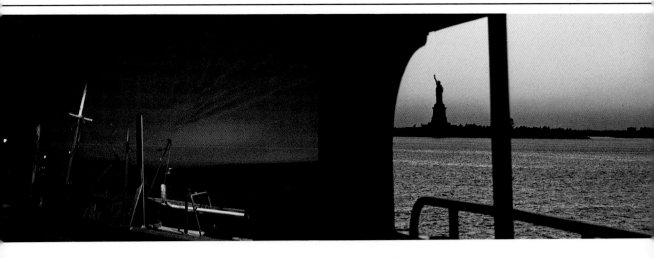

LEN SPEIER

190 Riverside Drive, New York, New York 10024 (212) 595-5480

Clients: ABC TV • East River Savings • Forbes • Fuji • Hyatt Hotels • Meridien Hotels
Metropolitan Life • New York Magazine • Omni • Random House, Inc. • Transamerica, Inc. • Weight Watchers

1983

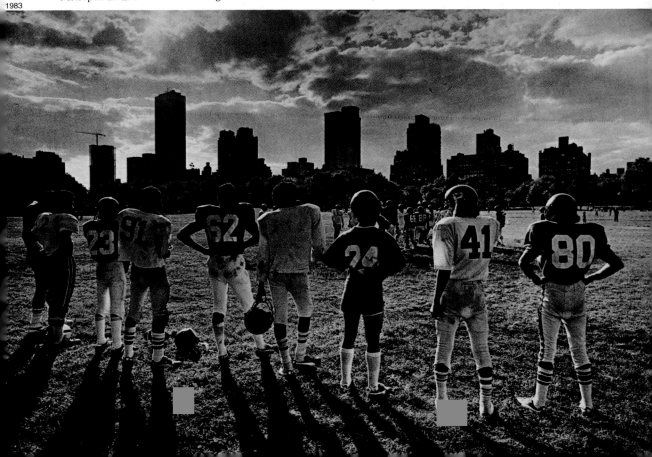

TOGASHI

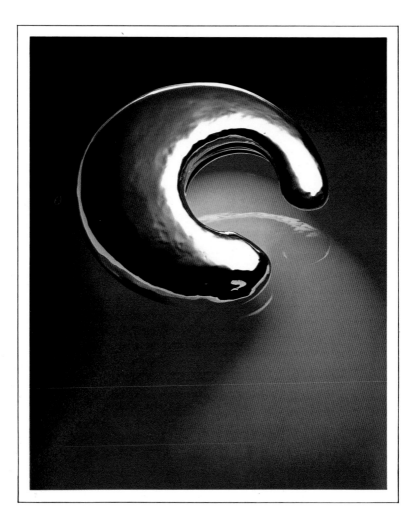

100 Fifth Avenue, New York, New York 10011 • (212) 929-2290

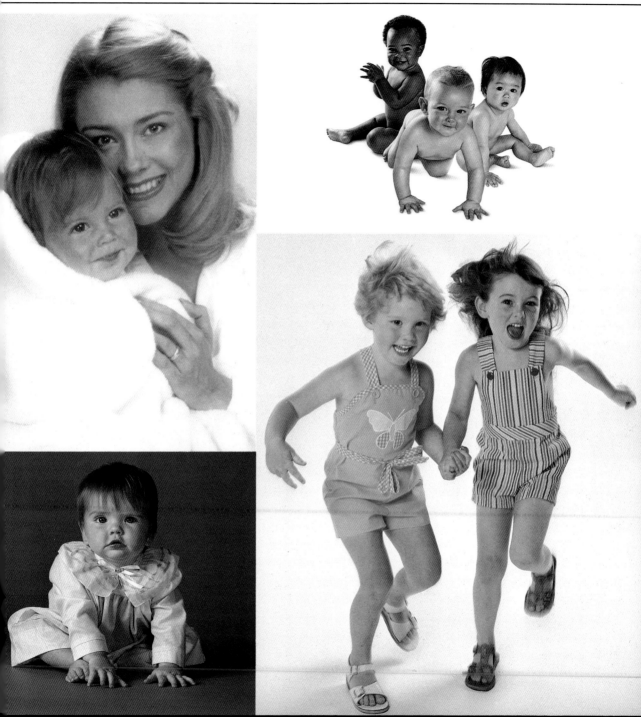

photographer of the "youngest" generation . . .

doris pinney

555 third avenue new york n y 10016 212-683-0637

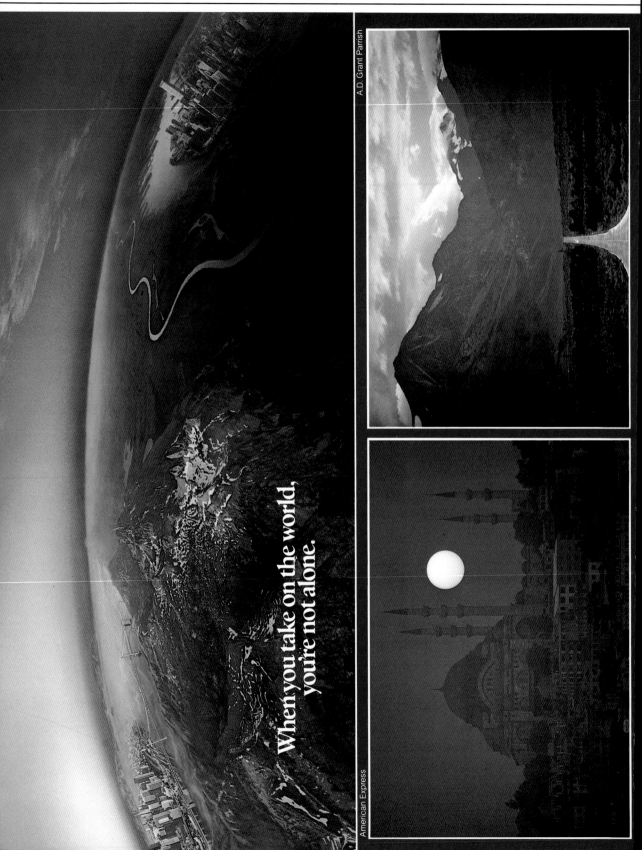

When you take on the world,
you're not alone.

A.D. Grant Parrish

American Express

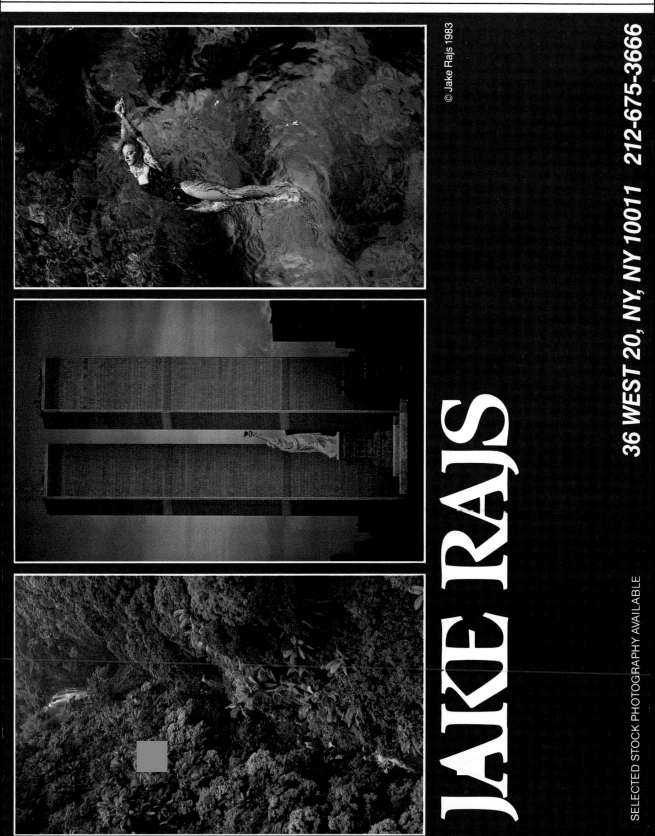

© Jake Rajs 1983

JAKE RAJS

36 WEST 20, NY, NY 10011 212-675-3666

SELECTED STOCK PHOTOGRAPHY AVAILABLE

Studio: 101 West 18th Street
New York, NY 10011
(212) 533-1422

PAUL BARTON

REPRESENTED BY
GARY LERMAN

(212) 683-5777

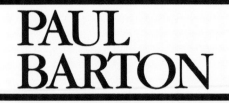

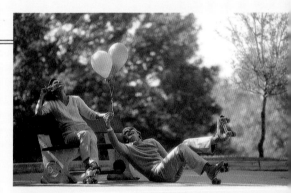

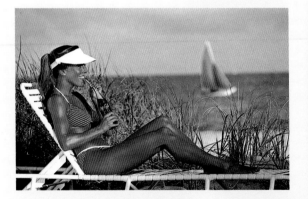

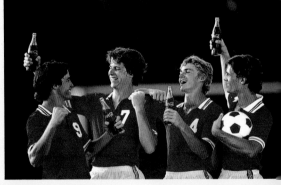

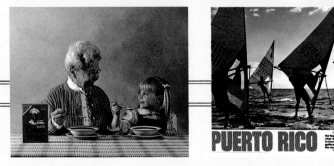

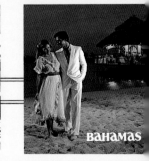

PUERTO RICO

BAHAMAS

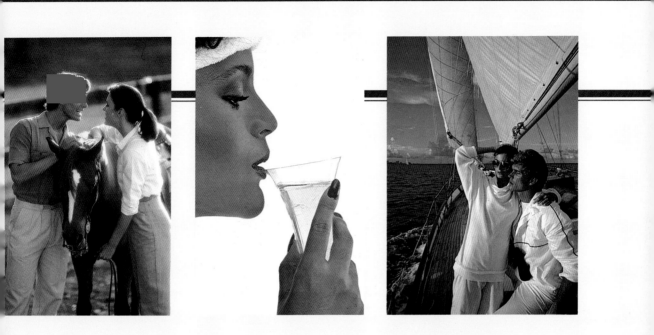

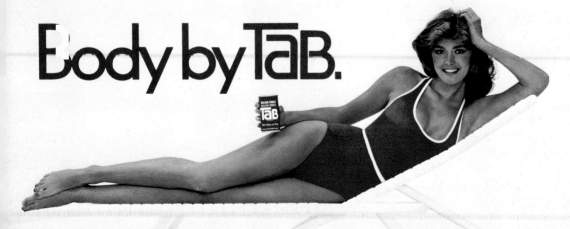

Body by TaB.

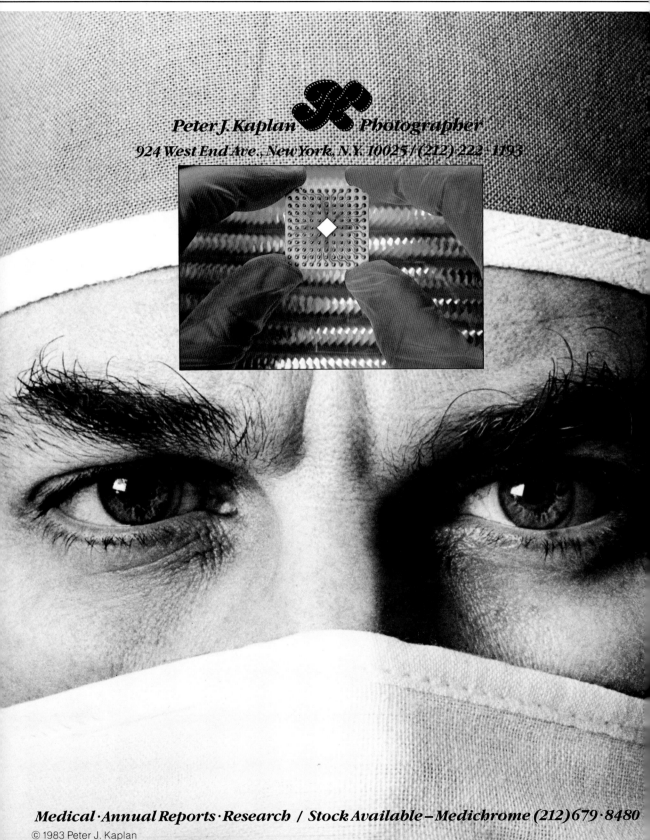

Peter J. Kaplan Photographer
924 West End Ave., New York, N.Y. 10025 / (212) 222-1193

Medical · Annual Reports · Research / Stock Available — Medichrome (212) 679 · 8480

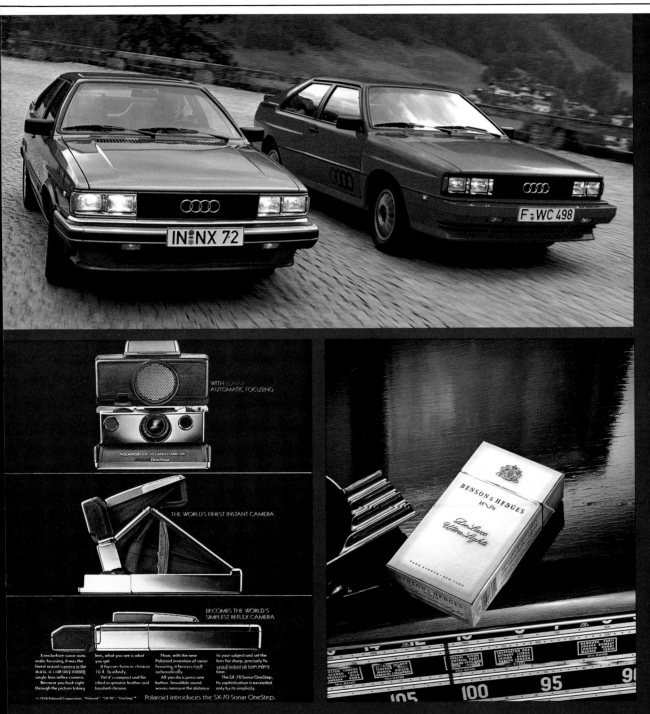

James Young

110 West 25TH St. New York, N.Y. 10001
924-5444

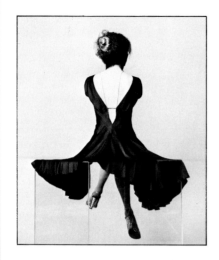
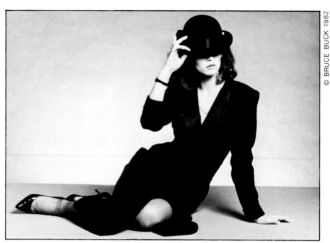

© BRUCE BUCK 1982

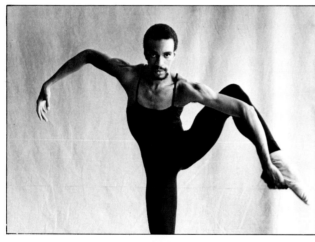
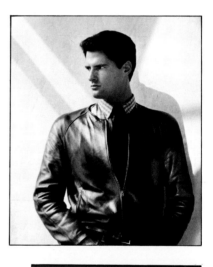

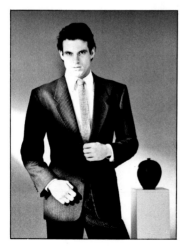

BRUCE BUCK

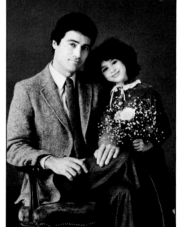

171 FIRST AVE. NEW YORK, N.Y. 10003 (212) 777-8309

$Abraham\ Menashe$ HUMANISTIC PHOTOGRAPHY

900 West End Avenue
NYC 10025 212-254-2754

Abraham Menashe accepts photographic assignments which celebrate the environment and man's triumphant spirit. Whether he is photographing our natural resources, the ordeal of the unfortunate, or an individual in pursuit of excellence, Menashe's vision affirms life and offers healing. His work is used by public service agencies, annual report designers, magazine editors, and advertisers. Internationally acclaimed for their poetic beauty and compassion, his photographs are in the collection of the Metropolitan Museum of Art, New York. He is the author of two photographic books: INNER GRACE, about America's multihandicapped population, and THE FACE OF PRAYER, images taken from around the world on the nature of reverence.

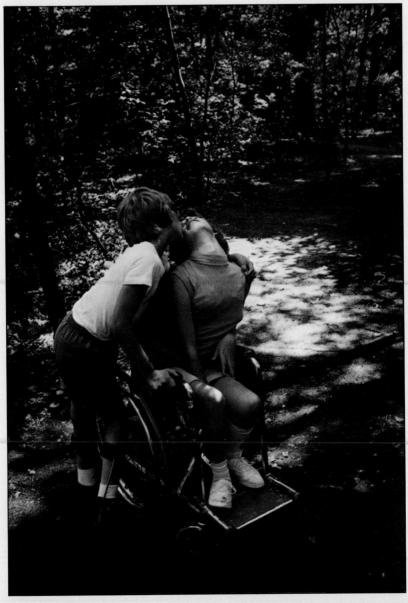

© *Abraham Menashe 1981.*

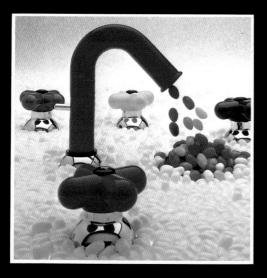

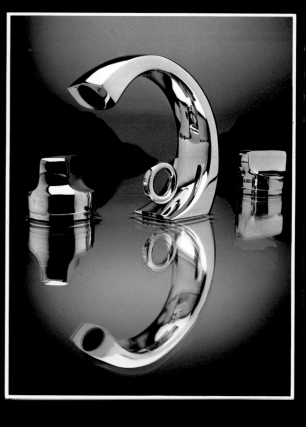

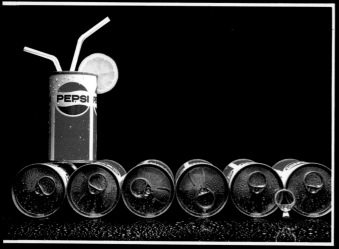

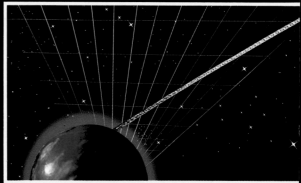

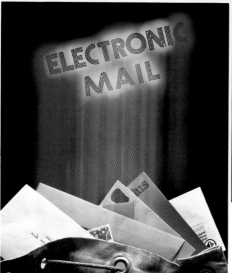

steve sint

six second road, great neck, new york 11021

516/487-4918

steve sint

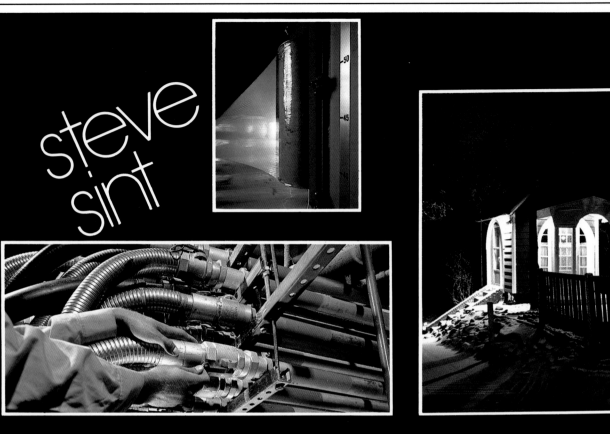

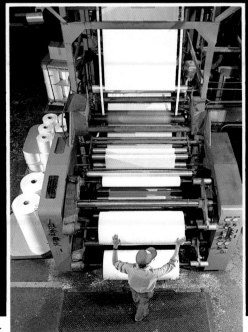

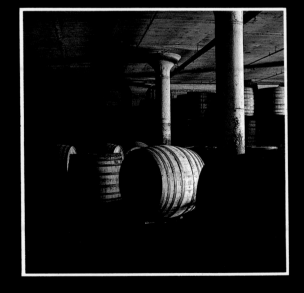

· steve sint six second road, great neck, new york 11021

516/487-4918

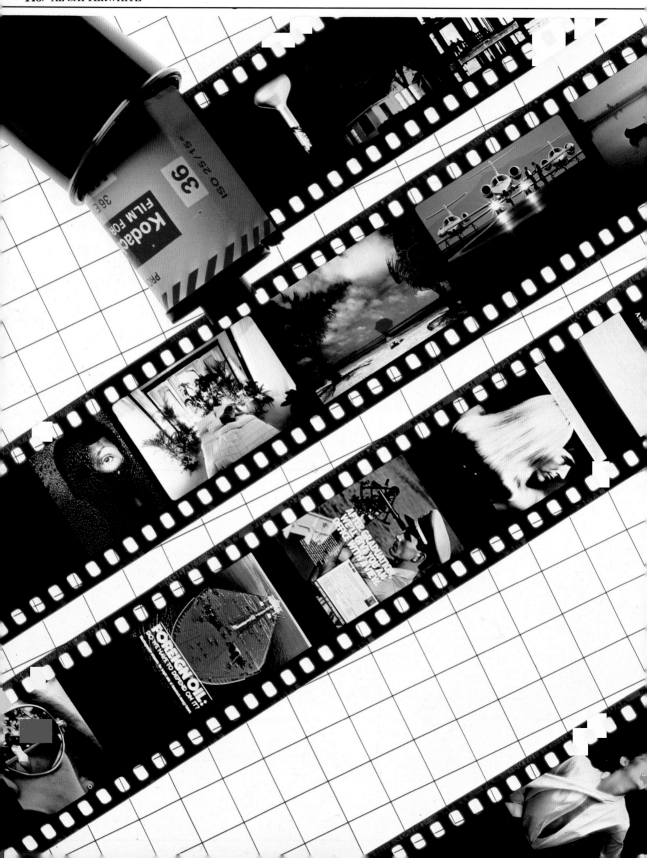

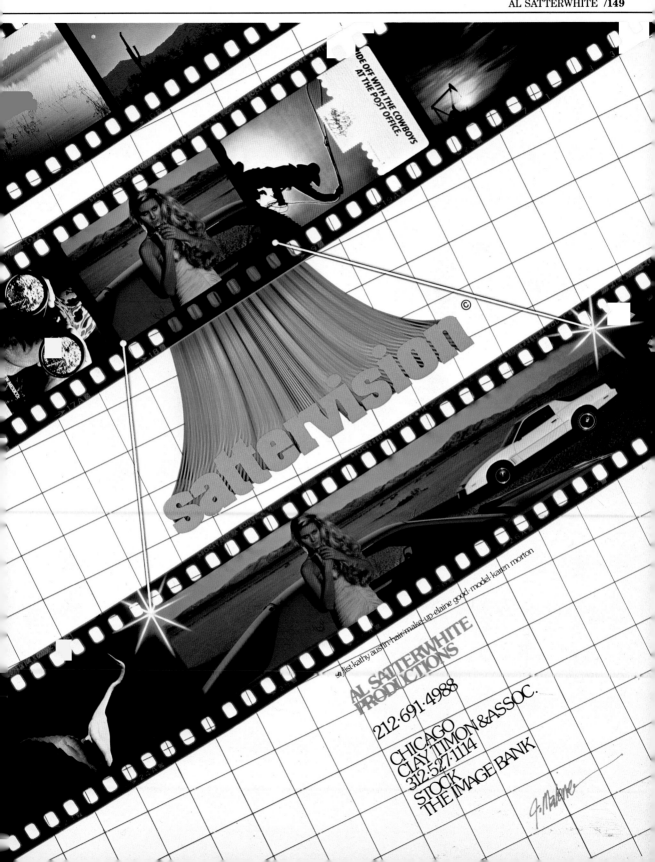

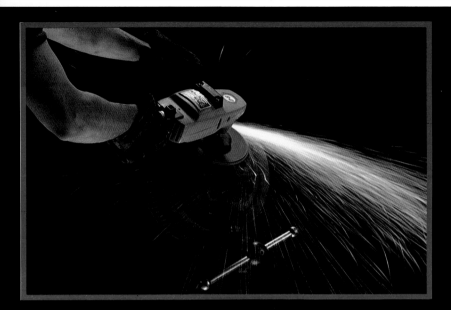

Don Mason

101 West 18th. Street
NYC. 10011
(212) 675-3809

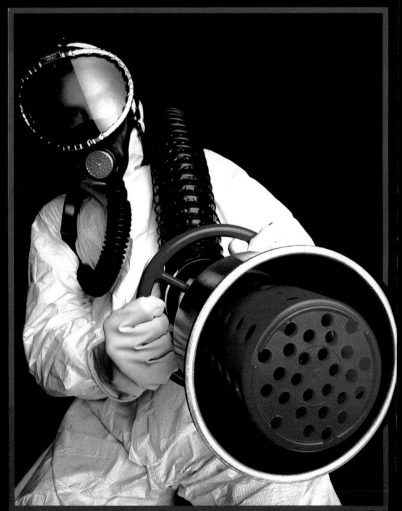

Represented by:
Kathy Mason
(212) 855-9074

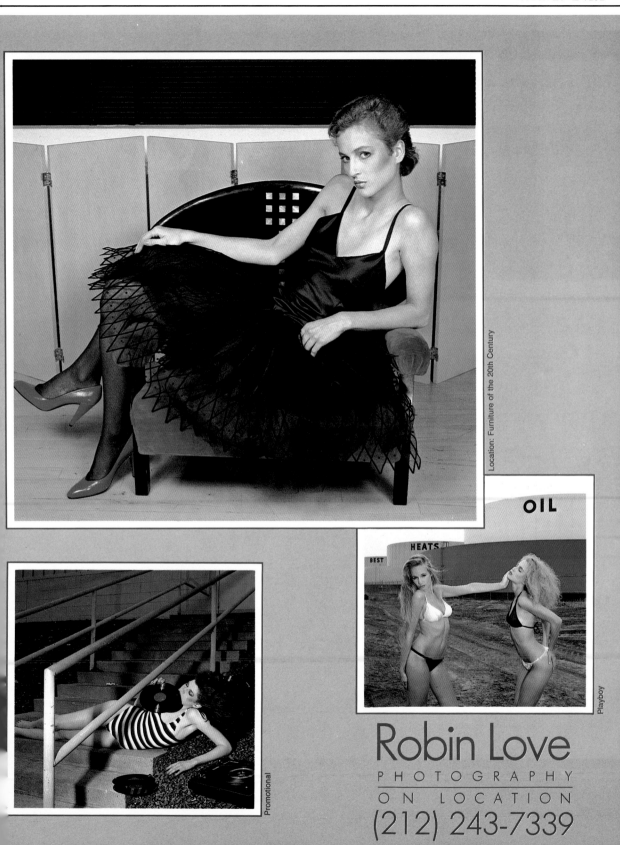

Location: Furniture of the 20th Century

OIL

HEATS

BEST

Playboy

Promotional

Robin Love
P H O T O G R A P H Y
O N L O C A T I O N
(212) 243-7339

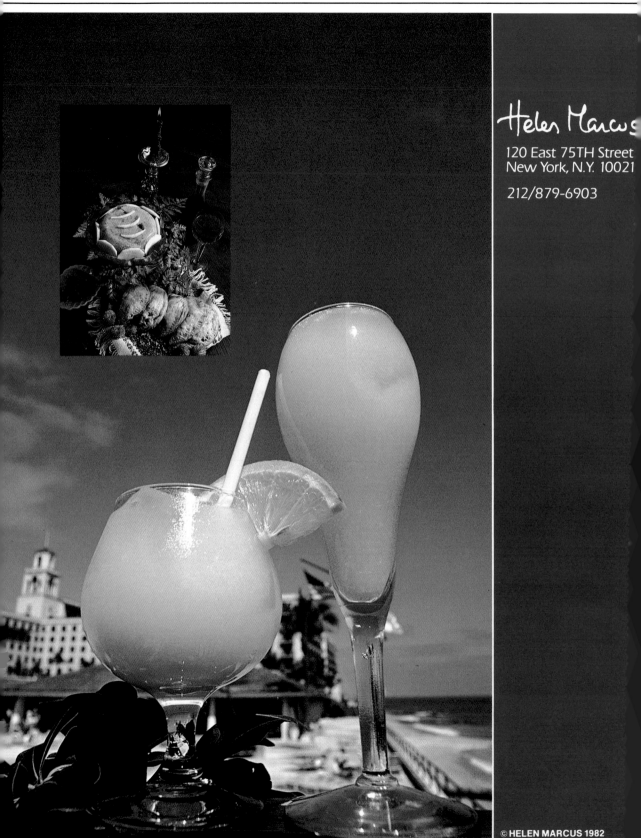

Helen Marcus
120 East 75TH Street
New York, N.Y. 10021

212/879-6903

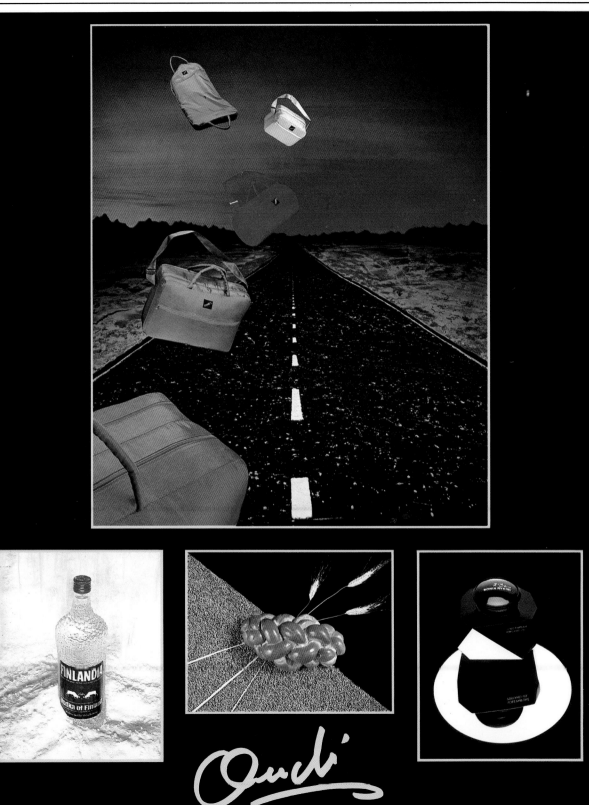

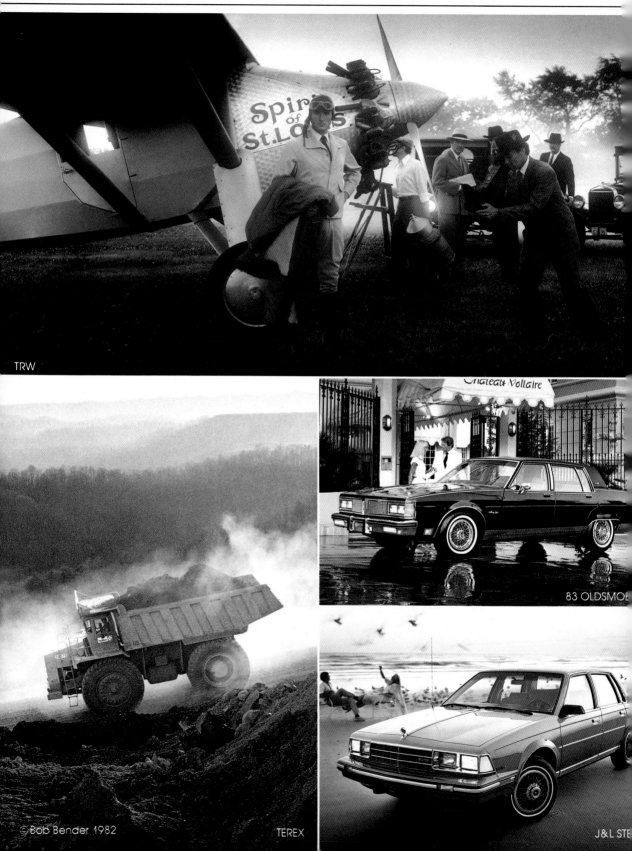

TRW

© Bob Bender 1982

TEREX

83 OLDSMOB

J&L STE

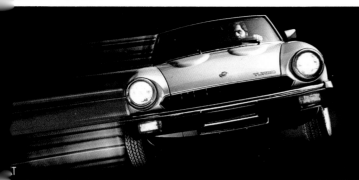

Evolution moves selectively toward perfection

*Introducing
the Mondial 8... an evolutionary sportscoupe —
perfect for your two plus two lifestyle.*

Ferrari

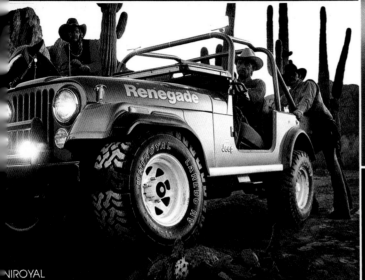

NIROYAL

BOB BENDER

One Rockefeller Building • Cleveland 44113 • (216) 861-4338
New York: Julia Della Croce (212) 355-7670
Chicago: Clay Timon (312) 527-1114
Tokyo: Dane Jampel 585-2721
London: (01) 250-1421

WHITE CONSOLIDATED

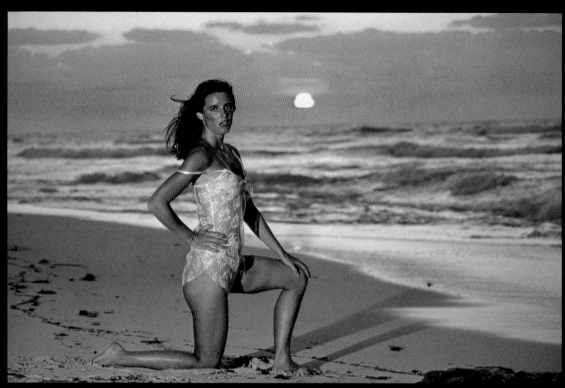

© Eric Schweikardt 1983

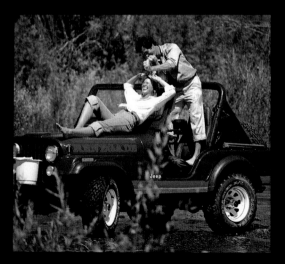

ERIC SCHWEIKARDT

P.O. Box 56 Southport, CT 06490 203/375-8181

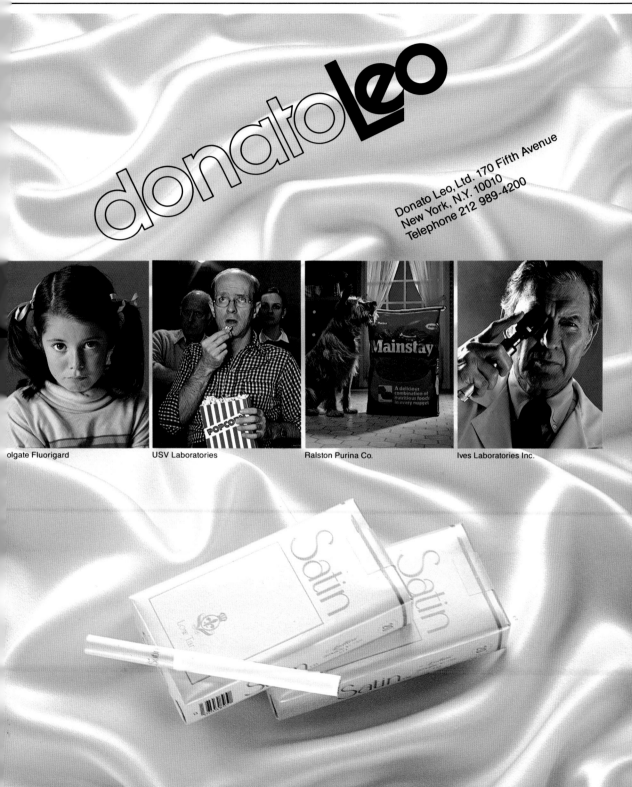

donato **Leo**

Donato Leo, Ltd. 170 Fifth Avenue
New York, N.Y. 10010
Telephone 212 989-4200

olgate Fluorigard USV Laboratories Ralston Purina Co. Ives Laboratories Inc.

Donato Leo, Ltd. 1983

MCFARLAND
LOWELL

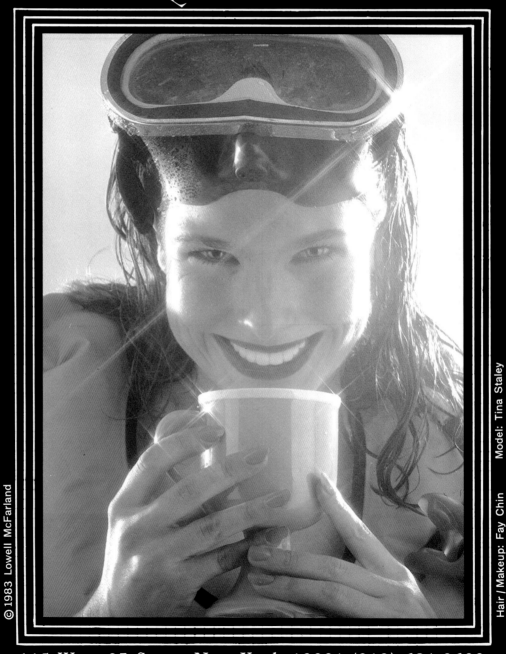

Hair / Makeup: Fay Chin Model: Tina Staley

115 West 27 Street New York 10001 (212) 691-2600

McFARLAND

NANCY

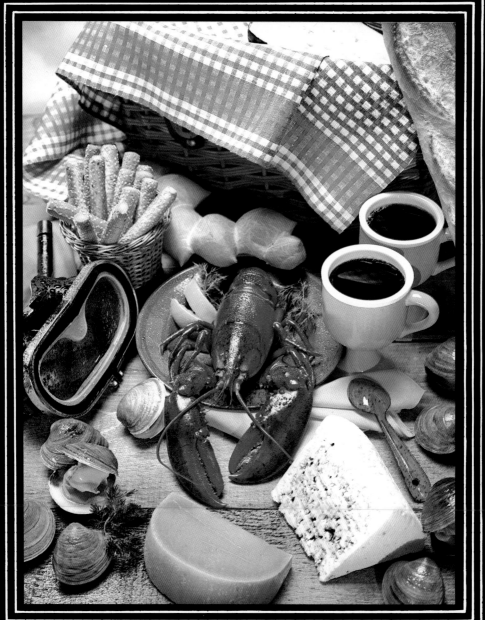

Home Economist / Food Stylist: Claudette Ambrose

115 West 27 Street New York 10001 (212) 691-2600

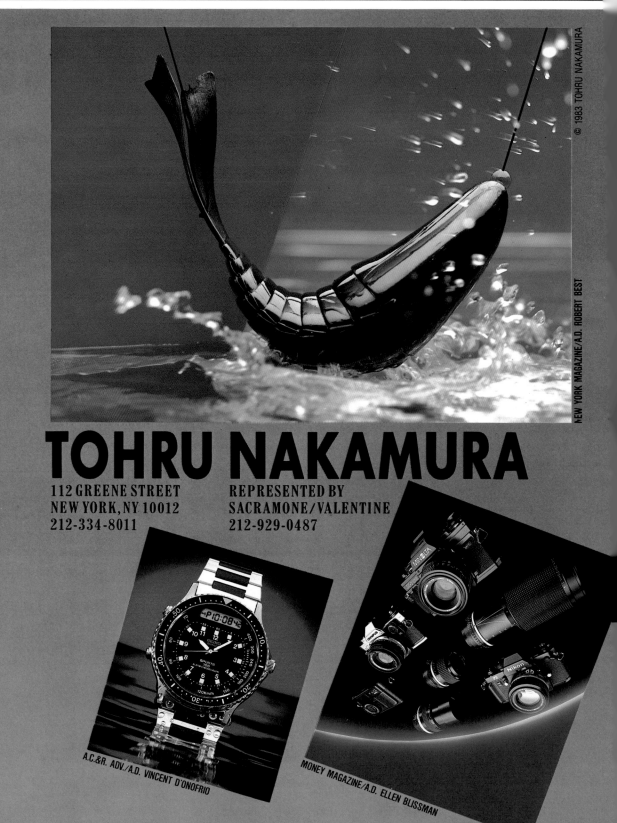

TOHRU NAKAMURA

112 GREENE STREET
NEW YORK, NY 10012
212-334-8011

REPRESENTED BY
SACRAMONE/VALENTINE
212-929-0487

© 1983 TOHRU NAKAMURA

NEW YORK MAGAZINE/A.D. ROBERT BEST

A.C.&R. ADV./A.D. VINCENT D'ONOFRIO

MONEY MAGAZINE/A.D. ELLEN BLISSMAN

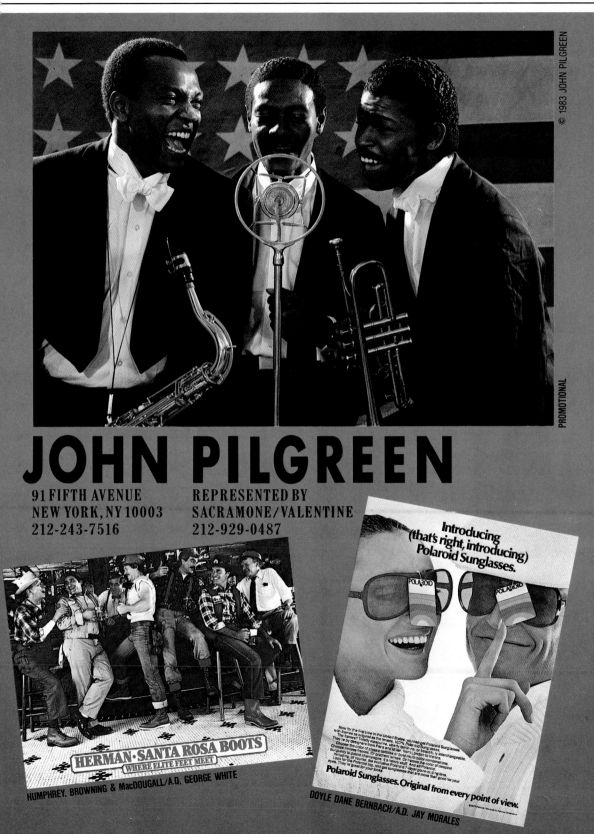

© 1983 JOHN PILGREEN

PROMOTIONAL

JOHN PILGREEN

91 FIFTH AVENUE
NEW YORK, NY 10003
212-243-7516

REPRESENTED BY
SACRAMONE/VALENTINE
212-929-0487

HERMAN · SANTA ROSA BOOTS
WHERE ELITE FEET MEET

HUMPHREY, BROWNING & MacDOUGALL/A.D. GEORGE WHITE

Introducing
(that's right, introducing)
Polaroid Sunglasses.

Polaroid Sunglasses. Original from every point of view.

DOYLE DANE BERNBACH/A.D. JAY MORALES

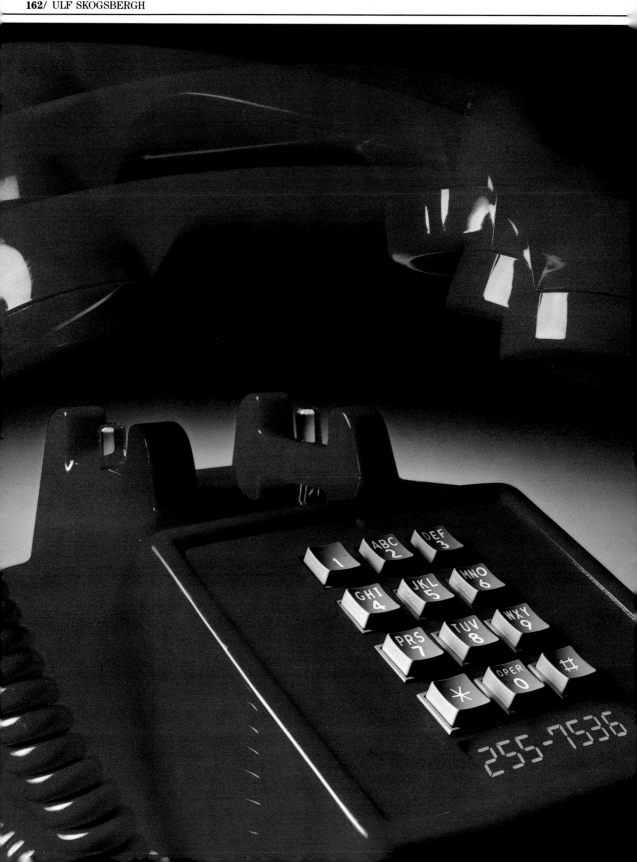

Ulf Skogsbergh

100 Fifth Avenue, New York, New York 10011 (212) 255-7536

Represented by Michael Groves (212) 532-2074

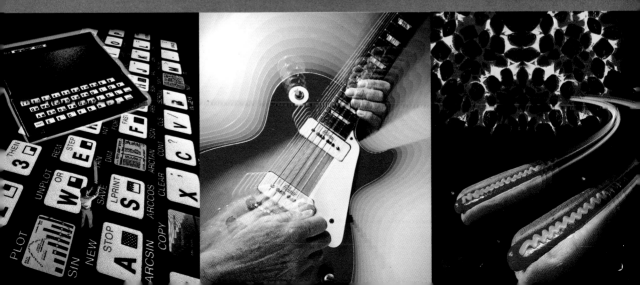

JOE DIAMOND PHOTOGRAPHY • 915 WEST E

(212) 316-5295

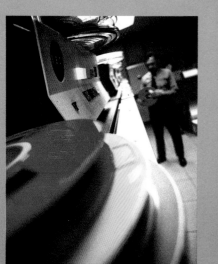

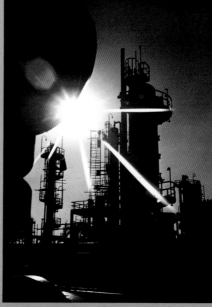

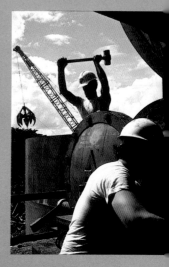

'ENUE • NEW YORK, NY 10025

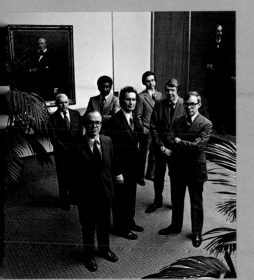

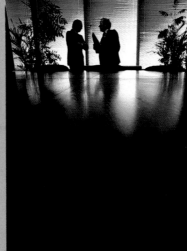

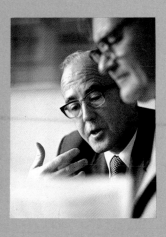

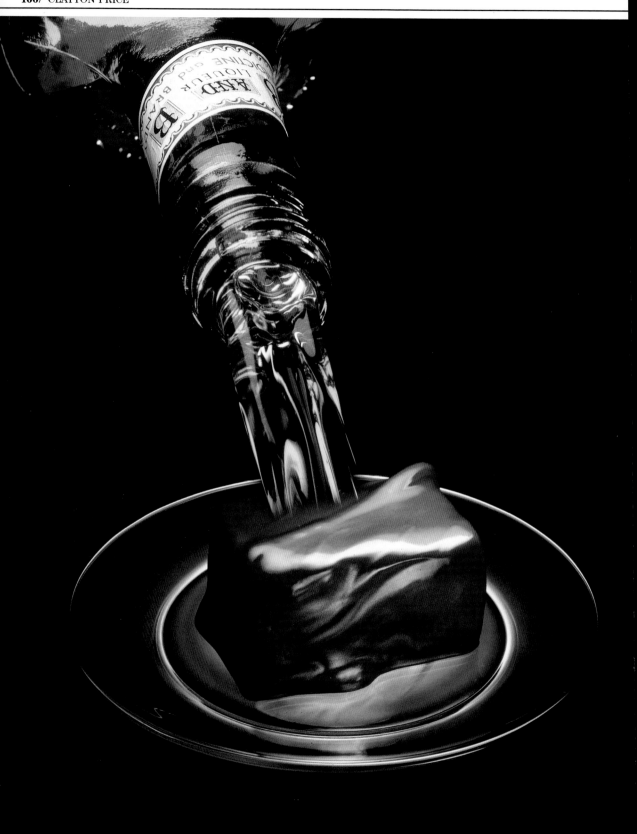

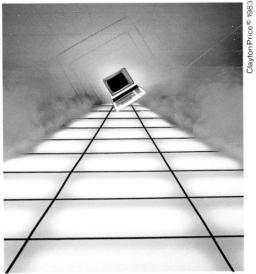

Clayton Price © 1983

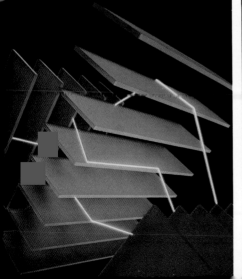

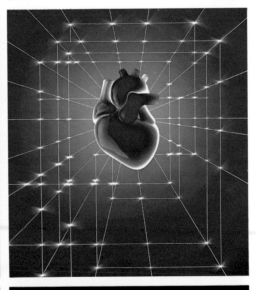

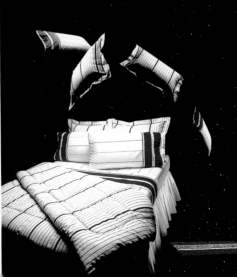

How do you catch an elephant falling from the sky? Shoot it—with Clayton Price.

Of course, any good photographer can make an elephant fly. That's an effect. The catch is to make it look natural. That makes an effect special—the way Clayton Price does.

In Clayton's world the imaginary becomes real—elephants fly, the stars shine on a sunny day and the moon is as natural in a bedroom as it is over Miami. The only limit is your imagination.

If you want an effect that's special, give Clayton a call. He has the eye, the imagination and the elephant.

Clayton Price
50 West 17th Street
New York, N.Y.
10011

(212) 929-7721

MAUREEN LAMBRAY
New York City (212) 879-3960

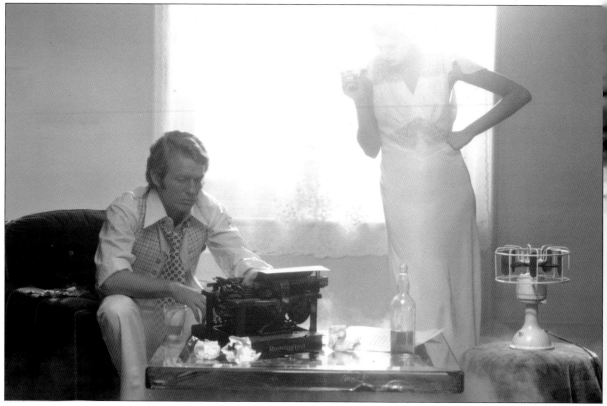

HARRIET LOVE CLOTHES, LTD.

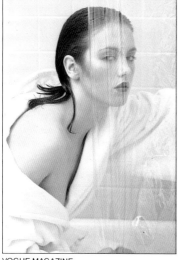

VOGUE MAGAZINE

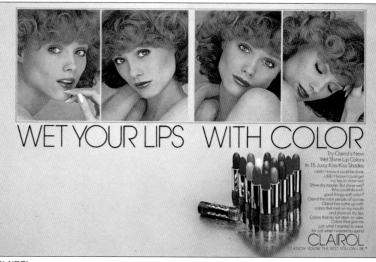

CLAIROL

MAUREEN LAMBRAY
New York City (212) 879-3960

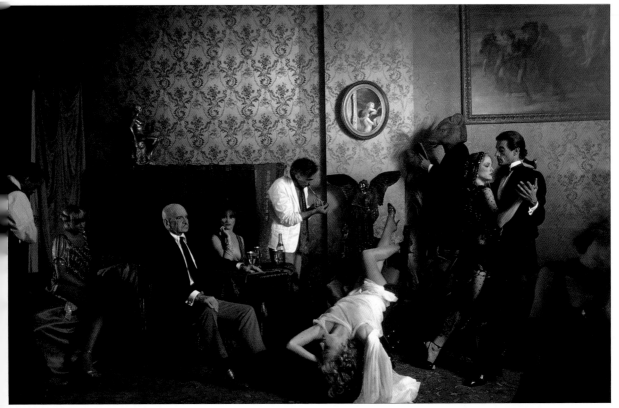

NUNN BUSH SHOES

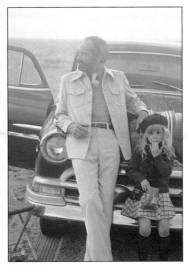

TREVIRA

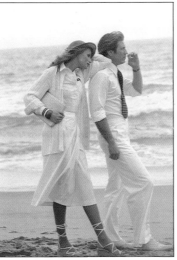

T. JONES SPORTSWEAR

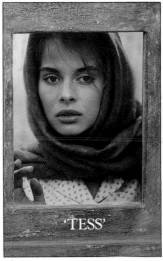

'TESS'

COLUMBIA PICTURES

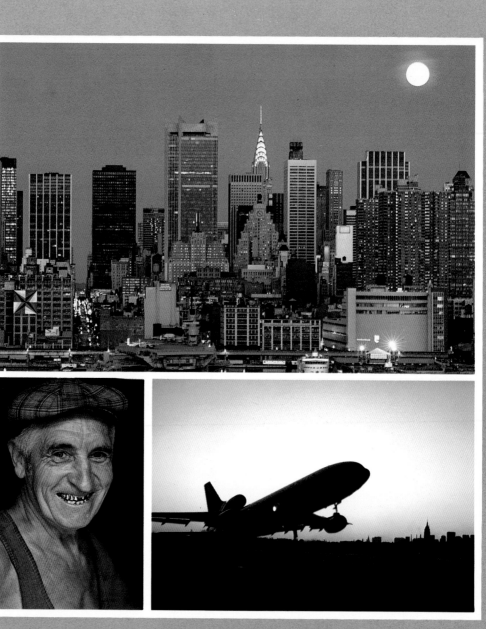

Catherine
Ursillo

1040 PARK AVENUE·
NEW YORK, NY 10028
(212) 722-9297

Richard Levy

*5 West 19th Street
New York City 10011
212 243 4220*

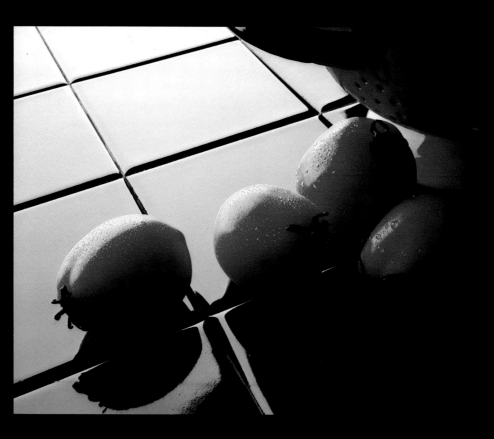

*IBM, Winthrop Labs,
Lever Brothers,
Gabriel Toys,
McNeil Labs, Ayerst,
Chanel, R.J. Reynolds,
Estee Lauder, Izod,
Philip Morris, Monet,
Schering Plough, Aramis,
Asta Cookware, Beecham,
Commodore Computers,
Schmidt's Brewery,
Kentile Floors,
Smith Kline & French,
Business Week,
Ralph Lauren Cosmetics,
Minolta Cameras,
Owens-Corning Fiberglas*

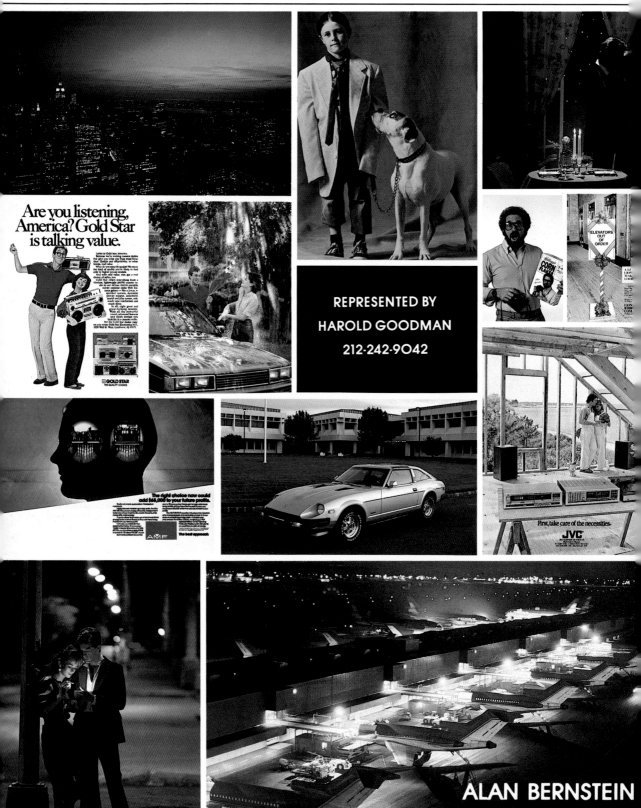

REPRESENTED BY
HAROLD GOODMAN
212·242·9042

ALAN BERNSTEIN
365 FIRST AVE. NYC, NY 10010
212-254-1355

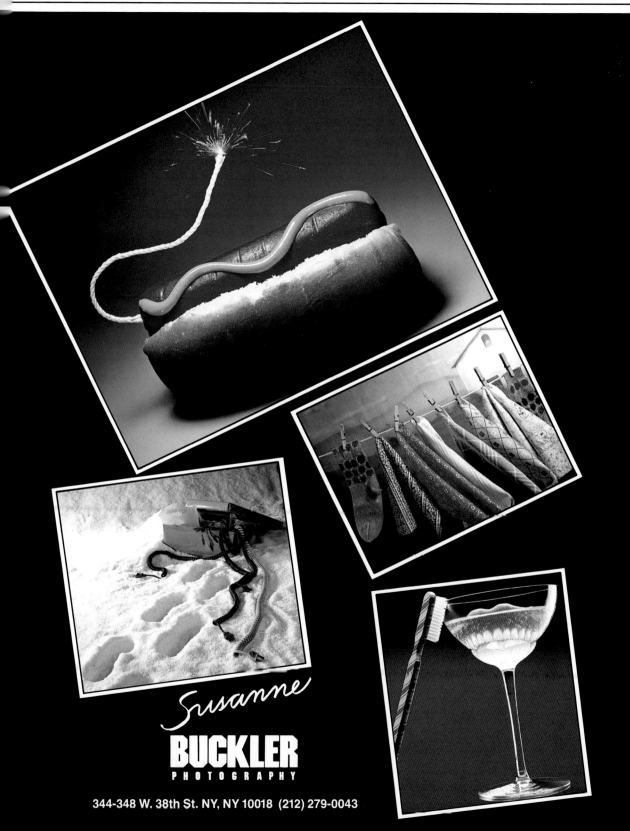

Susanne
BUCKLER
PHOTOGRAPHY
344-348 W. 38th St. NY, NY 10018 (212) 279-0043

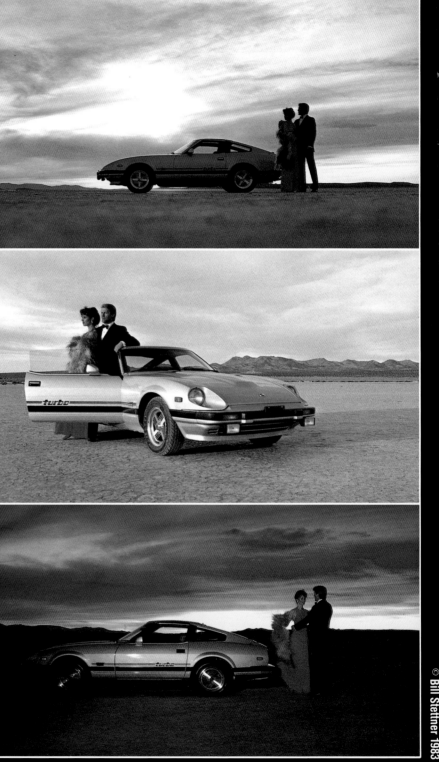

118 East 25th Street, New York, N.Y. 10010 (212) 460-8180

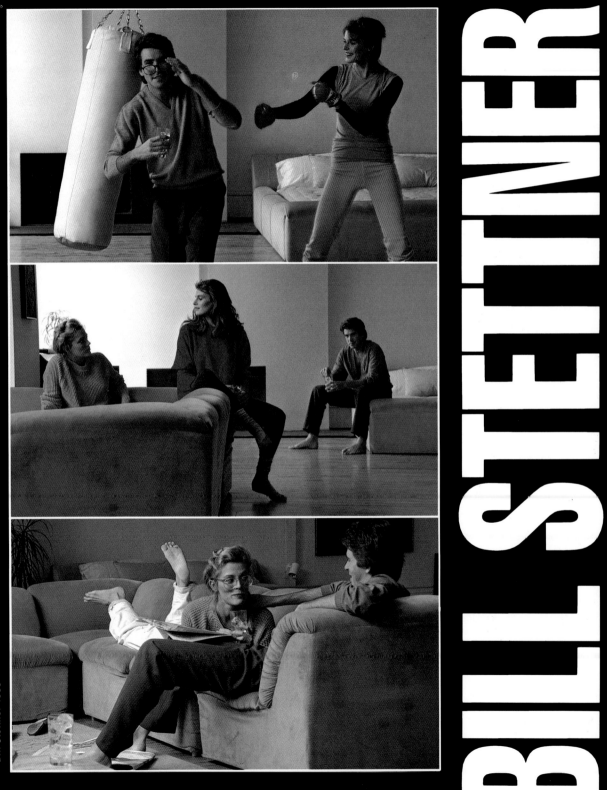

118 East 25th Street, New York, N.Y. 10010 (212) 460-8180

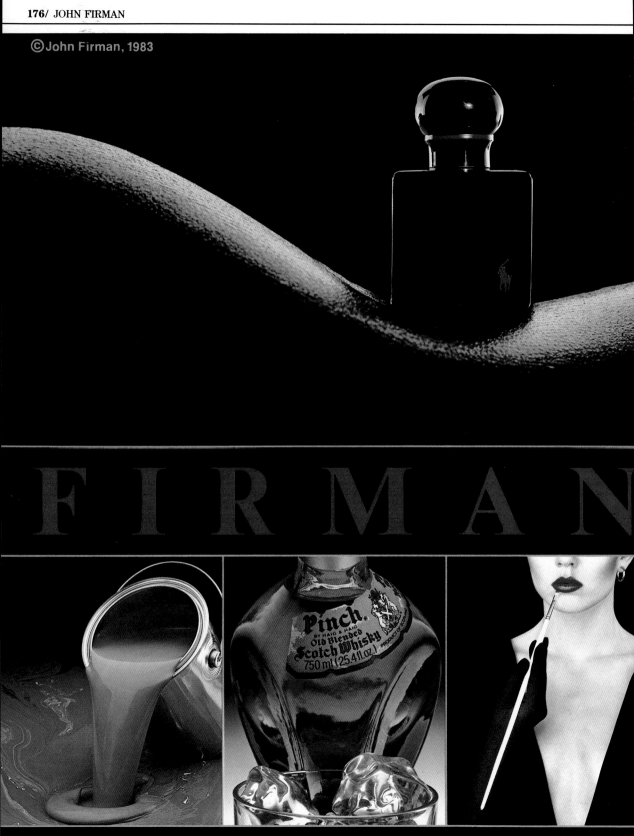

© John Firman, 1983

FIRMAN

JOHN FIRMAN 434 EAST 75th STREET NEW YORK, N.Y. 10021 (212) 794-279

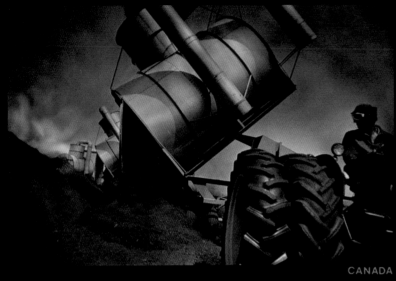

CANADA

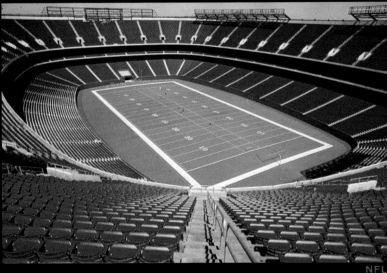

NFL

Clients:
IBM, American Cyanamid, Westvaco, Combustion Engineering, ABC, CBS, Ingersoll-Rand, Texaco, NFL, Time Magazine, New York Magazine, Bowne & Co., Business Week Magazine.

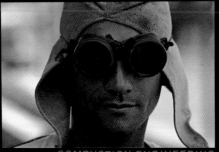

COMBUSTION ENGINEERING

460 West 24th Street
New York, N.Y. 10011
(212) 691-6878

EDGEWORTH

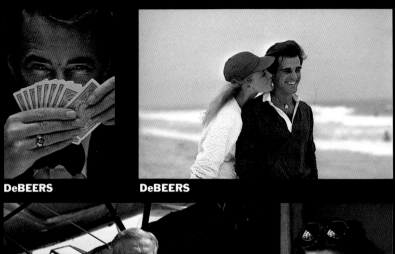

DeBEERS **DeBEERS**

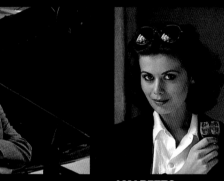

EASTERN AIRLINES **AMARETTO**

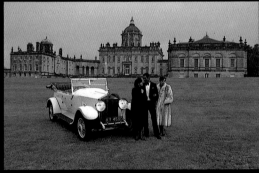

KOOL CIGARETTES **JORDAN MARSH**

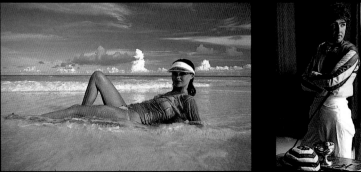

NIKON **FIELDCREST**

Anthony Edgeworth, Inc. 333 Fifth Avenue New York, N.Y. 10016 (212) 679 6031

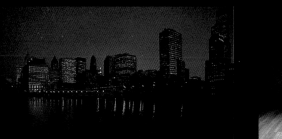

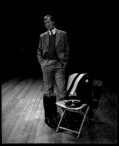

AMTRAK

R.S.C. GEO

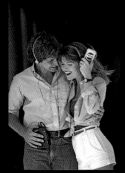

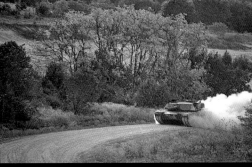

PEPSI COLA

U.S. ARMY

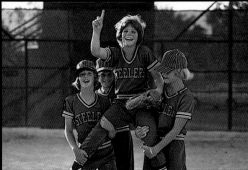

ARAMCO

TOWN & COUNTRY

EDGEWORTH

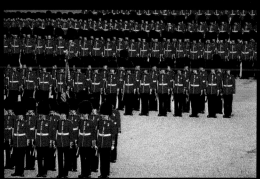

DeBEERS

"THE GUARDS"

Anthony Edgeworth, Inc. 333 Fifth Avenue New York, N.Y. 10016 (212) 679 6031

Cy Gross

59 West 19th Street
New York, New York 10011
212-243-2556

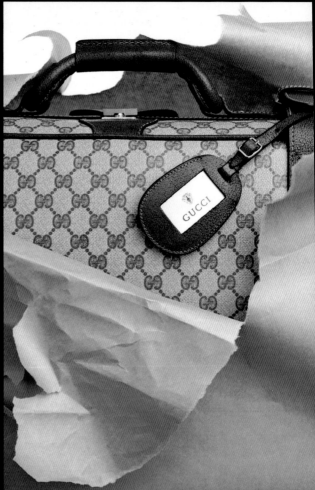

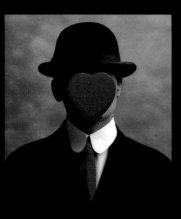

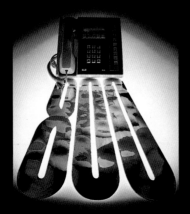

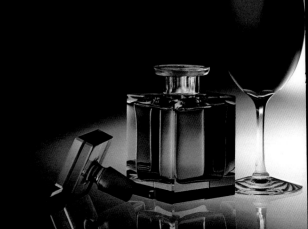

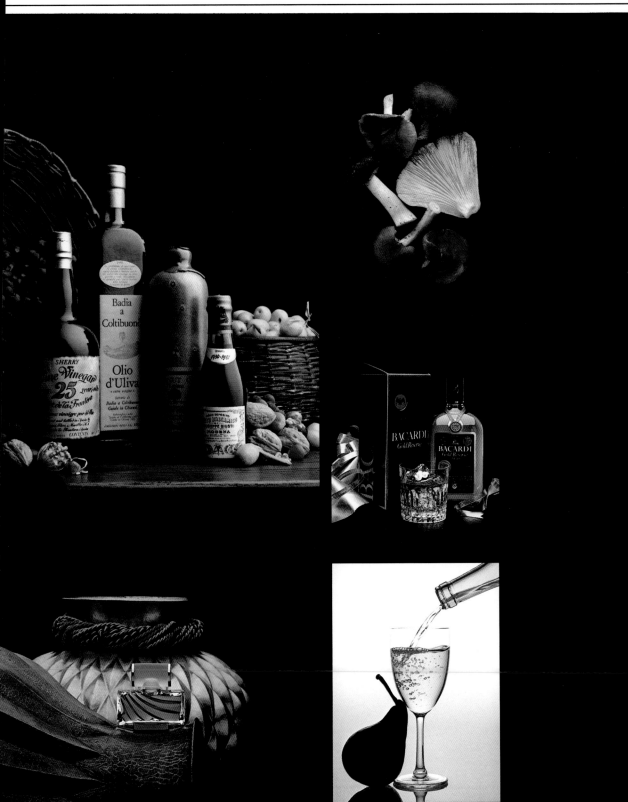

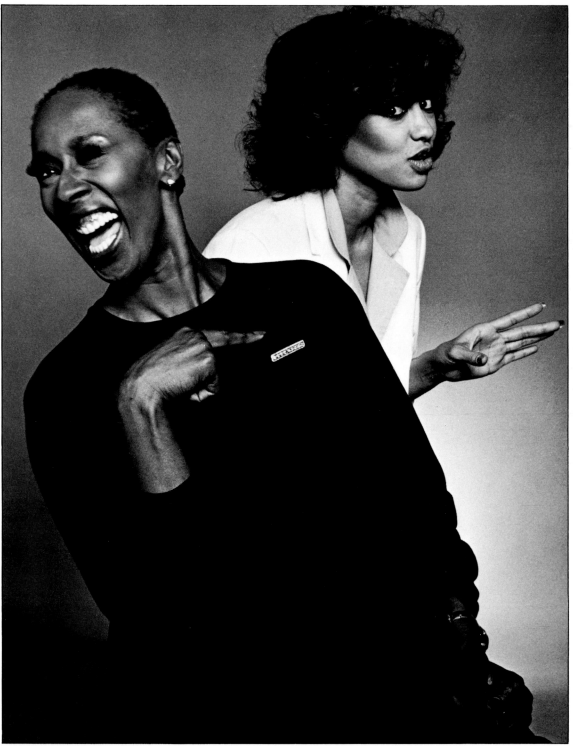

Judith Jamison & Phyllis Hyman, ESSENCE

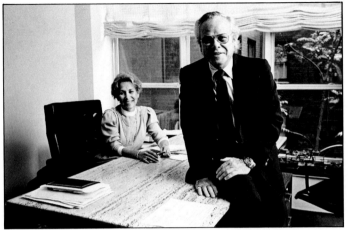

Eugene & Inge Judd, JUDD-FALK, INC.

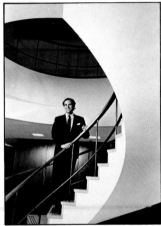

Peter Douglas, AMERICAN LAWYER

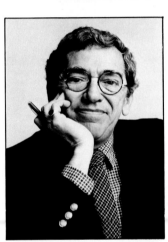

George Soter, ADWEEK

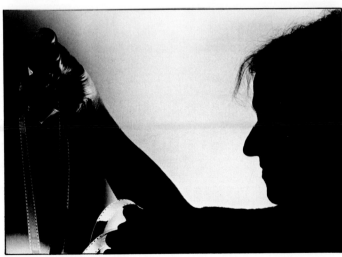

Faith Hubley, HUBLEY STUDIO, INC.

Olita Day
29 East 19th Street,
New York, N.Y.
10003
212-673-9354

© Olita Day 1982

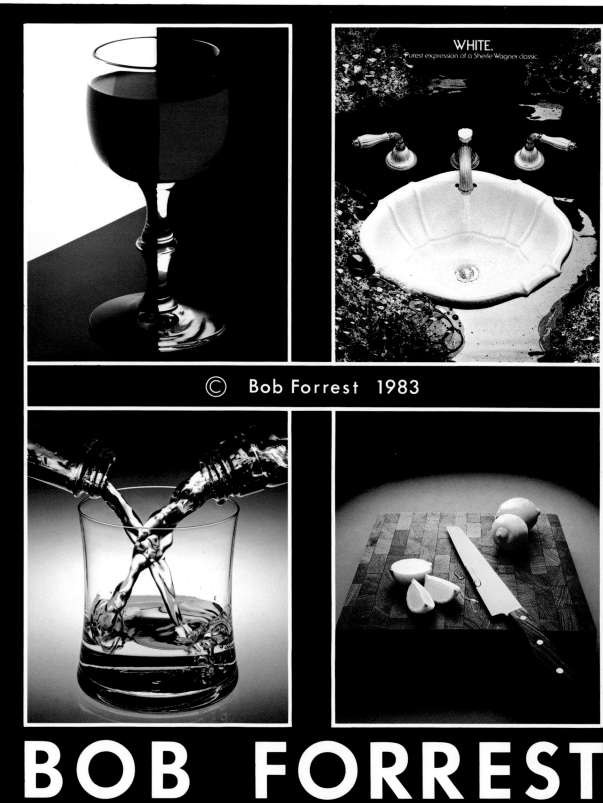

© Bob Forrest 1983

WHITE.
Purest expression of a Sherle Wagner classic.

BOB FORREST
273 Fifth Avenue New York City 288-4458

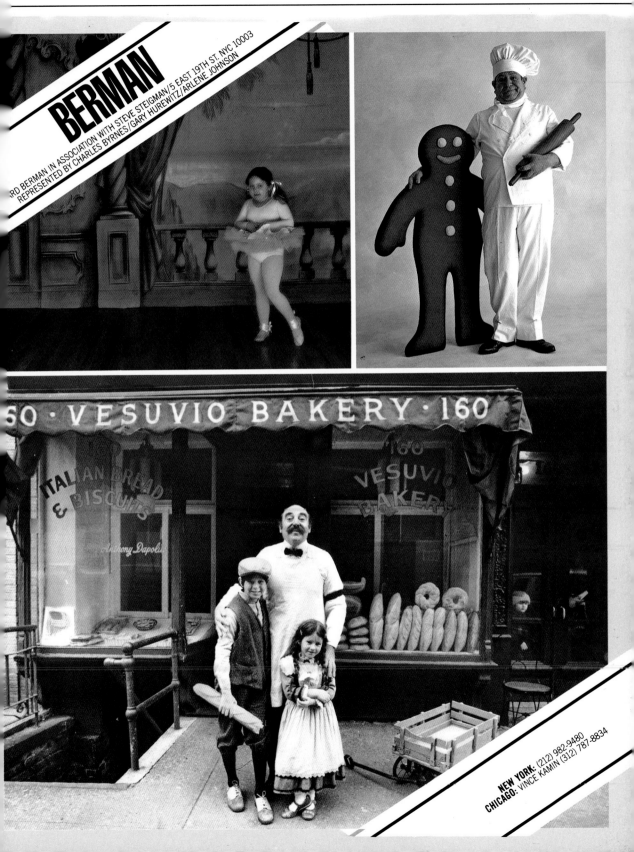

BERMAN

RD BERMAN IN ASSOCIATION WITH STEVE STEIGMAN/5 EAST 19TH ST. NYC 10003
REPRESENTED BY CHARLES BYRNES/GARY HUREWITZ/ARLENE JOHNSON

SO · VESUVIO BAKERY · 160

ITALIAN BREAD
& BISCUITS

Anthony Dapolito

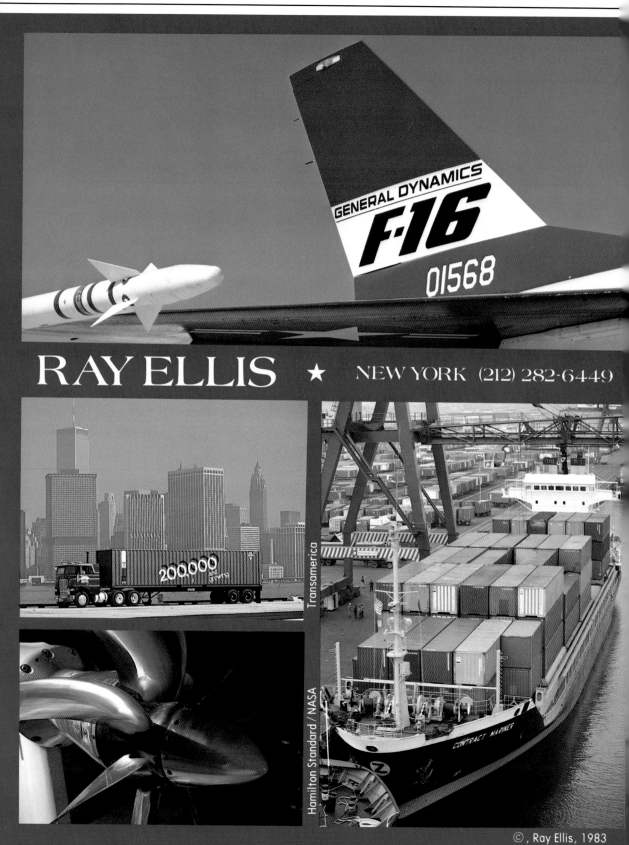

RAY ELLIS ★ NEW YORK (212) 282-6449

Transamerica

Hamilton Standard / NASA

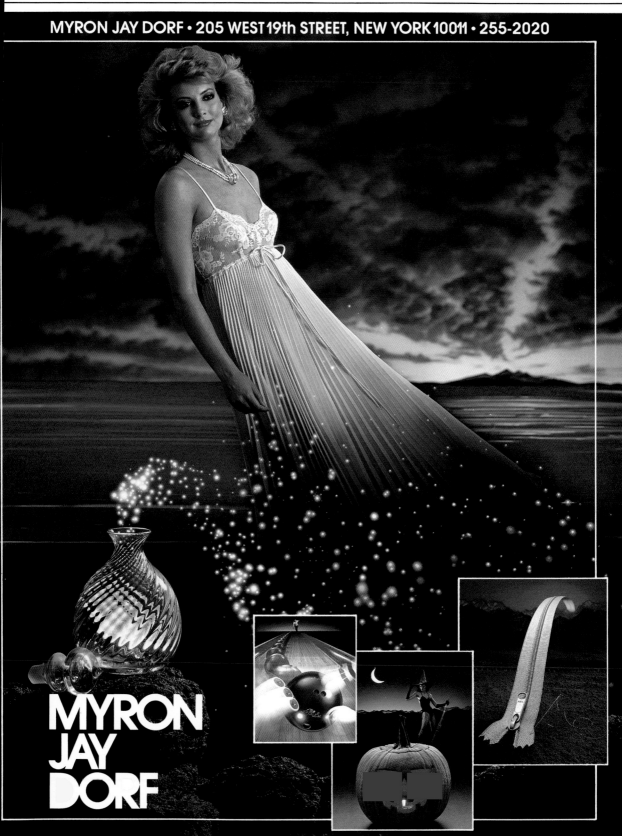

MYRON
JAY
DORF

WENDY BARROWS
(212) 685-0799

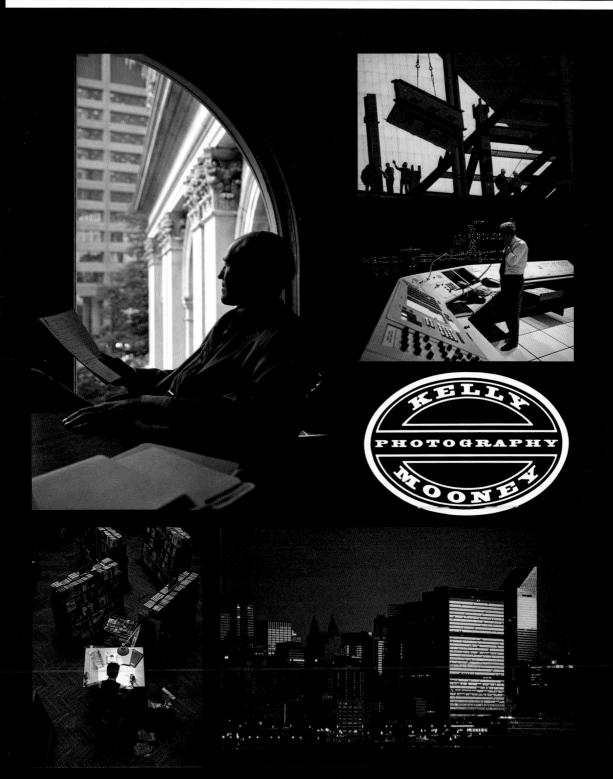

Tom Kelly & Gail Mooney (212) 360-2576
Location / Corporate / Advertising / Editorial

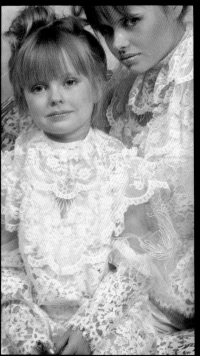

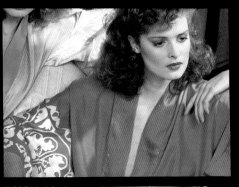
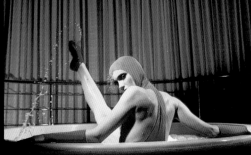
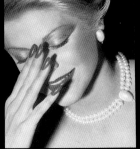

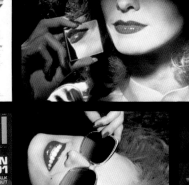
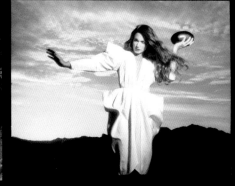

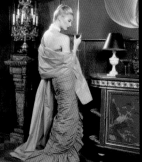

L U C I L L E

LUCILLE KHORNAK 425 EAST 58TH STREET, NEW YORK, N.Y. 10022 (212) 593-0933

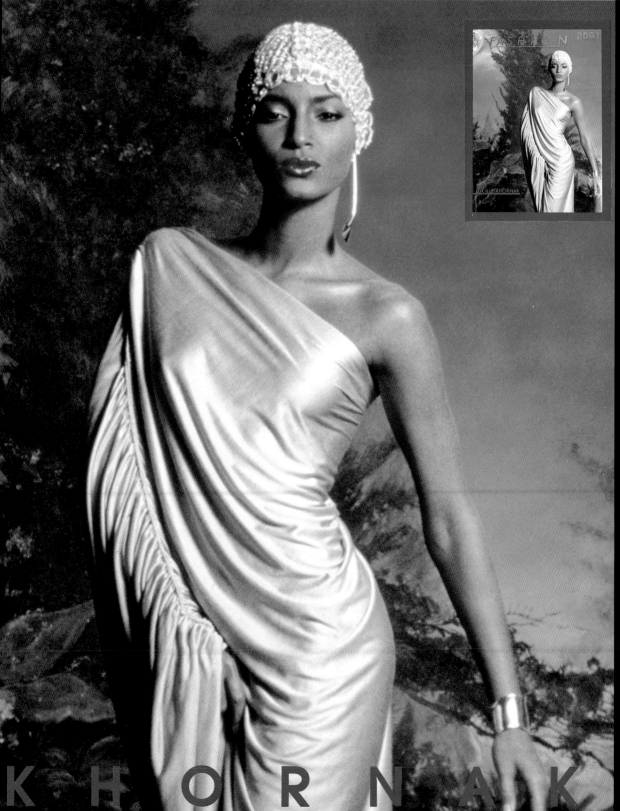

KHORNAK

LUCILLE KHORNAK 425 EAST 58TH STREET, NEW YORK, N.Y. 10022 (212) 593-0933

BILL BERNSTEIN

59 THOMPSON STREET, NEW YORK, NY 10012
TELEPHONE: (212) 925-6853

CORPORATE/INDUSTRIAL AND EDITORIAL PHOTOGRPAHY.

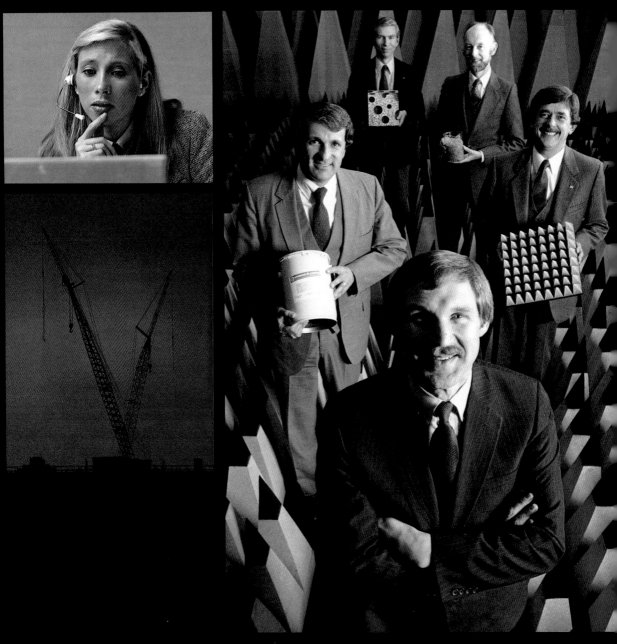

© 1983, BILL BERNSTEIN

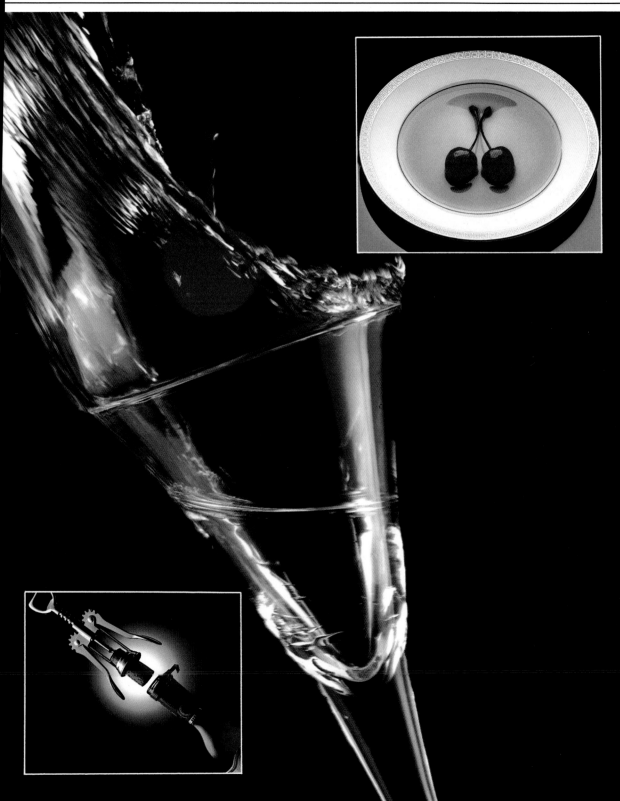

Peter Johansky 108 E. 16th Street N.Y., N.Y. 10003 (212) 260-4 01, (212) 361-7400

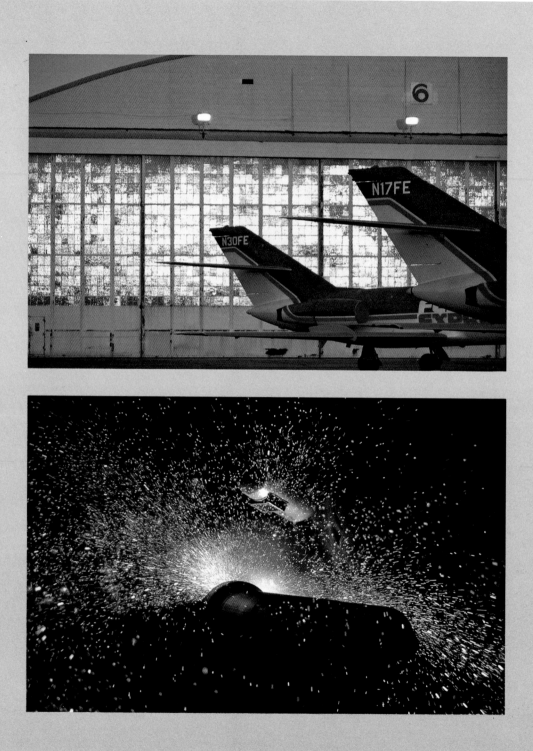

ALAN BOLESTA 11 RIVERSIDE DRIVE NYC 10023 212-873-1932

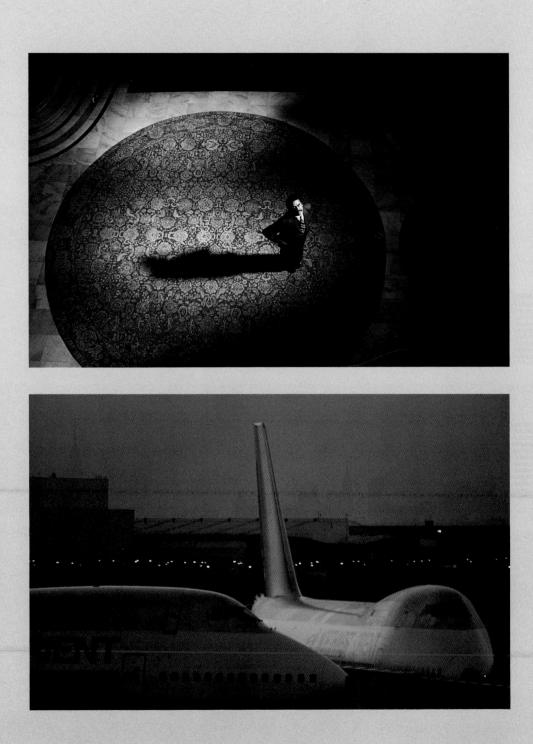

ALAN BOLESTA 11 RIVERSIDE DRIVE NYC 10023 212-873-1932

AL FRANCEKEVICH

PHOTOGRAPHY • 73-5TH AV. N.Y., N.Y. 10003 (212) 691-7456

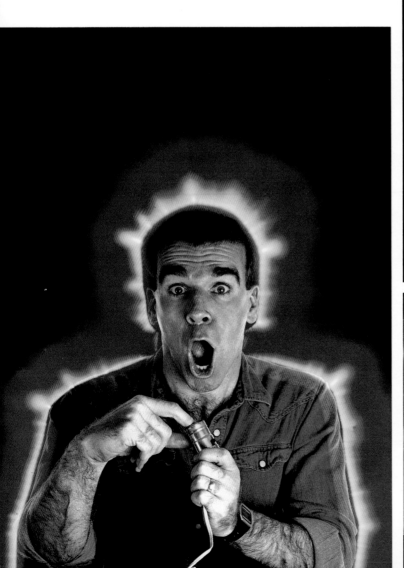

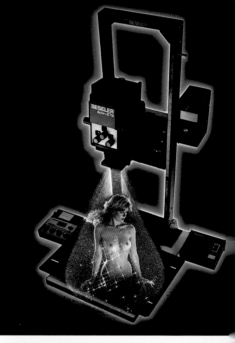

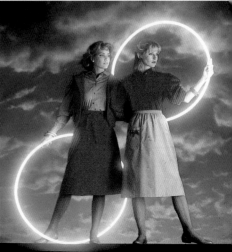

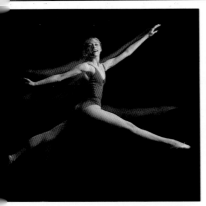

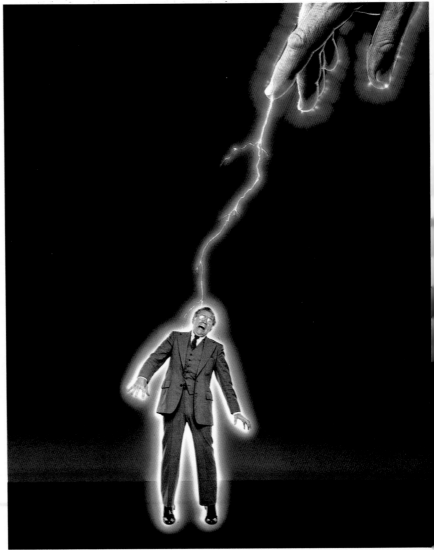

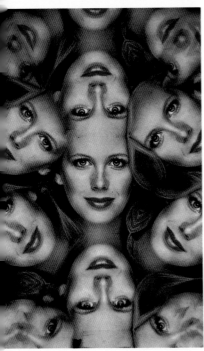

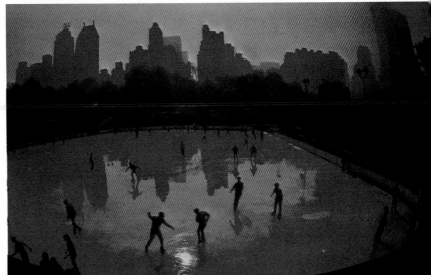

William Hubbell

Photography

99 East Elm Street
Greenwich
Connecticut 06830
203 • 629 • 9629

Representative:
Marian Hubbell
203-629-9629

Corporate — industrial — advertising
Location — studio
35 mm — 2¹/₄ — 4 x 5 — 8 x 10.

Stock:
Woodfin Camp & Assoc.
212-750-1020

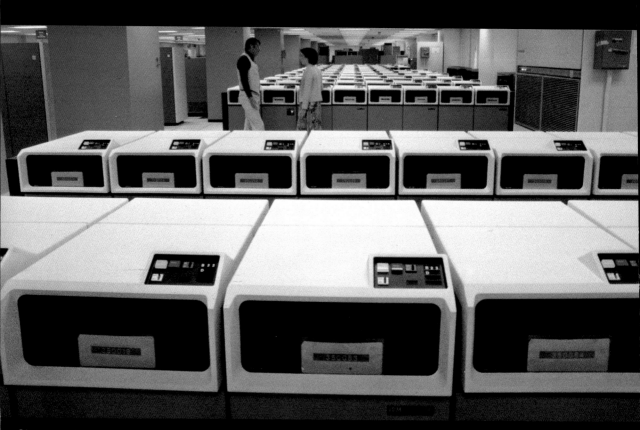

Chemical Bank

© William Hubbell, 198

William Hubbell

Photography

99 East Elm Street
Greenwich
Connecticut 06830
203 • 629 • 9629

Bill has worked with Fortune 500
companies, corporate publications,
business magazines and design
firms. We would be delighted to send
specific lists of clients and portfolio
materials upon request.

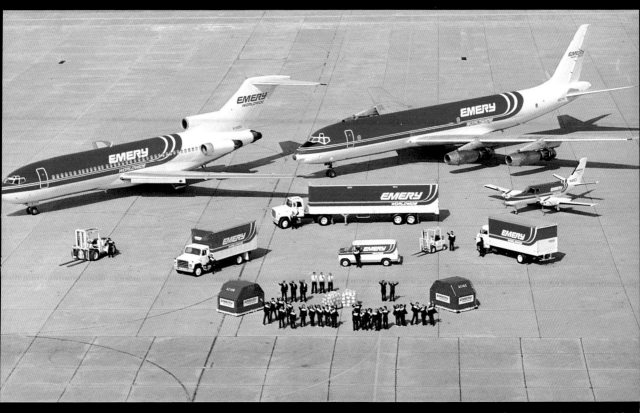

Emery Worldwide

Peter Weidlein
122 W. 26 N.Y.C. 212·989·5498

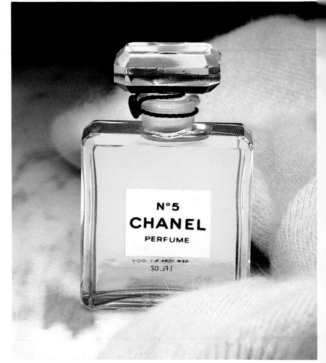

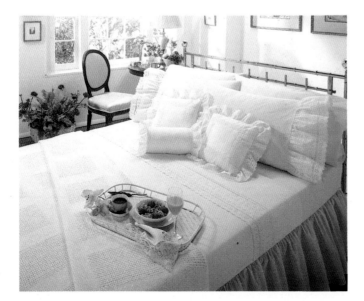

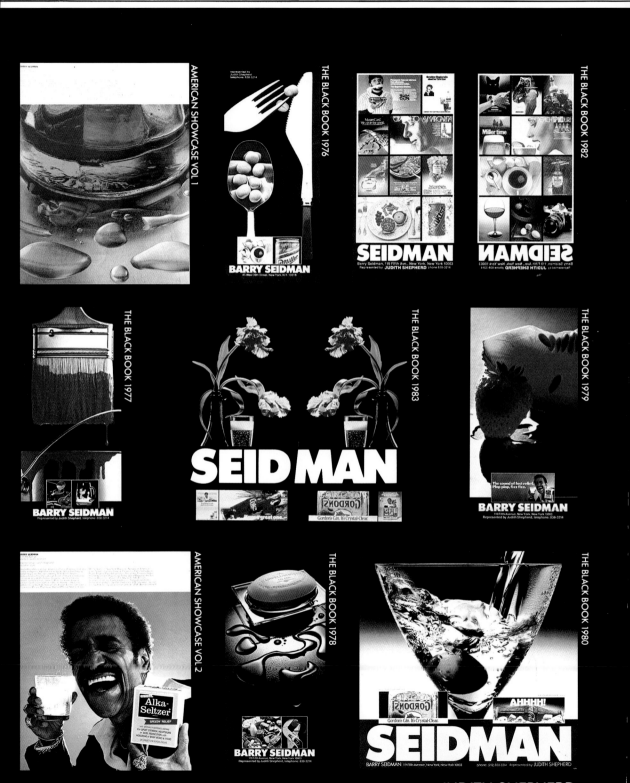

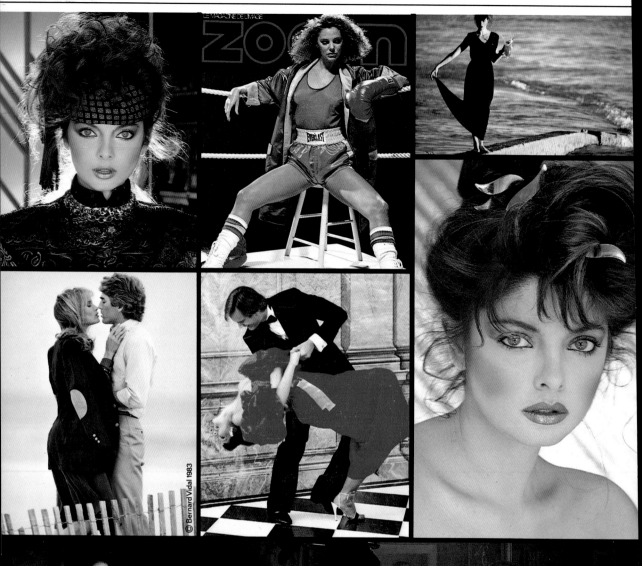

© Bernard Vidal 1983

VIDAL
REPRESENTED BY RITA HOLT 212·683·2002/212·582·3284

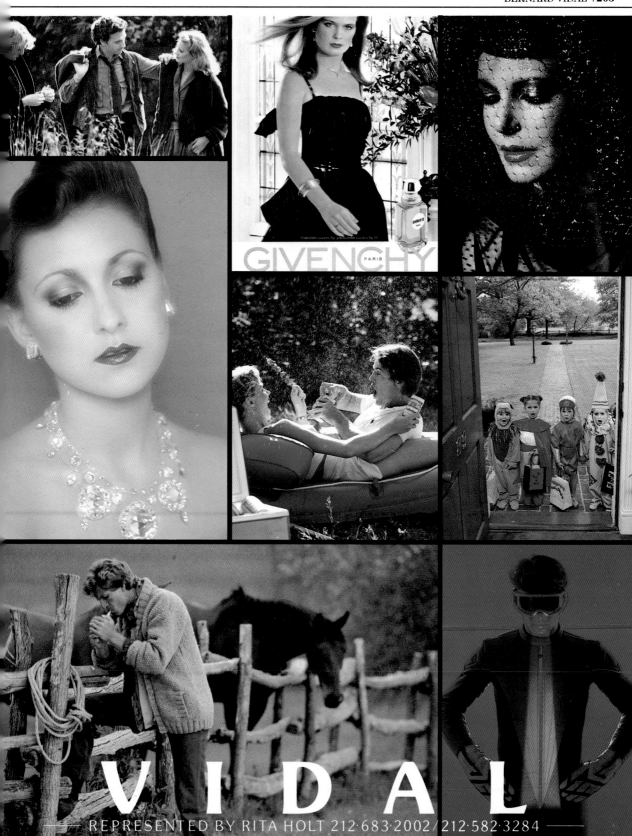

GIVENCHY PARIS

VIDAL
REPRESENTED BY RITA HOLT 212·683·2002 / 212·582·3284

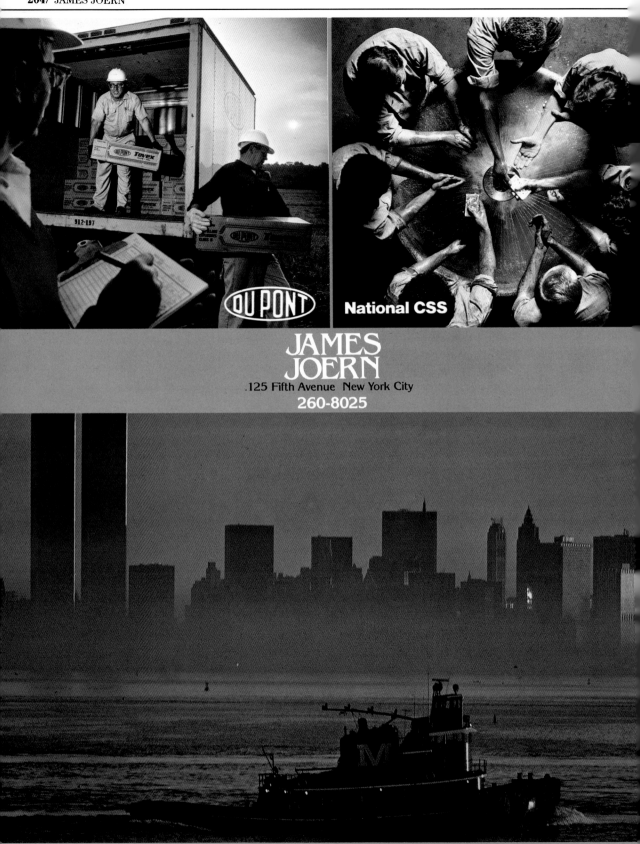

DU PONT

National CSS

JAMES JOERN
125 Fifth Avenue New York City
260-8025

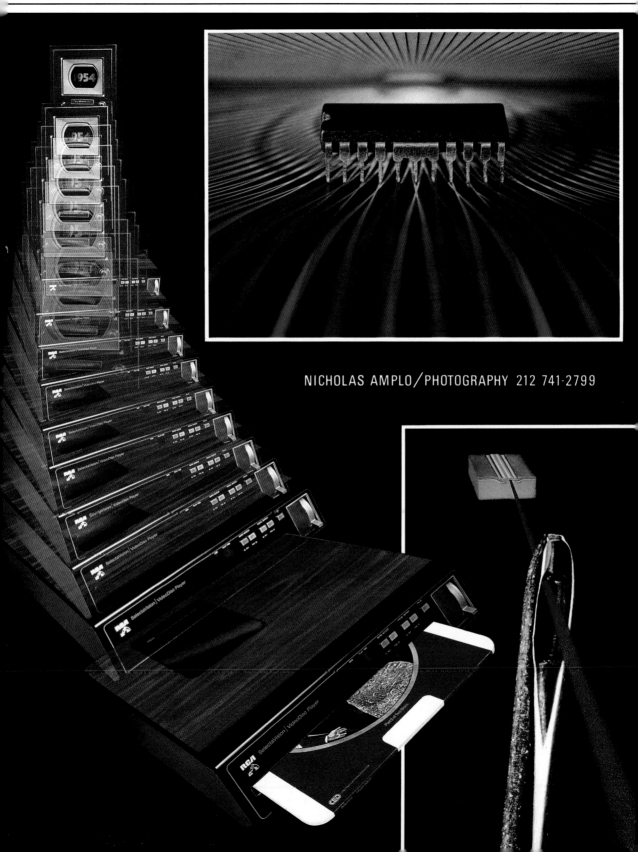

NICHOLAS AMPLO/PHOTOGRAPHY 212 741-2799

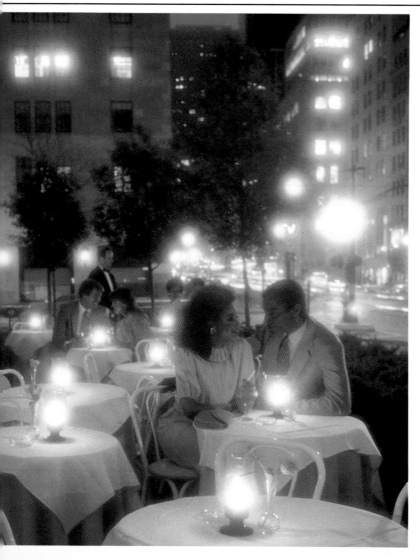

HAL DAVIS
220 EAST 23RD ST.
NEW YORK 10010
212-689-7787
REPRESENTED BY
KEN MANN
212-245-3192

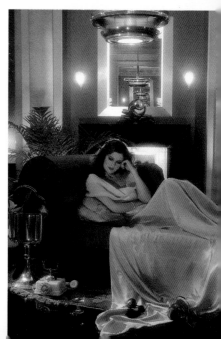

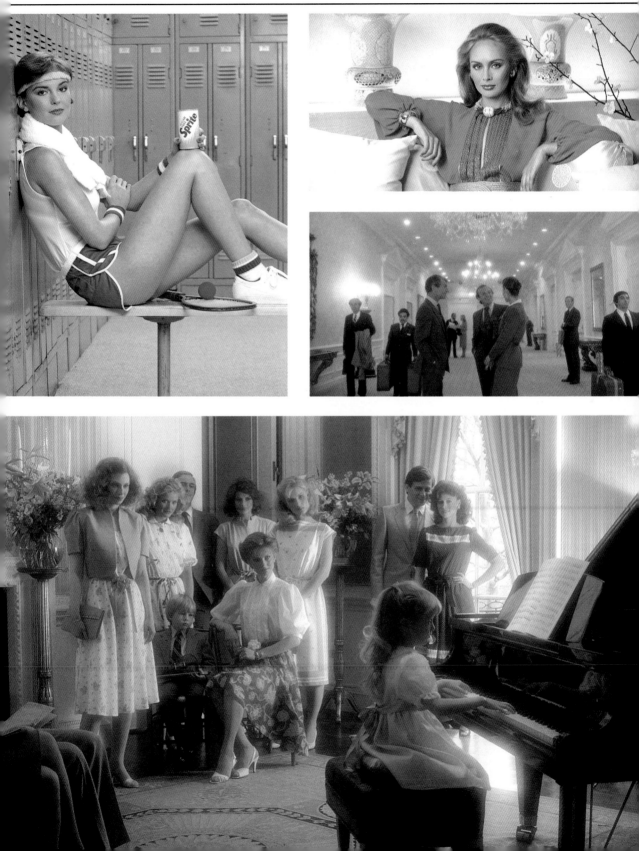

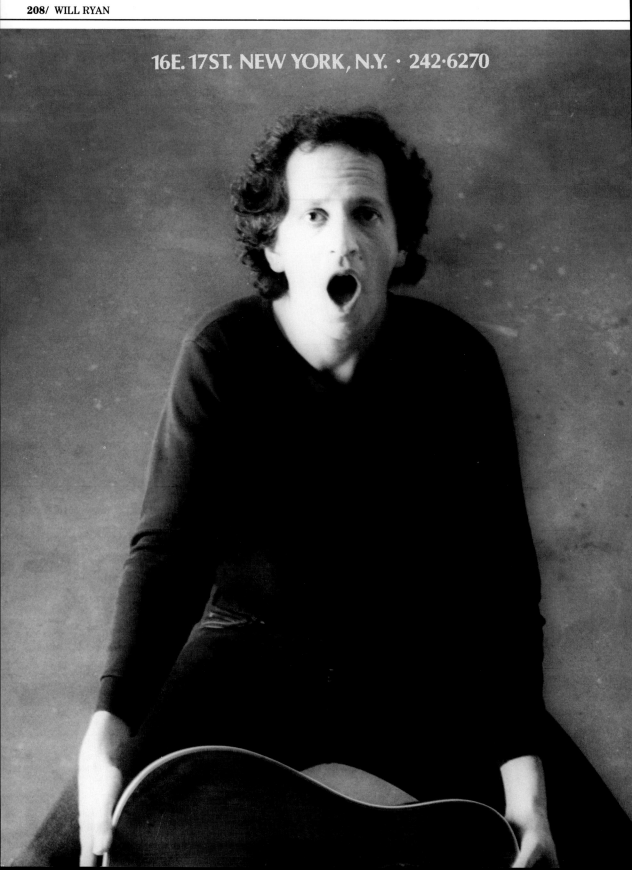

16E. 17ST. NEW YORK, N.Y. · 242·6270

Roger Bester 119 Fifth Avenue New York 10003 (212) 254-0108

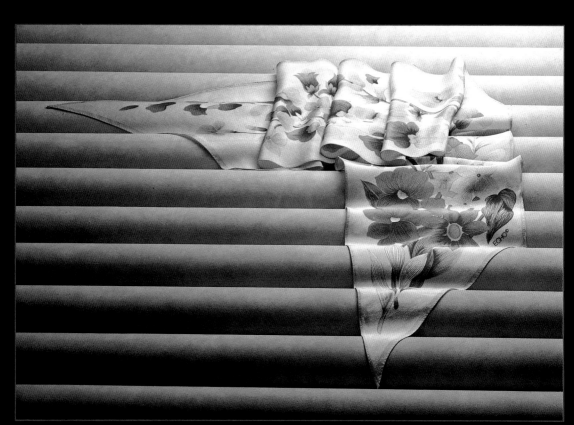

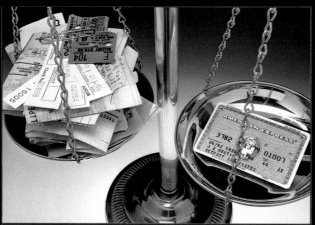

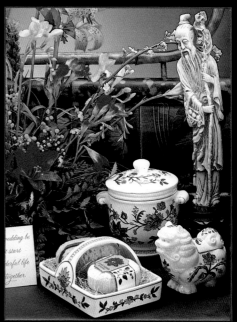

JEFF GLANCZ
38 WEST 21 STREET, NEW YORK 10010
212 741-2504

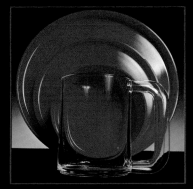

JEFF GLANCZ

38 WEST 21 STREET, NEW YORK 10010
212 741-2504

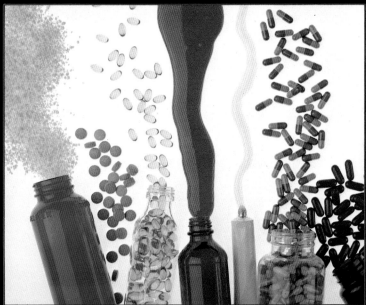

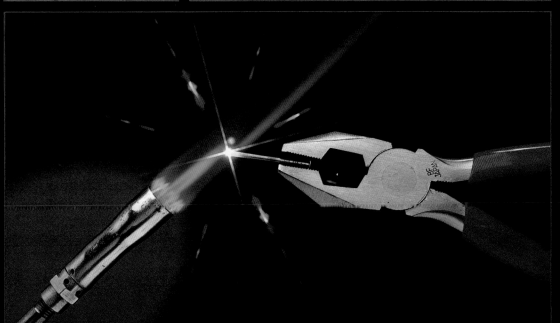

Bill Miller

The Fanwall Corporation

Cushman & Wakefield

"Our competition stood up and took notice.
Our correspondents stood up and cheered!"

R. L. Polk & Co. Inc.

OAG/FREQUENT FLYER

CONCORDE
THE FIRST FIVE YEARS

BOOKING A SEAT:
THE NEW ALTERNATIVES
GUIDE TO AIRLINE CLUBS
FREQUENT FLYERS AS
ABSENT PARENTS
EGON RONAY: PORTRAIT
OF AN ANGRY PASSENGER

Air France/Frequent Flyer Magazine

OAG/FREQUENT FLYER

DO RESERVATION COMPUTERS PLAY FAIR?

Frequent Flyer Magazine

Bob Guccione

36 East 20th St.
New York, N.Y.
10003
212-674-8026

YENACHEM
35W 31ST STREET NEW YORK NY 10001

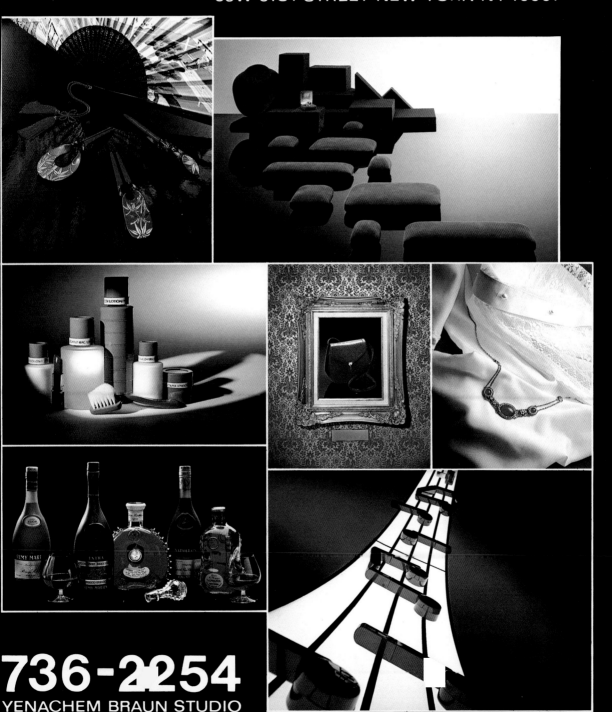

736-2254
YENACHEM BRAUN STUDIO

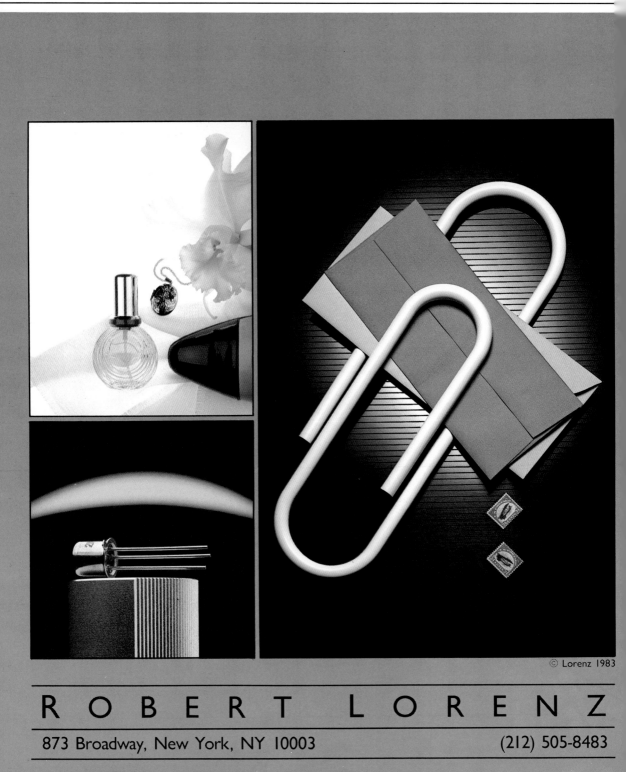

© Lorenz 1983

R O B E R T L O R E N Z

873 Broadway, New York, NY 10003 (212) 505-8483

CARDACINO

123 WEST 28TH STREET NEW YORK CITY 10001 212-947-9307

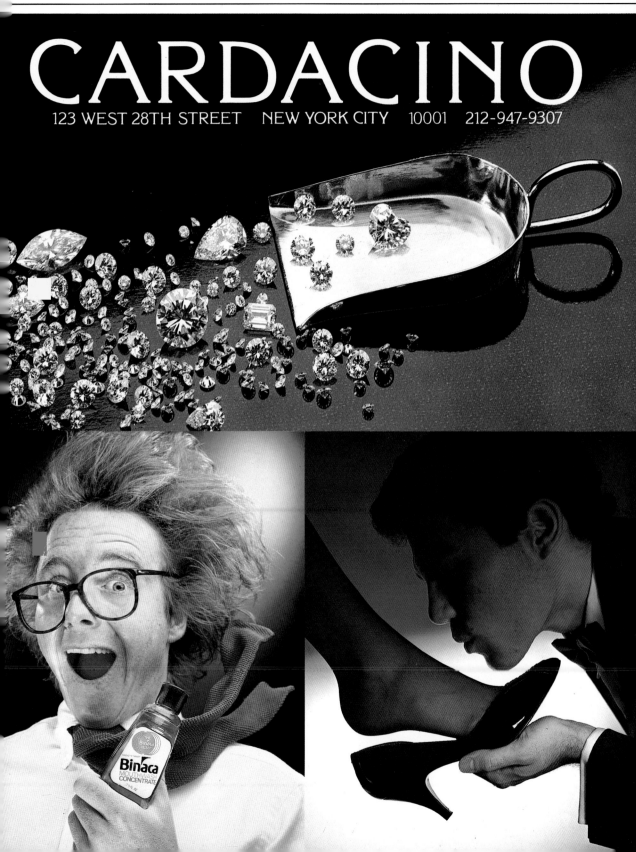

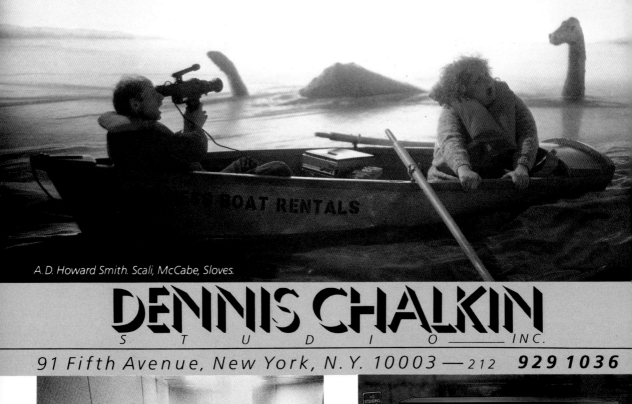

A.D. Howard Smith. Scali, McCabe, Sloves.

DENNIS CHALKIN
S T U D I O ━━━ INC.

91 Fifth Avenue, New York, N.Y. 10003 — 212 **929 1036**

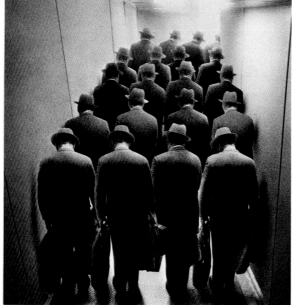

AIRLINES CONSIDER THE BUSINESS TRAVELER THEIR MOST IMPORTANT CUSTOMER. THEY JUST HAVE A FUNNY WAY OF SHOWING IT.

Business travelers are the airlines' bread and butter. They fly the most. They buy the most full fare tickets. They account for most of the revenue.

So why, businessmen ask, don't we get treated better?

Resume tales of delays and discomfort are commonplace on the airlines that some nightclub comedians have built routines around them.

The endless lines. The cattle car conditions on many flights. The odyssey that luggage often goes on before getting to its proper destination a week later. And so on.

Most airlines have an excellent excuse for all this. They've had to cut back their service because of rising fuel costs and other adverse economic factors.

It's the best way to reduce losses, they say.

ANOTHER WAY OF DOING BUSINESS.

SAS had a different approach. We looked at these unfavorable business conditions not only as a problem, but an opportunity as well. The president of SAS recently discussed this attitude.

"The only way you can make money in today's market is to raise business from your competitors. The only way you can do that is to give people better service, almost to force them to ask for an SAS flight instead of simply any flight."

He went on to say, "The business market is where the money is, so we started there."

Talk is cheap, right? Not in this case. It prompted a $24,000,000 investment on the part of SAS.

The objective? To get people to ask for an SAS flight instead of simply any flight.

YOUR RETURN ON OUR INVESTMENT.

First of all, we improved our already excellent punctuality record. Our president even had a computer terminal installed next to his desk to keep a close tab on the results.

But most of that $24,000,000 is being invested in our Business Class service. For commuters like a separate section to our planes, separate check-in facilities and separate lounges in many cities (more are being built at this very moment).

One thing you won't find on SAS, though, is the surcharge that some airlines impose on their business class passengers. (Our Business Class services are complimentary to all full fare passengers.)

IS SAS UNFAIR TO COMPETITORS?

This list these improvements have been getting mixed reviews.

Our passengers love it. Our competitors hate it. One even threatened to block SAS landings at a particular airport.

Obviously, they consider SAS new tactics unfair. We consider them good business. You will too.

SAS
SCANDINAVIAN AIRLINES

A.D. Ron Arnold. Ally & Gargano.

A.D. Ron Becker. Geers Gross.

A.D. Tom Wolsey. Ally & Gargano.

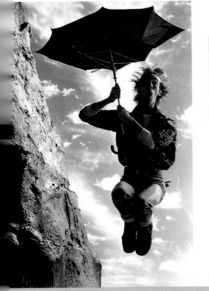

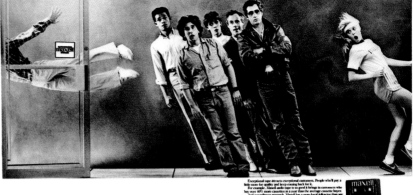

A.D. Cathy Campbell. Scali, McCabe, Sloves.

represented by **BARBARA UMLAS**

212 **534 4008**

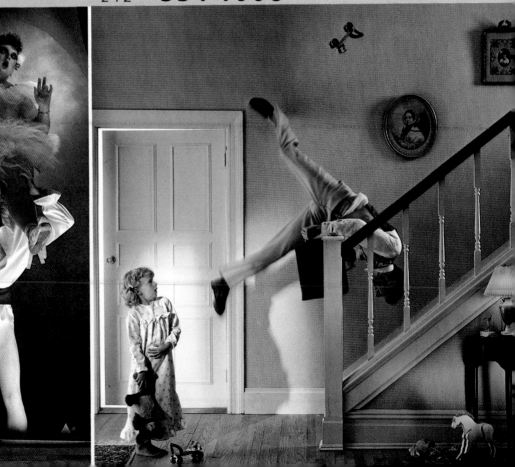

6:42 am

7:36 am

8:02 am

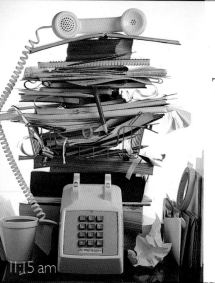

11:15 am

NORA
SCARLETT
37 WEST
TWENTIETH STREET
NEW YORK
NY
10011
(212)
741-2620
REPRESENTED BY
BARBARA
UMLAS
(212) 534-4008

5:57 pm

7:28 pm

9:50 pm

11:49 pm

CLOTHES YOU HAVE TO WEAR VS. CLOTHES YOU LOVE TO WEAR.

The way we figure it, clothes you have to wear make up about half of your wardrobe.

It's suits, and sports jackets, and shirts, and ties, and certain styles of shoes.

These are all clothes that, because of business requirements or social functions, you have to wear. Whether you feel like it or not.

But it's the other half of your wardrobe that we're interested in.

It's the clothes that you can't wait to get into when you can't wait to get out of the clothes you have to wear.

It's your jeans that go back to a time when jeans were called dungarees. After all these years, they still look and fit better than anything else you own.

It's shirts, and chinos, and crew necks, and leather belts, and corduroy jackets that have one thing in common. They've stood the test of time.

It's into this category that we place Timberland® handsewns. Which, you'll find, also get better over time.

The leathers, like any fine leathers, acquire a patina, making them softer and even more supple.

Then there's Timberland's handsewn moccasin construction, rare in this world of cookie-cutter production. This construction allows the shoes to form around your feet, making them so comfortable that you'll hold on to and enjoy them year after year.

Oh, don't get us wrong.

You'll like your Timberland's when you buy them. You're just going to like them a whole lot more after you wear them. And wear them. And wear them.

Timberland®

air passengers dine on china.

...inly you wouldn't choose an ...or its table setting. After all, ...is pretty basic. Which is just the

...en dining out, you expect a ...decorum to be observed. ...ldn't be any different whether ...down to a meal at your favorite ...ant or at 30,000 feet.

...wissair, attitude doesn't vary ...titude. For two reasons.

...ket you purchased from Swissair ...s you to the best we can offer, no ...where you sit. The food Swissair deserves the same.

...wissair serves the best food in ...it is because of the precise care ...es into the preparation of every ...Our chefs take great pride in ...ork. It wouldn't be right to ruin ...paper plates and plastic utensils. ...ve put in a little extra effort. ...at means starting with the basics. ...er we are serving a meal or ...g a reservation. When you pay ...on to the fine points, the rest ...es naturally.

...ad out for yourself what makes ...dinary plate extraordinary. Fly the ...that fills it.

...ssair departs worldwide from ...ork, Boston, Chicago, Toronto ...Montreal.

...l Swissair or your travel agent.

swissair

CHANEL

DOUBLE DUTY. UNDER MAKEUP OR ALONE, HYDRAFILM/PROTECTIVE MOISTURIZER REPLENISHES LOST MOISTURE WHILE MINIMIZING ULTRAVIOLET DAMAGE.

HYDRAFILM

PROTECTIVE MOISTURIZER

CHANEL

PARIS
NEW YORK

1.7 FL. OZ. 50 ML

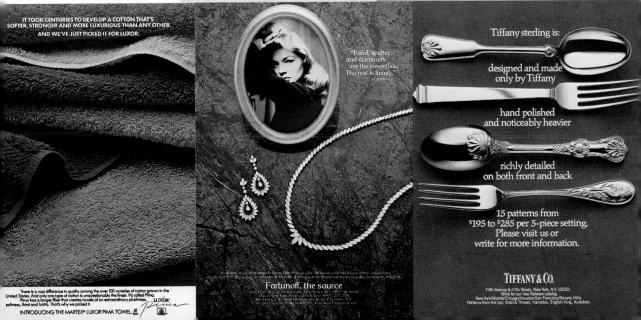

IT TOOK CENTURIES TO DEVELOP A COTTON THAT'S SOFTER, STRONGER AND MORE LUXURIOUS THAN ANY OTHER. AND WE'VE JUST PICKED IT FOR LUXOR.

There is a vast difference in quality among the over 100 varieties of cotton grown in the United States. And only one type of cotton is unquestionably the finest. It's called Pima. Pima has a longer fiber that creates towels of an extraordinary plushness, softness, thirst and lustre. That's why we picked it.

LUXOR Pima

INTRODUCING THE MARTEX® LUXOR PIMA TOWEL.

"Food, shelter and diamonds are the essentials. The rest is luxury."
Lauren Bacall

Fortunoff, the source

Tiffany sterling is:

designed and made
only by Tiffany

hand polished
and noticeably heavier

richly detailed
on both front and back

15 patterns from
$195 to $285 per 5-piece setting.
Please visit us or
write for more information.

TIFFANY & CO.

Fifth Avenue & 57th Street, New York, N.Y. 10022.
Write for our free flatware catalog.
New York/Atlanta/Chicago/Houston/San Francisco/Beverly Hills.
Patterns from the top: Shell & Thread, Hampton, English King, Audubon.

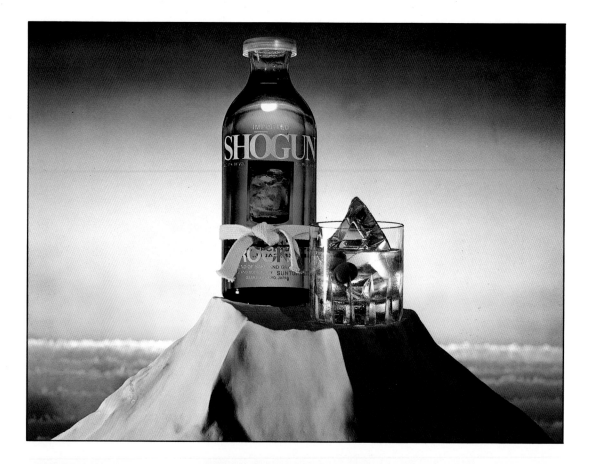

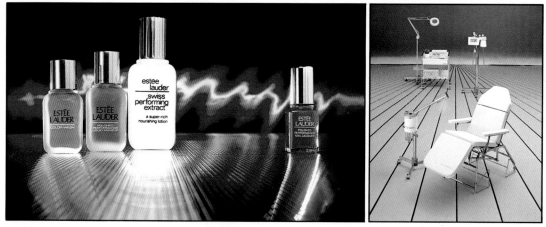

IHARA

5 Union Square West, New York, NY 10003
212/243-4862

Represented by George Creed

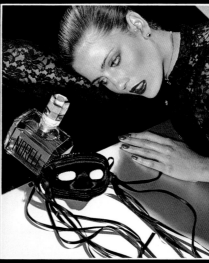

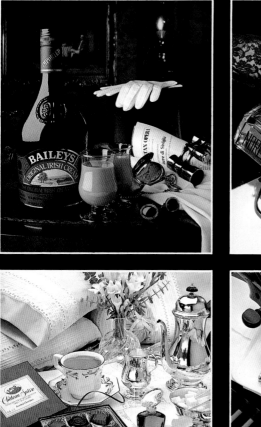

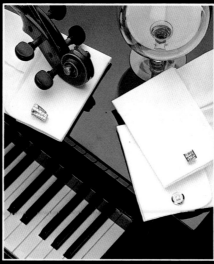

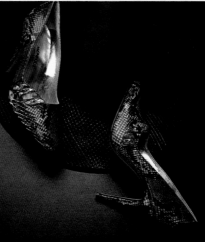

Dicran Studio
100 Fifth Avenue
NYC 10011
(212) 242-0055

HOPKINS

636 Sixth Avenue New York City 10011 212·243·17

Top left to right

Client: Conde Nast/Vogue

Client: Hopkins Stock
Model: Susan Gallagher, Ford Agency

Client: Boston Globe Magazine
Model: Brit Hammer

Client: Conde Nast
AD: Robin Sweet-Wyatt

Client: Revlon/Health Magazine
AD: Randy Dunbar

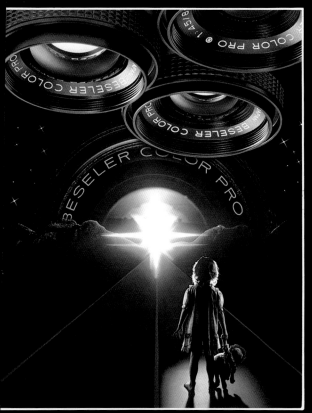

Drew De Grado Studio 212-860-0062

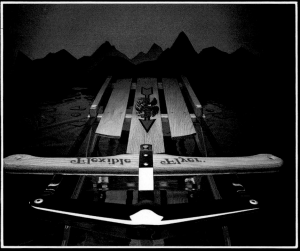

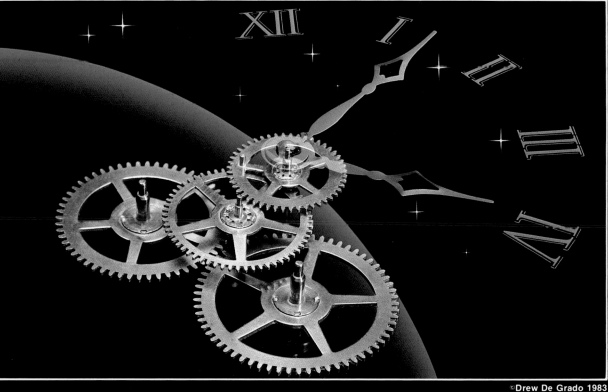

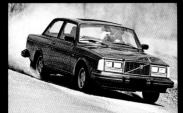
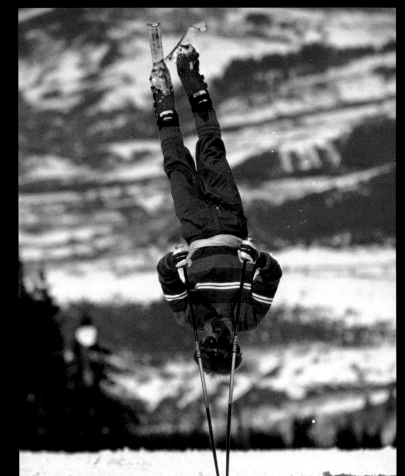

daniel hechter menswear

Like Every Style You've Never Seen...

Dan Baliotti

101 Fifth Avenue New York, N.Y. 10016 212 989-4600

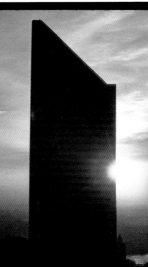

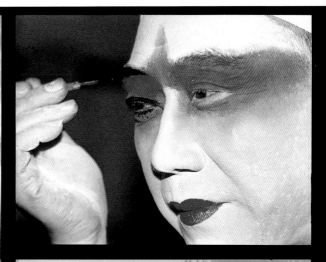

Marvin E. Newman
227 Central Park West
New York, N.Y. 10024
212/362-2044

Annual Review/Citicorp

We can't tell you who banks at Morgan.
But we can tell you why.

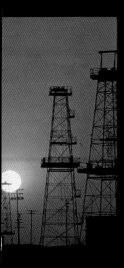

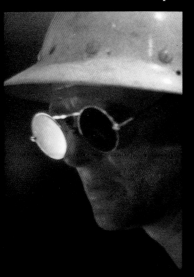

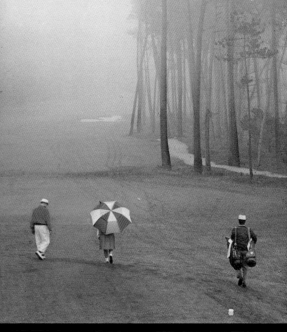

The Morgan Bank

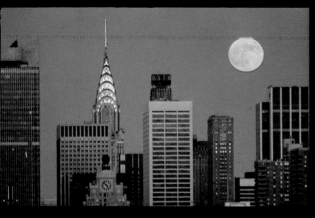

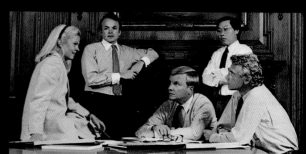

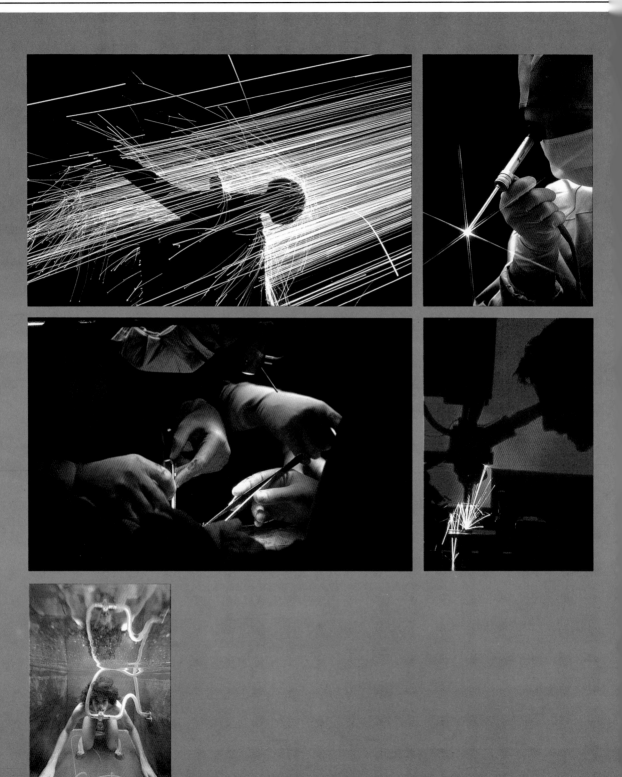

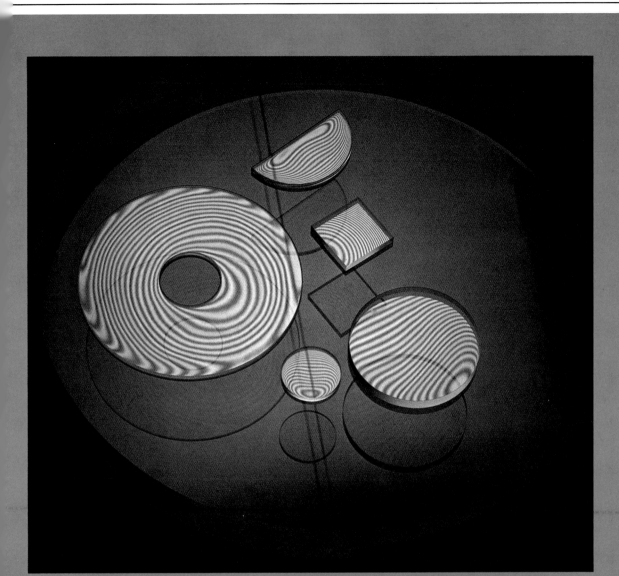

BURT GLINN

41 Central Park West
New York, N.Y. 10023
212/877-2210

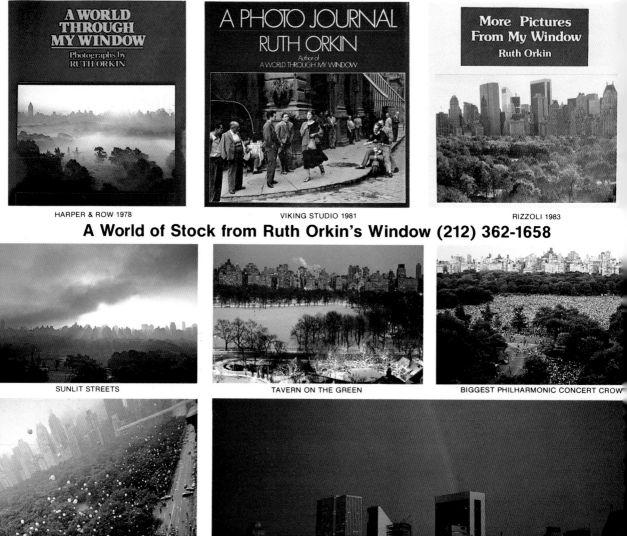

A WORLD THROUGH MY WINDOW
Photographs by RUTH ORKIN

HARPER & ROW 1978

A PHOTO JOURNAL
RUTH ORKIN
Author of
A WORLD THROUGH MY WINDOW

VIKING STUDIO 1981

More Pictures From My Window
Ruth Orkin

RIZZOLI 1983

A World of Stock from Ruth Orkin's Window (212) 362-1658

SUNLIT STREETS

TAVERN ON THE GREEN

BIGGEST PHILHARMONIC CONCERT CROW

START OF WOMEN'S MINI-MARATHON

CITICORP RAINBOW

PINK SKY

STARTING LINE — WOMEN'S MARATHON

COUPLE IN SNOW

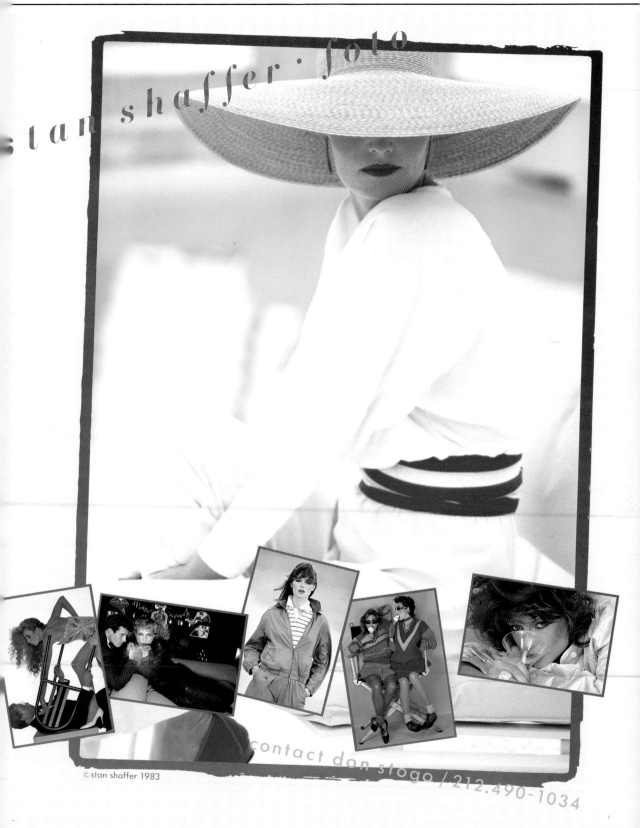

stan shaffer · foto

©stan shaffer 1983

contact don stogo / 212.490-1034

Peter B. Kaplan
126 W 23rd St
NYC 10011
212-989-5215

Some of the clients that Peter "B." has taken to greater heights have been: Fortune, Life, Smithsonian, Amoco, ATT, Goodyear, Philip Morris, Statue of Liberty Commission, Tenneco, Ogilvy and Mather and Wells, Rich, Greene.

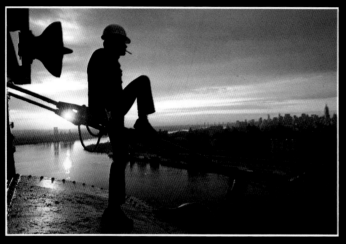

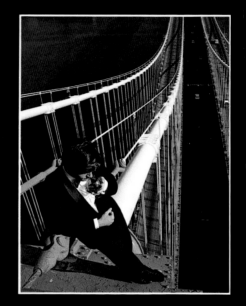

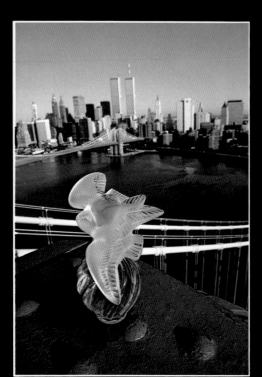

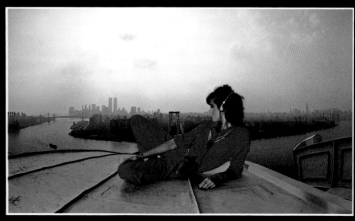

Stock available through studio

Stock available through studio

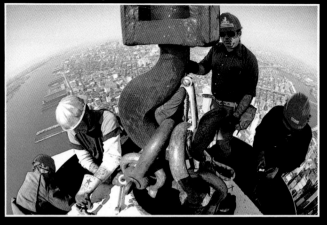

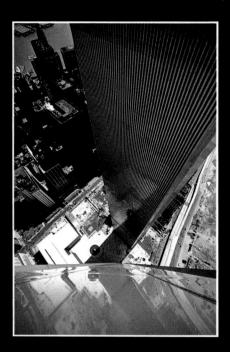

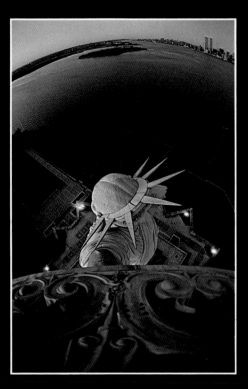

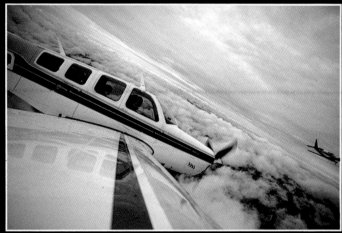

Some of the clients that Peter "B." has taken to greater heights have been: Fortune, Life, Smithsonian, Amoco, ATT, Goodyear,

Philip Morris, Statue of Liberty Commission, Tenneco, Ogilvy and Mather and Wells, Rich, Greene.

Peter B. Kaplan
126 W 23rd St
NYC 10011
212-989-5215

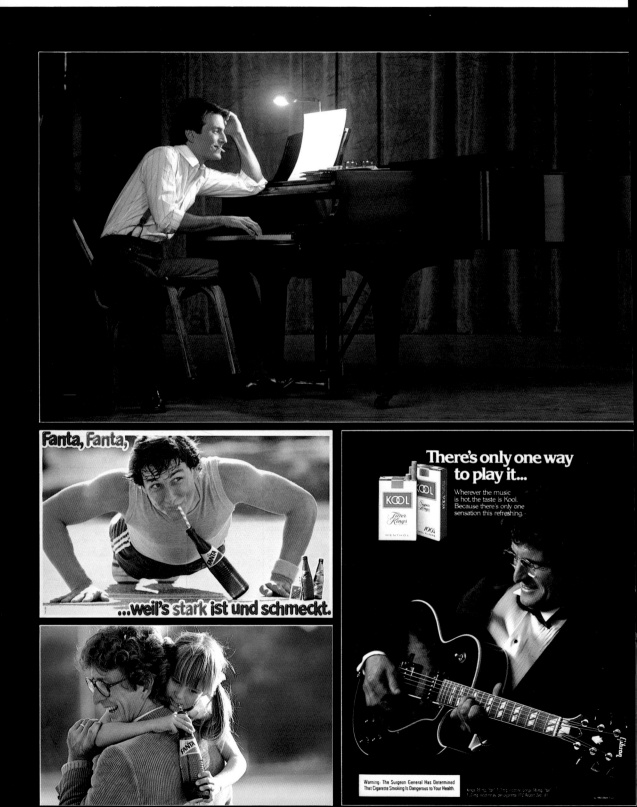

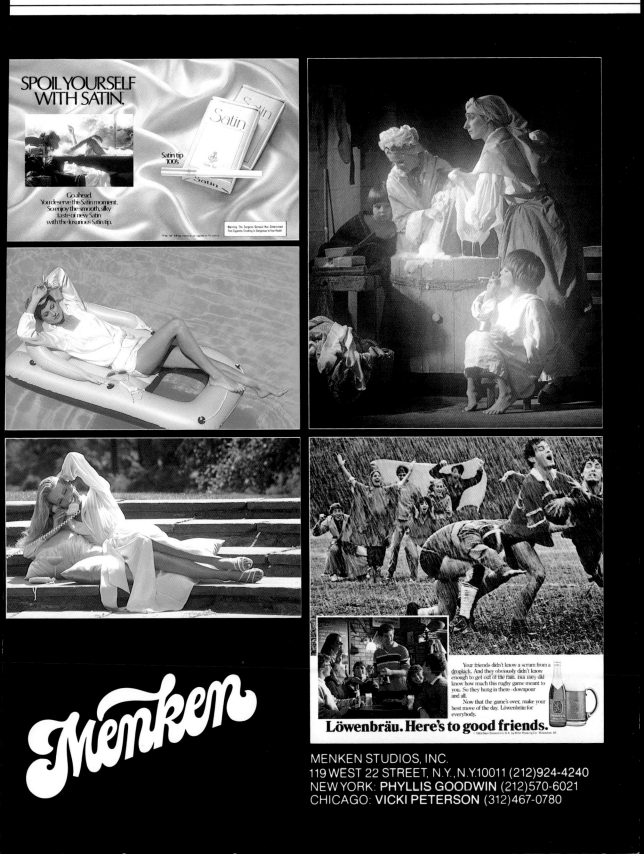

MENKEN STUDIOS, INC.
119 WEST 22 STREET, N.Y., N.Y.10011 (212)924-4240
NEW YORK: **PHYLLIS GOODWIN** (212)570-6021
CHICAGO: **VICKI PETERSON** (312)467-0780

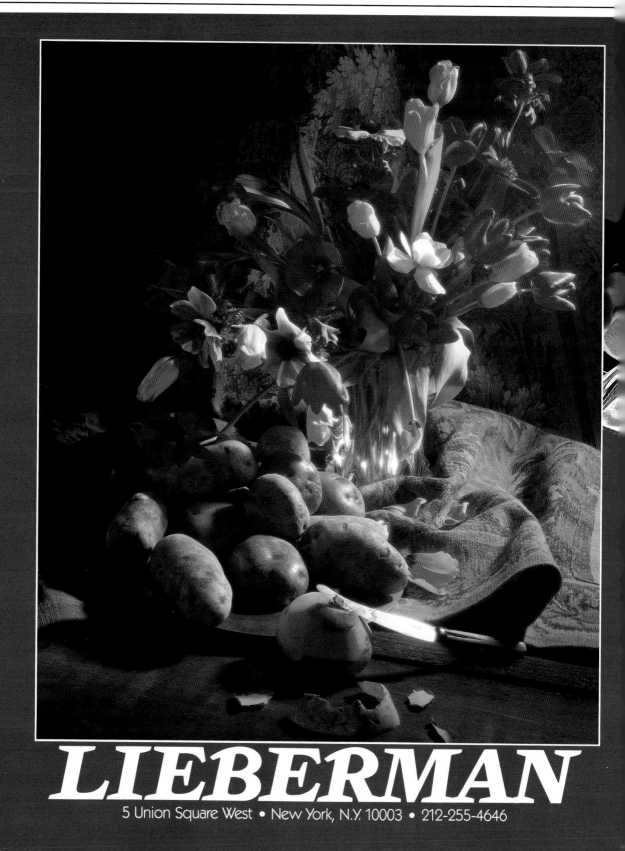

LIEBERMAN

5 Union Square West • New York, N.Y. 10003 • 212-255-4646

GENERAL MEMBERS NORTHEAST/MID ATLANTIC

A

ALEXANIAN, NUBAR 1 Thompson Sq, Box 311, Charlestown, MA 02129
(617) 242-4312; NY—Jullien Photo Agency (212) 505-1790 P 262

ALLARD, WILLIAM Marsh Run Farm, Box 549, Somerset, VA 22972 (703) 672-5316
ANDERSON, PETER R I T Riverknoll Apts, 336 Kimball Dr, Rochester, NY (617) 925-2358
ANDERSON, RICHARD 2523 N Calvert St, Baltimore, MD (301) 889-0585
ANDERSON, RONALD 8750 Georgia Ave - 404B, Silver Spring, MD (301) 589-5085
ANDERSON, SUSANNE Box 102, Waterford, VA 22190 (703) 882-3244
ASHE, TERRY 5021 Seminar Rd - 1519, Alexandria, VA (703) 820-8756
AVIS, PAUL Woodhill Rd, Bow, NJ 03301 (603) 224-2860

B

BAKER, BARBARA 2728 N Edison St, Arlington, VA (703) 534-3672
BALL, SKIP 7015 Heathfield Rd, Baltimore, MD (301) 296-7030
BALLANTYNE, THOMAS C. 270 Westford Rd, Concord, MA (617) 369-7599
BARTLETT, LINDA 3316 Runnymede Pl NW, Washington, DC (202) 362-4777 P 254

BATES, RAY West St, Newfane, VT (802) 365-7770
BENENATE, JOSEPH 83 Burlington St, Woburn, MA (617) 933-2575
BEZUSHKO, B. 1311 Irving St, Philadelphia, PA (215) 735-7771 P 243

BIBIKOW, WALTER 76 Batterymarch St, Boston, MA (617) 451-3464
BILLARD, PETER Burrows Hill Rd, Hebron, CT (203) 228-9243
BLANCHARD, ROY Box 201, Plainsboro, NJ 08536 (609) 799-5919
BLANCO, J. WILLIAM 1622 Chestnut St, Philadelphia, PA (215) 242-6885
BLAKE, MICHAEL 107 South St, Boston, MA (617) 451-0660
BLANK, BRUCE A. 202 Ross Rd, King of Prussia, PA (215) 265-0828;
Rep—Louise K. Ternay (215) 667-8626 P 249

BOWDEN, JOHN 1007 E St SE, Washington, DC (202) 543-3526
BRAGSTAD, JEREMIAH O. 72 Berman Cross Rd, Ithaca, NY (607) 273-4039
BRAVERMAN, ED 344 Boylston St, Boston, MA (617) 247-7257
BRUCE, BRADLEY H. Box 94, New Brighton, PA 15066 (412) 846-3962
BROWN, JIM 286 Summer St, Boston, MA (617) 423-6484 P 241

BROWN, MARTIN Cathance Lake, Grove Post Office, ME 04638 (207) 454-7708 P 261

BROWN, STEPHEN R. 1901 Columbia Rd NW, Washington, DC (202) 667-1965, 667-7551
BROWNELL, DAVID Box 97, Hamilton, MA 01936 (617) 468-4284; Winter—(303) 925-1181

C

CARAVELLA, MIRIAM New Delhi-USIS, US State Dept, Washington, DC
CARRIER, JOHN 601 Newbury St, Boston, MA (617) 262-4440
CARROLL, HANSON Norwich, VT 05055 (802) 649-1094
CASTELLOE, NAGGI Wood Wind Farm, Route 1 Box 14, Marshall, VA 22115 (703) 364-1969
CATANIA, VINCENT 19 McKinney St, Maynard, MA (617) 897-8396
CHERNUSH, KAY 3855 N 30 St, Arlington, VA (703) 528-1195 P 258-259

CLEFF, BERNIE 715 Pine St, Philadelphia, PA (215) 922-4246, (609) 235-5115
CLIFFORD, GEOFFREY Craggle Ridge Farm, Reading, VT (802) 484-5047
COHEN, LEONARD 326 Kater St, Philadelphia, PA (215) 922-6655
COLBROTH, RON 4421 Airlie Way, Annandale, VA (703) 354-2729
COLEMAN, ALIX 907 Weldon Lane, Box 23, Bryn Mawr, PA 19010 (215) 525-3828, 525-6482
COLLETTE, ROGER 39 Pinehurst Rd, East Providence, RI (401) 433-2143
COLLINS, FRED 186 South St, Boston, MA (617) 426-5731
CONBOY, JOHN 1225 State St, Schenectady, NY (518) 346-2346
CONDAX, JOHN 1320 Nectarine St, Philadelphia, PA (215) 923-7790
CONFER, HOLT 2016 Franklin Pl, Wyomissing, PA (215) 678-0131
CRANE, TOM 859 Lancaster Ave, Bryn Mawr, PA (215) 525-2444
CUNNINGHAM, CHRISTOPHER 9 East St, Boston, MA (617) 542-4640 P 248

CURTIS, JOHN 40 Winchester St, Boston, MA (617) 451-9117; NY—Abigail
Shearer (212) 509-2550 P 255

D

DAVIS, HOWARD 7609 Spruce Rd, Baltimore, MD (301) 243-7089 **P 266**

DE GAST, ROBERT Harborton, VA 23389 (804) 442-2438
DE GEORGES, PAUL 7223 Van Ness Ct, McLean, VA (703) 356-9353
DE CAMILLO, JOHN 4220 Kelway Rd, Baltimore, MD (301) 523-4430
DIMARCO JR., SALVATORE C. 1002 Cobbs St, Drexel Hill, PA (215) 789-3239
DISHMAN, LEON 12001-807 Old Columbia-Pike, Silver Spring, MD (301) 622-4883
DOMKE, J. G. 549 Industrial Dr, Yeadon, PA (215) 622-1130, 387-0212
DRAKE, JAMES A. 635 Spruce St, Philadelphia, PA (215) 925-8927
DREYER, PETER H. 166 Burgess Ave, Westwood, MA (617) 762-8550
DUFFY, JOHN 73 Central St, Woburn, MA (617) 662-6660, 933-3482
DUNOFF, RICHARD 407 Bowman Ave, Merion Sta, PA (215) 667-1278
DUNWELL, STEVE Box 390 Back Bay, Boston, MA 02117 (617) 247-2583
DURRANCE II, DICK Dolphin Ledge, Rockport, ME 04856 (207) 236-3990

EF

EASTWOOD, HENRY Rt 1 - Box 925, Washington, VA 22747 (202) 543-2929, (703) 675-3460
ENDRES, ANN Quechee, VT 05059 (201) 273-1757
EYLE, NICOLAS 304 Oak St, Syracuse, NY (315) 422-6231
FEIL, CHARLES, Mulberry Studio, 402 Grove Ave, Box 201, Wash Grove,
MD 20880 (301) 258-8328 **P 260**

FEILING, DAVID 214 Scoville Ave, Syracuse, NY (315) 474-0413
FEINBERG, MILTON 12 Gerald Rd, Boston, MA (617) 267-2000, 254-2360
FERREIRA, ALCIDES 41 Winship St, Hartford, CT (203) 249-2363, 273-1982
FISH, DICK 40 Center St, Northampton, MA (413) 584-6500
FITZHUGH, SUSIE 3809 Beech Ave, Baltimore, MD (301) 243-6112
FOLEY, ROGER 519 N Monroe St, Arlington, VA (202) 797-4183
FOSTER, FRANK 323 Newbury St, Boston, MA (617) 523-5508
FOX, PEGGY 371 Padonia Rd, Cockeysville, MD (301) 252-0003 **P 242**

FRANCIS, JON D. 1523 22 St NW, Washington, DC (202) 785-2188
FREEMAN, ROLAND L. 117 Ingraham St NW, Washington, DC (202) 882-7764
FREID, JOEL C. 812 Loxford Terr, Silver Spring, MD(301) 681-7211
FUMO, MARTY Rd 2 Box 279, Blackwood, NJ 08012 (609) 228-7404

G

GALLERY, BILL 86 South St, Boston, MA (617) 542-0499
GARBER, BETTE 2110 Valley Dr, Westchester, PA (215) 692-9076
GARLANDA, GINO Box 113, Youngsville, NY 12791 (914) 482-4415
GENSER, HOWARD Rt 5 - Box 3907, Deland, FL 37720
GERMER, MICHAEL Photography, 839 Beacon St, Boston, MA (617) 262-0170
GETTMANN, ROBERT 136 Temi Rd, Raynham, MA (617) 493-2366
GOELL, JONATHAN J. 17 Edinboro St, Boston, MA (617) 426-8160
GOLDBLATT, STEVE 32 Strawberry St, Philadelphia, PA (215) 539-7344, 925-3825
GOOD, RICHARD 5226 Osage Ave, Philadelphia, PA (215) 472-7659
GOODMAN, JOHN 337 Summer St, Boston, MA (617) 482-8061 **P 247**

GORRILL, ROBERT B. 70 Gladstone St, Squantum, MA (617) 328-4012
GRACE, ARTHUR 1928 35 Place, Washington, DC (202) 333-6568
GRIEBSCH, JOHN 183 St Paul St, Rochester, NY (716) 546-1303 **P 237**

GROHE, STEPHEN F. 186 South St, Boston, MA (617) 523-6655

H

HAHN, BOB 2405 Exeter Ct, Bethlehem, PA (215) 868-0339
HAMILTON, CHARLES F. 2300 Walnut-401, Philadelphia, PA (215) 567-7080
HAMOR, ROBERT 49 Atherton Ave, Nashua NH (603) 882-6061
HANKIN, JEFF 2 W 25 St, Baltimore, MD (301) 889-8770
HANSEN, STEVE 40 Winchester St, Boston, MA; Rep—Rita Hansen
(617) 426-6858 **P 256-257**

HARDING, DENNIS PO Box 1166, Pittsburgh, PA 15230 (412) 263-5954
HEAYN, MARK 17 W 24 St, Baltimore, MD (301) 235-1602
HEINEN, KENNETH 4001 Lorcorn Ln, Arlington, VA (703) 528-0186
HEIST, H. SCOTT 616 Walnut St, Emmaus, PA (215) 965-5479 **P 267**

HELMAR, DENNIS 134 Beach St, Boston, MA (617) 451-1496
HIRSHFELD, MAX 1209 E Capital St, Washington, DC (202) 543-1991
HOLLAND, JAMES R. 5 Brimmer St, Boston, MA (617) 742-5235, 321-3638
HOLT, JOHN 129 South St, Boston, MA (617) 426-7262
HOLT, WALTER PO Box 936, Media, PA 19063 (215) 565-1977
HOWARD, CARL 27 Huckleberry Ln, Ballston Lake, NY (518) 877-7615
HOWARD, LESLIE 69 Wood Ave, Monticello, NY (914) 794-3389
HOWARD, RICHARD PO Box 1022, Marblehead, Boston, MA 01945 (617) 631-8260

J

JOHNSON, CYNTHIA 2827 28 St NW, Washington, DC (202) 456-6505
JOHNSON, EVERETT 5024 Williamsburg Bl, Arlington, VA (703) 536-8483
JONES, PETER 139 Main, Cambridge, MA (617) 492-3545 **P 244-245**

JUDICE, EDWARD New Salem Rd, Wendell Depot, MA (617) 544-2739

K

KANE, MARTIN 7 S Springfield Rd, Clifton Hgts, PA (215) 237-6897
KATZ, MARTIN 1308 Pine Ridge Ln, Baltimore, MD
KEENEY, KAREN 1912 R St NW, Washington, DC (202) 265-4073
KENNEDY, THOMAS R. 33 S Letitia St, Philadelphia, PA (215) 592-0409
KENNERLY, DAVID 3332 P St NW, Washington, DC (202) 338-2028
KING, KEN 3629 Vacation Ln, Arlington, VA (703) 841-9111
KING, RALPH J. 103 Broad St, Boston, MA (617) 426-3565
KINGDON, DAVID 106 Willow St, Fair Haven, NJ (609) 921-4983
KNAPP, STEPHEN 74 Commodore Rd, Worchester, MA (617) 757-2507
KRUMBHAAR, ANNE B. K. 3213 Macomb St NW, Washington, DC (202) 364-0108
KULIK, WILLIAM R. 16048 Laconia Cir, Woodbridge, VA (703) 670-8324

L

LANGENBACH, RANDOLPH 24 Cambridge Ter, Cambridge, MA (617) 492-6823
LaPETE, WILLIAM 259 A St, Boston, MA (617) 482-3456
LAUTMAN, ROBERT C. 4906 41 St NW, Washington, DC (202) 966-2800
LAVENSTEIN, LANCE 4605 Pembroke Lake Circle, Virginia Bch, VA 23455
** (804) 499-9959** **P 263**

LAVINE, DAVID S. 1502 W Mt Royal Ave, Baltimore, MD (301) 523-2932
LEACH, GLEN 11201 Buckwood Ln, Rockville, MD (301) 530-6445
LIMONT, ALEXANDER 137 W Harvey St, Philadelphia, PA (215) 438-7259
LITTLEWOOD, JOHN Box 141, Woodville, MA 01784 (617) 435-5778
LLEWELLYN, ROBERT PO Drawer L, Charlottesville, VA 22903 (804) 973-8000
LOCKWOOD, LEE 27 Howland Rd, W Newton, MA (617) 965-6343

M

MacKAY, KENNETH 127 Hillary Lane, Penfield, NY (716) 385-1116
MACKENZIE, MAXWELL 2321 37 St NW, Washington, DC (202) 342-8266 **P 240**

MAGUIRE, WILLIAM M. 85 Columbine Rd, Milton, MA (617) 698-1190
MANHEIM, MICHAEL PHILIP PO Box 35, Marblehead, MA 01945 (617) 631-3560
MARISTANY, ERIC 8A Newcomb St, Boston, MA (617) 445-3581
MAROON, FRED J. 2726 P St NW, Washington, DC (202) 337-0337, (212) 972-1701
MARSHALL, JOHN 344 Boylston St, Boston, MA (617) 536-2988
MASSER, IVAN 296 Bedford St, Concord, MA (617) 369-4090
MASTERS, HILARY Ancramdale, NY 12503 (518) 329-1522
MATT, PHIL Box 3910, Rochester, NY 14610 (716) 461-5977
McCONNELL, JACK, McConnell McNamara & Co 182 Broad St, Old Wethersfield,
 CT (203) 563-6154
McCORMICK, NED 9 East St, Boston, MA (617) 542-7229
McCOY, DAN J. % Rainbow Main St, Housatonic, MA (413) 274-6211
McKEAN, TOM 742 Cherry Circle, Wynnewood, PA (215) 642-0966 **P 246**

McKENNA, ROLLIE 1 Hancox St, Stonington, CT (203) 535-0110, 535-2126
McLAREN, LYNN 42 W Cedar St, Boston, MA (617) 227-7448
McNEILL, BRIAN 840 W Main St, Lansdale, PA (215) 368-3326
MEDNICK, SEYMOUR 316 S Camac, Philadelphia, PA (215) 735-6100
MESMER, JERRY 1523 22 St NW Rear, Washington, DC (202) 785-2188
MILLER, ROGER 1411 Hollins St, Union Square, Baltimore, MD (301) 566-1222
MOPSIK, EUGENE 419 S Perth St, Philadelphia, PA (215) 922-3489 **P 252**

MORLEY, BOB 129 South St, Boston, MA (617) 482-7279
**MORROW, CHRISTOPHER 163 Pleasant St, Arlington, MA
 (617) 648-6770, 646-0508** **P 253**

N

NELDER, OSCAR PO Box 661, Presque Isle, ME 04769 (207) 769-5911
NETTIS, JOSEPH 1719 Walnut St, Philadelphia, PA (215) 563-5444
NEUBAUER, JOHN 1525 S Arlington Ridge Rd, Arlington, VA (703) 920-5994
NICHOLS, DON 1241 University Ave, Rochester, NY (716) 275-9666
NOCHTON, JACK 1238 W Broad St, Bethlehem, PA (215) 691-2223, 691-2913
NOVAK, JACK 505 W Windsor Ave, Alexandria, VA (703) 836-4439

O

OLSEN, LARRY 1523 22 St NW Rear, Washington, DC (202) 785-2188
O'SHAUGHNESSY 40 Winchester St, Boston, MA (617) 542-7122
OUZER, LOUIS 120 East Ave, Rochester, NY (716) 454-7582
OWENS JR., WILLIAM 5 W Hill Pl, Boston, MA (617) 742-8713

PQ

PARKER, ROBERT B. PO Box 102, Corning, NY 14830 (607) 962-4104
PEASE, GREG 2122 St Paul St, Baltimore, MD (301) 332-0583
PENNEYS, ROBERT 147 N 12 St, Philadelphia, PA (215) 925-6699
PHILLIPS, JAMIE 1331 Merchant Ln, McLean, VA (703) 556-9106
PICKERELL, JAMES 8104 Cindy Ln, Bethesda, MD (301) 365-1126, 762-7627
PIERSON, HUNTLEY S. PO Box 14430, Hartford, CT 06114 (203) 549-4863
PLATTETER, GEORGE 82 Colonnade Dr, Rochester, NY (716) 423-4336
POFF, BILL, Graphic Services 400 Campbell Ave SW, Roanoke, VA (703) 343-8243
POLUMBAUM, TED 326 Harvard St, Cambridge, MA (617) 491-4947 **P 264-265**

PORTER, CHARLES Georgetown Sq, Poughkeepsie, NY (914) 454-7033
POWNALL, RON 7 Ellsworth Ave, Cambridge, MA (617) 354-0846
PROFIT, EVERETT R. 533 Massachusetts Ave, Boston, MA (617) 267-5840
PURCELL, CARL 4400 Rosedale Ave, Bethesda, MD (301) 654-0282
QUINDRY, RICHARD 200 Loney St, Philadelphia, PA (215) 742-6300

R

RATHE, ROBERT 9018 Jersey Dr, Fairfax, VA (703) 560-7222, (301) 762-7629
RAYCROFT, JIM 9 East St, Boston, MA (617) 542-7229
RAYMOND, CHARLOTTE PO Box 4000, Princeton, NJ 08540 (609) 921-4938
REIS, JON 141 The Commons, Ithaca, NY (607) 272-1966
ROSE, EDWARD 232 Caroline St, New Bedford, MA (617) 521-6000
ROSEMAN, SHELLY 723 Chestnut St, Philadelphia, PA (215) 922-1430
ROSEN, OLIVE 3804 Moss Dr, Annandale, VA (703) 256-6996
ROSENTHAL, STEVE 59 Maple St, Auburndale, MA (617) 244-2986
ROSS, LEONARD Pine Top Trail, Bethlehem, PA (215) 694-6535
ROTMAN, JEFFREY L. 14 Cottage Ave, Somerville, MA (617) 666-0874
ROYTOS, RICHARD PO Box 4000, Princeton, NJ 08540 (609) 921-4983
RUTLEDGE, DON 13000 Edgetree Court, Midlothion, VA (804) 794-4636

S

Sa'ADAH, JONATHAN Box 247, Hartford, VT 05047 (802) 295-5321
SALENETRI, JOSEPH PO Box 4000, Princeton, NJ 08540 (609) 921-4983
SALGADO, ROBERT River Road - RD 2, New Hope, PA (215) 862-2895
SALSBERY, LEE 14 7 St NE, Washington, DC (202) 543-1222
SANFORD, ERIC 219 Turnpike Rd, Manchester, NH (603) 624-0122
SCHERER, JAMES 40 W Newton St, Boston, MA (617) 266-9414
SCHILL, WILLIAM PO Box 25, Haddon Hts, NJ 08035 (609) 547-0148
SCHMITT, STEVE 29 Newbury, Boston, MA (617) 247-3991

SCHOFER, LES 2220 Langhorne Rd, Lynchburg, VA (804) 528-4112
SEABURY, THOMAS 243 North St, Weymouth, MA (617) 331-0604
SEGER, TOBY 4025 Rt 8, Allison Park, PA (412) 487-6474
SEITELMAN, DAVID 5414 Richenbacker - 302, Alexandria, VA (703) 820-8425
SEITZ, BLAIR 227 State St - Rm 33, Harrisburg, PA (717) 238-0888
SHAFER, ROBERT 3554 Quebec St NW, Washington, DC (202) 362-0630
SHALLOW, MOLLY 5 Elm St, Woodstock, VT (802) 457-1646
SHARP, STEVE 15 E Baltimore Pike - 4, Media, PA (215) 566-7614
SHERRIFF, BOB 69 Lynnway, Revere, MA (617) 284-3228
SHROYER, JOHN PO Box 3220, Bethlehem, PA 18017 (215) 865-9409
SIEB, FRED Birch Hill Rd, North Conway, NH (603) 356-5876
SIMON, PETER R. State Rd, Gayhead, MA (617) 645-9575
SIMMONS, ERIK L. 259 A St, Boston, MA (617) 367-6655
SITEMAN, FRANK 136 Pond St, Winchester, MA (617) 729-3747
SITKIN, MARC 23 Lincoln St, Hartford, CT (203) 273-1982
SIMEONE, J. PAUL 29 S Carol Blvd, Upper Darby, PA (215) 459-6802
SMITH, ROGER B. 57 Rowley St, Rochester, NY (716) 442-4338
SPELLMAN, STEVE 15A St. Mary's Ct, Brookline, MA (617) 566-7330
SPIVAK, IRWIN, Spencer Assoc, PO Box 67, Lexington, MA 02173 (617) 861-0622
STAPLETON, JOHN 120 George St, W Conshohocken, PA (215) 972-1780
STEARNS, STAN 1814 Glade Ct, Annapolis, MD (301) 268-5777
STEIN, GEOFFREY 348 Newbury St, Boston, MA (617) 267-1675
STEPHENSON, AL 2726 N Edison, Arlington, VA (703) 237-8440
STRATOS, JAMES 56 Arbor St, Hartford, CT (203) 233-4636
STROMBERG, BRUCE 1818 Spruce St, Philadelphia, PA (215) 545-0842
SUSOEFF, WILLIAM 1063 Elizabeth Dr, Bridgeville, PA (412) 941-8606, 941-5241
SWEET, OZZIE Sunnyside Acres, Mill Village Hill, Francestown, NH (603) 547-6611

T

TADDER, MORTON 501 St Paul Pl, Baltimore, MD (301) 837-7427
TARDI, JOSEPH 100 7 Ave, Troy, NY (518) 235-1984
**TOLBERT, BRIAN R. 911 State St, Lancaster, PA (717) 393-0918;
Rep—Jill Brown (717) 393-0996** P 238-239

TOUCHTON, KEN PO Box 9435, Washington, DC 20016 (703) 534-4497
TRETICK, STANLEY 4365 Embassy Park Dr NW, Washington, DC (202) 537-1445
TWAROG, R.R. PO Box 355, 100 Chauncy St, Boston, MA 02112 (617) 426-1120, 648-4322

UV

UZZELL, STEVE 2505 N Custis Rd, Arlington, VA (703) 522-2320
UZZLE, BURK 831 Beechwood Dr, Havertown, PA (215) 896-6168
VALADA, M.C. 802 Ware St SW, Vienna, VA (703) 938-4509
VAN PETTEN, ROB 109 Broad St, Boston, MA (617) 426-8641
VAUGHN, TED Doe Run Rd - RD 5, Manheim, PA (717) 665-6942
VON WEHRDEN, MARK S. The Keen Sentinel, 60 West St, Keene, NH (804) 253-4331

WZ

WACHTER, JERRY Photography Ltd, 1410 Bare Hills Ave, Baltimore, MD (301) 337-2977
WAGGAMAN, JOHN 2746 N 46, Philadelphia, PA (215) 473-2827
WALCH, ROBERT 310 West Main St, Kutztown, PA (215) 683-5701
WARREN, MARION E. Old Annapolis Bldg, PO Box 1508, Annapolis, MD 21404 (301) 974-0444
WEEMS, BILL 2030 Pierce Mill Rd NW, Washington, DC (202) 667-2444
WEIGAND, THOMAS 717 N 5 St, Reading, PA (213) 374-4431
WEISENFELD, STANLEY 135 Davis St, Painted Post, NY (607) 962-3714
WELSCH, ULRIKE 42 Elm, Marblehead, MA (617) 631-1641
WEXLER, IRA 6108 Franklin Park Rd, McLean, VA (703) 241-1776

WHEELER, NICK Cor Turner & Pierce, Townsend, MA (617) 597-2919
WHITMAN, JOHN 604 N Jackson St, Arlington, VA (703) 524-5569
WILCOXSON, STEVE 1820 Bolton St, Baltimore, MD (301) 462-4234
WILLIAMS, LAWRENCE 9101 W Chester Pike, Upper Darby, PA (215) 789-3030
WILLIAMS, WOODBRIDGE PO Box 11, Dickerson, MD 20753 (301) 972-7025
WING, PETER 556-1B Chatham Park Dr, Pittsburgh PA (412) 531-3081
WINIK, PAUL 5 Dietz Rd, Hyde Park, MA (617) 267-2100
WOOD, RICHARD 25 Thorndike St, Cambridge, MA (617) 661-6856
WRIGHT, JERI PO Box 7, Wilmington, NY 12997 (518) 946-2658
WU, RON 179 St Paul St, Rochester, NY (716) 454-5600 **P 250-251**

WYMAN, IRA 14 Crang Ave, W Peabody, MA (617) 535-2880, 899-8000
ZOVKO, CHUCK 204 Washington Ave, Bethlehem, PA (215) 691-2187

B

BARONE, CHRISTOPHER 381 Wright Ave, Kingston, PA (717) 287-4680
BETHONEY, HERB 23 Autumn Cir, Hingham, MA (617) 451-0661
BOMZER, BARRY 382 Warren St, Needham, MA (617) 426-8955
BOWMANN-III, CARTER 5302 2 St NW, Washington, DC (202) 723-8478
BRILLIANT, ANDREW 520 Harrison Ave, Boston, MA (617) 482-8938
BRUNDAGE, KIP Stratton Estate, RFD 2, Lincolnville, ME (207) 338-5210
BRYAN, GAIL 285 Jerusalem Rd, Cohasset, MA (617) 383-0483
BULKIN, SUSAN 6719 Emlen St, Philadelphia, PA (215) 985-9090

CD

CASE, SAMUEL PO Box 1139, Purcellville, VA (703) 338-2725
CERTO, ROSEMARIE 1826 Wynnewood Rd, Philadelphia, PA (215) 878-3299
COOLIDGE, JEFFREY 7 Sawin St, Arlington, MA (617) 641-0614
CORWIN, ROBERT 309 S 12 St, Philadelphia, PA (215) 923-2854
DI VERDI, JO ANN 78 Bunkerhill Pkway, W Boylston, MA (617) 835-6640
DUKE, F. RANDALL RD 4, Bethlehem, PA 18015
DURLACH, HANSI 59 Old Mystic St, Arlington, MA (617) 648-7425
DWECK, ABOUD 3110 Wisconsin Ave NW, Washington, DC

EF

EHRENFELD, MIKKI 2 Ellery Sq, Cambridge, MA (617) 661-1640
ENGSTROM, FREDERICK Box 946, Bryn Mawr, PA 19010 (215) 527-4635
ENGSTROM, BARBARA Box 946, Bryn Mawr, PA 19010 (215) 527-4635
FINNEGAN, JAMES 635 Cricklewood Dr, State College, PA (814) 238-8659
FISHER, PATRICIA 2234 Cathedral Ave NW, Washington, DC (202) 232-3781
FOTE, MARY 487 Main St, W Seneca, NY (716) 675-1960
FOWLER-GALLAGHER, SUSAN RT 1 - Box 98, Staatsburg, NY 12580 (914) 889-4730

GHJ

GALLAGHER, LORI Box 144, Holmes, PA 19043
GAULT JR., JAMES 226 Clementon Ave, Blenheim, NJ (609) 228-3766
GOLD, GARY One Madison Pl, Albany, NY (518) 434-4887
HALL, TYRONE PO Box 57, Back Bay Annex, Boston, MA 02117 (617) 482-2347
JONES, MARVIN 3900 16 St NW - 511, Washington, DC (202) 726-9361
JOROFF, MANON PO Box 282, Leeds, MA (212) 757-9255

KL

KELLEY, WILLIAM 10 Loring Ave, Salem, MA (617) 744-5914
KOBRIN, HAROLD PO Box 115, Newton, MA 02159 (617) 332-8152
KOCHEL, THOMAS 1707 Kilbourne Pl NW, Washington, DC (202) 667-8785
KRISTOFIK, BOB 302 Dutchess Tpke, Poughkeepsie, NY (914) 473-7271
LEAMAN, CHRIS 105 Plant Ave, Wayne, PA (215) 688-3290
LEVINE, JACK 3414 Baring St, Philadelphia, PA (215) 382-8947
LONG, JOHN 4421 E-W Hwy, Washington, DC (301) 654-0279

MNO

MACK, PATRICIA PO Box 402, Exton, PA 19341 (215) 363-5992
MACYS, RAY RFD 1 - Box 52, Waitsfield, VT (802) 496-2518
McQUEEN, ANN 791 Tremont St, Boston, MA (617) 267-6258
MEDVEC, EMILY 151 Kentucky Ave SE, Washington, DC (202) 544-0555
MILLER, ROBIN 1700 Pine St, Philadelphia, PA (215) 989-9090
MURRAY, RIC 385 Westminster St, Providence, RI (401) 751-8806
NIEMANN, NEMO 1618A 14 St NW, Washington, DC (202) 328-1800
ORANSKY, ALAN 262 Upland Rd, Cambridge, MA (617) 354-5887

PRS

PANTAGES, TOM 7 Linden Ave, Gloucester, MA (617) 525-3678
PIKE, BOB 2612 Erie Blvd E, Syracuse, NY (315) 446-9539
PORTER, CHARLES Georgetown Square C-4, Poughkeepsie, NY (914) 454-7033
PUTMAN, SARAH 12 Alpine, Cambridge, MA (617) 547-3758
SAPIENZA, LOUIS 96 West St, Colonia, NJ (201) 382-5933
SATTERTHWAITE, VICTORIA 115 Arch St, Philadelphia, PA (215) 925-4233
SAWA, JOJI 270 Harvard St - 1, Cambridge, MA (617) 864-0744
SCHRAMM III, FRANK 313 Carver Dr, Bethlehem, PA (215) 868-8433
SEWEL, E. D. 1316 Dekalb St, Norristown, PA (215) 275-9692
SHARE, JED 61 Chestnut St, Englewood, NJ 07631
SHERMAN, MARK 1508 Scenic Dr, Ewing Twp, NJ (609) 883-0482
SIMIAN, GEORGE 9 Hawthorne Pl - 15K, Boston, MA (617) 720-0674
SMYTH, T. KEVIN 604 Main St, Belmar, NJ (201) 681-2602
SPAGNA, TED 791 Tremont St - E-512, Boston, MA (617) 267-5723
SPIRO, DONALD 52 Asbury Ave, Atlantic Highlands, NJ (201) 872-9196
STEIN, ART 4850-B S 28 St, Arlington, VA (202) 546-7500
SWEENEY, DAN 337 Summer St, Boston, MA (617) 482-5482

TWY

TAYLOR, JOHN B. 162 E 92 St, NYC (212) 410-5300
TERHUNE, WALLACE R R 2, 17 Turtle Cove Rd, E Sandwich, MA (617) 888-3010
TERK, HAROLD 170 Quarry Rd, Stamford, CT
TRUMAN, GARY PO Box 7144 Cross Lanes Branch, Charleston, WV 25313 (304) 755-3078
TUTTLE, STEVE 12 Ft Williams Pkwy, Alexandria, VA (703) 751-3452
WATSON, LINDA 45 Lila Rd, Boston, MA (617) 522-8469
WEISS, MARK 1019 W Cliveden St, Philadelphia, PA (215) 848-0186
WILLIAMS, MARK S. 4109 Farmhill Ln, Chesterfield, VA (703) 745-3975
YOUNG, BRUCE 4411 Garfield St NW, Washington, DC (202) 362-6818

JOHN GRIEBSCH

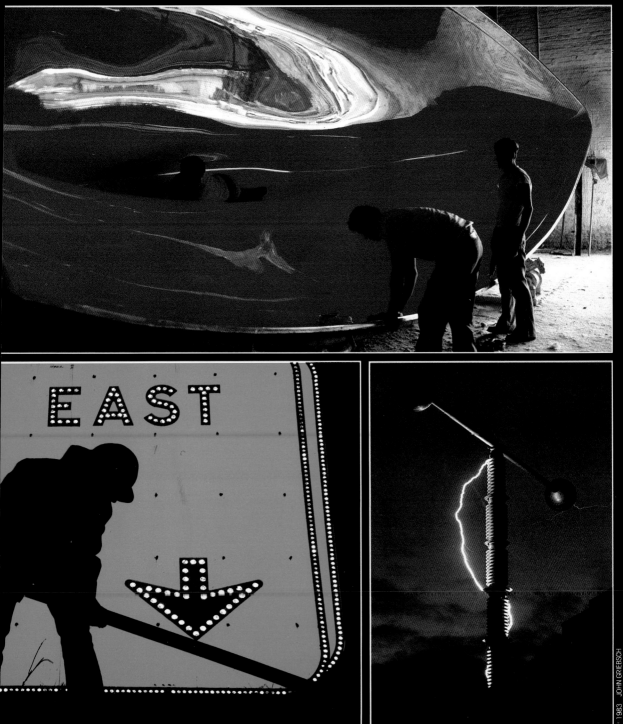

183 St. Paul Street/Rochester, NY 14604/716-546-1303

Photographic Illustrations
911 State Street • Lancaster, PA 17603
(717) 393-0918

On Location

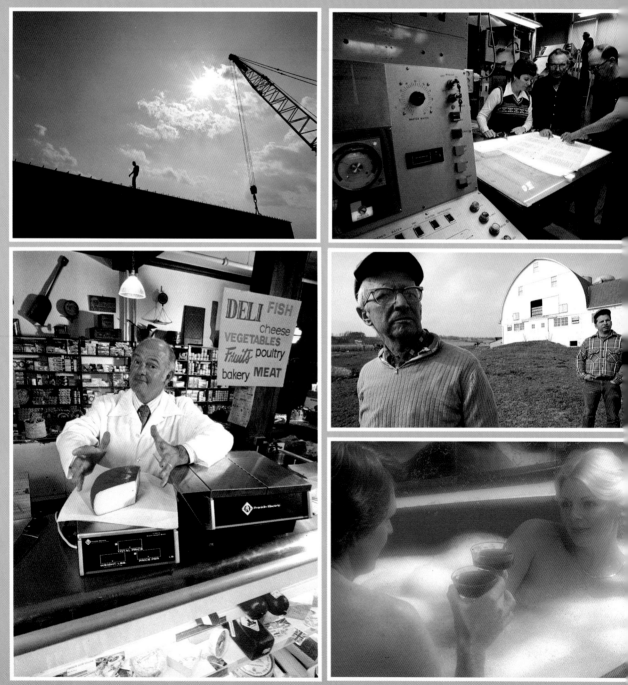

Brian R. Tolbert
Jill Brown • Sales Representative
(717) 393-0996

In The Studio

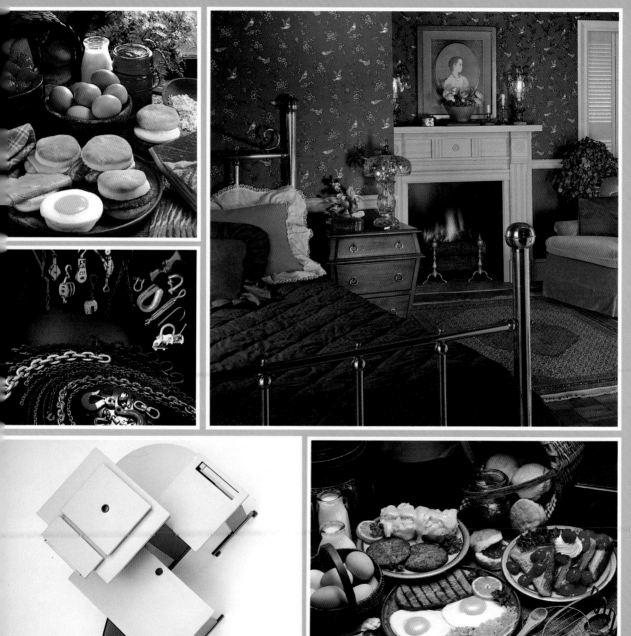

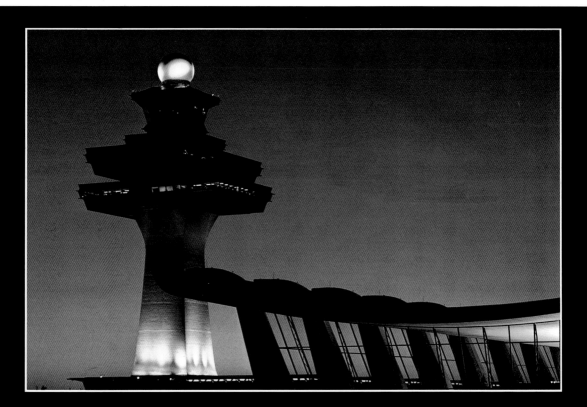

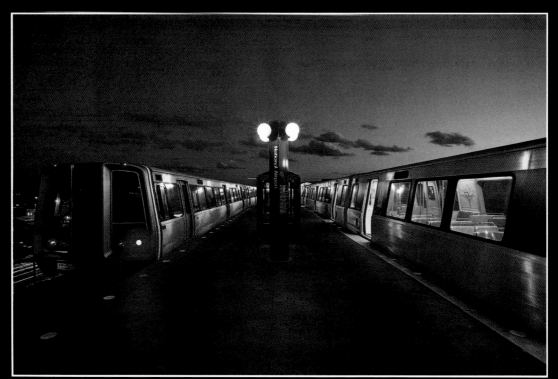

MAXWELL MACKENZIE

2321 37th Street, NW

Jim Brown · 286 Summer Street, Boston, MA 02210. (617) 423-6484.

Jim Brown

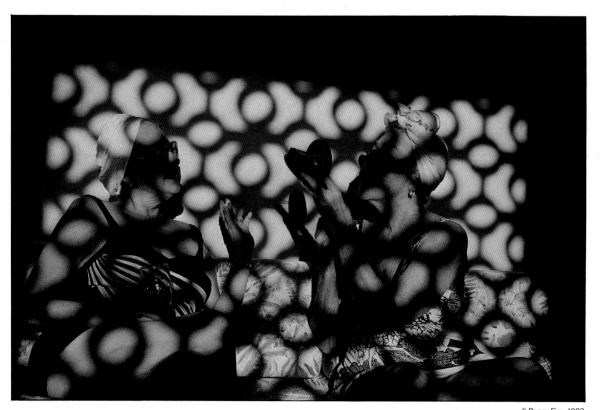

© Peggy Fox, 1982

Black and white in color.

Peggy Fox

371 Padonia Road

Cockeysville, Maryland 21030

301-252-0003

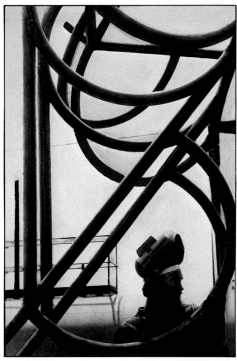

©Peggy Fox, 1982

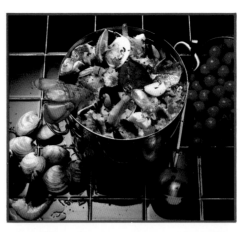

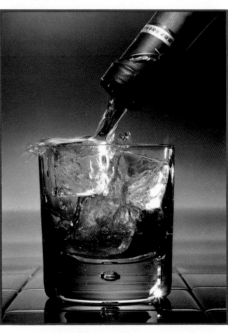

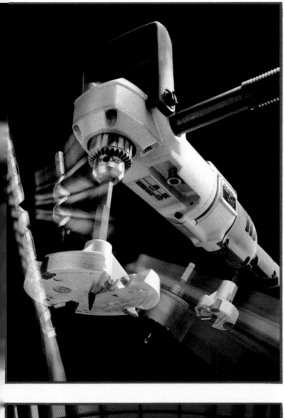

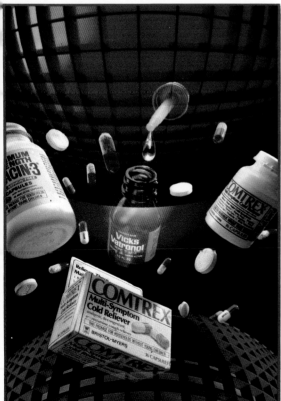

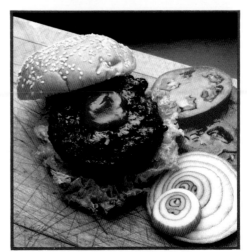

1311 Irving Street
Philadelphia PA 19107
215/735/7771

BEZUSHKO

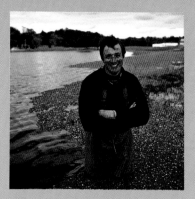

JONES

Peter Jones Incorporated

139 Main Street
Cambridge, Massachusetts 02142
(617) 492-3545

Location and studio
photography for advertising
and editorial: Polaroid, IBM,
Mitre, Paine Webber, Harvard
Business School

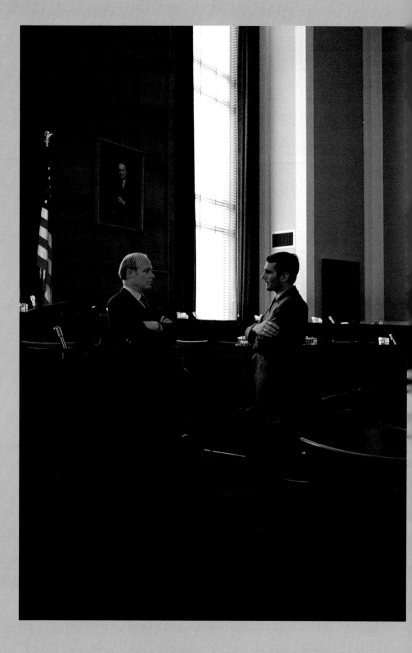

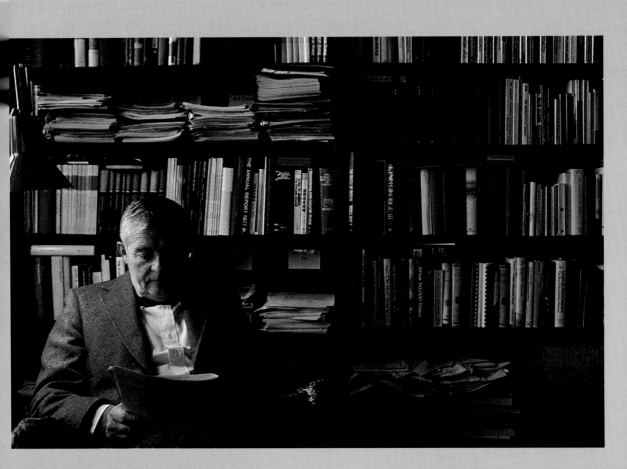

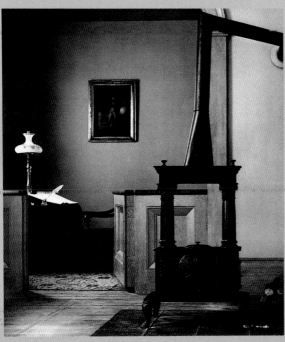

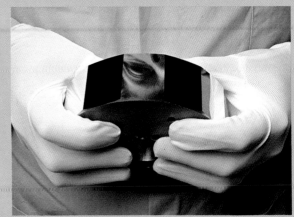

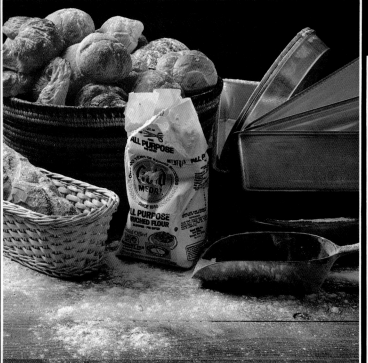

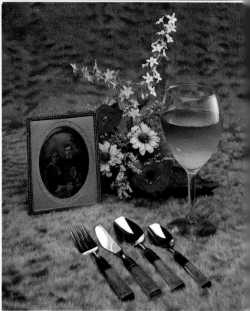

TOM McKEAN

742 CHERRY CIRCLE
WYNNEWOOD, PA 19096
215·642-0966

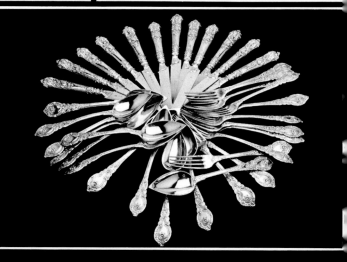

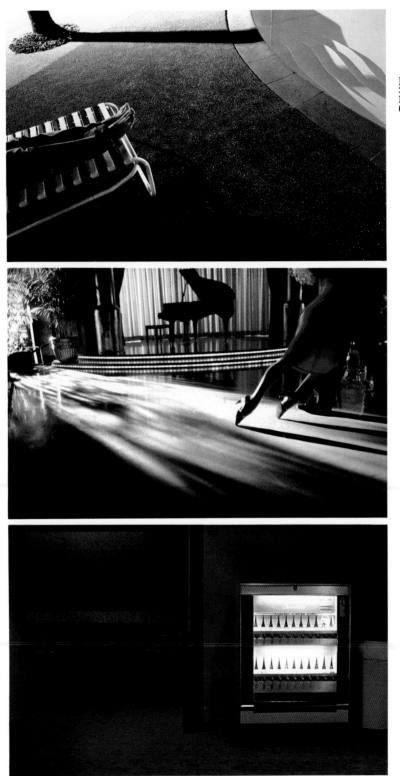

John Goodman Studio
337 Summer Street
Boston, Ma. 02210
617-482-8061

John Goodman 1982

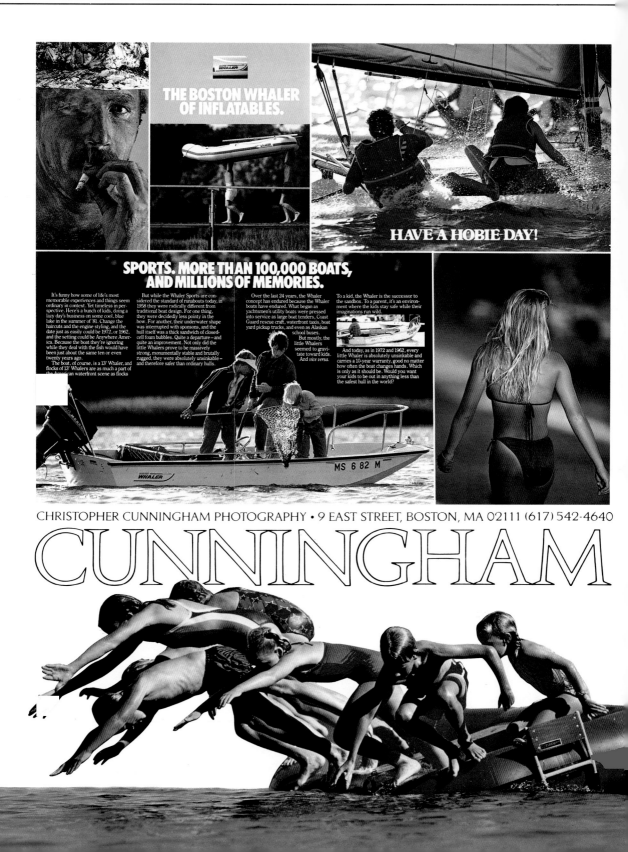

THE BOSTON WHALER OF INFLATABLES.

HAVE A HOBIE DAY!

SPORTS. MORE THAN 100,000 BOATS, AND MILLIONS OF MEMORIES.

It's funny how some of life's most memorable experiences and things seem ordinary in context. Yet timeless in perspective. Here's a bunch of kids, doing a lazy day's business on some cool, blue lake in the summer of '81. Change the haircuts and the engine styling, and the date just as easily could be 1972, or 1962, and the setting could be Anywhere America. Because the boat they're ignoring while they deal with the fish would have been just about the same ten or even twenty years ago.

The boat, of course, is a 13' Whaler, and flocks of 13' Whalers are as much a part of the American waterfront scene as flocks

But while the Whaler Sports are considered the standard of runabouts today, in 1958 they were radically different from traditional boat design. For one thing, they were decidedly less pointy in the bow. For another, their underwater shape was interrupted with sponsons, and the hull itself was a thick sandwich of closed-cell foam bubbles. Quite a departure—and quite an improvement. Not only did the little Whalers prove to be massively strong, monumentally stable and brutally rugged, they were absolutely unsinkable—and therefore safer than ordinary hulls.

Over the last 24 years, the Whaler concept has endured because the Whaler boats have endured. What began as yachtsmen's utility boats were pressed into service as large boat tenders, Coast Guard rescue craft, waterfront taxis, boat yard pickup trucks, and even as Alaskan school buses.

But mostly, the little Whalers seemed to gravitate toward kids. And vice versa.

To a kid, the Whaler is the successor to the sandbox. To a parent, it's an environment where the kids stay safe while their imaginations run wild.

And today, as in 1972 and 1962, every little Whaler is absolutely unsinkable and carries a 10-year warranty, good no matter how often the boat changes hands. Which is only as it should be. Would you want your kids to be out in anything less than the safest hull in the world?

CHRISTOPHER CUNNINGHAM PHOTOGRAPHY • 9 EAST STREET, BOSTON, MA 02111 (617) 542-4640

CUNNINGHAM

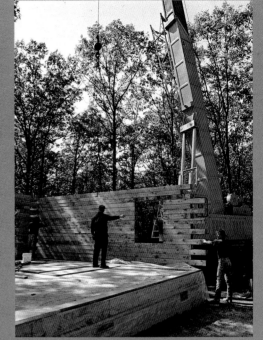

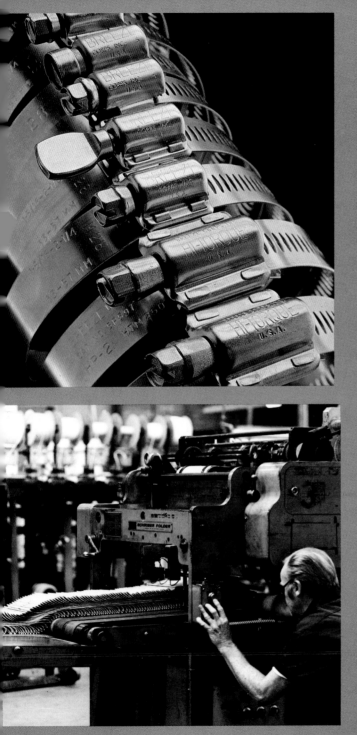

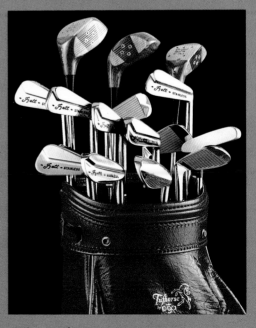

bruce
a. blank

215-265-0828

202 ROSS RD. · KING OF PRUSSIA, PA. 19406

REPRESENTED BY LOUISE K. TERNAY
215-667-8626

PHILADELPHIA

RON WU

179 ST. PAUL STREET ROCHESTER, N.Y. 14604 (716) 454-5600

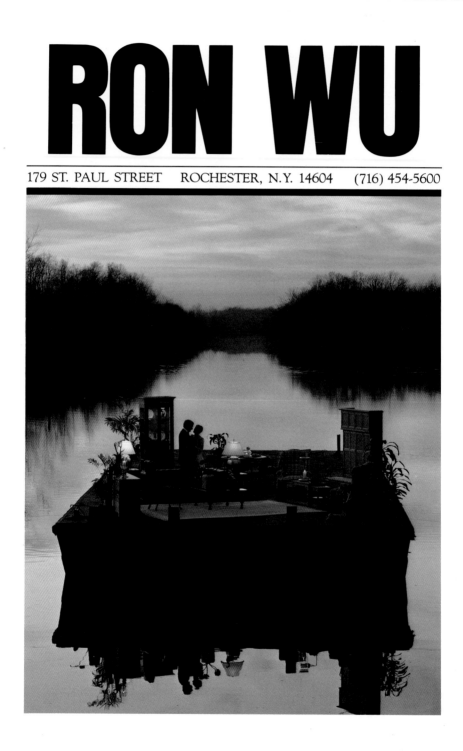

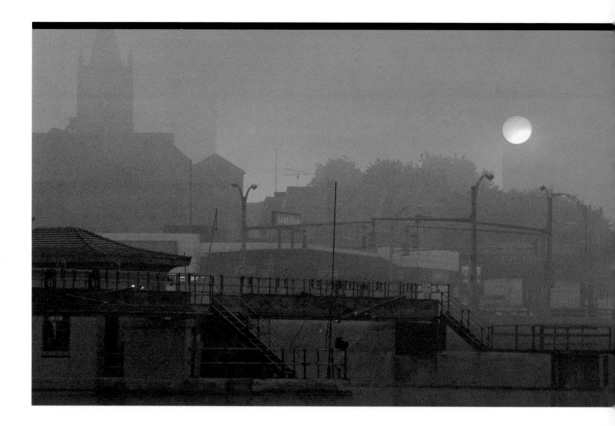

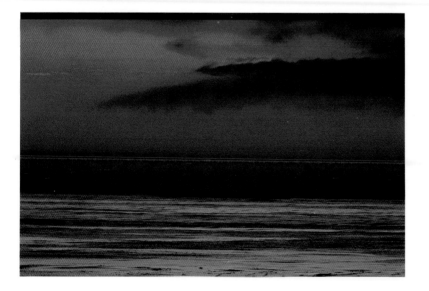

Advertising
Editorial & Corporate
Photography

EUGENE MOPSIK

Photography

419 South Perth Street
Philadelphia, PA 19147
215/922-3489

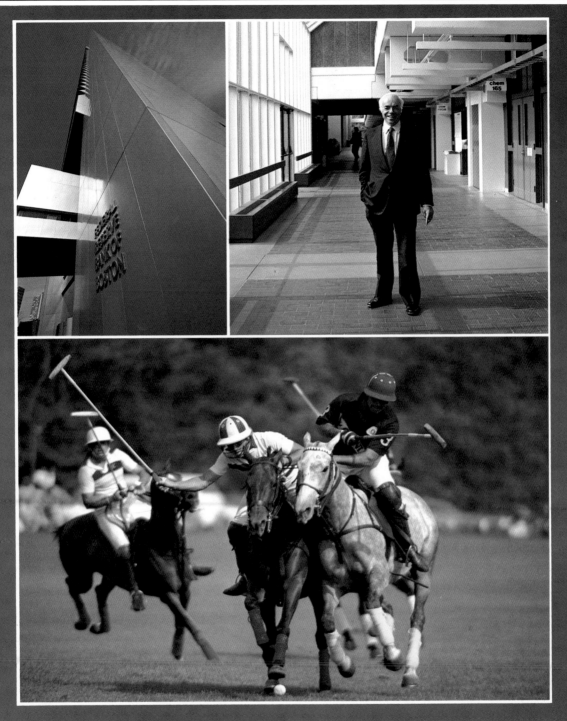

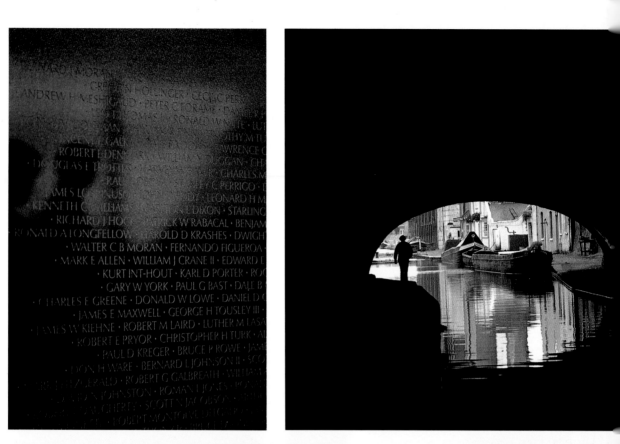

Essence: whether capturing the decisive moment or that special image for corporate and institutional clients, Linda Bartlett goes straight to the heart of the matter.

LINDA BARTLETT
3316 Runnymede Place, N.W., Washington, D.C. 20015
(202) 362-4777

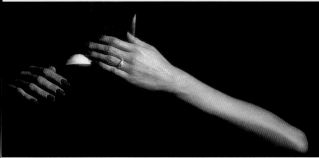

NOW SHOOTING IN AMERICA

JOHN CURTIS
PHOTOGRAPHY

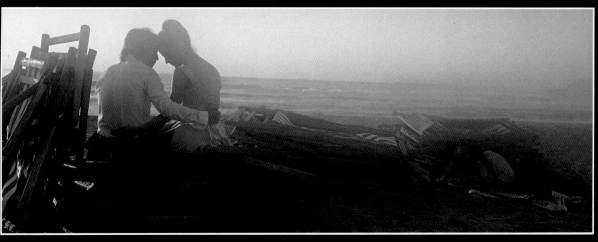

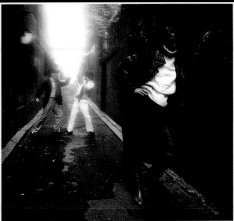

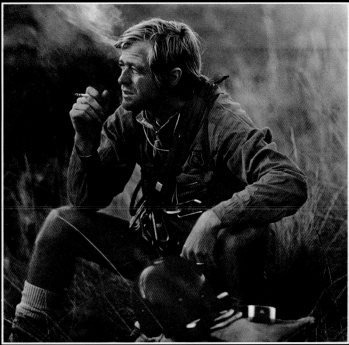

CLIENTS DeBeers/Alfa/Fiat/E F Hutton/Lever
Brothers/British Airways/Louis/Schweppes
Acrilan/Wang/Club Med/Martell Brandy
Johnson & Johnson/Phillips/Wrangler/Toyota
Rolex/Mary Quant/Martini & Rossi/Sun Silk
Shampoo/CinZano/Sure/Dial/Pepsi

Steve Hansen
represented by
Rita Hansen
Boston 617 426 6858

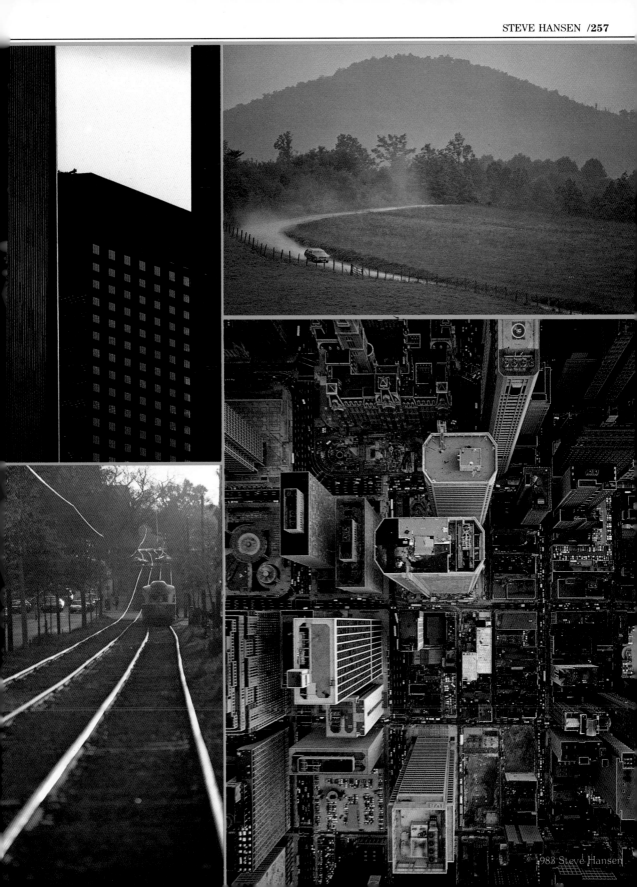

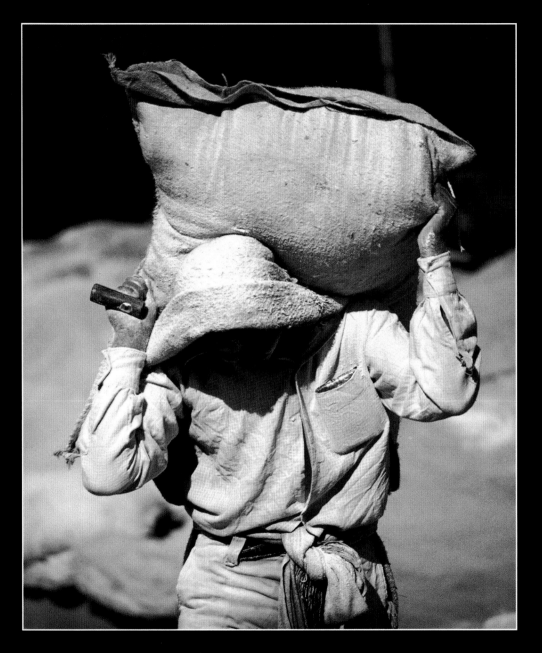

KAY CHERNUSH

L O C A T I O N P H O T O G R A P H Y • W O R

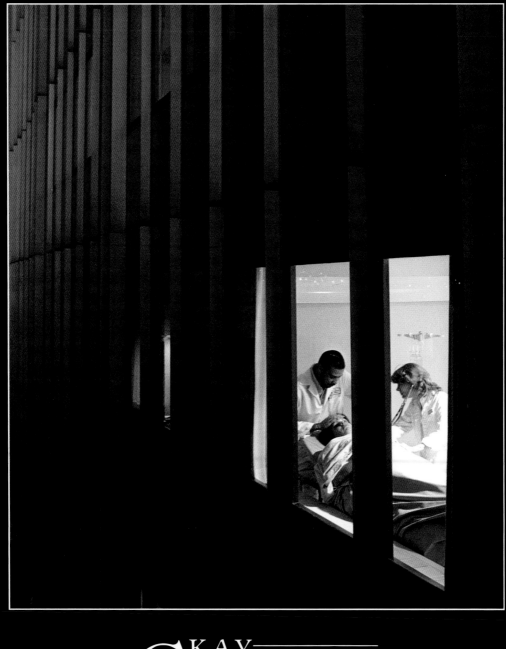

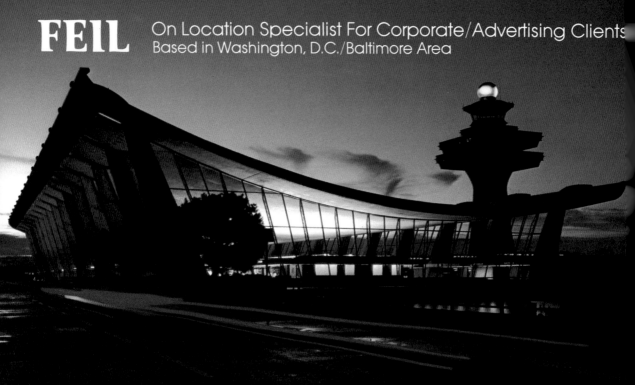

FEIL

On Location Specialist For Corporate/Advertising Clients
Based in Washington, D.C./Baltimore Area

Dulles International

A.R.C.

U.S. Navy

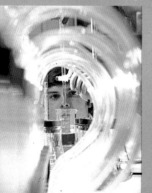

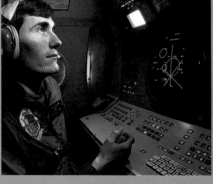

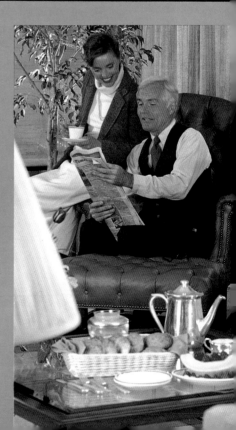

Marriott Corporation

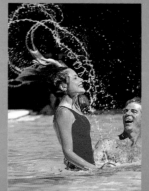

Charles Feil
Mulberry Studio

402 Grove Avenue, Box 201
Wash. Grove, Maryland 20880

(301) 258-8328

Stock Photos Available World Wide

Represented by Marilyn Davids

All Photos ©Charles Feil

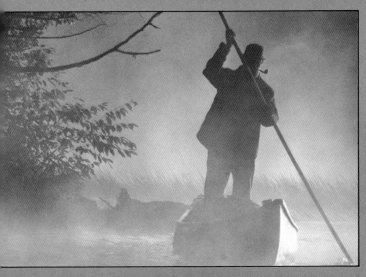
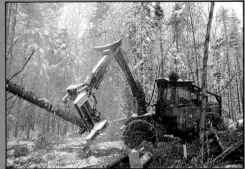
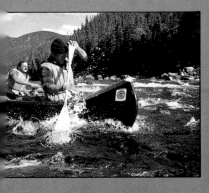
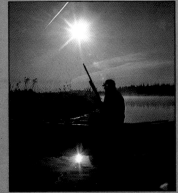
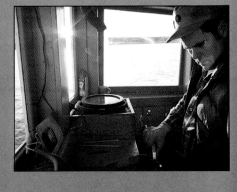
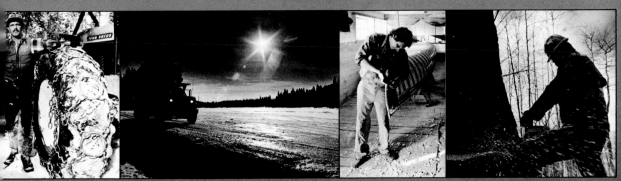

NUBAR ALEXANIAN

INDUSTRIAL • ADVERTISING • EDITORIAL • STOCK PHOTOGRAPHY

Representative:
Jullien Photo Agency
611 Broadway, Room 622
New York, New York 10012
(212) 505-1790

In Boston
(617) 242-4312

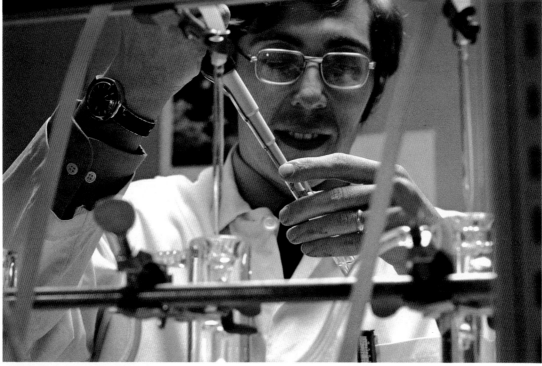

FORTUNE

HHCC, Boston

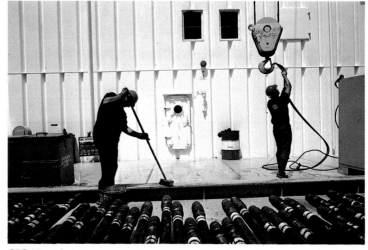

GEO Magazine

© 1983 Nubar Alexanian

LAVENSTEIN/STOCK

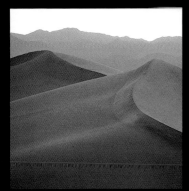

Lance Lavenstein photographs the environment in a unique manner. His stylistic nature, land and street scapes, as well as abstract and fine art photography are available on request.

For unusual stock photography contact Lance Lavenstein, 4605 Pembroke Lake Circle, Virginia Beach, Virginia 23455. Or call him at 804/499-9959.

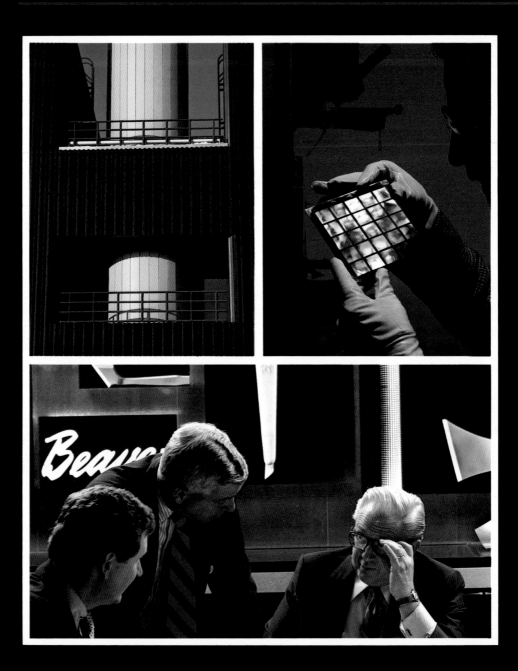

Design: Mike Szostakowski, Boston

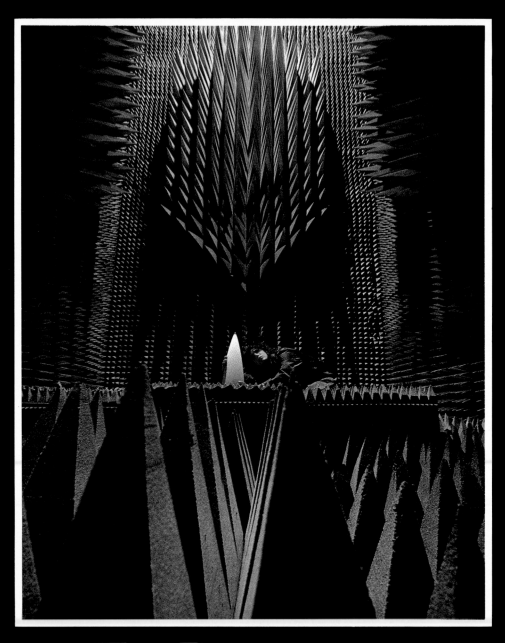

TED POLUMBAUM

326 Harvard Street, Cambridge, Mass. 02139
(617) 491-4947

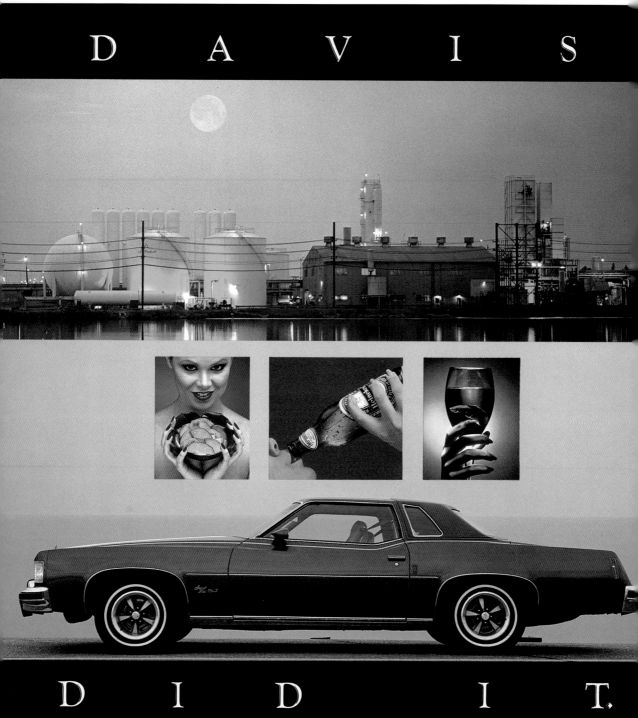

D A V I S

D I D I T.
ON LOCATION, IN THE STUDIO, DAVIS DOES IT EVERYTIME.

Howard Davis Studio • *Baltimore, Md.* • *301-243-708.*

Clients: AMF, Hanover Products, Hercules Corp., Ramada Inns, Anaconda Erickson, Equitable Bankcorporation, Westinghouse.

© 1982 Howard Davis

feel free to tear this page out of the book

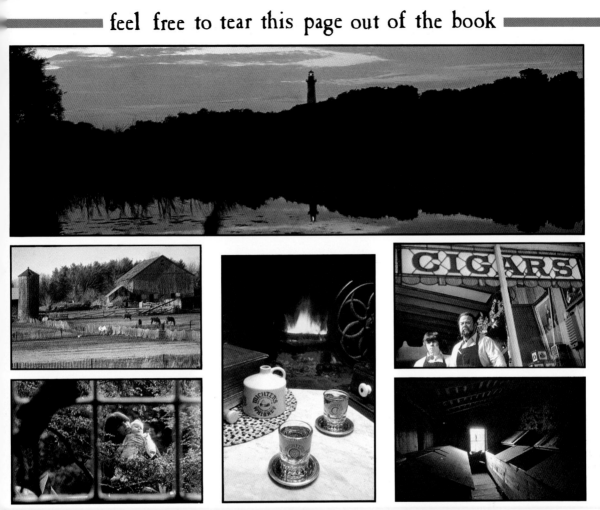

In response to the needs of discerning clients, we have developed the AMERICANA SERIES combining people, places, & still life in a single classic style. An unabashedly american view, it takes what is superb about the country & leaves the rest. Slightly nostalgic, warmly impressionistic perhaps, always complimentary. We've done AMERICANA VIEWS for Amex, IBM, Life, N.Y.T. Travel, SKF Labs, etc. Additionally, we offer warmth to corporate illustration & the finest handcrafting to a premium black & white. For more information or reprints of our pages; call my shop at 215·965·5479. Ask for Scott.

Our way of seeing might be right for each other.

this year ...

SCOTT HEIST...

is looking for 3 more quality clients.

©h. scott heist 83

GENERAL MEMBERS SOUTH/SOUTHWEST

A

ALDERDICE, BARHAM PO Box 52, Midlothian, TX 76065 (214) 775-3462, 775-3322
ALFORD, JESS 1800 Lear St - 3, Dallas, TX (214) 748-1310
ALLEN, DON Box 969, Morgan City, LA 70381 (504) 384-5127, 737-6819
ALSTON, R. COTTEN Box 7927 - Sta C, Atlanta, GA 30357 (404) 876-7859
ARRUZA, ANTONIO 131 Elwa Pl, W Palm Beach, FL (305) 586-0565
ASHLEY, CONNIE 2024 Farrington, Dallas, TX (214) 747-2501
ASSID, AL 122 Parkhouse, Dallas, TX (214) 748-3765

B

BACHMANN, BILL, Beautiful People, 1550 W 84 St, Hialeah, FL (305) 558-7023, 472-8834
BAGSHAW, CRADOC L. 603 High St NE, Albuquerque, NM (505) 243-1096
BAKER, BOBBE 1119 Ashburn, College Station, TX (713) 696-7185, 845-2211 x58
BAKER, KIPP 3000 Cullen - A, Ft Worth, TX (817) 654-3210
BARABAN, JOE 2426 Bartlett - Apt 2, Houston, TX (713) 526-0317;
 NY—Rabin & Renard (212) 490-2450; CHIC—Bill Rabin (312) 944-6655 **P 281**

BARLEY, BILL PO Box 447, Cayce, SC 29033 (803) 755-1554
BARNES, BILLY E. 313 Severin St, Chapel Hill, NC (919) 942-6350
BARON, RICHARD PO Box 5206, El Paso, TX 79953 (915) 533-3334
BARR, IAN 2640 SW 19 St, Ft Lauderdale, FL (305) 584-6247
BEDGOOD, BILL 18 S Rhodes Ctr Dr, Atlanta, GA (404) 872-3739
BEEBOWER, GORDON 9982 Monroe, Ste 401, Dallas, TX (214) 358-1219
BEECH, JACK 709 Royal, New Orleans, LA (504) 522-7419
BENOIST, JOHN Box 20825, Dallas, TX 75220 (214) 692-8813
BESWICK, PAUL 4479 Westfield Dr, Mableton, GA (404) 944-8579
BIRDYSHAW, BILL 1923 11 Ave S, Birmingham, AL (205) 870-0178
BISSONNET, DANIEL 705 E 23 St, Houston, TX (713) 880-3031
BLOCKLEY, GARY 2121 Regency Dr, Irving, TX (214) 438-4114
BOLCH, LARRY PO Box 50086, Dallas, TX 75250 (214) 943-8930
BORUM, MICHAEL 623 Sixth Ave, Nashville, TN (615) 259-9750, 256-1872
BRADSHAW, REAGAN PO Box 12457, Austin, TX 78711 (512) 458-6101 **P 324**

BRANNER, PHILLIP 2700 Commerce St, Dallas, TX (214) 698-1881
BRILL, DAVID Rt 4 - Box 121-C, Fairburn, GA 30213 (404) 461-5488
BROWN, RICHARD PO Box 1249, Asheville, NC 28802 (704) 253-1634 **P 269**

BRUCE, JR., DAVE A.D. PO Drawer 408, Scotland Neck, NC 27874 (919) 826-3600
BUFFINGTON, DAVID 2772 El Tivoli, Dallas, TX (214) 943-4721 **P 286**

DUMPASS, R. O. 2404 Farrington, Dallas, TX (214) 630-0180
BUNDERSON, STEVE 7315½ Ashcroft - 102, Houston, TX (713) 774-8565
BURKETT, WILLIAM 2422 E Newton Circle, Irving, TX (214) 255-4274
BYRD, SYDNEY 1205 Royal, New Orleans, LA (504) 588-9467

C

CABLUCK, JARROLD Box 9601, Ft Worth, TX 76107 (817) 336-1431; 732-5214
CALDWELL, JIM 2422 Quenby, Houston, TX (713) 527-9121 **P 333**

CAMPBELL, TOM 1815 E Indian School Rd, Phoenix, AZ (602) 264-1151
CANOVA, PAT 1575 SW 87 Ave, Miami, FL (305) 221-6731
CARLEBACH, MICHAEL L. 3634 Bayview Rd, Miami, FL (305) 444-8974
CARR, FRED, dba IMAGES, 8303 Westglen Dr, Houston, TX (713) 266-2872 **P 288-289**

CARRIKER, RONALD 565 Alpine Rd, Winston-Salem, NC (919) 765-3852
CARTER, JOHN C. 2682 Harrington Dr, Decatur, GA (404) 633-4946
CERNY, PAUL 610 Wood St, Zephyrhills, FL (813) 839-7710, 782-4386
CHALFANT, FLIP 1252 Eastland Rd, Atlanta, GA (404) 627-4451
CHEATHAM, EDGAR PO Box 18065, Charlotte, NC 28218 (704) 536-7257
CHISHOLM, BRUCE 3233 Marquart, Houston, TX (713) 623-8790
CLARK, H. DEAN 2209 Triway, Houston, TX (713) 467-5863
CLAUSSEN, PETER 6901 Mullins - Ste C, Houston, TX (713) 661-7498
CLAYTON, AL 141 The Prado NE, Atlanta, GA (404) 881-1170
CLINTSMAN, DICK 2201 N Lamar, Dallas, TX (214) 651-1081
CODY, DENNIE 5820 SW 51 Ter, Miami, FL (305) 666-0247 **P 285**

COHEN, BERNARD PO Box 13383, Atlanta, GA (404) 231-4354
COLEMAN, BOB 1201 Adams, New Orleans, LA (504) 866-9001
COMPTON, GRANT 7004 San Mettles Dr, Savannah, GA (912) 897-3771
CONNOLLY, DAN F. PO Box 1290, Houston, TX 77251 (713) 862-8146, GL (212) 888-7297
CONTORAKES, GEORGE PO Box 430901, S Miami, FL 33134 (305) 661-0731

COOK, ROBERT A. 6609 Anita, Dallas, TX (214) 821-4975
COWLIN, JAMES PO Box 34205, Phoenix, AZ 85067 (602) 264-9689
CRAFT, BILL 2008 Laws St, Dallas, TX (214) 748-1470
CRAIG, GEORGE 2405 Sage Rd, Houston, TX (713) 871-9329
CREIGHTON, WILLIAM 112 Linwood Ln, Summerville, SC (803) 873-3040
CROMER, PEGGO 1206 Andora Ave, Coral Gables, FL (305) 667-3722
CULBERSON, JIM Box 390, Sealy, TX 77474 (713) 885-7020

D

DE CASSERES, JOSEPH 418 Calhoun St NW, Atlanta, GA (404) 872-4480
DECHERT, PETER PO Box 636, Santa Fe, NM 87501 (505) 983-2148
DICKINSON, DICK 1854 County Line Rd, Sarasota, FL (813) 351-2036

DIETRICH, DAVID 13255 SW 119 St, Miami, FL (305) 385-4248
DIETZ, SUZANNE RAY 2008 Laws, Dallas, TX (214) 748-1672
DOBBS, DAVID 1536 Monroe Dr NE, Atlanta, GA (404) 885-1460

DOBEL, MIKE 307 Adair St - Apt E9, Decatur, GA (404) 373-3310
DOERING, DOUGLAS 1222 Manufacturing St, Dallas, TX (214) 330-0304
DOUGLAS, KING 1319 Conant St, Dallas, TX (214) 630-4700
DRYMON, TERRY PO Box 151568, Tampa, FL 33614 (813) 872-0603
DURAN, MARK 1095 E Indian School, Phoenix, AZ (602) 279-1141

E

EDENS, SWAIN 104 Heimen, San Antonio, TX (512) 226-2210

EDMONSON, DAVID 6704 Northwood Rd, Dallas, TX (214) 824-3094
ELMER, CARLOS PO Box 4005, Scottsdale, AZ 85258 (602) 948-2867
EMBERY, RICHARD 1701 E Granada, Phoenix, AZ (602) 252-6083
ENGELMANN, SUZANNE 446 Brazilian Ave, Palm Beach, FL (305) 833-5888
ENGLAND, THOMAS 1055 Monroe Dr NE, Atlanta, GA (404) 881-6262
ENGLISH, MELISSA HAYES PO Box 14391, Atlanta, GA 30324 (404) 261-7650

F

FAUST, RICHARD 426 W Main, Norman, OK (405) 364-8052
FERAY, C. MICHEL 215 Asbury, Houston, TX (713) 864-3638
FINEMAN, MICHAEL 7521 SW 57 Terrace, Miami, FL (305) 666-1250
FISHER, RAY 10700 SW 72 Ct, Miami, FL (305) 665-7659

FORER, DAN 1970 NE 149 St, N Miami, FL (305) 949-3131

FORSYTH, MIMI PO Box 992, Santa Fe, NM 87501 (505) 982-8891
FOWLEY, DOUGLAS 103 N Hite, Louisville, KY (502) 897-7222
FREEMAN, CHARLIE 3333 Elm, Dallas, TX (214) 742-1446
FREEMAN, TINA 7927 Jeannette St, New Orleans, LA (504) 865-9344, 949-1863
FRINK, STEPHEN PO Box 19-A, Key Largo, FL 33037 (305) 451-3737

FULLER, TIMOTHY 135½ S Sixth Ave, Tucson, AZ (602) 622-3900

G

GALLOWAY, JAMES 2210 N Lamar St, Dallas, TX (214) 651-1081
GANDY, SKIP 302 E Davis Blvd, Tampa, FL (813) 253-0340

GEFTER, JUDITH 1725 Clemson Rd, Jacksonville, FL (904) 733-5498; 733-8197; Stock—(714) 553-9333

GELBERG, BOB 3200 Ponce De Leon Blvd, Coral Gables, FL (305) 448-8458

GEMIGNANI, JOE 13833 NW 19 Ave, Miami, FL (305) 685-7636

GERCZYNSKI, THOMAS 2211 N 7 Ave, Phoenix, AZ (602) 252-9229
GLEASNER, BILL Rt 3 Box 592, Denver, NC 28037 (704) 483-9301
GOMEL, BOB 5755 Bohomme Rd - Ste 408, Houston, TX (713) 977-6390

GRAHAM, F. N. 12 N Hardee Circle, Rockledge, FL (305) 636-1329
GREEN, MARK S. 2408 Taft, Houston, TX (713) 523-6146
GREENBERG, JERRY 6840 W 92 St, Miami, FL (305) 667-4051
GRIGG, ROGER ALLEN PO Box 52851, Atlanta, GA 30355 (404) 876-4748, 971-5258

GRIMES, BILLY Box 19739 - Sta N, Atlanta, GA 30325 (404) 971-0446
GROENDYKE, BILL 7320 Fox Chapel Dr, Miami, FL (305) 822-7559 **P 294-295**

GROSSMAN, JOHN 1752-B Branard St, Houston, TX (713) 523-2316
GULLERS, KARL W. 4963 E Palomino Rd, Phoenix, AZ (602) 952-0609
GURAVICH, DR. DAN PO Box 891, Greenville, MS 38701 (601) 335-2444

H

HAGGERTY, RICHARD 1200 Lakecrest, High Point, NC (919) 869-6649
HALLINAN, DENNIS PO Box 1783, Winter Haven, FL 33880 (813) 293-7942
HALPERN, DAVID 4153 S 87 Ave, Tulsa, OK (918) 622-8218
HAMILTON, JEFFREY 6719 Quartzite Cyn Pl, Tucson, AZ (602) 299-3624
HANDEL, DOUG 3016 Selma, Dallas, TX (214) 241-1549 **P 282**

HANNAU, MICHAEL 13225 NW 42 Ave, Opa Locka, FL (305) 534-7927
HARRIS, CHRISTOPHER R. 3039 De Soto St, New Orleans, LA (504) 586-0209 **P 307**

HART, MICHAEL 7320 Askcroft - Ste 105, Houston, TX (713) 271-8250
HAWKS, BOB 1345 E 15 St, Tulsa, OK (918) 584-3351
HAYNES, MICHAEL 2700 Commerce, Dallas, TX (214) 698-1881
HAYNSWORTH, JOHN, Photography Inc, 86½ Highland Park Vill, Dallas, TX (214) 559-3700
HAZZARD, JOSEPH, Creative Photographers, 2214 Hawkins St, Charlotte, NC (704) 376-6475
HEINSOHN, BILL 5455 Dashwood, Houston, TX (713) 666-6515
HIGHT, GEORGE C. 1401 Linda Dr, Box 327, Gallup, NM 87301 (505) 863-3222, 5505
HILL, JACKSON BOX 15276, New Orleans, LA 70175 (504) 891-4747; 468-5575 **P 279**

HILLYER, JONATHAN 450-A Bishop St, Atlanta, GA (404) 351-0477
HOFLICH, RICHARD 1189 Virginia Ave, Atlanta, GA (404) 872-3491 **P 296-297**

HOGBEB, STEVE 2066 Drew Valley Rd, Atlanta, GA (404) 636-1515
HOLLAND, RALPH 3706 Alliance Dr, Greensboro, NC (919) 855-6422
HOUSEL, JAMES F. 1308 Welch St, Houston, TX (713) 523-2624;
Milan—Bradford Hilary 02.585603 **P 300**

HOWARD, JERRY PO Box 2354, Boca Raton, FL 33432 (305) 421-5563
HULSEY, JAMES C. 803 Northbrook Ave, Edmond, OK (405) 348-1156
HUNTER, BUD, Hunter Photography, 917½ Oxmoor Rd, Birmingham, AL (205) 879-3153

JK

JAMISON, CHIPP Earthwork Studio, 2131 Liddell Dr, Atlanta, GA
(404) 873-3636 **P 270-271**
JIMISON, TOM 5929 Annunciation, New Orleans, LA (504) 891-8587 **P 321**

JONES, C. BRYAN PO Box 66691, Houston, TX 77006 (713) 524-5594
KAPLAN, AL PO Box 611373, N Miami, FL 33161 (305) 891-7595
KATZ, JOHN 1222 Manufacturing, Dallas, TX (214) 742-8713
KAUFMAN, LEN PO Box 1892, Hollywood, FL 33022 (305) 920-7822
KEATING, FRANKE 141 Bayon Rd, Greenville, MS (601) 334-4088
KENNY, GILL 3515 N Camino De Vista, Tucson, AZ (602) 743-0963
KERNBERGER, KARL Box 241, 1321 Cerro Gordo Rd, Santa Fe, NM 87501 (505) 983-2934
KERSH, VIRON PO Box 51201, New Orleans, LA 70151 (504) 524-7255
KING, J. BRIAN 1267 Coral Way, Miami, FL (305) 856-6534
KIRKLEY, KENT 1345 Conant, Dallas, TX (214) 630-0051
KIVIAT, WILLIAM 1708 E Beth Dr, Phoenix, AZ (602) 276-7862
KLUMPP, DON 804 Colquitt St, Houston, TX (713) 521-2090
KNOWLES, JAMES 1419 So Quaker, Tulsa, OK (918) 584-8953
KNUDSON, KENT PO Box 26481, Phoenix, AZ 85008 (602) 251-0481 **P 322-323**

KOLLAR, ROBERT E. 1431 Cherokee Trail - Apt 52, Knoxville, TN (615) 632-2091, 573-8191
KRETCHMAR, PHILLIP 3333 Elm St, Dallas, TX (214) 744-2039

L

LANDRE, MAURICE Box 397, Merritt Isl, FL 32952 (305) 452-0262
LAU, GLENN H. 7665 SW 105 St, Ocala, FL (904) 237-4123
LEGEAR, SCOTT PO Box 855, Lake Helen FL 32744 (904) 228-3787
LEVITON, JAY B. 1271 Roxboro Dr NE, Atlanta, GA (404) 237-7766
LEVY, SANDY 6200 SW 108 Pl, Miami, FL (305) 595-4453
LEWIS, HUGH, Shooter-S Photographic Inc, PO Box 240502, Charlotte, NC 28224
(704) 525-4086
LOW, GERRY 369 Brianwood Villa, Sea Pines Plantation, Hilton Hd Isl, SC (803) 671-6752

M

MAGRUDER, MARY & RICHARD 2156 Snapfinger Rd, Decatur, GA (404) 289-8985, 284-9029
MALLES, ED, Triad Studios Inc, 807 9 Court S, Birmingham, AL (205) 251-0651, 833-6309
MANSKE, THAINE 7313 Ashcroft - 216, Houston, TX (713) 771-2220
MANSTEIN, RALF 5353 Institute Ln, Houston, TX (713) 523-2500　　　　　**P 314**

MARCHANT, LARRY 619 DeKalb Industrial Way, Atlanta, GA (404) 292-2010
MARKATOS, JERRY Rt 2 - Box 161, Pittsboro, NC 27312 (919) 542-2139
MARKHAM, JAMES 2739 SE Loop 410, San Antonio, TX (512) 648-0403
MARTIN, SYLVIA 1408 Cresthill Rd, Birmingham, AL (205) 592-7119
MASON, CHUCK 2117 Opa Locka Blvd, Opa Locka, FL (305) 769-0911
MAY, CLYDE 1037 Monroe Dr NE, Atlanta, GA (404) 873-4329
McCARTHY, TOM 8960 SW 114 St, Miami, FL (305) 233-1730; NY–Don Stogo
(212) 490-1034　　　　　**P 301**

McCOY, GARY 2700 Commerce St, Dallas, TX (214) 698-1881
McGEE, E. ALAN 1816 Briarwood Ind Ct, Atlanta, GA (404) 633-1286　　　**P 318-319**

McINTOSH, WILLIAM 605 Stillmeadow Dr, Richardson, TX (214) 783-0880
McINTYRE, WILLIAM 3746 Yadkinville Rd, Winston-Salem, NC (919) 924-6604
McLAUGHLIN, HERB & DOROTHY 2344 W Holly, Phoenix AZ (602) 258-6551
McNABB, TOMMY, McNabb Studio, 4015 Brownsboro Rd, Winston-Salem, NC (919) 723-4640
McNEE, JIM 1622 W Alabama, Houston, TX (713) 526-5110
McNEELY, BURTON 251E Dupree Dr, PO Box 338, Land O'Lakes, FL 33539
(813) 996-3025; NY–Lenore Herson (212) 953-0303;
CHIC–Monica Geocaris (312) 664-8400　　　　**P 327, 435**

MEDINA, NELSON 3211 Bay to Bay Blvd, Tampa, FL (813) 839-6754
MEYERSON, ARTHUR 4215 Bellaire Blvd, Houston, TX (713) 660-0405　　　**P 304-305**

MILLER, FRANK J. PO Box 1990, Hickory, NC 28601 (704) 324-8758
MILLER, FRANK LOTZ 1115 Washington Ave, New Orleans, LA (504) 899-5688
MILLER, RANDY 5770 SW 114 Terr, Miami, FL (305) 667-5765
MILLS, HENRY 5514 Starkwood Dr, Charlotte, NC (704) 535-1861
MOBERLEY, CONNIE 215 Asbury, Houston, TX (713) 864-3638
MOORE, TERRENCE PO Box 41536, Tucson, AZ 85717 (602) 623-9381
MORGAN, RED 970 Hickory Trail, W Palm Beach, FL (305) 793-6085　　　　**P 309**

MORIARTY, JIM PO Box 2000, Southern Pines, NC 28387 (919) 692-7915
MORRIS, GARRY 9281 E 27 St, Tucson, AZ (602) 885-5009
MUCH, MICHAEL 73 N Wilshire Dr, Phoenix, AZ (602) 253-7839
MULLEN, EDWARD F. 810 Ponce De Leon, Belleair, FL (813) 585-1763
MURRAY, STEVE 1330 Mordecai Dr, Raleigh, NC (919) 833-0702
MYERS, FRED 114 Regent Lane, Florence, AL (205) 766-4802
MYHRE, GORDON PO Box 1226, Indian Rocks Bch, FL 33535 (813) 584-3717

NO

NANCE, DAVID 8202 Fernbrook Ln, Houston, TX (713) 469-4757　　　　**P 331**

NAULT, CORKY PO Box 33175, San Antonio, TX 78233 (512) 655-1191
NEMETH, JUDY 1518 Park Dr - 1, Charlotte, NC (704) 375-9292
NOBLE, DAVIS 324 W 3 St, Tyler, TX (214) 592-3736　　　　　　**P 308**

NOLAN, NINA 5713 Worth St, Dallas, TX (214) 824-2509
OLIVE, JIM 2404 Taft, Houston, TX (713) 526-6560
OLIVE, TIM 754 Piedmont Ave, Atlanta, GA (404) 872-0500
OLVERA, JAMES 2700 Commerce St, Dallas, TX (214) 698-1881
OSBORNE, MITCHEL L. 326 Picayune Pl, New Orleans, LA (504) 522-1871, H (514) 947-1797

P

PANTIN, TOM Box 1146, Austin, TX 78767 (512) 474-9968
PARKER, GARY 3121 Highland Ave - 7, Birmingham, AL (205) 877-6202, H (205) 322-1816
PATRICK, RICK 401 Lavaca, Austin, TX (512) 472-9092 **P 278**

PAYNE, AL 830 N Fourth Ave, Phoenix AZ (602) 258-3506
PAYNE, TOM 2425 Bartlett, Houston, TX (713) 527-8670 **P 276-277**

PELHAM, LYNN 20 SE 8 St, Miami, FL (305) 371-2013
PERLSTEIN, MARK 1844 Place One Ln, Garland, TX (214) 690-0168
PIERCE, NANCY J. PO Box 30815, Charlotte, NC 28230 (704) 333-4221 **P 292**

POSEY, MIKE 3524 Canal St, New Orleans, LA (504) 488-8000

R

REDD, TRUE 2328 Farrington, Dallas, TX (214) 638-0602
REISCH, JIM 2025 Levee St, Dallas, TX (214) 748-0456 **P 311**

RICH, WILBURN 3233 Marquart, Houston TX (713) 623-8790
RIGGALL, MICHAEL 403 8 St NE, Atlanta, GA (404) 872-8242
RIPPEY, RHEA PO Box 50093, Nashville, TN 37205 (615) 242-1332
ROBBINS, JR., JOE D. 3505 Louisiana, Houston, TX (713) 526-1747
RODGERS, TED 1157 W Peachtree St NW, Atlanta, GA (404) 892-0967
ROE, CLIFF 14 Cassoway Lane, Woodlands, TX (713) 363-5661, 363-4226
ROGERS, CHUCK 508 Armour Cir, Atlanta, GA
RONQUILLO, LEON 2515 Montesquien St, Chalmette, LA (504) 255-2085
RUBIO, MV 1203 Techwood Dr, Atlanta, GA (404) 892-7083
RUNION, BRITT 1829 N Baywood Ave, Orlando, FL (305) 293-4195
RUNNING, JOHN, Running Productions, PO Box 1237, Flagstaff AZ 86002 (602) 774-2923
RUSSELL, GAIL Box 241, Taos, NM 87571 (505) 776-8474 **P 332**

RUSSELL, NICOLAS 2014 Waugh Dr, Houston, TX (713) 524-6432 **P 284**

S

SALAS, MICHAEL 1109 Whitehall Dr, Plano, TX (214)423-4396
SANDLIN, R MARK 1235 Maple Dr, Lilburn, GA (404) 923-2949
SCHERMAN, ROWLAND 929½ 22 St S, Birmingham, AL (205) 322-2333
SCHIFF, KEN 8380 SW 160 St, Miami, FL (305) 255-0666
SCHULKE, FLIP PO Box 430760, MIAMI, FL 33143 (305) 667-5671, (212) 679-3288
SCHUSTER, ELLEN 3719 Gilbert, Dallas, TX (214) 526-6712
SCOTT, RON 1000 Jackson Blvd, Houston, TX (713) 529-5868 **P 298-299**

SCRUGGS, JIM 2408 Taft, Houston, TX (713) 523-6146
SEITZ, ART 615 NE 12 Ave - 109, Ft Lauderdale, FL (305) 764-5635
SHAW, BOB 1723 Kelly St, Dallas, TX (214) 428-1757 **P 330**

SHELDON, MT Rt 2 - Box 61-A, Canton, NC 28716 (704) 235-8345
SHERMAN, BOB 1166 NE 182 St, Miami Beach, FL (305) 944-2111
SHERMAN, RON P.O. Box 28656, Atlanta, GA 30328 (404) 993-7197 **P 302**

SHIPMAN, JOHNNY 2201 N Lamar, Dallas, TX (214) 742-5563
SHOEMAKER, ED PO Box 4058, Salisbury, NC 28144 (704) 633-4900
SHORT, GLENN 78 West Cypress St, Phoenix, AZ (602) 252-0069
SIEBENTHALER, JOHN Drawer 338, Elfers, FL 33531 (813) 848-8196, 2927
SIMS, JIM 2433 Bartlett, Houston, TX (713) 522-0817
SIRVEN, FAUSTINO 16138 Olive Glen, Houston, TX (713) 496-6543
SLATER, EDWARD 6289 W Sunrise Blvd - Ste 203, Sunrise, FL (305) 949-5191,
791-2772 **P 280**

SMELTZER, ROBERT 10-B Sevier St, Greenville, SC (803) 235-2186
SMITH, RICHARD W 3718 Westfield, High Point, NC (919) 869-5034
SMUSZ, BEN 7313 Ashcroft - 216, Houston, TX (713) 774-2082
SPARKS, DON, Sparks Studio, 670 11 St NW, Atlanta, GA (404) 876-7354
SPERRY, BILL 3300 E Stanford, Paradise Valley, AZ (602) 955-5626
STEARNS, SUZANNE A. 1448 N Morningside Dr NE, Atlanta, Ga (404) 261-0439
STITES, BILL 1600 Park, Houston, TX (713) 522-1254
STORY, THOMAS PO Box 547, Tempe, AZ 85281 (602) 966-6134
STRODE, WILLIAM H. 1008 Kent Road, Prospect, KY (508) 228-4446

T

TEER, DAVE 1323 Levee, Dallas, TX (214) 741-5141

TERRY, PHILLIP 2039 Farrington, Dallas, TX (214) 749-0515

THIGPEN, ROBERT 11426 Sageperry, Houston, TX (713) 481-4856

THOMAS, J. CLARK, 2350 Elliston Pl - Apt C5, Nashville, TN (615) 327-1757

THOMPSON, DENNIS 6926 E 75 St, Tulsa, OK (918) 492-0755

THOMPSON, TOMMY 1317 N Highland Ave NE, Atlanta, GA (404) 881-8130, S(404) 524-1234

**TILLEY, ARTHUR, The Ice House, 1925 College Ave NE, Atlanta, GA
(404) 371-8086** P 334-335

TRIMBLE, STEPHEN Box 880, Flagstaff, AZ 86002 (602) 774-1331

**TURNAU, JEFF 10800 SW 68 Ave, Miami, FL (305) 666-5454; NY
(212) 926-2825** P 312-313

UV

UGRIN, BELA 7915 Woodway, Houston, TX (713) 840-5883, H (713) 781-3477

VAN CALSEM, BILL 824 Royal St, New Orleans, LA (504) 522-7346

VANCE, DAVID M 13760 NW 19 Ave - 4, Miami, FL (305) 685-2433

VAUGHN, MARC PO Box 660-706, Miami Spgs, FL 33166 (305) 888-4926

VULLO, PHILLIP 565 Dutch Valley Rd NE, Atlanta, GA (404) 874-0822

WZ

WALKER, BALFOUR 150 Avenida De Palmas, Tucson, AZ (602) 881-3373

WALTERS, TOM 804 Atando Ave, Charlotte, NC (704) 333-6294

WANDS, BOB 2605 S Lockwood Ridge Rd, Sarasota, FL (813) 922-8273

WARD, SHEILA Rte 8 Box 57, Tucson, AZ 85710 (602) 298-3727

WARD, JOSEPH III 920 Linden St, Shreveport, LA (318) 861-3697

WATKINS, JC 2329 Thomas Blvd, Port Arthur, TX (713) 982-3666

WEEKS, CHRISTOPHER M 103 E 35 St, Tulsa, OK (918) 749-1917

WELLS, CRAIG 537 W Granada, Phoenix, AZ (602) 252-8166

WERRE, BOB 5950 Westward, Houston, TX (713) 785-5754

WHEELER, DON 4928 E 26 Pl, Tulsa, OK (918) 744-8902 P 316

WHITAKER, JON 538 W McDowell, Phoenix, AZ (602) 257-1847

WHITLOCK, NEILL 2121 Regency Dr, Irving, TX (214) 438-4114

WHITMAN, ALAN PO Box 8446, Mobile, AL 36608 (205) 344-1572, 473-8626

WILEY, JR., ROBERT 1936 Church St, W Palm Beach, FL (305) 683-5559

WILLIAMS, JIMMY 501 Method Rd, Raleigh, NC (919) 832-5971

WILLIAMS, OSCAR 8535 Fairhaven, San Antonio, TX (512) 690-8888

WILLIAMSON, THOMAS 9501 SW Colonial Dr, Miami, FL (305) 255-6400

**WILSON, JENNIFER, dba WILCOM 8303 Westglen Dr, Houston, TX
(713)266-2872** P 287

WILSON, MICHAEL 3016 Selma, Dallas, TX (214) 241-1549 P 283

WINNER, ALAN 20151 NE 15 Ct, N Miami Bch, FL (305) 653-6778

WITT, LOU 5531 Timber Creek Dr, Houston, TX (713) 944-1603

WOLFHAGEN, VILHELM 4916 Kelvin, Houston, TX (713) 522-2787

WOLLAM, LES 5215 Goodwin, Dallas, TX (214) 760-7721

WOOD, PATRICK 2119 NW 39, Oklahoma City, OK (405) 525-2848

WRISLEY, BARD PO Box 18502, Atlanta, GA 30326 (404) 875-1087

WRISTEN, DONALD F. 2025 Levee St, Dallas, TX (214)748-5317 P 310

ZEEB, DEAN D 3707 N 7 St, Phoenix, AZ (602) 248-7753

ASSOCIATE MEMBERS SOUTH/SOUTHWEST

AB

ARONOVSKY, JAMES 4312 Betty, Bellaire, TX (713) 665-3545
BAKER, JEFF 2200 N Griffin, Dallas, TX (214) 651-9006
BARKER, KENT 1308 Conant, Dallas, TX (214) 330-1618
BARRS, MICHAEL 6303 SW 69 St, Miami, FL (305) 665-2047
BENTLEY, BEVERLY 2508 Reba Dr, Houston, TX (713) 528-4235
BINGHAM, DALE E. 7040 Fair Oaks - 1056, Dallas, TX (214) 750-6233
BROUSSEAU, JAY 1821 Levee, Dallas, TX (214) 826-1888
BUTKOVICH-MARTIN, KIM 2615 Waugh Dr - 304, Houston, TX (713) 526-6516

CDE

CALABRIA, DAN 2412 Converse, Dallas, TX (214) 691-2067
CAUDLE, ROD 1231-A Collier Rd NW, Atlanta, GA (404) 352-5580
CHENN, STEVE 9511 Windswept, Houston, TX (713) 785-0205
CLEMENS, FRANK H. 9900 Richmond - Apt 1605, Houston, TX (713) 784-3188
CORCORAN, TOM PO Box 52, Fairhope, AL 36532 (205) 928-5605
CRUZ, FRANCISCO 1821 W Alabama, Houston, TX (713) 520-0226
DEWEES, RICHARD 10750 Bushire Dr, Dallas, TX (214) 352-8141
DIAZ, RICK 7395 SW 42 St, Miami, FL (305) 264-9761
DOUGLAS, KEITH 5707 NE 27 Ave, Ft Lauderdale, FL (305) 491-8161
DREWITZ, MIKE 88 Farmington Dr, Woodstock, GA (404) 928-1644
ELLIS, GIN 1203 Techwood Dr, Atlanta, GA (404) 892-0783

FG

FODERA, ANTHONY 1723 Kelly St, Dallas, TX (214) 321-9006
GREEN, JEREMY 2700 Commerce St, Dallas, TX (214) 698-1881
GREENBERG, BOB 8625 NW 8 St - Apt 109, Miami, FL (305) 262-3135
GWINN, BETH PO Box 22817, Nashville, TN 37202 (615) 226-0845

HIJ

HAM, DAN 3431 Binkley - 7, Dallas, TX (214) 559-3739
HARRISON JR., ROBERT Whetstone Photo, Long Creek, SC (803) 638-2117
HEGER, JEFF 3915 Garrott, Houston, TX (713) 552-1120
HEUBECK, KERRY Rt 2, Box 2737, Ft McCoy, FL 32637 (904) 685-2420
HUNT, JOHN 7575 Cambridge - 1001, Houston, TX (713) 797-0133
IRVIN, MARCUS 3230 Rook Glen, Garland, TX (214) 530-1033
JENKINS, DAVID 101 Foster Dr, Ringgold, GA (404) 891-0570
JUREIT, ROBERT 916 Aguero Ave, Coral Gables, FL (305) 665-0917

KLM

KNUDSON, PAUL 1133 W Tucker Blvd, Arlington, TX (817) 277-8029
KOWENSKI, HAL 2999 Ruth St, Miami, FL (305) 442-4261
KUPER, HOLLY 3008 McFarlin Blvd, Dallas, TX (214) 750-6229
LAWRENCE, JOHN Box 330570, Coconut Grove, FL 33133 (305) 447-8621
LAWRIE, BILL 6516 Turner Way, Dallas, TX (214) 661-2358
MALONEY, JOHN W. 170 Leslie, Dallas, TX (214) 741-6320
MANN, ROD Rt 5 - Box 5082, Knotts Island, NC (919) 429-3009
MARINE, TOTSIE 215 Asbury, Houston, TX (713) 864-3638
MASSIE, WAYNE W. 6906 Northwood, Dallas, TX (214) 368-4389
MAYER, GEORGE 5106 Sandalwood Lane, Arlington, TX (817) 467-7956
McCARTHY, JANET 7045 SW 69 Ave, Miami, FL (305) 661-9003
MEAD, WIL PO Box 471, Islamorada, FL 33036 (305) 664-3681
MULLAN III, JOSEPH 1111 Woodlawn Ave, Dallas, TX (214) 946-8078

NO

NELSON, MARGO, The Photographic Eye, 2712 Meadowstone, Carrollton, TX (214) 242-0140
NORELL, J. B. 8600 Westpark - 110, Houston, TX (713) 521-2090
NORWOOD, NICK 125-34 Griffing Blvd, N Miami, FL (305) 893-2036
O'BRIEN, MICHAEL F. 2402 Clark Ave, Raleigh, NC (919) 828-0653

P

PACE, HAROLD W. 2404 Farrington, Dallas, TX (214) 243-3870
PARISH, JIM 4947 Victor, Dallas, TX (214) 823-6605
PERMAN, CRAIG 1645 Hennepin Ave - 212, Minneapolis, MN (612) 338-7727
PIETERSON, ALEX 4411 Sheridan, Miami Beach, FL (305) 538-3180
PLACHTA, GREGORY 3030 Corwallis Rd, Research Triangle Pk, NC (919) 683-5557
POFFENBERGER, STEPHEN PO Box 5321, Clearwater, FL 33515 (813) 442-9656
POTTS, MILTON % Howard, 4632 Old Spanish Terr, Dallas, TX
POULIDES, PETER PO Box 202505, Dallas, TX 75220 (214) 350-5395
PROCTOR, BLAIR 400 Lansbrook Ave - 27, Ponca City, OK (405) 767-2371

RS

RANTALA, JIM 1102½ E 7½ St, Houston, TX (713) 864-1585
REGAS, KAREN 3573 Linden Ln, Coconut Grove, FL (305) 442-0330
RICHARDSON, DALE PO Box 93182, Atlanta, GA 30318 (404) 944-8290
SALL, NARINDER 2024 Karbach - Ste 3, Houston, TX (713) 680-3717
SCHWARTZ, ALAN 1803-60 S Dixiana St, Hollywood, FL (305) 923-8234
SORLIE, MICHAEL PO Box 12604, Dallas, TX 75225 (214) 669-0984
STEIN, HOWARD 20240 SW 92 Ave, Miami, FL (305) 238-7361
STEMLEY, HERBERT R. Rt 9 - Box 1701, Brooksville, FL 33512

TW

THOMAS, MILES Rt 3 104 Ridgewood Cr, Roanoke, TX (817) 730-1349
THOMASON, DAVID 3117 Bigham Blvd, Ft Worth, TX (817) 739-4257
TRUFANT, DAVID, New Developments Inc, 1900 Highland Rd, Baton Rouge, LA (504) 344-0239
WEST, MICHAEL 928 St Charles Ave, Atlanta, GA (404) 872-9651

RICHARD BROWN
& ASSOCIATES, INC.

PO Box 1249
Asheville, NC 28802

704/253-1634

SPECIALIZING IN CATALOGS / E6 LAB ON PREMISES

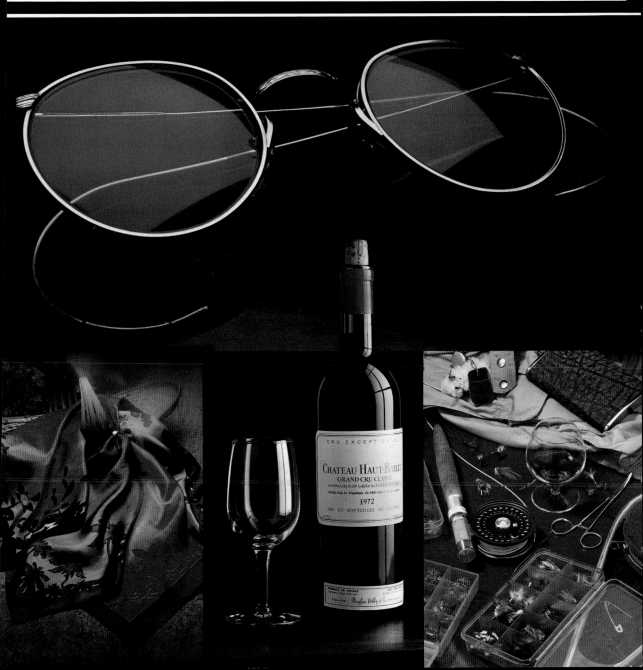

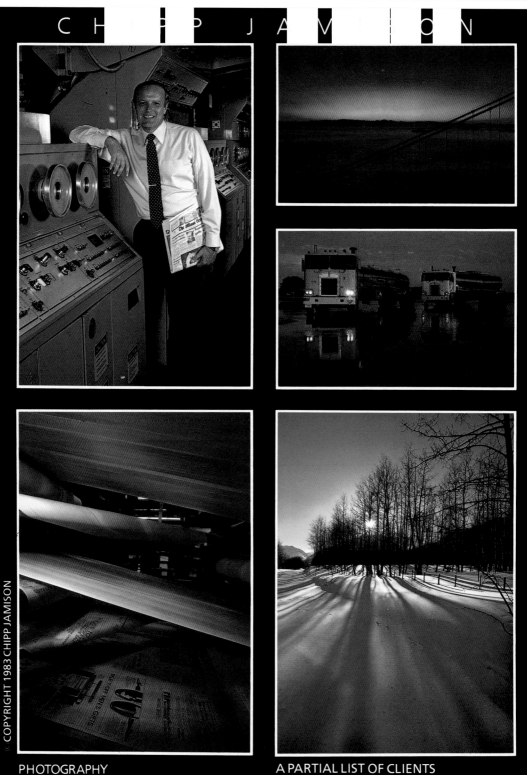

CHIPP JAMISON

© COPYRIGHT 1983 CHIPP JAMISON

PHOTOGRAPHY
ON ASSIGNMENT OR STOCK
EARTHWORK STUDIO ● (404) 873 3636
2131 LIDDELL DR ●ATLANTA, GA 30324

A PARTIAL LIST OF CLIENTS
AT&T ● COCA–COLA ● DELTA AIRLINES
DuPONT ● ETHYL CORPORATION
MOBIL CHEMICAL

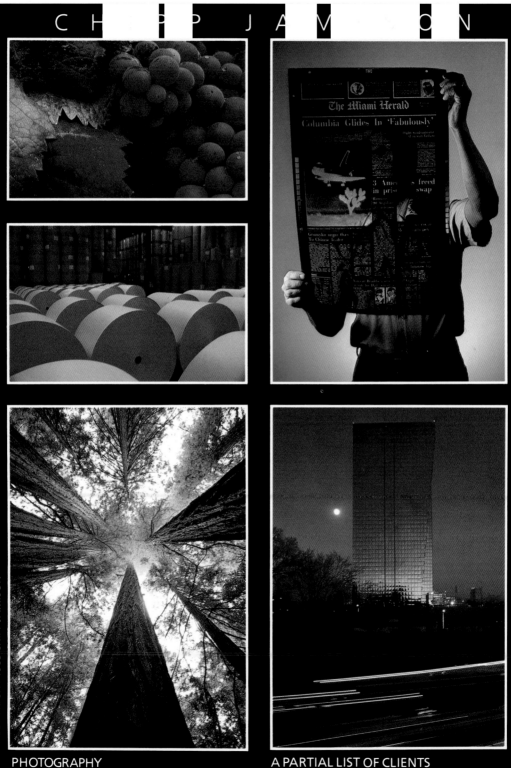

C H I P P J A M I S O N

PHOTOGRAPHY
ON ASSIGNMENT OR STOCK
EARTHWORK STUDIO ● (404) 873 3636
2131 LIDDELL DR ● ATLANTA, GA 30324

A PARTIAL LIST OF CLIENTS
RAYTHEON CO. ● ST. REGIS PAPER
KNIGHT−RIDDER NEWSPAPERS
MAGNAVOX ● WANG LABORATORIES

Judith Gefter

1725 Clemson Road
Jacksonville, Fl. 32217
(904) 733-5498

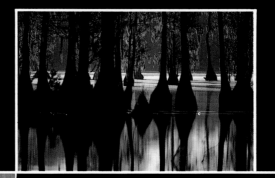

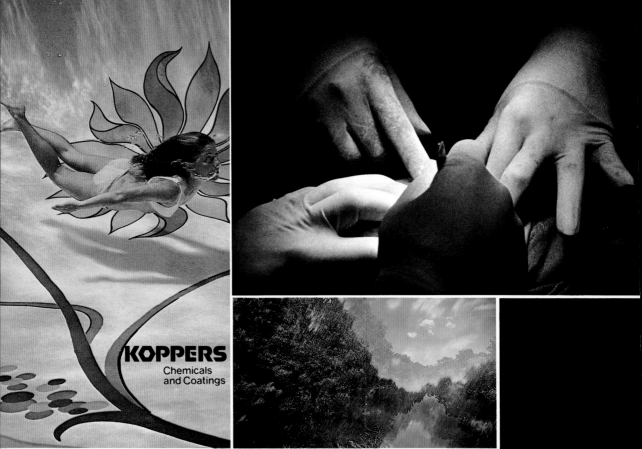

KOPPERS
Chemicals
and Coatings

Creative effects + Annual Reports + Travel + Medical + Advertising + Editorial + South
Western Electric + Forbes + Fortune + Business Week+ Blue Cross + Chevron + Charter + Kodak
Some Stock at: FirstVision, California (714) 553-9333

© 1983 Judith Gefter

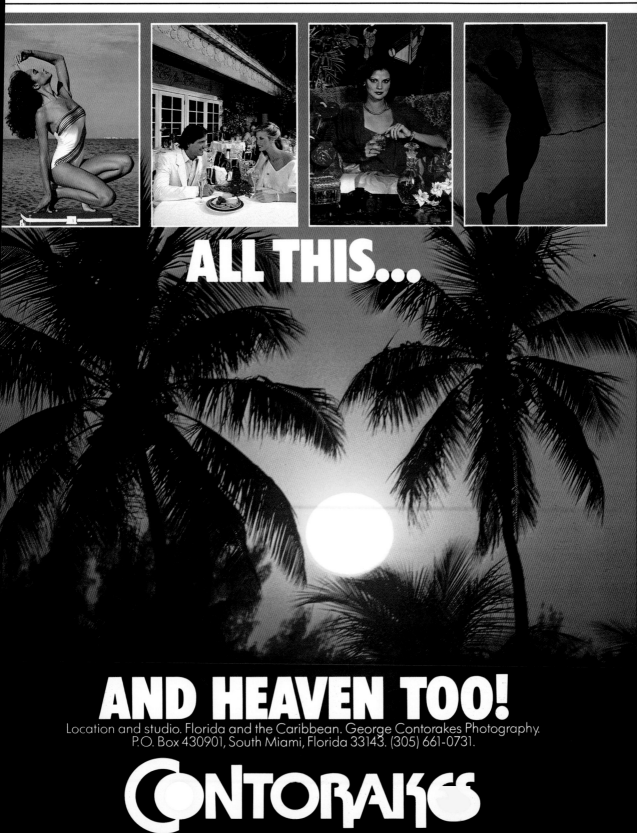

SWAIN EDENS

104 Heiman
San Antonio, Texas 78205
(512) 226-2210

SWAIN EDENS

104 Heiman
San Antonio, Texas 78205
(512) 226-2210

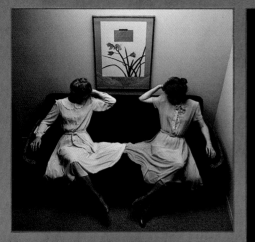

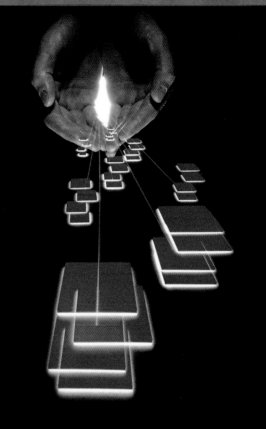

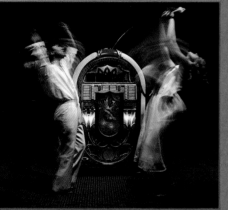

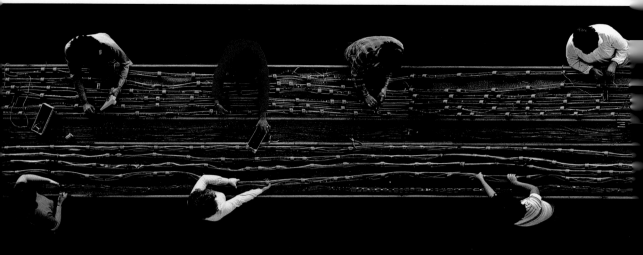

T O M P

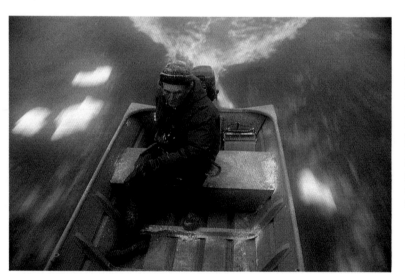

No one can shoot the outdoors like someone who's loved the outdoors all his life. Tom Payne knows the outdoors like the back of his hand. So when he has to go indoors, he makes sure it's worth the effort.

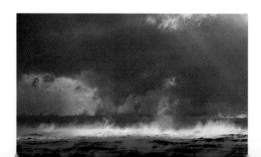

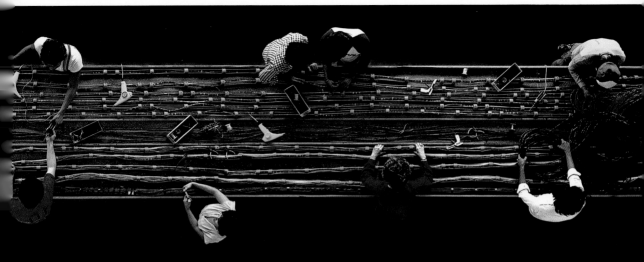

A Y N E

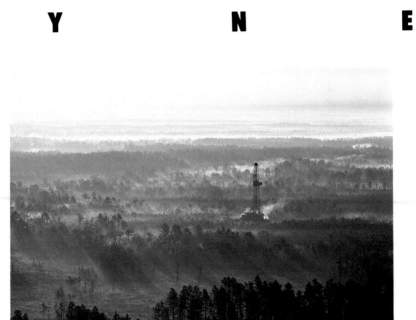

©Tom Payne
Photographer Inc.
2425 Bartlett
Houston, Texas 77098
(713) 527-8670

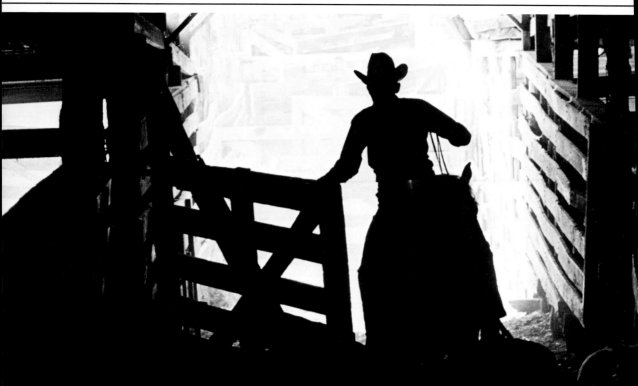

RICK PATRICK SHOOTS TEXAS.

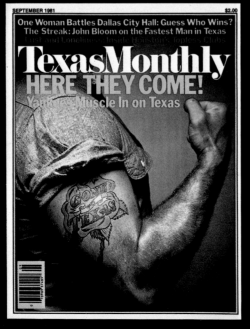

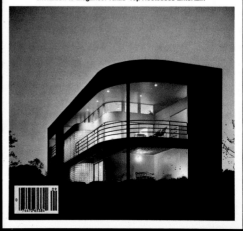

RICK PATRICK PHOTOGRAPHY · AUSTIN, TEXAS · (512) 472-9092

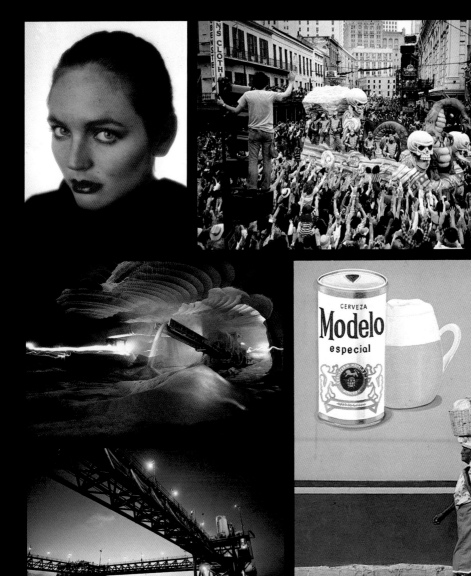

JACKSON HILL
Box 15276, New Orleans 70175 • (504) 891-4747 or (504) 468-5575

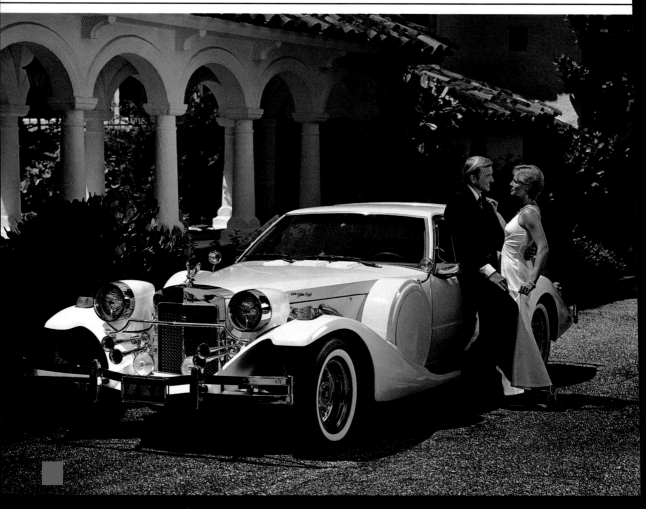

Edward Slater

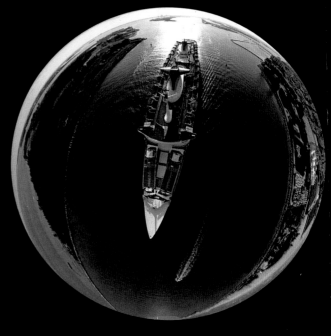

6289 West Sunrise Boulevard
te 203
Sunrise, Florida 33313
Miami (305) 949-5191
Fort Lauderdale (305) 791-2772

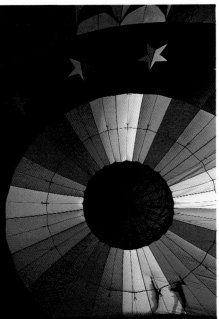

JOE BARABAN
Houston, Texas
(713)526 0317

Represented by:
Rabin and Renard in New York
(212)490 2450
Bill Rabin & Associates in Chicago
(312)944 6655

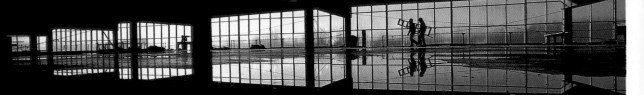

DOUGHANDEL

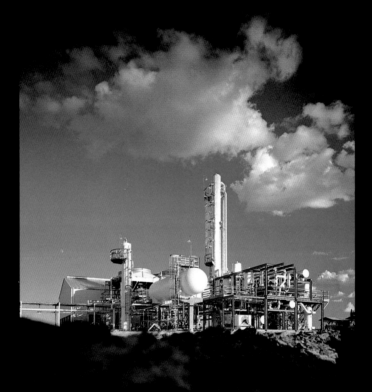

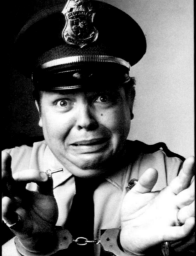

214/241-1549
DALLAS
©1982 DOUG HANDEL

MIKEWILSON

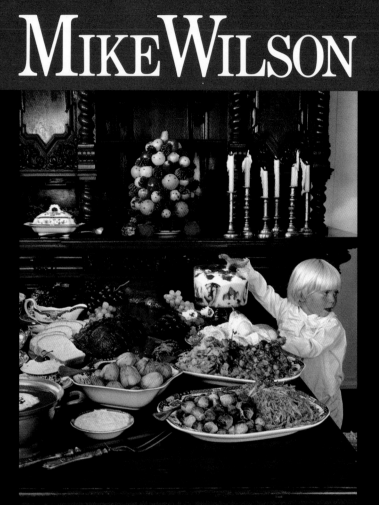

214/241-1549
DALLAS
©1982 MIKE WILSON

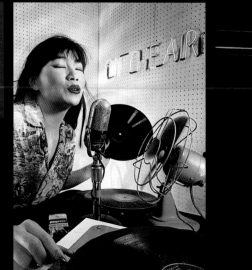

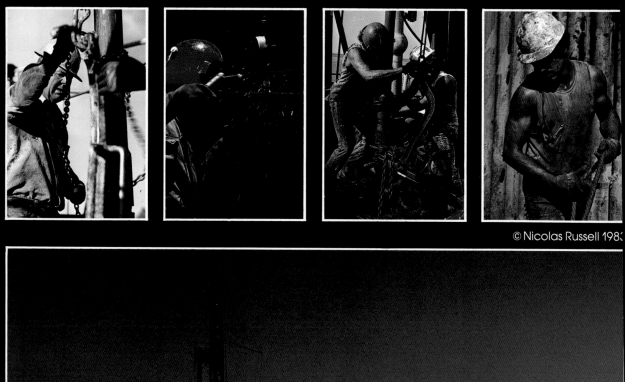

© Nicolas Russell 1983

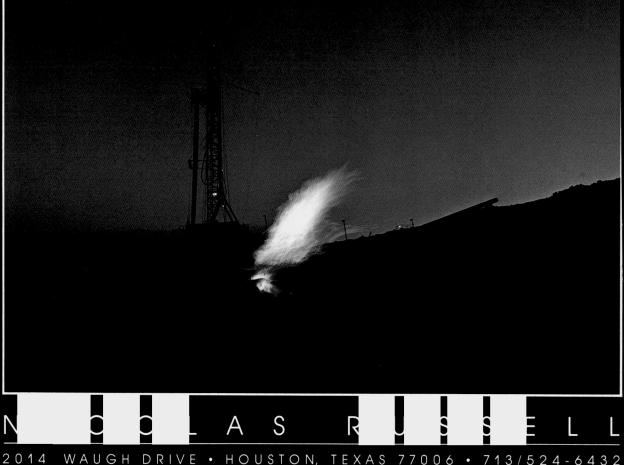

N I C O L A S R U S S E L L

2014 WAUGH DRIVE • HOUSTON, TEXAS 77006 • 713/524-6432

CODY

FUN IN THE SUN
ON LOCATION IN FLORIDA

Dennie Cody • 5820 S.W. 51st Terrace • Miami, FL 33155 • 305-666-0247

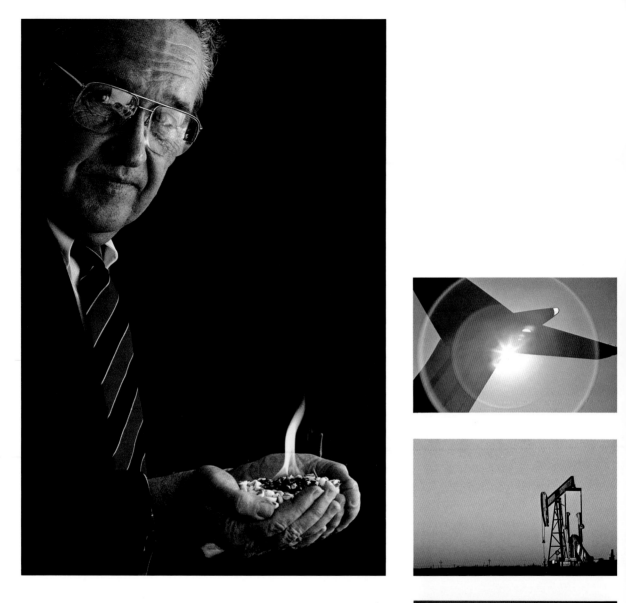

David Buffington, Photographer
2772 El Tivoli, Dallas, Texas 75211
214-943-4721

J. WILSON
HOUSTON
DBA WILCOM
713/266-2872

FASHION PEOPLE STUDIO LOCATION

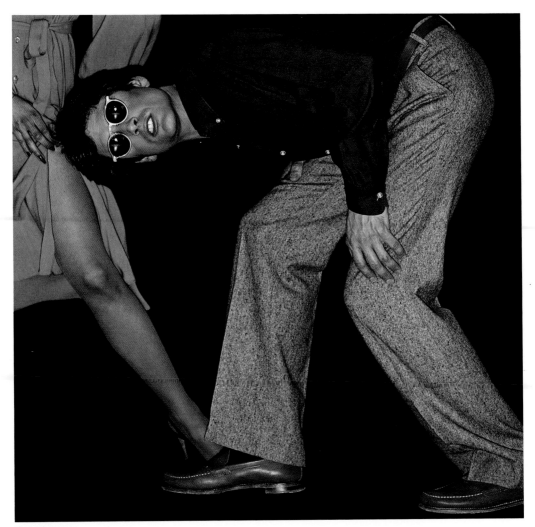

FRED CARR
HOUSTON
DBA IMAGES
713/266-2872

CORPORATE INDUSTRIAL INSTITUTIONAL STUDIO LOCATION STOCK

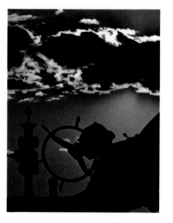

© FRED CARR, 1982

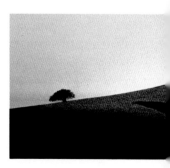

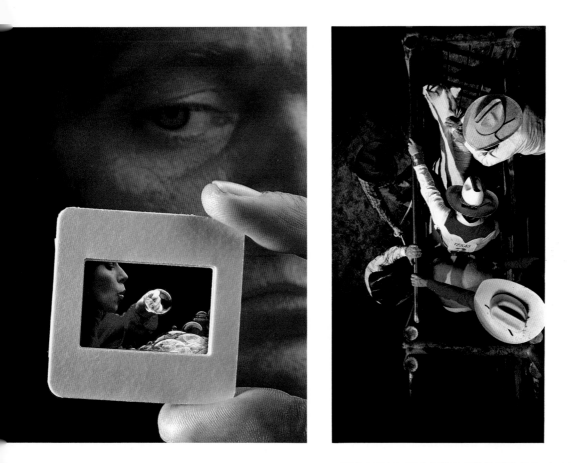

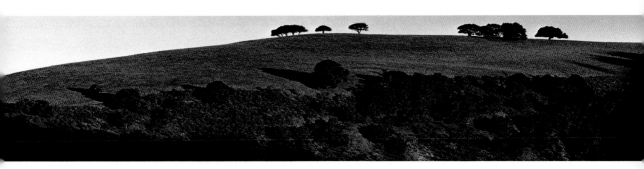

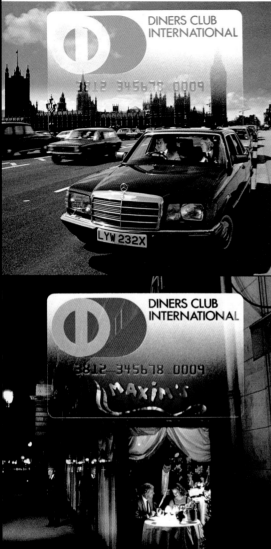

BOB GELBERG

**MIAMI (305) 448-8458
3200 PONCE DE LEON
CORAL GABLES, FL 33134**

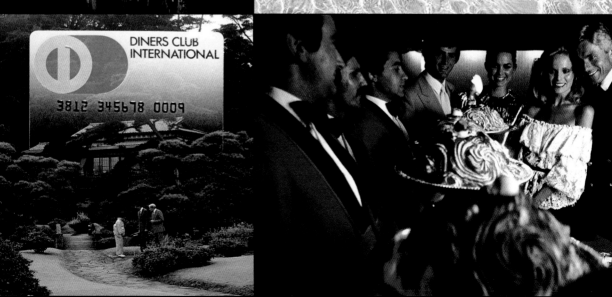

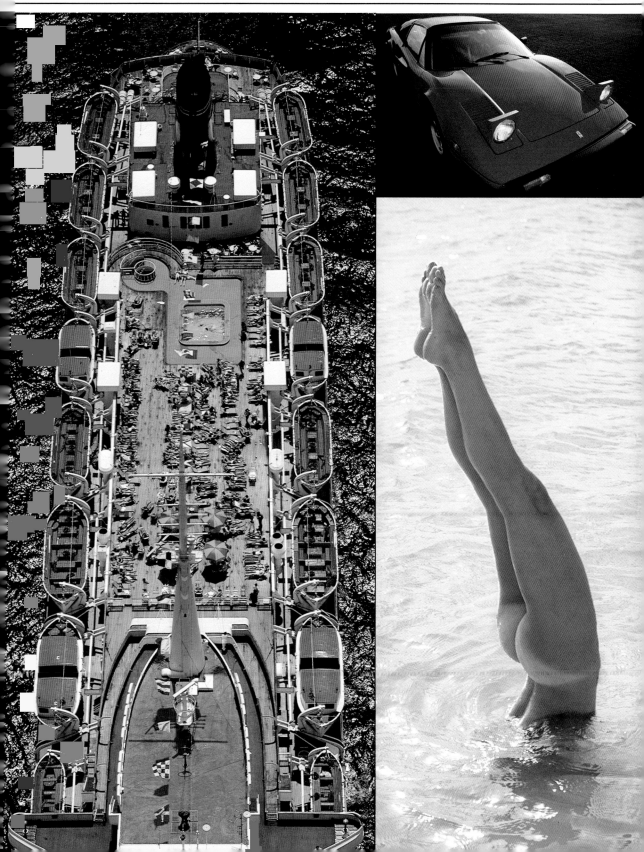

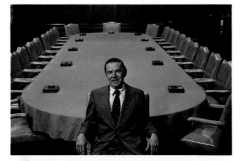

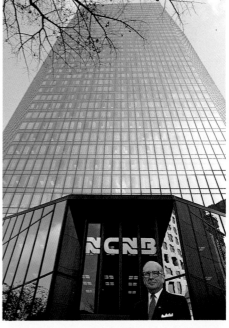

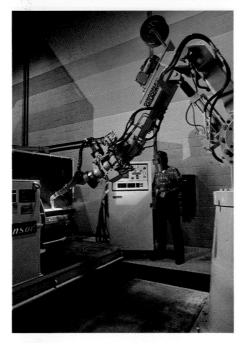

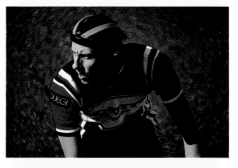

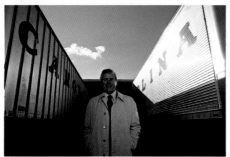

NANCY J. PIERCE

**Corporate and Editorial
Assignment Photography**

P.O. Box 30815
Charlotte, North Carolina 28230

(704) 333-4221

Clients:
Corporate: E.F. Hutton, AT&T,
Exxon, Dupont, Union Carbide,
IBM, Siecor, Nucor, Piedmont
Airlines, Georgia-Pacific.
Editorial: The New York Times, Time,
Smithsonian, Business Week,
National Geographic News
Service, USA Today

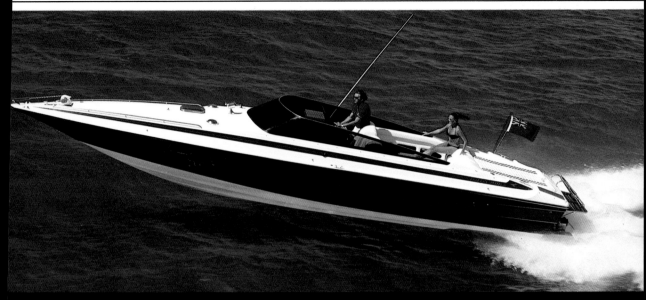

Skip Gandy

302 E. Davis Blvd.
Tampa, Fla. 33606

TELEPHONE (813) 253-0340

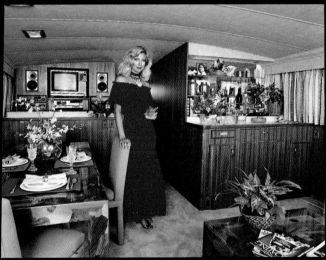

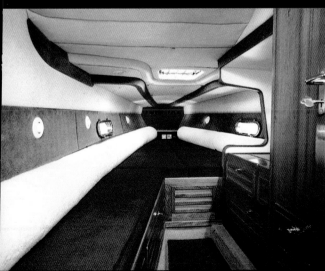

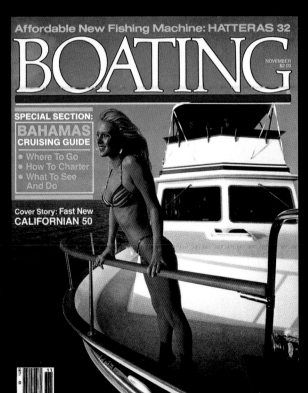

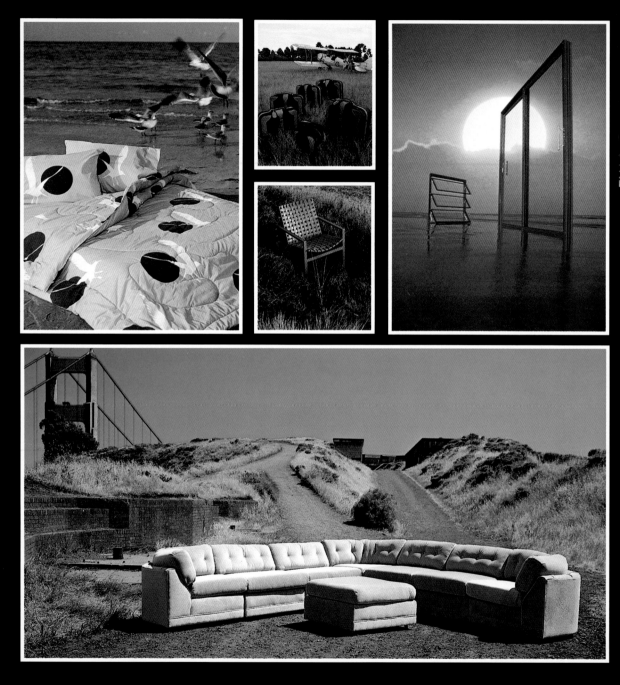

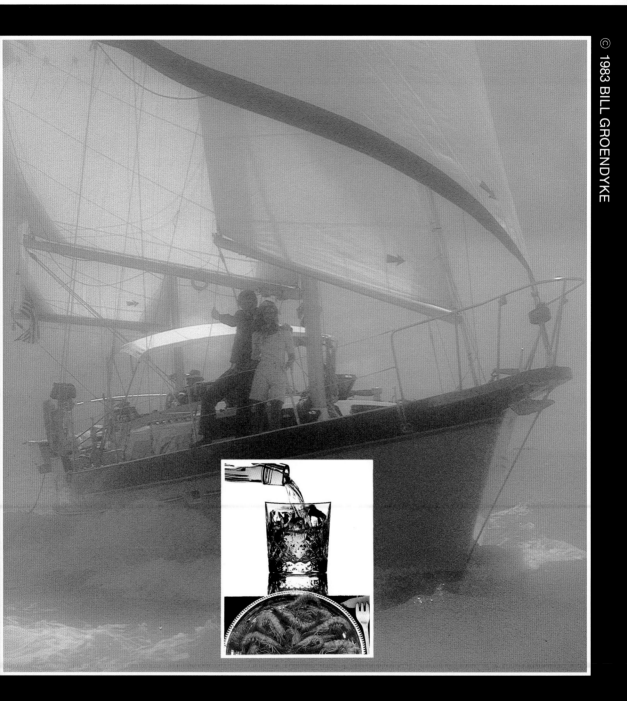

BILL GROENDYKE
7320 FOX CHAPEL DRIVE
MIAMI, FLORIDA 33015
(305) 822-7559

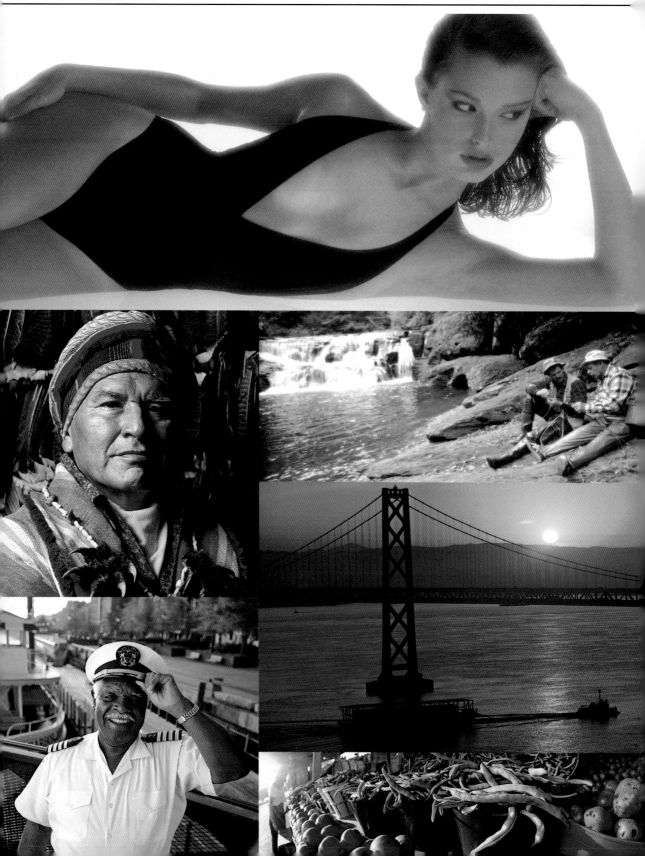

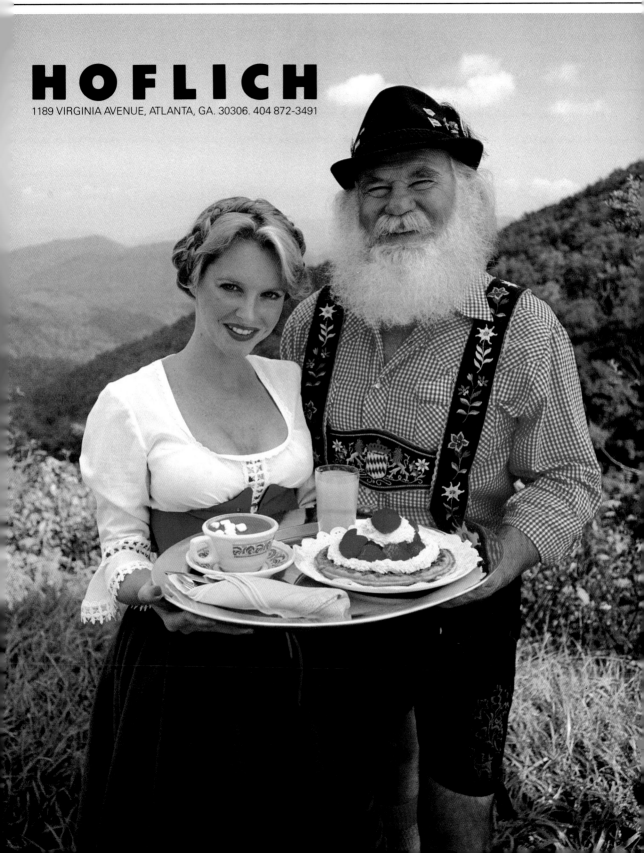

HOFLICH

1189 VIRGINIA AVENUE, ATLANTA, GA. 30306. 404 872-3491

S C O T T

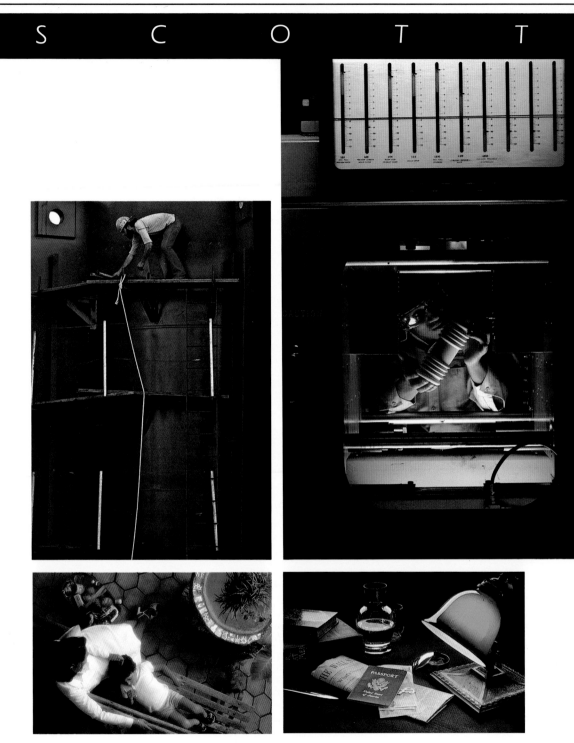

S C O T T

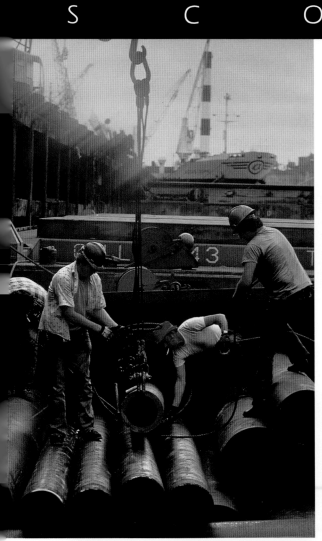

Ron Scott
1000 Jackson Boulevard
Houston, Texas 77006
(713) 529 5868

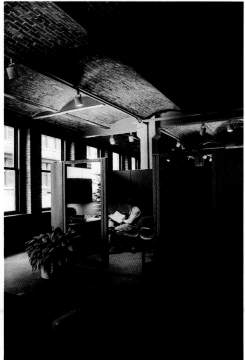

Please write for free "Color Samples"
book, a mini-portfolio. Additional
published work may be found in
Communication Arts Magazine,
Volume 19, Number 4 and The
Art Annual 1976, 1977, 1978, 1980
and 1982.

Existing photography
Energy/Oil and Gas
Industrial
Aircraft, ships and trains
Agribusiness and Landscapes
Houston skyline and buildings
Central Europe, Alaska, Mexico,
Africa, North Sea.

Many of the images shown here
are available. Call for details.

©1983 Ron Scott

JAMES F. HOUSEL
COMMERCIAL AND INDUSTRIAL
PHOTOGRAPHY FOR A WIDE
RANGE OF CLIENTS. LOCATION
AND STUDIO CAPABILITIES
PORTFOLIO UPON REQUEST.

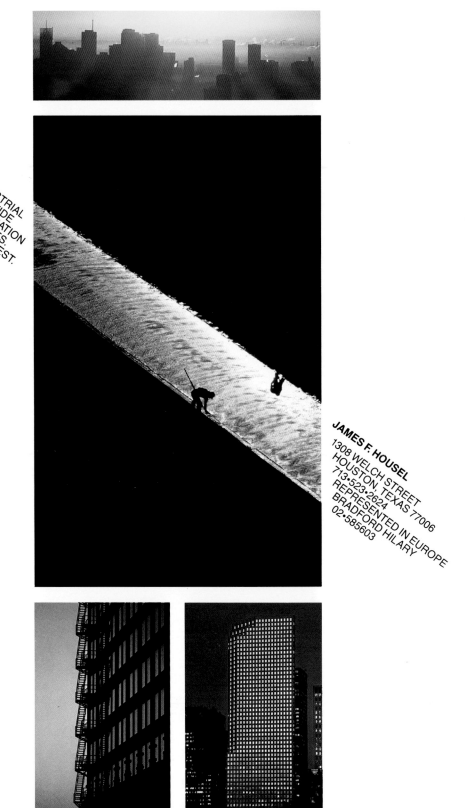

JAMES F. HOUSEL
1308 WELCH STREET
HOUSTON, TEXAS 77006
713•523•2624
REPRESENTED IN EUROPE
BRADFORD HILARY
02•585603

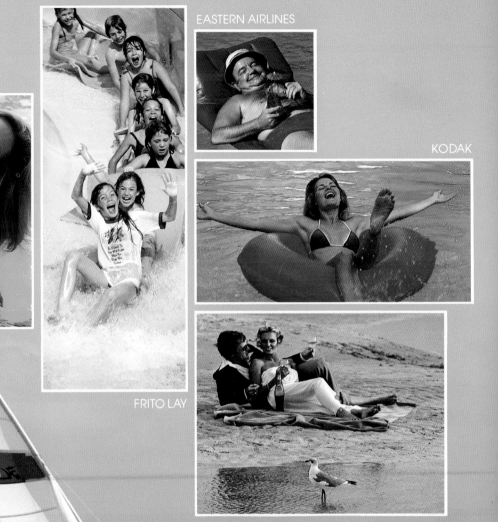

IMPERIAL CHEMICAL

EASTERN AIRLINES

KODAK

FRITO LAY

STOCK PHOTOGRAPHY

HOLIDAY INNS

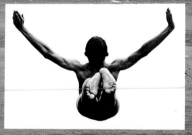

A.D. GOLD MEDAL/Y & R

Tom McCarthy is in Miami.

305/233-1703. Don Stogo, rep., is in New York. 212/490-1034.
Accumulated photographs available.

Ron Sherman

P.O. Box 28656
Atlanta, Ga. 30328
404-993-7197

Annual Reports
Advertising
Corporate Industrial
Editorial

Stock Photographs
Available

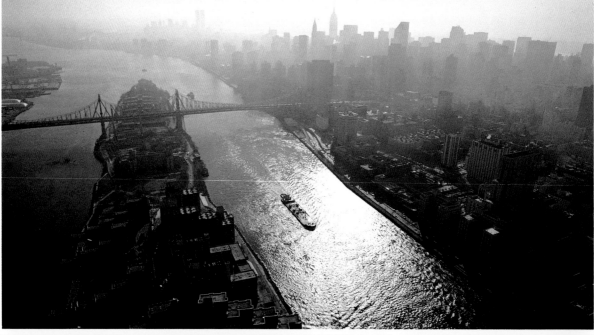

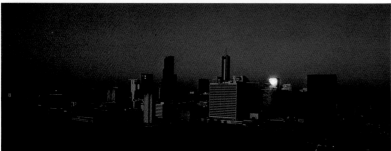

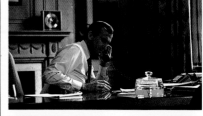

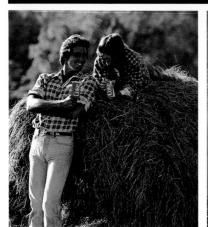

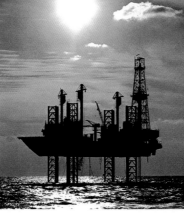

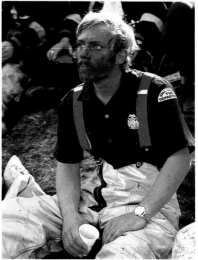

Design: Critt Graham Graphic Design Ltd.

Our Trademark is consistent style and imagination, promoting your ideas, your people, through a visual statement. A photograph that communicates.

We back up our quality photography with state-of-the art, processing and photographic printing—all in house. With seven years in the communications business, we professionally coordinate your project from a concept to profits.

Our solution is a "GOOD LOOK!"

- Advertising
- Architectural
- Aerial
- Annual Reports
- Corporate / Industrial
- Editorial
- Travel

David Dobbs
Photography Studios
1536 Monroe Drive N.E.
Atlanta, Georgia 30324
(404) 885-1460

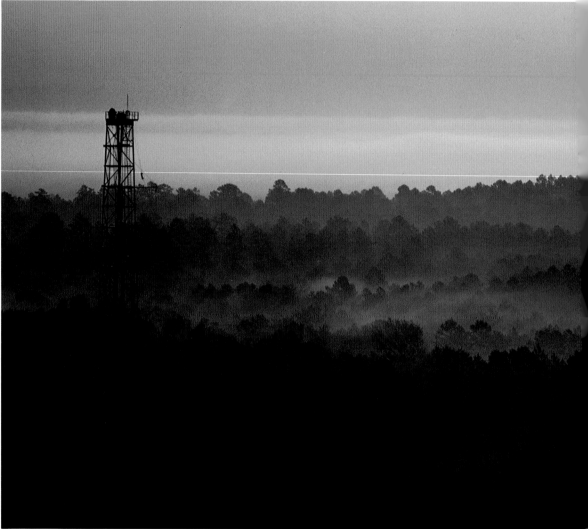

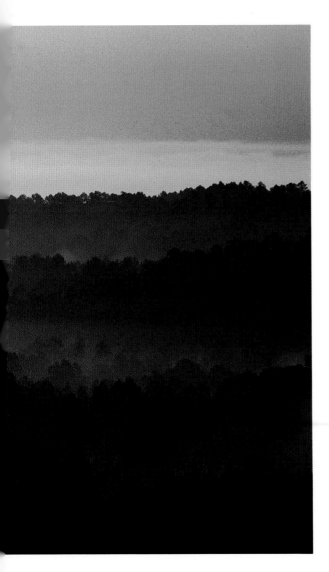

You have to get up pretty early in the morning to take better pictures than Arthur Meyerson.

For assignments and stock call:
Arthur Meyerson Photography, Inc.
4215 Bellaire Blvd.
Houston, Texas 77025
713-660-0405

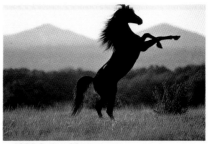

©1983 Arthur Meyerson

gemignani
incorporated

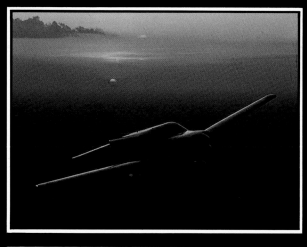

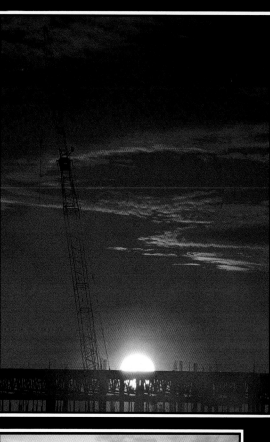

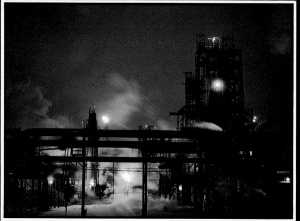

joe gemignani, photographer
13833 n.w. 19th avenue
miami, florida 33054
(305) 685-7636

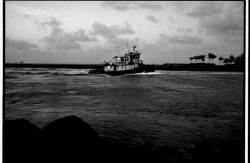

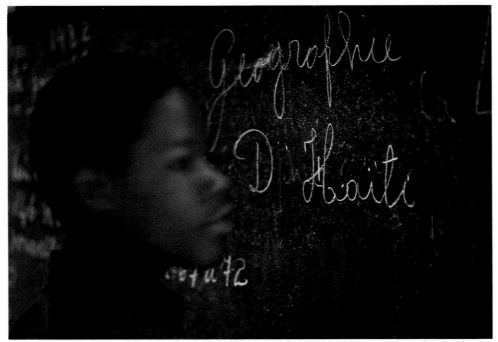

©1983 Christopher R. Harris

For over fifteen years
Chris Harris has worked on
assignments and projects
for major corporations and
publications throughout
the world.

Photography for corporate/
industrial, annual report
and editorial use. Still and
motion picture. Extensive
stock file.

Christopher R. Harris
3039 DeSoto Street
New Orleans, LA 70119
(504) 586-0209

Clients include:

Corporations

AT&T
Exxon
Shell Oil Co.
IBM Corporation
Ford Foundation
Freeport Minerals
Pfizer Pharmaceuticals
Federal Express
Avondale Shipyard
Air France
Xerox

Publications

Fortune
Forbes
Esquire
Time-Life Books
The New York Times
Life
Time
Newsweek
Sports Illustrated
Horizon
Discover

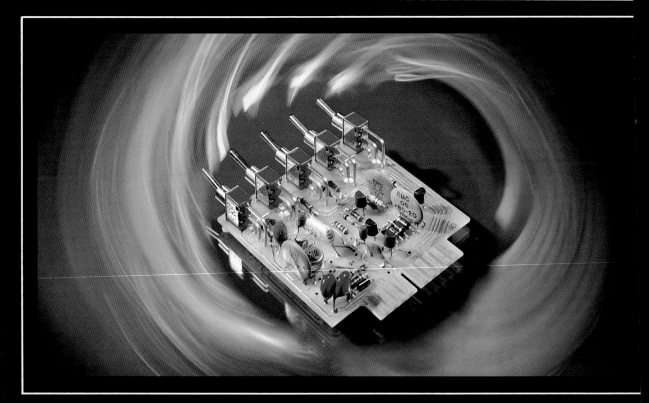

Davis Noble

324 West Third Street
Tyler, Texas 75701
Studio:
(214) 592-3736

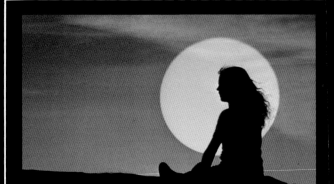

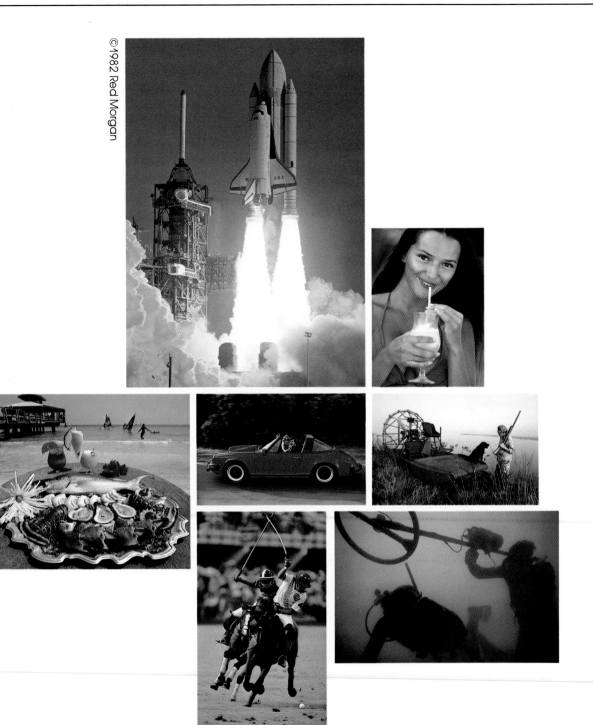

© 1982 Red Morgan

RED MORGAN · (3O5) 793-6O85
970 Hickory Trail • West Palm Beach, Florida 33411
Advertising • Corporate • Annual Reports • Editorial • Underwater • Travel • Stocks

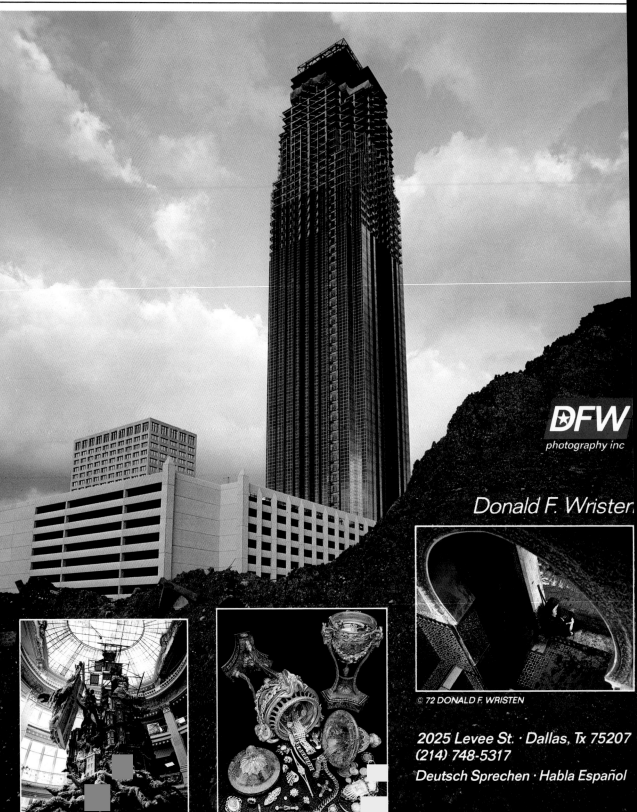

DFW
photography inc

Donald F. Wristen

© 72 DONALD F. WRISTEN

2025 Levee St. · Dallas, Tx 75207
(214) 748-5317
Deutsch Sprechen · Habla Español

© 83 DONALD F. WRISTEN
DESIGN: BRUCE BECK & CO. DESIGN · DALLAS

© 83 NEIMAN-MARCUS; SAN FRANCISCO © 82 GARRETT GALLERIES · DALLAS

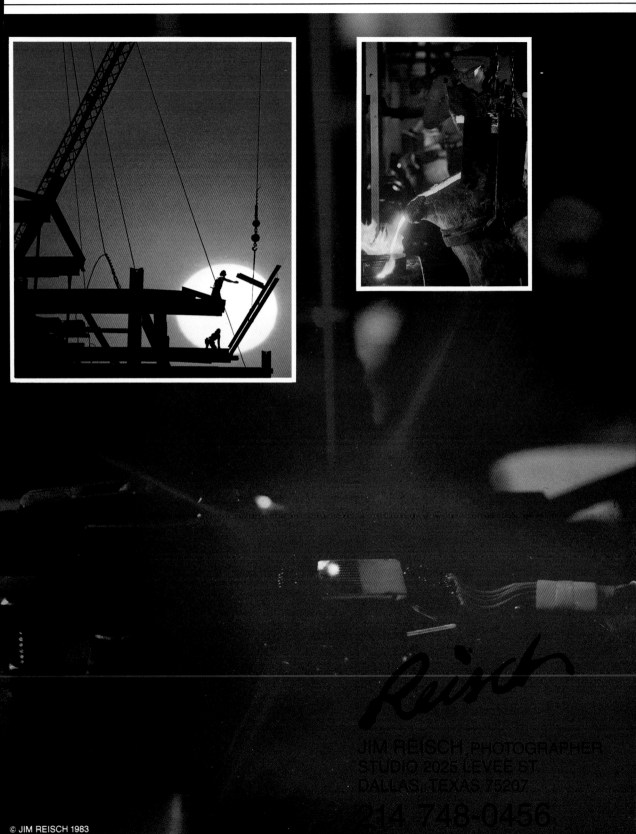

JIM REISCH, PHOTOGRAPHER
STUDIO 2025 LEVEE ST
DALLAS, TEXAS 75207
214 748-0456

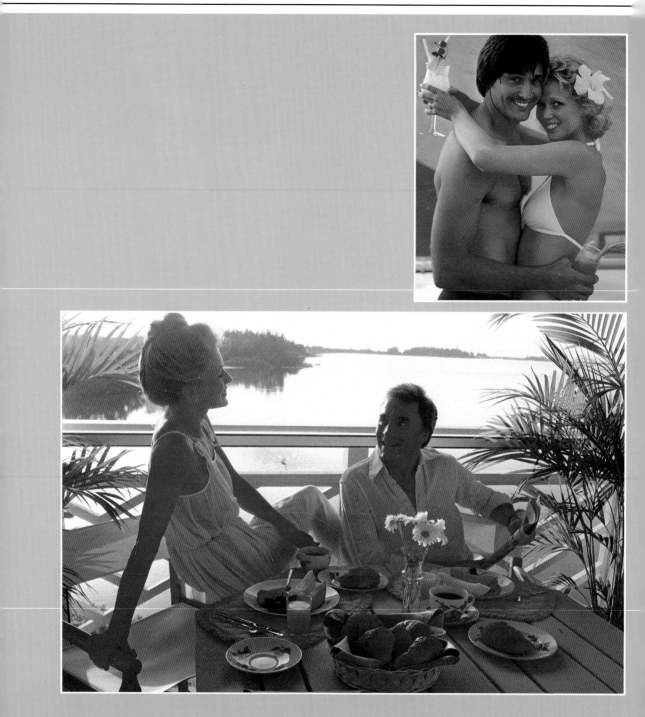

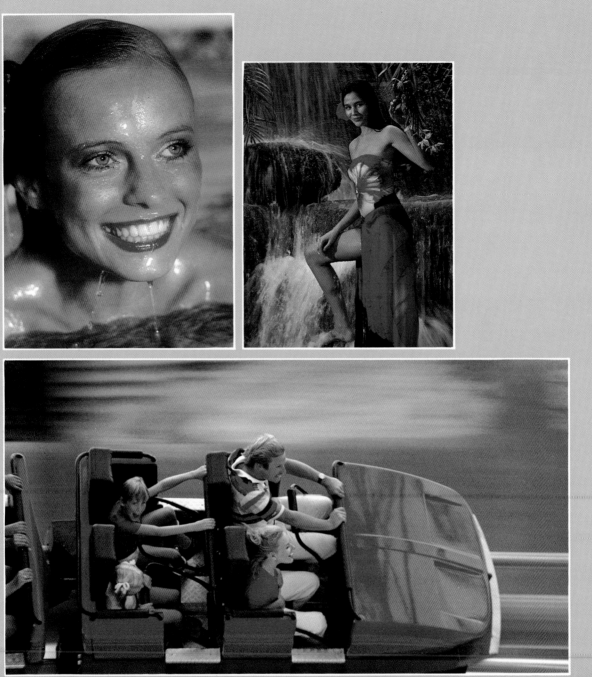

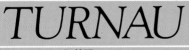

TURNAU

Jeff Turnau

10800 S. W. 68 Avenue, Miami, Florida 33156

Miami: 305/666-5454. New York: 212/926-2825

Ralf Manstein
PHOTO PRODUCTIONS

The beautiful rests on the foundations of the necessary. The line of beauty is the line of perfect economy. — Emerson

713 - 523-2500

5353 Institute Lane
Houston, Texas 77005

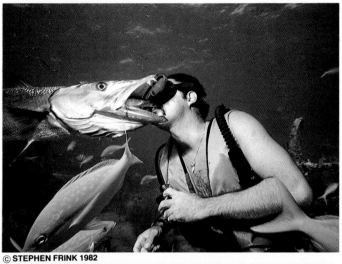
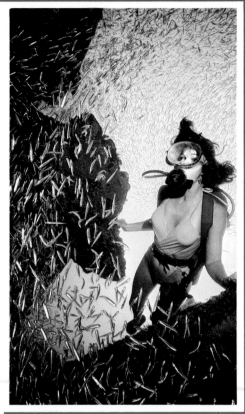
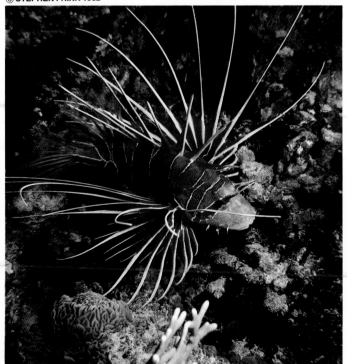

DON WHEELER, INC., 4928 EAST 26TH PLACE, TULSA, OKLAHOMA 74114, 918 744-8902

A New York photographer,
deep in the heart of Texas.

Bob Gomel.
In Houston,
713/977-6390.

Bob Gomel, 1982

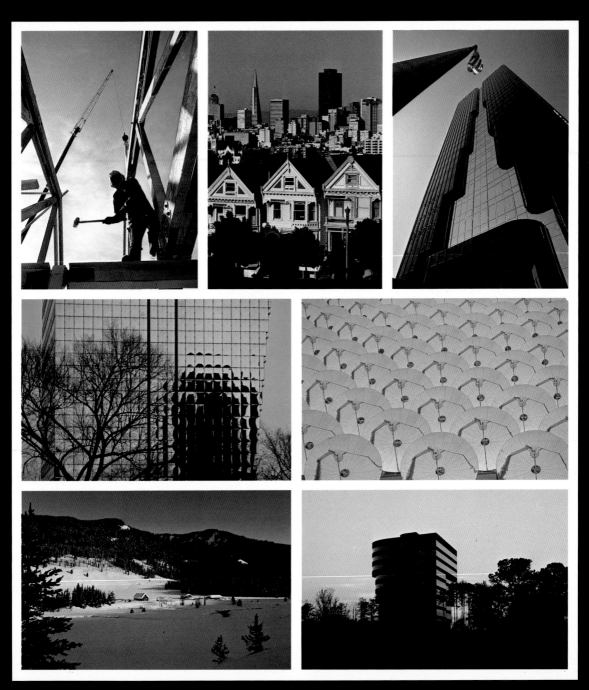

E. ALAN McGEE PHOTOGRAPHY INC.

Represented by Linda McGee

(404) 633-1286

1816 Briarwood Industrial Court Atlanta, Georgia 30329

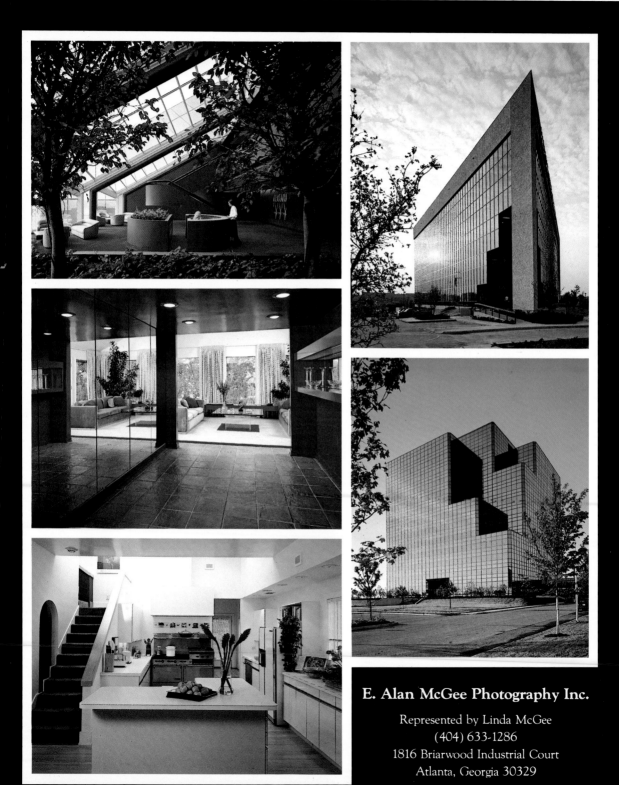

E. Alan McGee Photography Inc.

Represented by Linda McGee
(404) 633-1286
1816 Briarwood Industrial Court
Atlanta, Georgia 30329

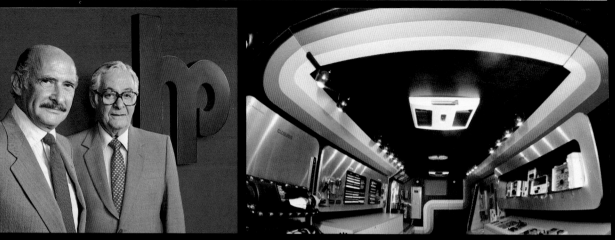

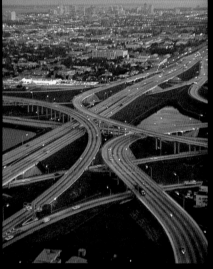

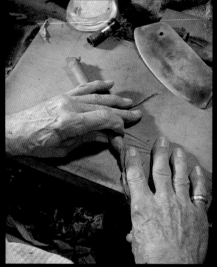

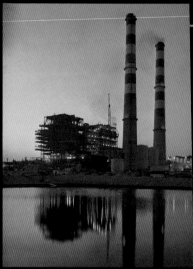

RAY FISHER
PHOTOGRAPHER

10700 SW 72 COURT
MIAMI, FLORIDA
33156
(305) 665-7659

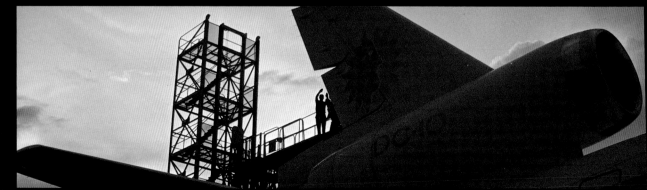

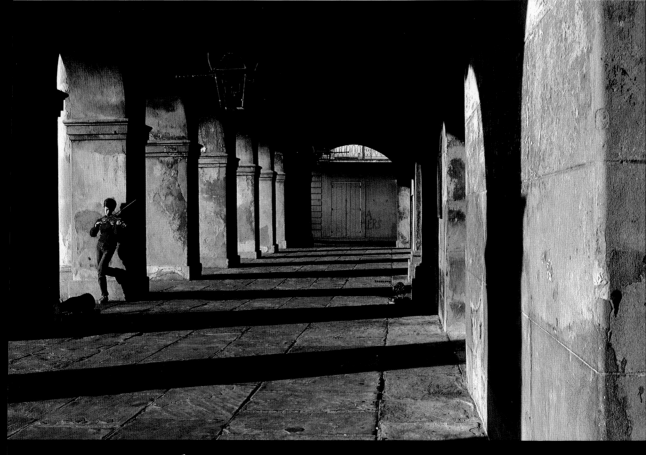

TOM JIMISON

5929 Annunciation
New Orleans, Louisiana
(504) 891-8587

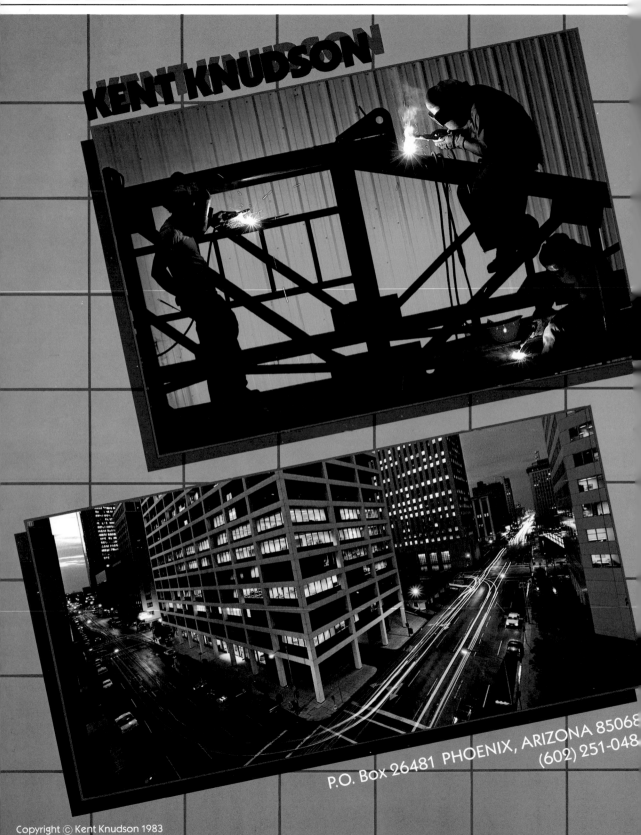

KENT KNUDSON

P.O. Box 26481 PHOENIX, ARIZONA 85068
(602) 251-048

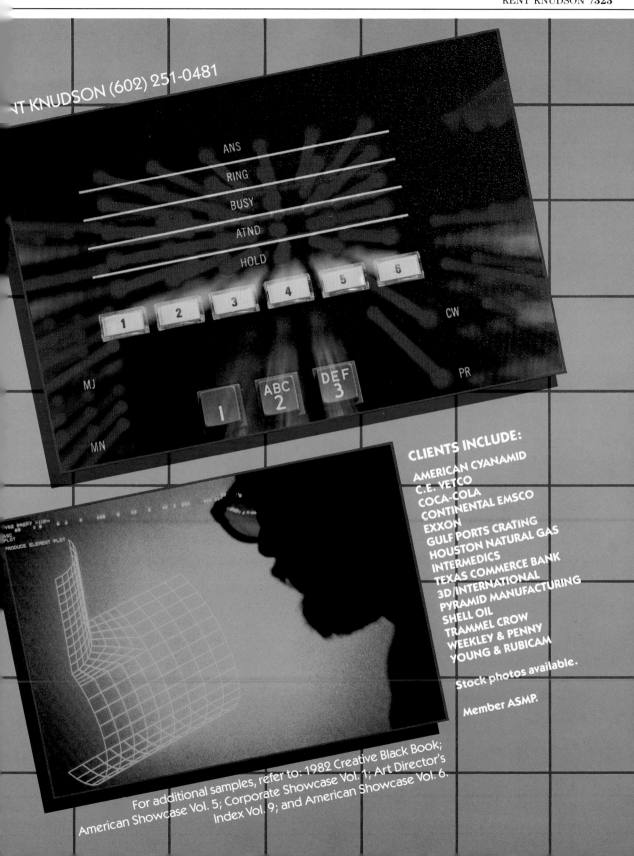

KENT KNUDSON (602) 251-0481

ANS
RING
BUSY
ATND
HOLD

1 2 3 4 5 6

CW

MJ

ABC
2

DEF
3

PR

1

1

MN

CLIENTS INCLUDE:

AMERICAN CYANAMID
C.E. VETCO
COCA-COLA
CONTINENTAL EMSCO
EXXON
GULF PORTS CRATING
HOUSTON NATURAL GAS
INTERMEDICS
TEXAS COMMERCE BANK
3D/INTERNATIONAL
PYRAMID MANUFACTURING
SHELL OIL
TRAMMEL CROW
WEEKLEY & PENNY
YOUNG & RUBICAM

Stock photos available.

Member ASMP.

For additional samples, refer to: 1982 Creative Black Book;
American Showcase Vol. 5; Corporate Showcase Vol. 1; Art Director's
Index Vol. 9; and American Showcase Vol. 6.

REAGAN BRADSHAW
Corporate and Advertising Photography
(512) 458-6101

Partial Client List:
IBM Corp. Exxon USA, Motorola, Comsat, Gebhardt Foods,
U.S. Home, General Electric, Widelite, Texaco, Tracor.

All Photography © Reagan Bradshaw

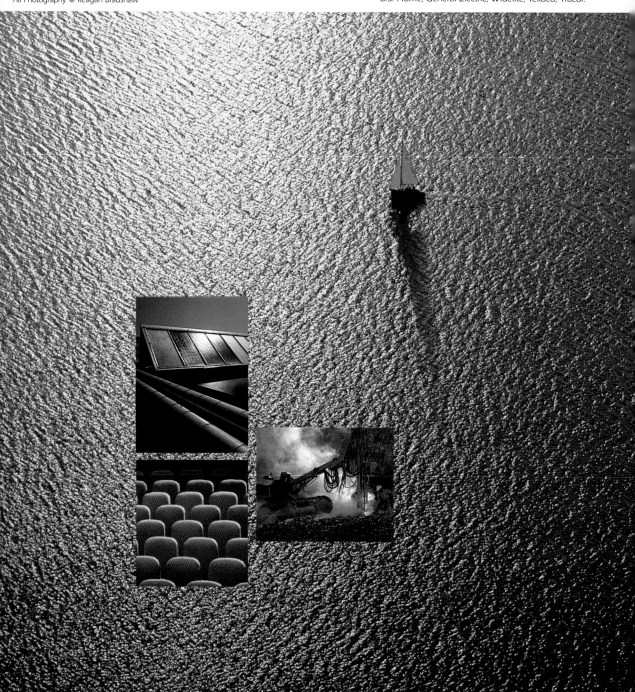

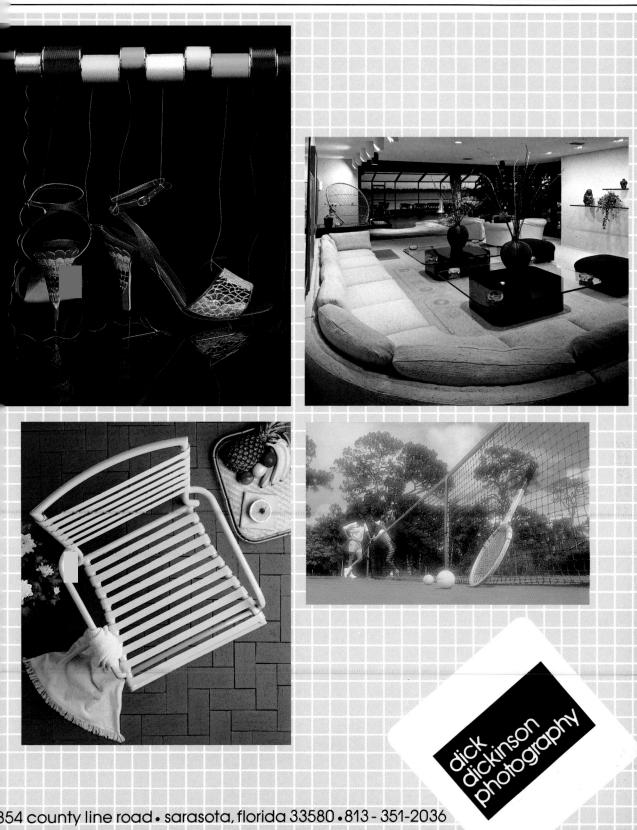

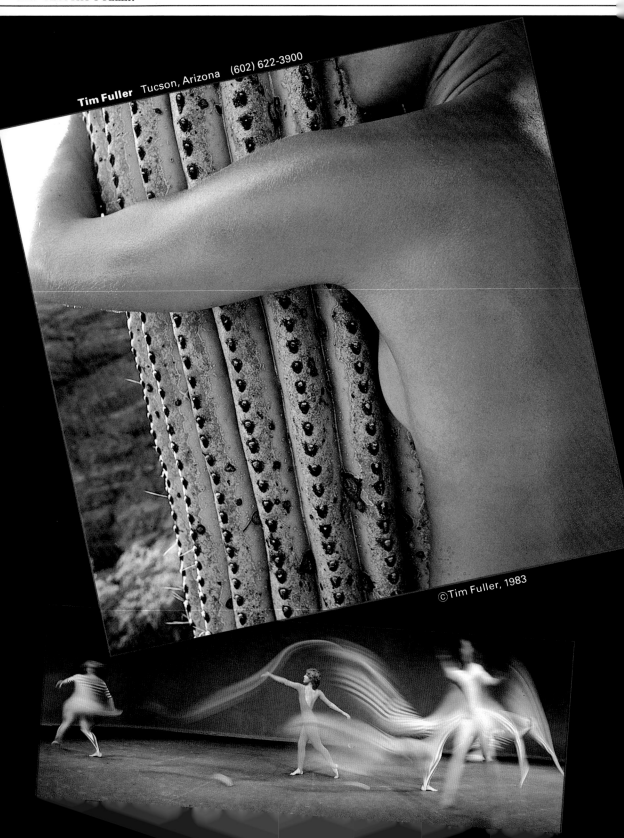

Tim Fuller Tucson, Arizona (602) 622-3900

©Tim Fuller, 1983

OUTDOOR SPECIALIST

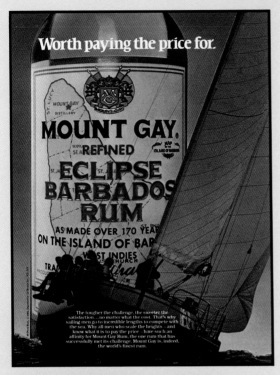

BURTON McNEELY–
offering confidence on major outdoor photo
needs. REPS:
New York—Lenore Herson, IMAGE BANK
212/953-0303
Chicago—Monica Geocaris, ATOZ IMAGES
312/664-8400
**P.O. BOX 338, LAND O' LAKES, FL 33539
813/996-3025**

Agency: **HENDERSON ADV.** Greenville, S.C.
Art Director: **JIM FARMER** (Sailboat photo only)
Location: **TAMPA BAY**

Agency: **BUNTIN ADV.** Nashville, TN
Art Director: **BILL HOLLY**
Location: **MT. JULIET, TN**

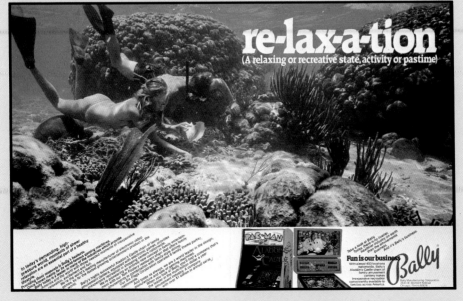

Agency: **LEE KING & PARTNERS**, Chicago, IL
Art Director: **RAY NYQUIST**
Location: **GRAND CAYMAN, B.W.I.**

Photos © 1983
Burton McNeely

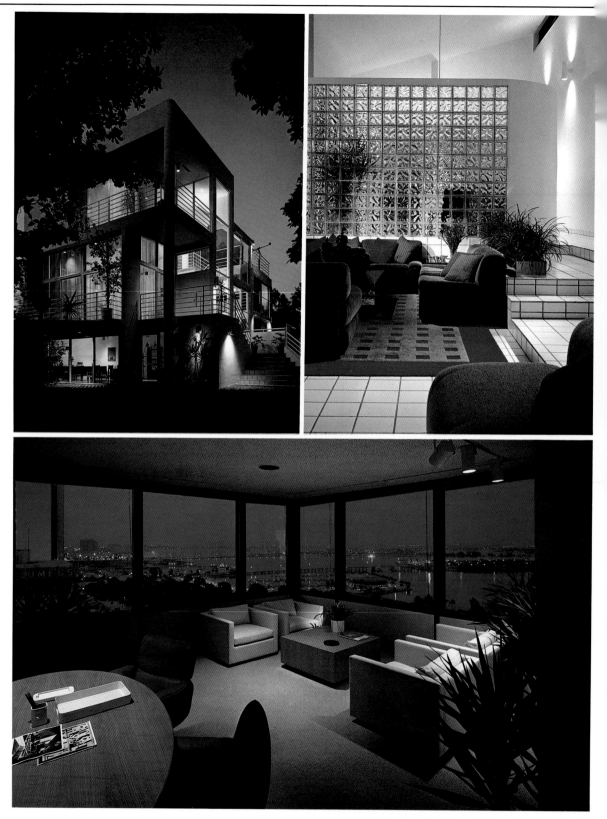

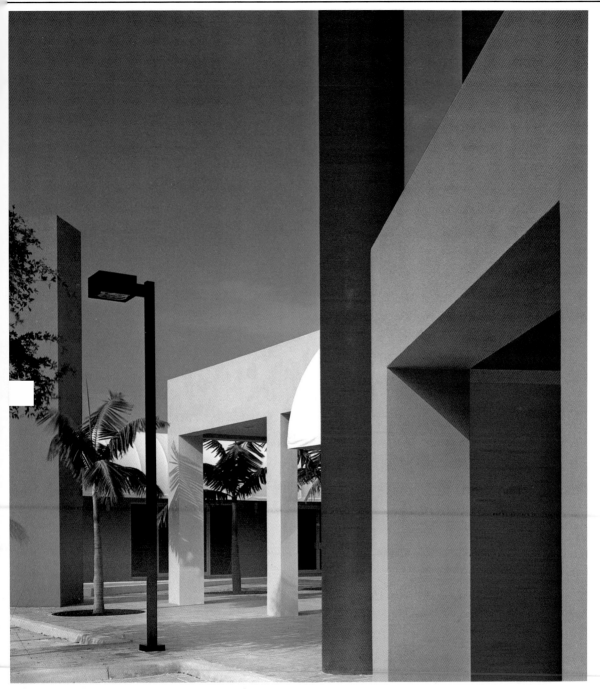

Forer, Inc.
1970 Northeast 149th Street
North Miami, Florida 33181
(305) 949-3131

Photography of architecture
and interiors.

Editorial photography: Architectural
Digest, House Beautiful, Architectural
Record, Interior Design, Progressive
Architecture, Professional Builder,
Florida Designers Quarterly, New York
Times Magazine, Palm Beach Life,
Signature.

Advertising photography: Bigelow
Carpet, Monsanto Fibers, Boise
Cascade, American Plywood
Association, Casa Bella, Levolor
Lorentzen, Integrated Ceilings,
Armstrong Floors, Holiday Inns, Wall
Street Journal, Woodward and Lothrup,
Dobbs House, Marriott Hotels.

Stock photography available.

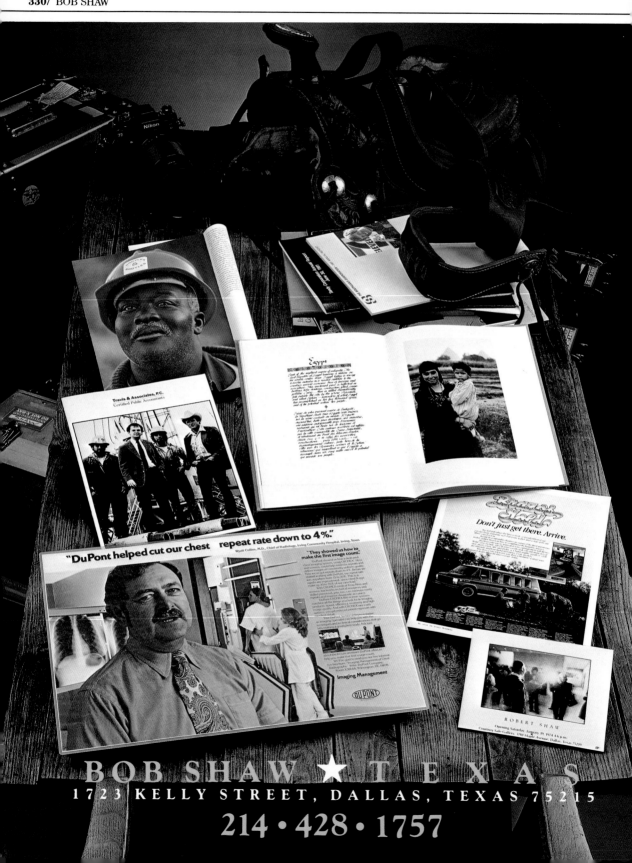

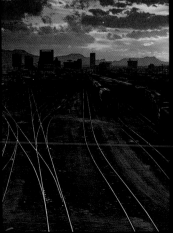

David Nance

Photographer

8202 Fernbrook Lane
Houston, Texas 77070
713-469-4757

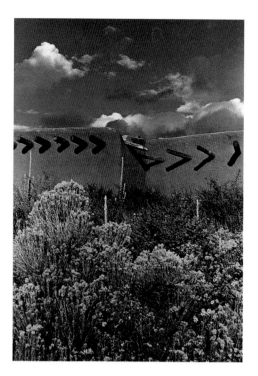

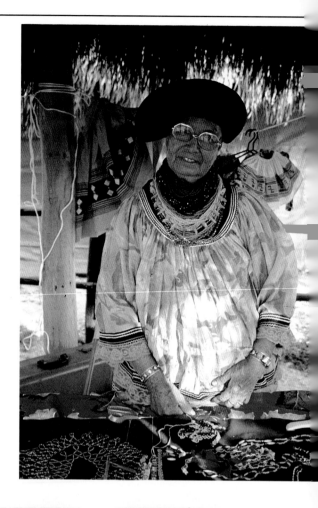

GAIL RUSSELL

BOX 241 TAOS, NEW MEXICO 87571
TELEPHONE: 505 • 776 • 8474

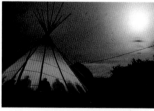

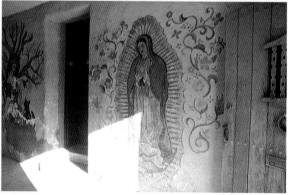

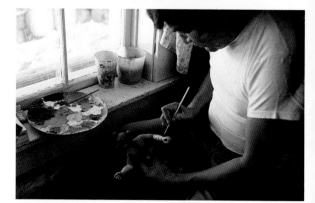

PICTURE STORIES • PEOPLE • ARCHITECTURE • DOCUMENTARY • MULTIIMAGE SLIDE PRESENTATIONS

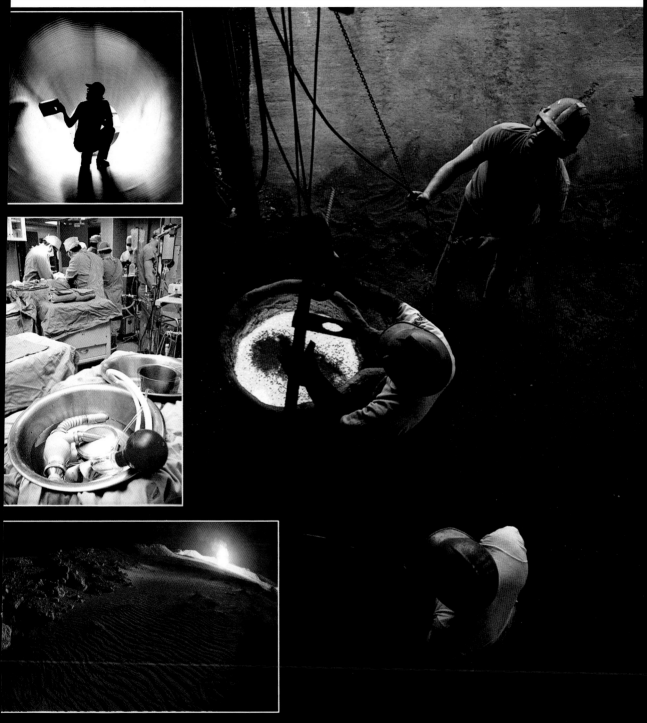

IM CALDWELL

422 Quenby, Houston, Texas, 77005 **(713) 527-9121**

Corporate/industrial, annual reports, editorial, still life, theatrical.

Major clients include: Coca-Cola Foods, Coldwell Banker, *Exxon U.S.A.,* Exxon Chemical Americas, Houghton-Mifflin Publishers, Kentucky Fried Chicken, Kingdom of Saudi Arabia, Lonza Corp., *Newsweek,* Owens-Corning Fiberglass, Prudential Insurance, *Shell Oil News,* Texas Heart Institute, *Texas Monthly, Time,* Warner Amex

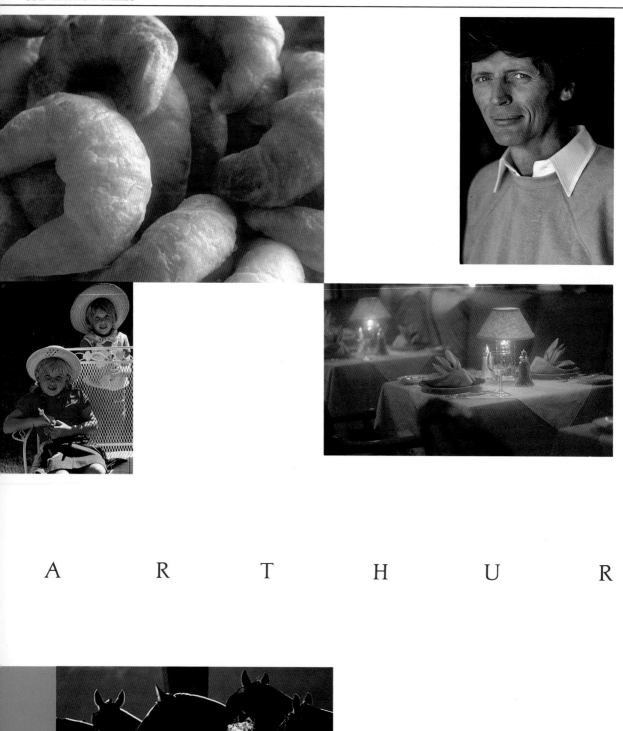

A R T H U R

ARTHUR TILLEY, PHOTOGRAPHER
THE ICE HOUSE
1925 COLLEGE AVE.
ATLANTA, GA. 30317
404-371-8086

DESIGN: COOPER-COPELAND, INC.

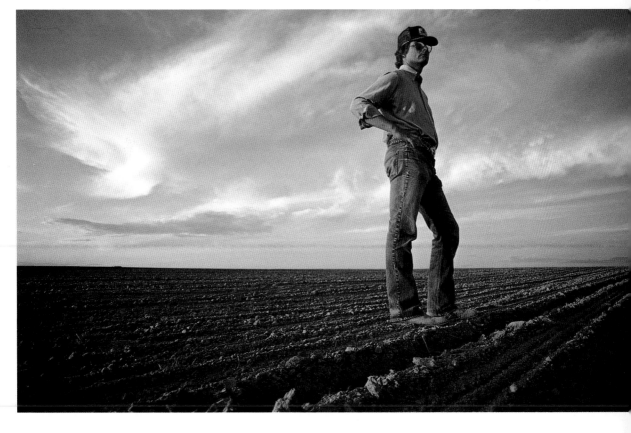

T I L L E Y

GENERAL MEMBERS MIDWEST

A

ALEKSANDROWICZ, F. J. 343 Canterbury Rd, Bay Village, OH (216) 696-4566, 971-5081

ALEXANDER, GORDON 920 Cherry SE - Rm 340, Grand Rapids, MI (616) 451-0735, 538-7848

**ALPHA PHOTOCHROME, Bob Shelli, Box 262, St Louis, MO 63158
(314) 772-8540** P 344

ARNDT, DAVID MacTAVISH 4620 Winchester, Chicago, IL (312) 334-2841

ARNDT, JAMES 1008 Nicollet Mall, Minneapolis, MN (612) 338-1984

ARSENAULT, BILL 617 W Fulton St, Chicago, IL (312) 454-0544

B

BAER, LEONARD 5807 Capri Lane, Morton Grove, IL (312) 966-4759

BALGEMANN, LEE 725 Monroe Ave, River Forest, IL (312) 771-9427

**BARRETT, BOB 3733 Pennsylvania, Kansas City, MO (816) 753-3208;
NY—(212) 244-5511** P 349

BAYALIS, JOHN 42 E Superior St, Chicago, IL (312) 266-9572

BEASLEY, MICHAEL 1210 W Webster St, Chicago, IL (312) 248-5769, (815) 455-1361

BENDER, ROBERT 1 Rockefeller Bldg, Cleveland, OH (216) 861-4338

BERKMAN, ELIE 125 Hawthorn Ave, Glencoe, IL (312) 835-4158

BERTHIAUME, TOM 1008 Nicollet Mall, Minneapolis, MN (612) 338-1984

BISHOP, G. ROBERT 10835 Midwest Industrial Blvd, St. Louis, MO (314) 423-8383

**BOCK, EDWARD Studio 207, 400 N First Ave, Minneapolis, MN (612) 332-8504,
377-5717** P 350

BRIMACOMBE, GERALD 7112 Mark Terr Dr, Minneapolis, MN (612) 941-3860

BROWN, ALAN J. 1151 Halpin Ave, Cincinnati, OH (513) 421-5588

BROWN, DAVID 900 Jorie Blvd - Ste 70, Oak Brook, IL (312) 654-2515

BROWN, JAMES F. 1349 McMillan, Cincinnati, OH (513) 221-1144

BUNDT, NANCY 4001 Forest Rd, Minneapolis, MN (612) 926-4390

C

CAMPBELL, ART 128½ Dayton St, Yellowspring, OH (513) 767-7902

CASALINI, TOM 10½ N Main St, Zionsville, IN (317) 873-4858, 873-5229 P 342

CHIN, RUTH 108 E Jackson, Muncie, IN (317) 284-4582

CHRISTIAN, MARVIN 5408 N Main St, Dayton, OH (513) 275-3775

**CLARK, JUNEBUG 30419 W Twelve Mile Rd, Farmington Hills, MI
(313) 478-3666, 474-6207** P 354

CLOUGH, JEAN 1059 W Columbia, Chicago, IL (312) 262-1732

COMPTON, TED A. 112 N Washington St, Hinsdale, IL (312) 654-8781

COSTER-MULLEN, JOHN E. 698 Ellis, Fondulac, WI (414) 923-6285

COWAN, RALPH 452 N Halsted, Chicago, IL (312) 243-6696

CRANE, ARNOLD H. 117 N Jefferson St - Rm 304, Chicago, IL (312) 346-9152 P 340

DEF

DAMIEN, PAUL 180 N 69 St, Milwaukee, WI (414) 259-1987

DAVIS, MYRON 5722 Stony Island, Chicago, IL (312) 493-9676

DREIER, DAVID 807 Reba Pl - Apt 2W, Evanston, IL (312) 475-1992

EILER, TERRY 330-B Barker Rd, Rt No 2, Athens, OH (614) 592-1280

EVANS, PATRICIA 1153 E 56 St, Chicago, IL (312) 288-2291

FARB, NATHAN 318 S Grove St, Bowling Green, OH (419) 352-3126

FAVERTY, RICHARD, Beckett Studios, 340 W Huron, Chicago, IL (312) 943-2648

FISCHER, ROBERT 26 N Walling, St Louis, MO (314) 434-2600

FLETCHER, MICHAEL 7467 Kingsbury Blvd, St Louis, MO (314) 721-2279

FRERCK, ROBERT 3830 N Marshfield, Chicago, IL (312) 883-1905

FUTRAN, ERIC 4637 N Paulina, Chicago, IL (312) 728-8811 P 362

G

GARDNER, AL 7120 Eugene, St Louis, MO (314) 752-5278 **P 358**

GOLDBERG, LENORE 210 Park Ave, Glencoe, IL (312) 835-4226
GOLDENBURG, ROBERT 628 S Jackson, Batavia, IL (312) 887-7500, Ext 1265
GOLDSTEIN, STEVEN 14982 Country Ridge, St Louis, MO (314) 532-0660 **P 353**

GRIGAR, JIM 3908 W Dakin St, Chicago, IL (312) 583-6273
GUBIN, MARK 2893 S Delaware, Milwaukee, WI (414) 482-0640

H

HALBE, HARRISON 7230 Forestate Dr, St Louis, MO (314) 993-1145, 842-6430
HANDLEY, ROBERT E. 1920 E Croxton Ave, Bloomington, IL (309) 828-4661
HARLAN, BRUCE 52922 Camellia Dr, South Bend, IN (219) 283-7350, 272-2904, 239-7350
HARPER, HUGO 7159 Washington Ave, St Louis, MO (314) 727-4735
HELMICK, WILLIAM 129 Geneva, Elmhurst, IL (312) 834-4798
HENDERSON, Al 828 S Grant, Hinsdale, IL (312) 322-8670
HENLEY, RICHARD Rt 5 Box 348, Grand Rapids, MI 55744
HENRY, DIANE 2943 N Seminary, Chicago, IL (312) 327-4493
HETISIMER, LARRY 1630 Fifth Ave, Moline, IL (309) 797-1010 **P 338**

HILL, ROGER 140 Jefferson SE, Grand Rapids, MI (616) 451-2501 **P 361**

HIRSCHFELD, CORSON 316 W 4 St, Cincinnati, OH (513) 241-0550 **P 345**

HOBSON, ROYDEN 436 Swan Blvd, Deerfield, IL (312) 459-9568
HOLCEPL, ROBERT 2044 Euclid Ave - 4 Fl, Cleveland, OH (216) 621-3838, (312) 787-5579
HUYCK, JEFFREY 1550 Lake Dr SE, Grand Rapids, MI (616) 456-1187

JK

JAMES, PHILLIP 2300 Hazelwood Ave, St Paul, MN (612) 777-2303
JOHNSON, DONALD 1680 Landwehr Rd, Northbrook, IL (312) 480-9336
JONES, DAWSON L. 44 E Franklin St, Dayton, OH (513) 435-1121 **P 343**

KELLY, TONY 828 Colfax, Evanston, IL (312) 864-0488
KIZOREK, BILL 5936 Greenview, Lisle, IL (312) 222-9311
KNIGHT, BILL 9906 Gilbrook Ave, St Louis, MO (314) 968-9510, 968-9511
KUFRIN, GEORGE 500 N Dearborn St - 1102, Chicago, IL (312) 644-5850
KUSLICH, LAWRENCE 115 Washington Ave N - Ste 200, Minneapolis, MN (612) 332-2425

L

LA TONA, TONY 1317 E 5 St, Kansas City, MO (816) 474-3119
LEAVITT, FRED 916 Carmen, Chicago, IL (312) 784-2344
LEE II, ROBERT 1512 Northlin Dr, Kirkwood, MO (314) 965-5832
LENDERINK, JAMES Ridgeland Ave, Box 84 - R1, Tinley Park, IL 60477 (312) 532-9099
LEWANDOWSKI, LEON 325 W Huron, Chicago, IL (312) 467-9577
LEWIS, JOHN Rt 3, Kaukauna, WI (414) 766-4281
LIGHTFOOT III, ROBERT 311 Good Ave, Des Plains, IL (312) 297-5447
LILJEGREN, STEPHEN 274 S Main St, Fond Du Lac, WI (414) 922-4551
LINDBLADE, G. R. PO Box 1342, Sioux City, IA 51102 (712) 255-4346;
 Rep—Barbara Lindblade (712) 276-3151 **P 347**

LOWENTHAL, JEFF, Newsweek Magazine, 200 E Randolph Dr - 794B, Chicago, IL
 (312) 861-1180

M

MacDONALD, ALBERT 32 Martin Lane, Elk Grove, IL (312) 437-8851
MALINOWSKI, STAN 1221 N Astor, Chicago, IL (312) 280-5353
MANDEL, AVIS 510 1 Ave N, Minneapolis, MN (612) 341-3362
MANN, MILTON PO Box 413, Evanston, IL 60204 (312) 777-5656
MARCU, JOHN V. Box 29546, Columbus, OH 43229 (614) 263-0332
MARSHALL, PAUL 117 N Jefferson St - Ste 305, Chicago, IL (312) 559-1270 **P 341**

MARQUARDT, WALTER 8044 N Tripp Ave, Skokie, IL (312) 675-5214
MARVY, JIM 41 12 Ave N, Hopkins, MN (612) 935-0307
McDONOUGH, TED RRD - Box 280, Coon Rapids, IA 50058 (712) 684-5449
McMAHON, WM. FRANKLIN 1319 Chestnut Ave, Wilmette, IL (312) 256-5528 **P 359**

McQUILKIN, ROBERT 1028 N Cherry, Wheaton, IL (312) 653-4500
MEINEKE, DAVID 703 E Golf Rd, Schaumburg, IL (312) 884-6006
MEYER, ROBERT 208 W Kinzie St, Chicago, IL (312) 329-1099
MILLER, FRANK 6016 Blue Circle Dr, Minnetonka, MN (612) 935-8888
MILLER, BUCK 8132 N 37 St, Milwaukee, WI (414) 258-9473;
Rep—Jane Gibbs (414) 644-8461; NY—(212) 679-3288 **P 348**

MOORE, DANIEL 5801 Hanover, Wichita, KS (316) 263-5537

N

NANO, ED 3413 Rocky River Dr, Cleveland, OH (216) 941-3373, 861-0148
NAWROCKI, WILLIAM 11401 S Lothair, Chicago, IL (312) 445-8920
NICHOLSON, LARRY B. 2100 Stark, Kansas City, MO (816) 461-0500
NOVAK, KEN 2483 N Bartlett Ave, Milwaukee, WI (414) 964-7979

OPR

OBERLE JR., FRANK 1635 Wilmes, St Charles, MO (314) 946-0554
OLAUSEN, JUDY 425 Portland Ave, Minneapolis, MN (612) 372-4163
O'ROURKE, JOHN PO Box 52, Wilmington, OH 45177 (513) 382-3782
OXENDORF, ERIC PO Box 10304, Milwaukee, WI 53210 (414) 871-5958
PAZOVSKI, KAZIK 2340 Laredo Ave, Cincinnati, OH (513) 281-0030
PETERSON JR., CHESTER N. PO Box 71, Lindsborg, KS 67456 (913) 227-3880
PIERATT, ED PO Box 187, Athens, OH 45701 (614) 593-7969
PLOWDEN, DAVID 609 Cherry St, Winnetka, IL (312) 446-2793
PORTNOY, LEWIS 5 Carole Lane, St Louis, MO (314) 567-5700, 432-2828 **P 351**

PRATHER, MAURICE 11611 Cherry, Kansas City, MO (816) 942-0853, 523-4004
PUZA, GREG PO Box 1986, Milwaukee, WI 53201 (414) 444-9882
ROCKER, DONALD 302 Seminole, Park Forest, IL (312) 747-8958
ROGERS, BILL ARTHUR PO Box 1082, 846 S Wesley Ave, Oak Park, IL 60304 (312) 848-3900

S

SACKS, ANDREW 20727 Scio Church Rd, Chelsea, MI (313) 663-7422;
CHIC—Mickey Hanks (312) 266-2240 **P 352**

SACKS, ED Box 7237, Chicago, IL 60680 (312) 871-4700
SCHWARTZ, THOMAS 244 Martha Ave, Centerville, OH (513) 433-8657
SEED, BRIAN 7432 Lamon Ave, Skokie, IL (312) 787-7880, 677-7887
SEED, SUZANNE 175 E Delaware, Chicago, IL (312) 266-0621
SEYMOUR, RONALD 314 W Superior St, Chicago, IL (312) 642-4030
SHAFFER, MAC 526 E Dunedin Rd, Columbus, OH (614) 268-2249
SHAY, ARTHUR 618 Indian Hill Rd, Deerfield, IL (312) 945-4636
SKALAK, CARL 4746 Grayton Rd, Cleveland, OH (216) 676-6508
SKREBNESKI, VICTOR 1350 N La Salle St, Chicago, IL (312) 944-1339
SMETZER, DONALD 2534 N Burling St, Chicago, IL (312) 787-7880, 327-1716
SMITH, R. HAMILTON 584 Rose Ave, St Paul, MN (612) 778-1408 **P 360**

STEIN, FREDRIC 229 W Illinois St, Chicago, IL (312) 222-1133
STERLING, JOSEPH 2216 N Cleveland Ave, Chicago, IL (312) 348-4333;
Stock—(312) 787-7880 **P 356-357**

STIERER, DENNIS 1831 Wells St, Fort Wayne, IL (219) 424-6641
STRANSKY, JEROME 318 Chester St, St Paul, MN (612) 221-9811
STRUSE JR., PERRY L., Rural American Graphics, 232 6 St, W Des Moines, IA
(515) 279-9761 **P 339**

T

TERKEURST, JAMES V. 242 Carlton SE, Grand Rapids, MI (616) 458-8602

THIEN, ALEX 2754 N Prospect Ave, Milwaukee, WI (414) 964-2711

THOMAS, BILL Route 4 - Box 387, Nashville, IN 47448 (812) 988-7865

THOMPSON, DALE 1943 N Larrabee, Chicago, IL (312) 347-2081, 943-4315

TRUDEL, GLENN 1319 Rutledge St, Madison, WI (608) 255-8919

TUCKER, BILL 114 W Illinois, Chicago, IL (312) 321-1570

TUCKER, PAUL 2518 Marigold Dr, Dayton, OH (513) 435-9866

UVW YZ

UMLAND, STEVEN 6156 Olson Memorial Hwy, Minneapolis, MN (612) 926-0117

UPITIS, ALVIS 620 Morgan Ave S, Minneapolis, MN (612) 374-9375

VAN MARTER, ROBERT 1209 Alstott Dr S, Howell, MI (517) 546-1923 P 355

VIZANKO, STEVEN 11511 K-Tel Dr, Minnetonka, MN (612) 933-1314

WEIDLING, MARK 1501 Ammer Rd, Glenview, IL (312) 988-5839

WEST, STU 430 First Ave N - Ste 210, Minneapolis, MN (612) 871-0333

WILLIAMS, BASIL 2607 W Crest Ct, Bettendorf, IA (319) 332-8273

WITTE, SCOTT 2534 N Prospect Ave, Milwaukee, WI (414) 963-0232 P 346

WITTNER, DALE EDWARD PO Box 11086, Chicago, IL 60611 (312) 787-6445

WOLF, BOBBE 440 W Oakdale, Chicago, IL (312) 472-9503 P 337

YATES, PETER 524 S First St, Ann Arbor, MI (313) 995-0839

ZANN, ARNOLD 502 N Grove, Oak Park, IL (312) 386-2864, (212) 679-3288

ASSOCIATE MEMBERS MIDWEST

CEF

CARLSON, DAVID 1321 Birchwood, Chicago, IL (312) 761-0544
CLAY, WILLARD 2976 E 12 Rd, Ottawa, IL (815) 433-1472
COX, D. E. 13500 Fenelon, Detroit, MI (313) 366-6679
CUNNINGHAM, ELIZABETH 1122 W Lunt Ave, Chicago, IL (312) 761-9323
ECKERT, SUSAN 1308 Sherman Ave, Evanston, IL (312) 864-4570
FISH, DAVID J. 1430 Sandstone Dr, Wheeling, IL (312) 541-8007
FORSYTE, ALEX 1180 Oak Ridge Dr, Glencoe, IL (312) 835-0307
FUNK, ED 16941 Willow Ln, Tinley Park, IL (312) 532-1511

GJK

GROETZINGER, ERIC 159 Westminster Sq, Racine, WI (414) 639-9042
JOEL, DAVID 1771 W Winnemal, Chicago, IL (312) 271-4789
JOHNSON, CHARLES PO Box 1813, Fond Du Lac, WI (414) 921-6249
KRANSBERGER, JIM 2247 Boston SE, Grand Rapids, MI (616) 245-0390

L

LAWSON, JAMES, Photo Associates Studio, 624 W St Clair, Cleveland, OH (312) 621-3318
LAWSON, JAMES 739 D E Stretsboro Rd, Hudson, OH (216) 650-4803
LE GRAND, PETER 413 Sandburg, Park Forest, IL (312) 747-4923
LEONARD, STEVE 825 W Gunnison, Chicago, IL (312) 275-8833

MNO

MELLOAN, CATHY 2042 W Melrose, Chicago, IL (312) 549-7366
NOCKUNAS, WILLIAM PO Box 1167, Iowa City, IA 52244 (319) 351-8287
O'CONNOR III, JOHN 155580 Old Jamestown Rd, Florissant, MO (314) 741-2034

PRS

PEARSON, STUART 1005 Campbell, Joliet, IL (815)726-5128
PHELPS, KATHERINE 1057 W Dakin, Chicago IL (312) 248-2536
POLIN, JACK 7306 Crawford, Lincolnwood, IL (312) 676-4312
POTTS, CAROLYN 2350 N Cleveland, Chicago, IL (312) 935-1707
ROWAND, CATHIE 540 Oak Knoll, Perrysburg, OH (419) 874-7694
SEXTON, KEN 3740 N Janssen, Chicago, IL (312) 342-7609
SMITH, JEFFREY 1570 Oak Ave, Dryden Hill 510, Evanston, IL (312) 869-1063
SPINGOLA, LAUREL 6225 N Forest Glen, Chicago, IL (312) 685-8593

VW

VARIAKOJIS, DANGUOLE 5743 S Campbell, Chicago, IL (312) 776-4668
WILLIAMS, ALFRED G. 5230 S Blackstone - Apt 306, Chicago, IL (312) 947-0991
WORTHINGTON, RICHARD K. PO Box 676, 338 Lupfer Ave, Whitefish, MO (406) 862-2354

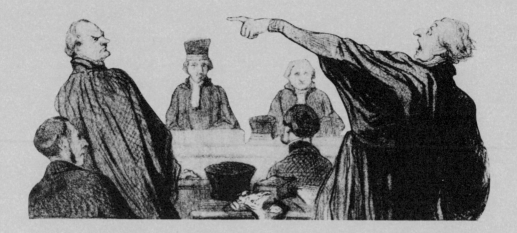

BETTER WAY

Since 1945, The **Joint Ethics Committee** has served the Graphics Industry by providing an alternative to litigation in the settlement of ethic disputes through peer review, mediation and arbitration.

Our five sponsors are the most respected professional organizations in the field: Society of Illustrators, Inc.; The Art Directors Club, Inc.; American Society of Magazine Photographers, Inc.; Society of Photographer and Artist Representatives, Inc.; The Graphic Artists Guild, Inc.

Selected representatives from these organizations serve as volunteers on the Committee. The services of the **JEC** are offered free of charge.

The **Joint Ethics Committee** has formulated a Code of Fair Practice which outlines the accepted ethical standards for the Graphics Industry.

To purchase the Code booklet for $2.50 or for further information please write to:

JOINT ETHICS COMMITTEE
P.O. Box 179, Grand Central Station
New York, NY 10163.

440 W. OAKDALE 312.472.9503 CHICAGO IL 60657

BOBBE WOLF

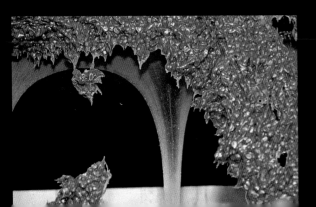
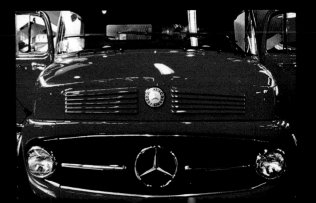

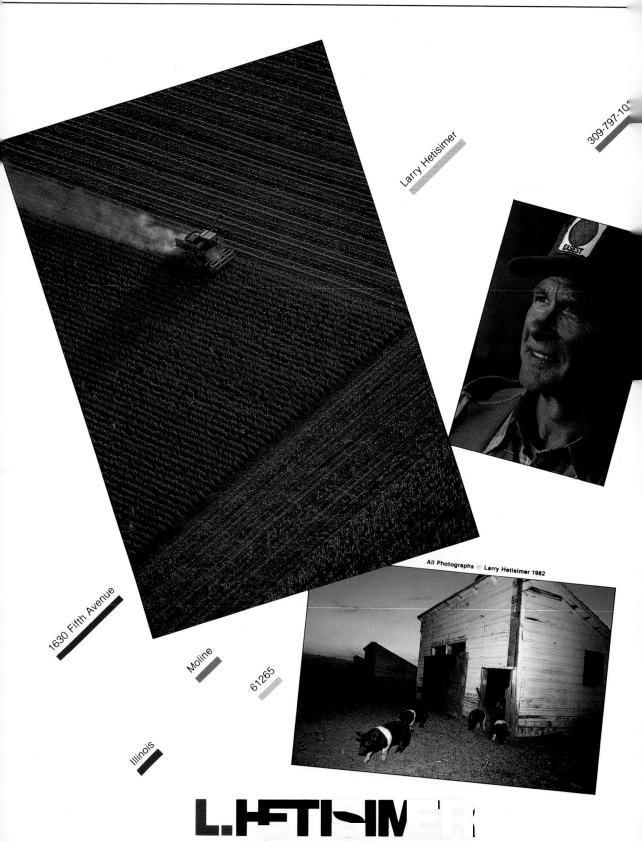

Larry Hetisimer

309-797-10

All Photographs © Larry Hetisimer 1982

1630 Fifth Avenue

Moline

61265

Illinois

L.HETISIMER

STruse

PHOTOGRAPHIC DESIGN

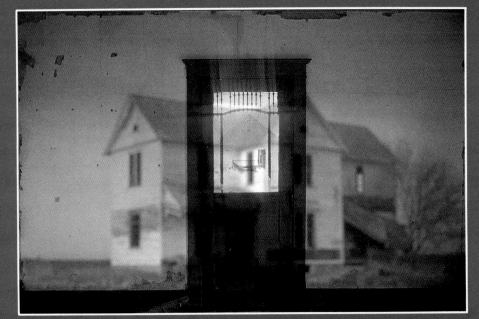

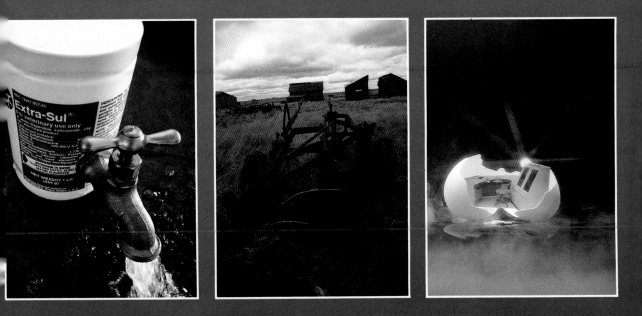

Perry L. Struse, Jr. 232 6th Street West Des Moines, Iowa 50265 • 515-279-9761

Rural American Graphics Inc.©

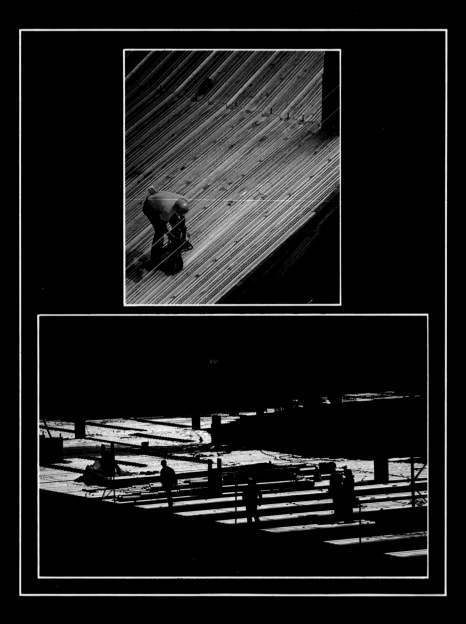

ARNOLD H.

PHOTOGRAPHER

117 NORTH JEFFERSON STREET • ROOM 304 • CHICAGO, ILLINOIS 60606 • (312) 346-9155

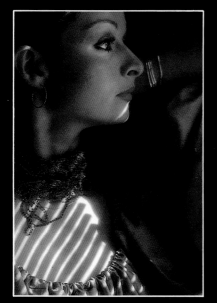

marshall

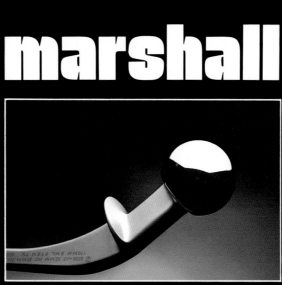

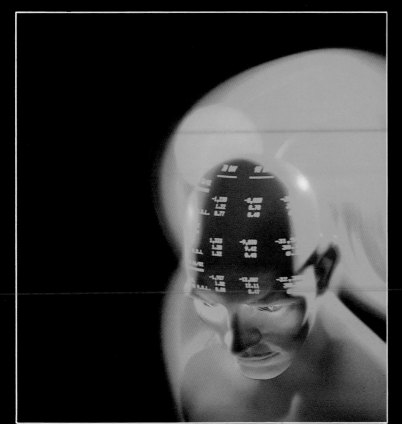

Paul Marshall, Inc.
117 N. Jefferson
Suite 305
Chicago, IL 60606
(312) 559-1270

Clients:
Allied Van Lines • Faberge
Forbes • Gulf + Western
Hart Shaffner • Holiday Inns
International Harvester
Jones & Laughin Steel
Miles Labs • Whirlpool

© Paul Marshall 1983

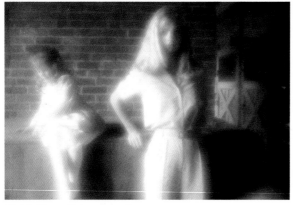

Melvin Simon & Associates, Inc.

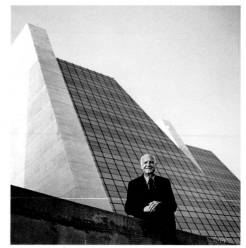

College University Corp.

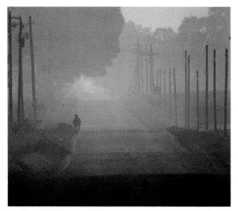

Indiana Knitwear Corp.

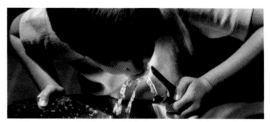

Melvin Simon & Associates, Inc.

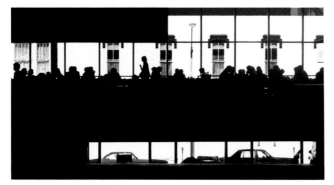

Merchants National Bank

Indianapolis Business Journal

CLIENTS INCLUDE:

Anacomp, Inc.

Bordens

Capital Holding Corp.

Dow Chemical

Eli Lilly & Co.

Mayflower Corp.

Stokely-Van Camp, Inc.

TOM CASALINI

Casalini Photography
317 • 873 • 4858

Ten and One Half North Main Street

Zionsville, Indiana 46077
317 • 873 • 5229

DAWSON L. JONES

PHOTOJOURNALIST

44 E. Franklin St.
Dayton, Ohio 45459
513-435-1121

My corporate aircraft allows
me to cover the U.S. with a
greater flexibility.

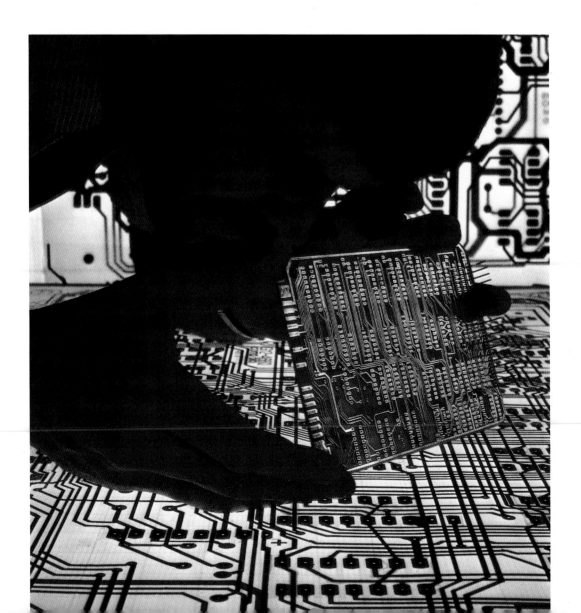

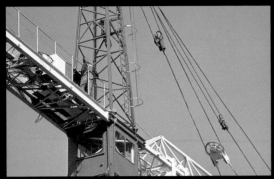

SOUTHWESTERN BELL TELEPHONE COMPANY

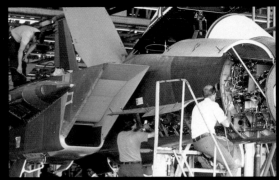

McDONNELL DOUGLAS CORPORATION

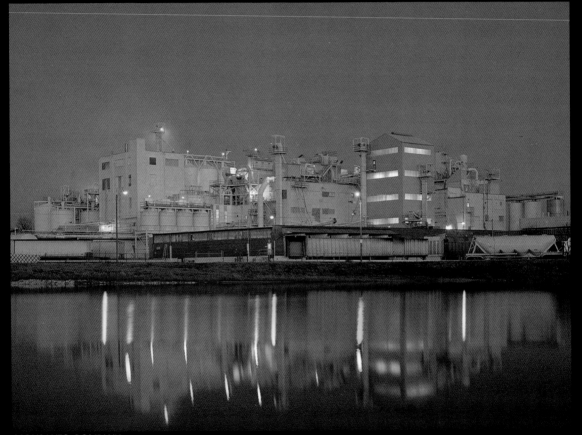

MONSANTO COMPANY

BOX 2062 · ST. LOUIS · 63158 · 314-772-8540

BOB SHELLI

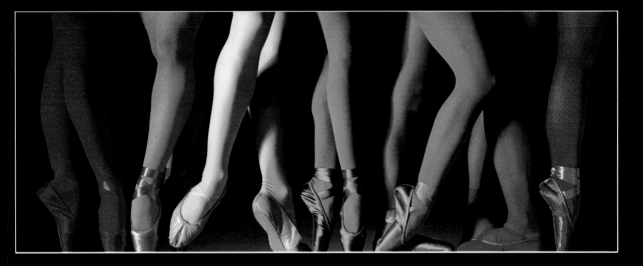

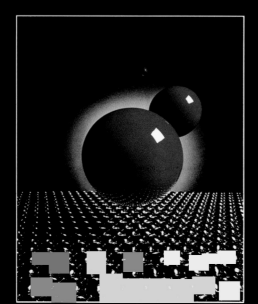

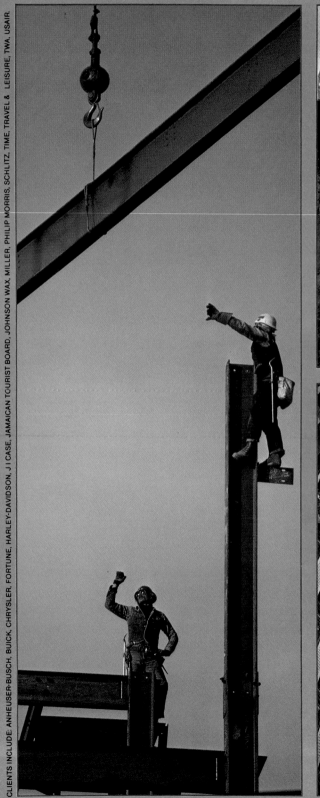

WITTE
M I D W E S T

Scott Witte
Milwaukee, Wisconsin (414)963-0232

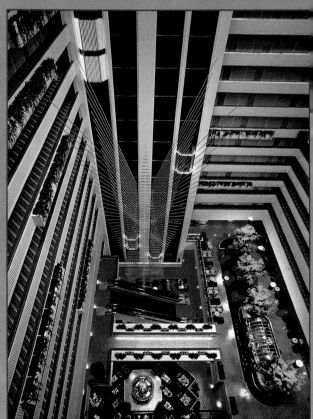

© Scott Witte, 1983

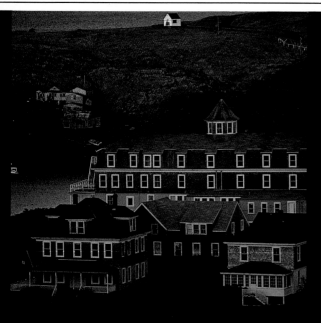
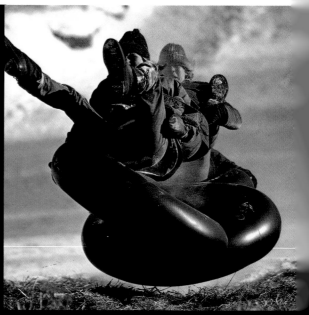
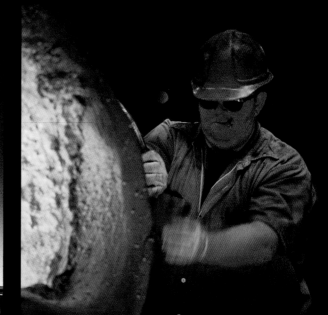

BUCK MILLER
LOCATION PHOTOGRAPHY FOR
ADVERTISING & ANNUAL REPORTS
(414) 258-9473
REP: JANE GIBBS (414) 644-8461
NEW YORK REP: BLACK STAR (212) 679-3288

**EVERYONE NEEDS
A CHANCE**

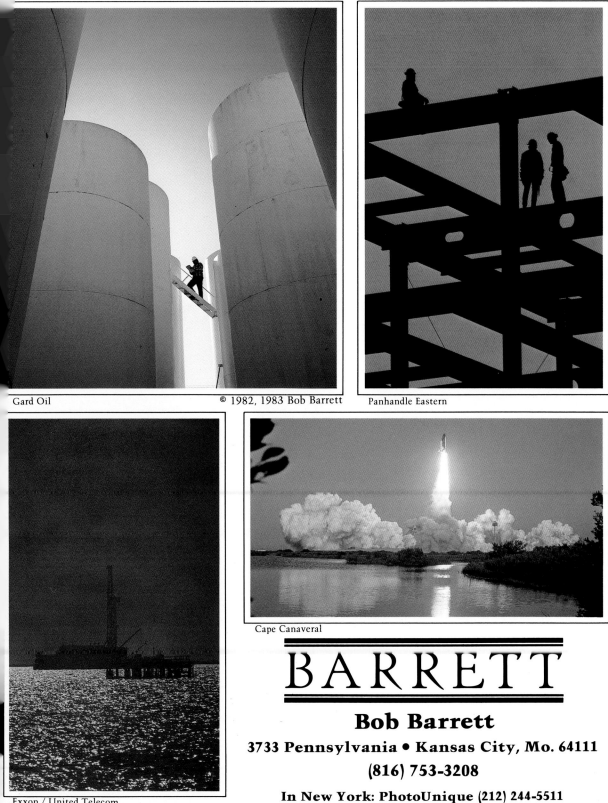

Gard Oil © 1982, 1983 Bob Barrett

Panhandle Eastern

Cape Canaveral

BARRETT

Bob Barrett

3733 Pennsylvania • Kansas City, Mo. 64111

(816) 753-3208

In New York: PhotoUnique (212) 244-5511

Exxon / United Telecom

Ed Bock Photography
Studio 207
400 North First Avenue
Minneapolis, Minnesota 55401
(612) 332-8504

Location, Audio Visual, Annual Reports

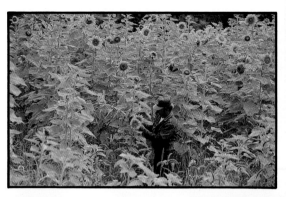

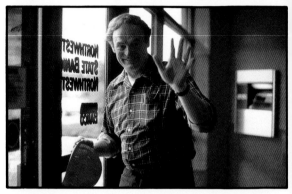

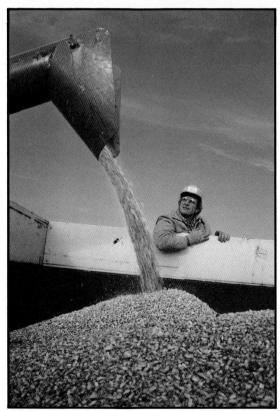

©Ed Bock 1983

Anheuser-Busch, Inc.
NBC Sports
Colgate / Palmolive
R. J. Reynolds
American Airlines
Needham, Harper & Steers
Doyle, Dane & Bernbach
D'Arcy, MacManus & Masius
Phillip Morris
Time

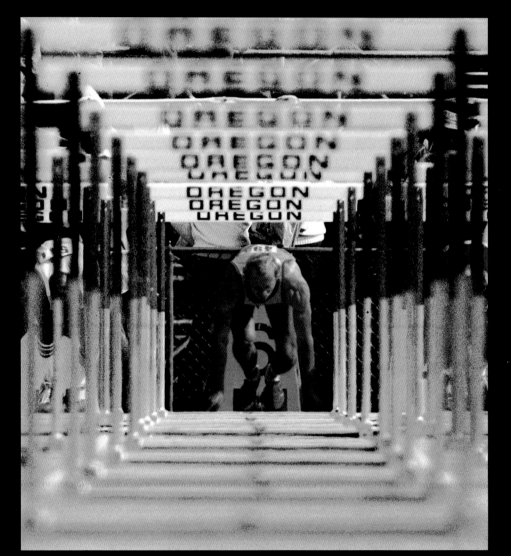

**START
HERE**

Lewis Portnoy
No. 5 Carole Lane
St. Louis, MO 63131
314-567-5700

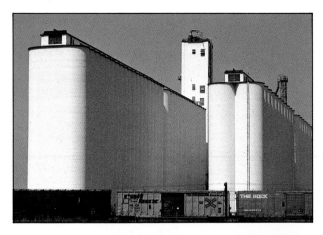

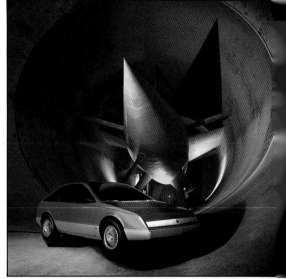

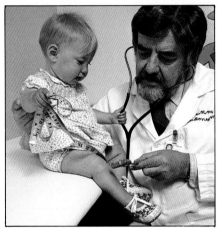

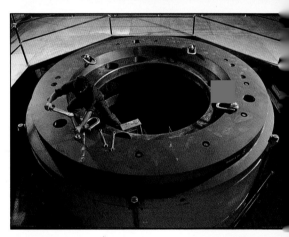

AndrewSacks

313/663-7422
20727 Scio Church Rd.
Chelsea, MI 48118
In Chicago call Mickey Hanks 312/266-2240

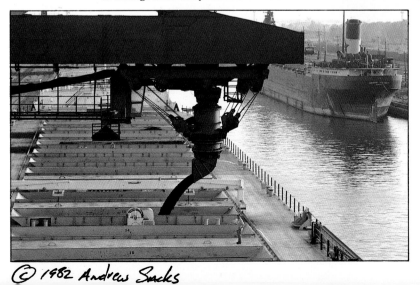

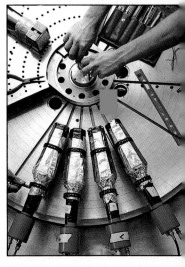

© 1982 Andrew Sacks

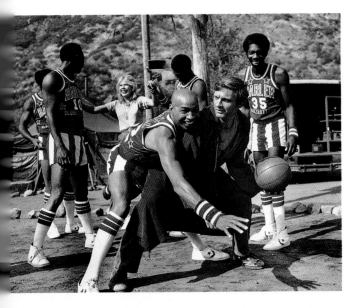

STEVEN GOLDSTEIN

14982 Country Ridge
St. Louis, Mo. 63017
314-532-0660

Editorial Clients Include:
Time, Sports Illustrated, and People.

Other Clients Include:
Addidas U.S.A., Harlem
Globetrotters, Hilton Hotels, MCA
Records, Miller Brewing, Rawlings
Sporting Goods, Shell Oil, Sheraton
Hotels, and Trans World Airlines.

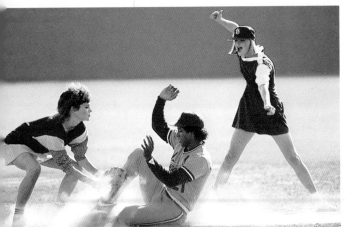

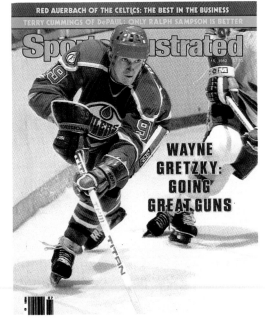

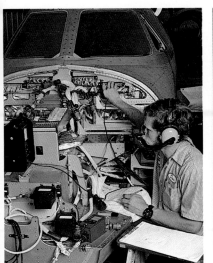

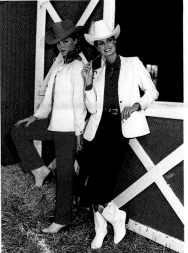

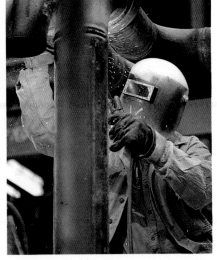

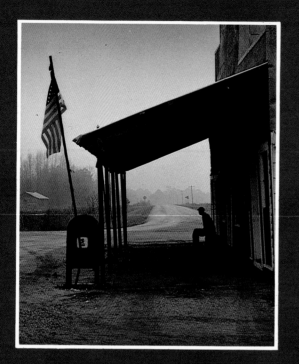

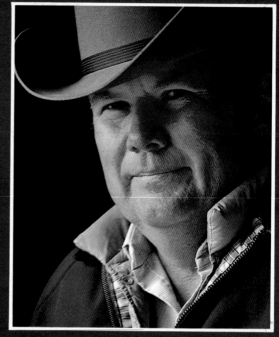

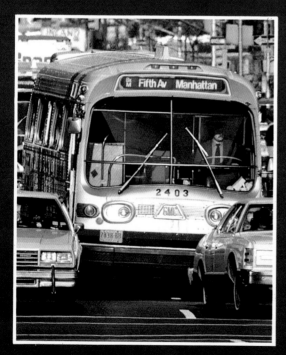

Junebug Clark

Pictures that tell a story

30419 West Twelve Mile Road
Farmington Hills, Michigan 48018

313/478-3666

The General Store

We all used to sit around the old gen'rl store
But we don't sit around no more
For the days are gone and the store is gone
And a supermarket ain't no store.

HillBilly SnapShooter

Call or write. We'll be happy to
send you our H.B.S.S. Bulletin and
answer any questions.

Advertising · Editorial Illustration · People
Location Photography · USA

©1983

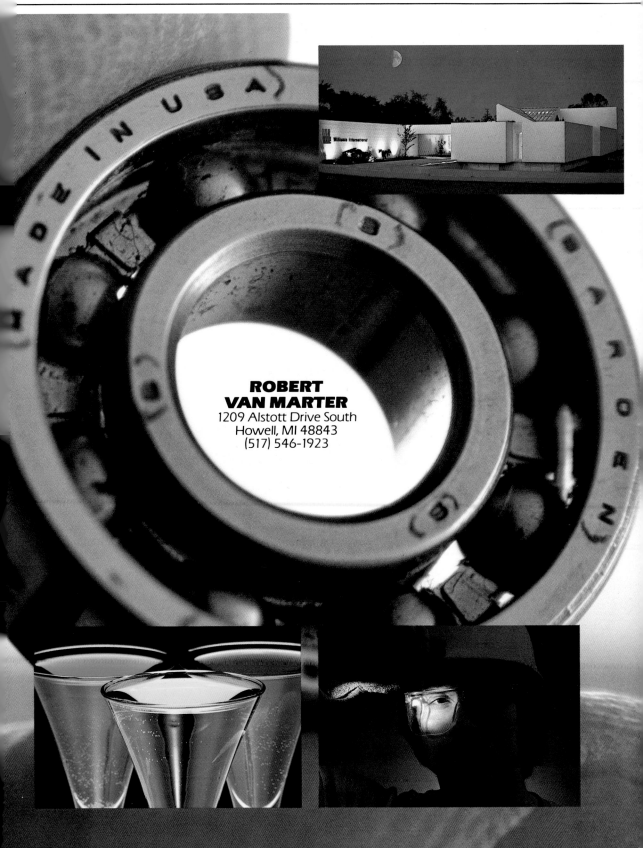

**ROBERT
VAN MARTER**
1209 Alstott Drive South
Howell, MI 48843
(517) 546-1923

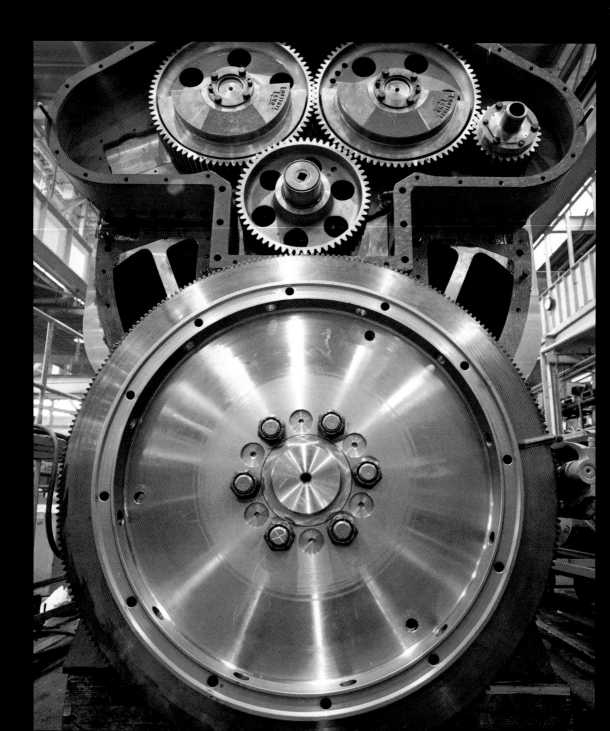

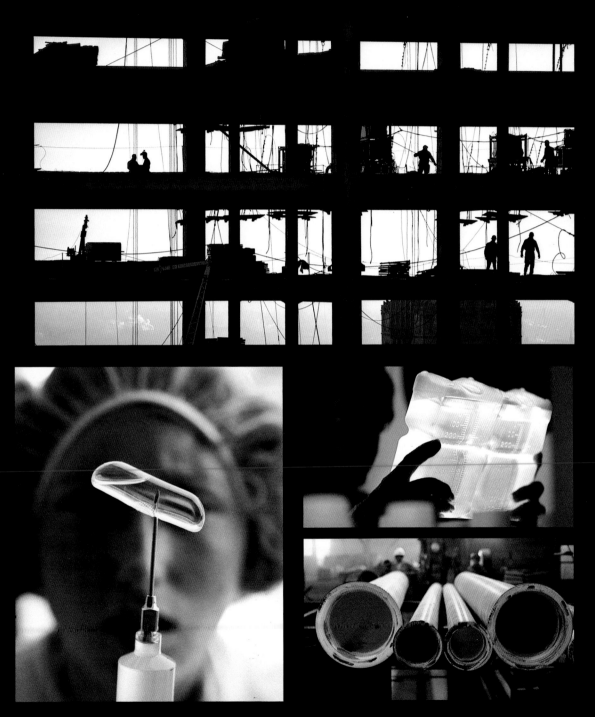

Joseph Sterling Chicago 312.348.4333

Stock Photos: CLICK Chicago 312.787.7880

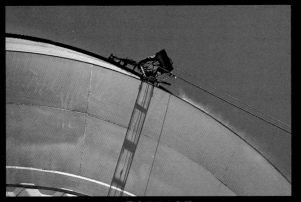

REPORTAGE

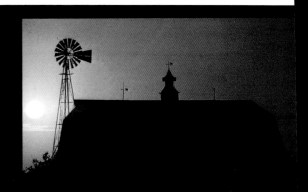

CHAMBER OF COMMERCE

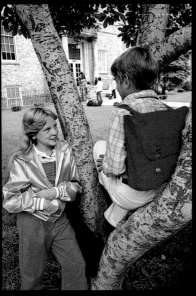

AOA

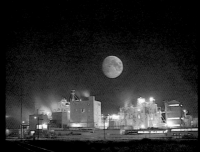

MONSANTO

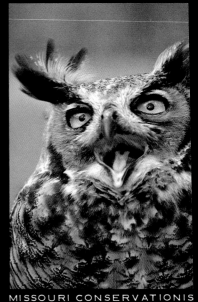

MISSOURI CONSERVATIONIS

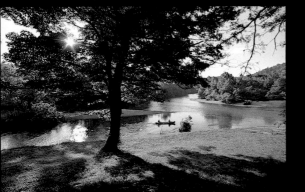

NATIONAL PARK SYSTEM

SOUTHWESTERN BELL

AL GARDNER

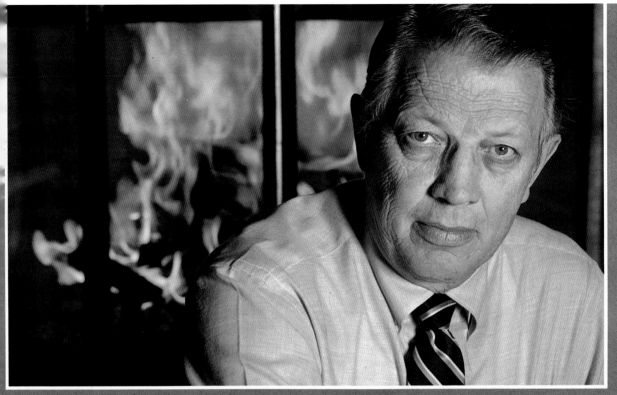

Bill Thomas, *CEO, Preway, Inc. (Fireplaces)*

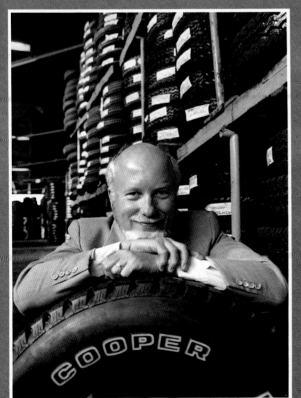

Edward E. Brewer, *CEO, Cooper Tire & Rubber Company*

WM. Franklin McMahon

1319 Chestnut Avenue
Wilmette, Illinois 60091
(312) 256-5528

Corporate and Editorial Photojournalism

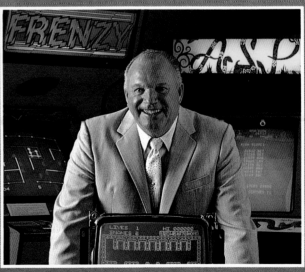

Albert S. Wells, *CEO, Wells-Gardner Electronics Corp. (video screens)*

R.HAMILTON SMITH

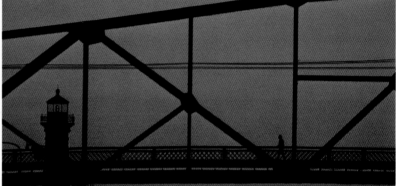

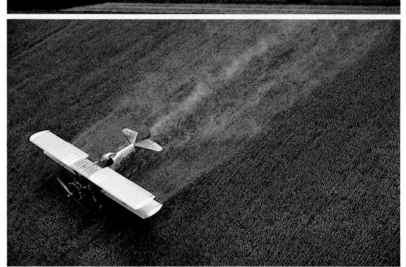

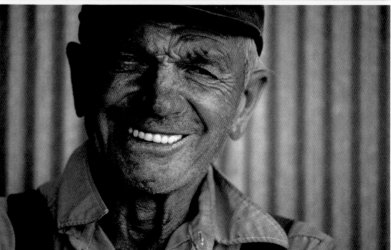

PHOTOGRAPHY

140 Jefferson S.E.
Grand Rapids, MI
49503
616-451-2501

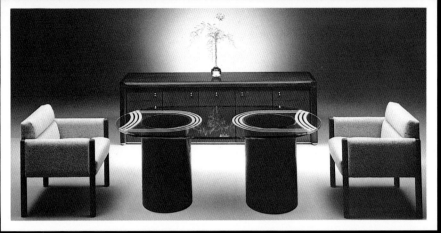

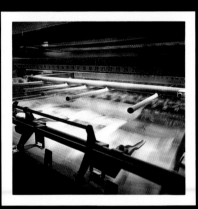

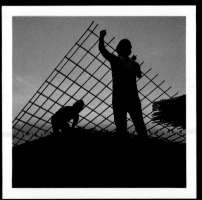

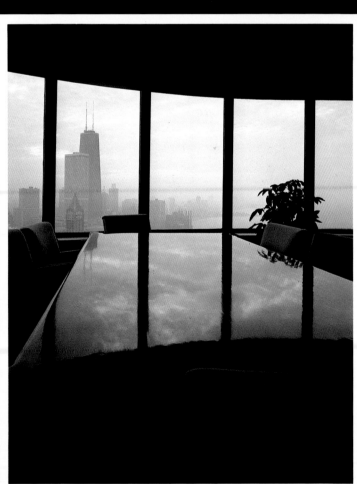

Eric Futran, Chicago. (312) 728-8811.

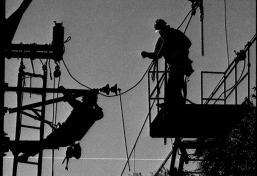

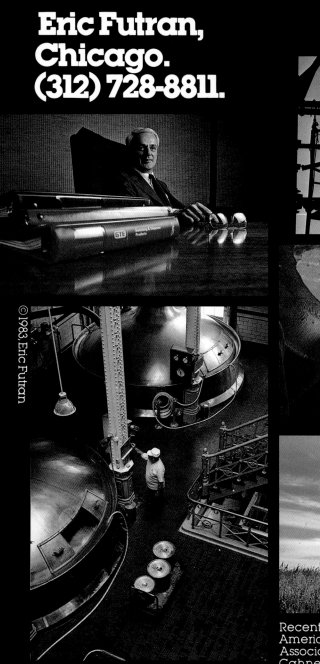

©1983, Eric Futran

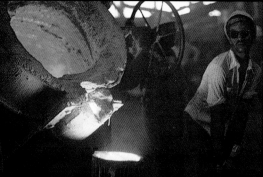

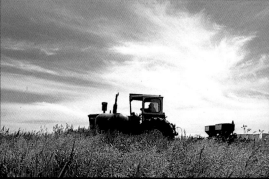

Recent clients include: Ace Hardware, American Hospital Supply, American Medical Association, Borg-Warner, Burson-Marsteller, Cahner's Publishing, G T E Automatic Electric, Hill and Knowlton, Inland Real Estate, Institute of Gas Technology, M & M/Mars, Midland-Ross, L. E. Myers, Olympia and York, Paine Webber, People's Energy/Trailblazer Pipeline, SCA Services, Jos. Schlitz Brewing, Urban Investment and Development.

GENERAL MEMBERS WEST/NORTHWEST

A

ABECASSIS, ANDREE L. 429 Berkeley Park Blvd, Berkeley, CA (415) 526-5099, 841-2895
AGRIMAGE, PHIL RUDY 411 E Olive Ave, Fresno, CA (209) 266-0305 P 396

AHLBERG, HOLLY, Ahlberg Photography 1117 N Wilcox Pl, Los Angeles, CA (213) 462-0731
AHREND, JAY 5047 W Pico Blvd, Los Angeles, CA (213) 934-9596
AIUPPY, LAURANCE B. PO Box 26, Livingston, MT 59047 (406) 222-7308 P 414

ALEXANDER, JESSE L. PO Box 5400, Santa Barbara, CA 93108 (805) 969-3916
ALEXANDER, MICHAEL 1717 Mason St, San Francisco, CA (415) 441-6700 P 422-423

ALLAN, LARRY PO Box 99585, San Diego, CA 92109 (714) 270-9549
ALLEN, JUDSON 654 Gilman St, Palo Alto, CA (415) 324-8177 P 368

ALLEN, RICHARD Box 1949, Steamboat Springs, CO 80477 (303) 879-4438
ALLISON, GLEN PO Box 1833, Santa Monica, CA 90406 (213) 392-1388
AMER, TOMMY 1858 Westerly Ter, Los Angeles, CA (213) 664-7624, 469-3305
ANDERSON, WELDEN 2643 S Fairfax Ave, Culver City, CA (213) 559-0059, 559-0126, 474-1894
ANDERSON, JOHN D. 6460 Byrnes Rd, Vacaville, CA (707) 448-4926
APLIN, WILLIAM PO Box 1027, Ventura, CA 93001 (805) 648-4457
APTON, BILL 577 Howard St, San Francisco, CA (415) 543-6313
AREND, CHRIS 160 Juanita Rd, Eagle River, AK (907) 694-9835
ARLEDGE, THOMAS 2510 N 47 St - Ste DD, Boulder, CO (303) 444-7580
ARNONE, KEN 4071 Hawk St, San Diego, CA (714) 234-5202
ASTON, BILL % Dolphin Northwest, 2415 2 Ave, Seattle, WA (206) 622-1066
ATTEBERY, BARTON L. 8406 Linden Ave N, Seattle, WA (206) 783-0321
AURNESS, CRAIG, Westlight, 1526 Pontious Ave - Ste A, Los Angeles, CA
 (213) 473-3736, 478-3655
AVERY, SID 820 N La Brea, Los Angeles, CA (213) 465-7193

B

BAER, MORLEY PO Box 2228, Monterey, CA 93940 (408) 624-3530
BAGGER, JEREL V. 1009 Castro St, San Francisco, CA (415) 495-8833, 647-1645
BAILEY, BRENT 759 W 19 St, Costa Mesa, CA (714) 548-9683
BAIR, ROYCE 409 W 400 South, Salt Lake City, UT (801) 328-9808
BARKER, JAMES H. Box 783, Bethel, AK 99559 (907) 543-2414
BARNES, DAVID 500 NE 70 St - Apt 306, Seattle, WA (206) 525-1965
BARR, JOHN Box 45909, Los Angeles, CA 90045 (213) 641-8282
BARTONE, THOMAS 7403 W Sunset Blvd, Los Angeles, CA (213) 876-5510
BARTRUFF, DAVE Box 800, San Anselmo, CA 94960 (415) 457-1482
BARTEK, PATRICK 4014 Avonwood Ave, Las Vegas, NV (702) 458-6653
BATISTA, BARBARA MOON 444 Pearl St - B1, Monterey, CA (408) 373-1947
BAUER, ERWIN A. Box 543, Teton Village, WY 83025 (307) 733-4023
BAUMAN, MARGARET 1024 Fifth Ave, Fairbanks, AK (907) 452-2751
BAYER, DENNIS 1261 Howard St, San Francisco, CA (415) 552-6575
BEEBE, MORTON 409 Bryant St, San Francisco, CA (415) 362-3530, (212) 247-3772
BELKNAP, BILL PO Box 365, Boulder City, NV 89005 (702) 293-1406
BENCZE, LOUIS 1025 SE 17 St, Portland, OR (503) 236-3328 P 393

BENSCHNEIDER, BEN 1711 Alamo Ave, Colorado Springs, CO (303) 473-4924
BERGE, MELINDA Box 4218, Aspen, CO 81612 (303) 925-2179
BERLINER, ALAN 100 N Laurel Ave, Los Angeles, CA (213) 935-2850
BERNSTEIN, CAL 722 N Seward St, Los Angeles, CA (213) 461-3737
BERNSTEIN, GARY 8705 Washington Blvd, Culver, CA (213) 550-0891,
 CHIC—Vincent Kamin (312) 787-8834 P 374

BETZ, R. TED 531 Howard St, San Francisco, CA (415) 433-0407
BEZ, FRANK 2425 Leona Court, San Luis Obispo, CA (805) 544-6565
BIGGS, KEN 1147 N Hudson Ave, Los Angeles, CA (213) 462-7739
BIRNBACH, ALLEN 3600 Tejon St, Denver, CO (303) 455-7800
BLAUSTEIN, JOHN 665 Alvarado Rd, Berkeley, CA (415) 845-2525;
 NY—Stock (212) 750-1020 P 400-401

BLUEBAUGH, DAVID 1051 E 88 Ave, Thornton, CO (303) 778-1246
BLUMENSAADT, MIKE 1261 Howard St, San Francisco, CA (415) 864-4172
BOULWARE, RICHARD 6060 E Dartmouth, Denver, CO (303) 837-0825

BOWEN, JOHN PO Box 1115, Hilo, HI 96720 (808) 935-2785, 959-9460
BRAASCH, GARY B. Box 1465 Portland, OR 97207 (206) 695-3844
BRADLEY, LEVERETT Box 1793 Santa Monica, CA 90406 (213) 394-0908
BRANDON, WILLIAM R. PO Box 224, Girwood, AK 99587 (907) 783-2773
BRAUN, ERNEST Box 627, San Anselmo, CA 94960 (415) 454-2791
BRENNEIS, JON 311 Wells Fargo Bldg, Berkeley, CA (415) 845-3377
BROOKS, DAVID 776 Inga Rd, Nipomo-Mesa, CA (805) 929-4327, (213) 737-4358
BROWN, DELORES McCUTCHEON 16616 Sultus St, Canyon Country, CA (805) 251-2416
BROWNE, RICK 145 Shake Tree Lane, Scotts Valley, CA (408) 438-3919
BRYAN, J. Y. 3594 Ramona Dr, Riverside, CA (714) 684-8266
BUDNIK, VICTOR 1121 Bryant St, Palo Alto, CA (415) 322-8036
BURDEN, S. C. 8826 Burton Way, Beverly Hills, CA (213) 271-7008
BURKHART, JOHN R. 1202 Sarah Kay Cir, Prescott, AZ (602) 778-0334
BURT, PAT 1412 SE Stark, Portland, OR (503) 284-9989
BURTON, RICHARD PO Box 648, San Francisco, CA 94101 (415) 541-0101
BUSHER, DICK 7042 20 Pl NE, Seattle, WA (206) 523-1426
BYBEE, GERALD 925 SW Temple, Salt Lake City, UT (801) 363-1061;
LA—Robin Ogden (213) 858-0946 P 378-379

C

CACCAVO, JAMES 4317 W 2 St, Los Angeles, CA (213) 385-6858 P 391

CAHEN, ROBERT 2725 Ralston Ave, Hillsborough, CA (415) 344-3232
CAPPS, ALAN 137 S La Peer Dr, Los Angeles, CA (213) 276-3724
CARROLL, BRUCE 517 Dexter Ave N, Seattle, WA (206) 623-2119
CARROLL, TOM 26801 Del Gado, Capistrano Beach, CA (714) 493-2665
CARRY, MARK 2224-1 Old Middlefield Way, Mountain View, CA (415) 967-8470
CASLER, CHRISTOPHER 1600 Viewmont Dr, Los Angeles, CA (213) 854-7733
CAULFIELD, ANDY 2233 Merton Ave, Los Angeles, CA (213) 258-3070, 385-7581
CHAMBERLAIN, ROBERT Box 229, Telluride, CO 81435 (303) 728-3525
CHESLEY, PAUL Box 94, Aspen, CO 81611 (303) 925-2317
CHESTER, MARK Box 99501 San Francisco, CA 94109 (415) 922-7512
CLARK, GORDON 1687 Third St, Livermore, CA (415) 443-4281
CLARK, NORRIS PO Box 9242, Boise, ID 83707 (208) 342-0333
CLARK, WLLIAM F. 515 S Flower - Rm 1685, Los Angeles, CA (213) 486-2564
CLARKSON, RICH, The Denver Post, 650 15 St, Denver, CO (303) 820-1010
CLASEN, NORM Box 4230 Aspen, CO 81611 (303) 925-4418
COCCIA, JIM PO Box 81313, Fairbanks, AK 99708 (907) 479-4707
COLEBERD, FRANCES 1273 Mills St - Apt 3, Menlo Park, CA (415) 325-4731
COLLISON, JAMES 3737 Weslin Ave, Sherman Oaks, CA (213) 784-4616,
 872-2717, (203) 227-3933
COLODZIN, BONNIE 4355 N Sepulveda Blvd - Apt 215, Sherman Oaks, CA (213) 784-4805
COOK, JAMES A. PO Box 11608 Denver, CO 80211 (303) 433-4874
COOPER, ED PO Box G, Elverano, CA 95433 (707) 996-1934
CORNFIELD, JIM 13836 Bora Bora Way, Marina Del Rey, CA (213) 938-3553
COURBAT, GORDON A. 331 E Ojai Ave, Ojai, CA (805) 646-5320, 646-1616
COURTNEY, WILLIAM 4524 Rutgers Way, Sacramento, CA (916) 487-8501
CRAIN, SCOTT 1427 Galveston St, San Diego, CA (714) 275-2650
CROUCH, STEVE Box 2085, Carmel, CA 93921 (408) 624-2030
CRUVER, DICK 1016 First Ave S, Seattle, WA (206) 325-3240
CUMMINS, JIM 114 Alaskan Way S, Seattle, WA (206) 623-6206
CUPP, DAVID 2520 Albion, Denver, CO (303) 321-3581

D

DAIN, MARTIN 16-B Ford Rd, Carmel Valley, CA (408) 659-3295, 625-1110
DANDRIDGE, FRANK 8033 Sunset Blvd - 191, Los Angeles, CA (213) 553-1517
DANIELS, JOSEPHUS 2987 17 Mile Dr, PO Box 7418, Carmel, CA 93921 (408) 625-3316, 372-8812
DANNEN, KENT Moraine Route, Estes Park, CO (303) 586-5794
DARBY, C. H. 5225 Balsam - 27, Arvada, CO (303) 431-5583
DAVIS, DAVE 1058 Doverfield Ave, Hacienda Hts, CA
DE CRUYENAERE, HOWARD 1825 E Albion Ave, Santa Ana, CA (714) 997-4446 P 365

DE LESPINASSE, HANK Box 14061 Las Vegas, NV 89114 (702) 361-6628
DENMAN, FRANK B. 131 15 Ave E, Seattle, WA (206) 325-9260, 285-1340;
Rep—Donna Jorgensen (206) 284-5080 P 421

DENNY, MICHAEL 2631 Ariane Dr, San Diego, CA (714) 272-9090
DE SCIOSE, NICHOLAS 3292 S Magnolia, Denver, CO (303) 455-6315, 756-0317, (212) 757-6454
DEVORE III, NICOLAS Box 812, Aspen, CO 81612 (303) 925-2317, (212) 683-5227
DeWILDE, ROC (aka) ROC DZIKIELEWSKI, 139 Noriega, San Francisco, CA
 (415) 681-4612 **P 415**

D'HAMER, MARGARET PO Box 5488, Berkeley, CA 94705 (415) 530-8433
DIMOND, CRAIG 257 S Rio Grande, Salt Lake City, UT (801) 363-7158
DOLGINS, ALAN 1640 S Lacienega Blvd, Los Angeles, CA (213) 273-5794
DONCHIN, CHIC 11675 Picturesque Dr, Studio City, CA (213) 985-4624
DONDERO, DONALD Box 52, Reno, NV 89504 (702) 825-7348
DRESSLER, RICK 1322 Bell Ave-M, Tustin, CA (714) 730-9113
DRIVER, WALLACE 2510 Clairemont Dr, No 113, San Diego, CA (714) 275-3159
DRUMBOR, DAVID 1330 Idaho St, San Jose, CA (408) 738-4965
DRYSDALE, INGER 993 Glen Oaks Blvd, Pasadena, CA (213) 796-7919
DUNBAR, CLARK 922 San Leandro Ave - Ste C, Mountain View, CA (415) 964-4225

E

EKLOF, ROLF 2845 Greenwich St, San Francisco, CA (415) 929-8666
ELDER, JIM Box 1600, Jackson Hole, WY 83001 (307) 733-3555; 5432
ELICH, GEORGE PO Box 255016, Sacramento, CA 95825 (916) 481-5021
ELK III, JOHN 583 Weldon, Oakland, CA (415) 834-3024
ELLZEY, BILL PO Box 1171, Telluride, CO 81435 (303) 728-4584
ENGLAND, JIM 602 Parkman Ave, Los Angeles, CA (213) 413-2575
ENKELIS, LIANE 764 Sutter Ave, Palo Alto, CA (415) 326-3253 **P 381**

F

FALCONER, DAVID 2722 SW Huber St, Portland, OR (503) 244-9174
FELT, JIM PO Box 5063, Portland, OR 97208 (503) 238-1748
FERRARA, JERRY General Delivery, Palomar Mt, CA (714) 742-3421
FINNEGAN, KRISTIN PO Box 8404, Portland, OR 97207 (503) 241-2701
FIREBAUGH, STEVE 3107 S Dearborn, Seattle, WA (206) 325-4044 **P 406-407**

FISCHER, CURT 276 Shipley St, San Francisco, CA (415) 974-5568
FISH, RICHARD 16642 Oldham St, Encino, CA (213) 986-5190
FISHER, ARTHUR VINING 271 Missouri St, San Francisco, CA (415) 626-5483
FLAVIN, FRANK PO Box 8-9172, Anchorage, AK 99508 (907) 561-1606 **P 390**

FLETCHER, BILL Box 421, Broomfield, CO 80020 (303) 466-9240
FLETCHER, PAUL 8200 E Pacific Pl - 402, Denver, CO (303) 696-1900
FOGG, DON 1641 El Camino Real, Palo Alto, CA (415) 321-3113, 3117
FOLKEDAL, ARNE PO Box 5764, Stanford, CA 94305 (415) 321-2228
FORSTER, C. BRUCE 1835 SE 10, Portland, OR (503) 232-0673
FRANDSEN, ROBERT PO Box 6752, Denver, CO 80206 (303) 355-2536
FRANZEN, DAVID 1149 Bethel St, Honolulu, III (808) 537-9921, 9922
FREEDHEIM, ROBERT 739 Sherman, Denver, CO (303) 831-7458
FREEMAN, HUNTER 852 Santa Fe Dr, Denver, CO (303) 893-5730;
 NY—Barbara Umlas (212) 534-4008 **P 402-403**

FREIS, JAY 416 Richardson St, Sausalito, CA (415) 332-6709 **P 412-413**

FRENCH, GERALD Pier 17, San Francisco, CA (415) 397-3040
FRIEND, DAVID 2631 Ariane Dr, San Diego, CA (714) 272-2090
FRIES, JANET 2017 Tiffin Rd, Oakland, CA (415) 482-5158
FRY III, GEORGE 10 Maple Ave, Atherton, CA (415) 323-7663
FUKUHARA, RICHARD 3267 Grant St, Signal Hill, CA (213) 597-4497
FUSCO, PAUL 7 Melody Lane, Mill Valley, CA (415) 388-8940, (212) 475-7600

G

GAGE, ROB 789 Pearl St, Laguna Beach, CA (714) 494-7265
GARRISON, RON San Diego Zoo, Box 551, San Diego, CA 92112 (714) 231-1515
GOODALL, ROY 5018 Eighth Ave NE, Seattle, WA (206) 722-0544
GORDON, CHARLES M. 19226 35 Pl NE, Seattle, WA (206) 365-2132
GORDON, LARRY DALE 2047 Castilian Dr, Los Angeles, CA (213) 874-6318;
 LA—Virginia Cervantes (213) 551-2729; NY—Nob Howde (212) 753-0462;
 CHIC—Ken Feldman (312) 337-0447; London—Carolyn Trayler
 01-370-4849; Hamburg—The Picture People (40) 44-26-95 **P 366-367**

GORDON, MICHAEL J. PO Box 8222, Missoula, MT 59807 (406) 721-3100, 542-2394
GOTTLIEB, MARK 378 Cambridge Ave, Palo Alto, CA (415) 321-8761
GRAHAM, ELLEN 614 N Hillcrest Rd, Beverly Hills, CA (213) 275-6195
GRIMM, TOM Box 83, Laguna Beach, CA 92652 (714) 494-1336
GROSS, RICHARD 1810 Harrison St, San Francisco, CA (415) 558-8075

H

HAGYARD, DAVE 1205 E Pike St, Seattle, WA (206) 322-8419 **P 380**

HALL, GEORGE 82 Macondray, San Francisco, CA (415) 775-7373
HAMILTON, JOHN R. 1455 W 172 St, Gardena, CA (213) 321-9993
HAMPTON, RALPH PO Box 480057, Los Angeles, CA 90048 (213) 934-5781
HANKEY, ROY 1037 N Wilcox, Los Angeles, CA (213) 464-3675
HARDER, PAUL 130 Kala Point, Port Townsend, WA (206) 385-4878
HARRINGTON, MARSHALL 2775 Kurtz - 2, San Diego, CA (714) 291-2775
HARRIS, PAUL 11844 Saticoy St, No Hollywood, CA (213) 982-3088
HEFFERNAN, TERRY 352 6 St, San Francisco, CA (415) 863-9300
HENDERSON, TOM Apt 48 - 333 Solana Hills Dr, Solana Beach, CA (619) 481-9451
HERBEN, GEORGE Box 10-2106 Anchorage, AK 99511 (907) 243-5563
HERRON, MATT Box 1860, Sausalito, CA 94965 (415) 332-7388
HEWETT, RICHARD 5725 Buena Vista Terr, Los Angeles, CA (213) 254-4577
HICKS, JOHN & REGINA Box 5162, Carmel, CA 93921 (408) 624-7573
HIGBEE, JACK 1420 N Claremont Blvd - 204A-9, Claremont, CA (714) 625-4573
HILDRETH, JIM 225 Jersey St, San Francisco, CA (415) 245-5812
HISER, C. DAVID Box 1113, Aspen, CO 81611 (303) 925-2317, 925-2179
HIXSON, RICHARD 3124 Rogers Ave, Walnut Creek, CA (415) 495-0558
HODGES, WALTER 4106 32 SW, Seattle, WA (206) 622-3474; Rep—Susan Trimpe
(206) 382-1100; Stock—(206) 621-1611 **P 417**

HOFFMAN, PAUL 4500 19 St, San Francisco, CA (415) 863-3575
HOLLENBECK, CLIFF Box 4247, Pioneer Square, Seattle, WA 98104 (206) 682-6300
HOLMES, MARILYN 8470 N Douglas Hwy, Juneau, AK (907) 586-2316
HOLMES, ROBERT 16 Parkwood Ave, Mill Valley, CA (415) 383-6783, 986-2733
HOLZ, WILLIAM 7630 W Norton Ave, Los Angeles, CA (213) 656-4061
HOOPER, H. LEE PO Box 517, Malibu, CA 90265 (213) 457-3363
HOUSER, DAVE 5580 La Jolla Blvd - Apt 293, La Jolla, CA (719) 755-2828

IJ

ISAACS, ROBERT 1646 Mary Ave, Sunnyvale, CA (408) 245-1690
JACOBS JR., LOU 296 Avenida Andorra, Cathedral City, CA (714) 324-5505
JACOBS, MICHAEL J. 7466 Beverly Blvd, Los Angeles, CA (213) 934-7863, 874-2941
JENSEN, JOHN 449 Bryant St, San Francisco, CA (415) 957-9449
JOHNSON, GEORGE, Johnson/Ulen Studio, 1640 S La Cienega Blvd, Los Angeles, CA
 (213) 858-6462
JOHNSON, LEE BAKER 1909 Pelham Ave, Los Angeles, CA (213) 670-8373, 849-6321
 Page #74682
JOHNSON, PAYNE B. 4650 Harvey Rd, San Diego, CA (714) 299-4567
JONES, DEWITT Box 116, Bolinas, CA 94924 (415) 868-0674 **P 394-395**

JORGENSEN, HANS 2402 First Ave, Seattle, WA (206) 622-4269
JOY, FRED PO Box 1681, Jackson Hole, WY 83001 (307) 733-4016, 733-3589
JUELL, TOM 1416 SE Stark, Portland, OR (206) 573-6203, (503) 231-0064

K

KAHANA, YORAM 1909 N Curson Pl, Hollywood, CA (213) 876-8208, 876-5430;
 TLX 67-33-18 KAHANASTAR LSA
KAPLAN, FRED 51 Cottonwood Dr, San Rafael, CA (415) 454-1100
KARAGEORGE, JIM 418 Precita Ave, San Francisco, CA (415) 648-3444, 821-7392
KEENAN, LARRY 7101 Saroni Dr, Oakland, CA (415) 339-9733
KEHRWALD, RICHARD J. 32 S Main, Sheridan, WY (307) 674-4679
KELLEY, TOM, Tom Kelly Studios Inc, 8525 Santa Monica Blvd, Los Angeles, CA (213) 657-1780
KELLY, JOHN P. Box 1550, Basalt, CO 81621 (303) 927-4197
KEMPER, SUSAN 3355 Skyline Blvd, Reno, NV (702) 323-7446
KERMANI, SHAHN PO Box 239, San Francisco, CA 94101 (415) 567-6073
KIMBALL, RON 2582 Sun-Mor Ave, Mountain View, CA (415) 948-2939 **P 410-411**

KIOUS, GARY 2104 Palm Ave, Manhattan Bch, CA (213) 545-3525

KIRKLAND, DOUGLAS 9060 Wonderland Park Ave, Los Angeles, CA (213) 656-8511
KON, PETER 1338 Edgemont St, San Diego, CA (714) 232-2224
KOROPP, ROBERT 901 E 17 Ave, Denver, CO (303) 830-6000 **P 376**

KRAMER, DAVID 1325 Morena Blvd, San Diego, CA (714) 265-7499
KRUPP, CARL PO Box 256, Merlin, OR 97532 (503) 479-6699
**KUHN, CHUCK 206 Third Ave S, Seattle, WA (206) 624-4706; CHIC—Bill Hults
(312) 880-5631; LA—Felice Hartenstein (213) 993-9321;
NY—Madeleine Robinson/Linda Siebert (212) 889-8127** **P 386-387**

KUHN, ROBERT 550 N Larchmont Blvd, Los Angeles, CA (213) 461-3656
KWONG, SAM 741 S La Brea Ave, Los Angeles, CA (213) 931-9393

L

LANG, ERWIN 700 Robinson Rd, Topanga, CA (213) 455-1526
LANKER, BRIAN 1993 Kimberly Dr, Eugene, OR (503) 485-0070
LAWDER, JOHN 2672 S Grand, Santa Ana, CA (714) 557-3657, 675-9097
LE BON, LEO, Mountain Travel Photo, 1398 Solano Ave, Albany, CA (415) 527-8100
LEE, C. ROBERT PO Box 897, Idyllwild, CA 92349 (714) 659-3325
LEE, LARRY PO Box 4688, N Hollywood, CA 91607 (213) 766-2677, (805) 259-1226 P 428

LEGNAME, RUDOLPH 389 Clementina St, San Francisco, CA (415) 777-9569
LEONELLI, ELISA 2033 N Beachwood Dr, Hollywood, CA (213) 466-0231
LEVIN, BARRY 23588 Connecticut St - Apt 5, Hayward, CA (415) 887-2040
LEWINE, ROB 8929 Holly Pl, Los Angeles, CA (213) 654-0830
LINDEN, SEYMOUR 1818 Euclid Ave, San Marino, CA (213) 799-6813
LISSY, DAVE Box 11122, Aspen, CO 81612 (303) 963-1410
LONCZYNA JR., LONGIN 257R S Rio Grande St, Salt Lake City, UT (801) 355-7513, 566-3713
LONGSDORF JR., ROBERT 669 Shadow Lake Dr, Thousand Oaks, CA (805) 496-4184, 496-4685
LONGSTREET, ORMAN 6977 Sunnydell Trail, Hollywood, CA (213) 876-0736
LOWRY, ALEXANDER PO Box 1500, Santa Cruz, CA 95061 (408) 425-8081
LYONS, MARVIN 2865 W 7 St, Los Angeles, CA (213) 650-8100

M

MADISON, DAVE 2284 Old Middlefield - Apt 8, Mountain View, CA (415) 961-6297 P 408

**MAHIEU, TED PO Box 42578, San Francisco, CA 94142-2578 (415) 641-4747;
NY—(212) 953-0303; Paris—260-30-06; Tokyo—585-2721/2** **P 388-389**

MALPHETTES, BENOIT 756 S Spring St, Los Angeles, CA (213) 629-9054
**MANGOLD, STEVE PO Box 1001, Palo Alto, CA 94302 (415) 469-9897,
(408) 378-2133** **P 419**

MARESCHAL, TOM 129 1 Ave W - Rm 202, Seattle, WA (206) 282-9478
MARRIOTT, JOHN 1271 California St - Apt 6, San Francisco, CA (415) 673-7159
MARSHUTZ, ROGER 1649 S La Cienega Blvd, Los Angeles, CA (213) 273-1610
MARTINELLI, BILL 608 S Railroad Ave, San Mateo, CA (415) 347-3589 **P 375**

**MASTERSON, EDWARD 11211 Sorrento Vly Rd - Ste S, San Diego, CA
(619) 457-3251, 455-7179** **P 404**

McAFEE, THOMAS 971 Howard St, San Francisco, CA (415) 777-1736
McALLISTER, BRUCE 701 Marion St, Denver, CO (303) 832-7496
McCRACKEN, SABRA, PO Box 2219, Fairbanks, AK 99707 (907) 479-5317
McDERMOTT, JOHN 3836 A Sacramento St, San Francisco, CA (415) 668-5622
McMAHON, DAVID 938 Bannock, Denver, CO (303) 628-8978
MEDSGER, BETTY 970 Bay St - 9, San Francisco, CA (415) 849-4445
MELICK, JORDAN 7925 E Harvard - Studio D, Denver, CO (303) 750-4575
MENZEL, PETER J. 136 N Deer Run Lane, Napa, CA (707) 255-3528
MENZIE, W. GORDON 2311 Kettner Blvd, San Diego, CA (714)234-4431, 2
MESSINEO, JOHN PO Box 1636, Ft. Collins, CO 80522 (303) 482-9349
MILLER, EDWARD L. 705 32 Ave, San Francisco, CA (415) 221-5687
MILLER, JIM 1122 N Citrus Ave, Los Angeles, CA (213) 466-9515
MILLER, PETER R. 1827 S Barrington, Los Angeles, CA (213) 474-5887
MILLER, WILLIAM 1411 Calistoga Ave, Napa, CA (707) 226-8415
MILMOE, JAMES O. 14900 Cactus Cir, Golden, CO (303) 279-4364
**MILNE, ROBERT 2717 Western Ave, Seattle, WA (206) 682-6828;
Rep—Susan Trimpe (206) 382-1100** **P 416**

**MITCHELL, DAVID P. 564 Deodar Lane, Bradbury, CA (213) 358-3328; NY—Ron Basile
(212) 244-5511; Stock—NY (212) 244-5511; Tokyo—585-2721/2** **P 370-371**

MITCHELL, MARGARETTA 280 Hillcrest Rd, Berkeley, CA (415) 655-4920
MOCK, WANDA Box 496, Absarokee, MT 59001 (406) 328-2637
MOLDVAY, ALBERT 1380 Morningside Way, Venice, CA (213) 392-6537
MONLEY, DAVID 940 McKendrie St, San Jose, CA (408) 247-7220
MORFIT, MASON 897 Independence Ave - 5D, Mt View, CA (415) 969-2209 **P 424-425**

MUCKLEY, MIKE 3731 Sixth Ave, San Diego, CA (619) 297-0271
MUENCH, DAVID Box 30500, Santa Barbara, CA 93105 (805) 967-4488 **P 405**

MULLENSKY, STEVEN Box 2199, La Jolla, CA 92038 (714) 454-4331
MULLIGAN, FRANK 7898 Ostrow St - Ste G, San Diego, CA (714) 569-8391
MURPHY, SUZANNE 2442 3 St, Santa Monica, CA (213) 399-6652
MURPHY, WILLIAM 7771 Melrose Ave, Los Angeles, CA (213) 651-4800
MURRAY, TOM 1896 Rising Glen Rd, Los Angeles, CA (213) 654-0364;
 Rep—Neal Pavolvsky (213) 650-6529 **P 418**

MURRAY III, WILLIAM J. 1507 Belmont Ave, Seattle, WA (206) 322-3377
MYERS, TOM 1737 Markham Way, Sacramento, CA (916) 443-8886, 445-7442

N

NANCE, ANCIL 9217 N Hudson, Portland, OR (503) 286-0941
NEBBIA, THOMAS 911 9 St - 202, Santa Monica, CA (213) 395-5679
NORMARK, DON 1622 Taylor Ave - N, Seattle, WA (206) 284-9393
O'BRIEN, GEORGE 1515 Merced St, Fresno, CA (209) 226-4000
O'NEAL, JANE 206 S Orange Dr, Los Angeles, CA (213) 931-3527
OPPPENHEIMER, KENT 1344 Devlin Dr, Los Angeles, CA (213) 652-3923
O'REAR, CHUCK Box 361, St Helena, CA 94574 (707) 963-2663, (213) 478-3655
OSBORNE, JAN 460 NE 70, Seattle, WA (206) 524-5220
OSWALD, JANET 1125 York St, Denver, CO (303) 321-7023

P

PAGOS, TERRY 3622 Albion Pl N, Seattle, WA (206) 633-4616
PAINTER, CHARLES 2513 Devri Court, Mountain View, CA (415) 968-7467
PATTERSON, MARION PO Box 842, Menlo Park, CA 94025 (415) 323-3482
PAVLOFF, NICK PO Box 2339, San Francisco, CA 94126 (415) 989-2664
PEARSON, CHARLES R. PO Box 350, Leavenworth, WA 98826 (509) 548-7983, 763-3333
PEEBLES, DOUGLAS 1100 Alakea St - 221, Honolulu, HI (808) 533-6686
PEREGRINE, PAUL 1541 Platte St, Denver, CO (303) 455-6944 **P 385**

PESIN, HARRY PO Box 350 Rancho Sante Fe, CA 92067 (714) 756-2101
PETERSON, RAGNAR M. 1467 Laurelwood Rd, Santa Clara, CA (408) 748-9049
PETERSON, ROBERT 1220 42 Ave E, Seattle, WA (206) 329-2299
PFLEGER, MICKEY PO Box 22457, San Francisco, CA 94122 (415) 355-1772
PHEIFFER, VIRGINIA PO Box 1806, Big Bear Lk, CA 92315
PITNER, MIRKO 243 Acalanes Dr - 11, Sunnyvale, CA
PHILLIPS, RON 6500 Stapleton Dr S, Denver, CO (303) 321-6777
PHOTOGRAPHERS/ASPEN, Paul Chesley, Nicholas Devore III,
 David Hiser, 1280 Ute Ave, Aspen, CO (303) 925-2317 **P 409**

PIDOT, RONALD 4455 4 St, Riverside, CA (714) 683-1002
PILDAS, AVE 1231 Ozeta Ter, Los Angeles, CA (213) 275-2353, 731-8074
PITCAIRN, ALAN 2538 Cam La Paz, La Jolla, CA (714) 571-0509, 454-7726
PORTER, JAMES 3955 Birch St - Unit F, Newport Beach, CA (714) 751-7231
POWERS, MEAD 4557 50 SW, Seattle, WA (206) 938-1198
PREUSS, KAREN 369 11 Ave, San Francisco, CA (415) 752-7545

R

RAFKIND, ANDREW 200 N 3 St - Ste 2, Boise, ID (208) 344-9918
RANDLETT, MARY PO Box 10536, Bainbridge Is, WA 98110 (206) 842-3935
RESSMEYER, ROGER 1230 Grant Ave - Apt 574, San Francisco, CA (415) 956-1205
RITTS, HERB 7927 Hillside Ave, Los Angeles, CA (213) 876-6366, (212) 888-7278
ROBERTS, DIANNE 6041 Beach Dr SW, Seattle, WA (206) 937-3279
ROBERTS, TONY 2867 Sacramento St, San Francisco, CA (415) 922-9547
ROGERS, KEN PO Box 3187, Beverly Hills, CA 90212 (213) 553-5532 **P 398-399**

ROKEACH, BARRIE 32 Windsor, Kensington, CA (415) 527-5376
RORKE, LORRAINE 146 Shrader St, San Francisco, CA (415) 386-2121
ROSENBERG, DAVE 16 W 13 Ave, Denver, CO (303) 893-0893 **P 372-373**

ROUSE, VICTORIA 4411 Geary Blvd - Ste 244, San Francisco, CA (415) 621-5660
ROWAN, ROB 209 Los Banos Ave, Walnut Creek, CA (415) 284-4910
ROWAN, RICHARD 805 Madison St, Monterey, CA
RUGGLES, JOAN 1950 N Alexandria Ave - Apt 1, Los Angeles, CA (213) 668-2261
RUNYON, PETER F. Box 1441, Vail, CO 81657 (303) 476-3142
RUSSELL, GENE 6992 El Camino Real - Ste 104-442, Carlsbad, CA (619) 436-4873
RYCHETNIK, JOSEPH S. 184 Palm Ave - Ste 106, Marina, CA (408) 384-3501

S

SABLOFF, STEVEN 7860 Fareholm Dr, Los Angeles, CA (213) 876-6507
SADLON, JIM 352 6 St, San Francisco, CA (415) 863-9300
SAGARA, PETER, Photog Inc, 736 N Labrea Ave, Los Angeles, CA (213) 933-7531
ST. JOHN, CHARLES Box 6580, Denver, CO 80206 (303) 393-6930
SANDERS, MARILYN 1420 Camden Ave - Apt 10, Los Angeles, CA (213) 828-3445
SANDLER, ROGER 1601 N Beverly Dr, Beverly Hills, CA (213) 275-9837
SANFORD, RON 599 Oregon St, Gridley, CA (916) 846-4544
SAVIERS, TRENT 1120 Huffaker Lane E, Reno, NV (702) 851-0514
SCHERER, WILLIAM PO Box 274, Greeley, CO 80632 (303) 353-6674
SCHERL, RON 218 Union St, San Francisco, CA (415) 421-1160
SCHILLER, LAWRENCE PO Box 5345, Beverly Hills, CA 90210 (213) 462-2284
SCHNEIDER, CHARLES R. 72 Half Moon Bend, Coronado, CA (714) 429-3897, 298-3114
SCHNEIDER, IRIS 3226½ Rowena Ave, Los Angeles, CA (213) 661-4254
SCHROEDER, ROXANNE 1665 Maurice La, San Jose, CA (408) 257-1940
SCHWARTZ, GEORGE J. Box 413 Bend, OR 97701 (503) 389-4062
SELIG, JONATHAN 3112 Barrington Ave, Los Angeles, CA (213) 827-4911
SHOLIK, STAN 15455 E Red Hill Ave, Tustin, CA (714) 731-7826 **P 392**

SHUMAN, KAI 738 Santa Fe Dr, Denver, CO (303) 595-0990
SHUMAN, RONALD 1 Menlo Pl, Berkeley, CA (415) 527-7241
SHUPER, PHIL & KAY 6084 W Pico Blvd, Los Angeles, CA (213) 852-0075 **P 382-383**

SIEVERT, JON 2421 Cabrillo St, San Francisco, CA (415) 751-2369
SILVA, KEITH 771 Clementina, San Francisco, CA (415) 863-5655
SLATTERY, CHAD 11627 Ayres, Los Angeles, CA (213) 477-0734
SLAUGHTER, MICHAEL 2867½ W 7 St - Studio A, Los Angeles, CA (213) 388-3361
SLAUGHTER, PAUL D. 14002 Palawan Dr, Marina Del Rey, CA (213) 822-2881
SMITH, ELLIOTT V. PO Box 5268, Berkeley, CA 94705 (415) 654-9235
SMITH, GRAFTON Box 3212, Aspen, CO 81611 (303) 925-7120
SMITH, ROBERT G. 2020 Alameda Padre Serra, Santa Barbara, CA (805) 969-2291
SODERBERG, BILL PO Box 547, Bonita, CA 02002 (714) 425-1741
SOKOL, HOWARD 3006 Zuni, Denver, CO (303) 433-3353
SOLLECITO, ANTHONY 1120 B W Evelyn Ave, Sunnyvale, CA (408) 773-8118
SPRINGMANN, CHRIS Box 745, Point Reyes Sta, CA 94956 (415) 663-8428
STAVER, BARRY 5122 S Iris Way, Littleton, CO (303) 973-4414
STEINBERG, MIKE 715 S Coast Hwy, Laguna Bch, CA (714) 494-2888 **P 377**

STEVENS, KEN 909 Yale Ave, Modesto, CA (209) 523-5887
STINSON, JOHN 376 W 14 St, San Pedro, CA (213) 548-5387
STOAKS, CHARLES 4811 NE 22, Portland, OR (503) 288-7993
STOTT, BARRY, Stott Shot, Box 1550, Vail, CO 81657 (303) 476-3334
STOY, WERNER 206 Koula St, Honolulu, HI (808) 536-2302, CABLE: CAMHAWAII
STRAUSS, RICK 1319 Harvard St, Santa Monica, CA (213) 453-2879
STREANO, VINCE PO Box 662, Laguna Beach, CA 92652 (714) 497-1908
STREET, CARL 24301 Southland Dr - Apt 216, Hayward, CA (415) 782-8250
STRESHINSKY, TED PO Box 674, Berkeley, CA (415) 526-1976
STRICK, DAVID 3865 Beethoven St, Los Angeles, CA (213) 397-0147
STRICKLAND, STEVE Box 3486, San Bernardino, CA 92413 (714) 883-4792;
Stock—(213) 852-0481 **P 384**

STRYKER, RAY 85 S Washington - Ste 314, Seattle, WA (206) 628-0218
SULLIVAN, JEREMIAH 1105 Sunset Cliffs Blvd, San Diego, CA (714) 224-0070
SUND, HARALD 6330 39 Ave SW, Seattle, WA (206) 932-1120
SUPER, ROB 933 Hilldale Ave, Berkeley, CA (415) 525-4855

SURBER, BRUCE 13622 NE 20 Bldg E - Ste D, Bellevue, WA (206) 641-6003
SUTTON, DAVID 11502 Dona Teresa Dr, Studio City, CA (213) 654-7979
SWARTHOUT, WALTER 370 4 St, San Francisco, CA (415) 543-2525
SYMES, DOUGLAS 487 Mississippi St, San Francisco, CA (415) 821-0996

T

TAGGART, FRITZ 1117 N Wilcox Pl, Los Angeles, CA (213) 469-8227, 664-6215
TERREBONNE, WAYNE 4015 Osage St, Denver, CO (303) 458-1590
THOMPSON, JOHN PO Box 422, Malibu, CA 90265 (213) 457-3621
THOMPSON, TIM D. PO Box 10221, Bainbridge Is, WA 98110 (206) 842-8245
THOMPSON, WESLEY 3316 53 St, San Diego, CA (714) 582-0812
THORNTON, TYLER 4706 Oakwood Ave, Los Angeles, CA (213) 465-0420
THUMHART, FRED 413 S Humboldt, Denver, CO (303) 777-8572
TILGER, STEWART 71 Columbia - Rm 206, Seattle, WA (206) 682-7818　　　**P 420**

TISE, DAVID 975 Folsom, San Francisco, CA (415) 777-0669
TITCHEN, JOHN 3874 Leahi Ave, Honolulu, HI (808) 992-1030
TOLBERT, RICHARD 127 W Broadway - 148, Anaheim, CA (714) 533-0333
TRAINOR, TED G. 1600 Broadway - 540, Denver, CO (303) 831-1113
TREGEAGLE, STEVEN 2994 C Richards St, Salt Lake City, UT (801) 484-1673
TRINDL, GENE 3950 Vantage Ave, Studio City, CA (213) 877-4848, 761-5030
TURNER, JOHN TERENCE 173 37 Ave E, Seattle, WA (206) 325-9073
TURNER, RICHARD P. PO Box 64205 Rancho Park Sta, Los Angeles, CA 90064 (213) 279-2645
TUTTLE, TOM 701 Welch Rd - 1119, Palo Alto, CA

V

VANDENBERG, GREGORY 1901 E 47 Ave, Denver, CO (303) 534-3434
VARIE, BILL 2210 Wilshire Blvd - 505, Santa Monica, CA (213) 395-9337
VEREEN, JACKSON 301 8 St - 211, San Francisco, CA (415) 552-7546
VICTOR, MEL 8221 Via Mallorca, La Jolla, CA (714) 455-7565
VIG, JILL Box 2945, Vail, CO 81657 (303) 476-0764
VIGNES, MICHELLE 654 28 St, San Francisco, CA (415) 285-0910

W

WAPINSKI, DAVID 92-972-13 Panama St, Makakilo, HI 96706 (808) 672-3855
WARREN, CAMERON A. 3355 Skyline Blvd, Reno, NV (702) 323-7446
WATSON, ALAN Box 3399, San Diego, CA 92103 (619) 239-5555, 281-0239
WECKLER, CHARLES PO Box 334, Anahola Kauai, HI 96703 (808) 822-3184
WEINER, STUART Box 405 Los Alamitos, CA 90720 (714) 554-0216
WERNER, JEFFERY 14002 Palawan Way, Marina Del Rey, CA (213) 821-2384
WHEELER, GEOFFREY 1827½ Pearl St, Boulder, CO (303) 449-2137
WHEELER, NICK 7444 Woodrow Wilson Dr, Los Angeles, CA (213) 850-0234
WHITE, CHARLES WILLIAM 11543 Hesby St, N Hollywood, CA (213) 985-3539
WHITLEY, DIANNA 8601 Appian Way, Los Angeles, CA (213) 656-2042
WHITMORE, KEN PO Box 49373, Los Angeles, CA 90049 (213) 472-4337;
　　NY— Joan Kramer (212) 224-1758　　　**P 369**

WILDER, MANI 3105 Nichols Canyon Rd, Los Angeles, CA (213) 874-2824
WILDSCHUT, SJEF 2311 NW Johnson, Portland, OR (503) 223-1089　　　**P 426-427**

WILKINGS, STEVE Box 22810, Honolulu, HI 96822 (808) 732-6288
WILSON, BURTON 3463 State St - 177, Santa Barbara, CA (805) 687-4408
WILSON, DOUGLAS M. 10133 NE 113 Pl, Kirkland, WA (206) 822-8604
WINDHAM, DALE 132 N 132, Seattle, WA (206) 367-0522
WOLEBEN, ARTHUR 1104 Ka Dr, Kula, HI (808) 878-1252
WOLF, MARVIN J. 1819 Alsuna, Huntington Bch, CA (714) 536-0435
WOLFORD, BUD 19132 Shoreline Ln, Huntington Bch, CA (714) 847-2220
WOLMAN, BARON PO Box 1000, Mill Valley, CA (415) 388-0181, 383-0202
WOOD, FRED PO Box 124, Livermore, CA 94550 (415) 933-8268

YZ

YOUNG, EDWARD 9 Decatur St, San Francisco, CA (415) 864-2448;
　　NY—Joan Kramer (212) 224-1758　　　**P 397**

YOUNGBLUT, JOHN 2336 Pearl St, Boulder, CA (303) 440-4545
ZIMBEROFF, TOM % Leanee & Kastner, 9401 Wilshire Blvd - 610 Beverly Hills, CA
　　(213) 271-5900, (212) 799-9570
ZIMMERMAN, J. G. 9135 Hazen Dr, Beverly Hills, CA (213) 972-0357
ZUREK, NOKOLAY 276 Shipley St, San Francisco, CA (415) 777-9210, 527-6827

ASSOCIATE MEMBERS WEST/NORTHWEST

A

ACHESON, WILLIAM 3246 Ettie St, Oakland, CA (415) 655-4583
ARENA, MICHAEL 2424 Oak St., Santa Monica, CA (213) 450-3699
ASHBAUGH, ROBERT 3216 - 46 SW, Seattle, WA (206) 932-7563
AUDA, WILLIAM 1313 Mt. Vernon Dr, Modesto, CA (209) 526-8533

B

BALOG, JAMES 2030 Quitman St, Denver, CO (303) 477-6156
BARE, JOHN 3001 Red Hill Ave - Ste 4102, Costa Mesa, CA (714) 979-8712
BATOR, JOSEPH 2011 Washington Ave, Golden CO (303) 279-5163
BERNITT, MARY KAY 307 Third Ave S, Seattle, WA (206) 382-1104
BIANCALANA, GARY 405 Studio Circle-I, San Mateo, CA (415) 579-2960
BLACK, NOEL PO Box 715, Kealakekua, HI 96750 (808) 332-3672
BLINDHEIM, DALE 10224 Fischer Pl NE, Seattle, WA (206) 322-3377
BOURDET, AL PO Box 2381, Olympic Valley, CA 95730 (961) 583-2959
BRUN, KIM 7842 Convoy Ct, San Diego, CA (619) 569-1690
BUCKMAN, ROLLIN 14285 Saratoga Ave, Saratoga, CA (408) 867-9203
BURGGRAF, CHUCK 2009 E 17 Ave, Denver, CO (303) 377-9145
BURNSIDE, MARK 116 S 9 St, Tacoma, WA (206) 272-1999

C

CARPENTER, MERT 21705 Virdelle, Los Gatos, CA (408) 370-1663
CHANEY, BRAD 370 4 St, San Francisco, CA (415) 543-2525
CHUNG, KEN-LEI 5216 Venice Blvd, Los Angeles, CA (213) 938-9117
CLARK, RICHARD 334 S La Brea, Los Angeles, CA (213) 933-7407
CLEMENT, JOHN 313 Bernard, Richland, WA (509) 943-9915
CLISE, ERIC Rt 1 Box 260, Vashon, WA 98070 (206) 567-4992
COATSWORTH, JOSEPHINE 5908 Ivanhoe Rd, Oakland, CA (415) 653-5852
COLLINS, III, ROBERT 12625 SW Hall Blvd - 16, Tigard, OR (503) 639-0290
COMPTON, JASONA 4411 Geary Blvd - Apt 202, San Francisco, CA
COOK, KATHLEEN Box 2159, Laguna Hills, CA 92653 (602) 254-3714
COOKE, GEORGE B. 124 W Broadway, Box C, Butte, MT 59701 (406) 723-5486
COWIN, MORGAN 252 Caselli Ave, San Francisco, CA (415) 431-0203
CUMMING, IAN 1919 San Diego Ave, San Diego, CA (619) 299-3419
CURTIS, JOHN 6618 SW 177 Pl, Beaverton, OR (503) 642-5535

D

DAVIS, DAVID 1058 Doverfield Ave, Hacienda Hts, CA (213) 330-3676
DELIKAT, DONNA 8069 Caminito Gianna, La Jolla, CA (714) 455-8775
DOBROWNER, MITCHELL 11154 Blix St, N Hollywood, CA (213) 985-7150
DORAN, DENNIS Box 4033 - Pioneer Sq, Seattle, WA 98104 (206) 621-8840
DRESSLER, TIM 11559 Kling, N Hollywood, CA (213) 769-2696
DU MAS, DONALD, Du Mas Prod Service, 1247 First Ave S, Seattle, WA (206) 624-9827

EF

EPSTEIN, MIKE PO Box 6753, Bend, OR 97701 (503) 382-7370
FAHEY, DIANE D 3732 Scottsdale D., Irvine, CA (714) 552-5068
FELD, DANNY 2127½ S Beverly Glen, Los Angeles, CA (213) 474-4255
FERGUSON, MYRLEEN PO Box 11079, Eugene, OR 97440 (503) 343-9017
FORTIN, ALFRED 2247 Auli St, Honolulu, HI (808) 595-7682
FRANK, LAURENCE 1516 E Broadway - Apt 15, Glendale, CA (213) 242-7835
FRAZIER, KIM 23964 Madeiros, Hayward, CA (415) 889-7050
FRITZ, MICHAEL 3234 Ibis St, San Diego, CA (619) 295-7629

G

GALBRAITH, TOM 3328 Mohican Ave, San Diego, CA
GEISSLER, RICHARD 1729 Vista Del Valle, El Cajon, CA (714) 440-5594
GILMAN, TERI 23314 Welby Way, Canoga Park, CA (213) 705-5672
GLUCKSTEIN, DANA 1455 Greenwich - 7, San Francisco, CA (415) 775-8464
GOLDEN, RENATA 1813 N Laurie, Phoenix, AZ (602) 257-4575
GOLDMAN, LAWRENCE 13900 Fiji Way - 113, Marina Del Rey, CA (213) 306-0981
GOODE, JOHN W. PO Box 99402, San Diego, CA 92109 (619) 272-0213
GOODMAN, MICHAEL PO Box 1256, La Jolla, CA 92038 (714) 222-0884

GORDON, HOWARD 2733 Belmont Canyon Rd, Belmont, CA (415) 592-7585
GRAHAM, KEN Box 272, Girwood, AK 99587 (907) 783-2796
GRANT, KEN 893 Cayo Grande Ct, Newbury, CA (805) 499-1572
GREEN, WENDY 510 Third St, San Francisco, CA (415) 495-7392
GREENLEIGH, JOHN 241 Upper Terrace - I, San Francisco, CA (415) 664-1296

HI

HANDEL, WILLIAM 1121 Lincoln Ave, Palo Alto, CA (415) 324-1886
HANSHEW, JON 6147 Aspinwall Rd, Oakland, CA (415) 339-9463
HARRIS, KAY 212 S 2 - Apt 2S, El Cajon, CA (213) 447-0786
HART, VICKI 409 Bryant St, San Francisco, CA (415) 495-4278
HARTSTEIN, MARK 4210 California Ave, Long Beach, CA (213) 427-0579
HELLER, MICHAEL 1666 N Beverly Dr, Beverly Hills, CA (213) 275-4477
HENKIN-KATANO, NICOLE 36 Clyde St, San Francisco, CA (415) 495-6549
HICKS, MICK 394 Fair Oaks - 3, San Francisco, CA (415) 282-1527
HOLMES, MARILYN 8470 N Douglas Hwy, Juneau, AK (907) 586-2316
HOLOWACH, THOMAS W. 694 S Grand Ave, Pasadena, CA (213) 799-7415
HOUSKE, MARTA 3 Spur Ln, Rolling Hills, CA (213) 850-0373
IWASAKI, RICH 1835 SE 10, Portland, OR (503) 232-0673

JK

JONES, DEBORAH PO Box 77307, 460 Brannon, San Francisco, CA 94107 (415) 647-3098
JUCKES, GEOFF 3185 Durand Dr, Los Angeles, CA (213) 465-6674
KALLSTROM, OLOF 4722 Irving St, San Francisco, CA
KATZ, SUSAN 1770 Pacific Ave - 404, San Francisco, CA (415) 928-0879
KEPLER, JEAN 1302 Taylor - 10, San Francisco, CA (415) 885-6238
KLEINMAN, KATHRYN 542 Natoma, San Francisco, CA (415) 864-2406
KRAMER, ANDREW 3600 Buckeye Ct, Boulder, CO (303) 449-2280

L

LANTING, FRANS 715-A Riverside, Santa Cruz, CA (408) 429-9490
LEE, TERRY 795 Pacific Ave - 321, San Francisco, CA (415) 329-2407
LEONELLI, ELISA 2033 N Beachwood Dr, Hollywood, CA (213) 466-0231
LIDZ, JANE 345 Coleridge, Palo Alto, CA (415) 321-4727
LOGAN, WILLIAM Box 922, El Cajon, CA 92022 (714) 271-1950
LOPEZ, LITO 716 Ninth Ave, San Francisco, CA (415) 387-2181
LUNETTA, STEVEN 4369 Date Ave, La Mesa, CA (619) 698-8737

M

MacKENZIE, MARCUS 525 Victoria - 12B, Costa Mesa, CA (714) 548-5619
MALMQUIST, JOHN 360 S Euclid Ave - Apt 130, Pasadena, CA (213) 577-0999
MARON, MICHAEL 812 N Sweetzer Ave, Los Angeles, CA (213) 655-2517
MARSHALL, JIM PO Box 2421, Carefree, AZ 85377 (602) 488-3373
MARTIN, GREGORY PO Box 57276, Los Angeles, CA 90057 (213) 385-8151
McALEER, MARY 3857 Birch St - Ste 170, Newport Beach, CA (714) 833-0208
McDERMON, MARIANNE A. PO Box 2188, Napa, CA 94558 (707) 255-3344
McHUGH, KIM 1422 E 21 Ave, Denver, CO (303) 837-9198
McINTYRE, GERRY 3385 Lanatt Way - Apt B, Sacramento, CA (916) 736-2108
McMACKIN, TOM Box 33592, Seattle, WA 98133 (206) 362-5460
McWILLIAMS, SUSAN 439 N Gardner, Los Angeles, CA (213) 655-9807
MILROY, MARK 5741 Sierra Cielo, Irvine, CA (714) 833-0208, 955-0127
MONKTON, ROBERT 430 Hill St, Laguna Beach, CA (714) 494-8473
MONROE, DON 2139 Euclid Ave, Camarillo, CA (805) 897-3915
MOSKOWITZ, SHELDON 4650 Kester Ave - 228, Sherman Oaks, CA (213) 990-9267
MYERS, JEFFRY 414 Joseph Vance Bldg, Seattle, WA (206) 622-2221; 542-6222

NO

NAKAMURA, MICHAEL 114 Alaskan Way So, Seattle, WA (206) 343-5623
NICHOLS, MICHAEL 81 Caselli, San Francisco, CA
OUNJIAN, MICHAEL 612 Myers St, Burbank, CA (213) 842-0880, 763-7695
OUTWATER, ROB 848 S Detroit St, Los Angeles, CA (213) 931-9017
OWENS, BILL 268 Yosemite, Livermore, CA (415) 447-5943

PQ

PARTIPILO, JOHN W. PO Box 1509, Los Angeles, CA 90028 (213) 461-4853; Res: (213) 463-9857
PATTERSON, ROBERT 915 N Mansfield, Hollywood, CA (213) 462-4401
PEABODY, CHACE PO Box 723, Idyllwild, CA 92349
PEDRICK, FRANK PO Box 411, Pt Richmond, CA 94807 (415) 237-7259
PERRY, RALPH 2228 NW Sixth Ave, Camas, WA (206) 694-8417
PETERMANN, HERBERT 1118 Fifth St - 7, Santa Monica, CA (213) 395-7668
PICKELLS, DON 4850 Redwood Rt Rd, Gilroy, CA (408) 842-3961
POUCEL, BILL 136-B Loureyro Rd, Santa Barbara, CA (805) 969-9382
PRESTON, M. LOUISA PO Box 60, Issaquah Dock, Sausalito, CA 94965 (415) 331-3057
PRITCHETT, WILLIAM PO Box 756, Coronado, CA 92118 (619) 435-3020
PROBSTEIN, BOBBIE 1014 9 St - Apt 5, Santa Monica, CA (213) 395-0770
QUINNEY, DAVID 423 E Broadway, Salt Lake City, UT (801) 363-0434

R

RABINOWITZ, NEIL PO Box 10171, Bainbridge, WA 98110 (206) 842-8727
RAMIREZ, EFREN PO Box 6025, San Francisco, CA 94101 (415) 864-1989
RANSON, JAMES PO Box 501, Laguna Beach, CA 92652 (714) 497-2621
RICHARD, ROGER 4658 18 St, San Francisco, CA (415) 585-5501
RICKETTS, DAVE 131 15 Ave E, Seattle, WA (206) 322-1137
RIGAU, FELIX 1271 Francisco St, San Francisco, CA (415) 928-1933
RIGGS, ROBIN 3785 Cahuenga Blvd W, Studio City, CA (213) 506-7753
ROBERTSON, JOHN DAVID 183 Stenner St - Apt 6, San Luis Obispo, CA (805) 543-9532
ROMANO, CAROL 3044 Paseo Tranquillo, Santa Barbara, CA (804) 687-8458
ROSS, ALAN C. 202 Culper Crt, Hermosa Beach, CA (213) 379-2015
RUPP, JOSEPH 4608 Dayton N, Seattle, WA (206) 632-7016

S

SAEHLENOU, KEVIN 1633 York, Denver, CO (303) 322-6601
SAIKI, LOREL KEIKO 10558 Eastborne - Apt 8, Los Angeles, CA–(213) 474-1966,
 (213) 879-1800 Ext 219
SAKBODIN, SORN PO Box 99427, San Francisco, CA 94109 (415) 441-5772
SANTULLO, NANCY 7213 Santa Monica Blvd, Los Angeles, CA
SCHWABER-BARZILAY, LISA 3040 Berkeley Ave, Los Angeles, CA (213) 662-0691
SCHWARTZ, MONSERRATE PO Box 413, Bend, OR 97701 (503) 389-4062
SHUPE, JOHN R. 4090 Edgehill Dr, Ogden, UT (801) 392-2523
SIBLEY, R. SCOTT 2774 Union St - Apt I, San Francisco, CA (415) 540-7365
SIEGLE, DAVID 1142 N Seward St, Los Angeles, CA (213) 461-3300
SILVERMAN, JAY E. 1039 S Fairfax Ave, Los Angeles, CA (213) 931-1169
SIM, VERONICA 2445 E Del Mar Blvd - Apt 302, Pasadena, CA (213) 449-9286; 681-7760
SIMPSON, STEPHEN 2040 Torrey Pines Rd, La Jolla, CA (610) 454-2040
SLOBEN, MARVIN 1065 15 St, San Diego, CA (619) 239-2828
SMITH, DIANE 9373 Activity Rd, San Diego, CA (619) 271-1950
SMITH, DON 915 Yale Ave N, Seattle, WA (206) 587-3700
SPIERING, NATHAN 663 Del Parque, Santa Barbara, CA (714) 586-1313
STEINER, GLENN 147 Bellevue Ave, Day City, CA (415) 239-0242
STEWART, THOMAS 1211 SE 165, Portland, OR (503) 238-1748
STRATTON, BRITTA 4727 Meldon, Oakland, CA (415) 436-7276
STUART, JIM Rt 1 - Box 193, Burton, WA 98013 (206) 587-0588
SUTTON, JOHN 6722 Sims Dr, Oakland, CA (415) 339-0924

TU

TAPP, CARLAN 89 Yesler Way - 4 Fl, Seattle, WA (206) 621-8344
THALER, SHMUEL 927 San Andreas Rd, Watsonville, CA (408) 722-1208
THOMAS, NEIL 1441½ Formosa Ave, Los Angeles, CA (213) 851-3941
TRAVIS, THOMAS 840 S Oneida - A109, Denver, CO (303) 377-7422
TUPPER, BEN PO Box 8155, Riverside, CA 92515 (714) 789-4140
TURNER, GEORGE PO Box 204, Springs of Water, Richardson Spg, CA 95973 (916) 343-5565
TUSCHMAN, MARK 300 Santa Monica, Menlo Park, CA (415) 322-5157
UNDERWOOD, RILLA 1930 Santa Monica Rd, Carpinteria, CA (805) 684-1244

V W Y

VANCE, FRED 5701 E Glenn - 63, Tucson, AZ (602) 298-1335; (1-800) 854-2003
 Ext 1212 (Except Calif); (1-800) 522-1500 Ext 1212 (Calif)
VAN NGUYEN, TAN 7425 Convoy Ct, San Diego, CA (619) 560-0280; 298-4071
VARNEY, FRANK 2600 King St, Denver, CO (303) 458-8546
VIKANDER, BRIAN 4929 Oakwood Ave, La Canada, CA (213) 790-6188; 877-0181
WADDELL, ROBERT 3418 Fay St, Culver City, CA (213) 838-3289
WADE, BILL 5622 E 2 St, Long Beach, CA (213) 439-6826; (714) 827-8093
WARD, DAVID 1733 Adams Ave, San Diego, CA (714) 295-7516
WEISS, JOHN PETER 4771 Boise Ave, San Diego, CA (714) 273-6536
WEISSMAN, JEFF 3025 Jordan Rd, Oakland, CA (415) 482-3891
WHITE, GARY 218 North 11, Pasco, WA (509) 545-1604
WHITTAKER, STEVE 111 Glen Way - 8, Belmont, CA (415) 595-4242
WILSON, DON 503 N 61 St, Seattle, WA (206) 783-8111
WILSON, GERALD 3938 Patrick Henry, Agoura, CA (213) 991-8237
WONG, KENNETH 245 N Lake Ave, Pasadena, CA (213) 681-3873
WOUJIE 250 24 Ave, San Francisco, CA (415) 668-0146
YOUNG, EDWARD 9 Decatur St, San Francisco, CA (415) 864-2448

ASMP
Professional
Business Practices
in
Photography

1982

A Compilation by the American Society of Magazine Photographers

PROFESSIONAL BUSINESS PRACTICES IN PHOTOGRAPHY

A Compilation by the American Society of Magazine Photographers

ASMP has published a new edition of its best-selling Business Practices in Photography book containing the results of surveys conducted about stock and assignment photography for the years 1979-1981, plus a separate pull-out section of updated contract forms.

Here you will find:

- A completely new section on Stock Photography with stock rates for more than 20 fields

- A completely new section on Assignment Photography with new rates and rights for all assignment specialties

- New sets of forms and releases

- An updated section on Copyright

- An expanded section on the Photographer/ Agent relationships with the new Photographer/Stock Agency Representation Contract

- A new section on ways to settle a dispute, how to select a lawyer and ways of determining the value of a lost or damaged transparency

plus valuable information on insurance protection, the book publishing field, and cost data . . . and much, much more

A MUST for photographers and users of photography

Order today at the following prices

Since 1945, The **Joint Ethics Committee** has served the Graphics Industry by providing an alternative to litigation in the settlement of ethic disputes through peer review, mediation and arbitration.

Our five sponsors are the most respected professional organizations in the field: Society of Illustrators, Inc.; The Art Directors Club, Inc.; American Society of Magazine Photographers, Inc.; Society of Photographer and Artist Representatives, Inc.; The Graphic Artists Guild, Inc.

Selected representatives from these organizations serve as volunteers on the Committee. The services of the **JEC** are offered free of charge.

The **Joint Ethics Committee** has formulated a Code of Fair Practice which outlines the accepted ethical standards for the Graphics Industry.

To purchase the Code booklet for $2.50 or for further Information please write to:

JOINT ETHICS COMMITTEE
P.O. Box 179, Grand Central Station
New York, NY 10163.

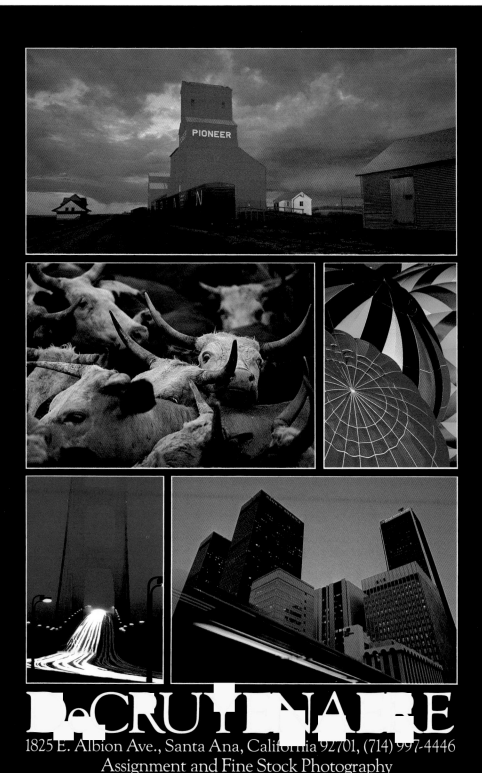

DeCRUYENAERE

1825 E. Albion Ave., Santa Ana, California 92701, (714) 997-4446
Assignment and Fine Stock Photography

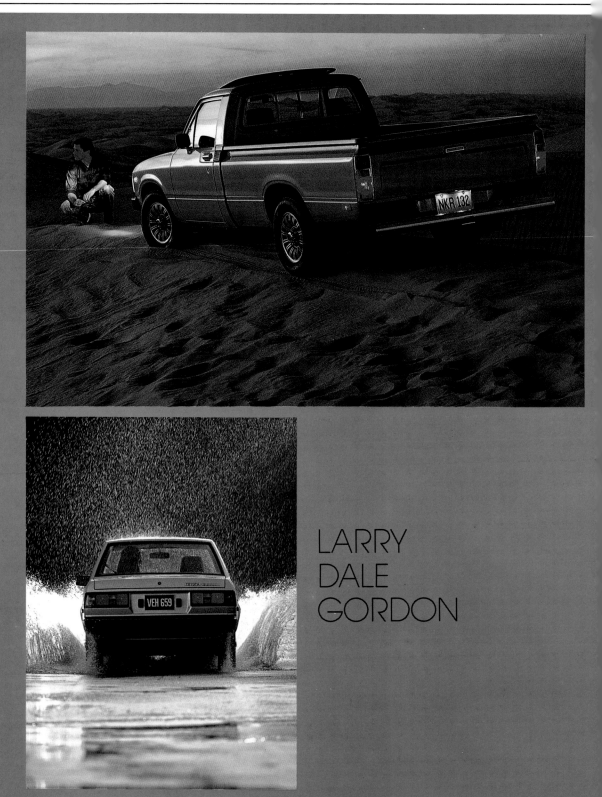



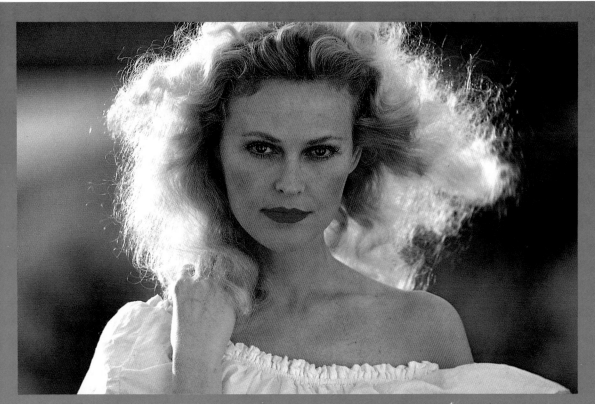

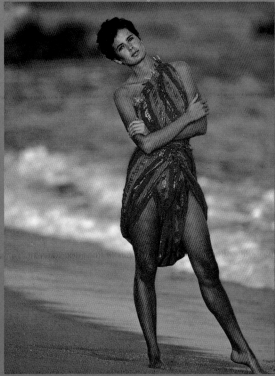

LARRY
DALE
GORDON

NEW YORK
Nob Hovde
212/753-0462

CHICAGO
Ken Feldman
312/337-0447

LOS ANGELES
Virginia Cervantes
213/551-2729

LONDON
Carolyn Trayler
01/370-4849

HAMBURG
The Picture People
40/44-26-95

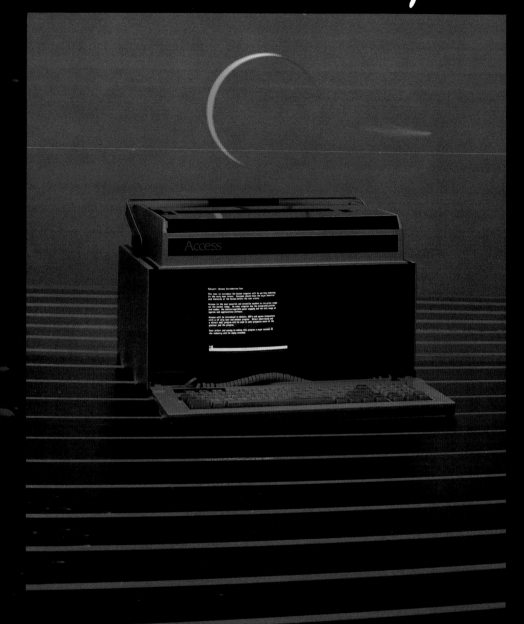

654 GILMAN STREET, PALO ALTO, CALIFORNIA 94301 (415) 324-8177
JUDSON ALLEN • PAUL FAIRCHILD

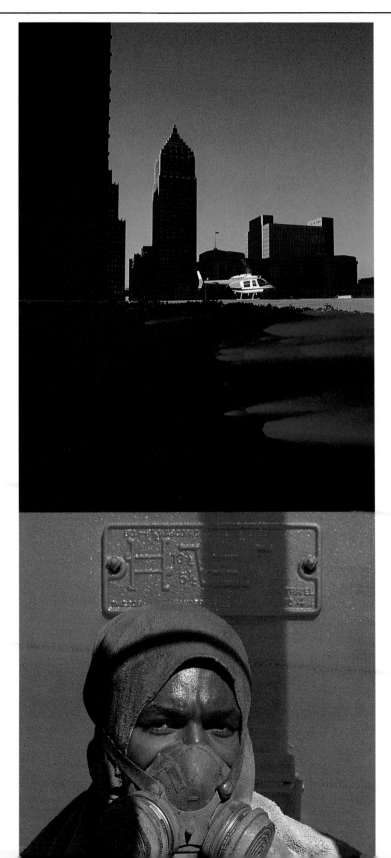

KEN WHITMORE
P.O. Box 49373
Los Angeles, California 90049
(213) 472-4337

New York Representative:
Joan Kramer
(212) 224-1758

Ken Whitmore, a specialist
in annual reports, editorial
and advertising photography
is a well seasoned traveler
and accepts assignments
throughout the world.

RECENT CLIENTS INCLUDE:

Alza Corp.
Avery International
BASF America
Baker International
Carnation
Family Circle
Fleetwood Enterprises Inc.
First Interstate Bancorp
FMC Corporation
Hughes
Lockheed Corporation
National Medical Enterprises
Science 83
The Signal Companies
Tiger International
TV Guide
The Strayton Corp
13/30 Corporation

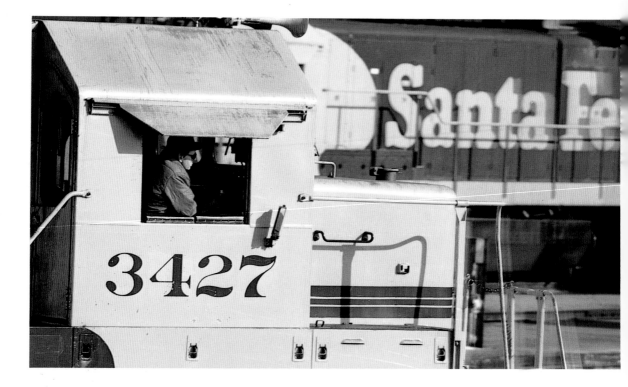

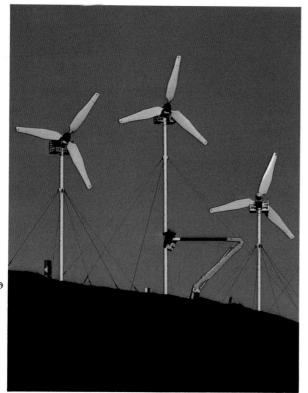

David P. Mitchell
Los Angeles
(213) 358-3328

Represented by:
Ron Basile
(212) 244-5511

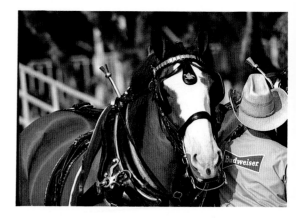

David P. Mitchell
Stock:
WORLDWIDE
PhotoUnique
New York
(212) 244-5511
JAPAN ONLY
Imperial Press
Tokyo
585-2721/2

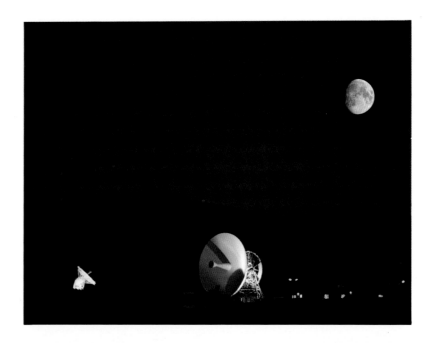

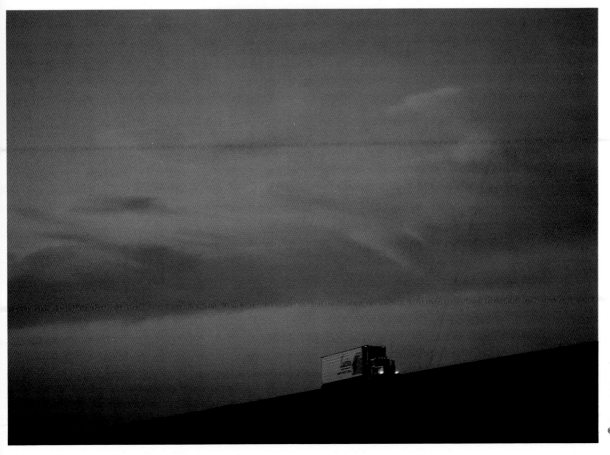

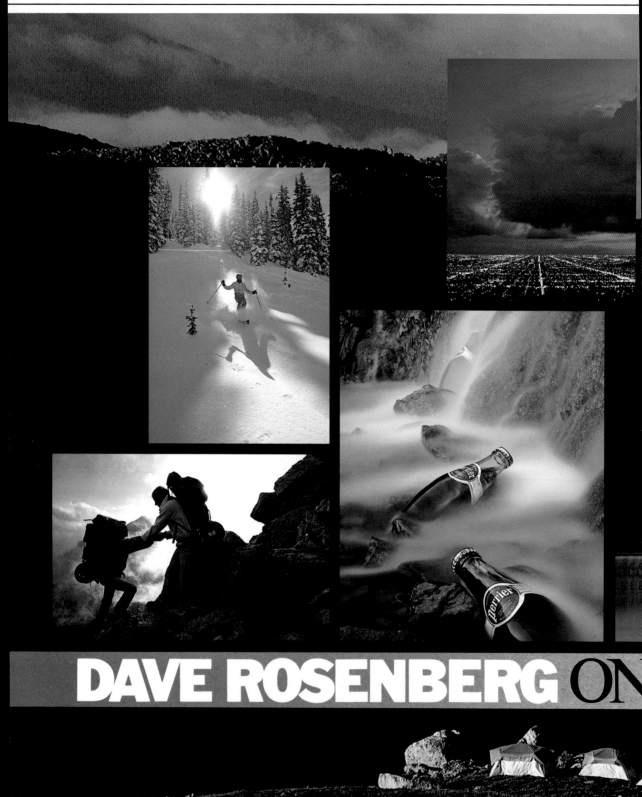

DAVE ROSENBERG ON

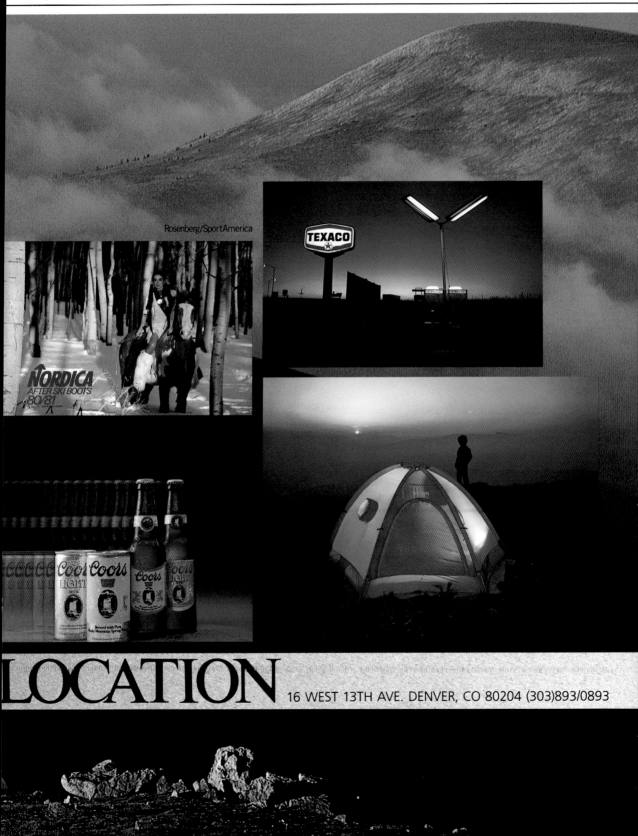

Rosenberg/SportAmerica

NORDICA
AFTER SKI BOOTS
80/81

TEXACO

LOCATION

16 WEST 13TH AVE. DENVER, CO 80204 (303)893/0893

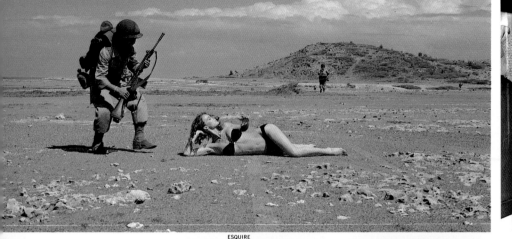

ESQUIRE

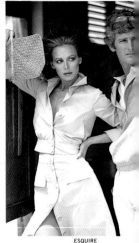

ESQUIRE

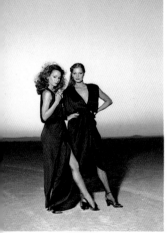

BULLOCK'S

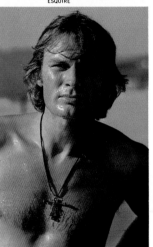

MENSWEAR

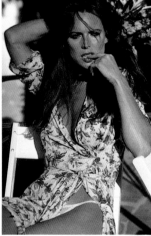

PRO ARTS

KAGAR PRODUCTIONS

SPECIALIZING IN FASHION, BEAUTY, ILLUSTRATION & PERSONALITIES.

A partial list of corporate clients include:

ABC Television; Aerobic Dancing, Inc.; Alberto-Culver; American Express; *Architectural Digest*; Avon Products; Beef Council; Bill Blass; Brittania; Donald Brooks; Pierre Cardin; Casablanca Records & Filmworks; Casual Corner; *Classic Magazine*; Conair; Cone Mills; *Cosmopolitan*; Cross Creek; Crown Publishers; Paul Davril; Dax Gentlemen's Apparel; Del Laboratories; Dino Cigars; Drackett; Dupont; East-West Network; *Esquire*; Faberge; Max Factor; Leslie Fay; *Family Circle*; Fiat; Gant Shirtmakers; Jean-Paul Germain; Gold Label Cigars; *Good Housekeeping*; Hunter Haig; *Harper's Bazaar*; Hart, Shaffner & Marx; Horchow; London Fog; Monsanto; Mr. Boston Rum; Munsingwear; *Newsweek*; Nikon; Old Gold Cigarettes; Palm Beach; Paramount Pictures; Pentax Corporation; Evan Picone; Pirelli; Ponds; Pro-Arts; Revlon; Rosanna; Saint Laurie Ltd.; Sauza Tequila; Scandecor; Simon & Schuster; Simplicity; *Ski Magazine*; Skyr/Scandia; Squib; J.P. Stevens; Truform; Giani Verasce; Egon Von Furstenberg; Warnaco; John Weitz; White Stag; Word Records; Yamaha.

A partial list of celebrity sessions:

Peter Allen, Herb Alpert, Paul Anka, Christopher Atkins, Burt Bacharach, Bjorn Borg, Donald Brooks, Kim Carnes, Chris Christian, Aldo Cipullo, Natalie Cole, The Commodores, Wilhelmina Cooper, Tony Danza, John Davidson, Mac Davis, Pam Dawber, Patrick Duffy, Robert Duvall, Jamie Farr, Farrah Fawcett, Peter Fonda, John Forsythe, Jean-Paul Germain, Vitas Gerulaitis, Frank Gifford, Alexander Godunov, Elliott Gould, Jack Hemingway, Margaux Hemingway, Reggie Jackson, Gene Kelly, Ronnie Laws, Hal Linden, Tina Louise, John McEnroe, Lee Majors, Dean Paul Martin, Johnny Mathis, Ricardo Montalban, Ilie Nastasse, Valerie Perrine, Victoria Principal, Lionel Ritchie, Kenny Rogers, Wayne Rogers, Marion Ross, John Schneider, William Shatner, Jacki Francis Watson, Tom Watson, Gene Wilder, Billy Dee Williams, Paul Williams, Natalie Wood.

8735 Washington Blvd.
Culver City, CA 90230
(213) 550-6891

Chicago Representative:
Vincent Kamin & Associates, Inc.
42 East Superior
Chicago, Illinois 60611 • (312) 787-88

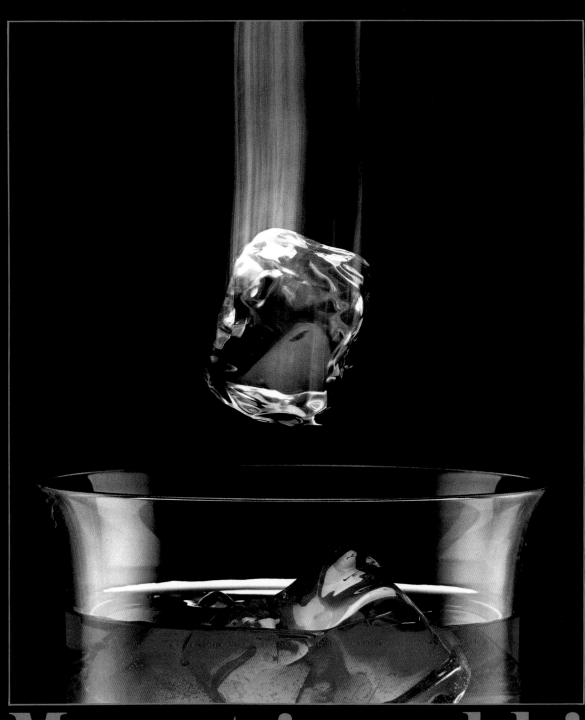

Martinelli

PHOTOGRAPHY 608 SOUTH RAILROAD AVENUE SAN MATEO CALIFORNIA 94401 415/347-3589

Imagination On Location . . .

ROBERT KOROPP

901 East 17th Avenu
Denver, CO 80218
(303) 830-6000

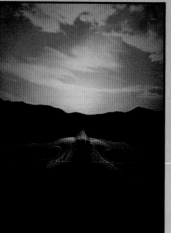
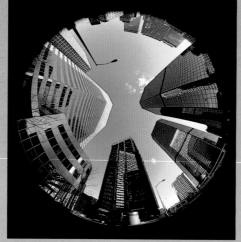
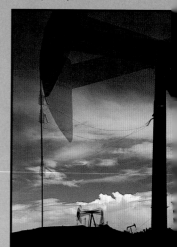

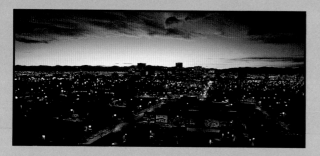
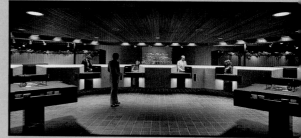

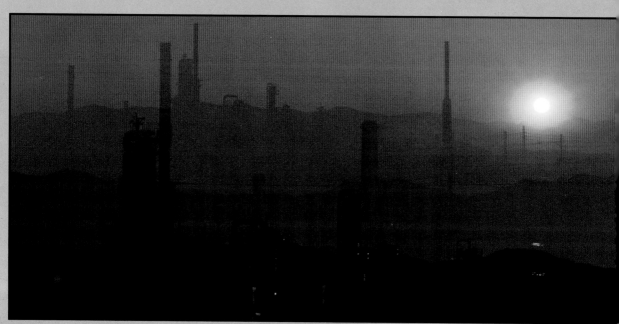

©Robert Koropp 1982

STEINBERG
corporate·commercial·industrial

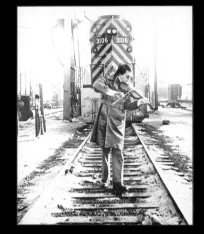

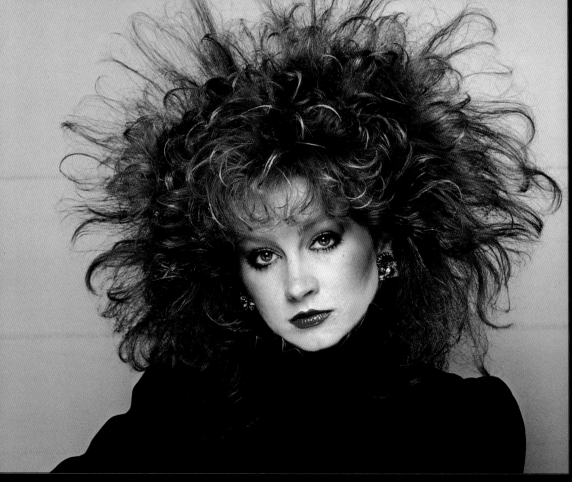

mike steinberg photography 715 so. coast highway·laguna beach·ca 92651 (714) 494·2888

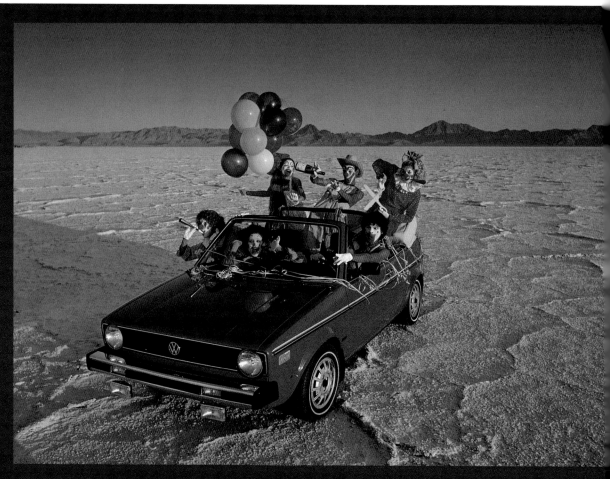

BYBEE

Los Angeles
Robin Ogden
(213) 858-0946

Utah
(801) 363-1061

THE WEST

THE
WEST

Los Angeles
Robin Ogden
(213) 858-0946

Utah
(801) 363-1061

©1983 GERALD BYBEE

BYBEE

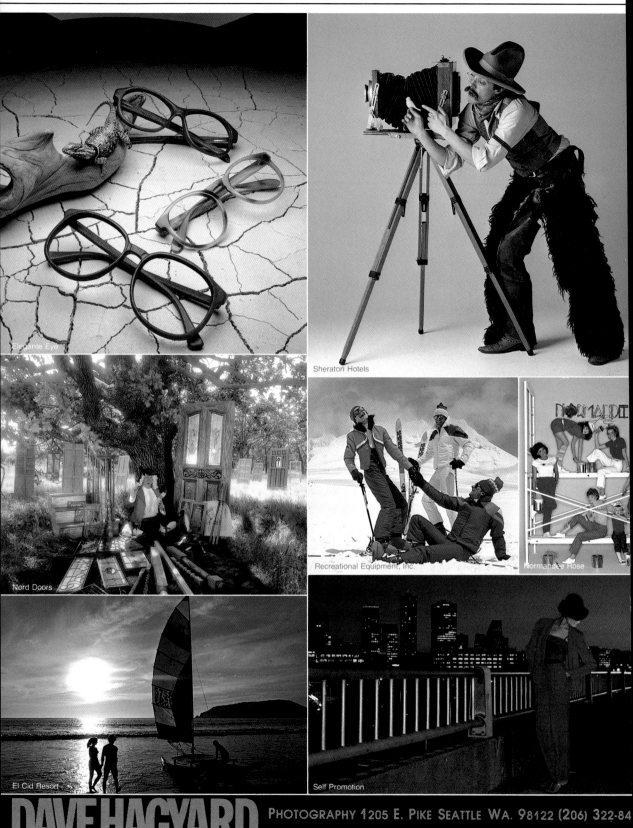

Elegante Eye

Sheraton Hotels

Nord Doors

Recreational Equipment, Inc.

Normandee Rose

El Cid Resort

Self Promotion

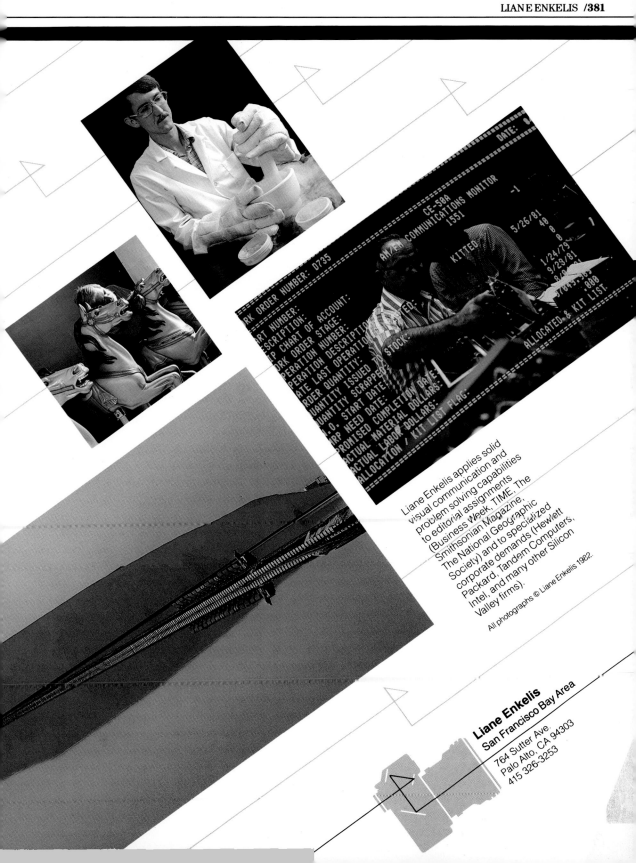

Liane Enkelis applies solid visual communication and problem solving capabilities to editorial assignments (Business Week, TIME, The Smithsonian Magazine, The National Geographic Society) and to specialized corporate demands (Hewlett Packard, Tandem Computers, Intel, and many other Silicon Valley firms).

All photographs © Liane Enkelis 1982.

Liane Enkelis
San Francisco Bay Area

764 Sutter Ave.
Palo Alto, CA 94303
415 326-3253

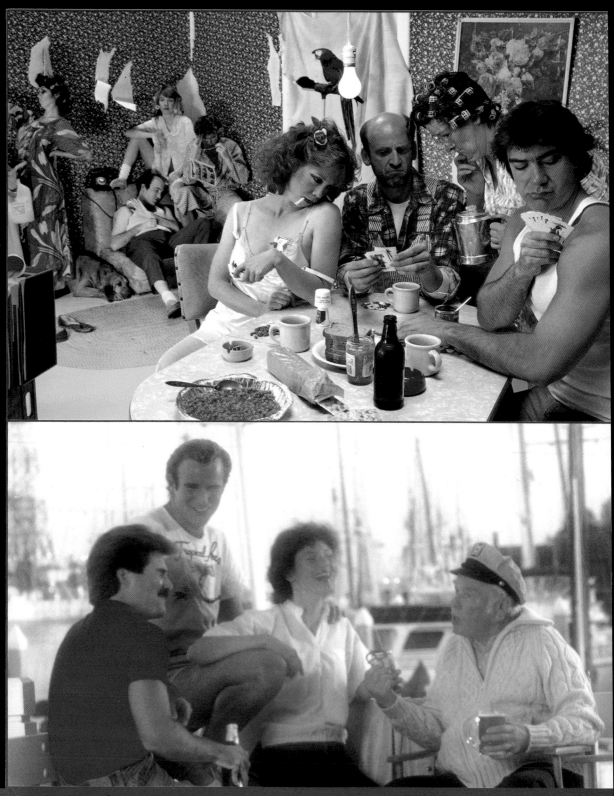

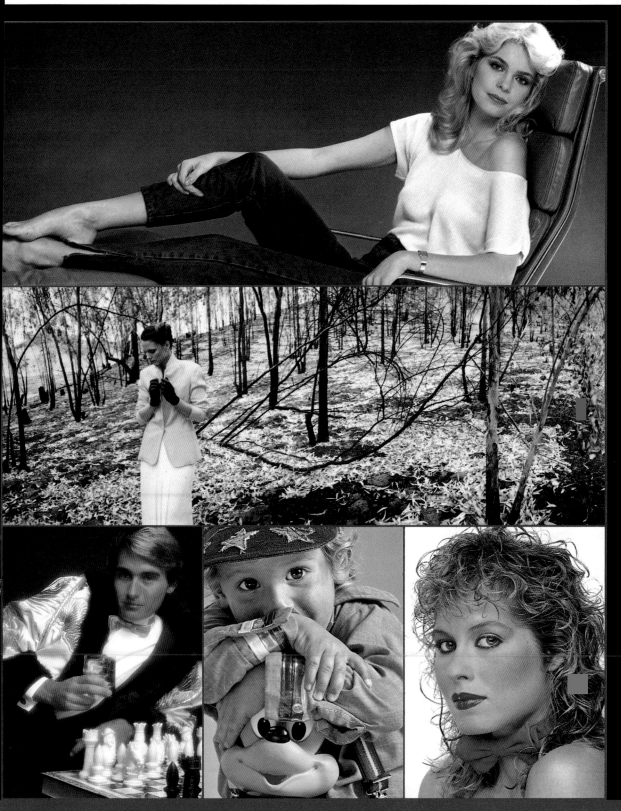

KAY SHUPER • PHOTOGRAPHER • 213 • 852-0075

Steve Strickland
Corporate-Industrial Photography
Post Office Box 3486
San Bernardino, California 92413
Telephone 714/883-4792
Stock Rep: Impact Photos 213/852-0481

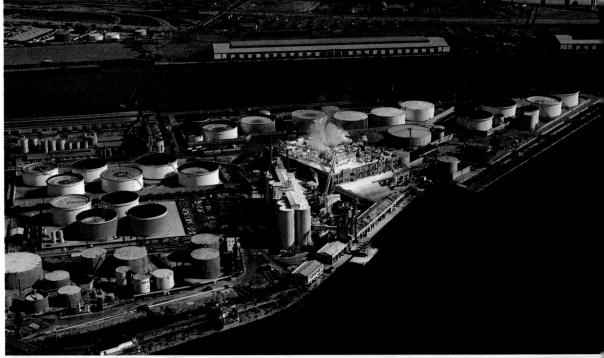

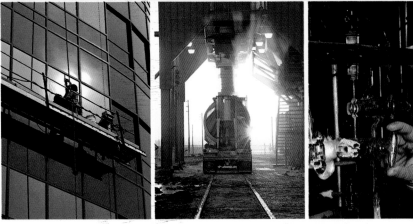

Clients
Georgia-Pacific
R.C.A.
Gifford-Hill
International Harvester
Raytheon
U.S. Borax
Calnev Pipe Line
B.F. Goodrich
Weyerhauser
Santa Fe Rail Road

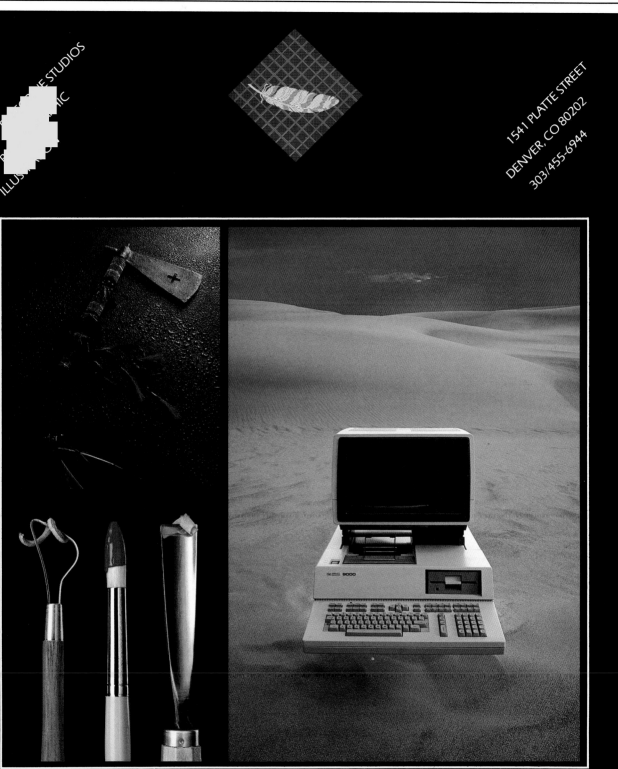

PEREGRINE

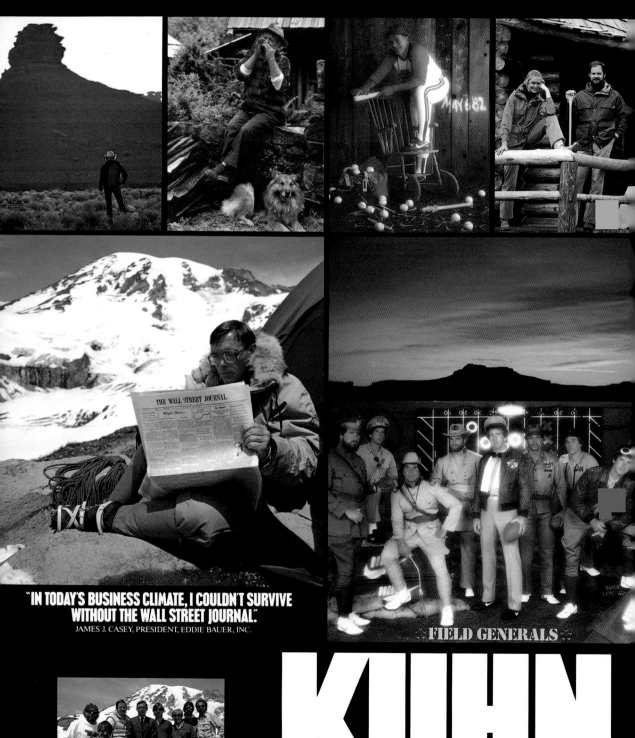

"IN TODAY'S BUSINESS CLIMATE, I COULDN'T SURVIVE WITHOUT THE WALL STREET JOURNAL."
JAMES J. CASEY, PRESIDENT, EDDIE BAUER, INC.

FIELD GENERALS

KUHN

BRAKE FOR ARTESIANS

TAKE HOME A TASTE OF WASHINGTON HOSPITALITY.

WASHINGTON'S APLETS & COTLETS.

WINDSOR

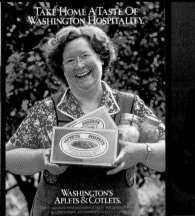

114 BARREL PROOF. SO SMOOTH, SOME PEOPLE WON'T GO ANYWHERE WITHOUT THE BARREL.

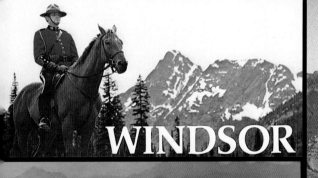

Come taste Olympia's World.

The Pacific Northwest. Olympia

Slightly more portable by the bottle.

114 OLD GRAND DAD

WEST

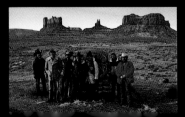

TED MAHIEU

P.O. Box 42578
San Francisco
CA 94142-2578

In San Francisco
415-641-4747

In New York
212-953-0303

In Paris
260-30-06

In Tokyo
585-2721/2

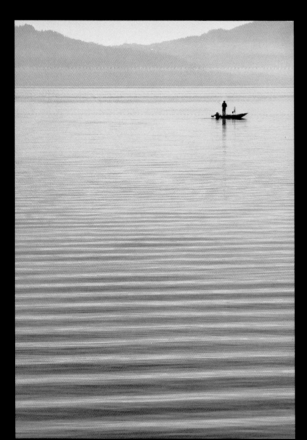

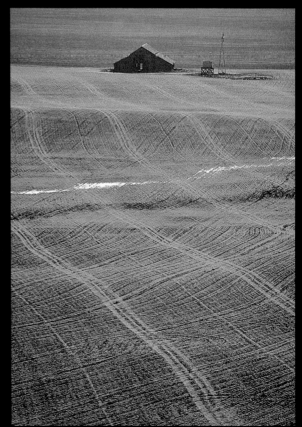

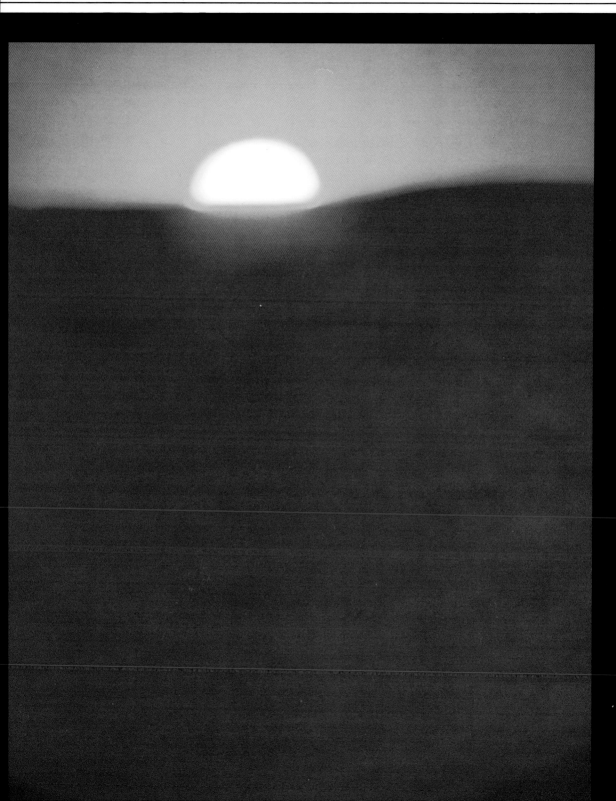

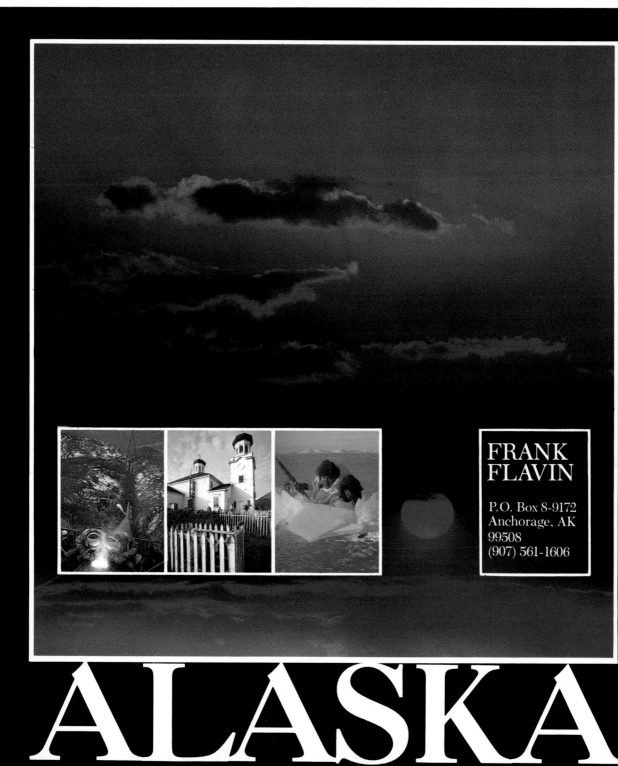

ALASKA

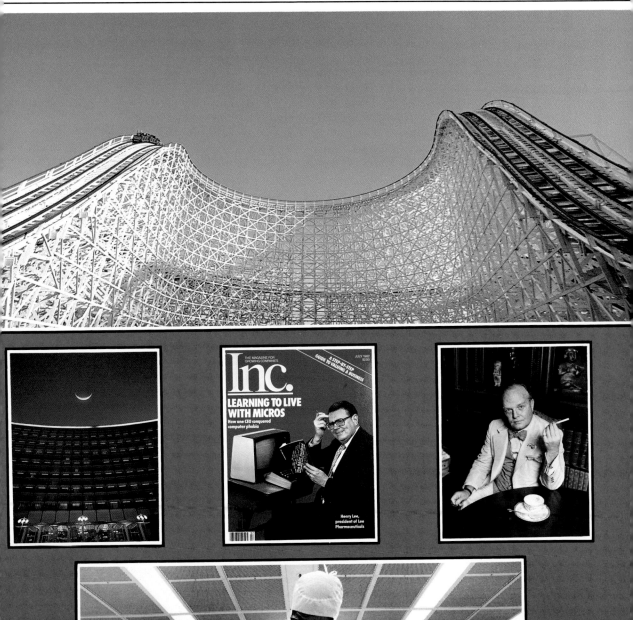

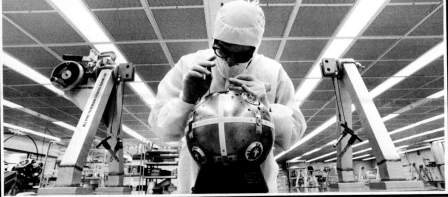

JAMES CACCAVO
4317 W. 2d. St., Los Angeles, California 90004
(213) 385-6858

© 1982

Large format Macro-Photography of small products

Specialized lighting and lenses available

for 1X to 10X magnifications in all formats

35mm through 8 x 10

Southern California Representative: MARIA PISCOPO 714/556-8133

STAN SHOLIK PHOTOGRAPHY · 15455 RED HILL AVENUE · SUITE E · TUSTIN · CA 92680 · 714/731-7826
Located within the Irvine Industrial Complex · Orange County CA

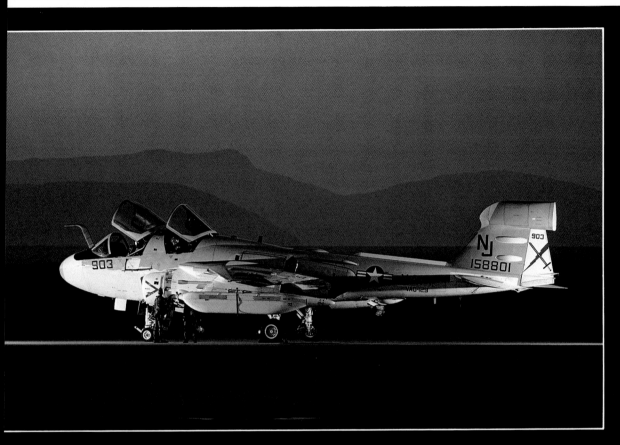

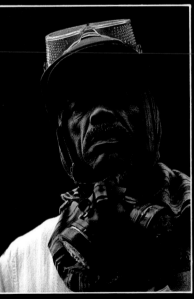

LOUIS BENCZE

1025 Southeast 17th, Portland, Oregon 97214, (503) 236-3328

Clients include Evans Products, Weyerhaeuser, Louisiana-Pacific, Georgia Pacific, Consolidated Papers, Willamette Industries, Inc., Freightliner, Raytheon, Exxon, Creamer Inc., Mobay Chemical, Chris Craft, Kenworth, Safeco Insurance, Intel, Tektronix, Peoples Bank, Crown Zellerbach.

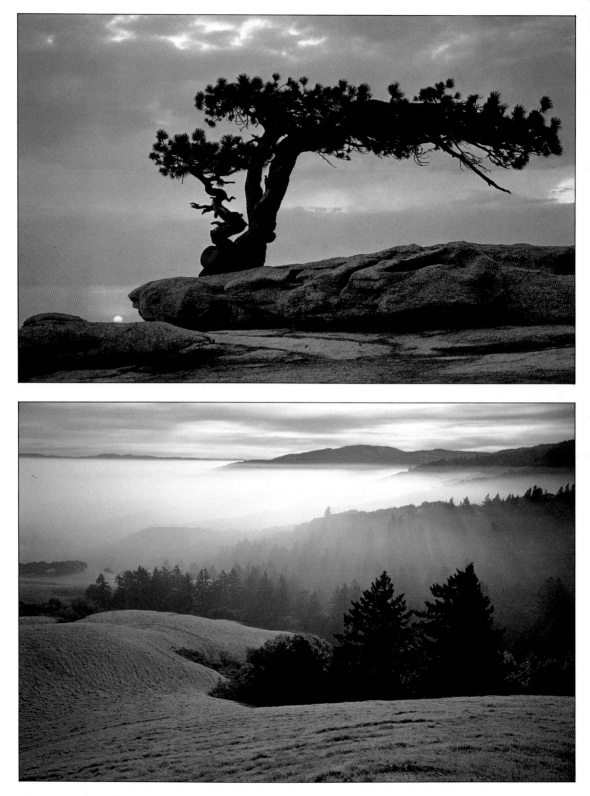

Dewitt Jones San Francisco 415 868 0674

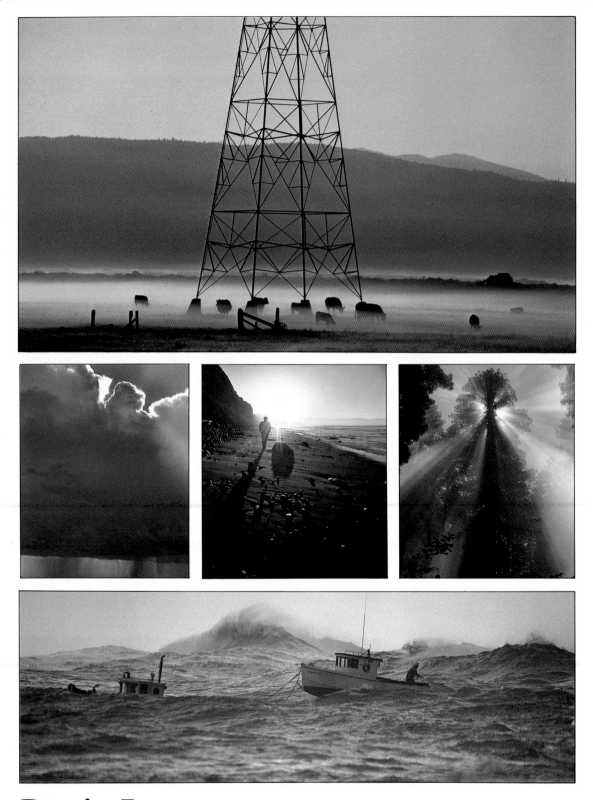

Dewitt Jones San Francisco 415 868 0674

A G R I M A G E

*Specializing In
Agricultural
Photography
Assignment & Stock*

*Telephone
209 266-0305
411 E. Olive Ave.
Fresno, Calif. 93728*

*A Division of
Ros-Lynn
Photography
Phil Rudy
Paul Rutigliano*

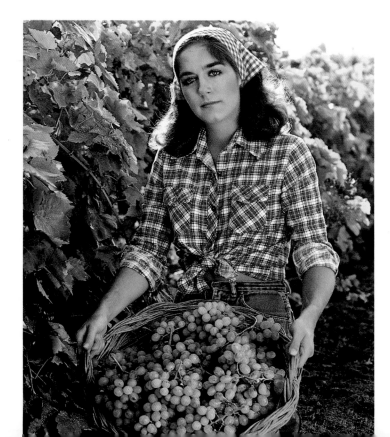

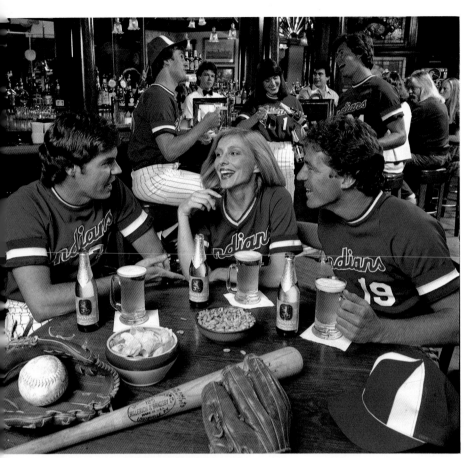

9 Decatur St.
San Francisco
Ca. 94103

415·864·2448

New York Rep:
Joan Kramer
212·224·1758

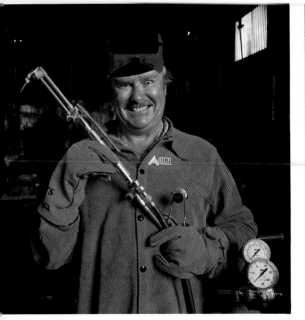

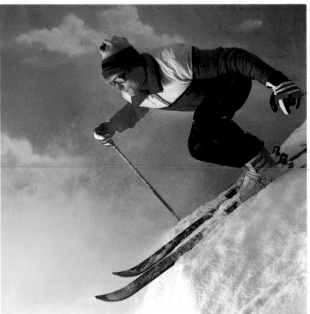

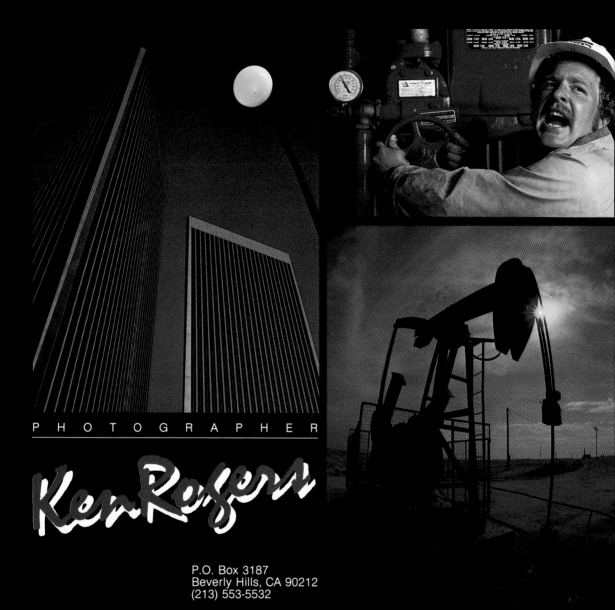

P H O T O G R A P H E R

Ken Rogers

P.O. Box 3187
Beverly Hills, CA 90212
(213) 553-5532

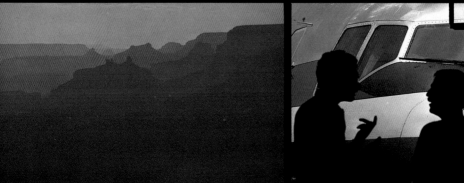

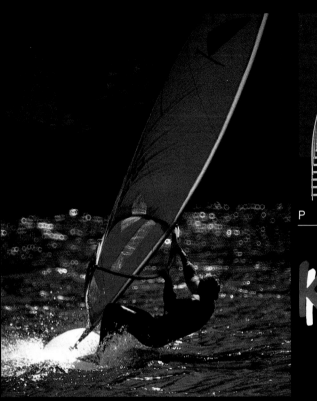

PHOTOGRAPHER

KenRogers

P.O. Box 3187
Beverly Hills, CA 90212
(213) 553-5532

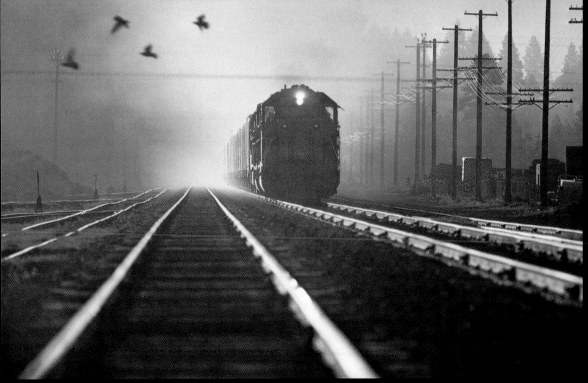

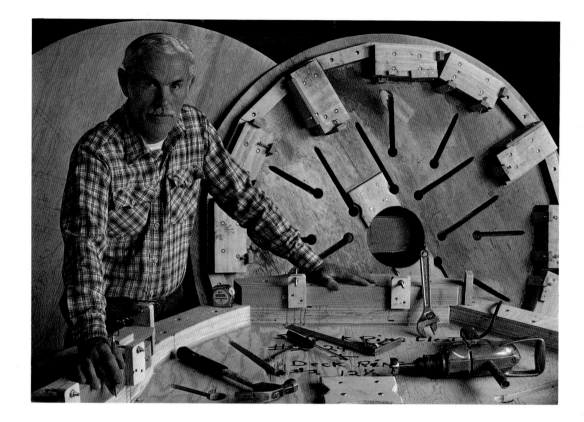

J O H N B L A U S T E I N

665 Alvarado Road
Berkeley, CA 94705
(415) 845-2525

STOCK REPRESENTATIVE:
Woodfin Camp & Assoc.
(212) 750-1020

CLIENTS INCLUDE:
Lawrence Bender & Assoc.;
Chermayeff & Geismar Assoc.;
Corporate Annual Reports;
Corporate Graphics (NY);
James Cross Assoc.;
Danne & Blackburn;
The Office of
Charles and Ray Eames;
Jack Hough Assoc.;
Jonson Pedersen Hinrichs
& Shakery; Unigraphics;
D'Arcy-MacManus & Masius;
Ketchum Communications;
Ogilvy & Mather.

ALSO SEE:
American Showcase
Volume 5 & 6;
Corporate Photography
Showcase Volume 1 & 2;
ASMP BOOK 1981.

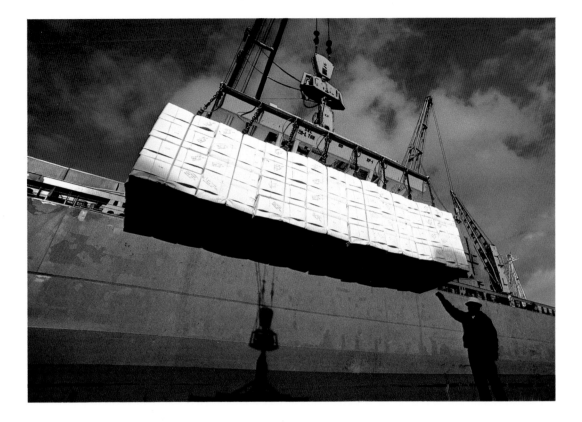

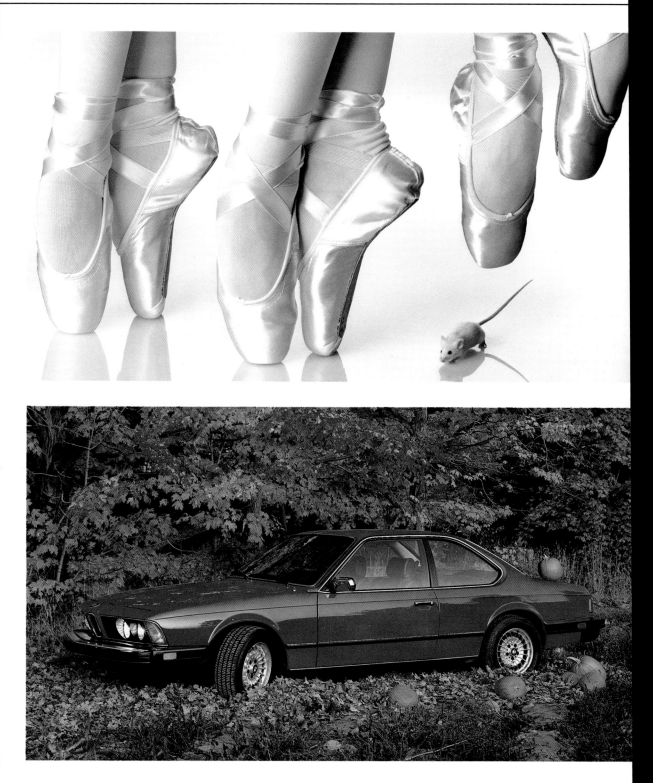

In New York, call Barbara Umlas 212 · 534 · 4008

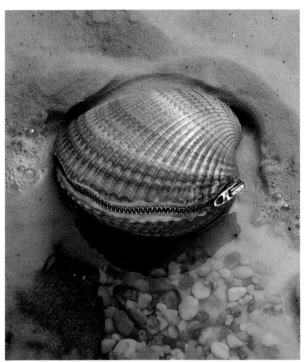

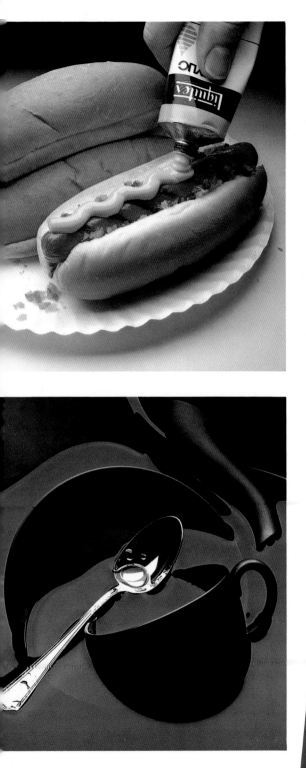

HUNTER
FREEMAN

852
SANTA FE DRIVE

DENVER
COLORADO 80204

303·893·5730

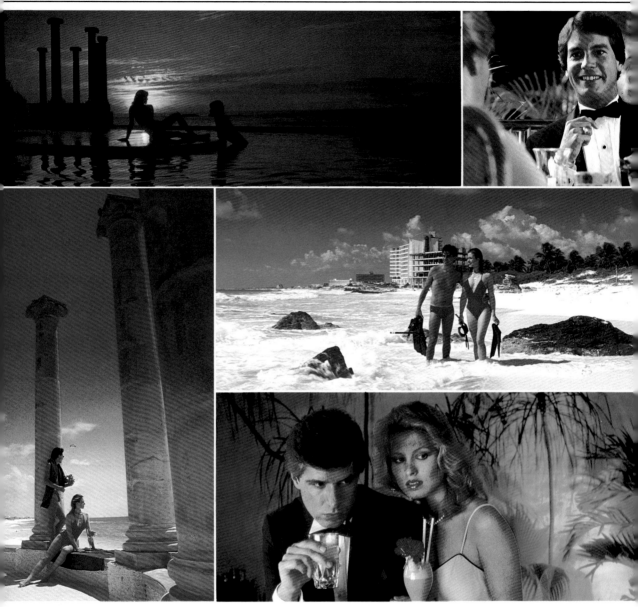

MASTERSON

11211 Sorrento Valley Rd./Suite "S"
San Diego, California 92121
(619) 457-3251
©ED MASTERSON 1983

COLOR SEPARATIONS: *20TH CENTURY COLOR GRAPHICS*

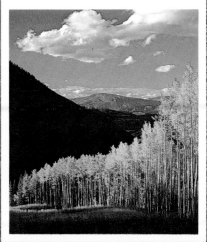

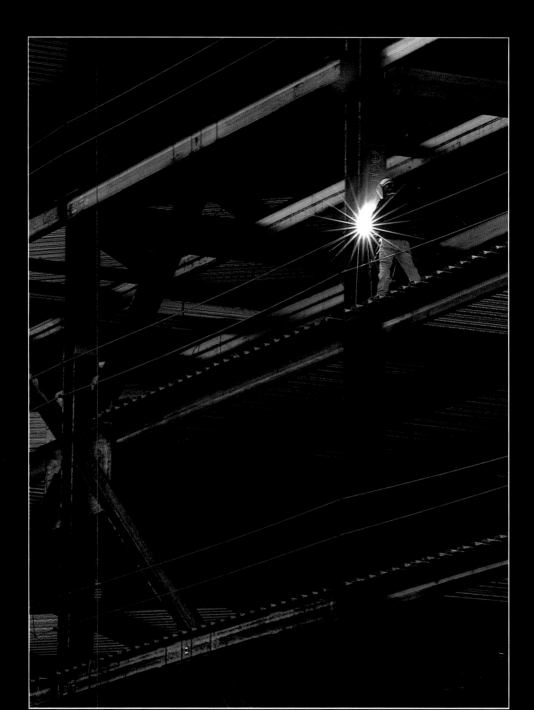

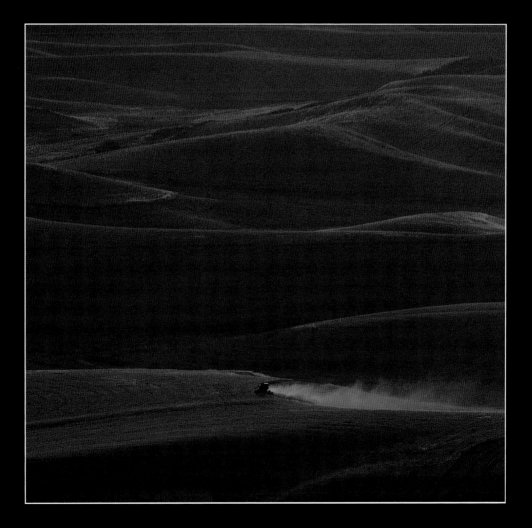

Steve Firebaugh

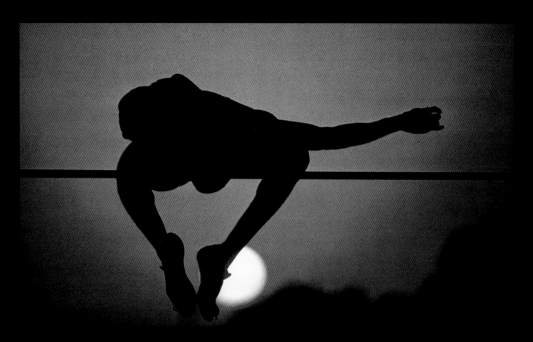

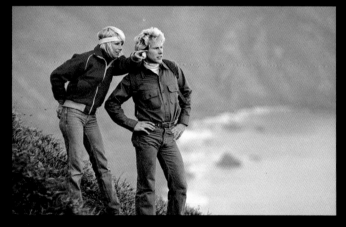

Dave Madison

The real sports look, for all seasons.

San Francisco 415 • 961 • 6297

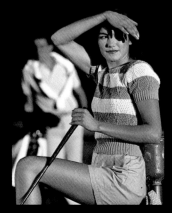

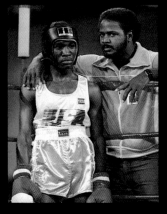

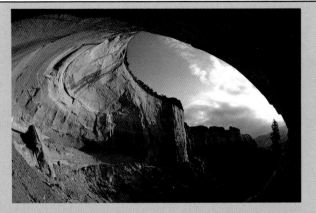

P H O T O G R A P H E R S / A S P E N

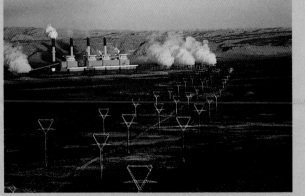

PAUL CHESLEY NICHOLAS DE VORE III DAVID HISER

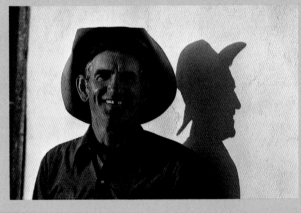

Assignments & Stock
303-925-2317
1280 Ute Avenue
Aspen Colorado 81611

Members ASMP

Clients:
AmTrak
Cathy-Pacific Airways
Exxon
Geo
Goodyear
Gulf Oil
Fortune
Levi Strauss
Miles Laboratories
Money Magazine
National Geographic
Swiss Air
Stern
Time
Tosco Corporation
United Airlines

We work world wide, but the West is our home.
We know the right people, the choice locations, and the best time to be there.

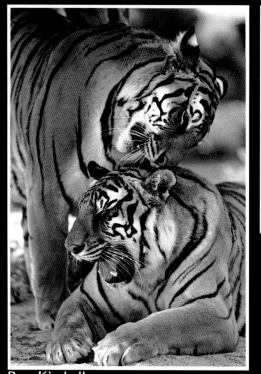

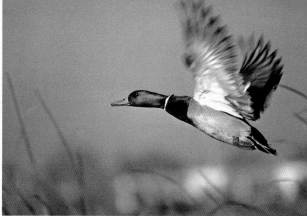

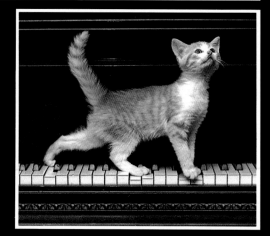

Ron Kimball
Photographer
2582 Sun-Mor Ave.
Mtn. View, CA 94040
415-948-2939

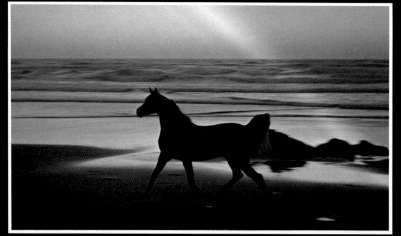

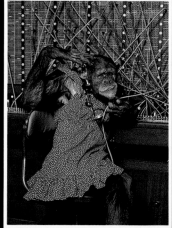

All Photographs © 1983 Ron Kimball

Ron Kimball

ANY ANIMAL
ANYWHERE
WE MAKE IT HAPPEN

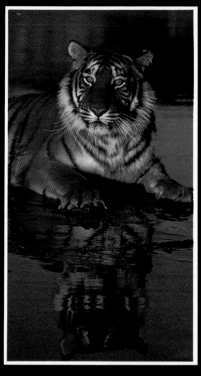

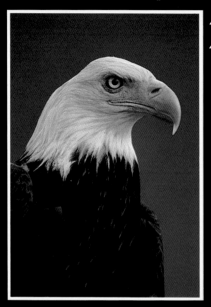

Ron Kimball
Photographer
2582 Sun-Mor Ave.
Mtn. View, CA 94040
415-948-2939

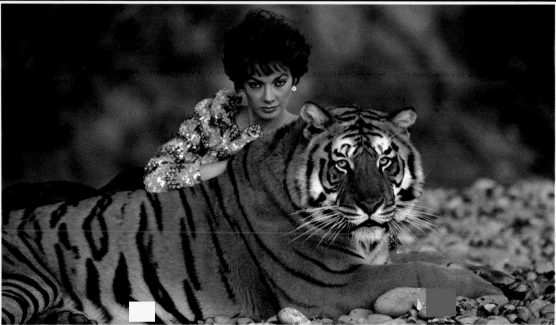

All Photographs © 1983 Ron Kimball

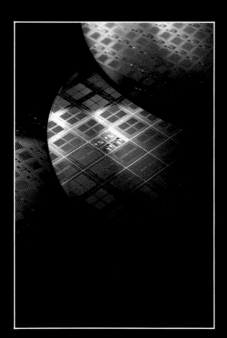

JAY

4 1 6
RICHARDSON

SAUSALITO
CALIFORNIA
9 4 9 6 5

4 1 5
3 3 2 - 6 7 0 9

DESIGNERS

John Cleveland, Inc.
James Cross Design
Jonson, Pedersen, Hinrichs & Shakery
Landor Associates
La Perle/Assoc.
Michael Manwaring
Robert Miles Runyan & Associates
David Torme Design

CLIENTS

Amdahl Corporation
American Building Maintenance
American Micro Systems
Amfac
Apple Computer
Collagen
Fortune Magazine
Geo Magazine
Getty Oil
Grupo Industrial Alpha
Harris Corporation
Holland America Line
Litton Industries
Measurex
Pacific Gas & Electric
Printronix
Royal Viking Line
Sunkist
Syntex

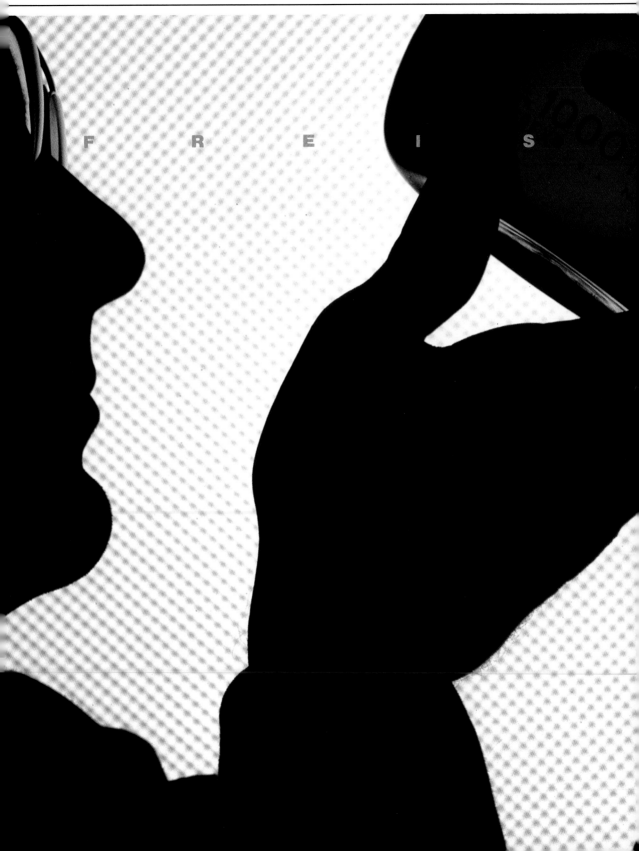

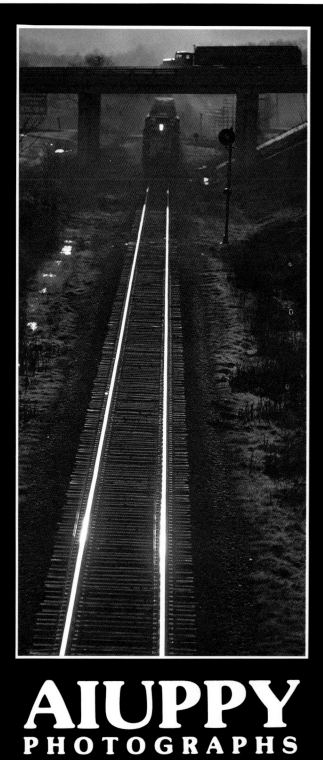

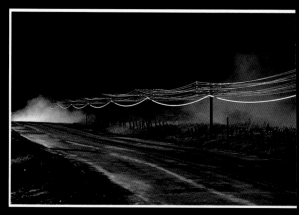

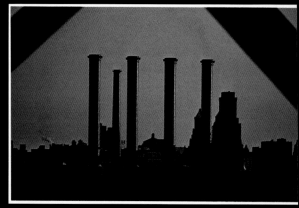

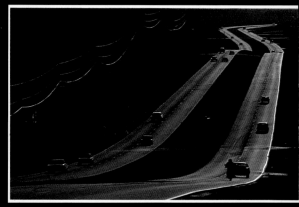

• ROC • D⁰WILDE •

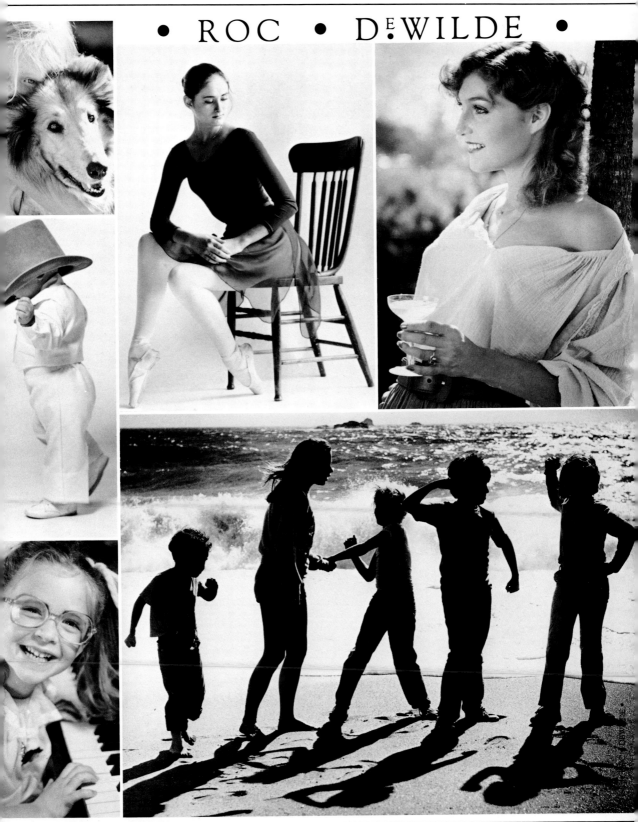

2717 WESTERN AVENUE, SEATTLE, WASHINGTON 98121 (206) 682-6828 REPRESENTED BY: SUSAN TRIMPE (206) 382-1100

"FIND IT HODGES!"

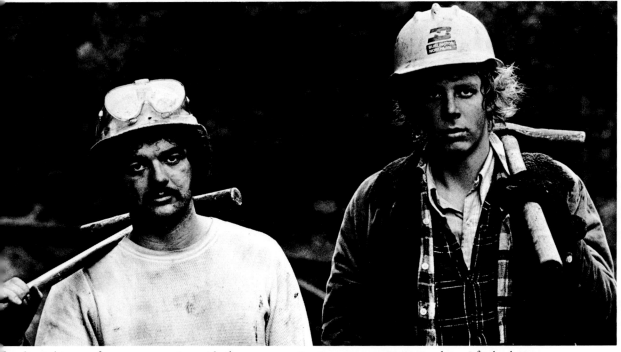

y clients hire me for one reason, I provide them with more than just another beautiful photograph. hotograph solutions. I take the time to listen, to under- nd and then I plan. Regardless of location, logistics or situation my promise is simple... I find solutions. Like Burlington Northern... "we need a working portrait of our men on a Tie Gang. Make it look gritty and strong, but leave them their dignity. **"FIND IT HODGES!"**

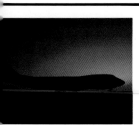

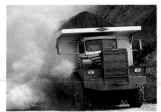

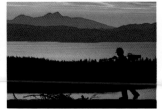

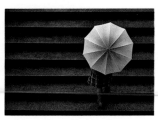

r Kuwait Airways, on the Arabian ..."we want you to photograph irplane, you can have it for half ur at dawn. It's 135° and you ave to maneuver the plane between ing planes. FIND IT HODGES!"

Or in Alabama for Kenworth..."dust is a real problem for us. We need a photograph of a hardworking coal truck in the dust. It's been raining for 3 days solid. FIND IT HODGES!"

Or in Southeast Alaska for Raytheon... "these guys work on their own out there in the wilds. They'd stay there forever if they could, they live their work. Pick up on that. FIND IT HODGES!"

Or for myself..."I kept this damn pink umbrella in the back of my car for 2 years. One day I found the right stairs, poured water on them, kidnapped the first woman I could find and found my solution!"

RESENTED BY
n Trimpe
Washington, Seattle, Washington 98104
382-1100

STOCK PHOTOS
West Stock
Seattle, Washington
206-621-1611

WALTER HODGES
PHOTOGRAPHIC DESIGN
4106 32nd S.W., Seattle, Washington 98126 206-622-3474

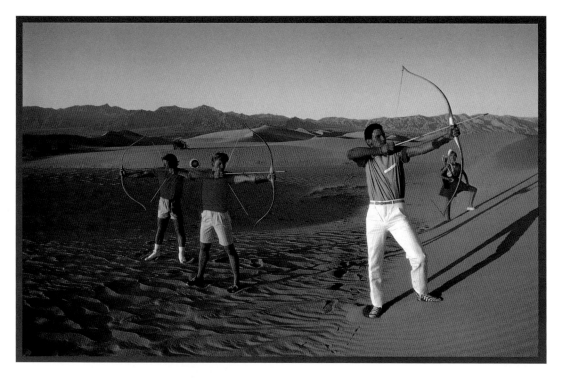

TOM MURRAY PHOTOGRAPHER
Los Angeles California (213) 654-0364

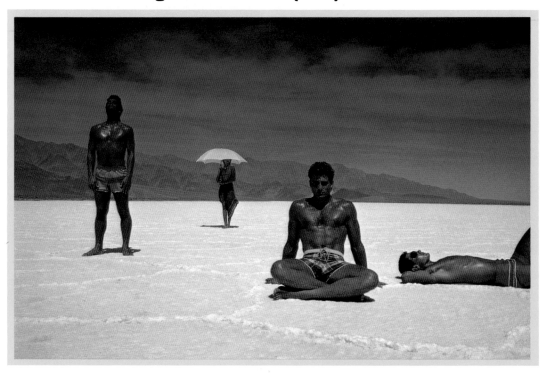

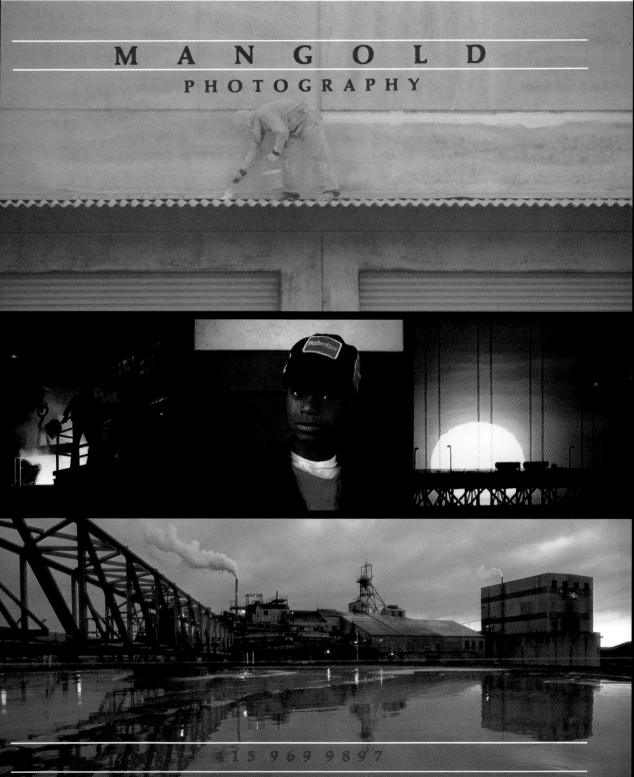

MANGOLD

PHOTOGRAPHY

415 969 9897

Box 601 Palo Alto, CA 94302/164 East Dana, Mountain View, CA 94041

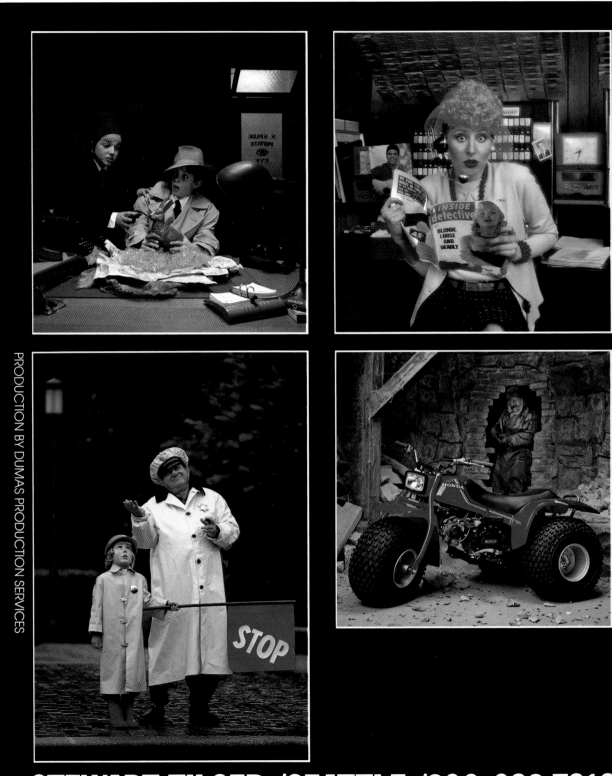

PRODUCTION BY DUMAS PRODUCTION SERVICES

STEWART TILGER/SEATTLE/206-682-7818

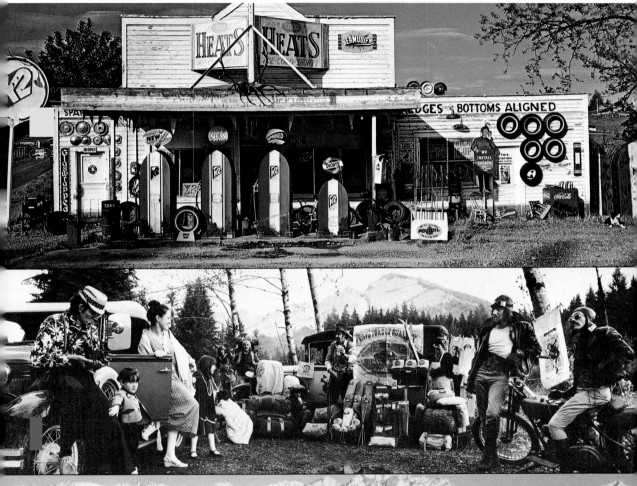

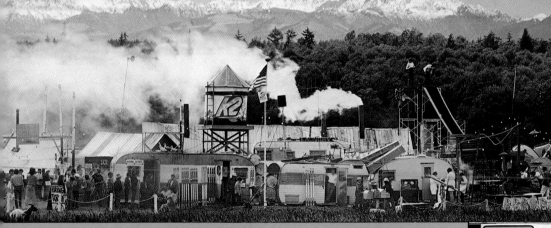

FRANK B. DENMAN

131 15th Avenue East, Seattle, Washington 98112 (206) 325-9260
Represented by Donna Jorgensen 206-284-5080

Specializing in studio and location problem solving, with
particular strength in handling complex location logistics.
Twenty years experience.
Clients include: Boeing, K2, Paccar, Nike, British Columbia Forest
Forest Products, JanSport, Honeywell, Physio-Control, Alaska Airlines,
Seattle First National Bank, Roffe, Snomass, AKI, Tally, Pacific Northwest
Bell, Flow Research, Sage, ITT-Rayonier, Heath-Tecna, Kenworth, Uniflite,
Simpson Timber, Warn Industries, Sundstrand, Owens-Corning, Weyerheuser.

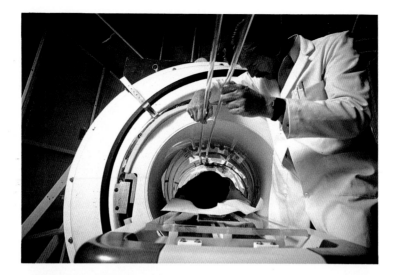

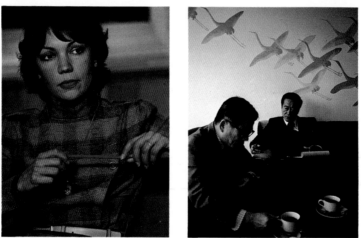

Michael Alexander

**Corporate and
Editorial
Assignment
Photography**

1717 Mason St.
San Francisco, Ca. 94133
(415) 441-6700

Corporate:
IBM, Del Monte, Avis,
Bank of America, Time Inc.,
Bell & Howell, General Mills,
Synapse Computer Corp.,
Norelco, Levi Strauss & Co.

Editorial:
Life, Look, Esquire,
Vogue, People, Fortune,
Time, New York Times,
Newsweek, Rolling Stone,
Horizon, Time-Life Books,
Sports Illustrated, Self,
Money, American Health

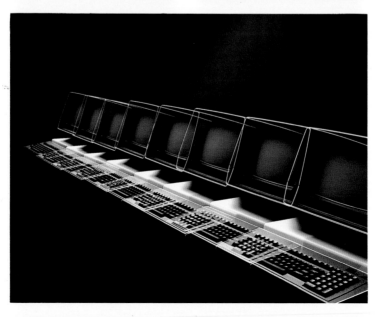

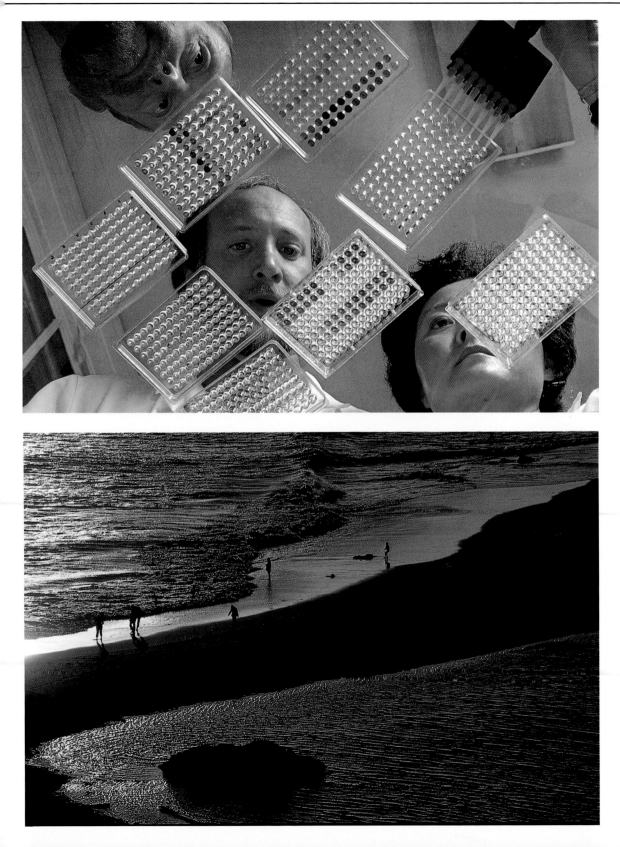

Mason Morfit, Inc.

897 Independence Ave., 5-D
Mountain View, CA 94043

(415) 969-2209

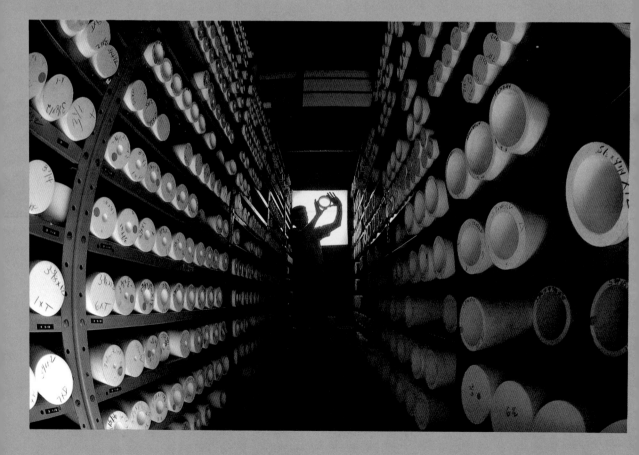

Clients Include:

Aerojet Liquid Rocket Co.
Arnold Saks, Inc.
Avon Products, Inc.
Cabot Corporation
Colt Industries

Fairchild Instrument
GCA Corporation
Herman & Lees Assocs.
Hewlett-Packard
Intel Corporation
Morse Shoe, Inc.

Norton Co.
Prime Computer, Inc.
RCA
Weymouth Design

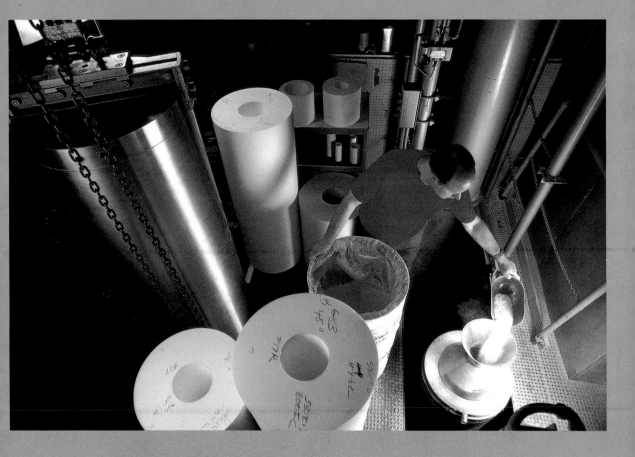

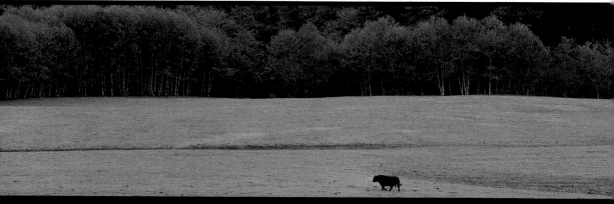

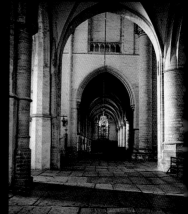

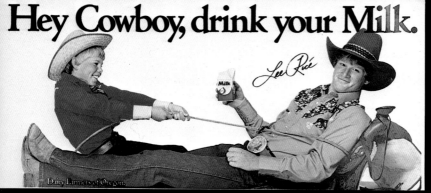

Hey Cowboy, drink your Milk.

Pronounced: Chef Vildskut. He has a 7000 square foot studio, and a 32 foot mobile studio with a four wheel drive unit towed behind to get you to those out of the way locations, and generators to light up the desert. He is the only one equipped this way in the Northwest. He is represented in EUROPE by Roel Hessel at 02977-630, THE NETHERLANDS, and in SEATTLE, WA by Jim Taggart at (206) 935-5524. With hundreds of national ads behind him he would be the right choice no matter what your budget is.

Sjef

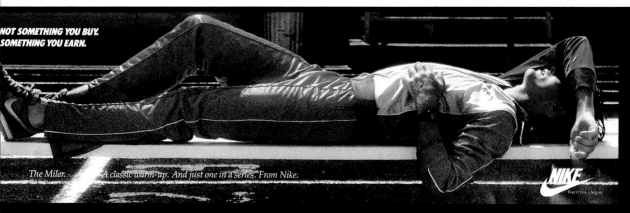

NOT SOMETHING YOU BUY.
SOMETHING YOU EARN.

The Miler. A classic warm-up. And just one in a series. From Nike.

NIKE Beaverton, Oregon

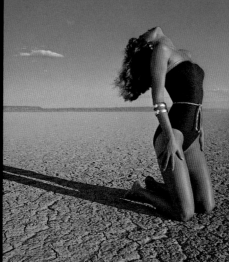

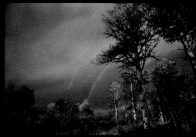

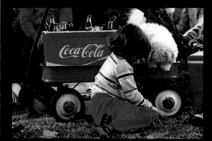

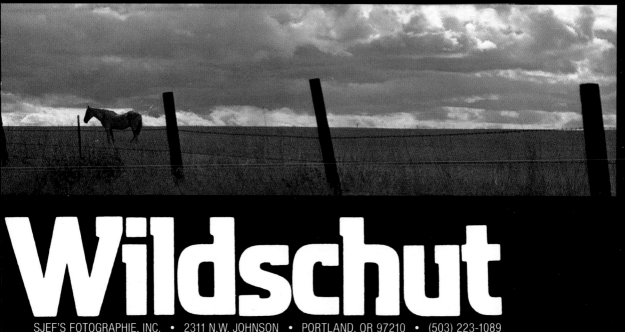

Wildschut

SJEF'S FOTOGRAPHIE, INC. • 2311 N.W. JOHNSON • PORTLAND, OR 97210 • (503) 223-1089

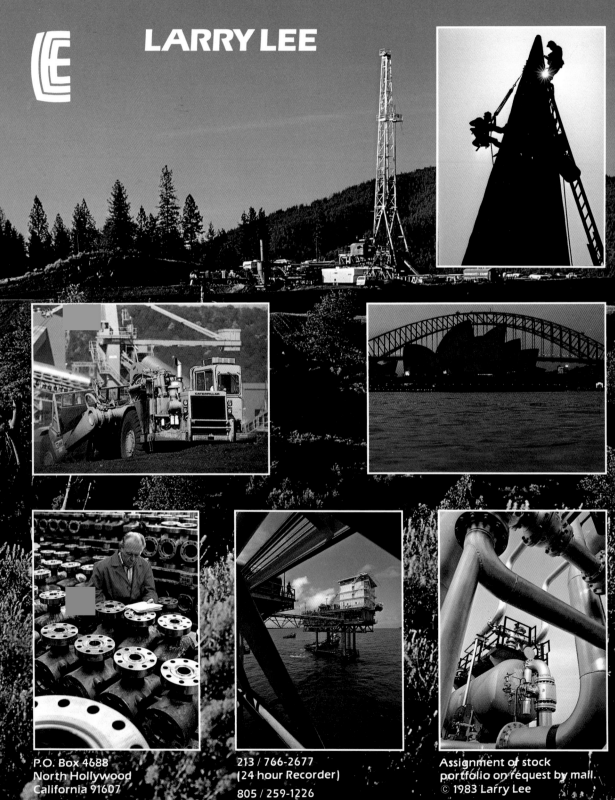

LARRY LEE

P.O. Box 4688
North Hollywood
California 91607

213 / 766-2677
(24 hour Recorder)

805 / 259-1226
(Studio & Home)

Assignment of stock
portfolio on request by mail.
© 1983 Larry Lee

SUSTAINING MEMBERS STOCK PICTURE AGENCIES

APERTURE PHOTOBANK 1530 Westlake Ave N, Seattle, WA (206) 282-8116
ARNOLD INC, PETER 1466 Broadway, NYC (212) 840-6928 **P 437**

BERNARD, MICHAEL G., Liaison Agency Inc, 150 E 58 St, NYC (212) 888-7272
BLUE CHIP STOCK PHOTOGRAPHY, 500 Park Ave, NYC (212) 750-1386 **P 433**

CHANDOHA, WALTER Annandale, NJ 08801 (201) 782-3666 **P 434, 92**

deWYS, LEO INC 200 Madison Ave - 2225, NYC (212) 689-5580 **P 438**

DONIN, LARA PO Box 446 Cooper Sta, NYC 10276 (212) 724-7400
EDITORIAL PHOTOCOLOR ARCHIVES, INC Ted Feder 65 Bleecker St, NYC (212) 697-1136 **P 429**

EYRE, SUSAN, The Stockmarket, 1181 Broadway, NYC (212) 684-7878
GENTRY, JERRY, Images Unlimited, 182 Quadrangle 2800 South, Dallas, TX (214) 747-8230
HENDERSON, ELLEN B., After Image Inc - Ste 402, 6855 Santa Monica Blvd, Los Angeles, CA (213) 467-6033
HINES, TRICIA, West Stock Inc PO Box 4327 Pioneer Sq Sta, Seattle, WA 98104 (206) 621-1611
HOPKINS, PHIL PO Box 49813, Barrington Sta, Los Angeles, CA 90049 (213) 829-2135
KANNEY, STANLEY M., The Image Bank, 633 Third Ave, NYC (212) 953-0303
KRAMER & ASSOCIATES, JOAN 720 Fifth Ave, NYC (212) 224-1758 **P 440**

LLOYD, SALLY, The Stockmarket, 1181 Broadway, NYC (212) 684-7878
MAZZASCHI, MIKE, Stock Boston Inc, 36 Gloucester St, Boston, MA (617) 266-2300
McNEELY, BURTON PO Box 338, Land O'Lakes, FL 33539 (813) 996-3025; Stock (212) 953-0303 **P 435**

TAURUS PHOTOS, Michalski, Ben 118 E 28 St, NYC (212) 683-4025 **P 432**

REESE, KAY 156 Fifth Ave - Rm 1106, NYC (212) 924-5151
SCHULTS, PETER % Photo Researchers Inc, 60 E 56 St, NYC (212) 758-3420
PHOTRI/PHOTO RESEARCH INTERNATIONAL 505 W Windsor Ave, PO Box 971, Alexandria, VA 22313 (703) 836-4439; NY–(212) 926-0682; CHIC–(312) 726-0433; LA–(213) 622-4220 **P 436**

SMITH, MARTHA, Life Picture Service, Time-Life Bldg - Rm 28-58, NYC (212) 841-2387
THE STOCKMARKET 1181 Broadway, NYC (212) 684-7878 **P 430-431**

TOMALIN, NORMAN OWEN, Bruce Coleman Inc, 381 Fifth Ave, NYC (212) 683-5227
WEIDLEIN, PETER 122 W 26 St, NYC (212) 989-5498 **P 439, 200**

WOODFIN CAMP 415 Madison Ave, NYC (212) 750-1020

STOCK

A stock picture is one that is already taken, available on file, and which may be licensed for use or reuse. The photographer may either license its use directly to a client or give permission to a designated representative, such as a stock photo agency, to license the use of the picture to clients in return for a percentage of the license fee. To "license" means to offer permission for limited use of the photograph which is subsequently returned to the owner or agent after reproduction or projection. While photographers may casually say they "sell" stock photographs, they mean they are selling the license to use such pictures, ownership of which remains in their possession.

Today, the selling of stock photography plays an important role in the business life of the professional freelance photographer. Since it can provide a significant and relatively dependable amount of income, it is important that the photographer and the client understand the mechanisms of stock picture licensing, as well as the principles of pricing. ASMP's *Professional Business Practices in Photography* book has become the industry source for such information. Included are more than eleven pages of stock rates in more than twenty fields. Each market has its own requirements, vocabulary and trade practices, and each applies its own scale of prices to photographs. It should be specifically noted that reproduction by any means, including print, audio-visual, TV, or other electronic process devised now or in the future is covered by copyright, and stock pictures may not be licensed or used without the permission of the copyright owner.

The New Copyright Law

The Copyright Law provides protection against reproducing a copyrighted work "in whole or any substantial part ... by duplicating it ... exactly or by imitation or simulation," without permission. Under the new law, a photographer owns the copyright to work that he or she has created on or after January 1, 1978. The major exception is that work done by an employee is owned by the employer, if it is part of the staff member's regular duties. This latter situation is one instance of "work made for hire."

Thus, freelance photographers commissioned for an assignment are not on a regular employment basis and are deemed the copyright owners of their work unless they specifically agree, in writing, to surrender that right.

Protecting Copyright

There are two essential methods of protecting copyright. The first is to include the proper copyright notice on all photographs and their reproduction, and the second is registration in Washington, D.C. It is good practice to include a copyright notice on all work, unpublished as well as published, whether registered or not. Improper notice or failure to provide a notice can result in a loss of protection. The new law, however, prevents the copyright owner from losing the copyright if copyright does not accompany a published photograph, when notice is a condition of license. This emphasizes the importance of also stipulating in writing that the publisher of a photograph is authorized to publish solely on the condition that proper copyright notice is provided.

Admittedly, the area of copyright is a vast one, but ASMP has set up a "hot line" arrangement whereby members and their clients may call ASMP's national headquarters in New York City for answers to questions concerning various aspects of the copyright law. The Society has taken an active and important interest in this area, and its knowledge of copyright ranges from registration procedures and unauthorized uses to fair use and assignments. (The Society's *Business Practices* book devotes eight pages to the workings of the new copyright law; ASMP also publishes periodically updated White Papers on the subject.)

ASMP member photographers are in the business of selling or licensing reproduction rights. The nature of such rights to a specific work which may be transferred to a specific client is primarily an economic decision. The photographer must decide whether the payment offered is adequate compensation for the rights being purchased. The client must decide if the rights acquired are worth the payment asked. The balance between these two factors is settled by negotiation.

APA
Advertising Photographers of America

A group of over 800 advertising photographers and assistants committed to keeping advertising photography a profitable and rewarding business.

APA is a professional trade association with chapters in four major US cities. Through discussion and education we hope to help individual photographers establish higher standards of business practices. APA endeavors to work toward and maintain a healthy, open, honest, and professional business environment.

It takes communication. Please call for information:

APA New York

118 East 25th Street
New York, NY 10010
(212) 254-5500
Diane Lyon

APA Chicago

10 West Elm, Studio D
Chicago, IL 60610
(312) 266-0367
Karyn McCarthy

APA Los Angeles

P.O. Box 480404
Los Angeles, CA 90048
(213) 935-7283
Dorie Laughlin

APA San Francisco

1061 Folsom Street
San Francisco, CA 94103
(415) 332-8831
Keehn Gray

BARRY ELZ

JOHN SCHEIBER

BARRY O'ROURKE

ED GALLUCCI

CHRIS COLLINS

MICHAEL K. DALY

ART KANE

RICHARD STEEDMAN

MICHAEL AMBERGER

BILL SUMNER

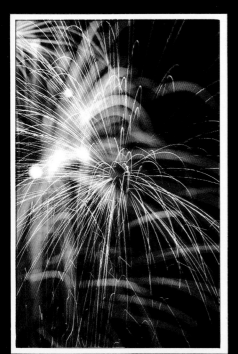
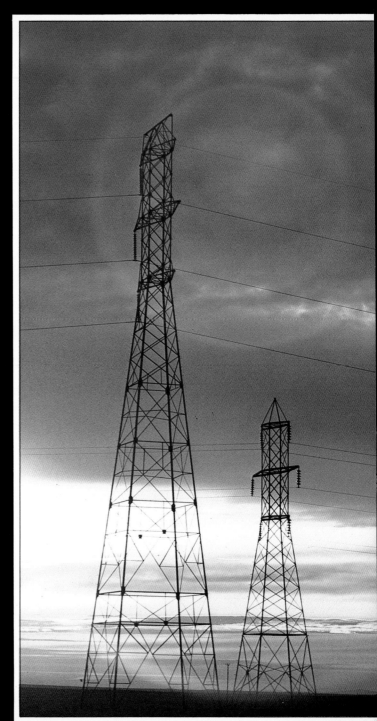

BLUE CHIP STOCK

BLUE CHIP STOCK PHOTOGRAPHY
500 PARK AVENUE
NEW YORK, N.Y. 10022 (212) 750-1386

Catalog on request.

NEW YORK LONDON DÜSSELDORF TOKYO

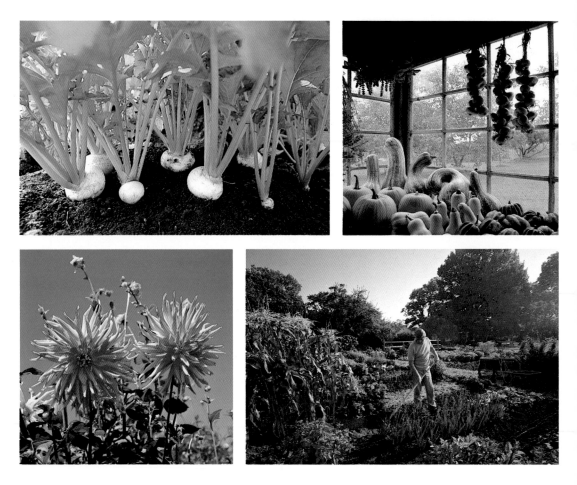

WALTER CHANDOHA

©Walter Chandoha 1983

CATS • DOGS • HORSES • FARM & AFRICAN ANIMALS
GARDENS & GARDENING • VEGETABLES & FRUITS • HERBS • BERRIES • GRAINS
WILD & DOMESTIC FLOWER • ECONOMIC & DECORATIVE PLANTS
SHRUBS • TREES • LEAVES • THE FOUR SEASONS • SUNS • SCENICS • SKIES
WEATHER & ENVIRONMENT • POLLUTION • CONSERVATION

Over One Hundred Thousand
ANIMAL • HORTICULTURE • NATURE
STOCK PHOTOGRAPHS

WALTER CHANDOHA • ANNANDALE, NJ 08801 • 201-782-3666

STOCK PHOTOS

BURTON McNEELY

Adventure, recreation and leisure-time activities with BELIEVABLE people. MODEL RELEASES for photos. **P.O. BOX 338, LAND O' LAKES, FL 33539, 813/996-3025.**

Stock agency:

IMAGE BANK, N.Y.C. (and world-wide) 212/953-0303.

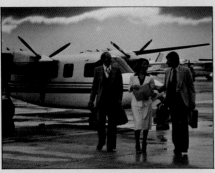

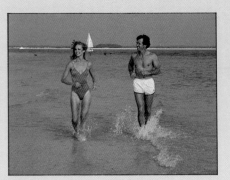

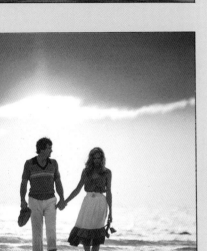

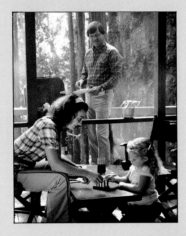

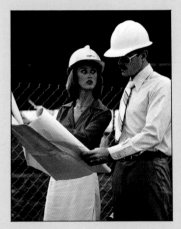

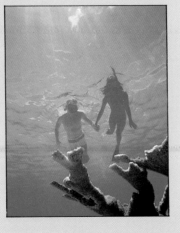

Send $2.00 for a color portfolio. We'll gladly submit a selection of any subject for a modest research and postage fee.

Photos © 1983
Burton McNeely

Photri Goes National...

"Capitol and Mall at Sunset"
Washington, D.C.

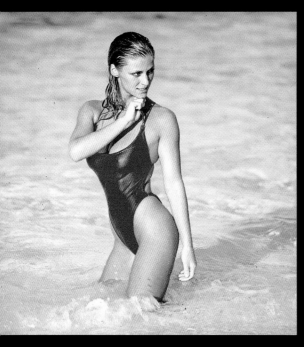

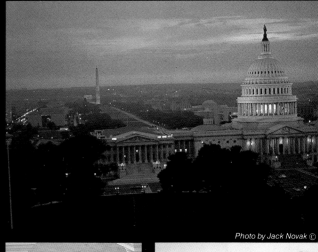

Photo by Jack Novak ©

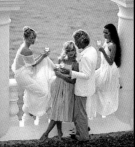

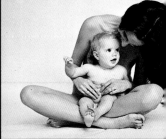

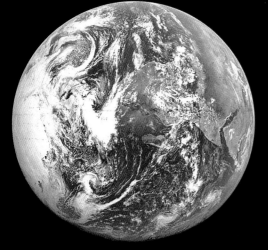

Try Photri first—save time and dollars.
Call us from anywhere, any time. We will have
the image you need on your desk when you
need it. Photri specializes in stock photos of
space, aerospace, military and the nation's
Capital. And that's not all: any subject from A to
Z...plus custom photo research. We have
satisfied customers from all over the world who
appreciate a little extra effort. Even New Yorkers
eventually rely on PHOTRI.

Photri **Photo Research International**
505 West Windsor Avenue
P.O. Box 971
Alexandria, Virginia 22313

Telex: 89-9167

© Photri 1983

Atlanta	Chicago	Dallas	New York	Los Angeles	Virginia	Washington, D
(404) 588-9609	(312) 726-0433	(214) 641-6049	(212) 926-9682	(213) 623-4220	(703) 836-4439	(202) 836-44

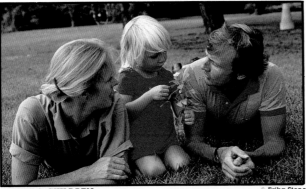
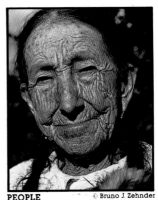
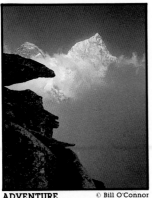
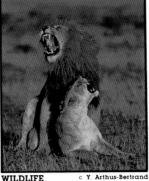
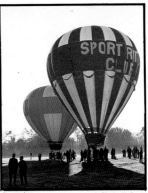
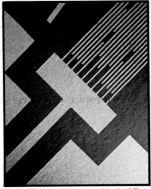
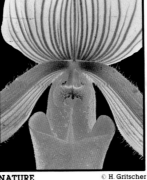
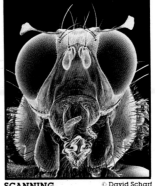

THE WORLD

By ° STEVE VIDLER

BALI

STATUE OF LIBERTY

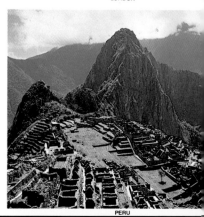

SPAIN

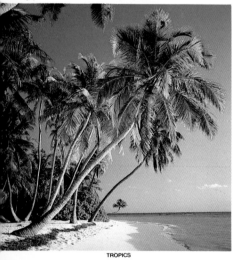

TROPICS

JAPAN

LONDON

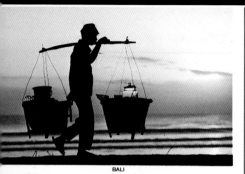

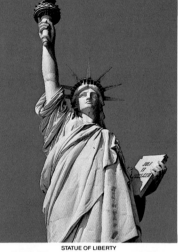

EGYPT

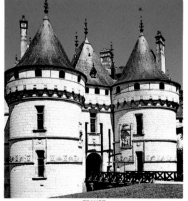

FRANCE

PERU

LEO de WYS INC.

CONTACT: REVA DORBIAN • (212) 689-5580 • 200 MADISON AVENUE, NYC, NY 10016 TELEX: 23866

Peter Weidlein
212 · 989 · 5498

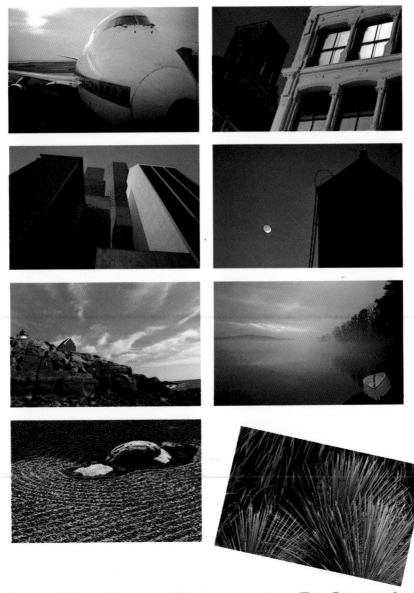

Advertising/Product Corporate/Industrial Travel

Peter King Weidlein 1983

A SURE THING IN THE STOCK MARKET

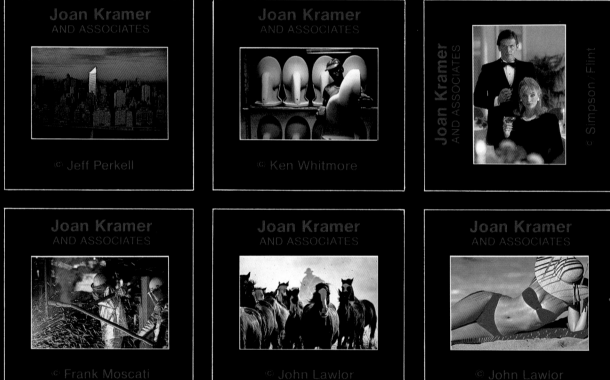

Joan Kramer AND ASSOCIATES

© Jeff Perkell

Joan Kramer AND ASSOCIATES

© Ken Whitmore

Joan Kramer AND ASSOCIATES

© Simpson/Flint

Joan Kramer AND ASSOCIATES

© Frank Moscati

Joan Kramer AND ASSOCIATES

© John Lawlor

Joan Kramer AND ASSOCIATES

© John Lawlor

CALL JOAN KRAMER AND ASSOCIATES

Thousands of photographs–all model released.
If you're in the market, we've got the stock.

(212) 224-1758

stock photography-photo assignments

© 1983 Joan Kramer & Associates, Inc.

INDEX